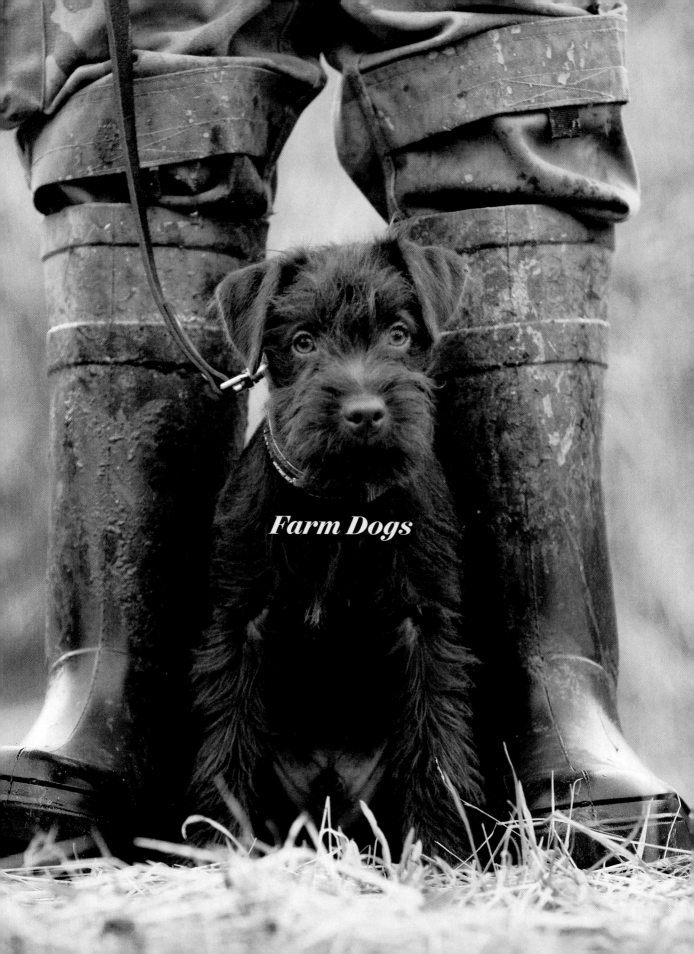

Farm Dogs

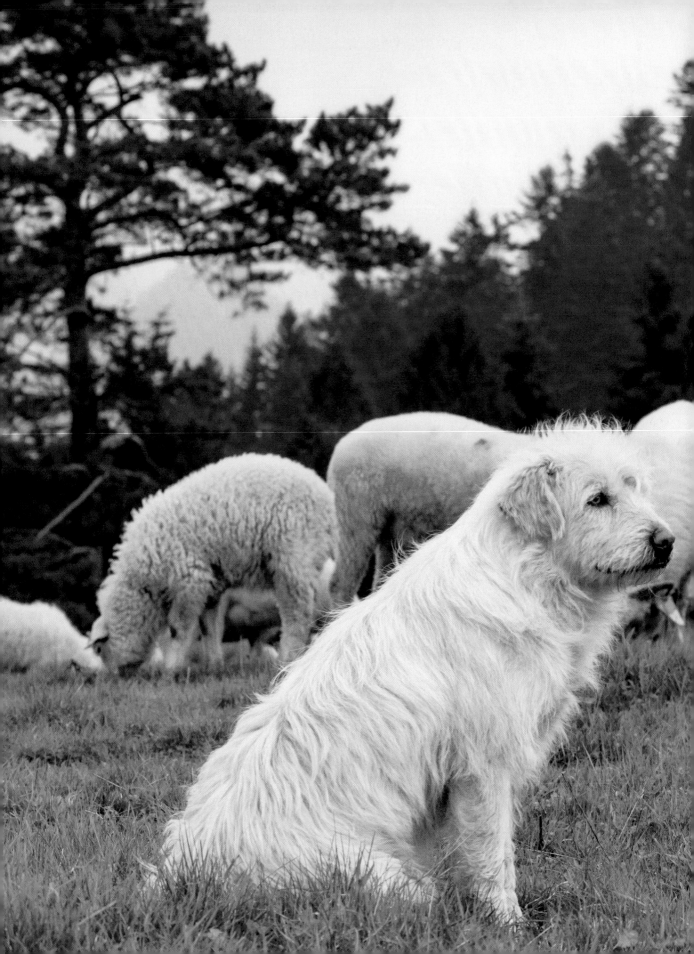

Farm Dogs

A COMPREHENSIVE BREED GUIDE *to*
93 Guardians, Herders, Terriers, and Other Canine Working Partners

Janet Vorwald Dohner

Storey Publishing

The mission of Storey Publishing is to serve our customers by publishing practical information that encourages personal independence in harmony with the environment.

EDITED BY Deborah Burns and Lisa H. Hiley
ART DIRECTION AND BOOK DESIGN BY Michaela Jebb and Mary Winkleman Velgos
COVER DESIGN BY Alethea Morrison
TEXT PRODUCTION BY Liseann Karandisecky
INDEXED BY Andrea Chesman

COVER PHOTOGRAPHY BY © Amana Images Inc./Alamy: back, top right; © Animal Photography/Alamy: back, top center; © Arco Images GmbH/Alamy: spine, top; © Grewe-Fotodesign/Alamy: front, top; © Grossemy Vanessa/Alamy: back, bottom; © John Daniels/ARDEA: front, bottom center; © Juniors Bildarchiv GmbH/Alamy: front, bottom left; Leuchtenderhund/Wikimedia Commons: back, top left; © Pam Langrish: front, bottom right and spine, middle and bottom

INTERIOR IMAGE CREDITS on page 340

BREED IDENTIFICATION ON COVER AND OPENING PAGES
Front cover, main image: Kuvasz
Back cover: (top, left to right) Greater Swiss Mountain Dog/Bernese Mountain Dog/Appenzeller Sennenhund/Entlebucher Mountain Dog, Anatolian Shepherd Dog, Pembroke Welsh Corgi; (bottom) Dachshunds
Spine: (top to bottom) Rough Collie, Australian Cattle Dog, Great Pyrenees puppy
Opening pages: (page i) Patterdale Terrier; (page ii) Polish Tatra; (page 5) Kangal Dog

Storey Publishing
210 MASS MoCA Way
North Adams, MA 01247
storey.com

Printed in the United States by R.R. Donnelley
10 9 8 7 6 5 4 3 2 1

Library of Congress Cataloging-in-Publication Data on file

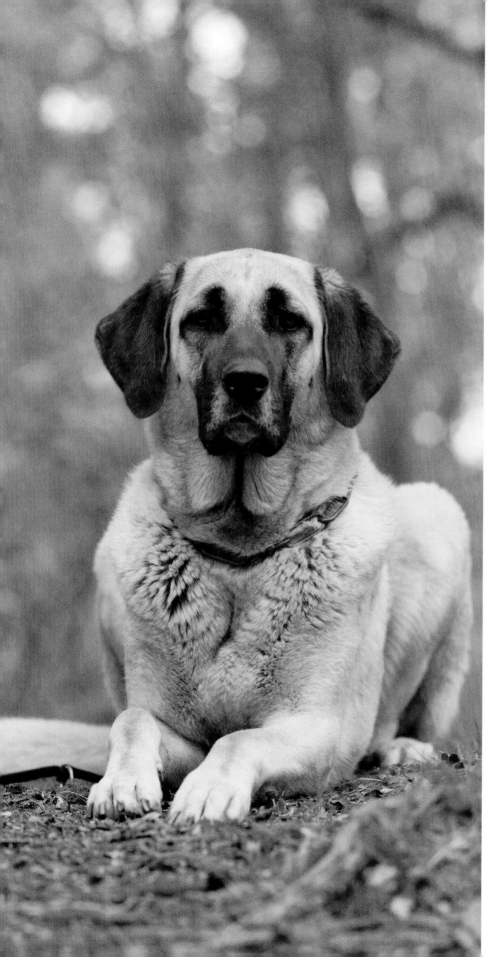

This book is dedicated to the owners and breeders who are committed to preserving the health, temperament, and distinctive working behaviors of their chosen breed. These breeds are a gift to us, selected and shaped by people who worked with their dogs in the past. It is our responsibility to treasure and preserve them for the future.

Contents

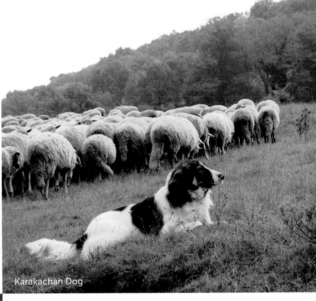
Karakachan Dog

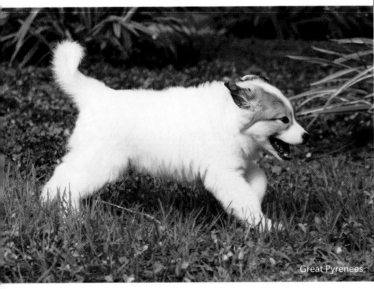
Great Pyrenees

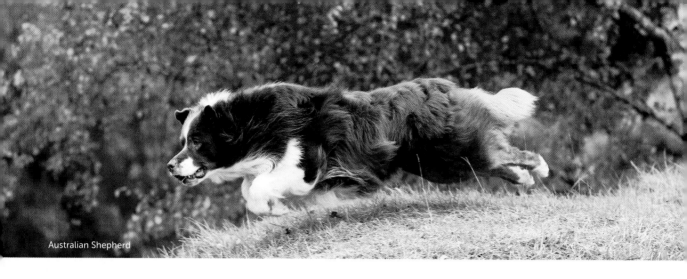
Australian Shepherd

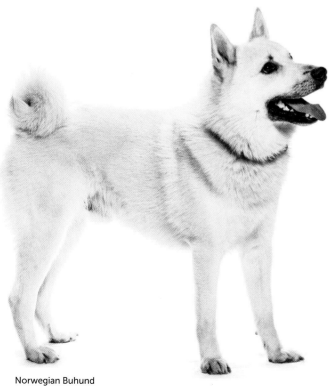
Norwegian Buhund

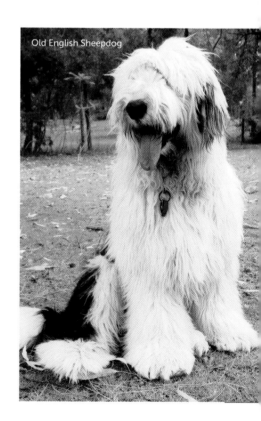
Old English Sheepdog

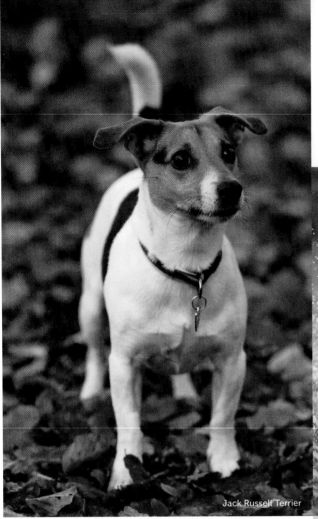

Jack Russell Terrier

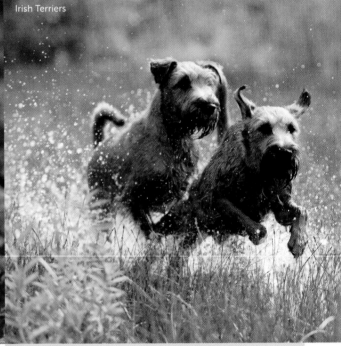

Irish Terriers

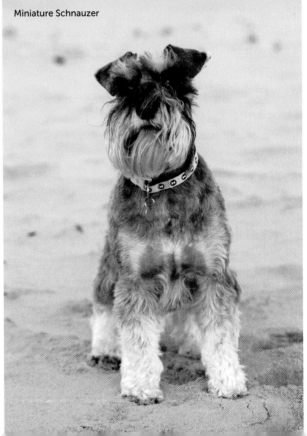

Miniature Schnauzer

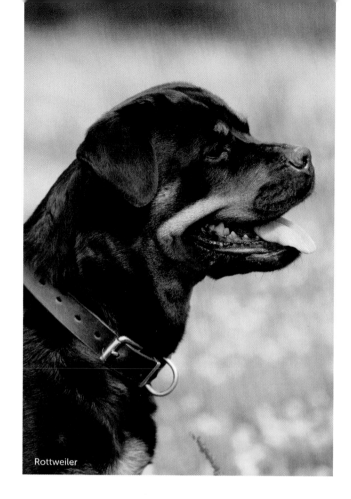
Rottweiler

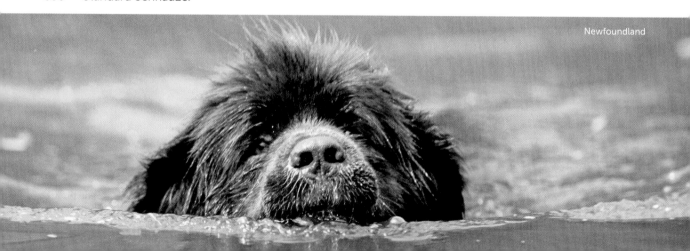
Newfoundland

Introduction

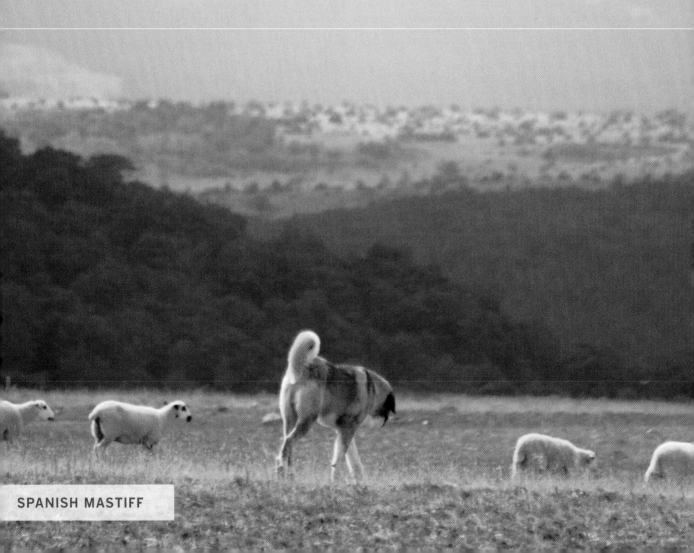

SPANISH MASTIFF

What do you see in your mind when you think of farm dogs? Probably sheepdogs first — agile Border Collies, old-style farm collies, shaggy shepherds, darting corgis, and tough stock dogs. Then there are the noble guardians that watch over flocks or herds and protect the property from intruders of all kinds. There's usually a terrier or earthdog — sleek, tousled, or wiry — somewhere on a farm pursuing rats and other vermin in the barns and stables and around the outbuildings, or digging and crawling through burrows and dens. And don't forget those great all-purpose dogs that traditionally did a little bit of everything on the farm from herding to protecting to small-predator control (some even pulled the farmer's carts to market).

For millennia, humans lived and worked with a handful of canine types that were selected and bred to do particular work. More recently, those basic types have been developed into 350 internationally recognized breeds and additional landrace types found around the world. This book focuses on the best dogs for farm life, be it as a true working partner or more of a family companion to a rural lifestyle. The dogs that traditionally and historically fulfilled these roles are still best suited to this role and place, and they make superb full- or part-time workers and companions.

The selection of breeds was determined by the jobs traditionally done by working farm dogs:

- Guarding the flocks
- Protecting the farmstead
- Herding, driving, and working with livestock
- Controlling rats and other vermin
- Pulling carts and other small conveyances
- Serving as all-around extra farmhand and jack-of-all-trades

Using these specific criteria meant leaving out some popular and favorite breeds. One of the biggest groups missing from this book is sporting dogs — gun dogs, retrievers, scenthounds, big game hounds, and sighthounds. Yes, they are amazing working dogs that often make good companions, but their primary role was as a hunting companion and not as an indispensable worker on a farm or ranch. Today, as well, hunting is for most people a hobby or a sport rather than an essential activity for feeding a family.

Sled dogs, though essential to the peoples of the Arctic lands, were not part of a traditional agrarian lifestyle. And again, dogsledding is now more of a sport than a survival activity for most people. Also not included are the breeds that were originally developed and have been used since ancient times as dogs of war or for bear and bull baiting or for dog fighting itself. Throughout history, these activities were never farm work. Giant breeds that are extremely large and heavy are not included, as they lack agility and are generally unable to do sustained hard work in all types of weather. Breeding for new extremes in size or weight is a recent trend that has altered the appearance and abilities of some former working dogs. Also excluded from this book are terriers that were not originally bred to actually work as ratters or earthdogs, unless they were traditional farm workers. Some terriers are primarily companion dogs and some never worked in this way at all. Very small companion dogs don't have a place here either.

While many of the breeds that are described above do make excellent family pets, they are specialists whose original purpose was not as a hardworking farm or ranch dog. In addition, some of their traits are not a good mix with the livestock or poultry often found on the farm. Are there exceptions? Of course there are, but the goal here is to introduce you to the breeds that possess real abilities for working on the farm. These breeds, many of which are active or quite large, are well suited for country life and happy to be there. In fact, most of these breeds don't do well without a job. Whether you are a working farmer or rancher or someone who enjoys living in the country, and you want a dog who has the brains and self-reliance and devotion to do a useful job, then this is the book for you.

Because this book discusses aptitudes and inherited behaviors for actual working jobs rather than categorizing the breeds by the groups designated by kennel clubs, it is organized a bit differently than most breed books. There are four groups here: livestock guardian dogs; herding and stock dogs; working terriers and earthdogs who go to ground; and multipurpose or traditional farm dogs.

These breeds were created and perfected by people who raised livestock or lived on farms. These are the dogs that farmers, ranchers, and folks who lived in the country depended on. You might not find all of the popular breeds in these pages, but you will discover breeds that are uniquely suited to working and living where people have space and jobs for them to do. Many folks have two or three! Somewhere in this book there is sure to be the right dog for you, your family, and your farm, whatever your situation.

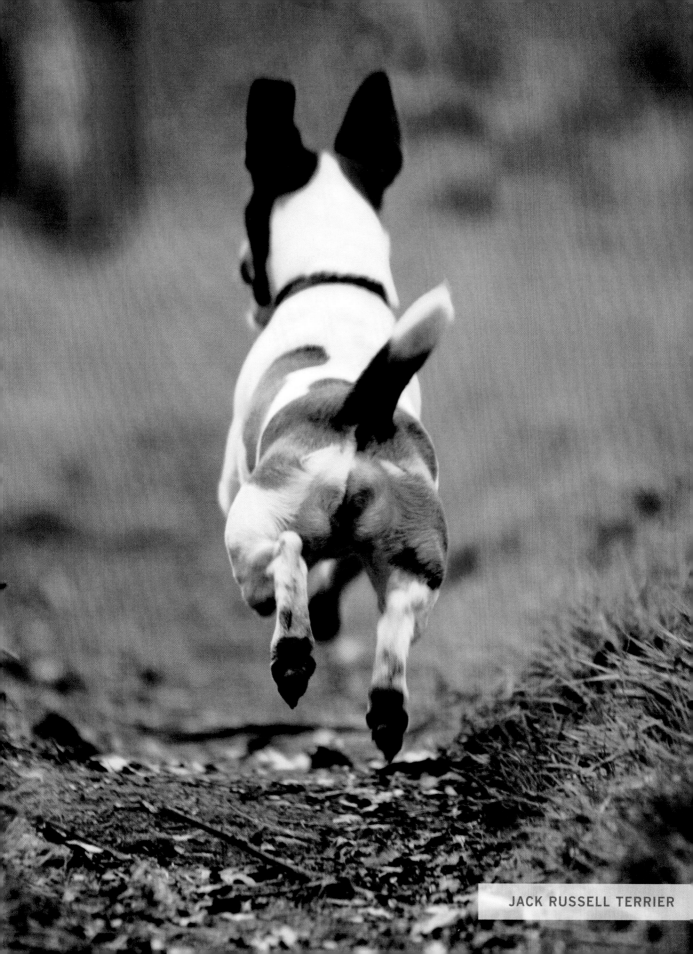

JACK RUSSELL TERRIER

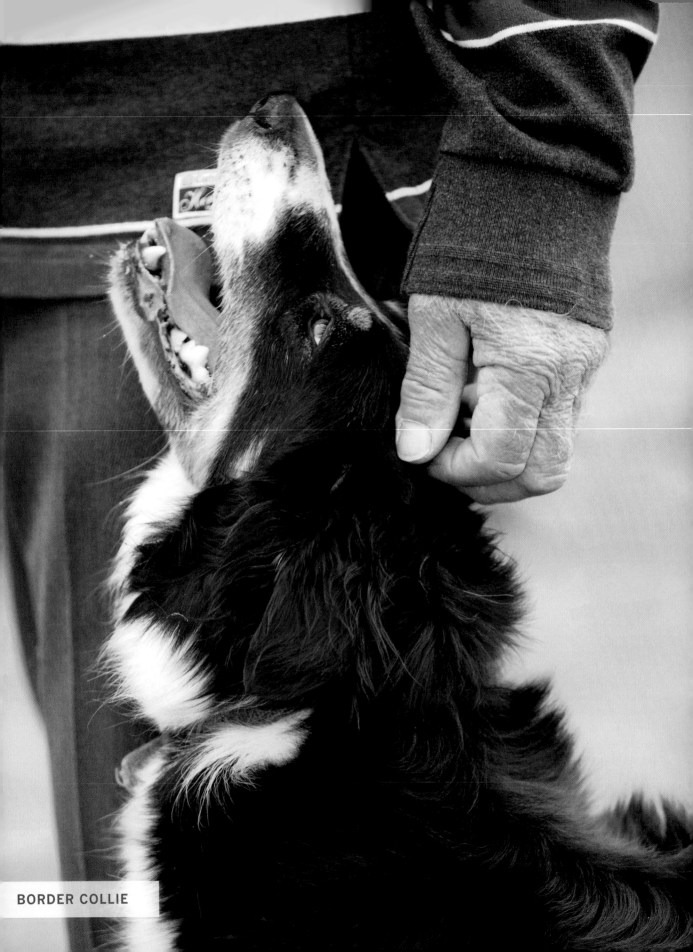

BORDER COLLIE

A Short History of Man and Dog Together

For centuries, dogs and humans have formed true working partnerships, with dogs acting as hunters, herders, guardians, and even warriors. Their work was extremely valuable and often indispensable, and it still is today, when most dogs primarily fulfill the role of family member and friend. No animal has been our companion longer, and on our journey together we have forged a unique bond.

Speculations about the origins of the domestic dog, *Canis familiaris*, continue to appear with new discoveries in genetics and archeology. The proposed time of dog and human association has varied from 14,000 to 135,000 years ago. Although it was previously widely believed that the dog descended directly from the gray wolf, the most recent genetic studies suggest that early dogs and gray wolves evolved separately from an older, now-extinct ancestor sometime between 11,000 and 16,000 years ago. This research also suggests that dogs are more closely related to each other and not to the gray wolves found in Europe, Asia, North Africa, and North America.

Since this divergence, interbreeding has occasionally occurred between gray wolves and domestic dogs, which accounts for the genetic overlap that does exist between the two. Discoveries from ancient human sites of what are likely dog remains date back 20,000 to 33,000 years ago; it's possible, however, that these remains belong to a different early dog that did not survive into modern times. Clearly identifiable domestic dog remains date to about 14,000 years ago. These remains can be found in human graves and graves of their own, surely indicating that the dogs were important to humans even then.

Scientific research supports the story of early dogs that were the companions of hunter-gathers before settled agricultural life began. Did domestication occur in one place or several? Who adopted whom? Did these early dogs see an advantage in associating themselves with humans? Or did humans bring dogs into their protective circle? Perhaps both developments occurred simultaneously. Rather than seeing domestication as being imposed on an animal by humans, some experts believe that the relationship is symbiotic and benefits both species. The complete story of dog domestication is complex, definitely incomplete, and perhaps unknowable. No doubt as this fascinating research continues, we will discover more clues to our joint story.

How It All Started

Assisting his human clan with hunting and guarding were probably the first jobs of the early domestic dog. The dog contributed his superior senses, his speed, and his aggressive strength to both jobs. Hunting as partners, human and dog were more successful, which benefited them both. The dog could also serve as a beast of burden and a source of food and/or fur. He certainly functioned as the scavenger and cleanup crew wherever humans camped or lived, as well as chased away wild animals that ventured too close.

Sometime after dogs entered the human sphere, goats and sheep were domesticated, although pigs may have been domesticated earlier in some places. Ten-thousand-year-old evidence points to goats and sheep living as domesticates in ancient villages found in modern-day Jordan, Turkey, Afghanistan, Turkmenistan, and Uzbekistan. When humans settled into an agrarian lifestyle, they began to select dogs for new jobs.

Different dogs with specialized behaviors were needed to herd and guard livestock, to hunt the vermin that threatened the stored foodstuffs, and to accompany hunters who left the settlements in pursuit of game. Large placid dogs worked as draft animals. Even among nomadic peoples, dogs protected both the humans and their livestock. All these ancient dogs, although unrecorded in word and picture, were the distant ancestors of all the breeds to come.

The Beginning of Breeds

As dogs began to be selected for performing specialized jobs, they began to evolve into identifiably different types. We see evidence of this early in the historical record — from the ancient Egyptians, Sumerians, and Assyrians, through the classical era of Greece and Rome to the early Middle Ages. Several broad types were recorded in images and text.

Shepherd's Dogs

Although the essential shepherd's dog could be found everywhere, the type was often dismissed by the aristocracy for its lowly and rough ways and was only rarely featured in artwork. These early sheepdogs were not the herding dogs we think of today, but the larger guardians of the flocks and herds. In the company of human shepherds, these dogs protected against wolves, wild or roaming dogs, other predators, and thieves. While the very earliest sheepdogs were described as dark in color, the Roman writers always recommended white dogs, although white and black dogs were also noted.

Spitz Dogs

Today we usually think of the prick-eared, curly tailed spitz dogs as northern breeds, but they were found in central Europe and into the Far East. Husky-like dogs with prick ears are depicted on Armenian carvings from three thousand years ago. At about the same time on the steppes of Kazakhstan, dogs that resembled the spitz were used to herd horses. Today we still find local *botai* dogs, of that type, hunting with humans and their horses. Spitz dogs were used as herders, hunters, and sled dogs in the north. In many areas, small spitz dogs were also kept as pets.

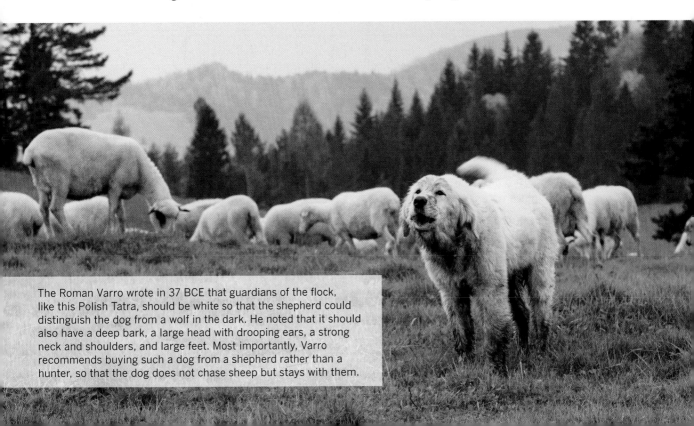

The Roman Varro wrote in 37 BCE that guardians of the flock, like this Polish Tatra, should be white so that the shepherd could distinguish the dog from a wolf in the dark. He noted that it should also have a deep bark, a large head with drooping ears, a strong neck and shoulders, and large feet. Most importantly, Varro recommends buying such a dog from a shepherd rather than a hunter, so that the dog does not chase sheep but stays with them.

Domestication

The biological process of domestication is a complex one that affects both behavioral and physical traits. To be a candidate for domestication, a species must be flexible in everything from diet to social structure to basic temperament to breeding patterns. Humans make use of this flexibility in selecting which animals to breed, choosing desirable qualities or traits. Because mammals change so much as they grow, there is great potential for human-directed differences. People often choose to breed certain species for juvenile appearances and behaviors in domesticated animals. This retention of juvenile traits is called "neoteny."

Because of neoteny, dogs can be selected for juvenile features, such as shorter jaws, flatter or shorter skulls, smaller bones or teeth, and rounder or larger eyes. Smaller brain size can result in lower intelligence or self-sufficiency, though some humans value those traits and select for them as well.

Dogs also possess altered social behaviors, some of them juvenile. The critical socialization period of dogs begins later than that of wolves and lasts longer before the fear stage emerges. Dogs also have increased docility and submissiveness. Adults can be less protectively maternal or paternal, allowing human interaction with their pups.

In dogs, the process of domestication and selective breeding has changed the adrenal system, the nervous system, the sensory system, and brain chemistry. Dogs have also been selected to mature earlier than other canids and they come into heat approximately twice a year rather than the single seasonal estrus of their wild relatives.

Selecting for desirable traits might have brought along some of these other changes. In Dmitri Belyaev's well-known farm-fox experiment, he selected only for increased docility toward humans, but other characteristics emerged, including a delayed development of the fear response, changes in coat color, floppy ears, curly and wagging tails, shorter and wider snouts, smaller skull size, earlier sexual maturity, larger litters, and a longer breeding season. The Belyaev foxes also respond to human cues, such as pointing, implying that the foxes were more attuned to human interaction.

Beyond selection for docility and juvenile appearance or behavior, captive breeding and human selection are responsible for much of the diversity of both physical traits and behaviors we see in dog breeds today. Different breeds possess typical temperaments and levels of reactivity or aggression. Dogs have also been selected for the different behaviors that form the parts of the predatory sequence. Predator behavior can be broken into separate elements or portions: search/stalk/chase/bite and hold/bite and kill/dissect/consume.

Through human selection, different dog breeds express one or more of these behaviors, amplified behaviors, and others are missing or suppressed. Early experiences and training can further shape and discipline these predispositions. Ratting terriers exhibit all of these behaviors except *dissect* and *consume*. The bully breeds display a strong *bite and hold*. Herding dogs strongly *stalk* and *chase* — and occasionally *bite and hold* — their sheep. Many hounds or hunting dogs excel at *search* or *chase*. Livestock guardian dogs display almost no predatory inclinations at all toward their charges but do attack predators.

As an interesting footnote, it appears that in some ways we evolved together — for example, both humans and dogs developed the ability to digest starches. Dog breeds native to the cradle of human agriculture have a far greater ability to do this than dingoes, or breeds from the Arctic.

Hounds and Hunting Dogs

We find images of sleek hounds from ancient Armenia to Egypt, in Greece and Rome, and far beyond. Heavy hounds that relied on scent were used to track game; swift, slender ones hunted by sight. Xenophon described the scenting type, known to the Greeks as the *Laconian*, as large dogs with smaller heads, upright ears, and long necks. These dogs worked in packs and were noted for their enthusiastic barking and baying when on a trail.

The slimmer greyhound type was at times called the *Vetragus*, and was noted for its refined appearance and great speed. The legendary Celtic-Irish wolfhounds, called *cu*, were known even before the Roman conquest of Britain and were imported into the Roman Empire from that distant frontier. Both chasing and coursing were primarily the pastimes of the wealthy and powerful. Fast, strong dogs for chasing down stags or boars were in high demand into the Renaissance.

In addition to the hounds, smaller hunting dogs were also recorded. Short-legged, long-bodied dogs were depicted in Egypt and elsewhere. The Greeks believed the small, prick-eared *Vulpine* was a cross between a dog and a fox. There was also a small hunting dog found in Britain, prior to the Romans.

Molossers/Mastiffs

The ancient Assyrian and Greek tribes used massive dogs in war and their images were widely recorded. These dogs, often called *molossers* after the Molossians, a Greek tribe, were found over a very large area. Beside warfare, *molossers,* or heavy mastiffs, were hunters of large game, such as lion, onager, and boar. They also worked as guardians of temples, homes, estates, and property. Tall and deep-bodied, with large, strong heads and necks, these impressive dogs radiated power.

The Romans used mastiffs as guardians as well. While shepherd dogs were white, Columella and other Roman writers advised that the heavier guard dog be dark in color so that he would be less visible in the night and more frightening in the daylight. The Romans used mastiffs as attack dogs and guardians of roads or fortresses, sometimes outfitting them with collars fitted with spikes or knives, as well as leather armor. Mastiffs were also used as fighters in the amphitheaters, often set upon human captives or large animals, such as bulls, bears, tigers, lions, and boars. At times they even fought each other.

These massive dogs of war came to be owned by the wealthy and powerful throughout Europe. War dogs would later accompany the explorers and Spanish conquerors into the New World, where they would be used to brutally attack the native peoples.

Pets

Although most dogs were workers, specific types of dogs were kept as pets. In Egypt, these small short-haired dogs had erect ears, pointed muzzles, and tightly curled tails. The Greeks called the well-known small dog from Malta, the *Melitan*, and he did resemble the longhaired modern-day Maltese. Small spitz dogs were also popular as pets.

Although many of our contemporary breeds closely resemble these ancient historic types, none are the direct genetic descendants, despite the claims of many breed aficionados. Human and dog migration, inevitable crossbreeding, historic events that led to near extinction and subsequent restoration, and the modern era of breed development and standardization have all resulted in much mixture of dog genetics. Recent genetic studies show that

Nothin' but a Hound Dog

The word "hound" comes from the Old English word *hund* — related to the German and Scandinavian *hund* and the Dutch *hond* — all meaning "dog." Many modern breed names are a mistranslation of *hund* or *hond* as "hound" instead of the correct "dog."

In English, "hound" originally referred to all dogs, but by the sixteenth century, it specifically meant hunting dogs. The word "dog" comes from the Middle English word *dogge*. In the fourteenth century, "dog" originally meant a specific group of hounds that included the mastiff. Eventually "hound" and "dog" switched meanings, and the latter came to mean all dogs.

perhaps only Basenjis, Salukis, and dingoes actually possess a somewhat different genetic signature from the rest of the dog population.

Developing Dog Breeds

As breed fanciers began to establish individual breed clubs and national kennel clubs, beginning in the 1860s in England, many traditional landrace, or native, breeds were transformed to standardized breeds. Landrace breeds may be quite old; they are usually highly adapted to their environment and share a specific set of behaviors. Landrace breeds were selected by humans to perform a valued function and, at times, for a preferred appearance as well. Within a landrace breed there is generally some variety in appearance, and different distinctive types of the same breed may also exist. Pedigrees may exist in either oral or written form but there is no organized group guiding the selection of dogs for breeding based on a written standard or a central registry of pedigrees.

The transition to a standardized breed begins when an organization or association decides on a standard description for its dogs. Dogs who meet the standard are entered in a registry. Eventually only dogs bred from registered, pedigreed parents can be entered in the breed registry, whereupon the registry is closed. The resulting animals, bred from two registered parents, are considered purebred. It is possible to preserve different types of dogs within a breed, but frequently only one type emerges as the ideal image of the breed.

An established breed type can change when breeders begin to select for a different function or appearance. Working breeds can lose their abilities if breeders choose to emphasize appearance over other traits. When this occurs, a split may develop between the traditional "working" type and the emerging "show" type. It is an ongoing challenge for people who breed dogs for show or pet homes to maintain the dogs' essential and instinctive working traits and behaviors. Unfortunately, specific physical traits can also become overemphasized, leading to extremes in appearance that are often counterproductive to good working abilities.

A breed can also develop genetic health issues unless great care is given to maintaining a diverse gene pool by avoiding the overuse of popular sires, which has occurred even in very popular breeds, such as the Golden Retriever and Doberman Pinscher.

Genetic bottlenecks can occur if too few dogs are used for breeding or a major portion of the registered population is lost, which did happen with many breeds after the world wars in Europe. In some cases, dedicated breeders have worked hard to reconstitute or re-create specific breeds such as the Lancashire Heeler, Belgian Tervuren, Leonberger, and Hovawart.

Still Changing

In some parts of the world, this transition from landrace to standardized breed is still occurring. These breeds are considered newly recognized rather than newly created. Many of these breed organizations still have open registries for admitting unregistered dogs that meet the breed standard. Newly recognized landrace breeds often have greater diversity and varying types than the well-established standardized breeds. Some working dog organizations also maintain open registries and accept diverse appearance and types.

Still other breeds are the result of deliberate creation. A single person or a group decides to develop dogs with a specific appearance or function. Newly created breeds can emerge from a desirable or unusual genetic mutation, or from an attempt to miniaturize an existing breed. Dogs from a selected population within a breed or different breeds are utilized. Offspring with the desired traits are usually *linebred* for many generations until the traits are fixed in the new breed and the registry is closed to new dogs. Any breed with a closed registry can suffer from inherited health or disease issues, but this is especially true when the breed is based on a genetic abnormality, a very small founder group, or extremely tight linebreeding.

It is important to know that this process of creating a new breed is very different than marketing puppies that are first-generation crosses between two established breeds. They may be given cute names, such as CorgiPoo, but they are simply mutts, not true breeds, because the second generation of CorgiPoo pups would continue to exhibit different mixtures of traits from the two original parent breeds. It takes many generations to create a truly new breed.

Registries, Kennel Clubs, and Breed Clubs

There are both single-breed registries and multibreed registries. Registries function as record-keepers of pedigrees and other vital information, such as DNA, titles, and ownership. Some dog clubs are also registries. Kennel clubs are multibreed registries.

Well-established kennel clubs include the following:

AKC — American Kennel Club
ANKC — Australian National Kennel Club
CKC — Canadian Kennel Club
FCI — Fédération Cynologique Internationale (worldwide umbrella organization of kennel clubs, not a registry)
FSS — Foundation Stock Service (record-keeping service for rare purebred dogs that are not currently recognized by the AKC; often a steppingstone into full recognition)
IKC — Irish Kennel Club
KC — Kennel Club (UK)
NZKC — New Zealand Kennel Club
UKC — United Kennel Club (US)

WARNING: Unless a specific breed registry is noted in the description of a breed in this book, be wary of any other registries or kennel club pedigrees or registrations. Some registries exist only to lend false credibility to pet shops, puppy mills, cross-breeding, and other questionable practices. Some use initials identical to long-established kennel clubs in an attempt to confuse the buyer. The most complete guide to legitimate and fraudulent registries — Dog Breed Registries in North America — is maintained on the website of Canada's Guide to Dogs.

Breed Clubs

A breed may have more than one club. The national kennel clubs usually appoint one breed club as the official *parent club*, which controls the breed standard. Some breed clubs may be affiliated with the parent club. Other breed cubs may be independent or focused on working dogs. In North America, many breed clubs serve both Canadian and America members, although there are Canadian-specific breed clubs. In Australia and New Zealand, there is often no single national breed club because regional or state clubs serve this function.

Some Breed Terminology

Breed. A group of animals that is reproductively isolated through either geography or human control of breeding. Members of a breed look like each other and produce offspring that look like the parents. Breeds also have common behaviors and abilities.

Inbreeding. The mating of closely related dogs, such as parents to offspring or siblings to each other. Inbreeding intensifies both good and bad genetics.

Landrace breed. A native breed without a formal registry, although breeders may keep written or informal pedigrees. Landrace breeds tend to have greater diversity of appearance.

Linebreeding. Within a breed, mating more distantly related dogs in an attempt to concentrate the genetics of a particular dog in the pedigree.

Pedigree. A record of ancestry.

Purebred. A dog with registered or pedigreed parents.

Standardized breed. Since the nineteenth century when dog registries were first organized, a standardized breed has been considered a group of dogs with standard pedigree information and a formal registry. Unless they were deliberately created, most standardized breeds began as landrace breeds.

Type. Conformation, character, and behaviors make a group of dogs distinct from another group. A breed may have one ideal type or several acceptable types.

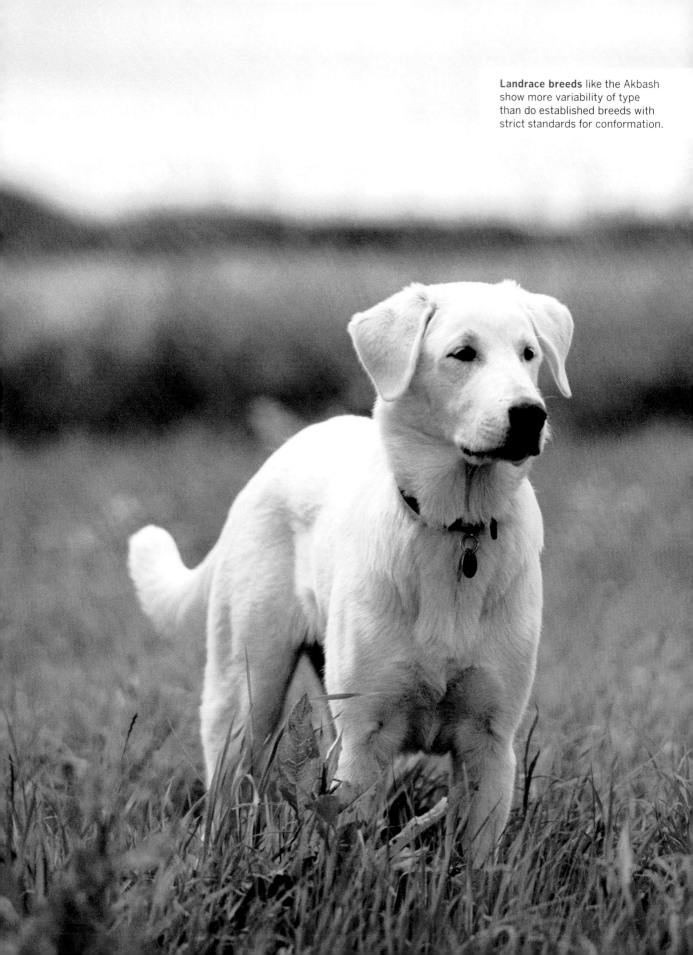

Landrace breeds like the Akbash show more variability of type than do established breeds with strict standards for conformation.

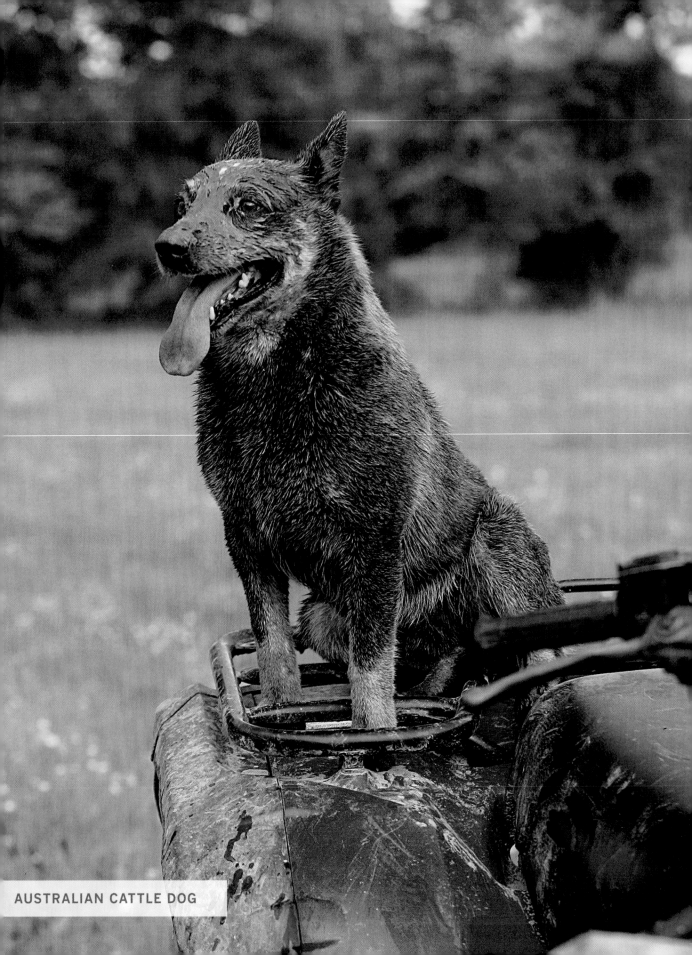

AUSTRALIAN CATTLE DOG

② Understanding the Working Farm Dog

Working farm dogs have been bred to fulfill specific functions, and many of these breeds are not necessarily a good addition to a farm if they aren't given the opportunity to do the job they are driven and born to do. Whether full of energy for hard work; instinctually driven to herd, patrol, or protect; or exceedingly clever and intelligent, working dogs need physical and mental outlets for their basic natures. In addition to needing a lot of exercise, many of these breeds are natural problem solvers that invent jobs (or trouble) for themselves in the absence of real work. Most of these breeds are also dominant and independent workers that need a confident leader in their working partnership.

The Job of a Farm Dog

Let's take a moment to consider some prospective roles for a country dog.

One specific type of working farm dog is the livestock guardian dog, or LGD, developed over centuries to display nurturing and protective behaviors toward livestock. An LGD generally lives outside full time as part of the herd or flock. Without 24-hour access to your stock, he cannot provide total protection against predators. The best way to raise this dog is to house him outside from the very beginning and to give all your attention to him outdoors in his working area.

LGD breeds can also serve as general farm and family guardians, as can other traditional farm breeds. These dogs sleep outside in a doghouse, an attached garage, or a barn but have access to the areas around your house, your outbuildings, your stock, and your equipment. They effectively and independently patrol and protect these areas, especially if they can move among poultry pens, small animal enclosures, and other areas. A guard dog often sleeps a lot during the day and is more active at night.

With good socialization to your stock and farm routines, most farm dogs are great companions as you do chores. They can be tremendously reassuring when you are working outside at night, especially if you live in a remote area or one with large predators. Because these dogs live outside, they can do a good job at protection as well as sounding an alarm for unusual situations.

Other outside dogs may sleep in a doghouse, kennel, or outbuilding at night, while fulfilling a specific role as your partner during the day. These tend to be hardworking herding dogs, contributing their valuable work to the farm or ranch and keeping you company during your workday. Some outside dogs come in the house for short visits while others prefer to stay outdoors. Do not raise an outdoor dog in the house as a pup or bring him inside to sleep, unless you want him to be companion dog who regularly spends time indoors.

Many country dogs are primarily family companions who spend a good portion of their time indoors but are especially well suited to country life and activities. Many of these dogs are all-arounders, capable of helping out with a variety of jobs, from working with stock to hunting vermin around the barn.

The Temperament of Working Dogs

All breeds are made up of individuals. Although the breed description or standard reveals much about working ability, temperament, and other qualities, dogs within each breed display variation in temperament and personality or character.

"Temperament" is a difficult word to define. In general, a dog's temperament dictates how he responds and reacts to the world. Temperament is genetic and inherited; although socialization, training, experiences, and environment can potentially modify the expression of any temperament. A dog's "character" is shaped by his environment and experiences. His "personality" is often regarded as a combination of his inherited temperament and his character.

In describing breeds, we can discuss the average or typical temperament of that breed. Temperament is an essential portion of overall suitability for working at a specific job. There are a number of terms that describe the different aspects of temperament. All of these traits can apply to the working-dog breeds, although some are more common and expected.

Prey Drive

Predatory behaviors are often called "prey drive." Prey drive can also be described as intensity or working drive. Dogs can display this drive with enthusiasm or happiness. Dogs who possess a high drive for chasing, as an example, work hard and happily in jobs and sports where this behavior is purposeful. These dogs often enjoy sports and games that utilize their instinctual drive.

Dogs can also possess great drive for other elements of predatory behavior, such as searching, biting and holding, or biting and killing. While owners can encourage and shape these behaviors when they are desirable, dogs that possess them are also driven by their genetics. Performing these behaviors is actually self-rewarding to the dog and makes him feel good. Prey drive can also be dangerous when dogs chase cars or attack animals, such as other pets or livestock.

Independent. Independent dogs have less desire or need for human interaction and direction. Although described as aloof or self-thinking, they are still affectionate toward their owners. Independence is highly desirable for some jobs.

Dependent. Dependent dogs have a greater need for human interaction, direction, and affection. Highly dependent dogs can also be clingy, suffering from separation anxiety.

Dominant. Dominant dogs are pushy, assertive, and strong willed. In the absence of leadership, they become increasingly bratty and misbehaving. Properly channeled, dominant dogs are excellent workers, but they require experienced, skilled, confident handlers.

Submissive. Submissive dogs lack confidence, which may prevent them from doing their job well or at all.

Sharp. Sharp dogs are too quick to react, without assessing the situation or thinking. This is a big problem in a working situation.

Shy. Shy dogs fear nearly everything — movement and noise and new people, places, and objects. Shy dogs don't recover from a fright easily or investigate threats. If shyness is caused by poor socialization or bad experiences, an experienced trainer may be able to build confidence in the dog. Sharp and shy dogs are often fear biters.

Reactivity or defensive aggression. In working dogs with protective or guardian natures, reactivity varies from low to high. Some breeds give more warning, are more tolerant or accepting of strangers, and are slower or more measured in their response. Other breeds escalate through the steps of reacting very quickly and give very little warning before attacking a threat. There are varied forms of canine aggression with different triggers, but true guardian reactive behaviors are only defensive in purpose, appropriate to specific breeds, and serve a working function.

Energy or drive. High-energy or high-drive dogs are bred to do a job where this characteristic is needed and appropriate. If their energy or drive needs are not met, they can become destructive, sometimes developing obsessive behaviors.

Willing. Willing dogs have a good, positive work ethic when asked to do a job or learn something new.

Sound. Mentally sound dogs are confident, curious, assertive, and courageous when required.

Unsound. Mentally unsound dogs can be overly fearful, submissive, shy, sharp, overaggressive,

and/or reactive. Their behavior can be unpredictable, unstable, and potentially dangerous.

Soft or sensitive. Soft dogs are sensitive to loud or harsh verbal corrections, as well as mild physical correction. Soft dogs can become withdrawn and uncooperative when rebuked. Soft dogs need calm, controlled, quiet, positive training, as well as shorter lessons.

Hard or insensitive. Hard dogs accept a verbal or mild physical correction without hurt feelings or shutting down. Hard dogs need a firmer hand and consistency when training. Hard dogs are resilient, are more able to tolerate noise and commotion, and are able to train for longer periods.

Hardness-softness continuum. Where a dog falls on the continuum is related to character, to temperament, and sometimes to breed. Being hard or soft is not a negative thing and has nothing to do with intensity or working drive. Some people have a preference for one or the other in a dog. Excellent working dogs can be hard or soft or somewhere in between, but it is important to take this knowledge of your dog into consideration when you are training.

Consider Your Needs

Before you choose a farm-dog breed, you need to be clear about what your needs are and what you expect from a dog. In addition to assessing your specific needs for a working dog, consider how the dog might fit into your family and overall farm environment. Many working dogs, large or small, are more challenging and strong-minded than typical family pets. Be sure you are prepared to handle its particular needs as well. Here are some issues to consider as you make your decision.

Function

Do you have a specific role for a dog to perform? Do you need a dog to guard livestock? Breeds with strong protective natures require experienced handling. Many traditional farm dogs are good watchdogs but not suitable as full-time livestock guardians. Do you need a herding dog? At what level of skill and how often will he be working? Would an all-arounder that can tackle several jobs be more practical?

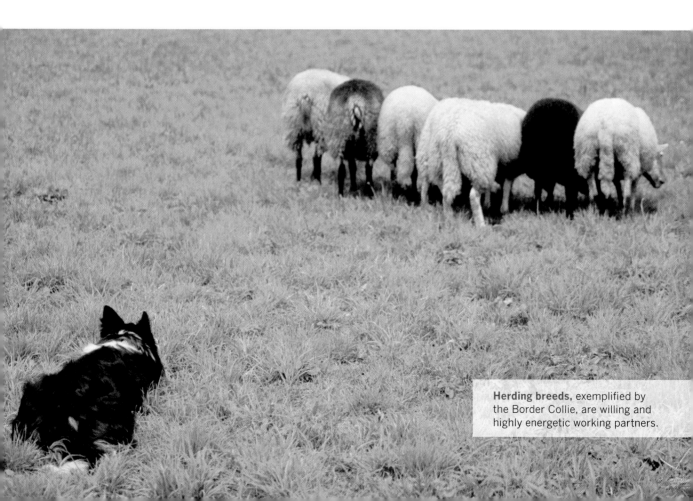

Herding breeds, exemplified by the Border Collie, are willing and highly energetic working partners.

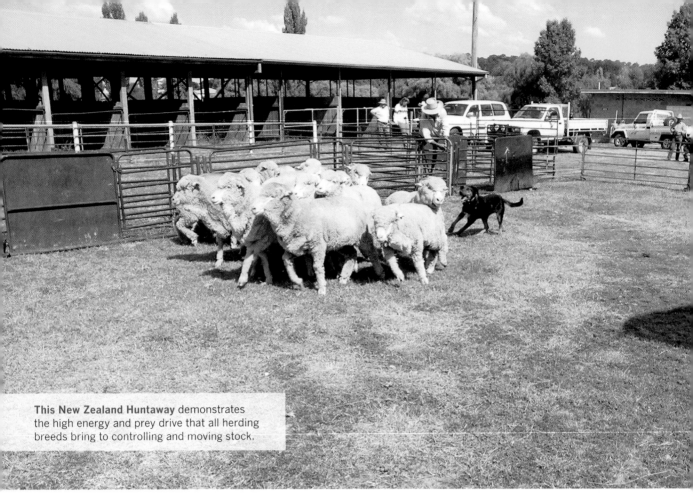

This New Zealand Huntaway demonstrates the high energy and prey drive that all herding breeds bring to controlling and moving stock.

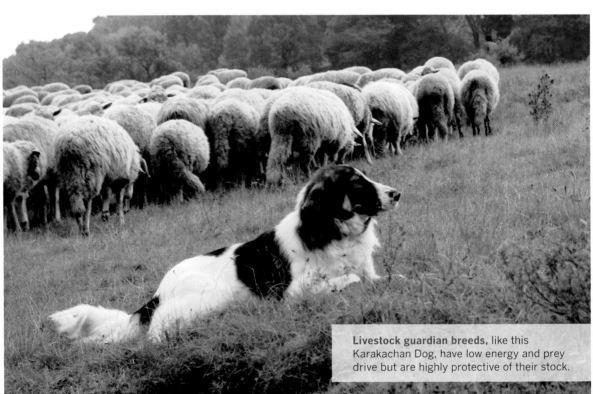

Livestock guardian breeds, like this Karakachan Dog, have low energy and prey drive but are highly protective of their stock.

Interaction with Others

Do family and friends visit your home frequently? Do you run a business with customers regularly coming and going to your property? If so, will you want your dog to come in contact with visitors? If not, how will you keep him separated? Are there children in your home or that visit frequently? Young children should not be left alone with most dogs, but some of these breeds are definitely more child-friendly than others.

Will there be more than one dog in the home or on the farm? What about other pets? Are there livestock and/or poultry on your place, and will your dog be expected to safely interact with them? Breeds with a higher prey drive will have difficulty dealing with cats and other small animals, free-ranging poultry, or even livestock in the farmyard. Many of these breeds can be aggressive toward other dogs.

Energy Level

Will your dog have a full-time or a part-time job? Consider how much time you expect to spend actually working with a dog every day. Do you need a dedicated, high-powered partner who is ready to work every day or a good worker who can also be a bit of a couch potato? What exercise requirements are you prepared to meet if you don't need a full-time working dog? What about energy levels? While some terrier breeds are more laid-back than others, most terriers have energy to burn. How would you provide exercise for a larger dog who needs more space?

Housing and Care

Will your dog need to live outside all the time to do his job or part of the time? Will he live in your house? How about size? While country life lends itself naturally to larger breeds, they do need more of everything, including fencing. Big dogs can also be more difficult to handle and care for, as well as more expensive to house and feed.

How much time are you willing to spend grooming? All dogs need regular grooming, but some breeds are especially demanding. Will your dog be going indoors and outdoors depending on the weather? Does shedding inside your house bother you? A shorter coat may be more practical than something dense and long. On the other hand, an outdoor dog needs a warm and protective double coat.

Companionship

Will this dog be primarily a work partner or do you want a family companion as well? What activities do you enjoy that could involve your dog? Breeds vary in their need for human companionship. Some are more aloof and self-reliant, while others need large amounts of human interaction or are eager to please.

Experience

What is your experience with dogs? Are you able to deal with a strong or highly reactive dog, especially a large one? Do you prefer a certain kind of temperament or personality? Can you handle a more dominant or self-thinking breed? Do you want a dog who is somewhat easier to train?

Consider the Breed

In addition to carefully evaluating your own needs and the overall type of dog that would best suit your situation, think carefully about the specific breed that would fulfill that role. Not all working breeds are suited to a quiet indoor life, especially if they have strong protective natures and high activity or exercise needs. Breeds that have traditionally worked long hours in close partnership with humans need a great deal of exercise and interaction; a half-hour walk simply will not suffice. Others, such as terriers, are tenacious, active, and bold, and their natures cannot be ignored.

Many of these dogs are truly born to work and must be engaged in purposeful activity. Frustration and boredom will lead them to create new jobs that might be bad for your house or furnishings. Frustration can also lead to depression, anxiety, or even aggression.

Pay close attention to the origins and purposes of the different breeds. Their essential natures may make them excellent companions, but those characteristics must to be taken into consideration as you plan how you will meet a dog's needs. An actual farm job can be replaced with other enjoyable activities, such as agility, herding trials, barn hunts, hiking, or carting — but you must be prepared to meet your dog's driving need for work.

Being a Good Leader

During everyday activities and more formal training the message you should be giving your dog is that you are the leader or the boss. This does not mean meting out harsh punishment but instead being the granter of everything he wants — attention, food, toys, treats, and walks — in exchange for proper behavior. Instill this by asking him to do something before receiving a reward. This technique is often called NILF (nothing in life is free). Withdrawing your affection or your attention in response to undesirable behavior is also a good training technique. As

an example, if you yell at your dog to stop barking, he discovers it's one way to get your attention, and for many dogs, even negative attention is better than none at all.

At times your dog may need verbal or mild physical correction, although some dogs are extremely sensitive to such corrections and can react poorly to them. The essential component of any correction is that it happens immediately in response to unwanted behavior and that the dog understands clearly what he is being corrected for. Misplaced correction or

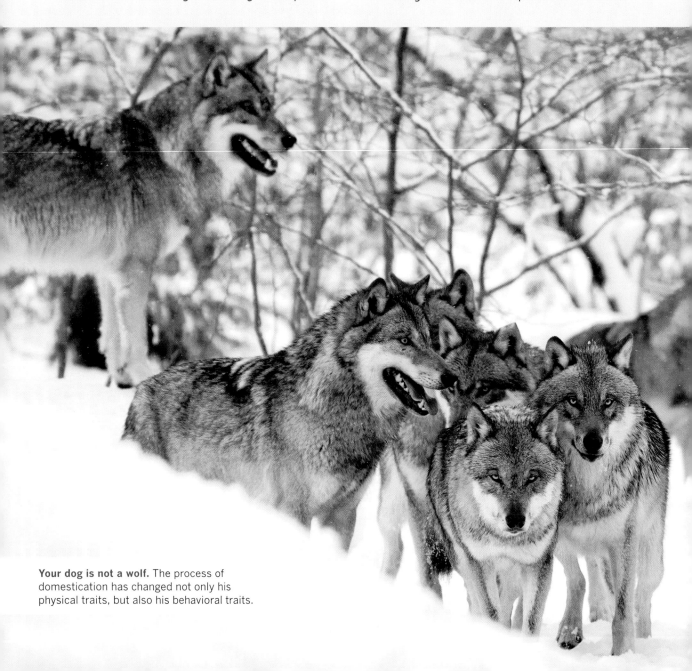

Your dog is not a wolf. The process of domestication has changed not only his physical traits, but also his behavioral traits.

a punishment that occurs long after the act is both confusing and ineffective. Above all, do not lose your temper and escalate the situation into violence, which is harmful to your working relationship and may actually be dangerous.

The So-Called Alpha Dog

Most dog owners have heard of the dominance theory of dog training — that you must be the "alpha dog" in your pack. It is based on research from the 1940s, when an animal behaviorist

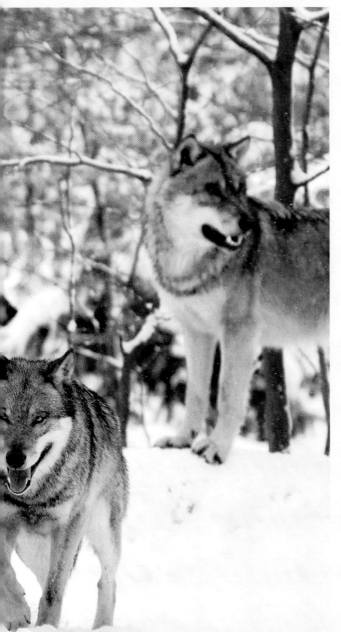

observed captive wolves fighting to gain dominance and postulated the idea of an alpha wolf. Biologists also assumed that wolf packs came together during the approach of winter so that the pack could hunt large prey. These observations were extended to dogs on the theory that they behave the same as wolves in a pack.

Today we know three things: (1) wolves in the wild don't exactly behave this way, (2) dogs aren't directly descended from wolves, and (3) even feral dogs do not create the same sort of packs as wolves. In the wild, wolf packs are most often a family headed up by a mated pair and their offspring, who leave after two or three years. The parents control the pack and the members are not fighting for dominance. At times, two or three families group together, but this is not a sustainable arrangement. Occasionally an unrelated wolf joins the pack.

Only in captivity do we see numbers of unrelated wolves forced to live together with resultant tension or violence. Wolf biologists no longer use the term "alpha wolf" to describe dominance, but it has lingered in the public perception of dog training. In reality, alpha rolls and other dominance practices are misguided and potentially dangerous.

Dogs Are Not Wolves

Behavioral science is giving us greater understanding of our dogs as not-wolves. One thing we know is that dogs are highly social and they want a relationship with humans. In fact, they often prefer an affectionate relationship with a human to one with another dog. They communicate in various and complex ways, including with body language. Hierarchy and social affiliations — both with you and other dogs — are important to them, but dogs are adaptable. They form changeable, fluid relationships, unlike wolves who develop specific social relationships and don't deal well with novel events. The most marvelous aspect of all is that dogs want to cooperate with people. This is truly the bedrock of our working relationship with them.

Needs of a Working Dog

Hardworking farm dogs have the same basic health-care needs as other dogs, but there are some additional issues and concerns that owners should consider. Working dogs are exposed to dangers and situations that pet dogs don't often encounter. Dogs who work and live outside deserve good food, shelter, and protection. Country dogs might not often meet new dogs or people, but that doesn't negate the importance of basic training and socialization. Rural dog owners also need to be aware of various legal issues that may impact them.

Health Care

Many working dogs are stoic in nature and they are typically extremely focused on their job. Their instincts also tell them to push hard and long. You will need to pay careful daily attention to noticing wounds, lameness, or signs of illness before they become serious, especially if your dog lives and works outdoors. Besides being more likely to be injured than a pet dog, working dogs are vulnerable to overheating, ingesting poisonous substances, and being bitten by venomous snakes and insects. They are also more likely to encounter skunks and porcupines — the former are mainly a nuisance, but porcupine quill wounds can fester and cause serious infection, interfering with a dog's ability to eat. Large breeds are susceptible to bloat, a condition that causes a section of the intestine to twist and can cause rapid death.

Plan ahead for how you will handle veterinary and grooming care. While some veterinarians perform annual exams, vaccinations, and emergency care during a farm visit, you should plan on regular visits to the clinic or office and socialize him appropriately. If a grown dog lacks experience riding in a car or visiting away from home, it will be difficult to get him into a vehicle when needed.

Outdoor Living

Although many breeds are well equipped to live outdoors year-round, all dogs need shelter from heat, cold, rain, sleet, and snow. Whether your dog spends just part of his day outside or lives outside full-time, he needs a shelter large enough to be comfortable but small enough to conserve body heat and make the dog feel secure. The shelter should also have an entrance designed to block exposure to weather, as well as proper insulation and shade. Bedding should be changed regularly to discourage fleas and other pests.

Many livestock guardian dogs prefer to bed down inside a barn or with their stock, but they still need a retreat of their own. If your doghouse is located inside a pasture, you may need to prevent goats or sheep from using it by placing it inside a stock-proof enclosure made of livestock panels. Whatever kind of housing you provide it is useful to have a secure kennel area with appropriate fencing available for times when your dog needs to be safely confined.

Fencing

Owning a dog, especially a large or powerful one, is both a responsibility and a liability in today's society. Good fencing does make good neighbors. Unless you live on vast acreage or rangeland, you need to protect your dog, your stock, and yourself with adequate fencing. Solidly built, secure fencing protects your livestock from predators and discourages dog theft, which is a distinct possibility in some areas.

It also keeps your dog from roaming and either being injured or doing damage to other people's livestock. If your dog is intact, a fence helps prevent unwanted pregnancies (neutering reduces roaming tendencies somewhat). A solid fence helps keep strangers, stray dogs, wildlife, and predators out of your dog's space so he can focus on his job.

The best advice is to build the highest and best fence you can afford. Many working-dog breeds are agile athletes who can easily scale a 4- or 5-foot fence. Remember that many dogs can climb over or dig under fences as well. It is essential that your dog learn he cannot get out of his enclosure. Once he learns that he can escape, he will try repeatedly. Formal boundary training is not successful with all breeds or all personality types, especially independent ones. Do not expect your dog to stay home "naturally" or because a previous dog never roamed. It is in the nature of many working dogs to protect their territory, and their idea of territory may extend beyond your property line.

Food and Water

Hardworking dogs and dogs who live outside need access to clean fresh water, summer and winter. Stainless steel bowls and buckets are easier to keep clean than plastic or rubber. Some folks use small

livestock troughs. Automatic water fountains or dispensers and heated buckets are also useful options in some locations. If you rely on your dog sharing a tank with your livestock, make certain he can reach the water level and that the stock permits him to drink safely.

You may choose to feed your dog inside your house, but if he will be living and working outside, you will need to develop a successful plan for handling his food outdoors. Allowing your dog to self-feed is less desirable than feeding him yourself every day, because self-feeding reduces your chances to monitor or interact with him and leaves the food exposed to insects and weather. However, in large farm, pasture, or range situations, self-feeders are sometimes necessary.

If you need to use a feeder, locate it away from the stock. Stock may eat the food and dogs may become protective if their food is not secure. Stock panels can be used to create a feeding and retreat area for a working dog, utilizing a dog door, porthole, or jump gate to exclude the stock. If you have more than one dog, it is safer to feed them separately to prevent food aggression.

Training and Socialization

All dogs, even working farm dogs with a specific job, need basic training, good manners, and socialization. Not only does training make him a better companion and a more cooperative worker, but in an emergency situation, you will appreciate the ability to safely handle your dog.

Unless his future will be as full-time livestock guardian, take your puppy to a basic training and/or canine good-citizen class. It is critically important that your pup receive some important experiences between the ages of three and twelve weeks before his socialization period closes. Socialization does not mean playing with other dogs at a park. Expose your dog to new and different situations, such as rides in vehicles, a variety of flooring surfaces, people of all different ages, other animals, and so on. In the beginning, avoid big crowds, dog parks, well-used walking trails, and any situation you can't control to avoid frightening your pup. Above all, make each experience as positive as you can without coddling him.

All dogs, including working livestock guardians and herding dogs, need to learn to walk on a leash

This Central Asian Shepherd is learning early to respect fences, an important lesson for all LGDs.

and heed basic commands, such as *no, sit, stay* or *wait, drop it* or *leave it,* and *come* or some other recall signal. Basic manners also include no biting, mouthing, jumping up, chasing or bothering people, rushing through doorways, moving out of your way when asked, and waiting for food.

Working dogs are often resilient self-thinkers and can even be somewhat pushy. This type of dog needs clear, consistent communication from you, not only in your commands but also in your expectations and boundaries. Even as puppies, working dogs need jobs. Learning new things is a job, with the bonus of your attention. As he grows, introduce him to his real working job and other activities you both enjoy.

Note: Don't hesitate to seek help if you feel unable to stop an undesirable behavior or believe there is a serious threat to the safety of your family, other people, or your other animals. Animal behaviorists are generally recommended for serious issues.

Legal Issues

There are often legal restrictions or regulations that dog owners need to be aware of. You may need to contact your local government and your insurance carriers to determine your own situation. State, regional, and federal laws or regulations may also apply to these situations.

Issues to be aware of include zoning and other legal regulations pertaining to fencing and outbuildings; animal welfare requirements for tethering dogs and/or keeping them outside, as well as working-dog conditions; breed bans and number of dogs permitted; necessary dog or kennel licenses; and ordinances about barking and noise, use of electronic or shock collars, biting and livestock attacks, and leash laws when off property.

Be sure to check Right to Farm laws, especially as they relate to working dogs and their activities. Last but not least, look at insurance issues — breed bans, working dogs, liability, and additional coverage.

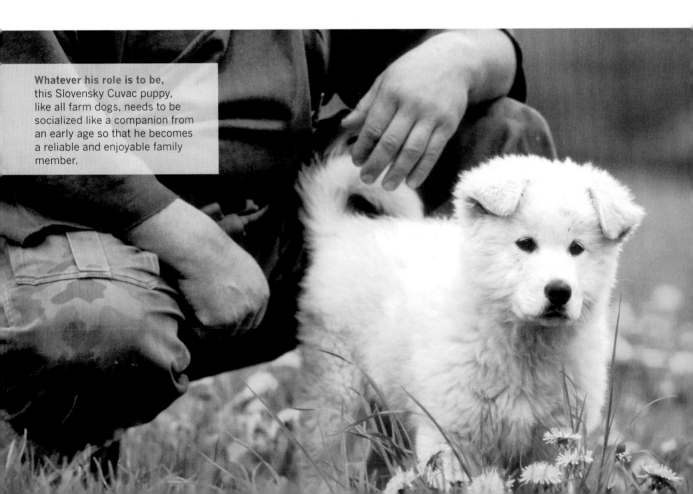

Whatever his role is to be, this Slovensky Cuvac puppy, like all farm dogs, needs to be socialized like a companion from an early age so that he becomes a reliable and enjoyable family member.

Some Dogs Live Outside

Livestock guardian dogs and other farm dogs often work and live outdoors. The opinion of some animal advocates that it is never acceptable for a dog to live outside is in direct conflict with the needs of farmers or ranchers, especially in providing nonlethal predator control. When laws or regulations are enacted to restrict outside living for dogs, there are usually exemptions for working dogs. It may be necessary to explain the working role of your farm dog to concerned outsiders. Be prepared to demonstrate that your dog is receiving proper care and that his basic needs (food, water, shelter, and health) are being met, even in extreme weather. Consult all local or applicable laws in your area. There may be regulations for size, ventilation, lighting, surfaces, and temperature control.

Guidelines for Safe Outdoor Living

If a dog will be working or living outside in cold or hot weather, there are guidelines to help evaluate the situation:

- Young puppies (eight weeks and under) and senior dogs may be vulnerable due to a meager coat, low body mass, or inability to regulate their body heat.
- Double-coated dogs with dense, lofty undercoats are equipped to handle weather; other coats are not. Long hair is not essential but proper double coat is. Shaving the coat destroys the insulating properties for both heat and cold.
- Dogs in poor health or recovering from injury or surgery need special consideration and care.

Cold weather demands more calories, especially high-quality fat calories.

Closely monitor any dog in cold weather. Signs that something is wrong include: shivering, whining or showing anxiety, refusing to leave the doghouse, or acting lethargic. Snow on the coat is fine, as it indicates that the coat is retaining body heat. Ice on the coat is not a good sign; it occurs when snow melts due to heat loss and then refreezes.

Also check footpads for irritation or frozen ice between the toes. Ointments or protective paw waxes can be helpful in some conditions.

Do not abruptly transition a dog to outdoor living if he is not acclimated to it.

Proper Shelter for Cold Weather

Each dog should have its own shelter that is tall enough for the dog to stand comfortably and large enough for him to lie down and stretch out. A house that is too big will not conserve body heat. A small entrance keeps out wind and weather, but should not be so short that the dog is unable to easily crouch to enter. Three-quarters of the dog's height works well.

Offsetting the door reduces the exposure to weather. A tunnel-like entrance is even better in very cold climates. A tunnel can be constructed on the entrance of a premade house as well. The doorway should face away from the prevailing winds in cold weather and it needs a flexible flap as well.

The structure needs to be insulated from both heat and cold. Wood is a good natural insulator while plastic is not. The floor should be raised off the ground at least a couple of inches, which is enough space to discourage pests and provide further insulation by keeping the floor off frozen ground. Hay or straw bales may be used for additional insulation or a windbreak.

Light-colored walls will reflect heat away; dark colors keep the structure warmer during cold weather.

Provide warm bedding in sufficient quantities. Straw and wood shavings piled thickly have insulating properties while blankets or rugs do not. Wet blankets also freeze and do not provide good insulation. Straw or shavings needs to be checked, relofted, and replaced when wet or frozen. LGDs outside on guard duty also appreciate dry straw to lie on.

Dealing with Heat

If there is little natural shade where your dogs are working, you need to provide it with a tarp or simple roofed structure. Keep cooling cross-breezes in mind and consider a large fan if heat is a serious threat. A large block of ice, frozen water jugs, dirt, or hard surfaces are often cooling, as are large wading pools of clean water. Some dogs dig their own cooling dens.

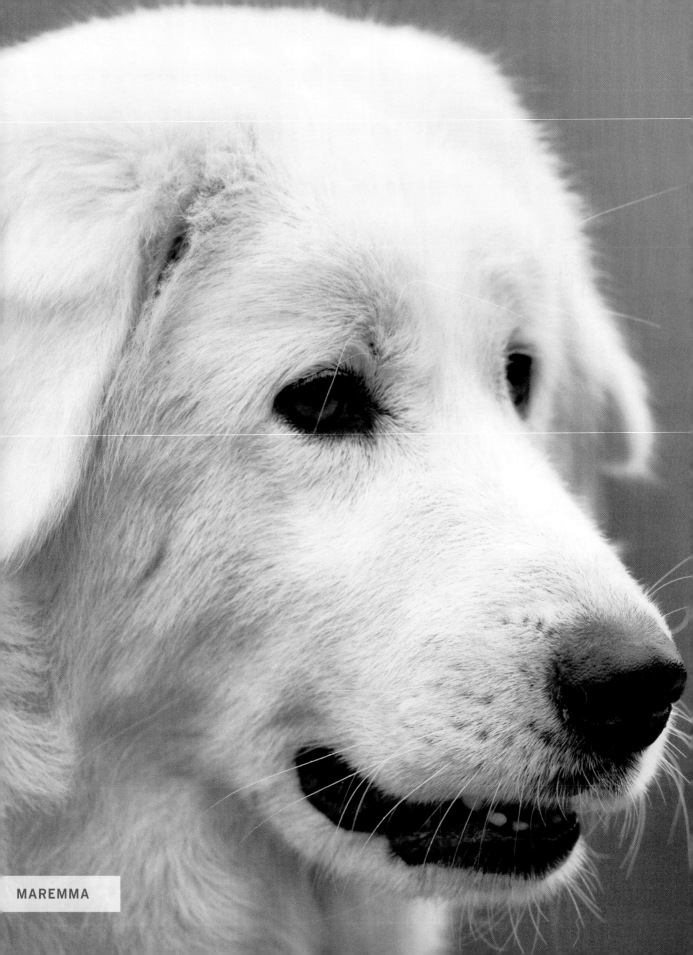

MAREMMA

③ Choosing the Right Dog

Determining which is the right farm dog for your situation is both exciting and daunting. So many breeds, so many functions and different roles! As you explore the different breeds, keep in mind your own needs and your particular situation. Consider the strengths of different breeds as well as their true natures. This chapter includes suggestions for finding a good breeder and guidance on pursuing adult rescue.

The breed descriptions in chapters 4 through 7 are general in their observations. Individual dogs are products of their genetics; they vary in physical appearance, behavior, and temperament. Dogs are also influenced by how they are whelped and raised; how long they stayed with their mother and littermates; how they are socialized; how they are handled and trained and the person who handles and trains them; the stock they interact with and situation they work in; geography; and other factors.

Please read the profiles realistically and remember that every year many purebred dogs are surrendered to rescue organizations or shelters because the owners are not prepared for the essential behaviors and traits of their dog. Working breeds come with hardwired genetic codes for specific instinctual reactions and tendencies. Socialization and training help you mold a good companion and coworker, but your dog is going to be what and who he is.

Certain protective breeds need heavy socialization to cope with the comings and goings of family and friends. With these breeds, a good breeder helps a potential owner select a pup with a temperament amenable to a life as a companion dog, if that is your purpose. Even companion dogs, however, need regular activity that burns energy and engages their minds, or they can become destructive or obsessed with protecting the house and family.

Finding a Breeder

After determining one or more breeds you are interested in, the next step is to locate a breeder. If you are not familiar with the breed, try to arrange to meet some adult dogs and talk informally with owners or breeders about their breed. Before you buy a pup, also make plans to visit the parents or grown offspring if at all possible. A puppy is unquestionably adorable but you need to be prepared to deal with the adult that he will grow up to be. You can gather valuable information about temperament by interacting with a pup's parents. Visiting a breeder's farm or kennel allows you to learn more about how the pups are cared for and how they've been handled and socialized since birth.

Be prepared for good breeders to question your purposes for owning their breed and how you plan to rise to the challenge. This is not elitism, as some folks assert. Knowledgeable and experienced breeders have witnessed many unhappy or abandoned dogs lose their homes or even their lives because someone was not truly prepared to own them. Any responsible breeder carefully evaluates potential owners before selling them a puppy. A good breeder is not only more than willing to have you visit the facility and meet the dogs, he or she may be willing to serve as your mentor for the life of your dog.

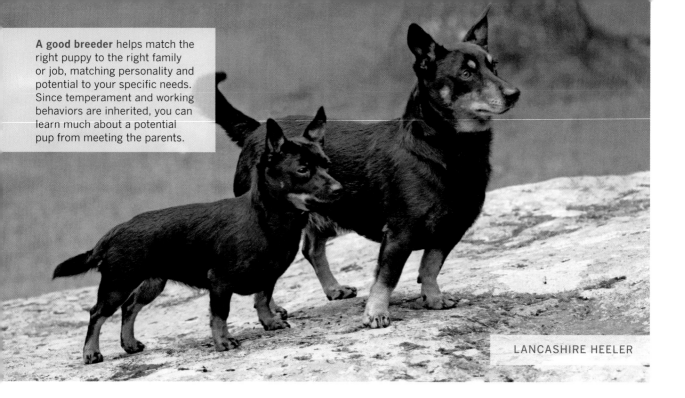

A good breeder helps match the right puppy to the right family or job, matching personality and potential to your specific needs. Since temperament and working behaviors are inherited, you can learn much about a potential pup from meeting the parents.

LANCASHIRE HEELER

Multiple Dog Households

Country homes often have more than one dog. Properly managed, multidog households can be wonderful, but there are serious issues to consider. A third dog is often the tipping point into pack chaos and conflicts, especially with dominant breeds. Increased aggression and protective behavior over food, toys, or attention are common. Dogs fight for rank within a pack and this can be serious.

Do not leave a pup or new dog alone with your existing dogs. Older dogs may bully or play roughly with the younger dog and a younger dog can harass or injure an elderly dog. After they mature at one to two years of age or so, young dogs often challenge older dogs. Intact dogs of both sexes pose another set of challenges, as same-sex aggression is common in many breeds.

Two Puppies at the Same Time?

Most experts warn strongly against the temptation of adopting or buying two puppies at once as it is very difficult to provide simultaneous and sufficient training and socialization. The pups are more likely to bond with each other than with you, making them more difficult to train and less affectionate with you. While two pups will play and keep each other company, they can also get into far more trouble as a duo; this is especially true of high-energy working breeds. In addition, housetraining can be a monumental challenge, not to mention that all costs are doubled.

Of course there are exceptions, especially among less dominant breeds. If you do choose to raise two puppies at once, do not keep them together constantly. Train, socialize, and play with them separately. In most cases, opposite-sex dogs get along better than same-sex dogs. Two dogs of the same sex or intact dogs definitely have more issues, especially females.

And choosing puppies from the same litter doesn't necessarily make a difference. Many experienced folks report that serious problems with bullying and aggression occur more often between two dogs from the same litter. This may not emerge until young adulthood, when the dogs begin to disagree over rank or dominance in their pack. Terriers and other dominant working breeds often have dog-aggression issues, even with familiar dogs.

Where to Start

One of the best places to locate a breeder is through a national or local breed club. It is a common misconception that breeders of purebred dogs are only interested in dog shows or that registration is meaningless in terms of working ability. Many breed clubs, particularly those dedicated to real working breeds, focus on preserving working ability, function, and good conformation, and on addressing health concerns. Registration, which is a form of record-keeping, is essential for knowing things like the health and functional working behaviors in a dog's pedigree. It also provides insurance for you that the pup is who the breeder claims he is.

Members of breed clubs generally subscribe to a code of ethics for both breeding and dealing with customers. They expect you to ask questions and they will no doubt have questions for you as well. They also screen for the appropriate health concerns for their breed. A breeder may ask you to fill out a questionnaire, and you may be placed on a waiting list for future pups. Good breeders often provide health or working guarantees. They may also ask you to agree to spay or neuter your pup unless you purchase a breeding-quality dog. Experienced breeders often select a puppy for you, matching personality and potential to your specific needs. Making this connection with a good breeder can be invaluable as your puppy begins his new life with you and beyond.

In some cases, a split has developed between working and show types within a breed, which means a more focused search to locate dogs of the right type for your purposes. Some of these breeds have clubs dedicated to working ability. You can also look for breeders who specifically raise and place working dogs, as well as ask for references for dogs placed in working homes.

If you know people with working dogs of a breed you are interested in, ask them to recommend responsible breeders. Livestock journals, dog magazines, websites, and Facebook dog-breed pages are also good sources for finding breeders, but you will need to dig deeper to learn more about them and their advertised dogs. It is important to remember that some breeders or puppy sellers misrepresent themselves online. An impressive website does not necessarily equate to a good breeder.

Neutering and Spaying

There is no doubt that spaying or neutering makes your dog easier to care for. It reduces undesirable behaviors; eliminates the need to confine a female during her twice-yearly heat cycles and a male's desire to roam in search of a female in heat; lowers the incidences of some health problems; and prevents unwanted pregnancies and undesirable pups. Pregnancies and raising a litter can take a working bitch away from her important work.

It is also true that there are too many dogs in shelters and rescue situations. You really shouldn't breed a dog unless it has good conformation and conforms to the standard of the breed; possesses an excellent temperament and appropriate working behavior; and is free of genetic medical issues (confirmed by testing). Even then, don't attempt to produce a litter until you are confident that you have committed homes for all the pups.

The timing and potential side effects of spaying or neutering are concerns to discuss with your veterinarian, as there are now differing opinions on the best age for surgery as well as potential health consequences. Spaying or neutering has no negative effect upon the dog's ability to work.

Signs of a Trustworthy Breeder

A good breeder does the following to ensure that his or her dogs are healthy not only physically and genetically but also mentally and emotionally:

- Only breeds adult dogs who are free of serious genetic defects, have good conformation, and demonstrate both good temperament and appropriate working behaviors
- Screens all breeding dogs for appropriate health concerns
- Only breeds dogs who are at least two years old and fully grown, and does not breed females on every heat cycle
- Provides puppies with good food, regular worming, and required immunizations

- Provides puppies with good socialization to people, situations, and livestock where appropriate
- Only sells puppies that are at least 8 weeks old, and preferably 10 to 12 weeks old
- Provides a health guarantee, bill of sale or sales contract, and registration for your pup

Here are some warning signs that you might be dealing with someone disreputable:

- Boasts that "puppies are always available"
- Sells many different breeds and crossbreeds
- Urges you to buy more than one pup
- Won't allow you to visit his or her kennel or farm and meet the parents and siblings
- Acts as an "agent" for a domestic or foreign breeder or importer
- Says that registration papers are not available right now or uses a questionable registry

The Cost of a Good Puppy

It is simply not possible to be a responsible breeder and still produce a pup for less than several hundred dollars and often more than that. Many things determine the cost of a puppy:

- How much did the breeder pay for quality, healthy parents?
- Are the parents good working dogs?

- What has the breeder invested in training the parents to prove their working ability?
- Are the parents and pups receiving good food and veterinary care?
- Has the breeder paid for DNA or other health screening?
- Is the breed rare or difficult to find?
- Is the breed in high demand?
- Are the pups from a specific breeding in high demand due to the working accomplishments of the parents?

Choosing a pup as a companion and partner is a weighty decision. You will invest not only money but also a great deal of time and energy in raising and training him. If he is to be a working dog, he is a valuable investment for your farm or ranch. While it can be tempting to buy a cheaper pup, or a puppy from someone who does not practice good breeding ethics or fails to appropriately screen for health or behavior issues, remember that you get what you pay for.

Even if you feel sorry for him, do not buy a puppy who is too young or filthy and malnourished or who appears sick. Most important, do not buy a puppy if the parent dog is overly aggressive, vicious, fearful, or untouchable.

Health Screening

Good breeders are aware of any inheritable disorders in their breed and make use of medical health screening and genetic testing to prevent the occurrence of these conditions in their breed. You may see reference to these tests and others on their websites and printed materials.

Deafness
- BAER — brainstem auditory evoked response test

Elbow and hip dysplasia
- BVA — British Veterinary Association Hip Scheme
- CHEDS — Canine Hip and Elbow Dysplasia Scheme (Australia)
- NZVA — New Zealand Veterinary Association
- OFA — Orthopedic Foundation for Animals
- PennHIP — University of Pennsylvania Hip Improvement Program

Hereditary eye disease
- ACES — Australian Canine Eye Scheme
- BVA — British Veterinary Association Eye Scheme
- CERF — Canine Eye Registry Foundation

Consolidated Database
- CHIC — Canine Health Information Center (database of multiple health screenings for individual breeds, searchable by breed, sponsored by OFA)

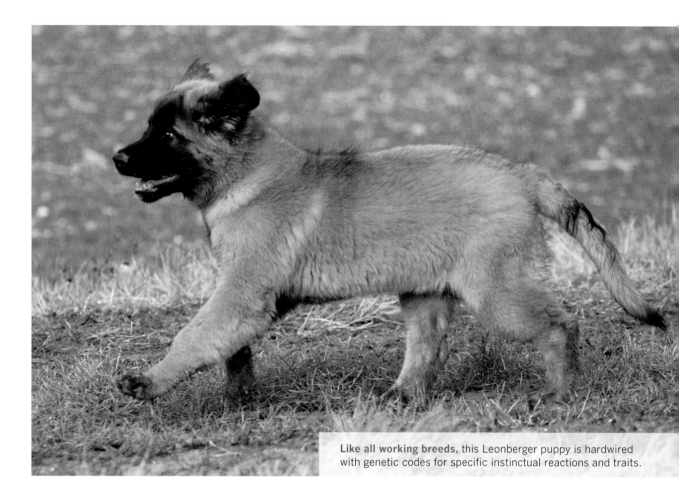

Like all working breeds, this Leonberger puppy is hardwired with genetic codes for specific instinctual reactions and traits.

Rescuing an Adult Dog

Rescuing a young or adult dog is another option. Unfortunately, many rescue dogs come from the working dog breeds. City or suburban owners often surrender them because they are unprepared or unable to deal with a highly driven dog in limited surroundings. Even people who think they need a working dog may find that they are unable to manage an independent, intelligent, and often demanding breed.

Cuddly pups soon grow into frustrated dogs with lots of energy, often turning their unhappiness into troublesome problems, such as barking too much, chewing, digging, or trying to escape. Some may develop serious behavioral issues and some simply grow too large or shed too much. Some of these dogs are definitely happier with space and a job to do, but do think carefully before pursuing this option.

Rescue dogs need time to adjust and to be supported during that adjustment period, but their genetic instincts still exist and may bloom in the right environment. On the other hand, if a working dog has already failed at real livestock work, the chances are small that he will improve in a different situation. An improperly raised pup is also problematic, especially if he was removed from his litter too soon and lacks bite inhibition, was abused, or was poorly socialized to people or other dogs and animals.

Rescue groups run by breed organizations are your best source for purebred dogs. Information about these groups can usually be found on the national breed club website. People who rescue specific breeds should be very familiar with the qualities and characteristics of the breed, so they can accurately evaluate good matches of particular dogs with potential homes.

Be aware that behavioral problems are generally more difficult to resolve than medical issues. All rescue groups have an adoption process and related procedures, which may include an application, veterinarian reference, and an interview or home visit. There is an adoption fee as well.

Rescue Red Flags

It is unfortunately true that some individuals or groups may misrepresent a dog's issues or problems out of a desire to find him a home. Be especially cautious of people or groups who rescue many different breeds. However well intentioned, they generally lack the knowledge to evaluate a dog's potential working ability. They may gloss over problems or issues, some of which could possibly be dangerous to you, your family, or your other animals. Some rescue groups don't place dogs in working homes, or in situations where the dog is expected to live outside, even if it is the right environment for that breed in general.

In addition, mixed-breed rescue groups and shelters often misidentify what breed a dog is, which can create serious problems on a farm or ranch where livestock is present. In particular, many shelters or rescue organizations do not correctly identify LGD breeds. If it looks vaguely like a Great Pyrenees, that's what it may be labeled. Crossbred dogs are especially challenging (see Crossbred LGDs, page 43). Be very concerned if you aren't offered proof of parents. In addition, these kinds of groups and shelters do not have the LGD experience to evaluate the behavior and potential of a working dog. Seek the input of an experienced LGD person to help you identify a potential dog.

Another drawback to a rescue dog is the lack of health, background, or behavioral information. Any working dog who has already failed at his intended work brings all existing problems with him; these may include chasing or killing stock or poultry, escaping fences and roaming, or showing aggression toward humans. Inexperienced herding dog, terrier, or LGD owners should not attempt to rescue an unsocialized, poorly raised, or improperly trained dog.

Finding an Appropriate Rescue Dog

When considering a rescue dog, it is very important to know why the dog is looking for a new home. A working dog who needs to be rehomed because his owners are relocating or selling their stock or farm is a good possibility. Dogs who transfer from similar situations and stock are more likely to adapt. Be very wary of any dog who has not been socialized or is difficult to catch

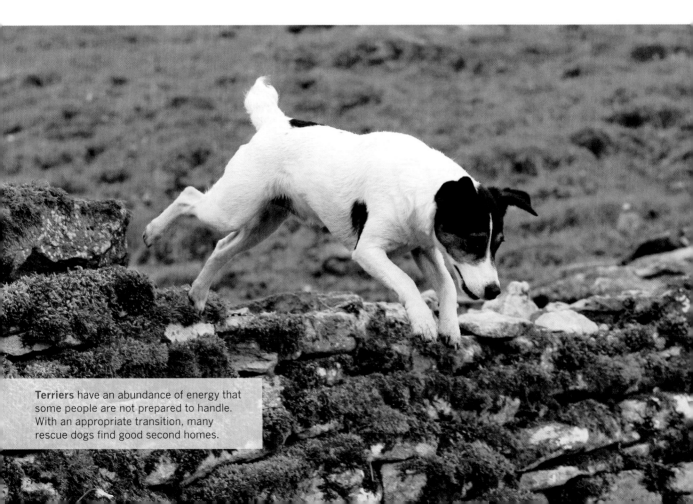

Terriers have an abundance of energy that some people are not prepared to handle. With an appropriate transition, many rescue dogs find good second homes.

and handle. Retraining a nearly feral livestock guardian dog, an improperly trained herding dog, or a poorly socialized terrier is not a job for an inexperienced person. In all cases, make sure the dog can be safely handled.

Many herding dogs and terriers are handed over to rescue organizations for the following reasons:

"Too hyper" or "needs too much exercise." "Hyper" dogs usually just need lots of exercise, as much as two hours a day for some breeds. It is important to remember that this is not "bad" behavior — these are the desired working traits of a herding dog or terrier. A dog who has already demonstrated his need for activity can be a good choice for someone dedicated to providing for his needs or engaging in dog sports.

"Impossible to control." An "out of control" dog is most often lacking appropriate training and handling; it may have been left alone too much without enough attention. A rescue dog will probably need retraining with an emphasis on consistent commands. An experienced owner may be able to provide the appropriate situation with consistent routines, rules, and expectations.

Herding dogs in particular want leadership as much as they want to impose order themselves. Most people are not equipped to train a dog who is capable of distinguishing among a multitude of commands with varying verbal terms, body language, or gestures. Terriers are independent, dominant, feisty dogs who are challenging to train. LGDs have very particular needs to be met and must be brought along slowly in a new situation. You must be willing to enroll in obedience training or work with a professional trainer if that is called for.

Biting, nipping, or snapping, especially with children. A dog who has nipped, bitten, or frightened young children may do better with older children or adults who understand not to run from a barking or nipping dog — especially one who is trying to herd — and who can learn to control the dog as well. Such a dog from a herding or terrier breed may never be trustworthy with groups of children because the instinct to chase and control cannot be completely trained away. Some terrier breeds are especially sensitive to touch or movement, and are often unsuitable for homes with small children. Some breeds are protective and territorial by nature. These breeds belong in homes that desire watchdogs and are equipped to handle them.

Destructive or obsessive behaviors. Many destructive issues displayed by working dogs, particularly terriers and herding dogs, can be traced to a lack of regular hard exercise. A dog who has engaged in destructive behaviors needs for his energies to be redirected. Such a dog may be an excellent choice for an owner who is able to provide work or participation in dog sports. Some obsessive behaviors in herding dog breeds may need the assistance of a trainer familiar with herding-dog behavior.

Dog aggression/chasing or killing other pets. Dog aggression is an aspect of terrier temperament, in particular, though many other breeds may also have issues. And most terriers are hardwired to chase and kill small, furry animals, which unfortunately can include family cats or other pets. For any dog who is not socialized to other animals and dogs, or is unable to get along with them, a home without these temptations is going to be a much better fit.

Roaming or hunting. Dogs that escape yards to roam or to chase people, other dogs, bikes, and cars, need better fencing, fewer irritations or temptations, neutering, and more exercise and activity.

Questions about Adult Dogs

Consider the following questions when evaluating any adult dog:

- Was he originally purchased from a conscientious breeder? He is more likely to be mentally and physically sound.
- Is he comfortable around people? He should not be overly submissive, clingy, fearful, or aggressive.
- Is he used to living outside? Although possible, it can be difficult for some housedogs to transition to living outside full-time, if that is your intention.
- Does he have any history of escaping fences, roaming, chasing animals, or biting? Depending on his age, some of these behaviors may be deeply ingrained. He could be dangerous to you, your family, or your animals.
- Can his reaction to stock be tested? An LGD might be excited or curious when first exposed to stock, but he should soon calm down or exhibit some submissive behaviors. A low-energy dog is more likely to succeed. A potential working terrier should exhibit interest in a safely caged rat. Herding aptitude can also be tested with supervised interaction with stock. (See individual chapters for more on specific aptitude testing.)

Specific Rescue Issues

While the overall concerns in choosing to rescue a working dog are similar, there are some issues that you should be aware of when looking for a particular type of dog.

Livestock Guardian Dogs

It is vitally important to know that a dog is truly from an LGD breed. Rescue groups, shelters, and owners may misrepresent or simply guess at a dog's breeding if he is not registered. A crossbred dog with a non-LGD parent can be very dangerous to your stock or unable to protect your animals.

If he was purchased as a pet, his owners probably found that he barked too much or shed excessively, or, as late adolescence came on, was difficult to control and contain. Given support and time to adjust, a dog with good instincts may turn into a good guardian and possibly a fine full-time working LGD. Indeed, he may be happier with a job to do and room to run.

Before you bring an adult dog home, you must have a very safe and secure location to keep him. Do not bring him indoors unless you intend for him to live there. A pen near your stock is excellent, as it allows the dog and your animals to become acquainted. Give him lots of attention in his new place.

A rehomed adult dog may be insecure, prone to separation anxiety, and determined to return to his previous home. Allow him plenty of time to adjust, and go slowly in introductions to your animals. It can take a full year for a dog to completely adjust to the routines in a new home. Be cautious in situations that he may not have experienced, such as lambing or breeding season. Seek advice if you experience problems that you can't resolve.

Herding Dogs

Dogs that have truly failed to show good herding instinct or desire can make good family companions, though they most likely still have a tremendous need for exercise and activity. Dogs that fail at competition herding may be perfectly suited to general herding on a small farm. Occasionally, dogs fail as herders or farm dogs because they kill or attack stock. Often these dogs have been allowed to roam and have caused unsupervised damage in fields of stock. This is not the dog for a beginner. Attacking stock is a serious problem that needs an experienced person to evaluate and possibly retrain the dog.

Terriers

It is critical to determine the reason for a terrier's placement in rescue. Terriers that are in rescue for the simple loss of their home can be an excellent choice. Their behavior still needs to be evaluated, and care should be taken with their rehoming, but these dogs may not have any serious issues.

Specialized terrier rescue groups are the most prepared to properly assess terrier behavior, as well as a dog's real problems and needs. All-breed rescue groups or shelters may view a terrier as overly aggressive or out of control, when his behavior toward other dogs and animals may primarily reflect his terrier instincts or lack of appropriate training and handling. For instance, a terrier that dismayed its former owners by hunting small animals in a suburban yard may be perfectly suited for a job in the country as a working ratter or vermin hunter.

Many rescue organizations will only place a terrier in a home situation instead of an outdoor or working home. However, most terrier organizations promote participation in appropriate activities for terriers, including earthdog trials and others.

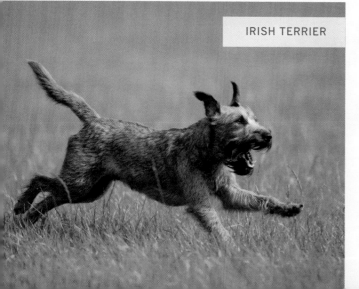

IRISH TERRIER

Herding dogs and terriers need lots of exercise and mental stimulation. This is also the reason many are turned over to rescue.

What about Crossbred Dogs?

Breeds of dogs were developed to display specific instinctual behaviors and combinations of those behaviors. Crossbreeding reduces the likelihood of the appearance of those exact behaviors and working abilities. If you require certain traits or temperament or size in your working dog, your chances of success are increased with a breed shaped for your purpose. When you consider the time and energy you will invest in training and raising your dog, as well as the value of your stock, it is always better to match the right breed to the job.

If you are thinking of adding a crossbred dog to your farm or family, please consider the following observations.

Crossbred LGD Dogs

In North America, it is common to see pups for sale who are the result of crossing one LGD breed with another LGD breed or even more. Many of these dogs are excellent, hardworking livestock dogs. There are two popular crosses, although others exist. Crosses between an Anatolian Shepherd Dog and a Great Pyrenees are very common, probably because these two breeds have been the most numerous and are often found on the same farm or ranch. The other well-known cross is often called a Big White Dog (BWD); it includes crosses between Great Pyrenees, Maremma, Akbash, Kuvasz, and other white LGD breeds.

Some people think that crossbreeding different LGD breeds creates healthier pups and reduces the chance of hip dysplasia (HD). In reality, if one or both parents have hip dysplasia, the odds are high that many of the pups will as well. Knowing the hip status of parents and grandparents is the best protection you can buy to decrease your chances of your pup developing HD. Purchasing a crossbred dog with no knowledge about parental HD or other health concerns is the same gamble as purchasing a purebred dog without health information. The same is true for other dominant genetic health issues or inherited traits. It is just as important to research the working behaviors and temperament of the parents of a crossbred pup as a purebred pup.

There is a common belief that crossbreeding LGD breeds levels out temperaments, behaviors,

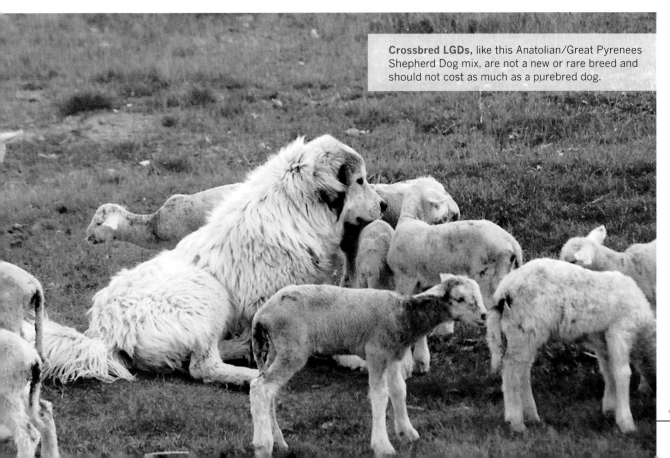

Crossbred LGDs, like this Anatolian/Great Pyrenees Shepherd Dog mix, are not a new or rare breed and should not cost as much as a purebred dog.

and physical traits. In some cases, these crosses are complementary and successful; however, crossing a highly reactive breed with a calmer, more placid breed does not mean that all of the puppies' temperaments will fall between both parents. In reality, some pups are like their mother, some like their father, and others have completely unpredictable temperaments and behaviors. Crossing breeds is not like mixing paint; genetic traits sort out randomly. There is no guarantee that you will get the best of each breed; in fact, you may get the worst.

It is important to realize that appearance does not indicate which parent a pup will be like. Pups can look like one parent and act like another. This is true for other inherited traits as well. Another problem that can occur with crosses is the loss of useful traits, such as a good working coat. Crossing two breeds with dissimilar coats can result in puppies with coats that don't protect against weather, that mat heavily, or that don't shed burrs and stickers.

Avoid These Types of Dogs

Most important, if you are looking for a working livestock guardian, do not purchase a pup who is a cross between an LGD breed and another breed type, such as a herding dog or hunting dog. Other breeds can make great farm dogs but they do not possess the genetic instincts and protective natures of an LGD. Being a livestock guardian is not a job you can train any other breed to perform. You cannot cross a recognized LGD breed with something else and end up with LGD puppies. These breeds were developed over many centuries to have low prey drive — exactly the opposite of the herding or hunting breeds. And LGDs are bred to be self-thinkers who bluff first and attack predators only when necessary — exactly the opposite of guard or personal-protection dogs who respond to commands.

Unfortunately, many puppies on farms are the result of LGD crosses with herding or other farm dogs. The prey or chase drives in many of these

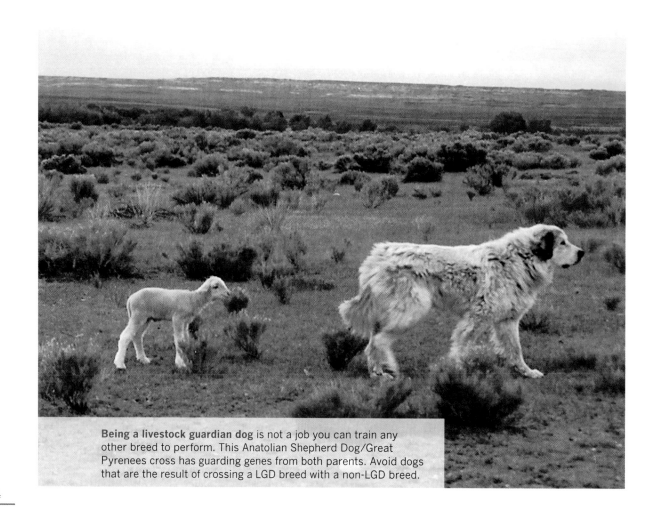

Being a livestock guardian dog is not a job you can train any other breed to perform. This Anatolian Shepherd Dog/Great Pyrenees cross has guarding genes from both parents. Avoid dogs that are the result of crossing a LGD breed with a non-LGD breed.

breeds are just too high to make them reliable guardians. Some breeds are excellent watchdogs but lack the nurturing instincts an LGD exhibits toward its charges. Other breeds lack the coat to work outside in difficult weather. Still others do not possess the size, agility, courage, or sense of responsibility to take on serious predators. Many breeds or crossbreeds make great all-around farm dogs, but they should not be trusted or expected to live reliably with stock 24 hours a day. Experienced and knowledgeable LGD owners never use dogs crossed with non-LGD breeds as working livestock guardians.

Crossbred Herding Dogs

It is not uncommon to find herding breed crosses (that is, *herding breed × herding breed*) among working ranch dogs in North America, especially with stock or cow dogs. Some handlers deliberately breed a cross they like to work with for specific reasons. They use dogs whose lineage they are very familiar with, especially with regard to working ability, style, and temperament.

Some ranchers or breeders develop their own lines of herding dogs that have predictable behaviors and consistent temperaments. Some even have working registries. An example of a deliberate and popular herding dog cross is the Texas Heeler, a cross between the Australian Cattle Dog and the Australian Shepherd or Border Collie.

Random crosses between herding dogs, however, can be incompatible and have unpredictable results. Serious working or trial folks do not use such crosses, which are not worth the time and energy needed to train a good herding dog.

Often an "oops" breeding on a farm, *herding breed × nonherding breed* crosses can make nice all-purpose farm dogs. However, they can never be full-time livestock guardian dogs because the pups often inherit and display many of the strong herding instincts from the herding breed parent. A herding breed crossed with any large dog can also result in a powerful, tenacious giant who chases stock or children. Such a dog is also likely to lack the energy or endurance to function as a serious herding dog. A herding breed crossed with a terrier or protection breed can display too much bite or even reveal kill tendencies.

Crossbred Terriers

Owners of working terriers or earthdogs often have specific needs in terms of size and traits, which can be compromised by outcrosses to dissimilar breeds. Crosses between similar breeds can be complementary and compatible, such as the smooth-coated Jack Russells and rat terriers, or between the fell or fox terrier types.

On the other hand, terriers are often used to create "designer dogs" in crosses with a nonterrier breed, such as a poodle. New owners are often surprised when the strong terrier traits result in a dog with unwelcome or unexpected tenaciousness, dog aggression, high energy, or high prey drive. However, this dog may be welcome on a farm as a companion and occasional helper with vermin hunting around the barn.

Crossbred Multipurpose Dogs

As with all crosses, prospective owners need to be prepared for any possible combination of traits from the two parent breeds. Some crosses can result in very large, dominant dogs with instinctual desires to chase stock. Crosses from either the livestock guardian or herding breeds with the traditional, multipurpose farm breeds can often make good, general purpose farm dogs but should not be expected to serve as specialist herding or livestock guardian dogs.

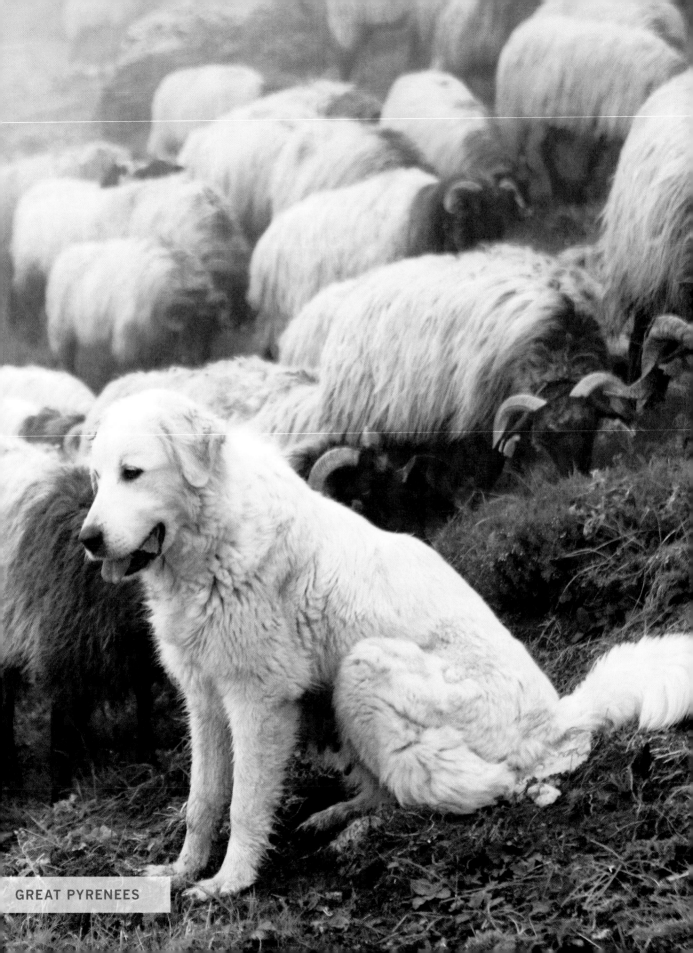

GREAT PYRENEES

Livestock Guardian Dogs

These breeds are the descendants of the ancient shepherd's dogs that guarded flocks against wolves, bears, big cats, roaming dogs, and the occasional two-footed thief. The livestock guardian breeds were developed and used throughout a sweep of lands from the western Iberian Peninsula and Pyrenees mountains, through the Alps, Apennines, Carpathians, Balkans, and Caucasus mountains, into western Europe, Turkey, and central Asia, all the way to the Himalayas. Livestock guardians still perform important functions in their homelands and on farms and ranches throughout North America.

Physical Appearance

The livestock guardian breeds share many traits and behaviors, as well as a common appearance. Most LGDs look a bit like fluffy, overgrown puppies with floppy ears, and curly tails. Tails are held low when relaxed but held higher and curved or curled when alert. All LGD breeds (with one unusual exception, the Cão de Castro Laboreiro) are double coated for insulation in both heat and cold and as a form of protection in fights with predators. The outer coat is harsh to the touch and weather resistant, and sheds heavily twice a year. Most breeds are medium-haired to longhaired, although there are some shorter-haired breeds that are also double coated.

Historically, shepherds in some areas bred for color or color patterns so that they could quickly locate their dogs near the flock or keep track of them in confrontations with predators. In other locations shepherds preferred dogs colored much like their sheep or goats, as a form of camouflage.

Roles for an LGD Breed

The first step in selecting an LGD breed is determining what role you want him to perform. While most of the LGD breeds can function in any of these roles, some are better suited than others for a specific job. The decision about role also influences which puppy you choose from the litter. It is essential in providing the correct early experiences and training. Both males and females work equally well.

Working Livestock Guardian

This dog lives outdoors full-time with his stock, and all the attention you give him should happen where he lives and works. He is content without constant human interaction. He does not come in the house or play with the family dogs in your yard. He needs to be raised and trained properly to do his job even though it is his traditional and historical role with humans.

Farm Guardian

This dog lives outside protecting his farm and family from predators and other threats much like a traditional watchdog. He patrols areas around farm buildings and animal enclosures. He accompanies you on chores, day and night. Without complete 24-hour access to pastures, he may not be able to provide complete protection, but he can warn predators away and alert you to situations that require your assistance. He may spend a portion of his day with stock and occasionally visit in the house, although some farm guardians are uncomfortable and restless inside.

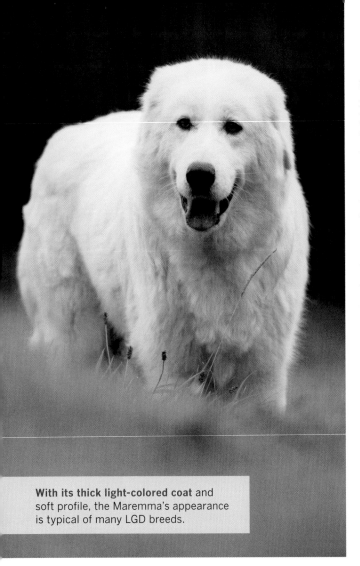

With its **thick light-colored coat** and soft profile, the Maremma's appearance is typical of many LGD breeds.

He needs proper socialization and training to be both a good livestock guardian and a family companion. Do not bring him inside to sleep unless you want him to be more of a companion than farm guardian. This is also a comfortable role for an LGD, and one that many performed in their homelands.

Companion

While LGDs are impressive and attractive dogs, they are dignified, powerful animals who are neither couch potatoes nor easygoing pets. A companion dog lives in the house with his family and also serves as a watchdog, providing excellent protection for a rural homestead. For the most part, LGD breeds were never meant to be traditional housedogs and some breeders are reluctant to sell a puppy to even an experienced, dedicated owner who lives in a city or suburb. For an informed and prepared family in the right situation, however, an LGD can be an exceptional companion. Some breeds are more amenable to family life, although LGDs are best suited to rural or country situations with lots of room for exercise and activity, even as a companion dog.

Whatever role your dog is to fulfill, owning an LGD is a serious responsibility and sometimes an insurance liability. This is the reason for good fences, educating your neighbors, socializing your dog, and posting signs that say LIVESTOCK GUARD DOG AT WORK.

Different Names, Same Dogs

Livestock Guardian Dog or Livestock Protection Dog? Some people and organizations choose to use one term over the other, but both refer to the recognized breeds of livestock guardian dogs and the job that they do. Here are some other terms by which these breeds are known around the world.

Sheepdog/shepherd. Many LGD breeds have these words in their names. In the past, dogs referred to as sheepdogs and shepherds were simply dogs that belonged to shepherds. LGDs are not herding dogs like a modern-day sheepdog or shepherd. Sometimes LGDs do accompany moving flocks, leading, trailing, or walking on the perimeter, but they are not herding the sheep.

Mastiff (*mastino, mastin*). Historically, the word "mastiff" often referred to any large, powerful dog. Confusingly, mastiff, *mastino*, or *mastin* are often found in the breed names of dogs that are not true mastiffs. Today the group of mastiff dogs includes breeds such as the English Mastiff, Great Dane, and Rottweiler, along with many others that are not LGDs but share the following traits: heavy bones; short coats; pendant ears; large, strong heads on muscular necks; and shortened muzzles.

Ovcharka. This Russian word simply means "shepherd dog."

Livestock Guardians Do Not Herd Stock

Some histories or descriptions of livestock guardian breeds say that the dogs also herded the animals. This is a misconception of behavior, and a misunderstanding of the words "sheepdog" and "shepherd." Human shepherds moved the flocks, often using actual herding dogs. The large livestock guardian dogs simply moved with the herd or flock, sometimes out ahead to scout for danger and other times on the sides or at the rear.

Walking with the flock might look like herding and it might encourage the animals to keep moving, but it is not active herding. When confronting a predator, an LGD often places himself between his flock and the threat, perhaps pushing them back and away. The flock may also respond to his protective behavior, clustering behind him or moving toward their barn. This is still not active herding.

Livestock guardian dogs do not fetch or gather animals. They do not sort or hold animals. They should never chase or bite their charges. Their animals trust them in ways they never would trust a herding dog. The large livestock guardian breeds were among the first specialized dog jobs, when humans first domesticated sheep and goats to keep as sources of food and fiber. The use of specialized herding breeds came much later.

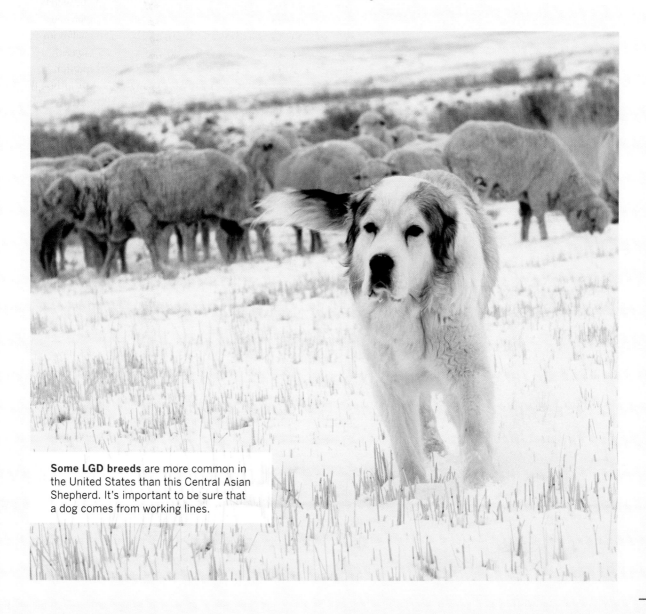

Some LGD breeds are more common in the United States than this Central Asian Shepherd. It's important to be sure that a dog comes from working lines.

Behavior and Temperament

Compared to wolves, dogs have a delayed period of fear response, which gives them a longer window of socialization to new experiences. LGDs, in particular, have a long period of socialization. This is especially important because it allows puppies more time to bond with people and other animals, such as sheep or goats.

Livestock guardian dogs have been selected for many centuries for their low or nonexistent prey drive and a physical appearance that suggests "friend." They have also been selected for attentiveness, trustworthiness, and protection without human direction. To successfully perform these behaviors, LGDs are strongly independent thinkers and dominant in temperament. They are always aloof and reserved with strangers and sometimes even with family.

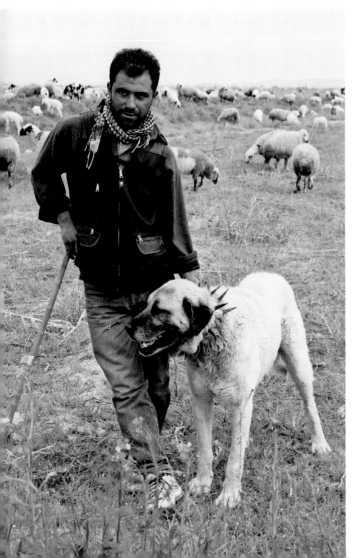

In LGDs, the predatory sequence — search/stalk/chase/bite and hold/bite and kill/dissect/consume — that was present in the earliest dog ancestors has been altered through selective breeding so that these dogs display almost no predatory inclinations toward their charges, but they do attack predators. When an LGD acts aggressively or threateningly, he is not hunting for prey but protecting his pack mates. He also possesses a graduated response (alert/bluff/threat or charge/attack) to warn off predators rather than immediately attacking them, although the relative speed of this reactivity varies strongly between breeds.

While most LGDs will not chase or retrieve objects, some puppies do attempt to play with stock by chasing or grabbing. Traditionally, an adult dog or a human shepherd would stop these inappropriate adolescent behaviors, and they would be extinguished by adulthood.

LGD breeds are lower energy dogs that often appear to be sleeping until a slight disturbance indicates a threat. Although these dogs are highly protective, police, military, and Schutzhund trainers have found them generally unsuitable because of their lack of strong predatory behaviors and their independent temperament. When they are used by the military or police, it is as a watchdog or a companion to a sentry rather than as an attack dog. LGDs do not need any training to be protective of home and flock and they do not attack on command.

All livestock guardian breeds demonstrate the following characteristics and behaviors in various combinations and strengths.

Protectiveness. LGDs naturally protect their territory, their people, and their animals against strangers and predators of any size. They will attack both small and large predators, including birds of prey, as well as wandering dogs or stray cats, if they are not warned off through barking, bluffing, or charging. LGDs can be threatening or aggressive to strangers on your property, including delivery people, farm customers, veterinarians, farriers, sheep shearers, or others working with their stock, including herding dogs. They need to be appropriately introduced to people you would like them to accept.

This Kangal Dog in Turkey wears a traditional spiked collar to protect it in fights against predators.

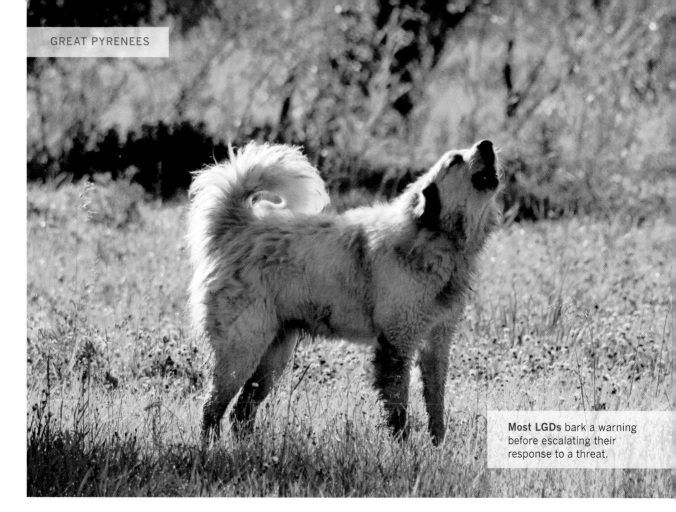

Most LGDs bark a warning before escalating their response to a threat.

Reactivity. These breeds are defensively aggressive. In working dogs with protective or guardian natures, reactivity is expressed on a continuum from a slower, measured warning to rapid engagement in physical confrontation. Livestock guardian reactive behavior is defensive in purpose and serves a working function. Reactivity (the speed of response from warning to attack) varies among LGD breeds.

Barking. All LGDs bark and patrol to warn off potential threats, especially at night when predators are most active. Young dogs are particularly prone to overbarking at noises and disturbances. You can gradually teach them to be more appropriate with their barking, and most become more selective as they mature. Dogs bark less in the house, although if they are left alone in a small yard, barking can be a nuisance to close neighbors. Dogs that don't have a job to do, aren't getting sufficient exercise, and have no territory to patrol bark more and engage in other destructive acts.

Roaming/wandering. LGDs will seek to patrol and expand their territory. These breeds were developed on open land, where they worked in the company of shepherds by day and guarded the flock by night. Among their duties were patrolling out ahead of the moving flock, expanding the protective zone around the flock through patrolling and marking, and chasing away large predators.

For their size, LGDs are amazing climbers, diggers, and jumpers — as well as fast runners — who are often quite determined to escape fencing to patrol and expand territory. Intact dogs may also roam in search of mates. The best antidote is for a pup to grow up thinking it is impossible to escape. Invisible fencing works only as a reinforcement to a visible fence. Good robust fencing is a must. Fencing needs to be tall, possibly with electric wire reinforcement.

Dominance. These are dominant breeds, some more so than others. Dominant dogs are assertive and strong willed; in the absence of leadership, they become increasingly bratty and can misbehave. Dominant dogs require experienced, skilled handlers.

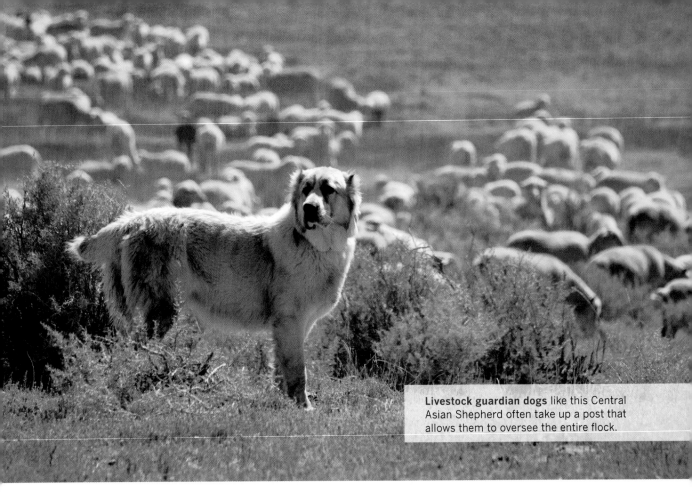

Livestock guardian dogs like this Central Asian Shepherd often take up a post that allows them to oversee the entire flock.

Independence. LGDs are independent thinkers and may ignore your commands in favor of their own decisions. These dogs have less desire and need for human interaction, although they are still affectionate toward their owners. Do not expect 100-percent reliable recalls or appropriate off-leash behaviors. Although basic training and socialization are absolutely essential, an LGD needs short, positive experiences rather than long sessions of repetitive work. If an LGD is not handled, he becomes nearly feral and uncontrollable. As an aside, keep in mind that LGDs are often not food motivated.

Slow to mature. LGD breeds grow slowly and do not fully mature until aged two or older. Their large size is deceptive and often encourages people to think of them as grown dogs far too soon. They need time, guidance, and supervision to become good family or farm dogs. Owners are often surprised by the sudden, serious change in their young dog's protective behavior at around age two.

All LGDs should be socialized to adult animals before being introduced to young livestock. Young LGDs can actually be overly maternal or protective of baby animals, removing them from their mothers

or licking them obsessively. Do not leave young dogs unsupervised with poultry or young animals, but do take him with you on your chores in and around your animal enclosures. Poultry is especially problematic for LGDs; they did not traditionally guard poultry in their homelands. Use caution around equines as well, as some have a strong antipathy toward canines.

Making the Right Choice

Despite common appearances, behaviors, and temperament, distinct and important differences exist among the various livestock guardian dog breeds. Individual breeds were developed for different kinds of work in varying locales, which required specific combinations of behaviors or responses to situations. The coats of some breeds are better suited to hot or humid weather while others excel in cold environments. Activity levels also vary between LGD breeds, sometimes due to climate but other times due to the needs of shepherds and flocks to travel long distances every day or frequently through the yearly patterns of transhumance.

Some livestock guard dog breeds historically lived in a close relationship with their owners, while

Myths and Misinformation about Working LGDs

The following widespread misconceptions are responsible for the majority of problems LGD owners face.

Myths

- Human contact is bad for LGDs.
- LGDs can't be trained.
- It is fine for a working LGD to be unapproachable or aggressive, even to his owner.

The Facts

For thousands of years, these dogs worked in partnership with shepherds and lived in close contact with humans. Interacting with your dog will absolutely not prevent him from being a good LGD. In fact, he will respond better to your praise and corrections if you have a good relationship. He deserves human contact, but that contact should be where he works in the barn or the pasture, not your house. Establishing a working partnership ensures that your dog is safe for you to handle and care for.

Myths

- LGDs are natural guardians and need no training.
- Even puppies can be left alone with stock.

The Facts

LGD pups were traditionally raised among their stock with complete supervision and guidance of experienced dogs and shepherds. They were not left in a field alone with stock, especially as a pup or juvenile dog. New situations such as birthing and baby animals or birds are also very problematic for young dogs.

Myth

- If a pup isn't raised with stock, he won't be able to work as an LGD.

The Facts

Although raising LGD puppies with stock is preferable, adult LGDs that were never raised with stock can still make good guardians if they possess the right instinctive behaviors. Not all adults can make this transition, and former bad habits might be too ingrained, but given good training and time, rehoming an adult dog into a working life can be accomplished.

Myths

- LGDs can easily guard poultry.
- If a young LGD kills a chicken or another small animal, he will be worthless as a guardian.

The Facts

Although LGDs were not traditionally used to guard poultry in their homelands, some owners have successful socialized their dogs to do so. Others have found that their dog can't do this reliably, even if he is excellent with sheep or goats. If you want to use your dog with poultry, constant supervision is required for his interactions. You should praise good behavior and immediately stop any attempts he makes to bite or mouth the birds. Never leave a pup or adolescent alone with birds.

Some dogs are good with adult birds but have trouble with young birds. Most successful owners admit they lost a bird or two along the way. If a mistake is made, redouble your efforts at training and do not allow unsupervised interaction. A mistake is not a death sentence for a young dog and tying a dead chicken around a dog's neck is useless.

Myth

- LGDs bond to their stock so fences aren't really important. Only bad LGDs roam.

The Facts

Unless you graze your animals on very large areas of public or private land, you need a good fence. In the company of their shepherds, LGDs were bred to patrol, guard, and chase away predators on open land. LGDs instinctively want to expand their protective territory, usually far beyond your farm.

A longer version of this material, coauthored with Carolee Penner, originally appeared in 2014 as a blog post for Mother Earth News.

others were more self-sufficient and less dependent on a great deal of human interaction. Some breeds were also used as estate, home, or camp guardians while others were primarily the dogs of shepherds on open grazing land. Most breeds are definitely more suited to owners who have experience with very large and dominant dogs; others make better "beginner" LGDs. Some breeds are accustomed to working in pack situations whereas some breeds might find this more difficult.

Sizes vary from slightly smaller, more agile breeds to larger, heavier ones. Overly massive dogs were not traditionally used as working LGDs, which need to be fast and agile when dealing with large predators. Among the LGD breeds, overly exaggerated dogs are often more mastiff-like in appearance, function, and temperament. Head, muzzle, neck, dewlap, and bone in these dogs are larger than in a traditional working dog.

Some of these dogs are being marketed as working LGDs, but their large size may hinder productive work, increase susceptibility to heat, increase joint and health issues as well as skin problems, and lower life expectancies. Breeding for size alone reduces good health and working ability. Very large or bulky dogs are also associated with dog fighting in some eastern European and central Asian countries. Size, bulk, or increased aggression is associated with outcrossing traditional LGD breeds with other non-LGD breeds or dog breeds developed for police or attack work.

Most important, breeds vary quite a bit in their level or rate of reactivity to a perceived threat. Broadly speaking, the breeds from Western Europe tend to be less reactive while the Eastern European breeds are more highly reactive. Some breeds fall somewhere between these two extremes. Some breeds are still protecting against wolves and bears in their homelands, while others have not confronted large predators in recent history. The types and amounts of predator pressure you face might dictate which breeds are more suitable to your needs.

Common Health Concerns

Hip dysplasia is present in all large and giant breeds, as are other bone and joint issues. All breeding dogs should be screened for hip dysplasia and for other health issues if warranted. Elbow dysplasia and cruciate ligament injuries are also a concern in some dogs. Pups should grow slow and be kept lean. Adult dogs should be kept at an appropriate weight, to help minimize the effects of any potential joint and ligament issues.

Osteosarcomas and other cancers are also found in LGDs. Ectropion, entropion, and other eyelid issues can be a problem in some breeds. Bloat is a threat to deep-chested breeds, although not widely seen in working LGDs. Anesthesia recommendations and surgery protocols for sighthounds and deep-chested breeds should be followed in all LGDs.

Recently Created Breeds

At times "new" LGD breeds or newly created LGD breeds are advertised online, where individuals may attempt to market their dogs through a flashy website or false and misleading information. Sometimes these dogs are advertised as "landrace" or "aboriginal" or "new to North America." Because all LGD breeds originated in Europe or Central Asia, always check to see if this "breed" is actually recognized or documented in its homeland by a reputable organization, kennel club, governmental agency, or university. *There are no landrace LGD breeds that have been completely hidden from the outside world.*

Be very cautious of newly created breeds that, despite their names, suggest that they are livestock guardians. Often these dogs are crosses between LGD breeds and mastiffs, large game hunters, or protection, bull-baiting, or fighting breeds. The instincts and temperament of these breeds are incompatible with good livestock-guardian behaviors. Some of these dogs were developed for dog fighting and are being remarketed as LGD or family protection dogs. Crosses between various recognized LGD breeds are also being marketed as a legitimate breed, rather than as crossbred dogs. And crossbred dogs should never cost more than purebred dogs.

What to Look for in an LGD Puppy

Good LGDs are valuable, often difficult to locate, and frequently command a relatively large purchase price. An LGD puppy is easier to find than a reliable adult. You might be tempted to consider buying a dog from a breeder who does not do routine health checks in an effort to save money. However, LGDs are slow to grow and mature, demanding a large investment of time and guidance to become good working dogs. Buying a dog from a reputable breeder, who selects for good health, working behaviors, and temperament, greatly increases your chances for success and a sound dog.

Breeders observe their puppies for several weeks to determine personalities and behaviors. If you are buying a pup from a distant breeder, rely heavily on his or her knowledge and opinion. Even if you are able to visit the pups in person, it is advisable to rely on the breeder's experience. Be honest in sharing your planned role for this dog, as well as giving a true assessment of your experiences with large dogs.

Besides overall good health, there are several indicators of good working LGD behaviors. Unless you are planning to breed or show, minor issues such as incorrect marking or color, are not important. Pink skin on eyelids, lips, and nose can lead to sunburn or lesions. Overly large puppies can suffer from orthopedic issues when grown. Undersized puppies may not develop the size and strength necessary to deal with predators. When looking at a pup, assess the following:

Activity level. Dogs with lower activity levels are generally more suited to be both working and companion dogs. They are easier to train and less inclined to roam than dogs with high activity levels. Exceptions can occur in situations with expansive pastures, large flocks of animals to monitor, and high predator pressure.

Prey drive. Pups with low prey or chase drive either just watch a small thrown object go by or investigate it once, but not again. Avoid puppies that chase or fight over a thrown object or continually chase it.

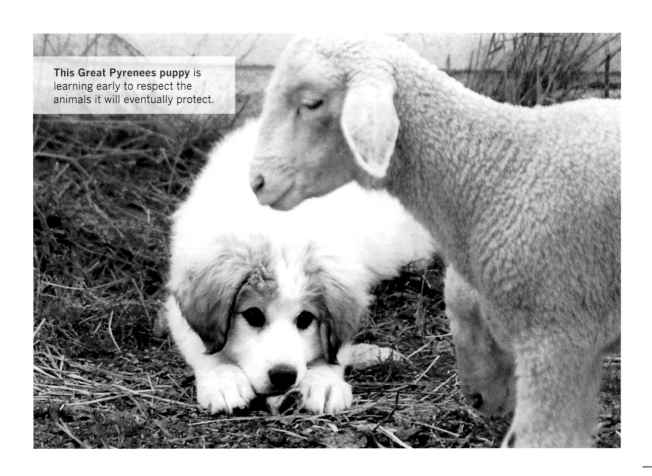

This Great Pyrenees puppy is learning early to respect the animals it will eventually protect.

Temperament. Look for a pup who is interested in you but not overly aggressive, fearful, shy, or clingy. Avoid the pup that runs up to you first or demands your attention. Calm, thoughtful puppies are desirable, as are ones that accept new objects or loud noises. Pups that walk away after meeting you, hang back from the rest of the puppies, or simply curl up and sleep are often good choices for a working dog. Avoid pups that struggle, growl, or bite when you handle them.

Pain threshold. Working dogs need to tolerate being jostled or bumped or run over by stock, so avoid pups that are sensitive to pain. You can test this with a gentle pinch between the toes or elsewhere. Typical LGDs are very stoic and do not admit to pain.

Reaction to stock. Look for a pup that is curious but cautious. Good indications of appropriate behavior include avoiding eye contact, a lowered head and tail, rolling over, licking at the mouth, and choosing to sleep next to stock. Avoid pups that bark, jump, or bite stock. Even when they are shoved or stepped on, LGDs should remain calm and gentle around livestock.

Bringing Home an LGD Pup

If your pup is going to be a full-time livestock guardian or a farm guardian who lives and works outside, he needs an escape-proof pen and shelter in the stock area, or a secure place in a barn next to his future charges. Give him safe objects to chew and play with. Leash him

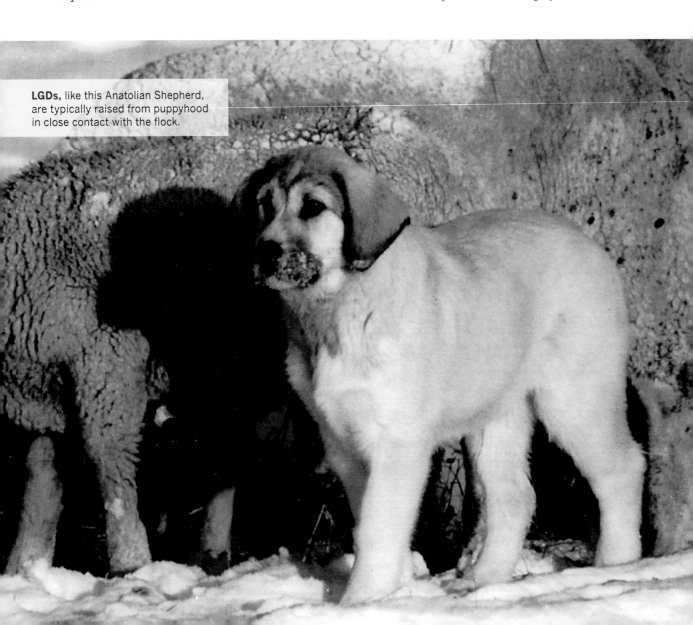

LGDs, like this Anatolian Shepherd, are typically raised from puppyhood in close contact with the flock.

and take him on chores or to visit other animals on your farm. Supervise his experiences with stock. You may have safe, calm, mature animals or a good adult mentor dog to help train your pup.

Unless he is too young or ill, he will be fine in an appropriate shelter even during winter. Don't respond to his cries when you leave him. Remove him from his working area only for necessary experiences away from the farm.

If the LGD pup is going to become a housedog and companion, he can be treated exactly like any other new puppy, including crating if desired. He should be left only in secure places; keep in mind he may become very destructive if bored. As a young pup, he will generally be fine with the family's other pets, even becoming quite attached to them. As he becomes older, however, issues of dominance or food aggression may arise.

Bringing him to puppy classes is a good idea and can be a good experience for him. It is vital that all members of the family participate in handling and training the dog, although children must always be supervised.

Regardless of his role, the LGD puppy grows and matures at a slow rate. He needs lots of supervision and training, rewards for good responses, and gentle corrections for inappropriate ones. Don't worry if your pup or young dog is overly friendly with strangers or not protective against predators. With maturity, he will become more serious and protective without any specific training.

It's important to thoroughly research the background of any breed. Though technically a livestock guardian breed, the Caucasian Ovcharka has also been bred to be a fighting or protection dog, making it a challenging choice for most people.

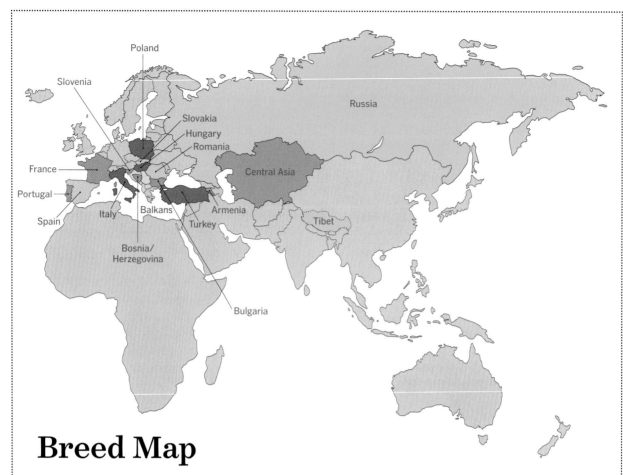

Breed Map

Armenia
Armenian Gampr

Balkans
Šarplaninac

Bosnia/Herzegovina
Tornjak

Bulgaria
Karakachan

Central Asia
Central Asian Shepherd

France
Great Pyrenees

Hungary
Komondor
Kuvasz

Italy
Maremma

Poland
Tatra

Portugal
Cão de Castro Laboreiro
Cão de Gado Transmontano
Estrela Mountain Dog
Rafeiro do Alentejo

Romania
Bucovina Shepherd Dog
Romanian Carpathian
 Shepherd Dog
Romanian Mioritic Shepherd
 Dog

Russia
Caucasian Ovcharka

Slovakia
Slovensky Cuvac

Slovenia
Karst Shepherd

Spain
Pyrenean Mastiff
Spanish Mastiff

Tibet
Tibetan Mastiff

Turkey
Akbash
Anatolian Shepherd
Kangal

Akbash Dog

AHK-bahsh | Also known as Akbas

Origin	Turkey
Size	**Male** 28 to 31 inches, 90 to 130 pounds **Female** 27 to 29 inches, 75 to 100 pounds
Coat	Outer hair short and flat to long, thick, or wavy with soft undercoat
Color	White, cream, or biscuit
Temperament	Independent, dominant, low energy, moderately reactive

The Akbash Dog, which combines a strong response to predators with reduced aggression to people, is considered one of the three best livestock guard dog breeds in the United States, according to one USDA study.

The breed has especially earned its well-deserved reputation among sheep producers on the western ranges, where the dogs are successfully protecting livestock against some of the fiercest predators.

Akbash Dogs work successfully in both fenced pastures and rangelands.

Akbash Dogs have the size, power, and protective nature of a heavier dog combined with the speed of the sighthound. They are especially alert and early to sound the alarm. Like all livestock guard dogs, they are self-thinkers and territorial. They are wary of people they do not know and do not accept intruders on their property, especially when their owners are absent.

Working traits. The breed standard notes the extreme maternal nature of the Akbash Dog. They form early and strong attachments to their charges.

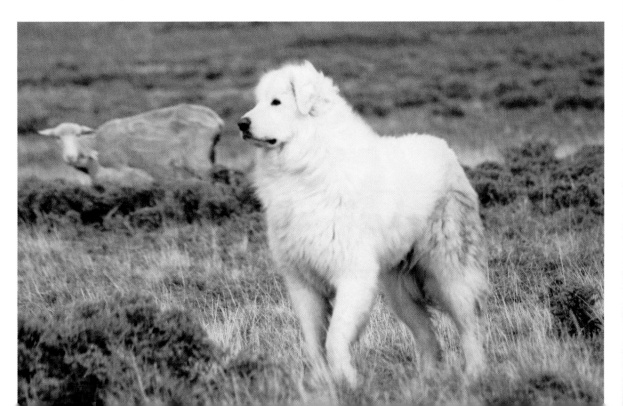

This maternal instinct can be seen in their submissive behavior toward livestock, especially toward young animals. Typically, Akbash puppies are raised with stock from an early age, and it is recommended that this practice be followed if your dog is to work as a livestock guard dog, although young dogs must be supervised.

Akbash Dogs are not suited to urban life, but they can make good, affectionate farm and family guardians in more rural areas, even without livestock to guard, especially if the owners are prepared to deal with serious working-dog temperament and behavior. Adult Akbash Dogs can be dog-aggressive, even off their property.

Appearance

The Akbash Dog is often described as elegant or graceful. He is generally leaner than the Kangal Dog and longer in the leg but not taller or heavier. Dogs bred and raised in North America tend to be larger, due to better nutrition and veterinary care, as well as some selection for bigger dogs. The breed is physically slow to mature and males may not reach full size until the age of three or older.

Some dogs are leaner with a narrower head, longer face, longer legs, less depth through the chest, and a more pronounced tuck-up. Other dogs have a broader head and muzzle, more dewlap, heavier bone, and broader chest. Tails are carried over the back in a tight or double curl to a gentle curve, hanging lower when the dog is relaxed.

Coat. The Akbash Dog is double coated and sheds twice a year. Coats vary in length between smooth and short to long and thick. Coat and body types can combine differently, reflecting the natural variation in the breed. A shorter coat, which can make the dog resemble a large Labrador Retriever, can be useful in hotter climates, such as the southern coast of Turkey and some areas of North America. Akbash Dogs also do well in cold climates due to their dense undercoat.

Color. The coat is white or cream, sometimes with some light biscuit color on the ears, the top of the back, or the undercoat but no other areas of spotting of any color.

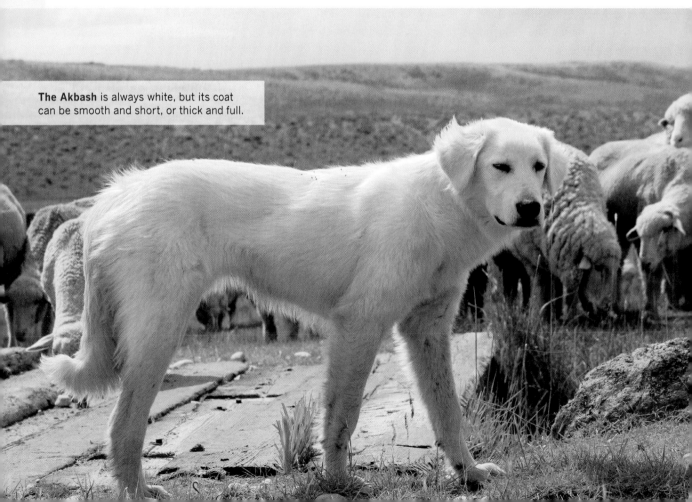

The Akbash is always white, but its coat can be smooth and short, or thick and full.

Under the coat, the skin is mottled. A preponderance of dark skin is preferable because of the sunburn risk. The nose, eyelids, and mouth are dark in color, with almond-shaped eyes colored light gold to dark brown. In Turkey, the ears may be cropped.

History

The location of many early human settlements, Turkish lands were also home to many different peoples as well as part of the Greek, Roman, and Byzantine empires. The history of Turkey as a national and cultural entity began with the migration of the Central Asian Turkish tribes in the eleventh century. The Turks arrived with their sheep, goats, and dogs, adding to the truly ancient types already found there.

Turkey is home to the mohair goat known as the Angora and several distinctive, indigenous breeds of sheep, such as the fat-tailed Karakamans and the Karakuls. The rise of the Ottoman Empire in the thirteenth century extended Turkish rule into North Africa, southeastern Europe, and western Asia. The modern Republic of Turkey was established after World War I.

Evliya Celebi, famous traveler and commentator of the seventeenth century, described brave dogs working with shepherds and guarding goats; he called them Angora Goat Dogs. *Akbas*, or "white head" dogs, were still on duty in the early years of the twentieth century, when foreigners described their encounters with these big white protectors. The Akbash Dog reveals a possible relationship of three ancient types — the large white livestock guardians, the mastiff breeds, and the sighthounds or gazehounds.

Some experts suggest that the Akbash may be the original white livestock guardian, carried by various peoples back to their homelands in Europe. Today we still find a range in types from the more elegant, long-legged and slim dogs to the heavier-boned dogs with stronger heads, although the medium-sized dogs are most numerous and popular with the shepherds.

Thirty years ago in Turkey, the Akbash Dog tended to be found in the provinces of Afyon, Ankara, and Eskisehir — sometimes called the "Akbas Dog triangle." At times he is also called *Akkus* or "white bird" in the western villages where he protects white Kivircik and Karaman sheep, as well as Angora and hair goats. The Akbash Dog protects his flocks against wolves, foxes, jackals, wild boar, and roaming dogs. When the flocks are not on pasture, he must live companionably in the villages.

More Recently

As Turkish society has changed and became more mobile, hastening the decline of sheepherding, the Akbash Dog population has drastically diminished. Crossbreeding of different regional types has also increased. While the Kangal Dog captured the nation's interest and affection, the Akbash has enjoyed somewhat less support, although that is beginning to change.

The Akbash Dog is recognized by KIF, the national Turkish kennel club, and organized breeding programs are under way. The Akbash Shepherd Dog Conservation and Research Association represents the breed, and FCI recognition is being pursued. It remains legal to export Akbash Dogs out of Turkey, although due to their rarity it can be difficult to find good specimens.

Remarkably, at the same time their numbers were decreasing in Turkey, the ancient Akbash Dogs became very successful livestock guard dogs in North America. Two Americans, Judy and David Nelson, conducted fieldwork on livestock guardians in Turkey in the 1970s. Several Akbash Dogs imported by the Nelsons were used in the USDA Livestock Guard Dog Program studies. The Nelsons and others continued to import Akbash Dogs, founded the Akbash Dog Association of America, and pursued UKC recognition of the breed, which was achieved in 1998. Small numbers of Akbash Dogs have been exported to Europe and elsewhere; however there is no formal recognition except in North America. The Akbash population is now estimated in the thousands in North America.

Akbash Dogs International, a separate organization, is dedicated to working dogs. There is a working relationship between ADI and AKAD in Turkey, and ADI maintains a worldwide breed registry including members in Europe. There is also a large group of unregistered Akbash Dogs in North America, primarily found in working situations. Akbash Dogs are often crossed with other large white livestock guardian breeds as well.

Anatolian Shepherd Dog

An-ah-TOLL-ee-an | **Also known as Anatolian, ASD, Coban Kopegi, Toli**

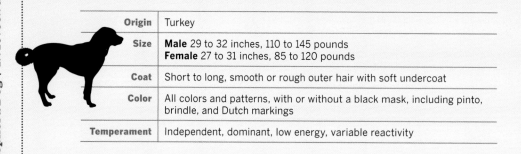

Origin	Turkey
Size	**Male** 29 to 32 inches, 110 to 145 pounds **Female** 27 to 31 inches, 85 to 120 pounds
Coat	Short to long, smooth or rough outer hair with soft undercoat
Color	All colors and patterns, with or without a black mask, including pinto, brindle, and Dutch markings
Temperament	Independent, dominant, low energy, variable reactivity

The mature Anatolian Shepherd should be a calm and observant dog. Anatolians can be reserved around strangers and away from their property.

At home, they are highly territorial and responsive to threats, although well-socialized dogs should tolerate other dogs when they are away from home.

An Anatolian is a challenging dog who demands a devoted, experienced owner. As a companion, he is best suited to homes with sufficient space rather than an urban environment. Anatolians are alert and active dogs that need regular exercise if not working.

Working traits. Anatolians are proven LGDs that can deal with serious and large predators. Their guarding technique may vary from staying close with the flock to observing from a more distant lookout spot. Anatolians bark to deter potential predators and in response to disturbances before escalating to more threatening intimidation. In general, ASDs are regarded as more rapidly reactive against threats and aggressive with predators than some of the western LGD breeds, but not as highly reactive as the eastern breeds.

Appearance

Due to its diverse genetic stock, the Anatolian has a greater variability in appearance and behavior than many other livestock guard dog breeds. In general, the Anatolian Shepherd is a powerful dog who should appear slightly longer than tall. The Anatolian should neither be too mastiff-like nor should he lack substance and appear sighthound-like.

The skull is broader in males than females, with a slight centerline furrow. The eyes are almond shaped and dark brown to light amber in color. Ears are often cropped in Turkey but are not acceptable on dogs bred in North America. All tail carriages are allowed.

Coat/color. Coat length can vary between 1 and 4 inches long. The coat is highly weather resistant

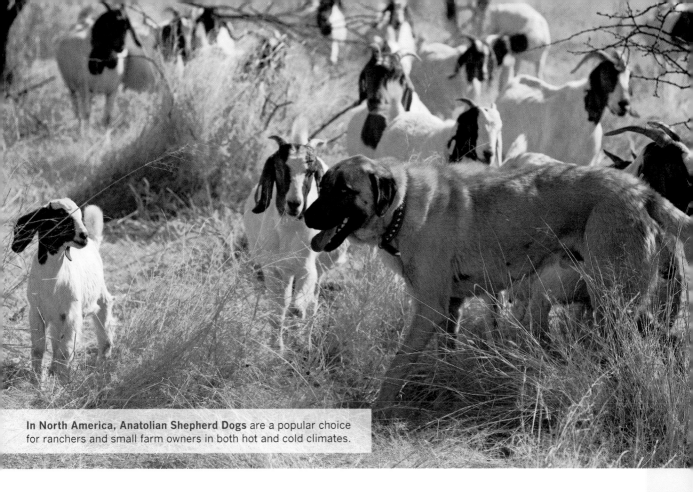

In North America, **Anatolian Shepherd Dogs** are a popular choice for ranchers and small farm owners in both hot and cold climates.

and suitable for both hot and cold climates. The short coat is seen more often and is desirable by some owners for its lower maintenance and suitability in hotter or wetter climates. All colors and color patterns — with or without a black mask — are accepted, including pinto, brindle, white Dutch markings on the face, and a collar around the neck.

History

From the earliest days of human settlement in Turkey, sheep, goats, and guardian dogs have been central to life. Turkey has also served as the crossroad between southeastern Europe, the Caucasus, western Asia, and the Middle East for millennia. The original Turkish Ottoman Empire encompassed even

more territory. It is not surprising that many of the *coban kopegi,* or shepherd's dogs, resemble dogs found in these various places. In modern Turkey, we find pinto and other-colored dogs, mastiff types, and breeds such as the fawn, black-masked Kangal, the white Akbash, and the rough-coated, ovcharka-type Kars Dog.

There have long been excellent *coban kopegi* of varied types and differing regional names, as well as centers of more selective breeding to a distinctive type. Some breeders believe that the livestock guard dogs of Turkey are part of one greater landrace group named the Anatolian Shepherd Dog. As a specific breed, Anatolian Shepherd Dogs are primarily bred outside of Turkey, and they are not accepted by KIF, the national kennel club

of Turkey. Outside of Turkey, the Anatolian Shepherd Dog has achieved great success and popularity, especially in North America.

Establishing the Breed

At first Turkish shepherd dogs were taken out of the country by people who worked or lived there. British archeologist Charmian Steele Hussey exported two Kangal-type dogs to Britain in 1965, registering them with the British Kennel Club, first under the name Anatolian Sheepdog and later the Anatolian (Karabash) Dog. The standard for this new breed specified a short-coated, fawn, black-masked dog.

After additional imports of other different *coban kopegi,* the decision was made to become more inclusive and the club was reestablished in 1983 as the Anatolian

Shepherd Club of Great Britain. This new group promoted the Anatolian Shepherd Dog in all colors with or without a black mask. Anatolian Shepherd Dogs are primarily family companions in Britain, although many also live at country homes or small farms. After many years of disagreement, the Kennel Club decided in 2013 to separate the ASD and Kangal Dog back into distinct breeds.

The FCI recognized the Anatolian Shepherd Dog in 1989. ASDs are now found throughout continental Europe. At times, confusingly, the dogs are referred to as Kangal Dogs because the short-coated, fawn, and black-masked dog is most often seen in Europe. Many kennels breed only dogs of Kangal pedigree, although these dogs are registered as Anatolian Shepherds.

American military personnel based in Turkey often returned home with their family dogs, although none of these individual dogs ever contributed to an organized breeding program until 1968. Navy Lt. Bob Ballard brought a male and female back to the United States, began a breeding program, and organized the Anatolian Shepherd Dog Club of America (ASDCA). More imports soon followed and continue today from Europe and Turkey, where it is still permissible to export Akbash and other shepherd dogs but not Kangal Dogs. The ASDCA has always accepted all colors and coat types, as do the other national Anatolian Shepherd Dog clubs.

The UKC recognized the breed in 1993, followed by the AKC two years later. Today the Anatolian Shepherd is one of the most numerous and popular livestock guard dog breeds in North America.

Anatolian Shepherd Dogs were imported to Australia in 1985. Although the population is not large, the dogs are working as livestock guardians and kept as family companions. For a time, Kangal Dogs were registered as a separate breed by the ANKC, but they have been included in the greater Anatolian Shepherd Dog registry since 2012. Anatolian Shepherd Dogs have also been imported in small numbers to New Zealand, including recent imports from Australia, the UK, and elsewhere. The NZKC recognizes the ASD and Kangal as separate breeds.

In North America, the Anatolian Shepherd Dog quickly proved itself to livestock producers, and the population increased rapidly. The breed, now highly regarded, has been included in many livestock guard dog studies. Most ASDs are found in working situations in North America, and there is a large unregistered and crossbred population as well.

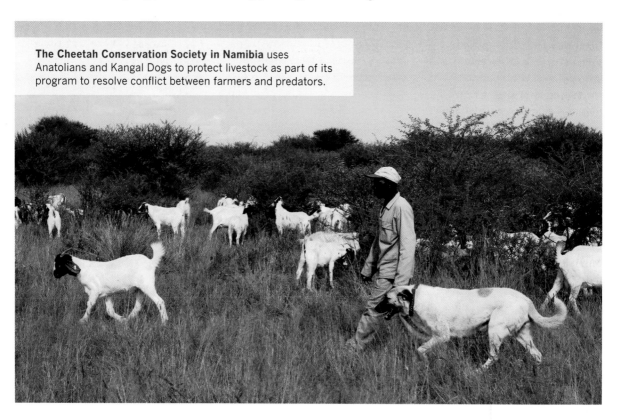

The Cheetah Conservation Society in Namibia uses Anatolians and Kangal Dogs to protect livestock as part of its program to resolve conflict between farmers and predators.

Armenian Gampr

GAHM-peer

Origin	Armenia	
Size	**Male** 25 inches and up, average weight 120 pounds **Female** 23 inches and up, average weight 110 pounds	
Coat	Short- or longhaired with soft undercoat	
Color	Any color or pattern, with solid colors more popular	
Temperament	Independent, dominant, low energy, more reactive	

A calm, serious, and cautious dog, the Armenian Gampr responds to challenges quickly and with great power.

He requires an experienced owner who understands that although this dog responds to direction, he is an independent thinker, sometimes dominant in nature, and much more reserved than a typical pet dog. Strongly protective and nurturing with children and their stock, the Gampr may display aggression toward other dogs, especially strange ones.

Working traits. As a working livestock guardian, the Gampr can be dedicated to patrolling, both at dusk and dawn. Gamprs can work well with other LGDs, although in a working pack or group they may at times vie for ownership of favorite things or duties. In addition to an experienced owner, the Gampr needs room to exercise, people or animals to protect, and excellent fencing.

Appearance

The Gampr is a large, strong dog with a powerful head, strong neck, and shoulders, yet he remains agile. Overall, the body structure is lean and built for endurance, with long, flat muscles over strong bones. Tails are carried high with a curve over the back unless the dog is relaxed. His ears and tail are often cropped. Eyes are almond shaped and the muzzle is tapered with tight flews. The diversity of types and varieties of the Gampr should be preserved.

Coat/color. The Gampr has a thick, dense double coat, which is suited to harsh weather. They shed heavily in the spring and fall, which can change their appearance remarkably. A wide variety of colors and color patterns are accepted, with solid colors more popular. Nose and eye rims are black. The Gampr can be shorthaired or longer-coated, but the coat should always be self-cleaning even at shedding time.

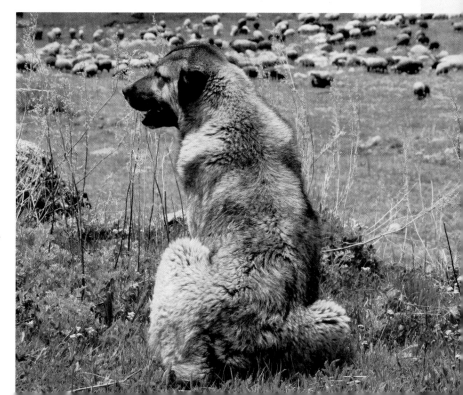

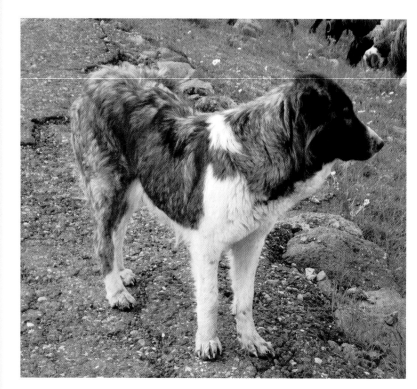

Left: Capable of taking on the largest predators, Gampr are powerful, dominant livestock guardians who demand an experienced and confident owner.

Below: Locating a Gampr to use as a working livestock guardian is very difficult in North America. Not only are numbers low, but many dogs from Europe were bred for other purposes.

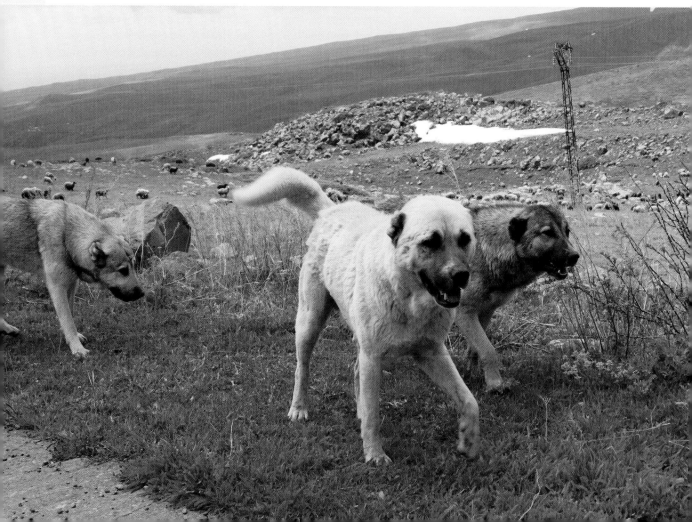

History

Situated in the southern Caucasus Mountains, Armenia is home to some of the earliest human civilizations. The Armenians repeatedly regained their autonomy through successive invasions of Arab, Byzantine, and Turkish empires. Beginning in the sixteenth century, central Asian tribes repeatedly invaded Armenia, and the Ottoman and Persian empires battled over this land for the next 300 years. In the early twentieth century, the Armenian people of the western regions endured a horrific genocide. Portions of northern Armenia were annexed into Soviet Georgia and the eastern edge into Azerbaijan. Afterwards, the people struggled through years of Soviet rule until independence was finally achieved in the early 1990s.

Armenia itself is primarily highlands and mountains with hot, dry summers and cold, snowy winters. Sheep, goat, and cattle herding has always been an essential part of Armenian life. In modern Armenia, both Armenian shepherds and Yezidi Kurds keep the native livestock guardian dogs with their stock. Traditionally the herds move to summer pastures high in the mountains in early spring and return to spend the winters in the villages. Both livestock and dogs are housed in huge barns, although some dogs are also used to guard homes and families, as wolves can be a threat in the villages during winter.

The native livestock guardian is called the *Gampr*, meaning "large hairy beast" or, at times, *Gelkeght*, meaning "wolf choker." The Gampr has long been described as a powerful and reliable livestock guardian in Armenian literature.

These tall, short-coated dogs were also a favorite of King Tigram the Great, who ruled a large kingdom between 95 and 66 BCE. When called to war, Armenian men would bring their powerful Gamprs with them to serve as watchdogs. In the early twentieth century, foreign visitors also reported on these large, fierce, and attractive guardians working with the shepherds on the Armenian highlands.

The Gampr is a landrace breed within the larger group of ovcharka (shepherd dog) found throughout the Transcaucasian area and are also related to the Turkish livestock guardians. As a landrace breed, the Gampr exhibits great diversity with many acceptable colors and a range of sizes and types.

Recent History

Large numbers of good quality dogs were exported to the Soviet Union when Armenia was under its control in the 1930s. In Russia, Gamprs were also utilized to develop the modern Caucasian Ovcharka. About this time, three Gamprs were taken to Germany, where they were first exhibited in Europe. In the early 1990s, a struggling economy led to another severe loss of Gamprs. Sheepherding is now in decline, although the demand for both sheep and goats is high in this region of the world. Wolves remain a serious threat to the flocks. More than 2,000 Gampr are still found in Armenia, primarily working in the mountainous grazing areas. Some dogs are used to guard homes and property, a traditional function of the Gampr, in both rural and urban situations.

Since independence from Russia, there has been growing popular and governmental support for this historic dog of the mountains. The first written standard for the Armenian Gampr was created in the 1990s. In 2011, the Gampr was recognized by the International Kennel Club, a Moscow-based organization of mostly former Soviet Union countries, under the guidance of the Armenian Kennel Club (AKU).

In 1998 in Armenia, Tigran Nazaryan created an online database (gampr.net) to help catalog the Gamprs in Armenia. Tigran also facilitated the export of Gampr puppies to the United States. Soon after, the Armenian Gampr Club of America was organized to continue Tigran's efforts and to promote and preserve the Gampr. Imports from Armenia continue today. There are now about 150 Gamprs in North America, primarily found in southern California. Increasingly, Gamprs are finding working homes across the United States, Canada, and Mexico.

Like other eastern LGD breeds, the native working Gampr is threatened by breeding overly large or aggressive dogs for the show ring or dog fighting. True working Gampr can be difficult to locate, and care must be taken in importing to identify correct working livestock guardian dogs rather than show or fighting types.

Caucasian Ovcharka

of-SHAR-ka	Also known as Caucasian Mountain Dog, Caucasian Shepherd Dog, CO

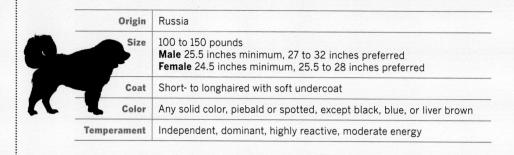

Origin	Russia
Size	100 to 150 pounds **Male** 25.5 inches minimum, 27 to 32 inches preferred **Female** 24.5 inches minimum, 25.5 to 28 inches preferred
Coat	Short- to longhaired with soft undercoat
Color	Any solid color, piebald or spotted, except black, blue, or liver brown
Temperament	Independent, dominant, highly reactive, moderate energy

Caucasian Ovcharkas are more trainable and people oriented than many other livestock guardian breeds due to their development as guard dogs; however, this breed absolutely needs a dedicated owner who is capable of ensuring the dog's safety and well-being.

The CO is a highly territorial dog who is often dog-aggressive. He requires careful and continuous socialization throughout his lifetime by an experienced and committed owner. Although dogs strongly bond with their owners, they might not obey the family's children or can overreact to protect them in play. Some owners report that COs have a higher prey drive which may make dealing with small animals and poultry problematic, although they are more likely to hunt small vermin. Experienced breeders recommend six-foot fencing.

Working traits. Although well-bred Caucasian Ovcharkas can and do work as livestock guard dogs, it's important to be aware that some strains of this breed have been bred as aggressive property guards or fighting dogs. Many dogs are generations removed from their traditional work and do not exhibit a measured response to a threat. COs selected for good livestock guardian traits and temperament, as well as good socialization to stock, can make good working dogs. It is highly recommended that you meet the parents, if possible, and find out if any related dogs are being used successfully as LGDs.

Because COs bond tightly with their owners, they are more responsive to commands, but less suitable as full-time or remote guardians without regular human interaction. Caucasian Ovcharkas are active at night, patrolling and barking.

Appearance

The Caucasian Ovcharka is a powerfully built dog with an imposing presence. Many breeders prefer much larger dogs than the minimum recognized height. The wedge-shaped head is an important feature for this breed, with deep set, slanted eyes, broad skull, and a blunt muzzle. Avoid dogs that have been selected to be overly huge and heavy, with massive heads and jowls. The ears are traditionally cropped close to the head, except where the law forbids cropping. The absence of earflaps combined with the long hair on the cheeks, back, skull, and neck form a striking mane and give the Caucasian Ovcharka a distinctive bear-like appearance. The tail, which may be carried low or curled over the back, should not be naturally bobbed or cropped.

Coat/color. Typically, the Caucasian Ovcharka is a double-coated breed with medium- to long hair. They can be short-haired although the rough coat is far more common. Legs and tail are also heavily feathered, and due to their heavy coat, they are not suitable for very hot or tropical climates. Dogs are preferred to be in any solid color except black, blue, or chocolate. Piebald and spotted color patterns are also acceptable.

History

The Caucasus Mountains run west to east, from the Black to the Caspian Sea. The mountains define a tremendous area encompassing parts of southern Russia, Georgia, Azerbaijan, Turkey, and Armenia. Seasonal use of pastures throughout the mountains has been a way of life for millennia, and where there are shepherds and flocks, there are livestock guardian dogs. These dogs showed variations that reflected differences in climate, from the harsh, dry steppes to the richer mountain pastures, and differences in the needs of the shepherds. Invading and nomadic tribes brought dogs from farther east, adding to the local types.

In the mountains, the shepherd dogs were larger, heavier, and more powerful in appearance with a rougher coat, while the guardians of the steppes generally were lighter in build, with longer legs and shorter coats suitable for a hot, dry climate. These landrace livestock guardians were used as both livestock and property guards throughout the Caucasus.

Early in the twentieth century, much of this land came under the control of the Soviet Union. The "conquest of the Caucasus" was not only military but also economic as modernization changed the land — traditional transhumance was disrupted and development displaced populations, affecting the continued use of the native livestock guardians and reducing their numbers.

Livestock guardian dogs were also taken into Russia in large numbers, to be bred by the Soviet Red Army and other state-run or factory kennels for use as guard and patrol dogs. The Red Star Kennels selected the best examples for their purposes, breeding for more uniformity and standardization, as well as protective abilities. The breeding program drew primarily on dogs from Armenia, Azerbaijan, and Georgia, with a preference for powerful, rough-coated dogs. The dogs were called the Caucasian Mountain Dog, Caucasian Shepherd Dog, or Caucasian Ovcharka. Some examples of the breed were also shown in Germany in the 1930s. Many COs were also sent to East Germany, for work with the military.

By the 1960s, the Caucasian Ovcharka was a well-established and popular breed with a registry and regular shows in the Soviet Union. Red Star Kennel dogs have had a significant influence on the standardized CO, as well as the selection by show breeders. The breakup of the Soviet Union in the 1990s led to the closing of numerous kennels and the abandonment of many dogs that were no longer needed by the military or as factory guards. By this time, however, the CO was among the most popular dogs in Russia.

The FCI soon recognized the breed with the Russian Kynological Federation (RKF) as its national club and registry. The breed has an open studbook, where after inspection, authentic landrace CO dogs can obtain a conditional registration. Some former Soviet countries are making efforts to establish their native Caucasian shepherd dogs as separate breeds, including the Georgian Nagazi and the Armenian Gampr. CO fanciers would prefer an open and inclusive studbook that includes all the indigenous dogs from the Caucasus.

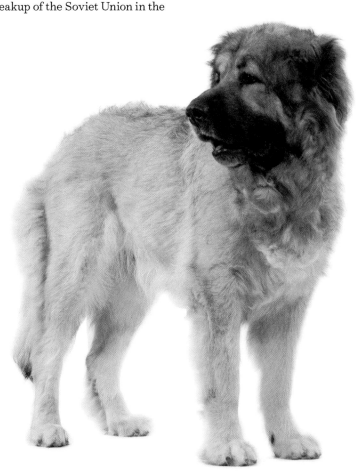

Recent History

Today the Caucasus Mountains are still quite rural and many people pursue agricultural and pastoral activities. In central and eastern areas, there has been a return to privately owned flocks of sheep and goats, as well as the movement of flocks to seasonal pastures. An increasing number of large predators has also renewed the need for working LGDs. Challenges to their successful use include the diminished numbers of quality dogs, the introduction of outside breeds, the resurgence of dogfighting, and destructive crossbreeding, both deliberate and ignorant, of the traditional dogs.

Outside of their homeland, COs became more visible in the 1970s and '80s, appearing at some large international dog shows. Before the breakup of the Soviet Union the breed had been imported into several other Eastern Bloc countries. With the opening of borders, the breed was taken to many other European countries and North America. Caucasian Ovcharkas were first imported to the UK in 2002, where there are now an estimated two hundred or more dogs. COs are not recognized by the British Kennel Club.

Although occasional COs may have been brought to North America earlier, serious imports began in the early 1990s. The breed is recognized by the UKC and the FSS. At this time there is no official parent club for the breed. Frequent imports of dogs from Russia, Poland, Ukraine, Hungary, Romania, Bulgaria, and other European countries continue. These dogs are generally from established FCI bloodlines, and not unregistered or aboriginal dogs from the Caucasus.

It is estimated that several thousand COs are now in North America but they are rarely used for work as livestock guardians. Since so many COs have been bred as either show dogs or as military/protection dogs, it can be difficult to locate a dog with good LGD temperament and working behaviors. Today the Caucasian Ovcharka is most often seen as a companion, a home protector, or show dog.

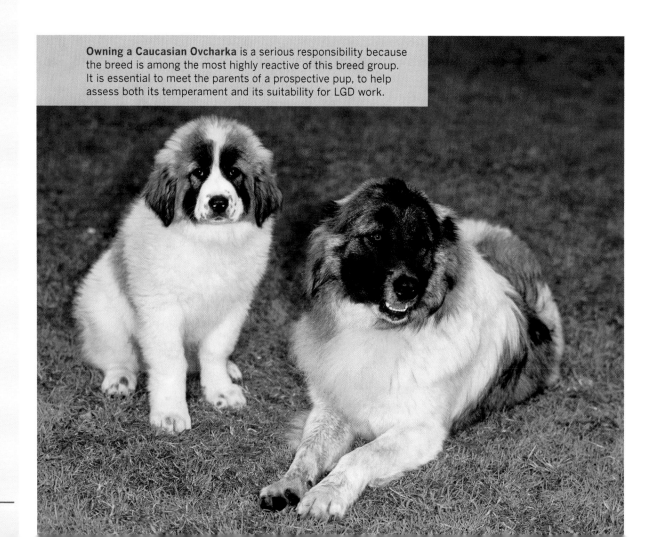

Owning a Caucasian Ovcharka is a serious responsibility because the breed is among the most highly reactive of this breed group. It is essential to meet the parents of a prospective pup, to help assess both its temperament and its suitability for LGD work.

Central Asian Shepherd

Also called CAS, Central Asian Ovcharka, Sredneasiatskaia Ovcharka, Central Asiatic Ovcharka, Middle Asian Ovcharka

Origin	Central Asia
Size	**Male** 27 to 31 inches, 110 to 145 pounds **Female** 22 to 29 inches, 88 to 125 pounds
Coat	Coarse short- to longhaired coat with soft undercoat
Color	Any except blue or brown in any combination, or black mantel on tan
Temperament	Independent, dominant, highly reactive, moderate energy

Central Asian Shepherds form close attachments to their owners and are somewhat more amenable to obedience training than other LGD breeds.

However, owners of this breed should be experienced with large dominant dogs and dedicated to handling them intelligently. A well-socialized CAS should accept strangers if properly introduced; however, they are generally less tolerant of intrusions and quicker to respond to a perceived threat. They are unlikely to accept even introduced outsiders if their owner is not present. They are generally fine with family pets if they are raised with them. Introduce new dogs carefully, since Central Asian Shepherds are aggressive to strange dogs.

Due to their nature and historical use, CAS do well as general farm and family guardians. In this role, socialization and basic training remain vital for these dogs throughout their lives. They do not require specialized training to provide protection to their family or farm. They are energetic dogs that require work and exercise. Owners report that the breed is unusually well suited as a hiking or walking companion. Because they bond strongly to their families, it can be difficult to rehome an adult dog.

Working traits. Central Asian Shepherds protect what they believe is their property. They work well in pack situations where there can be a division of roles, with some dogs remaining close to animals while others occupy higher overlook or patrol. Some owners report that CAS establish a wider than typical protective buffer zone between their stock and potential predator threats. Capable of handling serious predator situations, CAS are also very vocal, particularly at night.

These people-oriented dogs need daily interaction, making them less suitable for remote or isolated areas away from their shepherds. Young dogs mature slowly and require careful attention to their training around stock during this time. Central Asian Shepherds require robust fencing: a six-foot fence or good livestock fencing combined with a hot wire.

Appearance

The Central Asian Shepherd appears both massive and powerful, with a deep chest. The head is broad and large with a deep, blunt muzzle. From above, it appears more rectangular in shape, with only a moderate stop. The pendant ears are normally cropped close to the head. The eyes are oval in shape. The neck has a heavy dewlap, although very large or pendulous jowls are not appropriate. Extreme size or weight may be a sign of crossbreeding with larger breeds or selection for extreme size. The tail is usually docked; undocked it is a broad tail ending in a crook, generally carried low but curved over the back when the dog is alert.

Coat/color. The thick double coat may vary between 1.5 and 4 inches in length, but a shorter coat is more common. The outer hair is coarse and weatherproof; the inner coat insulates against both heat and cold. The Central Asian Shepherd is seen in many colors and patterns except blue merle, although some colors are preferred.

History

Central Asia generally describes the area from the Caspian Sea across Turkmenistan, Uzbekistan, Tajikistan, and Krygystan; extending south to encompass Afghanistan; and ending north at the Kazakhstan-Russia border. This is a land of immense mountains, high plateaus, vast deserts, and grassy steppes. The climate reflects this with seasons both hot and dry to cold and windy. The Silk Road trade routes, beginning in China and Mongolia, crossed through many of these lands. Tremendous numbers of nomadic peoples also followed seasonal paths with their sheep, goats, camels, and guardian dogs, migrating between areas, such as the Afghan highlands to the lowlands of Pakistan and Iran.

With all this movement, the guardian dogs of the travelers and the nomads were no doubt deeply intermingled and also influenced by the ancestors of the famed Tibetan dogs. The great nomadic tribes eventually gave way to more settled people; then, in the early twentieth century, to collectivization and industrialization when much of the traditional homelands of these Central Asian livestock shepherd and guardian dogs came under the centralized rule of the Soviet Union. In the case of Afghanistan, the people have struggled through a Soviet invasion and much upheaval. The newly independent Soviet republics are struggling but also reasserting their cultures, while Afghanistan remains deeply unsettled.

In some places, the traditional way of life continues with shepherds and their families moving sheep and goats to seasonal pastures. The ever-present livestock guardians protect them all from a wide assortment of large predators, including wolves, bears, jackals, hyenas, foxes, lynx, cheetahs, and mountain or snow leopards. These dogs were also the traditional guardians of homes and caravans, at times joining with their humans to fight off tribal or clan aggressors.

These working dogs are of ancient type, and are still selected for specific needs and preferences by different people. There are variations among mountain, steppe, and desert types. They are a very diverse population and still known by a variety of local names. The native dog of Afghanistan is known as Kuchi, or Koochee. The Alabai from Turkmenistan, Tobet from Kazakhstan, Tajik from Tajikistan, and Torkus or Sarkangik from Uzbekistan are also Central Asian livestock

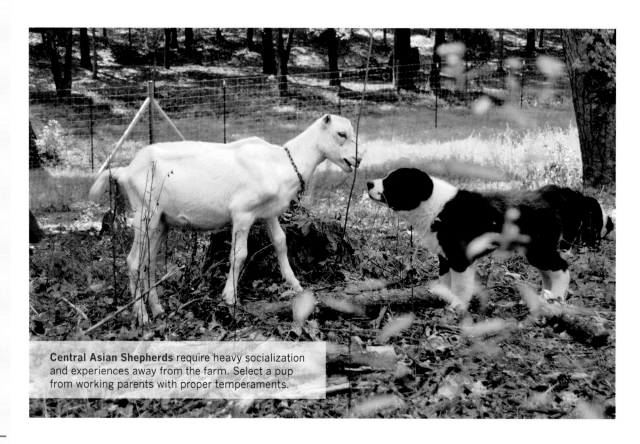

Central Asian Shepherds require heavy socialization and experiences away from the farm. Select a pup from working parents with proper temperaments.

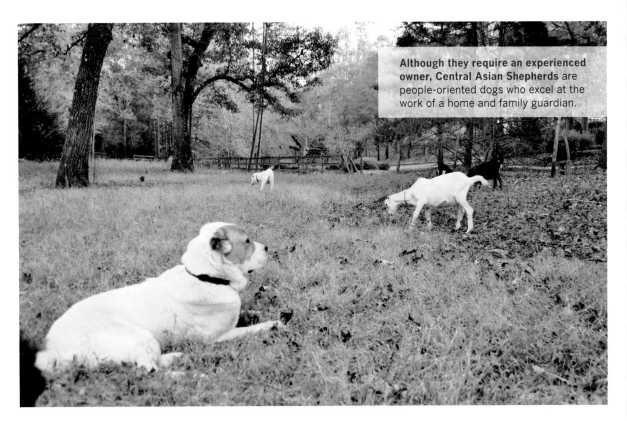

Although they require an experienced owner, **Central Asian Shepherds** are people-oriented dogs who excel at the work of a home and family guardian.

guardians. Similar dogs are found in Iran and Pakistan as well.

Under Russian rule, many traditional livestock guardian dogs from these countries were taken to work as guard dogs for factories or the military. By the 1930s, they were given the Russian name Sredneasiatskaia Ovcharka, or Central Asian Shepherd Dog. They were kept in Russian government breeding kennels and recognized collectively as a single Russian breed by the FCI, under the jurisdiction of the Russian Kennel Club. While the Sredneasiatskaia Ovcharka remains a popular dog in Russia, the native dogs are highly esteemed in their various homelands, where the population numbers are now improving. National pride often prefers the non-Russian names.

Recent History

The current Russian standard describes a dog that differs in color, temperament, and size from the remaining aboriginal or working landrace dogs still found in their native countries. Particular lines have also developed for show, military, and dog-fighting purposes, with differences in appearance and temperament. Individual countries may also move toward recognizing their own dogs as distinct breeds, such as the Alabai from Turkmenistan, or the Kuchi from Afghanistan, which may further separate these dogs from the modern Russian breed.

In the 1990s, it became possible to import these dogs from Russia or directly from Central Asia into Europe, North America, and elsewhere. The UKC and the AKC Foundation Stock Service now recognize the Central Asian Shepherd

Dog. Although there are many CAS imported into North America, there is no central national club at this time. Most CAS are kept as personal or family protectors rather than in working LGD settings. The CAS is also recognized in New Zealand by NZKC and in Australia by ANKC, although they are present only in limited numbers.

Dogs may come from various sources and therefore may exhibit a variety of temperaments and appearances. Dogs from Central Asia and working livestock origins are the most suited to jobs as livestock guardians or farm and family protectors. Dogs from kennels that are bred for sentry and military work or show purposes may be more trainable but may not exhibit good livestock guardian qualities. Beware of dogs from any kennel that specializes in fighting dogs.

Estrela Mountain Dog

es-TREL-ah | Also known as Cão da Serra da Estrela, Estrela, EMD

Origin	Portugal
Size	**Male** 24 to 30 inches, 80 to 115 pounds **Female** 23 to 28 inches, 80 to 95 pounds
Color	Fawn, yellow, wolf-gray, white markings or dark shading throughout; with or without brindling
Coat	Short- or longhaired with soft undercoat
Temperament	Independent, dominant, less reactive, low energy

Estrelas are protective of their family or property and prone to using their especially loud, threatening barks.

As adults, they become quite suspicious of strangers and sometimes are dog-aggressive; however, they tend to be less reactive than many other LGD breeds. EMDs are noted for their strong loyalty to their owner or family, as well as slightly more dependence on human companionship or interaction. Puppies go through a very active phase but they settle down into the calmness typical of this breed.

Agility and athleticism are important features of this breed. Accomplished climbers and jumpers, they need good fences. Their athleticism begs for walking or jogging with their owners or use in drafting. Their self-thinking nature has sometimes led these dogs to being called stubborn when owners attempt to train them for other canine activities.

Appearance

Because of their substantial bone and typical longhaired coat, Estrelas are an impressive dog, though not overly massive. Heavier mountain-type dogs, up to 132 pounds, are also found in Portugal. EMDs have a broad skull, long head, and tight lips. The oval-shaped eyes are dark amber in color.

Unusual for an LGD, the rose ears are small and folded backwards against the head. In the past, ears were often cropped but this is not common today. The low set tail is broad at the base, long and tapering, and ends in the distinctive small hook. When the Estrela is alert, the tail is held horizontal or slightly higher, but otherwise the tail is held low. Double dewclaws are found in the breed but not required.

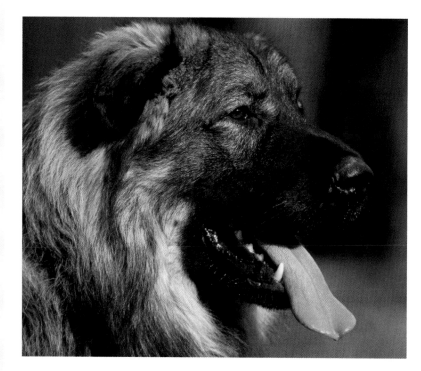

Coat. The Estrela has two recognized and acceptable coat types. The longhaired variety is seen most frequently but a large number of shorthaired dogs can be found working in the mountains. Both are double-coated, with a harsh outer coat capable of withstanding difficult weather. Longhaired Estrelas have a dense coat with thick ruff around the neck, feathering on the tail, and longer hair on the breeches. The hair is straight or slightly wavy. The shorthaired variety is rarely seen outside of Portugal, which is unfortunate because there is a need for working LGDs in hot or humid climates in the United States.

These two coat types are now generally bred separately and as a result the two varieties are beginning to develop further differences in appearance. In Portugal, crossing is permitted with permission but is done infrequently. Some breeders believe that more crossbreeding would be beneficial in the interest of genetic diversity, health, temperament, and working abilities.

Color. Permissible colors include light fawn through dark mahogany, yellow, and wolf-gray with or without brindling, limited white markings, and/or black shading. A dark, preferably black, mask is highly desirable. Other colors, color patterns, or lack of a mask may be unacceptable for the show ring but the dogs themselves make fine companion or working dogs. Fawn-colored dogs are most popular in the longhaired variety, where certain other colors such as

brindle are less common. Brindle color is still a strong preference among the shorthaired working dogs in Portugal.

History

Serra da Estrela, the Star Mountains, lie in the center of the country and mark the southern end of the great Iberian mountain ranges in Portugal. Portions of the mountainous, high central plateau are now a national park and a popular skiing location. Seven thousand years ago, this area was the home of pastoral peoples who raised goats

and sheep on the lower altitudes and took advantage of the high, green summer pastures. Wolf, bear, and lynx once roamed here; only the wolf remains, but its numbers are increasing.

The Cão Serrada Estrela descends from many generations of livestock guardian dogs who followed shepherds up into the summer grazing on the rugged Serra da Estrela Mountains. The flocks were accompanied by shepherds during the day and then confined at night. As the cooler fall weather set in, they returned to lowland pastures where the animals were sometimes

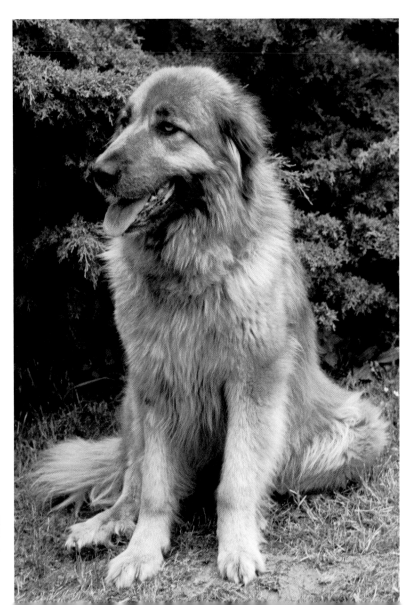

Estrela Mountain Dogs are noted for their strong attachment and loyalty to their family.

left alone with the dogs during the day. During the night, the sheep were herded into fenced areas and again left with the dogs. The dogs often protected property against two-legged predators as well. This area remained quite isolated from outside influence, developing a distinct landrace breed of livestock guardian with two varieties of coat — long and short.

At the beginning of the twentieth century, as foreign breeds began to come into Portugal, efforts were made to recognize this native breed and celebrate it at annual events called *consursos*. The *consursos* held working trials of a guardian dog's abilities and work with his shepherd. Faced with a large number of sheep in an enclosed field, the dog was judged on his correct behavior toward the sheep, his watchfulness, and his ability to gather strays when the shepherd moved the flock.

The first attempt at a standard, written in 1922, primarily described correct temperament and working qualities, although it did mention the presence of double dewclaws. By 1930, a more formal standard included specific physical features of the breed, such as the unusual rose ears, which were held folded back against the head, and the tail that ended in a small, curly hook. All colors were allowed.

Through the war years, however, farmers and sheepmen continued to breed their dogs to their own standards, not a written guideline. The *consursos* resumed after World War II. The early 1970s were perhaps the darkest days for the breed, with fears of extinction. It wasn't until after the Portuguese revolution in 1974 that popular interest grew in the native breeds of the country. The Portuguese

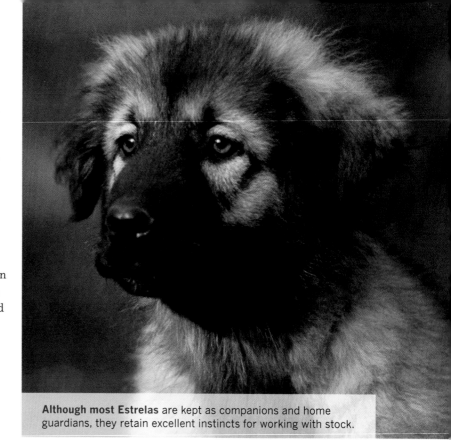

Although most Estrelas are kept as companions and home guardians, they retain excellent instincts for working with stock.

association for the breed was established in 1986, and it continues to work hard to promote the breed.

Recent History

Today the Estrela is one of the most popular of the native Portuguese breeds. The longhaired dogs are certainly favored at shows and among many breeders, although the shorthaired dogs remain popular as working dogs. The Estrela Mountain Dog still works as a flock protector and a home guardian, but it is also used, in a limited way, as a police and military dog. Increasingly, the Estrela is being kept as a pet or show dog. Grupo Lobo has also placed the shorthaired variety of the Estrela with livestock producers, achieving great success against wolf predation.

In Britain, the Estrela Mountain Dog Club was established in 1972 with the import of a breeding pair. A small but

dedicated number of breeders have continued to work with the breed. A second organization, the Estrela Mountain Dog Association, was formed in 2011. The Estrela is primarily a home guardian and family companion in Britain. Estrelas are also bred in several European countries but remain rare in Australia and New Zealand.

Estrelas were imported to North America beginning in 1972, but there was not an organized effort to organize a club until additional Portuguese registered dogs were imported beginning in 1998. The Estrela Mountain Dog Association of America was established in 2001. The UKC and the AKC Foundation Stock Service recognize the Estrela. With the need for good LGDs in North America, the increasing availability of EMDs has received a favorable response.

Great Pyrenees

PIR-uh-neez | Also known as Pyr, Pyrenean Mountain Dog, PMD, Chien de Montagne des Pyrenees, GP

Origin	France
Size	**Male** 27 to 32 inches, 100 to 140 pounds **Female** 25 to 29 inches, 85 to 110 pounds
Coat	Long outer hair with soft undercoat
Color	White; may have markings of badger, gray, various shades of tan
Temperament	Independent, low energy, low reactivity

The lovely Great Pyrenees is probably the most familiar livestock guardian breed in the world, even though most no longer work as livestock guardians in North America, Europe, or their Pyrenean Mountain homeland.

The breed's popularity extends far beyond France, and the Pyrenean Mountain Dog, as he is called outside North America, is found throughout the world.

The Pyr is a gentle dog, aloof around strangers and independent in nature. A strong trait is his love of children as well as tolerant, nurturing behavior with young animals. Despite the Pyr's essential good nature and calm demeanor, socialization and training are required. He is still a guard dog at heart and will protect his charges. The Pyrenees offers a measured response to threats but is known as a barker, especially at night. Pyrs have a strong urge to expand their territory, which can result in roaming if not properly contained by fencing.

Working traits. When efforts first began in North America in the late 1970s to utilize LGDs, the Pyrenees was the only breed that was already well established in the country. The Pyr did well in early tests and also proved himself the least aggressive to both humans and stock, making him an excellent choice for new owners of LGDs or in situations where the dog needs to accept regular visitors to the farm. Many Pyrenees work today as either general farm and home protectors or traditional livestock guard dogs. The Pyrenees works primarily through barking and warning threats, only making physical contact if the intruder persists. Owners often describe their dogs as territorial and active guardians at night.

Since so many Pyrenees are raised primarily as companion dogs, it is advisable to search for breeders who specialize in livestock guardians or those who pay careful

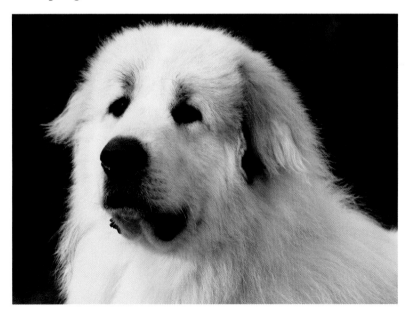

attention to good guardian qualities in their breeding choices. If the parents are not working dogs, ask if offspring have been placed successfully in working homes. Some dogs have been bred primarily for show or companionship and may lack proper working temperament, although there is no split in the breed between working and show lines.

A large number of these dogs, both purebred and crossbred, are turned over to rescue efforts, especially in North America. Barking, overprotectiveness, shedding, digging, and the inability to keep the dog contained are the primary reasons for surrender. The most common crosses are Anatolian/Pyr and Akbash/Pyr since these three breeds are the most common dogs in working situations today. Some of these dogs may be potential working livestock guardians or excellent family and farm guardians.

Appearance

The French describe the ideal GP head as resembling the Pyrenees brown bear, with very little stop between the muzzle and head. The Pyr has almond-shaped dark eyes, described in the breed standard as "kindly." The small to medium ears are carried low and close to the head. The Pyr should not resemble a mastiff with heavy flews, a blunt muzzle, or a dewlap. The plumed tail is carried low unless alert, when it can form a wheel over the back. The Pyr also has double dewclaws, which must not be removed according to the standard.

Coat/color. The Pyr often appears larger than he is due to his immense double coat. The long outer coat should be weather resistant and shed dried mud. The coat forms a ruff around the neck, especially in males. Working dogs in the Pyrenees can appear taller in the leg, with less coat than the dogs seen in the show ring and homes.

Although pure white dogs are frequently used to represent the breed, white dogs with one or two patches of light tan, gray, or red-brown are more common. *Blaireau,* or badger-colored, patches on the head are especially attractive and were often preferred by shepherds in the past. These colored marks may occur on the ears, head, tail, or elsewhere but should not cover more than one-third of the body. Many of these patches fade as puppies mature.

Strongly marked dogs are more common in Europe than in North America. Contrary to some claims, dogs with solid patches of black hair down to the root have not been acceptable since the earliest French standard in 1907.

History

There is no doubt about this breed's ancient role as a fierce protector against wolves and bears throughout the mountainous French-Spanish borderland. The Chien de Montagne des Pyrénées or, as he is nicknamed in France, *patou*, probably traces his heritage back to the dogs of the earliest pastoral peoples of this area. The fierce white dogs of the shepherds were certainly well known to the Romans.

Throughout the Middle Ages, sheep and shepherds moved in search of summer pastures in the Pyrenees. As early as 1407, the big white dogs were also used to guard the historic Château Fort de Lourdes. In 1675, King Louis XIV took a *patou* back to the palace at Louvre and declared the breed the national dog of France. Its popularity spread as more royalty took these striking dogs into their homes and estates as protectors and companions. At times, the dogs also served as elegant fashion accessories. By the early 1800s, visitors to small towns in the Pyrenees could buy puppies in the markets, which became a thriving business for the local people.

At the beginning of the twentieth century, fanciers began to organize clubs and write standards, hoping to bring renewed interest to their beloved breed, which was losing its traditional job as wolves were exterminated and rural people left for jobs in the cities. After World War I further decimated the Pyrenees' numbers in his homeland, Bernard Sénac Lagrange led a group of dedicated

Coat Care

Great Pyrenees breeders advise that the coat not be clipped or sheared since the dog needs it for protection from the sun as well as for insulation. Unfortunately, poor coats are a common complaint in working-dog situations. Instead of the correct harsh outer coat, too many dogs have soft "cottony" coats that mat, attract foreign matter, and retain dirt. If your dog has a cottony coat, be prepared for frequent grooming. In any case, do not expect a working Pyr to have a show-quality coat.

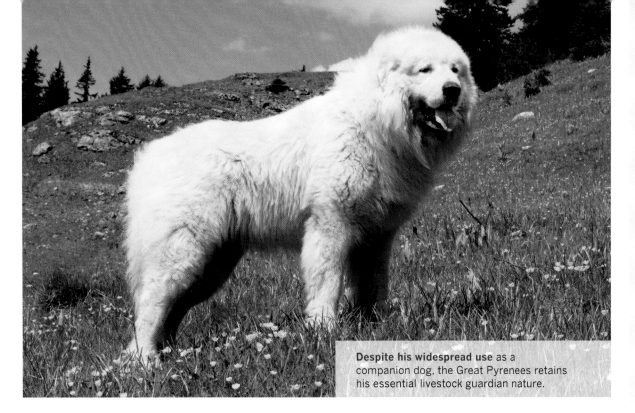

Despite his widespread use as a companion dog, the Great Pyrenees retains his essential livestock guardian nature.

breeders in saving the *patou*. The separate clubs came together and created the breed standard of 1927, which continues as the basis for the breed today, both in France and around the world.

The Reunion des Amateurs de Chiens Pyreneans now champions all the native breeds of the Pyrenees. Their efforts were needed again when the population of the Pyrenees fell to dangerously low levels after the Second World War and many observers believed that there were no working dogs left in the French Pyrenees.

Today there is renewed interest in pastoralism in the Pyrenees, both as agriculture and a cultural activity. The brown bear has been reintroduced, wolves have migrated from the Italian and Swiss Alps, and stray dogs threaten the flocks. Beginning in 1985, agricultural organizations and conservationists began efforts to reestablish working PMDs and their traditional herding dog partner, the Labrit, or Pyrenean

Shepherd. This mission was supported through the work of several groups, which are continuing to work with shepherds and dogs, as well as studying the most appropriate methods and techniques for living with predators.

By 1885, Pyrenean Mountain Dogs were recognized by the British Kennel Club, but attempts to establish the breed did not succeed until the 1930s, when the population increased and the Pyrenean Mountain Dog Club was organized. Most Pyrs in Britain today are companion dogs and especially suited to more rural lifestyles.

Across the Ocean

As early as 1662 Basque fisherman brought their French Pyrenean and Portuguese dogs to Newfoundland, where they contributed to the famous breed of that name. In 1824, it was reported that General Lafayette sent two PMDs from France to a friend in America. Thomas Jefferson also

asked some French friends to send him some sheepdogs. Absorbed into the American melting pot, the breed disappeared until the early 1930s, when Pyrenean Mountain Dogs were imported again to the Basquaerie Kennel in Massachusetts. The dogs were rapidly adopted, and the Great Pyrenees Club of America was founded in 1934, utilizing the French standard but taking an Americanized name. Fortunately, a number of dogs were brought over from France before World War II.

The beautiful Pyr quickly proved itself as a companion dog. When the need for working livestock guardians sharply increased in the 1970s, the Pyrenees was the most readily available LGD breed in North America, and some dogs saw a return to their original purpose. Due to his essential good nature, the Pyr remains a favorite choice of both country families and working farms. The Pyrenees continues his considerable popularity today,

with some 2,000 puppies registered annually. Many more unregistered and crossbred working dogs are also present.

Down Under

The history of the Pyrenean Mountain Dog in Australia paralleled that of the breed in North America in many ways. Samuel Pratt Winter purchased his dogs in the Pyrenees Mountains in 1843 and brought them to Victoria, where they were used on his property. For the next 35 years or so these working Pyrenean Mountain Dogs were bred and used as guardians against both dingoes and human thieves by many other people in both Victoria and Tasmania. Curiously, they disappeared as working dogs before the turn of the century.

New imports began in 1939, reestablishing the breed. The Pyrenean Mountain Dog Club of Victoria, organized in 1971, supports the breed nationwide. Numbers are not large, especially in working homes, with only about 50 pups registered each year. Fortunately, the breed pool is diverse, as dogs have been imported from North America and Britain, France, and elsewhere in Europe.

The Pyrenean Mountain Dog has also been found in New Zealand since 1947, with frequent imports from both Australia and Great Britain. The Pyrenean Mountain Dog Club was formed in the 1970s, and the breed is recognized by the NZKC.

The worldwide Pyrenean Mountain Dog community holds a series of world conferences focused on preservation, health, and a cooperative exchange of information. Small differences may exist between the standards of the various country organizations.

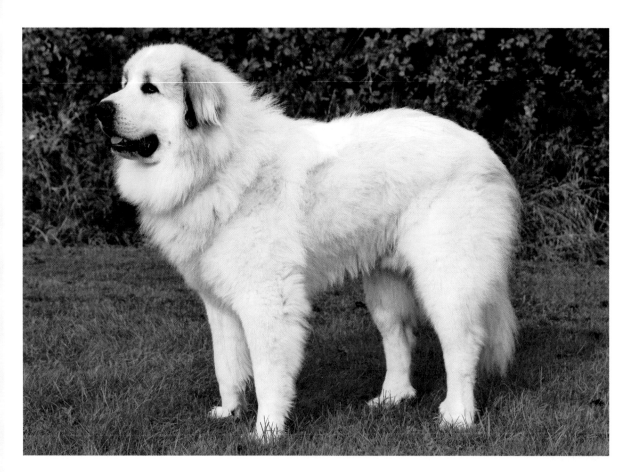

King Louis-Philippe, of France, gave Queen Victoria, of England, a Pyrenean Mountain Dog named Gabbas in 1844. Depicted on a painting by Thomas Musgrove the next year, Gabbas was banished to the Zoological Society after he bit the Queen.

Kangal Dog

KAHN-gall | Also known as Kangal Kopegi, Sivas Kangal

Origin	Turkey
Size	**Male** 30 to 32 inches, 110 to 145 pounds **Female** 28 to 30 inches, 90 to 120 pounds
Coat	Short outer hair with soft undercoat
Color	Shades of dun to steel gray, with black muzzle, mask, and ears
Temperament	Independent, dominant, low energy, moderately reactive

The Kangal Dog is noted for his solid temperament and gentleness with livestock, children, and pets. Compared with other livestock guard dog breeds, Kangal Dogs tend to be more people oriented.

Like many LGDs, adult Kangal Dogs can be quite territorial and dog-aggressive. Kangal Dogs grow up slowly, even compared to other LGD breeds. Goofy and adorable as puppies, at two or two-and-a-half years of age, Kangal Dogs become serious, protective, and watchful.

Working traits. When Kangal Dogs hear or sense disturbances in the distance, they bark in response. At first, they place themselves between the threat and their stock. If their warning barks are ignored, they then confront the predator with a roar and an attack if necessary. They often take a remote or high viewing spot to watch their stock although they take regular patrols around their territory. These breed traits make the Kangal Dog well suited to life as a farm or family guardian in addition to a full-time livestock guard dog.

Appearance

The Kangal Dog is a large animal with heavy bone, projecting a powerful image while remaining fast and agile. Though resembling the mastiff in coloring, the Kangal should not possess extreme head size, overly large dewlaps, loose lips, head wrinkles, or large bulk.

Dogs with these features are not correct and are usually the result of crossbreeding with heavier mastiff breeds. When the dog is alert, his tail is carried in a single or double curl over the back, although it may be carried low at other times.

Coat/color. The double coat is good at handling weather extremes, with a natural short coat in the heat of summer and a dense double coat in winter. The weatherproof coat sheds dried mud. The Kangal is seen in colors of light to golden dun. Depending on the amount of dark gray or black in the outer guard hairs, some individual dogs can appear almost sable or steel gray.

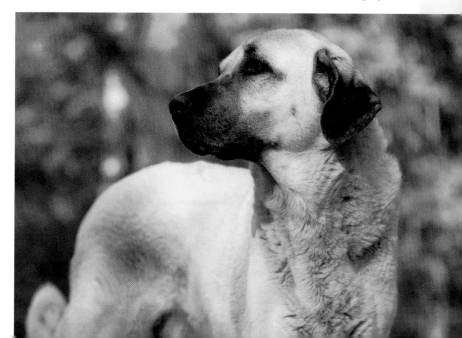

The black mask may completely cover the muzzle and extend over the top of the head and the pendant ears. Small amounts of white are allowed on the feet, chest, or chin, and white blazes on the chest may be outlined with dark hair. The curled tail often has a black tip and may also have a black spot in the middle.

History

The ancestors of the Kangal Dog may have come with Turkish tribes as they migrated from the steppes of Central Asia beginning in the eleventh century. The Turks were nomadic herdsmen who brought their sheep, goats, and horses with them, along with their war dogs, hunting dogs, and shepherd dogs. Genetic studies have, in fact, revealed that the Kangal Dog is related to livestock guardian dogs found today in the countries of Central Asia.

Although the Kangal Dog eventually received his name from the town of Kangal in Sivas Province, these dogs are found throughout the high, semi-arid central Anatolian plateau. Bordered and isolated by two mountain ranges, summers are hot and dry, while winters are cold and snowy.

References to "great yellow dogs with black faces" go back to the fourteenth century in Turkey. The Kangal Dog certainly resembles his charges: Kangal Karaman fat-tailed sheep with their drooping ears, black muzzles, and black rims around their eyes. Throughout the centuries, Kangal Dogs were also the favored by the *agas*, the powerful ruling families in the area.

Kangal Dogs are known for their fierce battles with predators, principally wolves, but also brown bears, feral dogs, mountain cats, foxes, jackals, and wild boar. In Turkey, the Kangal Dog works actively with shepherds, out with

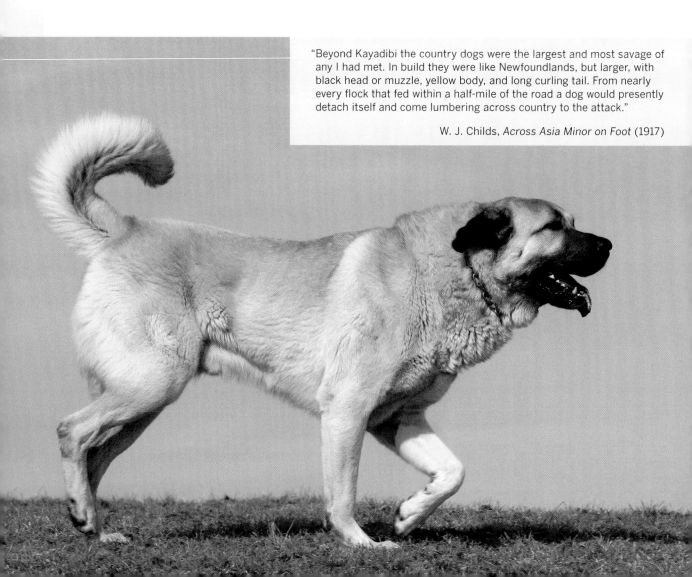

"Beyond Kayadibi the country dogs were the largest and most savage of any I had met. In build they were like Newfoundlands, but larger, with black head or muzzle, yellow body, and long curling tail. From nearly every flock that fed within a half-mile of the road a dog would presently detach itself and come lumbering across country to the attack."

W. J. Childs, *Across Asia Minor on Foot* (1917)

their flocks grazing by day and returning to the villages at night. In the villages, Kangal Dogs are expected to be gentle with children and tolerant of neighbors. They are generally not allowed to run free but are confined outside the home or with the sheep. Puppies grow up in the village with nearby stock until they are old enough to accompany the older dogs and learn from both them and the shepherds.

During the summer, flocks often make the journey to high summer pastures known as *yaylas*, far from roads and people. Two or three dogs accompany flocks of two hundred to three hundred sheep. Shepherds and family members spend the summer in small houses or huts, milking sheep to make cheese or yogurt.

Life was remarkably unchanged for the traditional village communities until very recently. At times, the Turkish military bred and used Kangal Dogs, and these dogs were also used as guardians of homes and factories elsewhere in the country. In the last two decades there has been a decline in both sheep raising and locally raised dogs, as people have left the villages for larger cities.

Kangal Dogs are increasingly seen as property guardians in urban areas throughout the country. Besides the loss of traditional working jobs, the Kangal is threatened by crossbreeding to other very large or aggressive dog breeds in order to create dogs with exaggerated size or for dog fighting.

Out of the Country

Kangals were also exported, leading to efforts elsewhere to standardize the dogs as a breed, which had not yet been accomplished in Turkey. Beginning in the 1980s in Turkey, efforts were made to create a standard for the breed through research with village dogs. Often described as *karabas* (black head) but also called variously Kangal, Kangal Kopegni, Sivas Kangal, or Sivas dog, the choice of a name eventually settled on the historic center of breeding.

In Turkey, the Kangal Dog is now recognized by KIF, the national kennel club, which is seeking official FCI recognition for the breed. The Kangal has been declared both the national dog of Turkey and a cultural treasure, celebrated at the annual Kangal Dog Festival. The Kangal Dog is conserved at university, military, and agricultural breeding centers within the country, in addition to private kennels.

Due to the widespread export of Kangals in the 1970s and '80s, it is now illegal for non-nationals to export Kangals from the province or the country without an official permit. In 2014, the Turkish government agreed to the export of 20 Kangal Dogs for the ongoing USDA predator-control study. The dogs are placed in working situations to evaluate their success against wolves and bears in the western United States.

Charmian Steele Hussey, an archeologist, imported two Kangal Dogs to Britain in 1965, where the British Kennel Club registered them as Anatolian Sheepdogs. Following more imports of various *coban kopegi*, the standard was revised to become the Anatolian (Karabash) Dog in 1983. Some Kangal breeders continued to maintain pedigree records of purebred Kangal Dogs, and the Kangal Dog was again recognized as a separate breed in 2013. The Turkish Kangal Dog Club has been reorganized and approximately 100 Kangal Dogs were entered on the new register. There are also a large number of unregistered dogs in the country. In Britain, most Kangal Dogs are found as family companions or guardians of small farms and their stock.

Kangal Dogs are bred in Germany, Holland, France, and Sweden, as well as several countries in Eastern Europe. Turkish immigrants to different European countries have also brought their dogs with them. Kangal Dogs are a recognized breed in South Africa, and are working in a cheetah conservation program in Namibia, among other African countries.

Judy and David Nelson, continuing their efforts to promote the use of livestock guard dogs in North America, imported Kangal Dogs in 1985. The Kangal Dog Club of America was also established, achieving UKC recognition for the breed in 1998. Imports have continued from both Turkey and other countries, although it can be difficult to locate quality purebred dogs. After years of relative rarity, numbers are increasing and the dogs are in great demand for combating large predators.

The first imports of British-bred Kangals to Australia were made in the 1980s, the Kangal Dog Association was formed in 1996, with recognition by ANKC soon after. In 2012, ANKC discontinued separate recognition and merged Kangal Dogs into the Anatolian Shepherd Dog registry. Imports to New Zealand at about the same time also led to official Kangal Dog recognition in 1999, although the numbers remain low.

Karakachan Dog

CAR-uh-kuh-chan | Also known as Bulgarian Shepherd Dog

Origin	Bulgaria
Size	**Male** 26 to 30 inches, 99 to 135 pounds **Female** 25 to 28 inches, 88 to 125 pounds
Coat	Short or long outer hair with soft undercoat
Color	Whole colors including white, brindle, and sable, with or without white markings, bicolored or tricolored patterns
Temperament	Independent, variable dominance, moderate energy, variable reactivity

The Karachan's temperament can vary from dominant to submissive, hard to soft, and low to higher reactivity.

Owners need to be prepared to deal with these differences within the breed; different temperaments can extend to different ways of working. The Karakachan Dog Association does not recommend that the breed be kept as a companion dog. Karakachan Dogs are typically gentle with children and accepting of other dogs, although same-sex aggression has been noted.

Karakachans are agile dogs that are noted as tough and steady workers. They appear attuned to their stock, are alert to changes or threats, and will move stock to areas they deem safer. Perhaps less likely to roam than some other LGD breeds, Karakachans can be territorial. They do bark to warn off predators and people. Karakachans are reliable and aggressive toward predators, including the largest. They should be less people aggressive than other breeds, and quite levelheaded with a steady temperament.

Appearance

The breed comprises a wide variety of types, sizes, and coats. Shepherds prefer broad and massive heads. Black noses are common but red noses are seen in red dogs. Tails are also variable with natural

bobtails, short tails, and long plumed tails all acceptable.

Early importers to North America were particularly looking for smaller size, less inclination to roam, reliability with stock, and less aggression toward humans. As a result, dogs at the lower end of the standard are valued, as is the diversity in color, coat, and tail. Karakachan Dogs should not look or act like any of the breeds that are sometimes used in crossbreeding in Bulgaria or Europe.

Coat/color. This is a double-coated breed seen in several whole colors, including white; brindle and sable, with or without white markings; and bicolored or tricolored patterns. White dogs with dark spots are popular. Both short- and longhaired types are acceptable.

History

The Karakachan Dog of Bulgaria is related to the larger group of livestock guard dogs in the surrounding countries of Greece and Turkey to the south, Macedonia and Serbia to the west, and Romania to the north.

The Karakachans, an ancient group of nomadic people, traveled over much of this area in search of grazing with their horses, sheep, and dogs. Sleeping in *chatura* (woven rug tents) or *kalivia* (temporary huts made of branches), the people raised sheep and made sheep's milk products. Over many centuries they developed distinctive animals: short, sturdy Karakachan horses; small, primitive Karakachan sheep; and the dogs that protected them from wolves and bears.

The well-known Karakachan dogs are often mentioned in Bulgarian literature. This traditional nomadic way of life continued into the early twentieth century, despite the Karakachan people's presence in a larger Bulgarian culture. Speaking their own language and tightly knit as a group, the Karakachans and their animals remained quite isolated.

Bulgar tribes also settled this area in the eastern Balkans. During the Middle Ages, the Bulgarian Empire ruled over much of the Balkans, until the rise of the powerful Ottoman Empire. Eventually a new Bulgarian state would ally with the Germans through two world wars and then fall under the control of Communism until 1989. For hundreds of years throughout this history, Bulgarian shepherds also moved their flocks between summer and winter grazing, utilizing Karakachan dogs and other landrace livestock guardian dogs. These dogs were also used in the national army prior to World War II.

Post–World War II

The Communist government nationalized the flocks, farms, and even the mountain sheep enclosures. Predators were hunted and poisoned. The government was hostile toward the livestock guardian dogs, and massive exterminations were conducted several times over the next 20 years. At times, the dogs were killed and their skins were marketed to the fur industry. The Karakachan peoples, being a minority, were especially persecuted. Their animals were confiscated and the people were forced into settled lives. Many of their dogs were assimilated into the remaining Bulgarian livestock shepherd stocks. In the end,

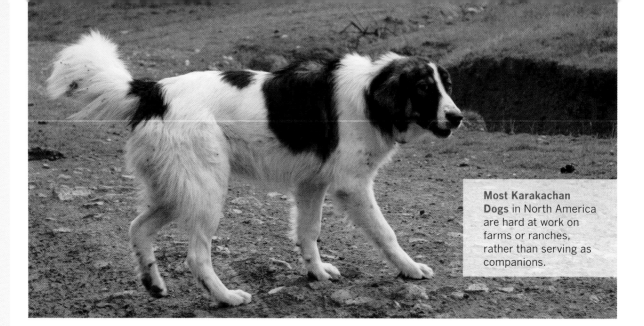

Most Karakachan Dogs in North America are hard at work on farms or ranches, rather than serving as companions.

livestock guardian dogs were only to be found at some government farms and in the extremely isolated rural areas. After Communist control ended, the government farms collapsed and more dogs were lost.

In the 1990s, with the first free elections, national pride turned toward saving the native breeds of sheep, horse, and dog. Breeders began to search out the traditional Karakachan and Bulgarian livestock guardians, which were threatened by increasing crossbreeding. Livestock predation also became a tremendous problem in Bulgaria, which now has one of the highest numbers and densities of wolves and bears in Europe, in addition to golden jackals and lynx.

Wildlife societies, carnivore conservation groups, and the Bulgarian Biodiversity Preservation Society Semperviva (commonly known as simply Semperviva) have all worked to supply shepherds and cooperatively grazed flocks with Karakachan Dogs since 1997. The dogs also protect the endangered Karakachan sheep and horses. The dogs are viewed as successful and their

owners are obligated to disperse their puppies to more shepherds.

The new national Bulgarian Shepherd Dog breed has become an important symbol for the country and both politicians and sheepherders own the dogs. Most dogs are now being raised as companions away from livestock. Unfortunately, there has also been crossbreeding with Caucasian Shepherds, Landseer Newfoundlands, and Saint Bernards.

The use of the name Karakachan Dog as opposed to Bulgarian Shepherd Dog is controversial. The national Bulgarian Shepherd Dog club and the Bulgarian Republican Federation of Cynology have plans to seek FCI recognition for the larger group of dogs under the name Bulgarian Shepherd Dog, which has been exported to the UK and other Europen countries, and Russia. Several hundred Karakachan Dogs are now found in Bulgaria. Semperviva and the International Karakachan Dog Association continues to pursue the breeding of the traditional Karakachan livestock guardian dog.

In North America, Dr. Philip Sponenberg and a small group of farm owners began importing traditional Karakachan Dogs in the mid-2000s. Subsequent imports have been selected with the assistance of Semperviva and dedicated individual breeders, such as Sidr Sedechev. North American owners have specifically focused on these traditional Karakachan working dogs within the greater national Bulgarian Shepherd Dog breed. The Karakachan Dog Association of America is affiliated with the International Karakachan Dog Association and maintains a registry.

In 2014, the USDA Wildlife Service imported nine Karakachan Dogs for livestock protection research studies. The breed remains somewhat rare in North America, with a population of 100 to 200 dogs, but Karakachan dogs are now successfully working on farms and the breed is expanding well.

Komondor

KOH-mohn-dor	Also known as Kom, mop dog

Origin	Hungary
Size	**Male** 27.5 to 31.5 inches, 100 to 130 pounds **Female** 25.5 to 27.5 inches, 80 to 110 pounds
Coat	Coarse, wavy outer hair with soft undercoat that forms cords
Color	White
Temperament	Independent, dominant, moderate energy, highly reactive

The Komondor's slightly comic appearance belies the fact that owning one is a serious responsibility.

A Komondor must be heavily socialized and well trained from an early age. Experienced owners also caution that this breed, although hard and pushy by nature, does not respond well to harsh discipline. Komondors (or Komondorok) can form very intense bonds with their owners and are protective of children in their territory, though not of unknown or teasing children.

The Komondor is an active and exuberant puppy who matures slowly into his role as a guardian. Experienced owners note that adolescent behavior can remain up to three and a half years old. Inappropriate behavior, such as mouthiness, must be dealt with early and consistently.

Working traits. The Komondor generally stays close to his flock and observes the area rather than constantly patrolling it; however, if an intruder refuses to leave, the dog will react quickly to knock down or chase away the threat. Experienced owners note that each individual Komondor makes his own decision as regards his guarding style; the owner needs to be prepared to accept it. He works well alone or in a group of working dogs and prefers an orderly routine. The Komondor is extremely territorial and he guards everything he considers his, including people.

If left alone with his flock and with little or no human handling, he can become overly protective against all humans, barking at every disturbance. As an adult, he is not prone to wander or chase predators, but he is an excellent fence climber.

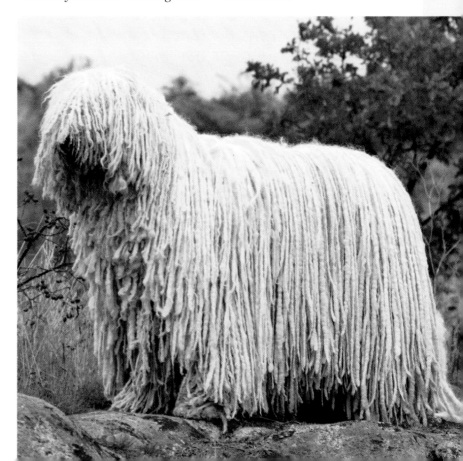

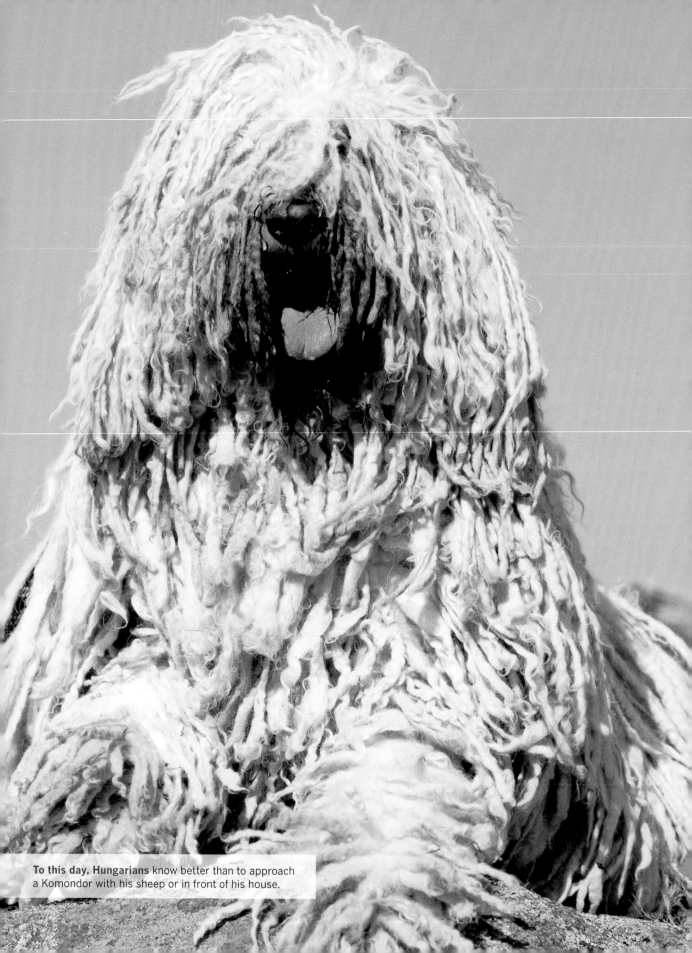

To this day, **Hungarians** know better than to approach a Komondor with his sheep or in front of his house.

Appearance

Komondorok have always been described as imposing dogs, with their appearance adding to their presence. Under all of that hair, the Komondor is medium boned but strongly muscled. The broad head has drop ears, almond-shaped eyes, and a wide muzzle. The tail is carried low unless curved up slightly on alert. The skin is gray but the nose and lips are black in color.

Coat/color. Komondors are double coated. The distinctive cords begin to form at about six to eight months of age as the soft undercoat is trapped into the coarse wavy outer hairs. The coat color is white; cream or buff shading in puppies usually fades out. Do not expect the coat of a working Komondor to look like the dogs prepared for the show ring. Even with extreme care it is nearly impossible to keep the cords of a mature dog white since it does not shed its coat.

History

A vast grassland plain spreads across much of Hungary, the home of two old livestock guard dog breeds — the Komondor and the Kuvasz — each the dog of different peoples. A kingdom since 895 CE, Hungary was the home to tribes from the Eurasian steppes. Eventually the Mongols pushed another nomadic warrior tribe, the Cumans, into Hungary and the surrounding areas.

By the mid-thirteenth century, King Bela IV had arranged an alliance with the Cuman leader Koten Khan, who ultimately settled his people in the central part of the kingdom. The Cumans and the Hungarians would remain separate peoples in Hungary, each keeping to their own villages and culture.

The Cumans arrived with a livestock guardian dog, the Komondor, so beloved that their remains have been found buried in Cuman tombs. These dogs were closely related to the *ovcharkas* found in the original Cuman homelands. Living out on the grassland from April to November, the Komondor was reputedly protected from both weather and wolves by his coat's long, heavy cords and felted plates. Despite his somewhat comic, moplike appearance, the Komondor was a serious and imposing livestock guard dog. He was rarely taken into the cities as a house guard, remaining primarily in rural areas. Komondors are currently being used in Hungary as property guards and police dogs.

The Komondor is mentioned by name as early as 1544. From that point on all the descriptions and depictions of the breed

Special Coat Care

The owner usually has to help the cords form by splitting larger mats into 1-inch cords. This must be done frequently until the cords develop, or large undesirable mats, called plates, will develop. Adult dogs also need attention to prevent the newly growing coat from matting together at the base of the cords. It is usually necessary to clip the underparts and the area around the mouth. Dogs must also be checked regularly for long hair between the pads of the feet and in the ear canals. Komondors shown in the conformation ring must have corded coats. It is best to have an experienced person demonstrate coat care to new owners.

Working Komondors are often kept without cords and clipped yearly, much like their sheep. Owners of corded working dogs usually keep them clipped about 4 to 6 inches in length. The Komondor's coat is suited to drier climates similar to that of its homeland. Moisture can lead to hot spots, odor, and mildew. A fully corded adult dog can take two to three days to dry out completely. Dogs also scratch out cords if fleas or ticks bother them. Remember to make allowances for the weight of the full coat when using anesthesia or medications prescribed by weight. Flea preparations are also held in the coat so be cautious of overuse.

closely resemble the modern dog. Komondors began to find their way to Europe in the early 1900s. Pedigree records in Hungary begin in 1924, when the first formal breed standard was created.

World War II devastated the breed; by many estimates only a few dozen dogs survived postwar, and rebuilding was a slow process. Today the Komondor is a national treasure and the breed now numbers about 2,000.

Out of the Country

Komondors are also found in Western Europe in small numbers, primarily as show and pet dogs. About 100 dogs are found in Great Britain, where the Komondor Club was established in 1978. Komondors are also quite rare in Australia and New Zealand.

Komondors were occasionally imported to North America in the twentieth century, but not as working dogs. The AKC recognized the breed in 1937, but due to World War II and the early years of Communist rule, it was difficult to establish the breed. Imports resumed in the 1960s and the Komondor Club of America was founded. When interest in using the breed for its traditional job as a livestock guardian began, Komondor numbers were still very low. It remains difficult to find a purebred working Komondor, although the breed remains well suited to this role because of its formidable nature.

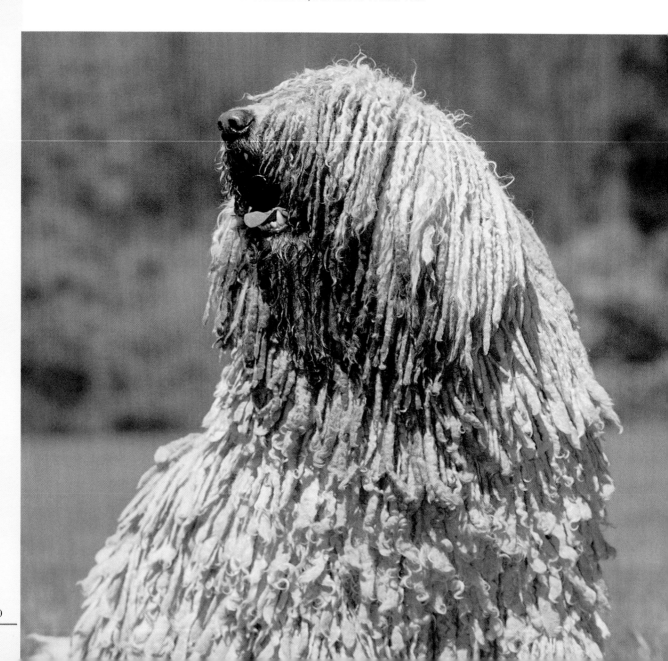

Kuvasz

KOO-voss

Origin	Hungary
Size	**Male** 28 to 30 inches, 100 to 115 pounds **Female** 26 to 28 inches, 70 to 90 pounds
Coat	Wavy, medium outer hair with soft undercoat
Color	White
Temperament	Independent, dominant, moderate energy, variable reactivity

Often described as a one-family dog, the Kuvasz (plural: Kuvaszok) is affectionate and loyal to those he regards as his responsibility.

Some breeders are wary of selling a Kuvasz to a home for use as a full-time working guardian, believing the dog will not be happy unless it has the opportunity to develop a strong human bond. Being so human oriented, the Kuvasz makes an excellent family and farm protector, although he remains suspicious of strangers and is independent in nature.

Experienced owners caution that the Kuvasz is a guardian but not a playmate for children, because he may interpret rough play from strange children as a threat to his flock. Whether kept in the field or the home, the Kuvasz requires socialization, control, and good fencing. The Kuvasz tends to be a soft-tempered dog who needs firm but positive training in short sessions. He is also active, fast, agile, and athletic.

Working traits. With the renewed need for protection against predators, the Kuvasz has found a working home as an LGD in North America. As a livestock guardian, he generally works at a distance from the flock, observing potential threats. He is quick to respond to disturbances, although there is a range of reactivity depending on breeder selection. If you are choosing a Kuvasz as a livestock guardian, the best advice is to seek out a breeder who breeds working dogs, exposes puppies to farm stock, and is able to choose the most appropriate dog for your situation.

Appearance

The Kuvasz is a medium-boned dog who appears lithe or lean compared to many other livestock guard dogs. The North American Kuvasz tends to be slightly larger than dogs in Hungary. One of his most notable features is a lovely wedge-shaped head with almond eyes, drop ears, and black eyelids, nose, and lips. The Kuvasz should not have loose lips, a blunt muzzle, or a large broad head. The plumed tail is carried low but rises level when the dog is alert.

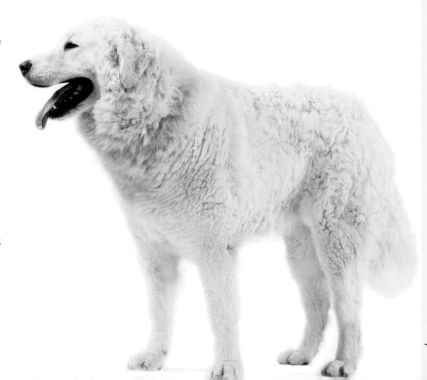

Coat/color. Another important Kuvasz feature is the wavy or undulant coat that should not form cords. In Hungary, this coat is combed, not brushed, to maintain its traditional appearance. The white, medium-length coat is wash-and-wear with coarse outer hair and an undercoat that sheds twice a year. Some standards permit ivory-colored dogs although this is not preferred. The skin is well pigmented with slate gray or black.

History

The semi-nomadic Hungarian tribes who lived on the steppes of Eurasia, eventually moved into the Carpathian Basin of modern-day Hungary and the surrounding areas. In 895 CE, these unified tribes established the kingdom of Hungary. The plains became home to a successful sheep-raising culture that has continued into the present. No doubt, the early Hungarian shepherds brought along their big white guardian dogs, and sheep grazing is still practiced in the traditional shepherding style. The Kuvasz is related to the closely neighboring breeds the Polish Tatra and Slovak Cuvac.

Although the first job of the Kuvasz was as a flock guardian against bears and wolves, he also protected cattle and horses, and was taken into the villages and homes. During the fifteenth century, King Matthias, the most famous devotee of the Kuvasz, raised hundreds of them in his kennels as personal protectors, estate guardians, and hunting dogs for use on large game, such as boar. At times, the Kuvasz was also used as a war dog with the cavalry. The Kuvasz remained a popular dog of royalty in Hungary and beyond, admired for its beauty and noble, refined appearance. The Kuvasz was depicted in many works of art and literature in Hungary, where he remains the most popular native breed.

Organized breeding of the Kuvasz began in the late nineteenth century, with the first standard written soon thereafter. The FCI accepted the Kuvasz in 1934, as the first livestock guard dog breed from middle Europe. By this time the Kuvasz was no longer primarily employed as a flock protector, but he was still popular in villages and homes. At times he was also used as a police or guard dog. The Second World War devastated the country and the unsettling years of Communist control severely affected the breed.

Post–World War II

Following the war, the estimates for surviving purebred Kuvaszok were as low as 12 dogs. Efforts to save the breed took place in Hungary, using Kuvasz-type dogs without pedigrees and a few closely related Slovak Cuvac and Tatra dogs, as well as a German-bred male Kuvasz. The Kuvasz has once again become a popular dog in Hungary, where is it widely admired as a historical breed.

The Kuvasz was bred in Germany as early as 1901. For a time the Komondor was interbred with the Kuvasz. As an overcorrection, selection was made against the traditional wavy Kuvasz coat. During the years of separation and isolation from Hungary, a different style or type developed in Germany — this dog looked more like a Great Pyrenees in head and body size. A revised Hungarian standard was rewritten in 1966 and is generally accepted worldwide as the correct description of the breed. The Kuvasz is bred in several countries; a separate German type no longer exists in Europe.

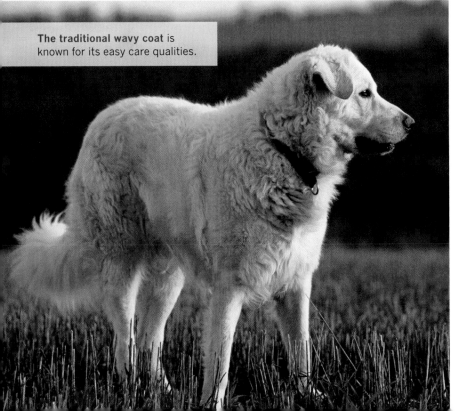

The traditional wavy coat is known for its easy care qualities.

The Kuvasz was imported to America in the 1920s from both Hungary and Germany. The AKC initially accepted the Kuvasz in 1931, although it was difficult to maintain the breed until more dogs could be imported in the 1960s. In 1974, a new standard was written and the breed was readmitted to the AKC. The Kuvasz was recognized in Canada in 1982. With the fall of Communism, the ability to exchange dogs and information improved. Efforts began to correct mistaken trends in Kuvasz selection and there is now a renewed interest in selecting for the traditional Hungarian standard. Both German and Hungarian types, with coats ranging from very wavy to straight, can be seen in the show ring.

The breed was imported to Australia in 1998, but it remains rare in both Australia and New Zealand.

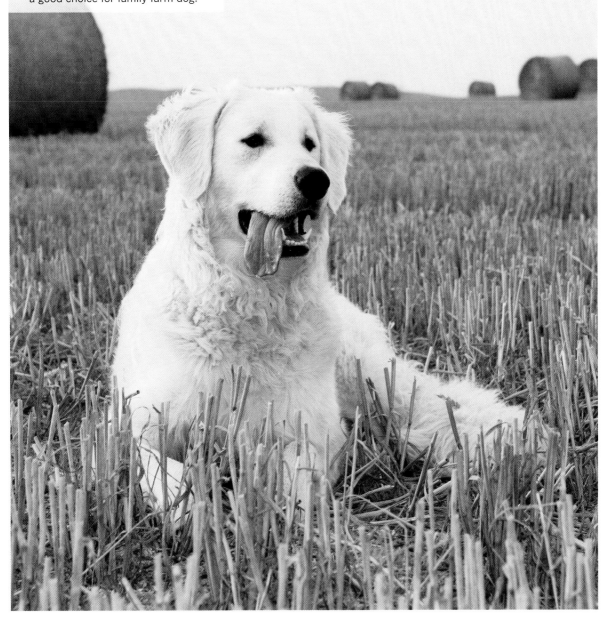

Traditionally used as both an LGD and a home guardian, the Kuvasz is a good choice for family farm dog.

Maremma Sheepdog

mar-EMM-ah

Also known as Maremma and Abruzzese Sheepdog (the official FCI name), Pastore Maremmano, and Pastore Abruzzese

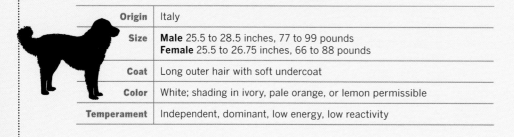

Origin	Italy
Size	**Male** 25.5 to 28.5 inches, 77 to 99 pounds **Female** 25.5 to 26.75 inches, 66 to 88 pounds
Coat	Long outer hair with soft undercoat
Color	White; shading in ivory, pale orange, or lemon permissible
Temperament	Independent, dominant, low energy, low reactivity

The Maremma is independent minded and protective, although not highly reactive.

Even the most socialized dog needs to be introduced to strangers and still may not accept them as visitors in the future, unless his owner is present. The Maremma can serve as a general family and farm guardian, but they prefer to live outside.

The Maremma Sheepdog Club of America is committed to breeding Maremmas as working dogs and discourages the keeping of this breed as a pet. Although some breeders may sell a pup to a well-qualified but nonworking home, 90 percent of the dogs that come as rescue dogs to the United States are from pet homes.

Maremma Rescue Victoria in Australia finds that about 80 percent of their rescue dogs are from pet homes. In Australia, where Maremmas are sometimes marketed as pets, rescue dogs come from irresponsible breeders, and lack registration as they are not from established kennels breeding for show or working dogs.

Working traits. The Maremma bonds closely to his flock, which lessens the tendency to wander, although it does not negate the need for fencing. Maremmas patrol their perimeters and leave scent marks to discourage canine predators but they spend most of their time with their stock or observing them from a higher spot. He is especially suited to flock situations where he interacts with the farmer through daily routines. Owners report that their dogs are affectionate and loyal to them but happiest when they are out with their stock.

Appearance

An attractive dog with a refined appearance, the Maremma is slightly smaller than many LGD breeds, with dogs rarely weighing more than 100 pounds. The head is triangular with small high-set ears that hang down. The lips, nose, and eye rims are black with a dark

almond-shaped eye. The lips are tight and there is no dewlap under the neck. The tail is carried low when the dog is relaxed and rises when he is alert, although it is not carried in a curl over the back.

Coat/color. The long double coat is somewhat harsh and sheds dried mud. The hair forms a collar or mantle around the neck. Two types of coat are still seen — from rougher, longer, and wavier to shorter, straighter, and softer. In winter, the Maremma has a thick undercoat that is well suited to extreme weather. The summer coat is much thinner and can have some color changes. The Maremma is a white dog with some shading of cream, ivory, pale orange, or lemon permitted.

History

The big white dogs that protected sheep from wolves were well known to Roman writers. These ancient observers described the preferred white color, best size, prime age, and even the nail-studded leather collars they wore, called *melium*, to protect the dogs from wolves and bears. The big white dogs are also found in paintings and literature through the centuries. The breed now known as the Maremma Sheepdog traces its heritage back to these *cane de pastore*, the dogs of shepherds in central Italy. The Maremma region itself spreads from southwestern Tuscany into northern Lazio. The climate of the coastal western land is distinctly Mediterranean, mild in winter with good grazing.

Traditionally, as the grass withered in the summer heat, the sheep, goats, and the *pastore maremmano* dogs were moved up into the cooler Apennine Mountains which divide the central area of Italy from the eastern regions of Marche, Abruzzo, and Molise. On the Abruzzo side of the mountains, sheep and *pastore abruzzese* dogs traveled southward to the lower Apulian plains for winter pasture. Everywhere, the movement of people and animals followed a complex network of sheep tracks and cattle roads of distinct and differing sizes.

Through the centuries both the Tuscan and Abruzzese shepherds selected strictly for temperament and working ability, as well as appearance. They also guarded their best dogs against outsiders who might seek out the dogs or try to improve them. However, as sheepherding decreased, more Maremmano Abruzzese Sheepdogs began to be kept as majestic estate guardians, especially in Tuscany. Important Maremmano kennels were established by historical Tuscan families, such as the Marchese Chigi and Prince Tommaso Corsini, which lead to awareness of the breed throughout Italy and Europe.

Two Types to One

Originally, the *pastore maremmano* and *pastore abruzzese* were viewed as two separate types. Abruzzese sheepdogs were generally larger with a rougher long coat, while the Maremmano sheepdogs were somewhat smaller and lighter with a finer coat. Abruzzo pride in the native dogs was strong, although the best-known kennels were found in the Maremma. The Maremmano was recognized in 1894, with the first standard written in 1924.

In the 1950s, the Italian national kennel club made the decision to combine the somewhat heavier Abruzzese and refined Maremmano types into one recognized breed, the Pastore Maremmano Abruzzese, with a standard describing a moderate dog lying between these two types.

To some extent, these two types can still be found and both have ardent admirers. Many working Maremmanos are registered, although even today it is still possible to locate "rustic" or unregistered dogs, who can be entered in the open Italian registry. There is a commitment to preserve the working abilities of the breed as well as the genetic health through exchange of dogs bred for work or show. The breed population is now about 7,000 dogs.

Sheep are still found in the national parks of Abruzzo, as are wolves. The Maremmano Abruzzese are vitally important and can be seen throughout the countryside. Today in the Maremma, sheepkeeping is less common; however, wolves and bears are returning and the use of dogs among shepherds is increasing. With the reappearance of the wolf in the Alps, there is renewed interest in other countries in the Maremmano's guarding abilities. The Maremmano is also bred elsewhere in Europe for show and as family companions.

Out of the Country

In 1872, a "Roman" Maremmano was exhibited in Britain. Queen Victoria also owned a pair of these "Italian Mountaineer" dogs, reputed to be loving yet excellent watchdogs. In the 1930s, Helen Home became acquainted with the dogs of the Marchese Chigi, imported quality dogs, and supported efforts for the breed. Additional imports came from the Corsini kennels. The British Kennel Club recognized the breed as the Maremma Sheepdog in

1936. The Maremma Sheepdog Club of Great Britain was established in 1950, but it struggled with low numbers of dogs until the 1980s and '90s, when interest was renewed and important imports were made. Maremmas in Britain are primarily family companions, especially in the countryside.

The first Maremmas were imported from Britain to Australia in 1982. More British and Swedish imports to both Australia and New Zealand continued into the 1990s. Recently it became possible to import dogs directly from Italy, which should benefit the available diversity. Maremmas have become

well established in Australia, with more than 4,000 dogs registered to date and large numbers of unregistered or crossbred dogs as well. Breeding is primarily centered in Victoria, where the dogs are in demand as workers on sheep stations there and across the country. Show kennels and breeders are now specializing in working livestock guardians.

In New Zealand, although numbers are much smaller, Maremmas are used by both sheep and alpaca breeders to guard against roaming dogs and human intruders. The Maremma is recognized by both the ANKC and NZKC

In the 1970s, Dr. Ray Coppinger imported Maremmas to the United States for the first extensive studies on the use and effectiveness of LGDs. Maremmas proved to be one of the most successful breeds in these studies. The Maremma Sheepdog Club of America was created to register the dogs and provide support for their owners. The Maremma was recognized by the UKC in 2006. Maremmas have become a well-established breed in North America, viewed favorably for the strong bonds they make to their stock and their ability to deal with large predators. They are also used to crossbreed with other white guardian breeds.

The Maremma is also known as Maremma and Abruzzese Sheepdog (the official FCI name), Pastore Maremmano, and Pastore Abruzzese.

Polish Tatra Sheepdog

TA-trah | Also known as Owczarek Podhalanski, Polish Mountain Sheepdog, Tatra

	Origin	Poland
	Size	80 to 130 pounds **Male** 26 to 28 inches **Female** 24 to 26 inches
	Coat	Moderate to long outer hair with soft undercoat
	Color	White
	Temperament	Dependent, dominant, moderate energy, low reactivity

The Tatra is an even-tempered dog who shows great restraint and lacks the short trigger of some other livestock guard dog breeds.

It is a good choice for small farms that need a livestock guardian who accepts visitors. Although he is a self-thinker, he is more dependent than many LGD breeds in his need for human interaction. Because he is a social and affectionate dog, he is not as well suited to large-range situations.

A good family companion, the Tatra still requires exercise and good fencing. He barks at disturbances, especially at night. He likes consistency and fairness in training as well as socialization.

Working traits. The Tatra, who works well with other dogs, is also noted for his style of protection against predators. He places himself between the flock and predator and remains close to the flock while barking to warn the predator and alarm the shepherd. The Tatra attacks only if the predator persists and moves in close to the flock. The Tatra is also an alert, active dog who patrols his territory.

The FCI standard describes the Tatra as a herder and watchdog. Some Tatra owners in North America report that their dogs are willing herding assistants as well. Herding behaviors, including chasing or driving stock, are incompatible with reliable, full-time livestock guardian work. If you are looking for an LGD, it is inadvisable to select a pup who displays high energy or prey drive and the desire to herd. This is less important if the dog is intended to function as a companion or family and farm guardian.

Appearance

The Tatra is a large and lovely dog with an impressive presence. The rectangular skull is slightly rounded with a distinct stop. The eye rims, lips, and nose are dark-colored. The tail may rise higher when the dog is alert, but does not curve over the back.

Coat/color. The breed's massive appearance is partially due to his abundant, straight to slightly wavy coat. The hair forms a ruff on the neck and abundant feathering on the legs. The outer coat is

weather resistant and sheds dried mud, but it requires regular care to prevent matting. The dog's coat is white and his nose, lips, and eye rims are black.

History

Poland lies across the beautiful Tatra Mountains from Slovakia, and the lovely Polish Tatra is most

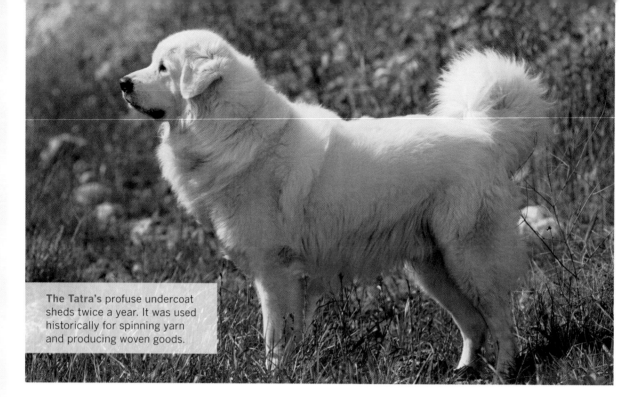

The Tatra's profuse undercoat sheds twice a year. It was used historically for spinning yarn and producing woven goods.

likely related to the Slovensky Cuvac. For many centuries in the Podhale highlands of southern Poland, shepherds took sheep and their guardian dogs up into the summer pastures. The shepherd's days were busy with milking three times a day and making cheese, including the famous *oscypek*, while two or more dogs watched the sheep.

When the sheep returned to lowlands in the winter, the Tatra acted as home and farm guardian, as well as hauling small carts for the dairies and other small businesses. Tatras also helped their shepherds as calm assistants when moving sheep. Functioning as more of a multipurpose mountain dog, the Tatra always worked closely with people rather than as a remote livestock guardian. As a result, they are a people-oriented breed and somewhat less intense in their reactions to strangers and situations.

The Tatra mountain sheepdog who was described in Polish literature of the nineteenth century

closely resembles the modern dog. In the 1930s, a standard was written for the breed and these dogs began to receive some international recognition. Experts noted that there were two varieties of Polish Tatra sheepdogs — a larger mountain dog and a smaller lowland dog.

Post–World War II

World War II seriously threatened the breed except in traditional shepherding areas where it was somewhat protected. In 1954, the Communist government confiscated all private property in the highlands and created a national park in the Tatras. The shepherds were displaced to other sites in the Carpathian Mountains and sheepkeeping declined. Ironically, the Tatra mountain meadows are now overgrown with weeds, and the park authorities are hoping to reestablish summer grazing. Shepherds in other areas are still using livestock guardian dogs with documented success and their use is now encouraged as large predators return to the Carpathians.

Fortunately, lovers of the Tatra and the Polish Kennel Club rallied around the Tatra in the 1960s. Outcrossing with related breeds, the Slovensky Cuvac and Kuvasz, may have occurred in this rescue effort. There are now approximately 3,000 Tatras worldwide, with several hundred found in Poland, although many do not work as flock guardians. Tatras were exported to Europe beginning in the 1970s. They are bred today in Germany, Holland, and France, as well as a few other locations throughout the world. Individual dogs have been imported to Britain.

About three hundred Tatras are now found in North America, beginning with the early imports in the 1980s. The Polish Tatra Club of America maintains control of its open registry, which is affiliated with the UKC. The club requires DNA typing on all of its dogs, permanent identification, and mandatory OFA hip screening for dogs used in breeding.

Pyrenean Mastiff

pyr-a-NEE-en | Also known as Mastín de los Pirineos

Origin	Spain	
Size	120 to 150 pounds or more **Male** 30.5 to 32 inches, minimum **Female** 28.5 to 29.5 inches, minimum	
Coat	Long outer hair with soft undercoat	
Color	White with dark patches and a mask covering eyes and ears	
Temperament	Dominant, independent, low energy, low reactivity	

Today there is great national pride in native Pyrenean breeds, with several thousand Pyrenean Mastiffs in Spain and elsewhere in Europe.

The dogs are primarily used as property guardians and family companions, or for show, although there is renewed interest in the breed as a working dog since the return of wolves in the Pyrenees. Although the working *mastín* is no longer a common sight in the countryside, efforts are underway to reestablish both sheep and the traditional transhumant systems in the Pyrenees.

This breed is more active than the Spanish Mastiff but also calmer, less reactive, and perhaps more suited to family life, though it is capable of strong reaction to threats when aroused. His bark is deep, but he does not seem to bark as much as other livestock guard dogs, which can make him a good neighbor. He is suspicious of strangers, but will accept visitors who are introduced properly.

Some owners report that the Pyrenean Mastiff has a particularly hearty appetite and eats more than many other livestock guardian breeds. He is also an excellent fence climber and needs to be safely confined.

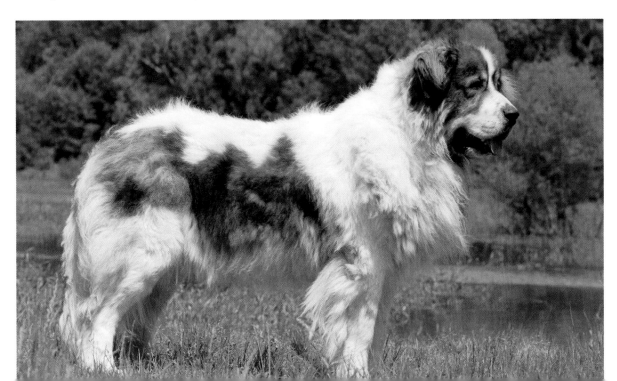

Appearance

The Pyrenean Mastiff is a very large dog, giving the impression of size and power. There is no maximum height limit; tall, well-proportioned dogs are much appreciated. The Pyrenean Mastiff shows the influences of its two neighboring breeds, the Great Pyrenees to the north and the Spanish Mastiff to the south.

Slightly less refined and larger than the Great Pyrenees, the Pyrenean Mastiff is broader in the body with a wider head and double dewlaps. The face bears some resemblance to that of the Spanish Mastiff, with its pendulous lips, sleepy look, and deep muzzle, but both head and the double dewlap are smaller. Pyrenean Mastiffs are also droolers.

The small eyes are almond shaped and dark colored, and the lower eyelid can show some haw or membrane on inside corner of the eye. The medium-sized ears hang flat but are set higher than those of a Great Pyrenees, and they tend to blend back into the mask color of the head. The ears are not cropped. The plumed tail hangs low, and the last third is curved with a hook at the tip. When the dog is alert it is carried up and slightly curved but it is never carried over the back. Double dewclaws on the back feet are common.

Coat/color. The double coat of the Pyrenean Mastiff is less profuse than that of the Great Pyrenees but longer than the Spanish Mastiff's. It is dense, medium-long, and coarse and not soft or wooly. Although he can handle dry heat by retreating to cool dens, humid climates can be uncomfortable for a Pyrenean Mastiff, who is much better equipped for cold weather. The base color is always pure white with well-defined patches in one of various colors including: medium gray, golden yellow, brown, black, silver gray, light beige, sandy, or marbled. Red is not desirable nor is a tricolored coat.

History

The Pyrenees Mountains have long formed the natural boundary between the Iberian Peninsula and France. Just south of the Pyrenees, lies the autonomous communities of Navarra, Aragon, and Catalonia. This is a region rich in history and tradition. Sheep grazed the high meadows of the mountain valleys from summer through early fall. Wearing spiked collars called *carlanca*, large dogs known as *mastínos*, guarded the flocks from wolves and bears.

The *mastín d'Aragon*, the *mastín d'Navarra*, and other types were also the favored guardians of both castle and home in the kingdom of Aragon. In the countryside, the travels of sheep, shepherds, and their dogs were generally confined to the local areas. The livestock guardians of the Aragon somewhat resembled their French Pyrenees neighbors, but also showed the influence of the southern Spanish Mastiff livestock guardians.

The beloved *mastín* faced a serious crisis in the twentieth century. Beginning in the mid-nineteenth century, the wool industry declined worldwide, which stressed the marketing and transhumant systems of northern Spain. Due to the falling rural population of people and livestock, along with the extermination of the large predators from the Pyrenees, the need for large livestock guardian dogs drastically decreased. The Spanish Civil War also took a terrible toll on the economy of the country; people simply could not afford to feed the big dogs, so their numbers declined severely.

Resurgence

In the 1970s, a group of admirers searched the countryside and were able to identify about 100 excellent specimens. In 1977, a club was formed, El Club del Mastín del Pirineo de España. The historical type was researched, and a standard was written; selected dogs were registered and then carefully bred and selected for the traditional type. The Mastín del Pirineo was recognized by the FCI in 1982.

A pair of Pyrenean Mastiffs were imported to North America in 1996. A breed organization and registry, the Pyrenean Mastiff Club of America, was also created that year. More imports from Spain and other European breeders have followed. The club remains closely aligned with the standard and health requirements of the parent club in Spain.

The Pyrenean Mastiff was recognized by the UKC in 2006 and received AKC FSS status in 2014. Pyrenean Mastiffs have found homes as show dogs, companions, and working livestock guardians. They remain a rare breed, although the population is growing.

Although recognized by the British Kennel Club, Pyrenean Mastiffs are uncommon in Britain. The breed arrived in Australia about 10 years ago and is now recognized by both the ANKC and NZKC.

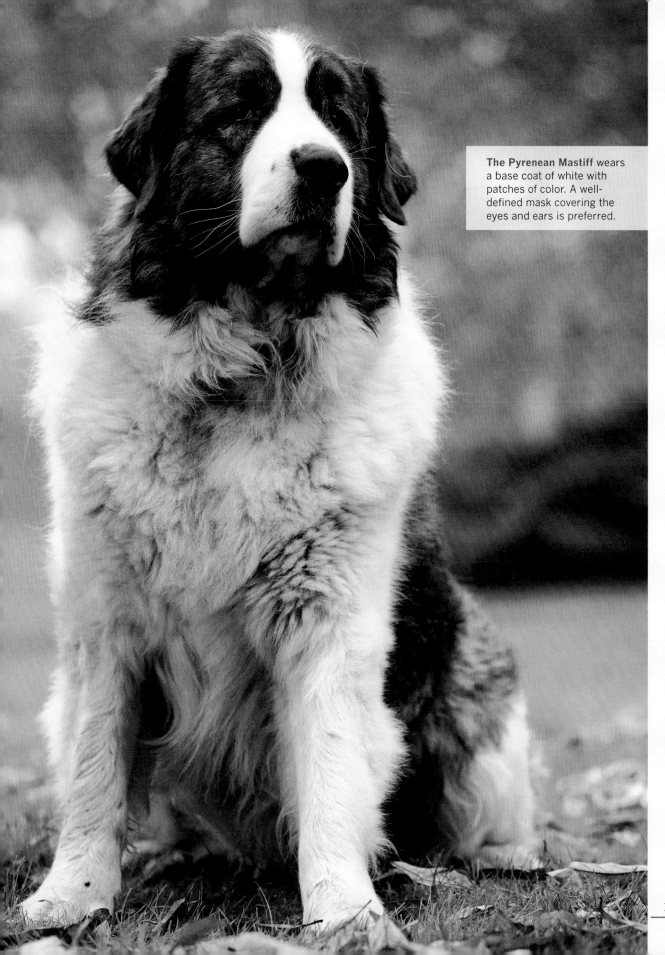

The Pyrenean Mastiff wears a base coat of white with patches of color. A well-defined mask covering the eyes and ears is preferred.

Šarplaninac

*shar-pla-NEE-natz or
shar-pla-NEE-nac*

Also known as Illyrian Shepherd Dog, Macedonian-Yugoslavian
Shepherd Dog, Sharplanina, Sharplaninatz, Shar, or Šar

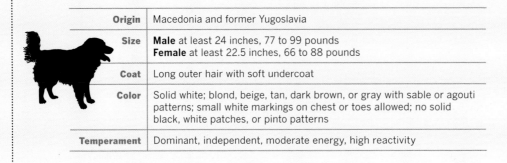

Origin	Macedonia and former Yugoslavia
Size	**Male** at least 24 inches, 77 to 99 pounds **Female** at least 22.5 inches, 66 to 88 pounds
Coat	Long outer hair with soft undercoat
Color	Solid white; blond, beige, tan, dark brown, or gray with sable or agouti patterns; small white markings on chest or toes allowed; no solid black, white patches, or pinto patterns
Temperament	Dominant, independent, moderate energy, high reactivity

Noted for his courage and toughness against predators, the Šarplaninac is an excellent livestock guardian who is finding an important role on Canadian and American ranches.

More reactive than some other LGDs, the Šar is a strong-willed, intelligent, highly protective dog. He prefers regular human contact, which might make him slightly less suitable on a range situation.

The Šarplaninac is an active dog who is definitely happiest in the country with a job to do and room to patrol. Often described as calm, he is also a dominant and independent-thinking dog who requires very consistent and clear handling and training.

Coat/color. The heavy double coat forms a ruff around the neck and is long on the back, breeches, and backs of the legs. This breed is not suited to extremely hot and humid climates. Šars are rarely white and more often solid colors with agouti or sable patterning. The color can appear darker on the top of the dog, shading lighter underneath and on the extremities. Very small white marks are allowable on the chest or toes. Pinto or bicolor dogs are not accepted.

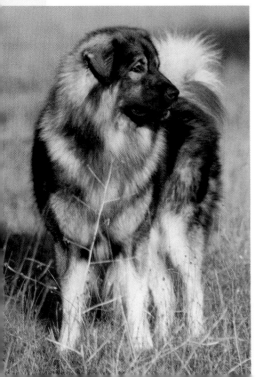

Appearance

Slightly smaller than many other livestock guardian dogs, the Šar is a heavy-boned dog with an abundant long coat and especially large teeth, which gives the impression of greater size. Šarplaninac dogs in North America tend to be taller and heavier than ones in their homeland. The skin must be dark and the nose and eye rims black. The plumed tail is slightly curved when the dog is relaxed but may rise above his back when he is alert.

History

Although this mountain breed is named for a specific place — the Šar or Shar Planina Mountains of Macedonia, Kosovo, and Albania in the former Yugoslavia — it certainly descends from the larger group of old livestock guardians that have existed in the area since ancient times. Now, as then, throughout the region of the western Balkans, sheep are taken up into the high, rugged mountains for summer grazing and returned to the lowlands for winter. The predators are still fearsome — bear, lynx, and wolf.

Over many centuries, the challenging environment and predators shaped the dogs. In different areas these dogs developed recognizable differences, although collectively they were called Illyrian Shepherds by the ancient people of the western Balkans. A closely related breed from Slovenia, known as the Istrian Shepherd, was later recognized as the Krasevec or Karst Shepherd.

Early observers of the Šarplaninac noted the distinctive long coat and coloring, as well as the slightly smaller size compared to many neighboring livestock shepherds. Another noteworthy trait was the breed's calm and measured nature, somewhat less ferocious than many other eastern livestock guardians. No one doubted their ability to handle the predators that threatened their sheep, and they were also used at times with goats and cattle. The Yugoslavian Royal army kept Šarplaninacs as war and guard dogs in the years before World War II.

The nation of Yugoslavia was created after World War I, but ultimately came under the control of Josip Tito and the Communist government in 1946. The government controlled the breeding of the Šarplaninac in state kennels and by forbidding export of the breed. The dogs were bred for military, police, and other guard work. While some dogs were kept in traditional lines in the state kennels, many military Šarplaninac dogs were crossbred with German Shepherds, Caucasian Ovcharkas, and other breeds.

Current Status

More recently, after the dissolution of Yugoslavia, there has been a sharp increase in popularity of the Šarplaninac in urban areas. Many breeders in these areas are

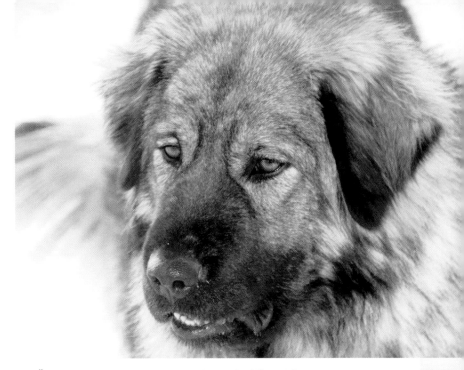

The Šar's long coat and coloring are distinctly different from many other LGD breeds.

crossing the traditional working Šarplaninac with western and eastern breeds, including several mastiff breeds and other large dogs. The results of these breeding projects are advertised as giant or fighting-dog types. Great caution must be taken to import real Šarplaninac livestock guardians and not dogs with military-sourced pedigrees or the current crossbred dogs. It can be difficult to locate a sound, registered traditional working Šarplaninac.

Outside of the country, the Šarplaninac and the Karst Shepherd were jointly recognized by the FCI as the Illyrian Sheepdog in 1931. In 1957, the breeds were separated and the name was changed to the Yugoslavian Mountain Dog. At that time, the Karst Shepherd from Croatia and Slovenia was recognized as a distinct breed. Following the breakup of Yugoslavia in the 1990s, the Šarplaninac was again renamed as the Macedonian-Yugoslav

Shepherd Dog — Šarplaninac. The Šarplaninac is regarded with great national pride in Macedonia, where he is depicted on currency.

In the 1970s, it became legal to export Šarplaninac dogs, and they soon found their way to Europe and North America. Šarplaninac dogs were successful in early trials of livestock guard dogs in the United States, but they did not immediately achieve the popularity of some of the other tested breeds, primarily due to their small population. There are now several independent breeders of Šarplaninac in North America but no established clubs. The Šarplaninac was recognized by the UKC in 1995. Today the Šarplaninac has earned a positive reputation as a working livestock guardian and is expected to grow in popularity.

Slovensky Cuvac

CHEW-vatch | Also known as Slovakian Chuvach, Slovak Cuvac, Slovensky Tchouvatch

Origin	Slovakia
Size	**Male** – 24 to 27.5 inches, 80 to 97 pounds **Female** – 23 to 25.5 inches, 68 to 82 pounds
Coat	Wavy, moderate to long outer hair with soft undercoat
Color	White
Temperament	Independent, dominant, moderate energy, less reactive

The Slovensky Cuvac is noted for his loyal, affectionate nature and strong bond with his family (including children), although he remains independent and sometimes aloof.

He is often described as lively, agile, and fast; this is a dog that definitely requires daily exercise. Despite the purposeful efforts by breeders to create more of a companion dog, the Slovensky Cuvac remains a guardian dog at heart and requires socialization by a dedicated owner. He is reserved and distrustful toward unfamiliar humans and animals. A Slovensky Cuvac needs adequate space, excellent fencing, and neighbors who tolerate barking.

The use of the Slovensky Cuvac as an LGD has been limited in North America. Most dogs are home guardians and companions, although a few work on small farms. As a guardian, the breed is alert but slow to react, primarily using barking and intimidation to scare away threats. Besides having them as companions and watchdogs, owners enjoy their dogs in activities that include hiking, search and research, service work, and even agility.

Appearance

As a breed, the Slovensky Cuvac varies in size, reflecting the breed's origins from a larger mountain type and a smaller lowland type. Today, most dogs are of the larger type. The long tail is bushy but not feathered and is carried low unless the dog is alert.

Coat/color. The Slovensky Cuvac has an abundant coat, 2 to 6 inches long and moderately wavy. The undercoat is particularly dense and sheds heavily. Males have a distinct ruff of hair around the neck. This breed requires regular grooming to prevent mats. The color is white with yellow shading allowed on the ears and pink skin. Nose, mouth, eye rims, and palate are black.

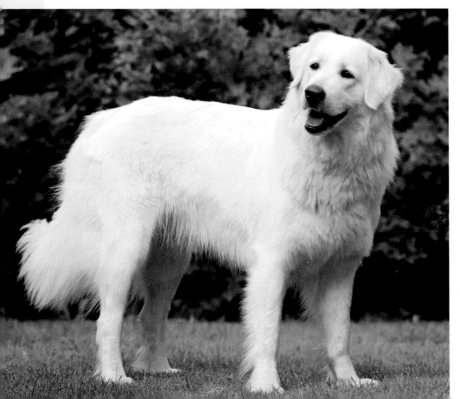

History

The Slovensky Cuvac is related to the Polish Tatra to the north and the Hungarian Kuvasz to the south. The Carpathian Mountains stretch across most of the country with the Tatra peaks reaching the highest points. Sheep flocks were taken up into summer pasture camps, or *salase*, accompanied by shepherds who milked and made cheese daily. Wolves and bears were the original predators, although heavy hunting of them resulted in decreased numbers during the first half of the twentieth century.

In addition to guarding, the breed, known then as the Tatransky Cuvac, assisted with herding, droving, and guarding cattle, goats, and other livestock, as well as poultry. Residents used the dogs as they patrolled the mountains as members of a national civilian defense organization. In some ways, the Slovensky Cuvac functioned as a multipurpose mountain or farm dog rather than a remote livestock guardian.

Traditional sheep-raising methods were increasingly abandoned as the wolf population was reduced. World War I also impacted breed numbers, which were already in decline. By the 1920s, the numbers of Slovensky Cuvac had fallen drastically. Alarmed at the potential loss of a valued native breed, veterinary professor Antonin Hruza identified dogs from several regions and began a controlled breeding project in 1929, using the two traditional types of dogs found — small lowland dogs and large mountain dogs.

The larger type that emerged from this effort established the breed standard that is still used today. Post–World War II efforts continued to preserve the breed. The official standard was adopted by the FCI in 1965 and the Slovensky Cuvac breed was recognized in 1969, its name changed to distinguish it from the Polish Tatra. The FCI also recognized the breed as separate from the closely related Hungarian Kuvasz.

Current Status

By the 1950s and '60s, livestock guard dogs, usually chained at the farms or summer pastures, were primarily kept to warn against human thieves. Generally, livestock owners hired workers to work at the *salase* rather than actively shepherding the flocks themselves. This is still the situation today. With the resurgence of large predators in the Carpathian Mountains, there has been a renewed interest in the traditional use of livestock guard dogs.

Unfortunately, the knowledge of how to socialize dogs to the sheep and patiently train them through their adolescence has been lost. Ongoing efforts to reestablish the Slovak Cuvac as a true working livestock guardian have been undertaken by the Slovak Wildlife Society. With proper working techniques, the breed has shown it still possesses good instinctive traits.

These lovely dogs have found a new role as a family and house protector in cities and rural areas. Today there are about 1,000 registered Slovensky Cuvac in Slovakia. The breed has been exported to other European countries, including Britain, but it remains rare worldwide. Fewer than 40 dogs have been exported to North America.

Of Note

The AKC accepted the Slovensky Cuvac into the FSS in 2009, placing the breed in the Herding Group, and approved it for herding tests. All other LGD breeds are in the Working Group. Some breeders support the breed's dual-purpose use as a herding dog, which is in direct conflict with maintaining reliable livestock guardian traits. Others feel that as a breed, the Slovensky Cuvac is best suited to a role where he has close contact with his family rather than as a full-time livestock guardian.

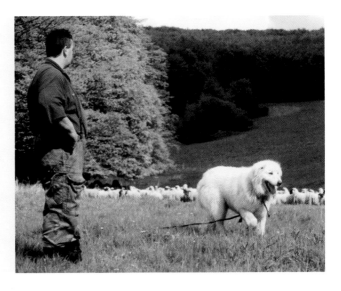

Spanish Mastiff

Also known as Mastín Español, SM

Origin	Spain
Size	No recommended weights, up to 220 pounds **Male** minimum height 30.5 inches **Female** minimum height 28.5 inches
Coat	Medium–long outer hair with soft undercoat
Color	All accepted but favored solid colors include yellow, fawn, red, black, wolf-gray; brindle, pinto, large white collar also favored
Temperament	Independent, dominant, low energy, low reactivity

The working Spanish Mastiff may appear more passive and sleepy than other livestock guard dog breeds, but he makes his presence known by his sheer size and his deep bark or growl when alarmed.

He does not react quickly, but if he feels his territory is being threatened, he attacks the intruder with ferocity. He is deeply suspicious of strange animals and people. He can be an aloof dog, not overly affectionate, and naturally independent. Owners describe their dogs as even-tempered but tending toward stubbornness. This breed requires a serious owner who is committed to socialization and training.

Working traits. As a working LGD, the Spanish Mastiff proves extremely useful in situations with large predators and in general appears to be less reactive and aggressively threatening to humans. He is certainly well tested against wolves. He tends to adopt a close working style with his charges. Although he occasionally patrols his territory, he often

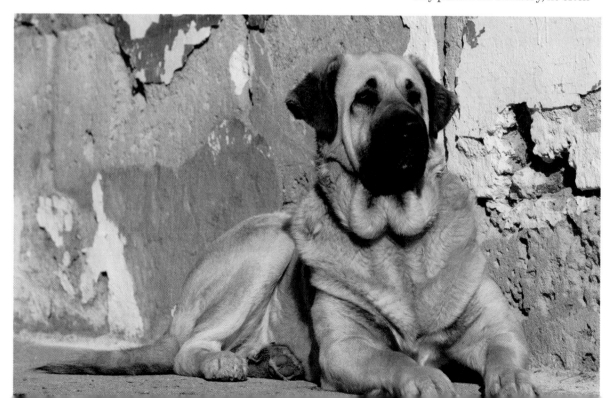

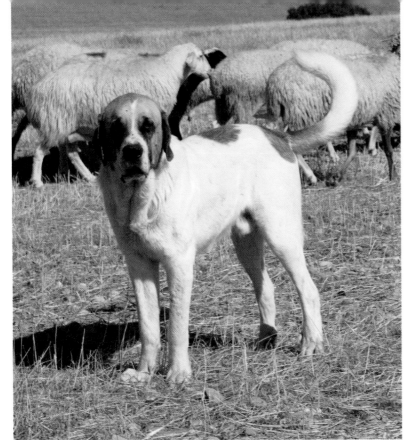

A small group of breeders selects the SM to produce an oversized dog with exaggerated features. This is not the authentic and traditional livestock guard dog, which must be fit, agile, and suited to real work in the field. Working dogs in Spain, although tall, are usually lighter than many overly bulky or show specimens.

selects an observation point with a good view. The Spanish Mastiff traditionally worked closely with his shepherds and tends to do best with regular human interaction.

Appearance

The Spanish Mastiff is among the largest and heaviest of the LGD breeds, but most serious breeders value appropriately sized, authentic dogs over oversized dogs. This is a rectangular dog with a large, broad head and loose lips. Drooling and snoring are common. Ample, loose skin covers his head, neck, and shoulders with a double dewlap under the neck. His eyes are almond shaped and appear small

in his large head. The pendant ears are not cropped. The tail is thick and carried low unless the dog is alert, in which case the tail rises but never curve over the back. Heat with high humidity can be a problem for these massive dogs.

Coat/color. The double-coated Spanish Mastiff is well suited to both hot and dry or cold and snowy climates. The coat is of medium length and dense. The Spanish Mastiff may be of any color or color pattern. Breeders prefer whole (solid) colors, with or without a black mask, though brindles, pinto coloring, and white markings are also admired. The most common colors are fawn, yellow, red, black, or wolf-gray.

History

Spain is the home of a great and traditional transhumance that still holds a deep cultural connection for the Spanish people. Millions of sheep and huge numbers of cattle traveled considerable distance along the *canadas* — the wide, centuries-old passageways between the lush, summer, mountain pastures and the warmer winter pastures closer to the Mediterranean. Dating back to 1273, La Mesta, the powerful association of sheep raisers, secured the right to move sheep along the traditional *canadas*, which are legally protected in perpetuity. Thousands of livestock guardian dogs also traveled with the transhumances and protected the flocks and herds against wolves, bears, and lynx.

The pastoral peoples of Iberia used livestock guardian dogs to protect their sheep, goats, and cattle long before the Roman occupation and the introduction of Roman dogs. In fact, Roman writers particularly noted the native Iberian guardians of sheep and cattle. This landrace breed specific to Spain, called the *mastine*, was also used to protect property, brought into estates of the nobility, and portrayed in art and literature. Although he bears the name mastiff and certainly shares the breed's physical appearance, he is more properly a livestock guardian dog.

Over the last century, only a small portion of Spain's sheep and cattle herders continued to practice transhumance. As both the wolf and the large flocks of sheep diminished, so did the numbers and quality of working Spanish Mastiffs. While the breed continued its role as guardians of home or property,

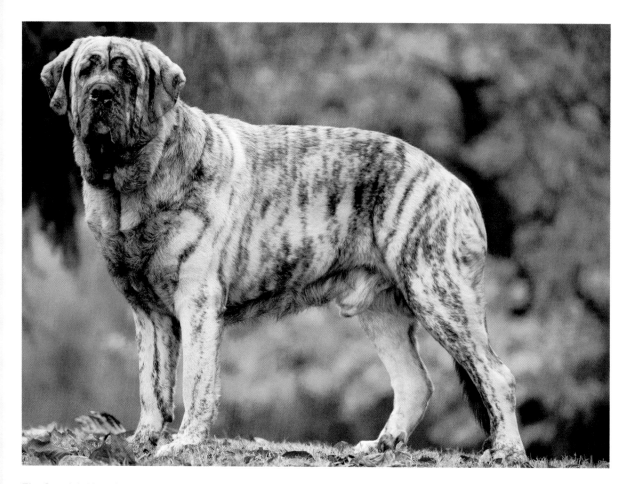

The Spanish Mastiff grows rapidly but is slow to mature. A male is not fully mature until two and a half to three years of age. Care should be taken in feeding young dogs to lessen the development of hip and joint issues.

some were used by the Spanish military as guard dogs. Interest in the native breed was revived in 1970. A little over 10 years later, a club was organized, an updated standard was written, breeding specimens were identified, and the breed experienced a true resurgence.

Current Status

The Asociación Española del Perro Mastín Español believes that size and health need to be restored to the breed. A second organization, the Ortros Group, has the goal of producing functional working dogs for shepherds, which are much needed in Spain to combat the growing population of wolves. This organization coordinates donations of puppies to shepherds and supports transhumance of sheep and cattle.

Working Spanish Mastiffs are still very much present in Spain, primarily partnering with shepherds in open grazing land, where they routinely demonstrate their ability to deal with wolves. The Spanish Mastiff is a national symbol and among the most popular of the dog breeds in Spain, numbering more than 20,000 dogs. The breed has found a new role as a family pet, although it is a powerful, challenging dog to own.

Spanish Mastiffs are also bred elsewhere in Europe, where they are seen primarily as companions or show dogs rather than working dogs. Spanish Mastiffs are recognized by the Australian and New Zealand kennel clubs, though they are quite rare. The breed is not often seen in the UK, where it is unrecognized by the British Kennel Club.

Although Spanish Mastiffs from both Spain and other European countries have been imported to North America, they are still uncommon, and diversity in the gene pool is limited. The population is estimated at 250 to 300 dogs. There is much interest in the Spanish Mastiff as a working LGD who can deal with large predators, such as wolves. Unfortunately, breeders use some of this limited population to produce crossbred dogs with other LGD and non-LGD breeds. The Spanish Mastiff was recognized by UKC in 2005 and is registered with the AKC FSS.

Tibetan Mastiff

Also known as Do-Khyi, TM

Origin	Tibet
Size	**Male** 26 to 29 inches preferred, 90 to 150 pounds **Female** 24 to 27 inches preferred, 70 to 120 pounds
Coat	Long outer hair with dense undercoat
Color	Black, blue-gray, brown with or without tan markings; light to red gold, with or without sabling
Temperament	Independent, dominant, low energy, variable reactivity

The intelligent Tibetan Mastiff is deeply loyal to his family and enjoys interacting with them.

But he also possesses the protective and independent nature of an LGD, and owners should be confident and consistent in their handling. Tibetan Mastiff pups mature slowly and as a breed they prefer calm and routine to disruptive changes. Socialization is important, and it is best to introduce other family pets to your Tibetan Mastiff while he is young. When the family has two dogs, TMs generally do better in opposite-sex arrangements.

The American Tibetan Mastiff Association does not recommend the use of this breed as a full-time livestock guardian and TM rescue groups do not adopt dogs to be used for this purpose. Many breeders regard Tibetan Mastiffs as more of a property guard than a traditional livestock guard dog. These dogs can be tremendous barkers if left outside at night; they were bred for their distinctive deep, bell-like bark.

Due to their traditional role, the breed is perhaps more suited to the role of a farm and home guardian rather than as a remote livestock guardian. Some owners definitely report success with their TMs living full time with their charges on smaller farms where the dogs also have a great deal of interaction with their owners. Many breeders recommend 6-foot fencing with precautions against digging and climbing.

Appearance

The Tibetan Mastiff projects power through his serious expression, heavy bone, and abundant coat and mane (found on both sexes but more profuse on males). The head is heavy with a rounded skull, pendant ears, and often a single deep wrinkle running from above the eye to the mouth. The muzzle is broad and blunt, often with moderate flews and some dewlap under the neck. The brown, almond-shaped eyes are slightly slanted. The plumed tail is set high and curls over the back when the dog is alert.

Coat/color. The double coat is dense and straight, forming a ruff or mane around the neck, and a shawl

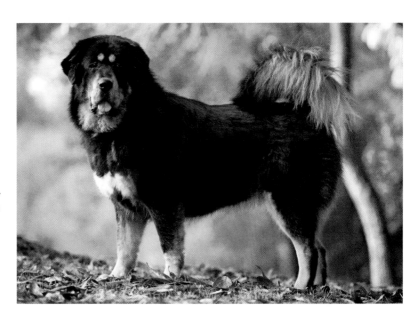

or mantle down the spine. Tibetan Mastiffs are not recommended for tropical climates due to their heavy coat. The AKC standard specifies black, brown, and blue-gray colors, with tan marking permissible. Gold color can be expressed from very light to a deep red, with or without sabling. In Tibet, spots of tan above the eyes — known as "four eyes" or "spirit eyes" — were believed to signify excellent night vision or the ability to see evil spirits, while a small white spot on the chest was a sign of courage. White, cream, wolf-sable, brindle, and spotted dogs are not acceptable. There are some differences between allowable colors in various standards.

Worldwide, the Tibetan Mastiff varies greatly in size, type, and temperament, due to the efforts of some breeders seeking to develop taller and heavier dogs. These dogs have extreme features, such as heavy dewlaps or wrinkles, drooping eyelids, and excessive flews and loose lips, which cause drooling. These overly large and bulky dogs are not suitable for living and working outside in fluctuating weather and diverse terrain.

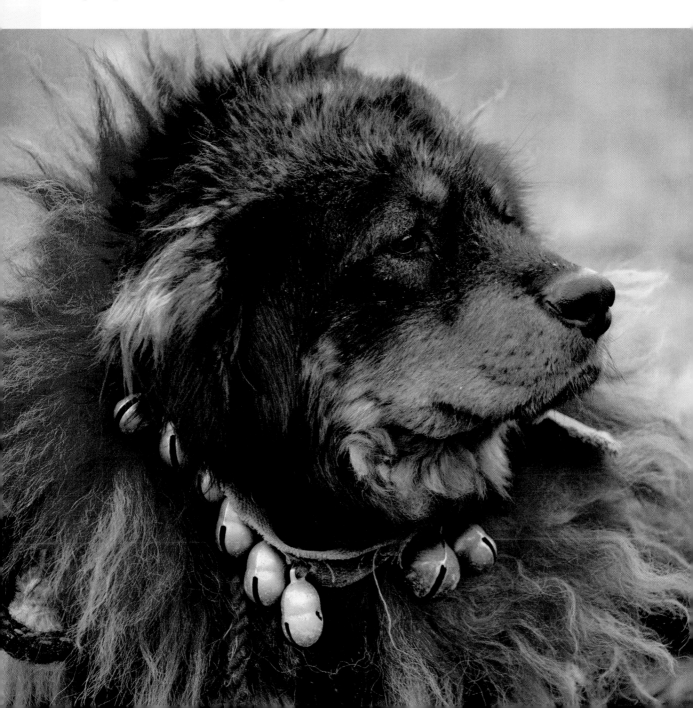

History

The Tibetan Mastiff can appear reserved, aloof, and even a bit mysterious. His physical appearance differs somewhat from many of the other livestock guardian breeds, but like them, he is an ancient companion and partner of humans. Despite his romantic history, the Tibetan Mastiff is probably not the

In many places these imposing dogs wore large, wreath-like collars of reddish-colored yak hair, which enhanced the size of their natural ruff.

ancestral form of all the molossers, or mastiffs, as both the Victorian and early-twentieth-century naturalists believed. Nor did Marco Polo discover them in the thirteenth century, since it appears that he never actually visited Tibet and may have only traveled as far as western China. He did describe the dogs he saw on his travels along the Silk Road as "large and fierce," which they no doubt were.

Through the 1700s and early 1800s, outside observers described the Himalayan and Tibetan dogs, but it wasn't until the mid-nineteenth century that increasing numbers of Western explorers made that truly difficult journey. The magnificent dogs they described were called *do-khyi*, variously translated as "watchdogs," "tied dogs," or "gate dogs." There were also dogs known as *tsang-khyi* (the largest of the guardian dogs) and *kyi apso* (the bearded guardians). In Mongolia, the livestock guardian dogs were known as *bankhar*.

The English name Tibetan Mastiff describes a standardized breed descended from the wide group of these dogs found throughout the vast Himalayas and the Plateau of Tibet, including Tibet itself, Nepal, Bhutan, northern India, and western China into Mongolia. The historical records are clear — large guardian dogs of this type have been in this area throughout recorded time. The isolation of their homelands has also kept them distinctly separate.

In their native areas, these guardian dogs were literally everywhere. Nomadic herders of sheep, goats, yaks, and horses needed protection from predators including wolf, bear, snow leopard, and lynx. Dogs were often tied during the

day and set loose at night to patrol. *Do-khyi* were also used as pack dogs when their owners traveled.

In the villages, the dogs were tied at the door of each house or kept in the walled courtyards and then turned loose at night to roam, bark deeply, and guard the entire village. As reported by many visitors, the palaces of the nobility or other powerful people, as well as the monasteries, were home to the finest and largest of these dogs that were often chained or kept in cages near the entrances. The early descriptions of these dogs closely resemble the traditional Tibetan Mastiffs we see today.

Tibetan dogs occasionally made their way to the West during the nineteenth century, and the British Kennel Club officially named the breed the Tibetan Mastiff in 1873. The dogs remained rare until the British military incursion into Tibet from 1903 to 1904, when the country was opened to diplomats and mountaineers. The British expeditionary forces recorded their continuing interactions with the fierce guardians.

More Recently

Perhaps the most famous account of Tibetan dogs is found in the article "Dogs from the Roof of the World," published in the *American Kennel Club Gazette* in 1937. The author was Irma Bailey, who lived with her husband in Lhasa, Tibet, for several years. In 1928, they imported five *do-khyi* to Britain. Mrs. Bailey describes most *do-khyi* as black with the traditional tan points, although she noted that there were also dogs that were completely black and red. In 1931, Mrs. Bailey formed the Tibetan Breeds Association in Britain, and the Kennel Club adopted the standard.

In 2004, the FCI recognized the Do-Khyi, or Tibetan Mastiff, as the native Tibetan dog.

In 1950, the Chinese government invaded Tibet, and the traditional way of life came to an end. Following an uneasy agreement and an unsuccessful revolt, the Dalai Lama fled in 1959. The nomad areas were reformed into communes, the caravans ceased, the monasteries were closed, and ethnic Chinese resettled the urban areas of Tibet. Following failures in food production, direct ownership of animals was restored in 1981.

The Chinese government has recently organized Tibetan Mastiff Breeding Centers and authorized privately owned companies to encourage export of dogs out of Tibet and China. The dogs coming out of China today, however, are greatly changed. Sometimes called *tsang-kyi*, these dogs are much larger in size with grossly exaggerated features, a wide range of colors, and temperaments that are unsuitable for traditional livestock guardian work. Unfortunately, the breeding of these giant dogs has spread from Asia to Europe and America.

Out of the Country

President Eisenhower was surprised to receive two Tibetan Mastiffs from Nepal in 1958. The dogs were placed on a farm but not used for breeding. Beginning in 1969, several dogs came to North America from Nepal and India. A few dogs were imported from Britain, Holland, and Germany as well. In 1983, two existing breed organizations combined their efforts with full recognition by both the AKC and UKC in 2006.

Until recently, the founding population for the Tibetan Mastiff in both Europe and North America was quite small. The population in North America is estimated at 3,000 dogs, with about 300 in Britain. There are fewer TM breeders in Canada, where they are recognized by the CKC. Tibetan Mastiff dogs are also recognized by the NZKC and ANKC, with several active breeding kennels present in Australia. TMs are now bred throughout Europe and Asia.

The bearded *kyi apso,* or long-haired dogs, were never as popular with exporters as the smooth faced *doh-khyi* dogs, although they are members of the same greater landrace breed. Serious efforts to import *kyi apso* dogs weren't undertaken until the late 1970s and '80s, when nine dogs were brought to the United States in an effort to establish them as a separate breed. They remain extremely rare.

The Do-Khyi was recognized as the native Tibetan dog in 2004 by the FCI.

Tornjak

TORN-yack | Also known as Bosnian and Herzegovinian–Croatian Shepherd Dog

Origin	Croatia, Bosnia and Herzegovina
Size	77 to 110 pounds **Male** 26 to 27.5 inches; **Female** 24 to 26 inches
Coat	Long outer hair with dense undercoat
Color	White color with patches is desirable
Temperament	Independent, dominant, moderate energy, low reactivity

The Tornjak is a calm dog who projects indifference. Slow to respond to threats, he is capable of great determination when protecting his territory.

He is aloof with strangers and independent minded. He does require a firm but fair owner and socialization to people and other dogs. The Tornjak is not particularly suited to urban life; he is an active dog and a barker who needs robust and secure fencing.

When moving with the flocks, Tornjaks position themselves at the head and rear. At other times they patrol and mark the grazing area. Tornjaks usually work in groups of two or three dogs. Tornjaks are comfortable working with herding dogs and they socialize well with other family-owned dogs as well. This breed is slow to mature; puppies are traditionally socialized with sheep from birth until five months. At that time, they are separated from the flock to grow up and returned to the sheep when they are fully mature at about two and a half years of age.

Appearance

The Tornjak has a large head, with a broad skull and muzzle, but his head can look small due to the profuse coat. The head is carried on a slightly longer neck than many other LGD breeds, to facilitate the dog's ability to scout over rough ground. Ears are set up higher and the eyes are almond shaped. The lips are not pendulous and there are no dewlaps.

Sandor Horvath emphasizes that the standard is not set in stone nor is it perfect, and should therefore be flexible in the future. The real importance of the preservation work was reestablishing a healthy, diverse, and large population. Some of his distinctive features make the Tornjak suited to rough, steep terrain: he is squarely built and of moderate size, with a slower, ambling gait rather than a fast trot.

Coat/color. The Tornjak is densely double coated, and the hair forms a ruff around the neck and feathering on the legs. A shorter-haired dog is acceptable. The plumed tail, which is carried

high over his back when alert, can be somewhat variable in shape.

The Tornjak usually has a white coat with patches or spots of solid color: black, brown, gray, fawn, yellow, or red. Some dogs are very dark with white markings. A dog with a lot of color and distinct head markings is the most favored but all are valued.

History

Church documents and other papers from the ninth through the fourteenth centuries describe the large, multicolored mountain dogs in this area. These historic dogs are no doubt the forerunners of the sheep-guarding dogs native to Croatia, Bosnia, and Herzegovina. These shepherd's dogs have always been described as white with bi- or tricolored patches.

The effects of the post–World War II economy and Communist policies led many people to leave rural agricultural lives for the cities. Many of the sheep flocks and the dogs that watched them were eliminated and the survivors were pushed into a few remote areas. Concern grew that the traditional dogs were being lost. In 1968, Sandor Horvath began to research and locate the traditional dogs. After identifying some 30 dogs, he established a foundation kennel with the goal of preserving this working portion of the cultural heritage.

With the efforts of dedicated fanciers and without outcrossing to other LGD breeds, the population was increased to more than 2,000 dogs by the early years of the twenty-first century. Recognizing and preserving a large variety in type and features no doubt contributed to this success.

With the resurgence of wolves and bears, several groups actively promoted the restoration of livestock guardians. Most of the Tornjak population has actually returned to its roots as working livestock guardians and the use of Tornjaks as companions in more urban areas is recent. Similar efforts on behalf of the Bosnian-Herzegovinian dogs had also begun in the 1970s, with a standard created in 1990. In 2005, the closely related Croatian and Bosnian-Herzegovinian types were recognized collectively by the FCI as one breed. Although shepherds used various different names for the dogs, the breed is now called Tornjak, meaning "guardian of the pen."

A few Tornjaks are being bred elsewhere in Europe, including the UK. In North America, the Tornjak received UKC recognition in 2011 and AKC Foundation Stock Service in 2012, however the numbers remain low. While some Tornjaks are working with stock, others serve as companion animals.

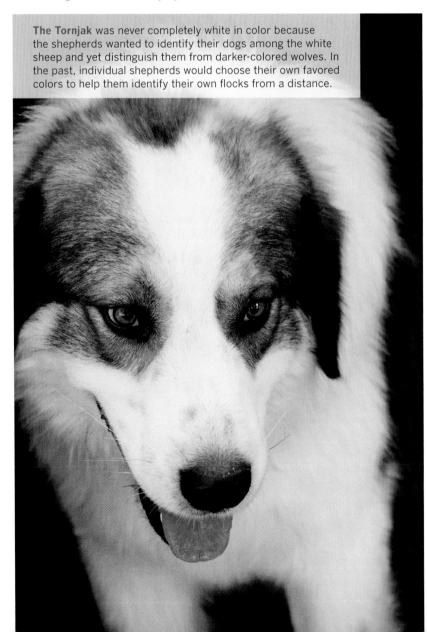

The Tornjak was never completely white in color because the shepherds wanted to identify their dogs among the white sheep and yet distinguish them from darker-colored wolves. In the past, individual shepherds would choose their own favored colors to help them identify their own flocks from a distance.

Additional LGD Breeds

These LGD breeds are, with rare exception, found only in their homelands. They are all recognized by the FCI.

ROMANIAN

Romania is home to a long and continuous history of livestock guardian dogs who defended against wolves, bears, and lynx. Half of its sheep and cattle migrate into the Carpathian and Transylvanian mountains each summer. Livestock guardians accompany all of these animals. The Carpathian Large Carnivore Project studies the native predators and promotes the use of well-bred native LGDs.

Bucovina Shepherd Dog

Boo-ka-VEE-na

Also known as Ciobănesc de Bucovina

The rarest of the Romanian LGDs, the Bucovina is also the largest. Males stand 27 to 31 inches tall and weigh 75 to 99 pounds, with females somewhat smaller. The breed is heavy and massive in appearance with a moderately long, abundant double coat. He is colored white or white-beige with clearly defined patches of reddish-black, gray, or brindle. He is an active patrol dog with an aggressive and suspicious nature toward potential threats.

Romanian Carpathian Shepherd Dog

Car-PAA-thi-an

Also known as Ciobănesc Românesc Carpatin

There is much national pride for this breed, which is still selected primarily for its working abilities. It is found in the Carpathian Mountains, often working in packs to protect sheep flocks against bears, wolves, lynx, and wild boars. The Carpathian stands at about 26 inches tall and weighs up to 110 pounds. He has a moderately long double coat with a profuse mane and tail. The standard has preferred fawn-colored dogs with wolf-gray markings since the 1930s.

Romanian Mioritic Shepherd Dog

MEE-oh-ree-tic

Also known as Ciobănesc Mioritic

The Mioritic is the most popular of the Romanian breeds and is owned by many public figures. He is a working dog but is also now seen as a family and home guardian. Several Mioritic Dogs have been seen as watchdogs at the Romanian Embassy in Washington, D.C. He is recognized by the UKC.

Noted as a calm, trainable dog, he is known for his personal loyalty and strong attachment to his owner. He is still an LGD at heart and requires socialization and exercise. He is an impressive dog — large and bearded with a long coat. He is colored white, light cream, or light gray, often with patches of black or gray.

SLOVENIA

Karst Shepherd

Also known as Kraševec, Kraški Ovčar, Istrian Sheepdog

This dog is closely related to the Šarplaninac; from 1939 until 1968, the two breeds were classified together as the Illyrian Sheepdog, when Slovenian experts convinced the FCI of the historical, behavioral, and physical differences between them. Following Slovenian independence, the Karst Shepherd became a symbol of national pride for the country. Today there are more than 1,000 Karst Shepherds, an active breed club, and exports to Europe. Some dogs still work with sheep, though most are companion dogs.

Somewhat lighter and smaller than the Šarplaninac, males stand 22 to 25 inches tall and weigh 58 to 88 pounds. Females can be slightly smaller. The double coat is of medium length and colored iron-gray, with possible shades of silver to dark gray. A dark mask and striping on the legs are also permissible. He has a typical LGD temperament — strong, suspicious, and watchful. Some are more family oriented.

PORTUGAL

Cão de Castro Laboreiro

COW duh KAS-trew lab-var-AY-dew

Also known as Portuguese Cattle or Watch Dog

This unusual livestock guardian is a shorthaired, single-coated dog. He may be colored light to dark wolf-gray, brindle, or black. He is small, standing 20 to 24 inches tall and weighing 50 to 75 pounds. Reported to be somewhat less stubborn than most other LGDs, he is a very active dog.

The Laboreiro originates in the extreme northern tip of Portugal, where he was used primarily as a cattle guardian. Today he can also be found guarding small sheep flocks or country homes. There is a breed organization in Portugal, where Grupo Lobo has also placed the dogs in wolf-prevention programs. The Livestock Guardian Dog Project imported three of these dogs in the 1980s, with successful results. They are recognized by the UKC in North America, although they are rare.

Rafeiro do Alentejo

ra-FAY-ro dew ah-len-TAY-joo

Another cattle guardian, the Rafeiro do Alentejo migrated with his herds between the southern Alentejo lowlands and the Douro highlands in the north. He protected his charges against wolves and bears. At times he was also used to guard flocks of sheep and farms or rural estates. The breed remains rare even in its homeland, where it has also been placed by Grupo Lobo to protect sheep from wolf predation.

These dogs have a smooth but dense short- to medium-length coat. Many colors are acceptable including black, tan, yellow, wolf-gray, and brindle. White markings can be extensive and pinto coloring is seen. Males range between 26 to 30 inches tall and weigh 110 to 132 pounds, with females slightly smaller. This is a strong-willed, dominant, and independent dog.

Cão de Gado Transmontano

COW duh GA-dew trans-mon-TA-new **Also called Transmontano Mastiff**

As a working livestock guardian, the Transmontano is noted for its calm, curious nature and measured reaction to threats. This is much appreciated in Portugal where he works in areas open to the public. Transmontanos are noted for their ability to work in mixed packs of intact females and males, but young dogs need to learn to temper their dominance to fit in. Training needs to be respectful and never harsh, for a Transmontano will carry a grudge. As companions, females tend to be more affectionate and docile. These dogs are enthusiastic diggers; without good fencing they'll set out to expand their territory.

This is a powerful dog with a large head and broad muzzle. Males stand 29 to 33 inches tall and weigh 121 to 143 pounds; females are 26 to 30 inches and 99 to 132 pounds. The lips are moderately pendulous with a single dewlap. The triangular ears sit medium to high on the skull. The thick tail curls high over the back when the dog is alert.

Coat/color. The coat is short to medium in length with a dense undercoat. The dogs are generally white with large patches of solid or brindled markings in black, yellow, fawn, or wolf-gray. White areas can be flecked or ticked and dogs can also be tricolored with black patches and tan markings. Half-masks are often present on fawn, yellow, or wolf-gray dogs along with white markings on the head. Solid white or black coats are not acceptable.

History

The province of Tras-os-Montes lies in the extreme northeastern corner of Portugal. This is an area of high plateaus, mountains, and lush river valleys. The climate is warm and dry and the landrace livestock guardians are uniformly adapted for it with shorter coats. The native Transmontano is related to the southern livestock guardian dog of Portugal, the Rafeiro do Alentejo, who traveled up each year with his cattle herds to the northern highlands for many centuries. These long migratory trips ended in the early twentieth century and two landrace types became more separated.

Tras-os-Montes was primarily a pastoral area until the first half of the twentieth century when the government of Portugal encouraged land clearances and changed agricultural focus to the raising of grains. Today many fields have been allowed to return to grazing areas for cattle and sheep, which is now the primary and increasingly profitable pursuit. Transmontano dogs are used to protect both cattle and sheep. Cattle are generally raised in the lush lowlands while the sheep rotate daily and seasonally through various types of grazing from scrubby areas to fallow or cropped fields to pastures.

Two to five livestock guardian dogs, and sometimes herding dogs, accompany the shepherds and the flocks as they are moved throughout the day between grazing opportunities and returned to barns or enclosures at night. Some of the LGDs move out ahead of the flock as it travels to clear the area of potential threats, while others remain with the flock. This is an active style of grazing and the working dogs need to be agile and fit. The primary predators are foxes, wolves, and wild boar.

Establishing the Breed

The Cão de Gado Transmontano has not achieved FCI recognition yet, although a dedicated breeders' association — Criadores de Cão de Gado Transmontano — has organized a provisional standard and registry. Both the breeder's organization and the Portuguese Kennel Club work in cooperation with the Parque Natural da Montesinho, the national park, to promote the use of the breed in protected areas where wolf predation is occurring with sheep flocks or cattle herds. Operating since 1994, the program places well-bred puppies with flock and herd owners, and registers dogs and litters.

The Cão de Transmontano is still primarily hard at work as a livestock guardian, but has also found acceptance across Portugal as a companion dog. In 2014, three Cão de Transmontanos were selected in Portugal and imported for a USDA study on combating wolf predation in the western United States.

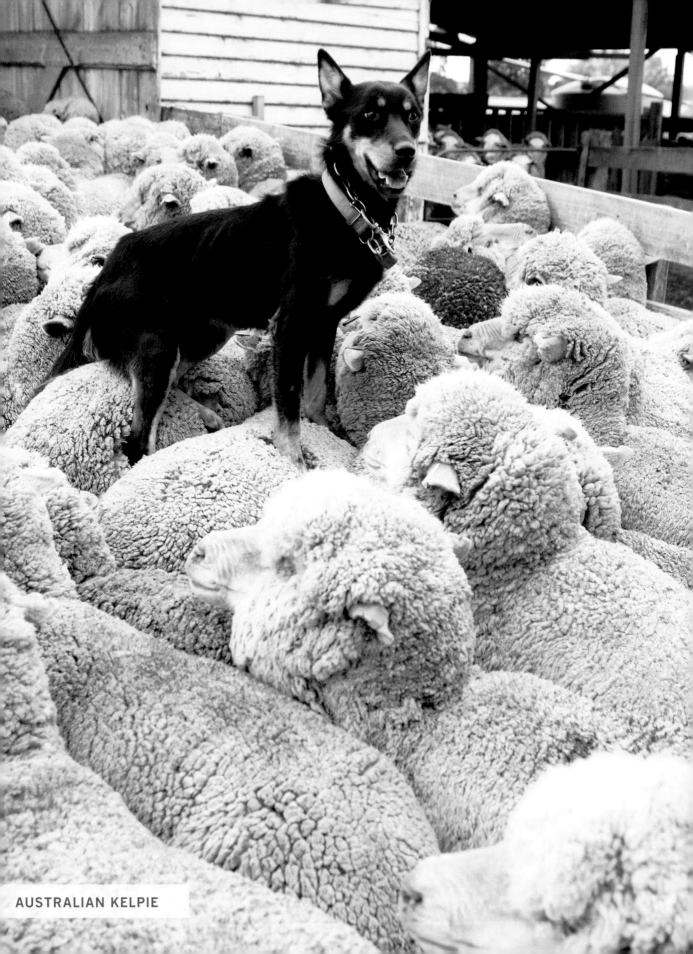

AUSTRALIAN KELPIE

⑤ Herding Dogs

The first sheepdogs, as described by the earliest historians and observers, were primarily guardians of the flocks. In some places, livestock guardian breeds still work with shepherds in this way, without herding dogs, but in many areas shepherds and cattlemen began to utilize dogs more specifically to help control their flocks and herds. Droving dogs were needed to drive stock long distances to distant pastures or to market. Boundary work, sometimes known as a "living fence," became very important as shepherd and dog needed to keep their animals from encroaching on planted fields and other property. This style of herding is still used in areas of open grazing.

Enhanced strong-eyed behaviors, a hallmark of the Border Collie, did not emerge until the late nineteenth century in Britain, following the movement to open up large grazing lands by the removal of small crofters. After the eradication of serious predators, sheep could be left alone on open, rugged grazing. Neither human shepherds nor livestock guardian dogs were required on a daily basis, but dogs were needed to collect and gather often skittish sheep over large areas. This type of herding, sometimes called "fetching," eventually traveled around the world with the Border Collie and now dominates herding competitions in many areas.

A number of different dogs and herding abilities made their way with colonists to North America, Australia, and New Zealand. When they fit into the shepherd or cattleman's needs, they took hold. At other times, new breeds were forged to fit the new situations. The herding dog is still needed on farms and rangelands, but he is also now valued for his high intelligence and degree of trainability.

Physical Appearance

The process of domestication and selective breeding by shepherds and cattlemen over several centuries shaped the differences seen among the many breeds in this group. Because they have been developed to meet specific terrain, stock, and husbandry needs, herding dogs tend to vary in appearance, temperament, and behavior more than the livestock guardian breeds.

Size is variable but herding dogs are generally medium sized, weighing as little as 20 to 25 pounds up to 50 pounds. Herding dogs generally stand 18 to 26 inches tall. The exceptions include the corgis and some heelers, who are actually medium-sized dogs with short legs. Truly large herding dogs, weighing 70 to 80 pounds, are unusual and were developed for specific jobs.

These dogs also display a wide range of colors and patterns. A working dog is not often judged by his color, although owners may have preferences. Herding breeds have coats that are short, smooth, rough, long, and even corded. Coat choices often reflect the weather and environment of a breed's homeland. Ears are most often erect, pricked, or folded over, and only occasionally hanging. Tails are sometimes naturally bobbed or docked but often long. Curled tails are only found in the Nordic dogs that herd, reflecting their close relatives, the spitz dogs.

Behavior and Temperament

Segments of the predatory sequence that were present in all the early dog ancestors (search/stalk/chase/bite and hold/bite and kill/dissect/consume) have been amplified or suppressed over centuries of domestication and selective breeding. In herding dogs, the strong search, called "eye," and the crouch of stalking behavior can be very pronounced. Chasing is certainly an important behavior, as is biting and sometime holding in some breeds; however, the act of killing has been suppressed.

Herding breeds were developed in response to the need to keep a group of animals together by circling or by nipping. This instinct lies in the hunting behavior of the proto-wolf pack, in which some members function as headers, who race ahead of the fleeing prey to turn it back or stop it, while others worked as heelers at the back of the herd, preventing escape. Dogs can be strong eyed or loose eyed or somewhere in between (medium eyed). Most dogs are gatherers, and can be either loose- or strong-eyed. Some are more driving breeds, while others came from tending roots. (See Different Herding Behaviors, page 122.)

Herding dogs use several inherited traits or instincts in their work — eye, grip, bark, power, intensity, energy or drive, balance, and savvy. Most important, though, all herding dogs are intelligent and biddable. They are willing and eager to please their owner in carrying out their jobs. The way in which these behaviors work together in specific ways and strengths is called "style." The various combinations and strengths of these traits distinguish one breed from another. Many versatile breeds can perform more than one style and function, and can work with different animals as well.

All herding breeds demonstrate the following characteristics and behaviors in various combinations and strengths.

Intelligence. The cleverness and intelligence of the herding dog demands careful attention in training so that the dog learns exactly what is wanted rather than what is not. It is easy to accidently teach unintended associations to these dogs. These breeds like routine, order, schedules, and enforcing rules. They may try to ensure that other family dogs follow the rules as well. Easily bored, they are independent thinkers who can solve problems or devise their own activities, which can sometimes be troublesome.

Willingness and trainability. Herding dogs are biddable, meaning they are willing and eager to please their owners. Usually affectionate and loyal, they enjoy their owners' company and bond easily to a regular handler. They like to learn and are easy to motivate, making them good performers in work and dog sports. Alert to nuances of body language,

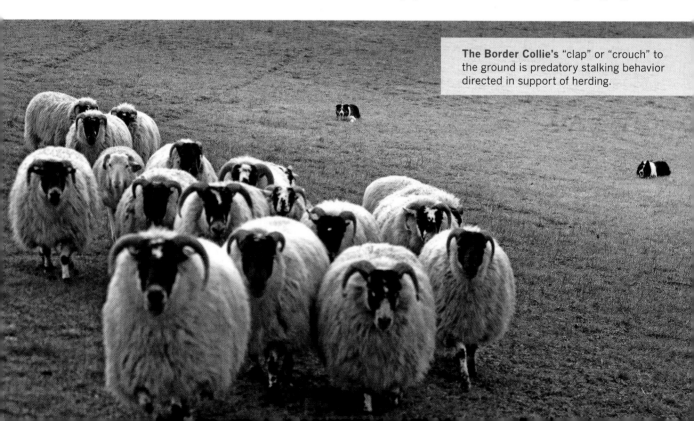

The Border Collie's "clap" or "crouch" to the ground is predatory stalking behavior directed in support of herding.

they focus intently on their handlers and look for direction. Herding dogs can make great workday companions. They tend to follow their handler from place to place, even in the house. Some don't like their family scattered within the house or for people to leave, and can suffer from separation anxiety.

Eye. Herding dogs watch and follow their stock, using their gaze to help move them. Strong-eyed dogs stare intensely and continuously. A strong eye is often accompanied by a crouching stance. Loose-eyed dogs survey the animals, watching for individuals that may bolt or stray. This is usually accompanied by an upright stance. Medium-eyed dogs can make strong contact but don't do so continuously, which reduces the pressure on the animals. These dogs may have some crouch.

Grip. Herding dogs use gripping, biting, or heeling as an important part of their job. A dog who is willing to nip or bite at its charges has grip. A heading dog grips at the nose or top of the head. A heeling dog grips low on the leg or heel, ducking to avoid kicks. Heading or heeling is inherited. Gripping elsewhere on the body is inappropriate and this may also be inherited.

Puppies need to be raised with an understanding of the appropriate or acceptable use of this trait, although the instinctual urges to herd, to chase, to gather, and to control cannot be completely trained out of a herding dog. Dogs with strong herding instincts can be difficult in families with small children, since the dogs can respond to running play with a need to chase and stop it.

Bark. Many of these breeds use voice or bark to help to control or move animals. This is an inherited behavior and part of their job, although herding dogs also bark during play and out of excitement.

Power. Herding dogs project power; a sense of authority is how they make their livestock move. They are courageous, don't back down, and may use their bodies to enforce their desires. This can make them bossy or pushy and sometimes unwilling to defer to you. This is another reason they need obedience training.

Intensity. These dogs have great focus and concentration. The stare and stalk of a strong-eyed dog can actually be somewhat unnerving. While some breeds are more laid-back when not working, others can be obsessive workaholics. Lacking an activity to focus on, they can become fixated or compulsive on certain behaviors.

This New Zealand Huntaway exemplifies the energy and athleticism of the herding dog breeds.

Energy or drive. Herding dogs can work hard and have great endurance, sometimes to the point of exhaustion. Short walks and spending time alone in a small yard are not sufficient for most of these dogs. Some breeds need at least two hours of attention and exercise every day. Agile and athletic, these dogs are fast, accurate, and good judges of distance. They are also able to make quick turns and sudden stops.

Their need to be active extends beyond physical exercise; they must be challenged mentally and have work to do. Without sufficient stimulation and exercise, these dogs are often frustrated or destructive and can develop obsessive behaviors. Most breeds are also very tenacious and don't want to stop playing or working. Engaging in bursts of energetic play on their own is common.

Balance and savvy. These traits also come from the proto-wolf ancestor, who had to position himself the optimum distance from his prey, sensing how they would move, before forcing them to his will.

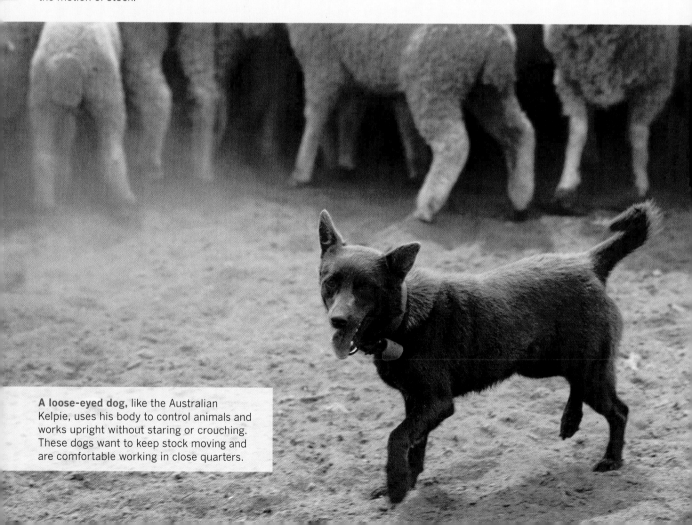

A strong-eyed dog stares intensely and stalks animals in a crouching manner. Strong-eyed dogs, exemplified by the Border Collie, tend to work stock from a distance and want to stop the motion of stock.

Different Herding Work

Dogs may perform more than one type of work.

Driving. Working or pushing from close behind the stock, the dog may use body, bark, grip, and loose-eyed behaviors.

Droving. The dog works from behind, to the sides, or in the front to take animals to market or along roads.

Fetching. Sent out to gather animals and return them to a shepherd, the dog usually works at some distance from the animals and may exhibit strong-eyed behaviors.

Tending or boundary work. Watching and keeping a flock within a certain grazing area, with the supervision of a shepherd, the dog usually works close to stock. Tending is more common in unfenced grazing areas. Breeds used for this work can be more protective.

A loose-eyed dog, like the Australian Kelpie, uses his body to control animals and works upright without staring or crouching. These dogs want to keep stock moving and are comfortable working in close quarters.

Making the Right Choice

In addition to the diversity of size, coat, and activity levels, there are distinct differences in herding styles among the breeds. Some breeds are more suitable for different kinds of stock, as well as the geography and climate of a specific area. Some breeds are also more relaxed in the home, while others are powerful, even fixated, workers.

Herding breeds can be specialists with particular instincts and aptitudes for specific stock and work. Some breeds are more adaptable and versatile. Breeds cannot be completely categorized of course — herding is a complex activity and individual dogs are capable of learning different skills and behaviors — but, in general, breeds possess specific combinations of instinctual behaviors, as well as strengths and weaknesses.

Historically, herding breeds were developed for precise needs with specific stock in a particular geography and in a particular method of agriculture. Knowing the specifics of this history and purpose can help you select the most appropriate breed for your needs and, then, the best way to train him.

How to Select a Herding Dog

Assess the role your dog will serve: full-time working dog, part-time herding or stock dog, general farm help, or primarily a family companion. Do you have an interest in competitive sheepdog trials or more casual herding activities? Do you plan to use this dog in performance events or dog sports? Or do you want a dog who will enjoy a moderately active life? Consider your real needs and how this dog will fit into your family, and then choose an appropriate breed.

Some herding breeds are definitely more relaxed, all-purpose dogs than others, which is also an important consideration if you are looking for a general farm dog or family companion. Some breeds are capable of working steadily all day; others are able to perform hard or fast work; while others tend to be rather laid-back until asked to help. Some breeds are more dominant and territorial, which can be helpful if you want a general farm watchdog as well, while others are very friendly and accepting of strangers.

Consider your stock. Are your sheep or goats fast and nimble, flocking or nonflocking, spooky or accustomed to daily handling? Do you have dairy cattle or ranch cattle? Some herding breeds are suited to working cattle or hogs, while others can adapt to the variety of animals found on a small farm. Turkeys, geese, or ducks pose particular challenges.

Consider your husbandry practices. Do you utilize large or small pastures? Open range or feedlots? Do you actively shepherd with your dog daily or only occasionally? Do you use more than one dog? Will your dog need to deal with extremes of weather?

For a part-time worker and general farm helper, very strong working abilities can definitely be problematic. Many people who need such a helper dog find the less intense and energetic breeds are a better fit, as these dogs can be content with an active family life as well. In a purely family situation, the strong presence of working ability in a pedigree may not be important. In fact, strong herding dogs are often not the best choice for a companion dog who may not ever be asked to herd.

Common Health Concerns

Certain breeds have specific issues. Several herding breeds — Australian Shepherds, Collies, Border Collies, and others — have a genetic mutation that causes multidrug resistance (MDR). Dogs can be tested for this condition. If your dog is a carrier or his status is unknown, you should use great caution with certain drugs, including antibiotics, antiparasitics, antidiarrheals, heart medications, Ivermectin, and steroids. Reputable breeders also check for issues such as collie eye anomaly (CEA), progressive retinal atrophy (PRA), congenital deafness, and hip dysplasia (HD). Congenital deafness can be linked to specific pigmentation patterns, such as merle and white coats, often found in the herding breeds.

Hardworking herding dogs are also susceptible to dehydration, overheating, and heat exhaustion, as well as various work injuries.

What to Look for in a Herding Pup

Unless you are experienced with herding dogs, it is a good idea to look for a pup that is moderate or average in terms of temperament. Avoid the extremes, which can pose additional challenges in handling and training. In some breeds, divisions have developed between working and show lines.

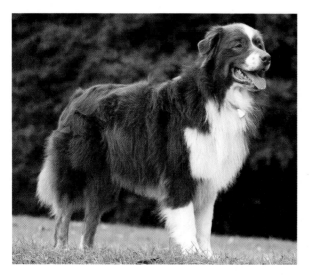
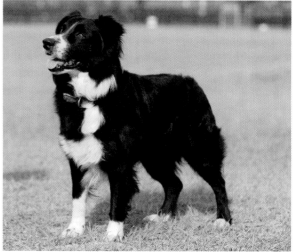

In some breeds, including Australian Shepherds, different lines have been developed. Dogs bred primarily for show may differ in conformation from working dogs or demonstrate a lack of working aptitude.

Pay attention to coat quality, as there can be a difference between a show or glamour coat and a weather-resistant work coat that sheds dirt. Some breeds occasionally produce "fluffy" pups with coats that are too soft and long to be practical in the field and unacceptable for a show ring; although they can be fine for a companion owner who doesn't mind the extra grooming. Unless you are planning to show or breed, mismarked coats or similar issues are unimportant.

Temperament Is Key

Temperament is very important in a herding dog. A good breeder who has carefully selected the parents and observed the litter can be relied upon to provide good recommendations about a pup's behaviors, instincts, and tendencies. Your breeder can also help you determine whether a pup is softer or harder in nature. Dogs with either tendency can be good workers, but owners often prefer one or the other and the dog's nature also determines how you train. Very hard or dominant dogs can be dedicated workers but are often not as suited to herding trials or dog sports without an experienced handler. More aggressive or pushy pups may need an experienced trainer. Highly independent dogs can be less eager to please and harder to motivate. Dogs that are somewhat submissive often follow your direction and leadership well.

There can also be differences between males and females as working dogs. Males may be stronger and larger, which can be important in some working situations. Males can also be harder and more independent. Females can be more biddable, sensitive, and soft in temperament. Again, though both are good workers, some owners and handlers have a preference.

Whether you are looking for a full- or part-time worker or a family companion, look for a pup who is

- Self-confident, outgoing
- Determined
- Curious
- Friendly, affectionate
- Biddable, attentive, eager to please
- Easy to handle
- Comes right away when called
- Follows you
- Chases thrown objects and possibly retrieves them

Avoid a pup who is

- Overly sensitive to noise
- Very soft or anxious
- Shy, fearful, or aggressive when restrained
- Uninterested in thrown objects, lethargic
- Very independent, indifferent, inattentive, or aloof

Herding Dogs Do Not Guard Livestock

Histories and descriptions for herding breeds frequently state that these dogs also guarded the flock. This is a misconception of the herding dog's role. Herding dogs actively worked with shepherds in unfenced grazing or were sent out to fetch animals and return them to the shepherd. They were not left alone with the animals 24 hours a day, like a livestock guardian dog.

In many areas and among some transhumant peoples, herding dogs traditionally worked in partnership with the larger livestock guardian dogs and the shepherds. They might sound an alarm to alert the shepherd or run off a roaming dog, but they left predator control to the guardians. When he was not working, the herding dog was at the feet of the shepherd. There is a tremendous difference between a watchdog and a guardian. Herding dogs are alert and vocal; they sound an alarm at a threat or disturbance. They may even charge or attack a threat. However, most herding breeds are not large enough to successfully confront large predators or packs of predators.

True herding dogs lack the placid, watchful nature of an LGD. They have powerful instincts to chase, gather, and fetch, even if not given instructions to do so. Roaming or unsupervised herding dogs often cause tremendous damage to a flock of sheep, worrying or running them to death.

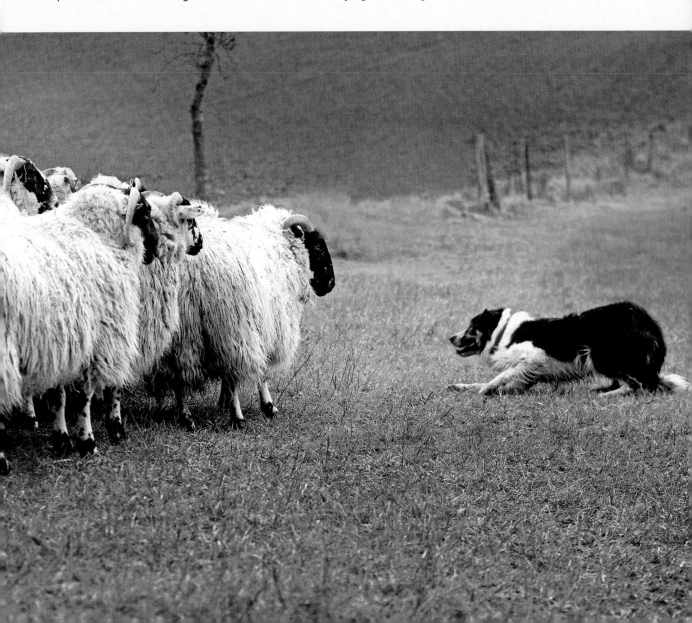

Activities for Herding Dogs

Many herding dogs can find a fulfilling role even without having daily contact with livestock, if they have an appropriate outlet for their energy and drive. Both working farm dogs and family companions can participate in the following activities.

Herding Organizations

- AKC Herding Program — tests and trials for recognized AKC herding breeds
- American Herding Breed Association — tests and trials open to many herding breeds
- Australian Shepherd Club of America — tests and trials open to many breeds
- Australian Sheep Dog Worker's Association
- Canadian Border Collie Association — primarily Border Collie
- International Sheepdog Society in Britain — primarily Border Collie
- New Zealand Sheep Dog Trial Association
- US Border Collie Handler's Association — primarily Border Collie
- Verein für Deutsche Schäferhunde (SV) — primarily German Shepherd tending style

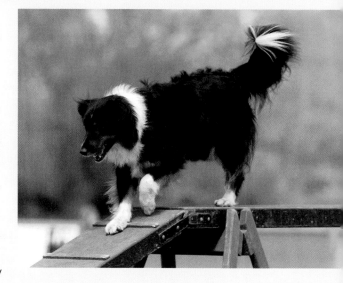

Organized Activities

Herding breeds excel at the following activities, all of which have local and national organizations that are easily found online.

- Agility
- Disc sports
- Flyball or catchball
- Obedience or rally
- Musical freestyle
- Bikejoring, scootering, canicross, or skijoring

Backyard Games

Games are not only useful training tools for young herding dogs, they are great outlets for adult dogs as well.

- Fetch — Use tennis balls, discs, and other toys. Mix it up by throwing high and low.
- Treibball — Teach your dog to herd a large, fitness-style ball into a soccer net in your yard; this is also an organized dog sport.
- Hide and Seek — Vary it up with different objects and hiding places; teach your dog to find family members or friends also.
- Tricks — Herding dogs are eager learners. Clicker training is especially suited to building up complex routines.
- Backyard agility — Build a safe but flexible obstacle course that can be changed around or run in a different order.
- Freestyle obedience — Exercise to music with your dog or combine commands in varying orders.

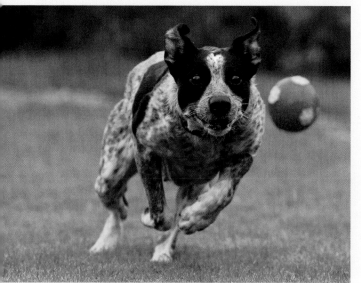

Working Ability and Instinct Tests

Although herding dogs need to reach maturity before their true working abilities and style are revealed, you can perform some basic instinct testing on a pup. Because herding instincts are so strongly inherited, however, one of the best indicators of potential is the herding ability of the parents and other dogs in the pedigree. Are the parents and older siblings working? Temperament and physical soundness are also very important in a working dog. If you are looking for a serious working or competitive trial dog, watching the parents work, in person or via video, is extremely valuable.

Pups as young as four or five weeks can be introduced to ducks or young lambs with careful supervision. This is best done by someone knowledgeable about herding behaviors — the signs can be very subtle. It is sometimes possible to see the early presence of eye or crouching; gripping or heeling; attentive watching; chasing or following; desire to keep the group together; heading; and balance or distance. It is also true that some pups show very little interest in herding until they are older but go on to become good working dogs.

More serious tests of herding instinct need to wait until the pup is older, beginning at about six months, when early training can also begin. Earlier controlled exposure to stock is also helpful to a young pup. Your puppy can learn basic obedience tasks before then, some of which are introductions to herding commands. Some training games are also beneficial.

Bringing Home a Herding Pup

Consistency and precision in handling any puppy is important, but especially so with herding breeds. If this is a working dog, decide who will handle and train it. Make certain other family members do not use conflicting commands or behaviors with the pup. Herding dogs are very smart. They can distinguish between many commands with varying verbal emphasis combined with body language and gestures, but they can become confused over similar commands given in slightly different ways or with different expectations.

The new pup needs to have his own place to sleep, hang out, and eat. Establish boundaries and expectations early. If you expect him to live outside, start him out there rather than changing his situation later. Socializing to people, experiences, and other animals or pets is definitely important. If he is going to work with birds or stock later, he needs to become socialized to them as well.

Basic obedience training — sit, down, stay, and a reliable recall — is required. To continue more formal herding training, consult a good training book or work with an experienced mentor in order to teach commands appropriately and with good word choices. Handlers have different word preferences, as well as slightly different meanings, for specific commands, and may choose words that don't sound alike for different commands. Some handlers also use whistle commands, which you can begin in early training.

Herding dogs respond best to kindness and patience, not heavy-handed training methods. Consistency and encouragement are necessary to build a confident and courageous dog. The building of a trusting relationship between handler and dog is all-important.

Herding Organizations

- **AKC Herding Program** — arena trials (recognized AKC herding breeds)
- **American Herding Breed Association** — tests and trials
- **Australian Shepherd Club of America** — arena tests and stock-dog trials open to all breeds, including a noncompetitive Ranch Dog Program, with all-around herding, including driving
- **Australian Sheep Dog Worker's Association**
- **Canadian Border Collie Association** — primarily Border Collie
- **International Sheepdog Society in Britain** — primarily Border Collie
- **New Zealand Sheep Dog Trial Association**
- **US Border Collie Handler's Association** — primarily Border Collie
- **Verein für Deutsche Schäferhunde (SV)** — primarily German Shepherd tending style

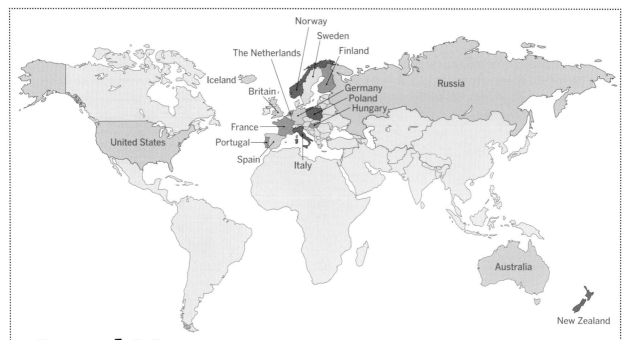

Breed Map

Australia

Australian Cattle Dog
Australian Kelpie/Working
 Kelpie
Australian Koolie
Australian Shepherd
Stumpy Tail Cattle Dog

Britain

Bearded Collie (Scotland)
Border Collie (England,
 Scotland, Wales)
Rough and Smooth Collie
 (Scotland, England, Wales,
 Ireland)
Shetland Sheepdog (Scotland,
 England)
Cardigan and Pembroke Welsh
 Corgi (Wales)
Lancaster Heeler (England)
Old English Sheepdog (England)

Finland

Finnish Lapphund

France

Beauceron
Berger Picard
Briard
Pyrenean Shepherd

Germany

German Shepherd

Hungary

Mudi
Puli

Iceland

Icelandic Sheepdog

Italy

Bergamasco
Bouvier des Flandres

The Netherlands

Dutch Shepherd
Schapendoes

New Zealand

Huntaway

Norway

Norwegian Buhund

Poland

Polish Lowland Shepherd

Portugal

Portuguese Sheepdog
Portuguese Water Dog

Russia

Samoyed

Spain

Catalan Sheepdog

Sweden

Swedish Lapphund

United States

Australian Shepherd
Louisiana Catahoula Leopard Dog
Hangin' Tree Cowdog
English Shepherd
Texas Heeler
McNab Dog

Australian Cattle Dog

Also known as Australian Heeler, Queensland Heeler, Blue Heeler, Red Heeler, Cattle Dog, ACD, AuCaDo

Origin	Australia
Size	35 to 50 pounds **Male** 18 to 20 inches; **Female** 17 to 19 inches
Coat	Smooth, straight, hard outer hair with short, dense undercoat
Color	Blue, may be mottled or speckled, with or without black, blue, or tan markings on head, tan markings on body; red speckled with or without red markings on head
Temperament	Independent, dominant, high energy, high prey drive, upright, loose to medium eyed, close, heeler, bite

The Australian Cattle Dog is an independent self-thinker and problem solver. Although very intelligent, he can be stubborn and needs a strong leader who provides quiet, consistent training from an early age.

He forms a strong, intense bond with his owner and prefers to go everywhere with them. He does not tolerate harsh treatment. There is a myth that red dogs are bad tempered, which is probably linked to the old belief that red dogs have more dingo blood.

The best home is where he has a job, can work hard, and can be in the company of his owner. He is not a good choice for city or suburban life. If he doesn't have a job, he needs to be heavily exercised in active sports or other exercise for two to three hours daily. He also needs to be engaged in learning and performing tasks but is easily bored by repetitive training. Australian Cattle Dogs take to agility, rally obedience, disc sports, and serious hiking or running.

Aloof and suspicious with strange people or animals, the ACD is alert, vigilant, and courageous. He is highly protective of family and home, and may react defensively by biting, attacking, or chasing if provoked or if he feels his owner is threatened. He is fine with older children but may herd or nip at smaller children who are running or playing. He needs to be well socialized to a variety of people and other dogs and animals to prevent overly aggressive behavior.

With a high prey drive, he will chase small animals, strange pets, and family cats, although he should get along with another family dog.

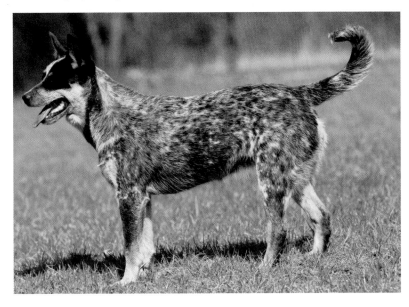

He can have dominance issues and is unlikely to live calmly in a pack situation. He is likely to be aggressive with strange dogs. These dogs are excellent jumpers and climbers and have strong sense of curiosity, all of which fuel a tendency to roam and escape.

Working traits. Heeling instinct is strong in this breed. A roaming ACD is likely to chase or harass stock. The ACD was developed to work over distance without direction, to drive stock for long distances, and to work close when needed. They were bred to be used on cattle but can work sheep or goats. ACDs are considered upright and loose to medium eyed. While they charge in low to bite and heel animals, they also confront forcefully at the head. Some dogs drop into a crouch to bite at the nose while others remain upright and confront with their body.

Australian Cattle Dogs display good balance with groups of animals. The tendency to fetch or to drive is based on both the dog's style and training. The ACD is primarily a silent worker who occasionally barks when needed; continuous barking is undesirable.

Appearance

The Australian Cattle Dog is compact, muscular, and slightly longer than tall. Rugged and tough, he should be athletic and possess great endurance. He is thicker, stockier, and less leggy than his cousin, the Stumpy Tail Cattle Dog, and he uses this body in his work. The ACD has a strong head with a broad skull, a slight stop, a powerful, tapering muzzle, and a deep, well-developed jaw. His dark brown, oval eyes are medium sized and set well apart for a wide range of vision.

The wide-set, pricked ears are preferably smaller than larger. The entire head echoes his dingo ancestor. The Australian Cattle Dog has a strong, muscular neck and shoulders, with wide forequarters, a level back, and a long sloping croup. The feet have thick, hard pads. The tail is set moderately low and follows the slope of the croup, hanging in a slight curve and rising when alert, but not past vertical. This is not a naturally bobtailed breed and the tail is never docked in his homeland.

Coat. Australian Cattle Dogs have a double coat that is smooth and flat, with a short, dense undercoat. The outer hair is straight, hard, and rain resistant. It is slightly longer on the neck and thighs, and the tail has a brush.

Color. The ACD is seen in two roan colors. Blue dogs may be mottled or speckled, with or without black, blue, or tan markings or patches on the head. The forelegs may be tan to the midpoint, with tan on the breast, throat, and jaws. Tan extends to the lower hind legs and the inside of the legs and thighs. The undercoat is blue. Red dogs are speckled with or without darker red markings on head, with balanced markings preferred. Other red markings on the body are permitted but not preferred. In both colors the white and dark hairs are mingled throughout the coat.

Dogs are born white with body patches and then fill in with black or red flecking that darkens with age. The Bentley mark, named for an important early stud dog, is a white blaze on the foreface. Dogs may be plain faced, half masked or single, and full masked or double, although balanced, even markings are preferred at shows. Dogs often have a solid, colored spot at

the base of the tail and a white tip at the end. Other colors, such as chocolate or white, are just mismarked according to the standard. Mis-colors and mismarkings are common and do not affect working ability.

History

Known by various names — Australian Heeler, Queensland Heeler, Blue Heeler, Red Heeler, and just the Cattle Dog — this Australian native has earned worldwide popularity. His origins are often debated and presented in various stories; however, the most documented research into the true history of the breed comes from an article by A. J. Howard, "Hall's Heelers — Origins of the Cattle Dog in Australia" (2000).

Thomas Hall explored and established cattle-raising properties beginning in 1925, when he was just 17 years old. He ultimately ran cattle operations on over a million acres of grazing land in New South Wales and Queensland. The challenges of cattle ranching in the interior were enormous, including the sheer size of the grazing lands, the numbers of increasingly wild cattle, the long drives to market in Sydney, the harsh climate, and the terrain itself, which could be mountainous, covered in thick brush, or open plains full of burrs.

Almost above anything else, Hall needed good working dogs who were completely suited to these difficult conditions. He imported a pair of Northumberland droving dogs from northern England, and began a crossbreeding development effort between his drovers and captured dingoes in 1832. There are no details about his breeding program, other than

the existence of a type of cattle dog who came to be known as Hall's Heelers. Perfectly adapted to their environment, these stocky, tireless dogs would be used on Hall's properties for the next four decades.

After Hall died in 1870, the dogs were bred by other working stockmen and came to be known across the country as Blue Heelers and Queensland Blue Heelers, although red-speckled dogs also existed. Crosses with other herding and droving dogs were probably inevitable, and it is believed that Kelpies were crossed with Heelers, perhaps helping to create some of the unusual markings found in the Queensland Heeler. A more recent

development, the Kelpie was based on strong-eyed British and Scottish collie types, possibly crossed with dingoes as well. The breeding of hardworking Queensland Heelers continued over the coming decades.

In Sydney, a group of townsmen had organized a Cattle Dog Club with an interest in breeding various cattle dog types. Several members were breeding dogs descended from Hall's Heelers. It is possible that they experimented with the introduction of outside breeds, such as Bull Terriers and Dalmatians. The name Hall's Heeler was gradually replaced with Blue Heeler or Red Heeler and finally Australian Heeler. The first standard for the

Australian Heeler, later renamed the Australian Cattle Dog, was published in 1903.

The Impact of War

World War II exposed many American soldiers to the Australian Cattle Dog. Impressed with their working ability, some soldiers brought ACDs home with them or later imported them to America. In Australia, the Queensland-style Cattle Dogs became popular in the show ring after the end of the war, heavily influencing the bloodlines of the Australian Cattle Dog from that point onward. Australian Cattle Dogs are still working with cattle in their homeland despite changes in

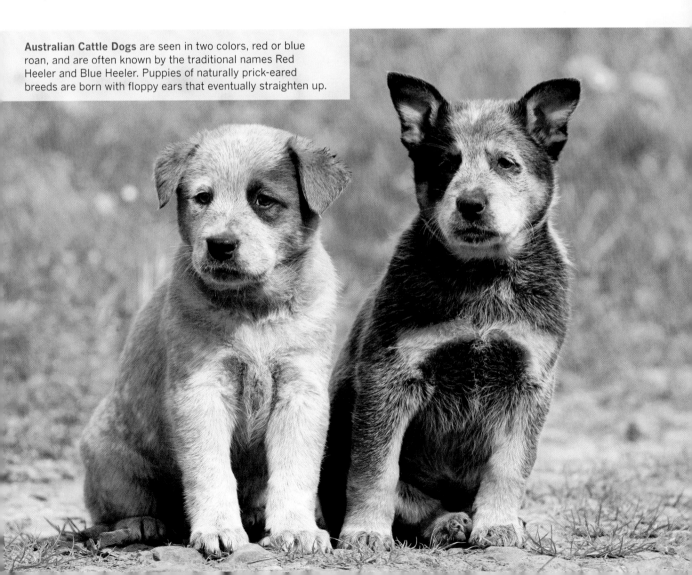

Australian Cattle Dogs are seen in two colors, red or blue roan, and are often known by the traditional names Red Heeler and Blue Heeler. Puppies of naturally prick-eared breeds are born with floppy ears that eventually straighten up.

cattle ranching that have reduced the need for these hardworking dogs. They are also found in companion homes and participating in dog sports. The ACD is the most popular breed in his native country, although registered numbers are declining.

The breed has spread around the world, having found great acceptance on cattle ranches and stockyards in North America. Their reputation for working with tough cattle is well earned. Australian Cattle Dogs have also found homes as companions, especially in rural areas where the dogs have room to exercise, and they excel at all sorts of dog sports. Population numbers are smaller in Canada, where most dogs are still working on farms or ranches. ACDs were imported to Britain in 1980, and imports have continued from various countries. Supporters have organized a club and achieved KC recognition.

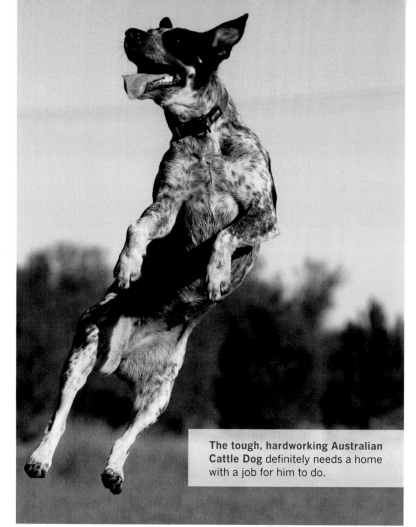

The tough, hardworking Australian Cattle Dog definitely needs a home with a job for him to do.

Breed Scandal

In the 1940s, Dr. Allan McNiven, a Sydney veterinarian, began breeding ACDs, experimenting with outcrosses to dingoes, Kelpies, Kangaroo Dogs (an Australian sighthound-type used to hunt kangaroos), and German Shepherds. His dogs were eventually removed from the ACD registry in Australia due to falsified pedigrees, but many had already been exported to the United States, where they were recrossed with purebred ACDs.

Called both Queensland Heelers and Australian Cattle Dogs, they proved themselves as working dogs. Working stock dog registries, such as the National Stock Dog Registry (NSR) in the United States, entered these nonpedigreed dogs in their studbooks along with other Australian pedigreed ACDs. The stock dog registries were the only pedigree service available until the founding of the Queensland Heeler Club, later renamed the Australian Cattle Dog Club of America. Some of the founding members of the club discovered that some of their own dogs descended from McNiven-bred dogs.

The club made the difficult decision to only include dogs with verifiable Australian pedigrees in their stud book. The AKC, CKC, and UKC all eventually recognized the Australian Cattle Dog. Confusingly, the various older names are still used by many people in North America —Blue Heeler, Red Heeler, Queensland Heeler, and Australian Heeler. Dogs with unknown ancestry are now registered as American Cattle Dogs by the NSR. Crossbred ACD x Australian Shepherds, known as Texas Heelers, are also popular.

Australian Shepherd

Also known as Aussie

Origin	United States
Size	40 to 65 pounds **Male** 20 to 23 inches; **Female** 18 to 21 inches
Coat	Medium long, straight to slightly wavy outer hair with soft undercoat
Color	Black, blue merle, red, red merle
Temperament	Dominant, high energy, high prey drive, willing, upright, loose eyed, wear, close, head, bite, power

The attentive, animated, and enthusiastic Aussie is an all-purpose stock dog who works hard in the company of his owners but can relax in the house.

An Aussie is affectionate and devoted to his owner and sometimes one specific person. He prefers to accompany his person all day while doing chores. Without sufficient exercise or attention, he can become destructive or display obsessive barking, hyperactivity, and symptoms of separation anxiety. A good home is either a working situation or a more rural setting with active owners who enjoy the challenge of a smart dog with boundless energy. He requires two to three hours of daily exercise along with the challenge of learning new things. He is a great companion when jogging, hiking or trail riding, and participating in dog sports, even to the highest levels of competition.

Obedience training and good socialization are required. Aussies learn quickly, and consistency is important to prevent them from learning what they can get away with; some care must be taken so that these dogs do not out-think their owners. They are excellent at solving problems, including how to escape from the yard or open doors. In the absence of a leader, Aussies can be dominant and take charge. With their strong desire to please, they can overwork themselves or work while injured.

Aussies are generally reserved, aloof, or cautious with strangers. They bark at disturbances but are not aggressive, although may react if harassed. A lack of socialization may lead to shyness or aggression.

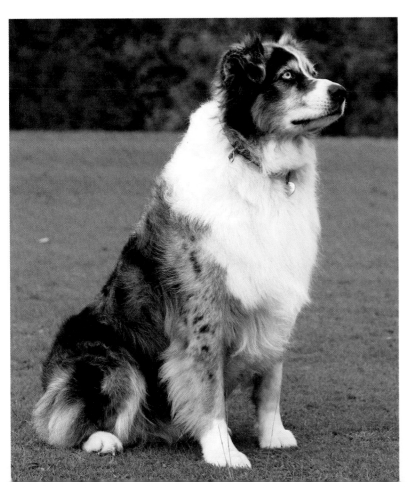

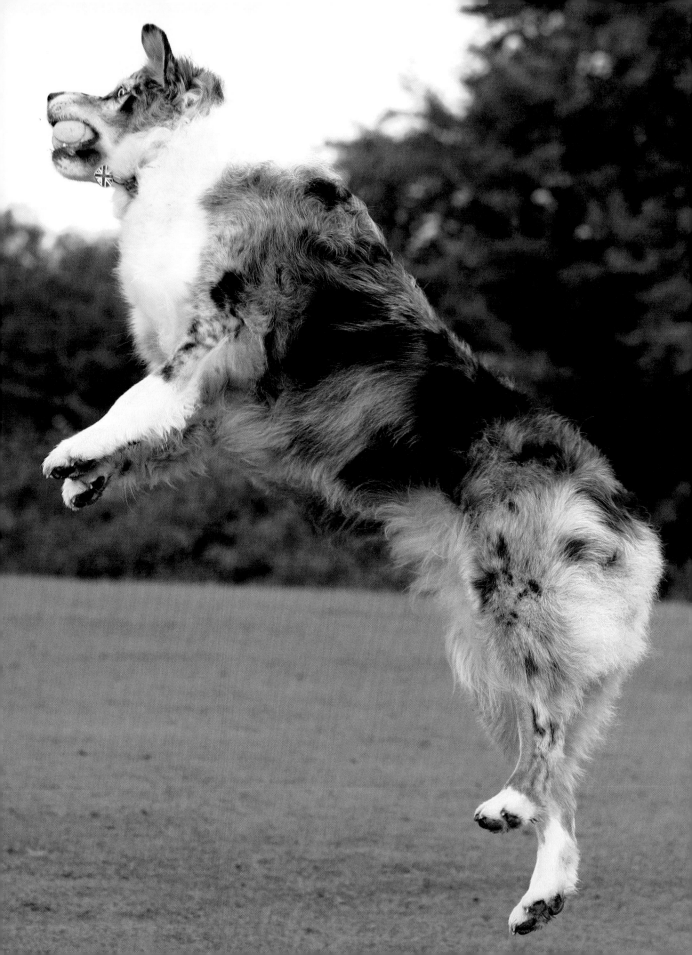

Aussies usually enjoy children and love to play. While adults are gentle, puppies may be rowdy or exhibit a tendency to herd or nip. Aussies are generally fine with other dogs, especially when socialized, although males may exhibit dominance issues or resource guarding.

Working traits. As a herding dog, Aussies are highly versatile and adaptable to different stock, but they are best suited to large groups of sheep, cattle, or working stock in close. The breed is also suited to herding unusual animals like ducks or rabbits; focused training and socializing promote this. Although loose-eyed, they use some eye when penning or being challenged. Aussies show lots of *wear*, meaning they flank from side to side, which is needed for moving large flocks. They can also be trained to work more at a distance to relieve the pressure on stock. Aussies are upright workers who display confidence and authority. They should instinctively head. Usually silent, they use force if needed, first by bark and then bite on the face or nose. They also heel low.

Today, Aussies are primarily companions and performance or sport dogs, and may not display strong herding instincts. Owners seeking a working dog should search out kennels or breeders producing working lines. Dogs bred for work tend to have more physical variety, a lighter more athletic body, and a shorter coat. Some lines have been developed to be heelers or driving dogs over heading, while other lines show strong fetch and gather. There is concern among herding enthusiasts that some lines are showing more Border Collie traits or are being bred for success at sheep trials rather than as a gritty, close, loose-eyed dog.

Appearance

Australian Shepherds are medium-sized, sturdy but not stocky, and slightly longer than tall. The head is clean and strong, with a slightly rounded or flat skull, a moderate but well-defined stop, and a muzzle that tapers gradually. The moderately sized eyes are set a tad obliquely. All eye colors are acceptable, including flecking, marbling, bicolored eyes, or two differently colored eyes (an early nickname for the Aussie was "the ghost-eye dog").

The ears are set high, triangular and moderate in size. The ears lift when alert, but should not be pricked or completely flat. Some dogs from working lines may have prick, semi-prick, or two different ear carriages. The tail is a natural bob or docked and should not exceed 4 inches in length. If left undocked, the tail is mid-length to long, and feathered.

Coat. Aussies are double coated with medium-length outer hair, although among working dogs the coat can be short to moderately long. The hair is medium in texture, straight to slightly wavy, and weather resistant. The moderate mane is more profuse in males, the backs of the forelegs are feathered,

Miniature Versions

Dogs advertised as miniature Australian Shepherds can confuse potential buyers. Breeders and clubs use several different names for these dogs. The Australian Shepherd Club of America does not recognize them as a variety of the Aussie, and sees them as separate and distinct breeds.

Miniature Australian Shepherd/Mini Aussie

Beginning in the late 1960s, efforts began to breed a smaller version of the Australian Shepherd, keeping the other traits and characteristics intact. Mini Aussies are defined as dogs 14 to 18 inches tall and weighing about 20 to 40 pounds. The Mini Aussie remains within the greater Australian Shepherd registered population, and full-sized Aussies may be used in breeding. Still registered with either the AKC or UKC, Mini Aussies are too small for successful conformation showing as the standard breed.

Miniature American Shepherd

A group of Mini Aussie breeders sought recognition from the AKC and UKC as a separate breed called the Miniature American Shepherd, which would allow the dogs to be shown in conformation events. The AKC granted FSS status to this breed in 2011. The AKC club for the standard Australian Shepherd recognizes this miniature as a separate breed.

and the breeches are full. The soft undercoat varies with the climate but can be dense. Daily coat care is required and Aussies are heavy shedders seasonally.

Color. Australian Shepherds are solid black or red, and blue or red merle. Any color may have white markings or tan points. Blue merle and black dogs have black nose, lips, and eye rims, which are liver colored in red and red merle. The area around the ears and eyes should not be colored white, and white should not exceed the point of the withers. Merle colors usually darken with age. Other colors or patterns and mismarks occur but are not acceptable for showing.

History

Despite his name, the Australian Shepherd is thoroughly American in origin and like many Americans, his ancestry is a melting pot that contains some mysteries. Genetic studies prove that the breed is related to the old varieties of British working sheepdogs, but they could have arrived as Australian immigrants, been brought west with pioneering ranchers, or imported directly from Britain in the late nineteenth and early twentieth centuries.

By the 1850s, newspaper accounts relate that "Australian sheepdogs" were arriving with their imported sheep on the San Francisco docks. They were described as shaggy or having long, curly hair, and displaying great intelligence, strength, and docility. The Australian sheepdogs of that era were still mainly a mix of old British sheepdog types. The true Australian breeds — Koolie, Kelpie, Cattle Dog or Heeler, or Stumpy Tail Cattle Dog — were all still in development themselves and would not emerge as recognizable types until 1870 or later. Up until the 1840s, earlier crosses with dingoes had not proven successful, as the dogs were too savage on stock, so it is unlikely that those early Australian imports contained much dingo blood. The dingo was used in the development of the recognized Australian sheep and cattle dog breeds, but with care and back breeding to British-type dogs. The new Australian breeds certainly made their way to North America in the 1920s and '30s, and again after World War II.

The sheepdogs of the American settlers and pioneer farmers were also a mix of old English, Scottish, Welsh, and possibly German sheepdogs or shepherds, some now extinct and others standardized. The modern British breeds — Border Collie, Rough and Smooth Collie, Shetland, Old English Sheepdog, Welsh, and Bearded — all emerged as recognized breeds around the 1870s or later. But any of these dogs at various times may have been involved in the Aussie's ancestry, contributing to his working traits and appearance.

There is also a possibility of Basque and Spanish sheepdog influence in the Aussie. The Spanish missions and large *ranchos* in California, the southern United States, and Mexico, all had sheep- or cattle-herding dogs and larger livestock guardian dogs before the arrival of the American settlers in the mid-nineteenth century. And the Basque shepherds, who came to the American west as sheepherders, may have brought some sheepdogs with them but others acquired dogs here and then bred them. Spanish and Portuguese sheepdog types included the Castilian shepherd, Carea or Pastor Leonés, Catalan, Pastor Vasco or Basque shepherd, Pyrenean Sheepdog, and others. Many more Basque shepherds came to work on the western sheep ranches in the 1940s and '50s, but dogs did not often accompany them.

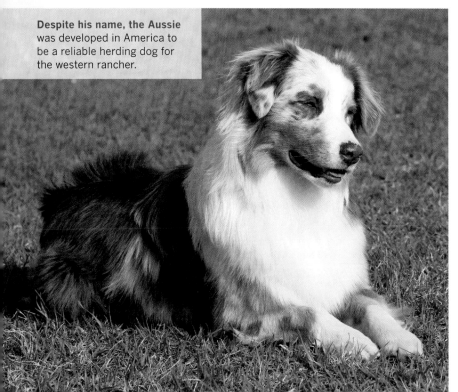

Despite his name, the Aussie was developed in America to be a reliable herding dog for the western rancher.

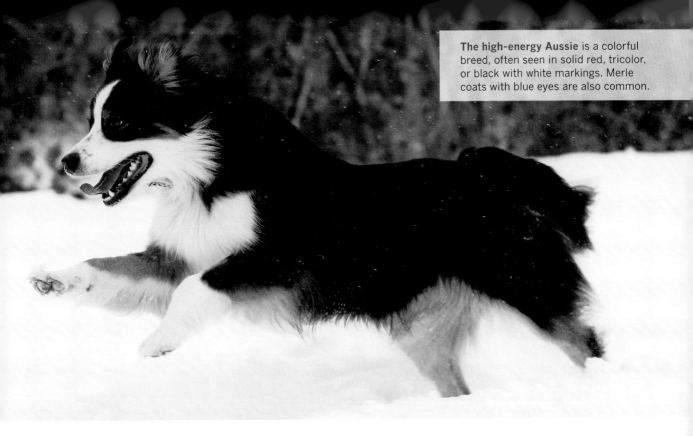

Recent History

The Australian Shepherd's more recent history is a bit easier to trace, although exactly why he bears his name is somewhat mysterious. Whether it was due to the early Australian dogs and their sheep, the later true Australian breeds, or to differentiate them from English shepherds from the eastern United States, eventually all the western herding dogs who displayed merle color, a certain physical type, and working ability came to be called "little blue dogs" or Australian Shepherds.

In the first half of the twentieth century, Australian Shepherds were found in northern California, Oregon, Idaho, Nevada, Colorado, Montana, and up into Alberta and nearby areas. Certain places, such as Colorado, became important in breeding dogs that would form the Aussie's foundation. Australian Shepherds also began to appear in cowboy films, Wild West shows, rodeos, and even the circus. The growing popularity of Western horseback riding was often linked with Aussies, as well, and they soon became the "farm dog" of the American and Canadian western ranch.

In 1957, a group of breeders and supporters organized the Australia Shepherd Club of America in support of the working breed and working trials. The stock-dog registries also created studbooks for the breed. This was the era of true breed development, with a strong focus on working ability. The Club established an independent registry in 1972, and soon after wrote the first breed standard, which resulted in more standardization of type. Seven years later, the breed was recognized by the UKC, which was supported by stockmen as a working dog kennel club.

In 1991, there was a split in the club membership when the AKC recognized the breed. The existing club did not support this move and a new AKC affiliated club, the United States Australian Shepherd Association, was organized. Most working-dog owners did not support AKC recognition, fearing the change in focus for the breed, away from its working roots and an unwelcome boom in breed popularity. The Aussie is now a popular AKC breed and is continuing to grow. Also recognized by the CKC, FCI recognition followed in 2007. FCI attention brought more recent interest in the Aussie elsewhere in the world.

Herding-dog fanciers imported Aussies to Britain in the mid-1980s. Frequent imports followed, and the population is now at about 2,500 dogs and growing. Because they are able to participate in many activities, Aussies have found a home among people experienced with other herding breeds.

Australian Stumpy Tail Cattle Dog

Also known as Stumpy

Origin		Australia
Size		35 to 50 pounds **Male** 18 to 20 inches; **Female** 17 to 19 inches
Coat		Short, straight, harsh outer hair with soft, dense undercoat
Color		Blue speckle or mottled, may have black markings on head and body; red speckle, may have red-brown markings on head or body
Temperament		Independent, dominant, high energy, high prey drive, upright, loose to moderate eyed, close, head, heel

Stumpy Tail Cattle Dogs are highly intelligent but can be difficult to train, being dominant and strong willed. The owner needs to display consistent leadership.

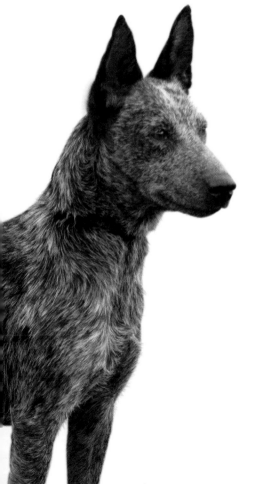

Stumpies are also loyal and devoted to family. If raised with children they should be tolerant, although they may chase or nip, and can be irritated by commotion or play. Aloof and suspicious toward strangers, Stumpies are watchful guard dogs.

Stumpies are often dog-aggressive, especially toward the same sex. They have a strong prey drive and are likely to chase pets or small animals. Without an outlet for their energy, they can default into destructiveness, excessive barking, hyperactivity, or other behavior issues. Stumpies love to run and require secure fencing.

Working traits. Stumpy Tail Cattle Dogs are silent, upright, and loose to moderate eyed. Faster and more agile than the Australian Cattle Dog, they drive and work close. Stumpies are natural heelers but also head. They display courage and power with cattle.

Appearance

The Stumpy Tail Cattle Dog presents a rugged, tough, and natural appearance. The Stumpy is a square dog, lean and leggy, with a characteristic bobtail. The skull is broad and flat, with a very slight stop, and a strong, blunt muzzle. The oval, dark brown eyes are moderate in size. Set higher than Australian Cattle Dog's, the Stumpy's ears are pricked and nearly pointed. The tail is set high and naturally bobbed not to exceed 4 inches long. Stumpies are never docked and puppies are occasionally born with long tails.

Coat/color. The outer hair is short in length, straight, and harsh while the undercoat is dense and soft. The hair forms a mild ruff on the neck. The breed comes in two ticked or mottled colors. The blue or mottled may have black markings on the head and body. The red may have red-brown markings on the head or body. Other colors or patterns are prohibited.

History

The Stumpy Tail Cattle Dog is closely related to Australian Cattle Dog but has some distinct differences. Both breeds were developed to herd cattle in open-grazing and confined areas under harsh conditions. Australians imported many varieties of herding dogs, primarily from England and Scotland, but they discovered that most of these dogs were not up to the difficult conditions and huge scope of raising cattle and sheep in Australia. Cattlemen commonly crossed these dogs with dingoes in an effort to create tougher dogs, often finding that the first generation was too aggressive with stock and hard to control. There are two theories about the origin of the Stumpy Tail Cattle Dog but few provable facts.

The first story shares much of the early history of the Australian Cattle Dog. Thomas Hall, who owned huge cattle stations in New South Wales and Queensland, was known for his cattle droving dogs. Hall imported what was described as a Northumberland blue merle drover's dog from Britain, which he crossbred with dingoes.

These dogs, which could be blue or red, became known as Hall's Heelers. It is possible he bred both Australian Cattle Dogs and Stumpies as separate strains, but kept them within the family from 1840 to 1870. The Halls and other stockmen in New South Wales and Queensland continued to breed and use these working dogs through the nineteenth century.

Another story has it that Stumpies were the creation of cattle and sheep drover Jack Timmins, who worked stock between Sydney and Bathurst. Timmins supposedly crossed bobtail dogs, which may

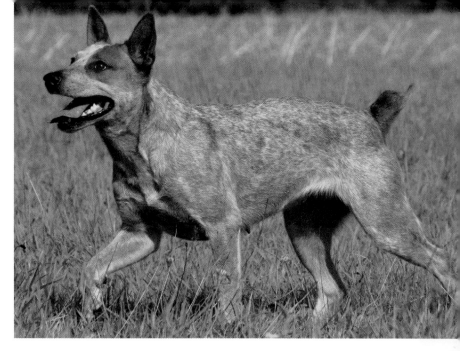

Stumpies are not a merle breed, but ticked or roan, like the Australian Cattle Dog.

have been Smithfield sheepdogs, with dingoes. Smithfield Dogs were longhaired, drop-eared cattle drovers from the Smithfield meat markets in southwestern England. His Red Bobtails were also called Timmons Biters as they were known to be too rough on cattle.

Recognition

Whatever his origins, the Stumpy Tail Cattle Dog was known as a tireless, silent worker and a fearless heeler. He was used on cattle properties throughout the country but was never as popular as the ACD. It is probable that the two breeds were occasionally crossbred. Since 1890, both were at times shown as separate breeds or varieties of the same breed. Confusingly, Stumpies were sometimes called Smithfield Dogs, Smithfield Heelers, or Blue Heelers.

In 1917, ANKC recognized the ACD and Stumpy as separate breeds. Although primarily a working dog, the Australian Cattle Dog also became a popular show and companion dog. The Stumpy Tail Cattle Dog remained almost

exclusively a working dog whose registered numbers were in decline by the 1960s.

From 1988 to 2007, ANKC authorized a preservation program or Redevelopment Scheme for the Stumpy Cattle Dog registry. Unregistered dogs were graded on their closeness to standard, with good specimens added to the registry. This effort successfully increased the registered population, while still meeting the conformation and working ability standards. The name of the breed was officially changed to the Australian Stumpy Tail Cattle Dog, and the breed was tentatively recognized by the FCI. There are still large numbers of unregistered working dogs in the countryside.

Today Stumpies are companion, show, and sporting dogs, but are still primarily a working dog. Since World War II, small numbers of dogs have been exported to North America, where they were recognized by the CKC and UKC. The population remains small, however, with no organized clubs.

Bearded Collie

Also known as Beardie, Beardy

Origin	Scotland
Size	45 to 55 pound **Male** 21 to 22 inches; **Female** 20 to 21 inches
Coat	Long, harsh, flat outer hair with soft, close undercoat
Color	Shades of black, blue, brown, and fawn, all with or without white or tan markings
Temperament	Independent, moderate to high energy, low prey drive, willing, upright, loose to medium eyed, gather, bark

In the right home, Beardies are great family and chore companions, very trainable, and good herding dogs.

Although they can be independent in their decision-making and occasionally stubborn, they are not aloof or reserved with their family. Beardies usually get along with other dogs, as the breed is not often dominant or territorial. While they bark at strangers, they are not guard dogs and generally welcome visitors. Beardies also have a low prey drive, which means they get along with other family pets especially if raised with them.

Beardies are high-energy, agile, and athletic dogs, and they need space to run freely and play. They make good running or biking companions, and they enjoy the mental stimulation of interactive activities. Affectionate and gentle, Beardies generally form friendships with children. They may attempt to herd people through nudges. Some dogs may suffer from separation anxiety, as they really want to be with their people all day. Training should be firm and consistent but positive; the breed is reward oriented. Owners note that females are often more strong willed, independent, and outgoing than males.

Working traits. Bearded Collies have been used in expansive areas as hunters or huntaways, sent out to seek and gather widely scattered sheep. Using their voice to locate and flush sheep, Beardies naturally gather and circle. Generally upright and loose eyed, some dogs show more eye. Beardies were also used as cattle drovers and handled cattle in pens. They can work close, using bark and body but not bite or grip. Beardies work with enthusiasm, often bouncing at stubborn animals. Owners can find dogs with strong herding instincts, and the breed works well at trials.

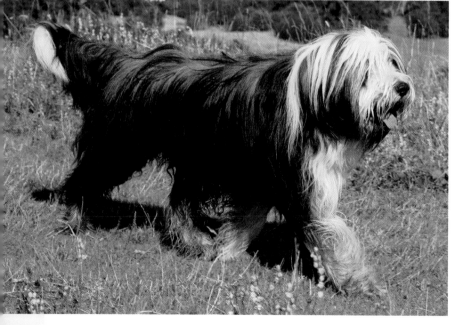

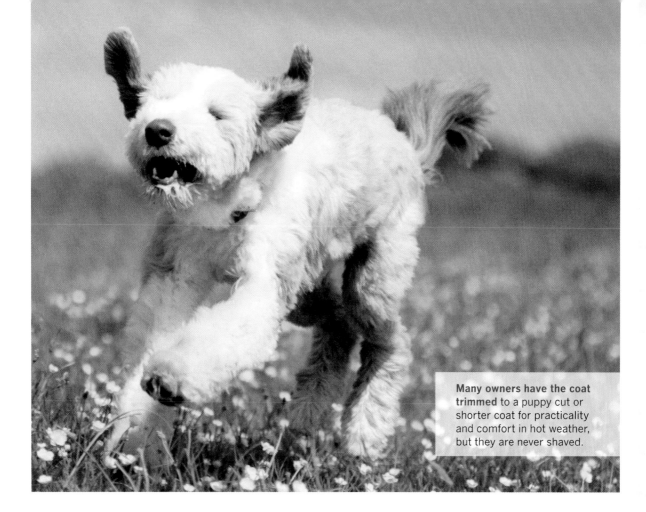

Many owners have the coat trimmed to a puppy cut or shorter coat for practicality and comfort in hot weather, but they are never shaved.

Appearance

The Bearded Collie is a medium-sized dog, longer than tall, and lean not bulky. Despite the resemblance, the Bearded Collie definitely has a different body shape and size than an Old English Sheepdog. The skull is broad and flat, with a moderate stop, a strong, full muzzle, and a large nose. The large eyes are set wide apart. The medium-sized ears are set level with the eyes, hang down and are covered with hair. The neck is moderately long and slightly arched, with a level back blending into a curved croup. The long tail is set low, carried down with a slight curve or swirl at the tip and raising level when alert.

Coat. The Bearded Collie is double coated, with a soft, furry, close undercoat. The long outer hair is flat, harsh, and shaggy. A slight wave is permissible, but the coat is not curly, wooly, or silky. The coat falls naturally to each side without being parted. The hair forms a beard and moustache on the face. While there is long hair over the eyes, most Beardies have unobstructed vision or the hair may be trimmed slightly. Beardies are shown naturally and untrimmed. The coat requires a thorough weekly brushing to prevent matting as well as regular trimming of underparts to keep the dog clean. The beard and mustache collect food and water.

Color. Bearded Collies are born black, blue, brown, or fawn — all with or without white markings. As they age, the coat color usually lightens. Black color can become shaded from slate to silver. Brown, blue, and fawn also may become shaded from dark to light. White markings may appear as a blaze on the foreface and skull; on the tip of the tail, on the chest, the legs, the feet; and around the neck. Tan markings may also appear on the eyebrows, inside the ears, on the cheeks, under the tail, and on the legs where white joins the main color. Black aging to gray is the most common color. Occasionally other colors or patterns occur, such as pinto or mostly white.

History

Rough-coated bearded dogs are an old type of sheepdog seen in Britain for centuries. Genetic analysis has

revealed that the Bearded Collie shares ancestry with the various old British sheepdog and collie types. He also resembles the extinct old Smithfield drover, Sussex Bobtail, and Welsh Grey — all breeds from the west of England. The Old English Sheepdog is perhaps a cousin as well. Large, shaggy, bearded drovers and sheepdogs were seen all over Europe, although there is no real evidence that these breeds were involved in the Bearded Collie's development.

During the seventeenth and eighteenth centuries, both rough-coated and bearded herding dogs were found in the border counties, where they were often used to drive all sorts of stock back and forth between the Scottish Highlands and England. The two types seemed closely related, despite some differences in coats and colors. The shaggy Highland strain was a smaller herding dog used with sheep while the bearded Border strain was more of a drover, used with cattle and horses as well. In both Scotland and northern England, this type was sometimes called the Hairy Mouthed (or Moued), Goathaired, Scotch, Highland, or Bearded Collie. The dogs were sheared like sheep each year; their coats were unkempt and rough, but definitely bearded.

By the early 1800s, the Scottish Bearded Collie was common and well documented. It was used more often as a sheepdog on the Highlands than as a drover. Sent out on the Highlands, the Beardie barked to help locate and roust stray sheep. Shepherds were seen with both bearded and collie dogs, and they were sometimes crossed together. The name Bearded Collie was first used in the 1880s, when he was primarily a working dog not often seen at shows. Early descriptions noted his excellent temperament and how easily he was trained. There were suggestions that the Bearded Collie was related to the Old English Sheepdog, although physically they are very different dogs. It is possible the two breeds were interbred at times.

Recent History

At the beginning of the twentieth century, some Bearded Collies were registered with the International Sheepdog Society Registry, but except on working farms in Scotland, most were in danger of being lost due to the immense popularity of the Border Collie. A Bearded Collie club was organized in 1912 and a breed standard written, but the effort did not survive World War I. Another attempt was made in the 1930s. By this time, photographs show dogs very similar to the modern Bearded Collie complete with longer coats, probably due to grooming for show purposes. The Bearded Collie was still rare and there was concern over their declining numbers, although there were still Beardies working on farms.

Near the end of World War II, Mrs. G. Olive Willison, who lived in England, became interested in the breed when she mistakenly received a Beardie puppy from a Scottish kennel, rather than the Shetland Sheepdog she requested. It was a most fortunate accident, as she became interested in preserving the breed and, with a few interested breeders, helped establish a Bearded Collie Club in 1955; the breed received Kennel Club recognition just four years later. Both bearded and nonbearded puppies appeared in early litters of both Border Collies and Beardies, no doubt due to frequently cross-breeding in the past. The newly recognized breed focused more on temperament and obedience, although many owners continued to use both registered and unregistered dogs for herding. The Beardie is still often used in combination with the silent Border Collie, especially when barking is useful.

The Working Bearded Collie Society maintains a registry for Beardies without KC pedigrees and promotes the use of the dogs for herding. Working shepherds tend to support this effort, as they have some concerns about the potential loss of ability and a tendency for excessive coats in the registered dogs. Working Beardies tend to have shorter, rough coats. Dogs from these working lines have also been exported to the United States and Australia.

Across the Ocean

The first Bearded Collie import to the United States occurred in 1957, with the AKC registering the breed nearly 20 years later. The Bearded Collie Club of America was organized in 1969, and about 800 pups are registered yearly. Modern imports to Canada began in the 1960s. Today the CKC registers 100 to 150 dogs yearly. In North America, Beardie breeders are supportive of their dogs being involved in herding activities. Like the Old English Sheepdog, the smart and loveable Beardie is frequently employed in television and film, especially children's entertainment. Beardies have also made their way into several European countries and elsewhere. In Australia, ANKC registers about 60 dogs yearly.

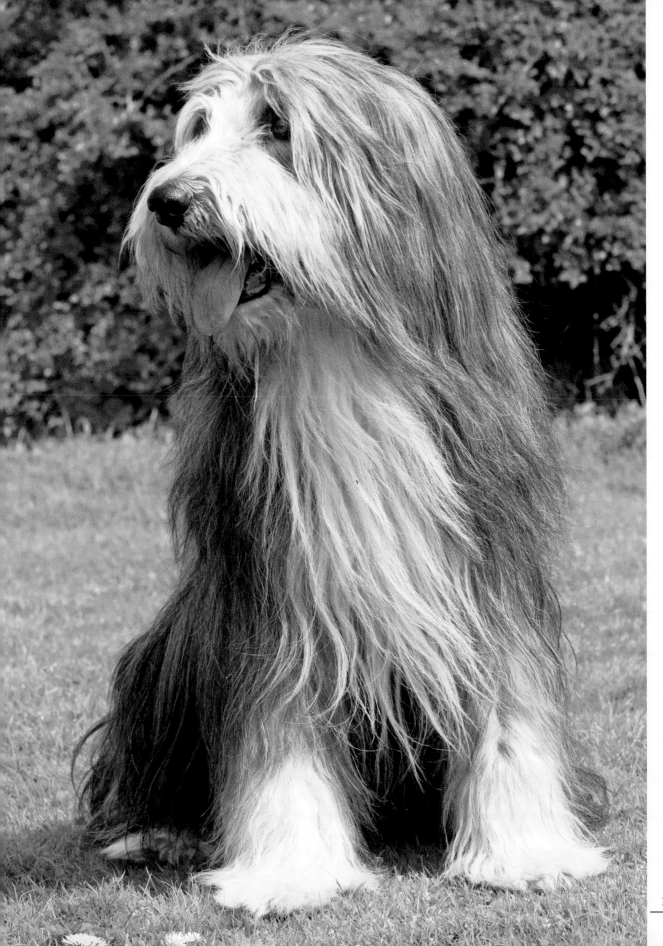

Beauceron

BO-sur-ahn | Also known as Berger de Beauce, Bas Rouge, Beauce Sheep Dog

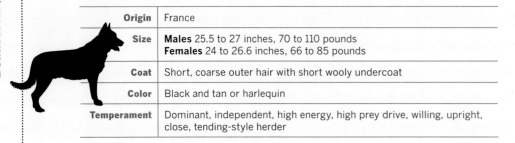

Origin	France
Size	**Males** 25.5 to 27 inches, 70 to 110 pounds **Females** 24 to 26.6 inches, 66 to 85 pounds
Coat	Short, coarse outer hair with short wooly undercoat
Color	Black and tan or harlequin
Temperament	Dominant, independent, high energy, high prey drive, willing, upright, close, tending-style herder

The Beauceron is a serious working dog. Eager to please, obedient, and intelligent, he can also be pushy and dominant.

In the absence of an experienced owner, he will assume leadership. As with many strong-willed breeds, harsh training and physical corrections do not work well. Beaucerons excel at Schutzhund, personal protection, scent and tracking work, agility, weight pulling, search and rescue, and as military and police dogs.

High-drive male Beauceron puppies who test highly dominant are very demanding; they require owners who engage them in a hard-working sport or activity. They are not suitable for nonworking homes and some family situations. Females, who are smaller and have less drive, are often easier to handle and recommended as companion dogs. Beaucerons are inclined to be same-sex aggressive. It is highly advisable to meet the parents, who should have confirmed *Journee du Beauceron* cotations, or certifications, to ensure a well-bred and stable temperament.

Beaucerons need vigorous exercise and mental stimulation. Loyal and highly protective, they want to be with their owners even in the house. Very affectionate with their families, they are reserved with strangers. The breed is usually good with children but should be supervised due to its strength and size. They also tend to be mouthy and need to be taught not to grab hands or clothes.

Working traits. The Beauceron is not a natural fetch or gather herding dog. He has affinity for stock but with a strong urge to chase, he may be a threat to livestock and other family pets if not supervised. His natural style is the Continental living fence or tending style of work. The breed is known for its fluid, ground-covering, extended trot.

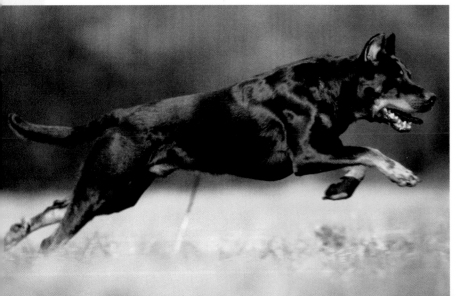

Appearance

The Beauceron is a strong, well-muscled dog who projects a sense of power, nobility, and grace. He is somewhat longer than tall and should never appear heavy. The head and square muzzle are equal in length and long, with a slight stop. The head should appear chiseled. The eyes are slightly oval. The ears are set high and may be traditionally cropped or natural.

Cropped ears are erect and point slightly forward. Uncropped ears are flat, rather short, and half prick or drop. The tail strong and large at the base, carried in a J-shape, but never above the topline. The rear feet must have double dewclaws.

Coat. The weather resistant Beauceron short coat is 1.25 to 1.5 inches long. The outer hair is coarse and thick, lying flat and smooth in most areas. The coat may be a little longer on the neck and fringed on the back of the hind legs and tail. The undercoat is mouse-gray, short, and wooly.

Color. Originally, Beaucerons were found in solid black, brown, gray, and gray with black patches, as well as the traditional black and tan. By 1965, black and tan dogs were by far the most common color. The deep black has tan markings, or points, which breeders describe as rusty tan or red squirrel in color. The tan points include dots above the eyes, on the muzzle, throat, tail, two patches on the breast, the feet and lower legs. The eyes in black and tan dogs are a dark brown color. In 1969, the French breed club recognized harlequin as a permitted color. Harlequin is a black and tan coat with blue-gray patches, balanced and even throughout, with slightly more black color desirable. The eyes may be brown or pale blue. It is prohibited to breed harlequin-colored dogs together since puppies can have serious abnormalities.

History

The Beauceron is named for the area around Paris known as La Beauce, although this native breed was found throughout a larger area in northern France. Also

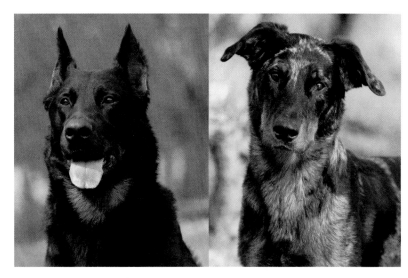

With either traditionally cropped or natural ears, black-and-tan dogs are far more numerous, but harlequin is an accepted color.

called Berger de Beauce or Bas Rouge, meaning "red stockings," it is believed that the breed is closely related to the longhaired Briard or Berger de Brie. The Beauceron is an old shorthaired shepherd, the largest of the French sheepdogs; however, the breed was also a general purpose farm dog, protecting house, family, and stock. Historically working with a shepherd, they tended large flocks of sheep, moving them to grazing, keeping them from intruding on cropland, and driving them home or to market.

The first attempt to describe the different French herding types or breeds was in 1809, but it would be nearly another 90 years before they were officially divided and given descriptive names. The Club des Amis du Beauceron formed in 1922.

Known for its obedience and intelligence, the Beauceron was widely used by the French Army in both world wars for scent work, mine detection, search and rescue, and patrol and protection. Being of value to the military, relatively large numbers of dogs survived the devastation of war. While some Beaucerons still tend cattle and sheep, they are increasingly used for protection work by the military and police, as well as in canine sports and Schutzhund. As the breed's population began to grow outside of France, the practice of testing and inspections were instituted in the 1960s. This official program encompasses measurement, temperament testing, herding, obedience, and other competitions.

The Beauceron is now found throughout Europe. In Britain, although the numbers are small, a Beauceron Club was established in 2009, and the breed was recently moved into the Pastoral Group. Still rare in North America but growing in popularity, the Beauceron received full AKC recognition in 2007, four years after the American Beauceron Club was organized. The Canadian Kennel Club does not recognize the Beauceron at this time.

Bergamasco Sheepdog

berg-a-MAS-co | Also known as Bergamasco Shepherd, Cane da pastore Bergamasco

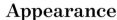

Origin	Italy
Size	**Male** 22.5 to 24.5 inches, 70 to 84 pounds **Female** 21 to 23 inches, 57 to 71 pounds
Coat	Mixed goat and wooly outer hair with fine, short undercoat
Color	Solid or shaded gray; solid black; white markings and faded ends of locks permissible
Temperament	Independent, moderate energy, upright, close, loose eyed

The Bergamasco is an alert watchdog who is more moderately protective and territorial than some other herding breeds but not aggressive without cause.

Some dogs are quite friendly after introductions to new people while others will remain aloof. This breed forms close, affectionate bonds with his people and wants to be with them. He is expected to be tolerant and gentle with children and is good with family pets if raised together. He usually gets along with other dogs, although he tends to be dominant to them. He may chase small animals, especially strange ones.

The Bergamasco is an intelligent, independent, and self-thinking dog. Calm, positive, and reward-based training is the most successful approach. Although he has great endurance, he is more moderate in his activity needs than many other herding breeds and likes to relax in the house.

He remains a versatile herding dog, although this is not the focus of the international breeding program. He is an upright, loose-eyed dog who works in close to stock using his imposing presence and size to his advantage.

Appearance

The Bergamasco Sheepdog is a medium to large dog, strong with heavy bone, almost square in appearance, and only slightly longer than tall. He has a large head, a pronounced stop, and a large nose.

Under the long hair, his brown eyes are large and oval, set slightly oblique. His small, thin ears are set high on his head, dropping down but pricking up at the base when alert. The ears are covered in softly wavy hair. The tail is thick at the base but tapering, with the last third forming a crook. The tail rises

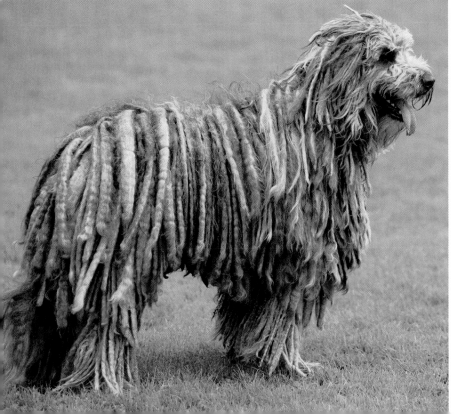

when the dog is alert and is held over the back but not curled.

Coat. The entire dog is covered in long, abundant, and continuously growing hair. Two types of outer hair, unevenly distributed throughout the coat, lend each dog a distinctive appearance. The *goat* hair is long, straight, harsh, and rough while the *wooly* hair is somewhat finer and softer. Goat hair predominates on the neck and withers down to the middle of body, forming a smooth or slightly wavy saddle. The head and tail have mostly goat hair as well.

On the back half of the body and legs, woolly dreadlocks called *flocks* form. They are irregular in shape or diameter and sometimes flattened. The Bergamasco also has a fine, short, dense undercoat with an oily feel.

Color. The Bergamasco Sheepdog coat can be found in a solid gray or shaded from very light to nearly black, including a shaded and patchy gray. Dogs may also be a dull, lustrous, or shiny black. White markings are acceptable up to 20 percent of the coat. Faded color is permissible on the lower ends of the flocks.

History

Bergamo lies right at the foothills of the Alps in Lombardy. Transhumance was central to the economy, moving sheep from the lower Po Valley in winter to the higher Alpine pastures in summer. The native shaggy sheepdog was critical to this work. The Italian breed association explains that the sheepdogs were conductors that both drove and led the sheep, at times keeping them to paths and away from fields. They were skilled at grouping, separating, penning,

Special Coat Care

The flocks begin to develop between 8 and 10 months or later and require specialized care and manual separation of the mats as they form, until the dog is about three years of age when the process is completed. New owners need guidance from experienced breeders or groomers. The mature Bergamasco coat is never brushed. An adult dog should only be bathed one to three times a year and must be dried thoroughly.

Despite claims that the coat is nearly carefree, it still needs to be maintained and kept clean of burrs, sticks, weed seeds, and dirt. The coat can become stained with urine and may mildew if not dried properly. Breeders advise that the coat should not be shaved, although some owners clip or trim the flocked coat to 4 to 5 inches or prefer a brushed, fluffy appearance.

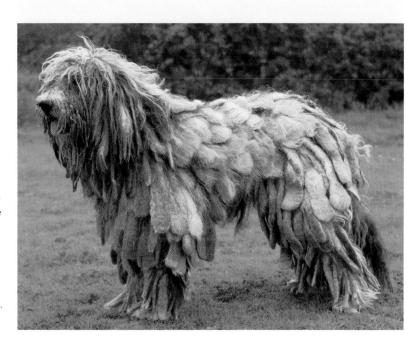

and fetching stragglers. And like all herding breeds, they worked closely with their shepherds. The dogs also worked with cattle on the lowlands.

In Europe, there are other herding or guardian breeds with long, thick coats with a tendency to felt or cord, but there is no evidence that the Bergamaso sheepdog is related to any of them in particular and so his origins remain somewhat mysterious.

The old breed was often called the Alpine or Northern Italian sheepdog but it appears the majority of dogs with the most uniformity in appearance were found in the Bergamo valley. After World War II, industrialization changed the economy and diminished the primacy of agriculture in much of northern Italy. There was a major decrease in the wool sheep population although some sheep continue to produce milk, cheese, meat,

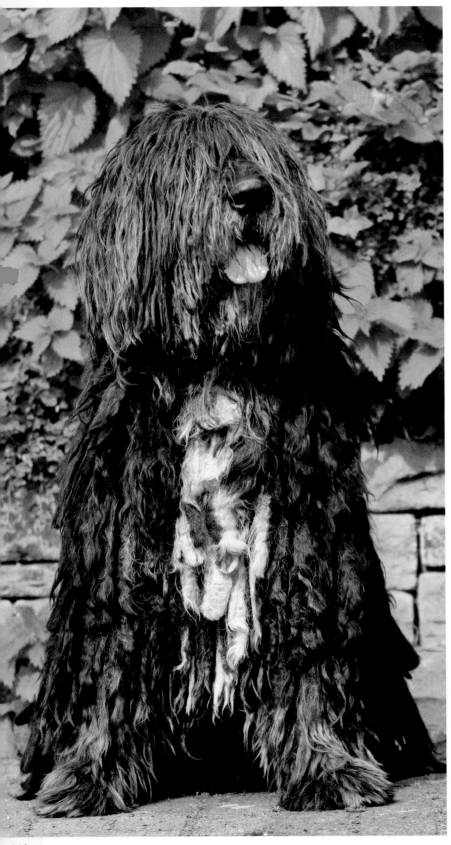

and leather. The loss of herding work and the reduction in breeding through the war years sharply reduced the sheepdog population. The surviving dogs were increasingly crossbred with foreign breeds.

Enthusiasts and dedicated breeders came together to preserve the native breed that had been so much a part of northern Italian life, although very much unknown outside of Italy. In 1949, the breed association was organized and a standard was soon compiled. There was a decision to officially name the breed Cane da pastore Bergamasco or the Bergamasco Sheepdog. In the early years, only one or two litters were born per year. Numbers slowly grew to about 150 dogs born annually. Today's Bergamasco is primarily a show and companion dog, although some dogs still herd cattle or sheep. A mixed or crossbred population is also still at work with sheep. With FCI recognition, the Bergamasco was exported to several other European countries, North America, and Australia. An international association fosters communication between national breed clubs.

In Britain, the Bergamasco Sheepdog has Kennel Club recognition and a recently formed breeder and owner association but remains a rare breed. However, the Bergamasco has gained a considerable following in North America, where it was first imported in the mid-1990s. Breed clubs were organized and gained placement in the AKC Herding Group in 2015. An estimated 1,200 Bergamasco Sheepdogs exist in the United States.

The corded or felted coat seen in a few breeds is reputed to protect the dog from weather, predators, other dogs, and insects.

Berger Picard

bare-ZHAY pee-CARR | **Also known as Picardy Shepherd**

Origin	France
Size	50 to 70 pounds **Male** 23.5 to 25.5 inches; **Female** 21.5 to 23.5 inches
Coat	Harsh, medium-length outer hair with short, soft undercoat
Color	Fawn with or without dark markings; fawn with charcoal; brindle
Temperament	independent, moderate energy, high prey drive, soft, upright, loose eyed, close

The Berger Picard is an independent, intelligent self-thinker who is a clever problem solver and a bit of a mischief-maker.

He is also very sensitive and loyal. Inclined to attach himself to one person, he has a strong need to be with his owner and may have separation anxiety if left alone too much or for long periods of time. He is reserved and distrustful with strangers, naturally protective, and a good watchdog.

If socialized, he does well with children although may attempt to herd them and might become overstimulated by screaming and rough play. Berger Picards tend to suffer from sensory overload — they are sensitive to loud voices, their owner's moods, and harsh physical corrections. Training needs to be positive, calm, consistent, patient, and conducted in short sessions. His independent nature can make him more difficult to motivate than many other herding breeds, and he can be seen as somewhat willful, assertive, or stubborn. This dog needs an experienced owner who enjoys his personality and abilities.

Although he needs an outlet for exercise, Berger Picards tend to be quiet and relaxed in the home. Jogging, dog sports, or an active country life suit him well. He usually does well with dogs he knows and other family animals, but has a high prey drive and may engage in chasing. Picard body language, especially a strong stare, can be read as aggressive by other dogs, so caution is required in situations like dog parks.

Primarily used to herd and move cattle, he also works well with sheep in an upright, loose-eyed style and tends to be a close, driving dog.

149

Appearance

The Berger Picard is a medium-sized dog, built sturdy and solid, and slightly longer than tall. While he has heavy bone, he is never bulky or heavy. The head is in proportion to the body and rectangular with a slight stop. The oval eyes are medium to dark in color.

Important to his distinctive appearance, his ears are moderately large, 4 to 5 inches long, set high, and wide at base. They are naturally erect and facing forward. The tail is medium to long, ending in a crook or J-shaped hook. It is lifted when the dog is alert or active but never over the back.

The Berger Picard's double coat is harsh, wiry, and crisp to the touch. Often slightly wavy, the length is ideally 2 to 3 inches long over the entire body including the tail. The undercoat is soft, fine, short, and dense. The hair on the face is shorter and should not be overly long on his ears. The eyebrows should not cover the eyes and the moustache and beard are thin, not overly heavy. The overall appearance is shaggy, rustic, tousled, and natural — not scissored or shaped in any way.

Berger Picards are found in three distinctive colors. The most common color is light to reddish fawn with charcoal markings, known as *fauve charbonné*: charcoal gray or black trim on ears, a dark necklace or collar, and a ring of dark hair on the tail. The coat can also have a gray underlay everywhere else. Some darker markings fade as the dog ages. Brindle coats are found in any shade of fawn or light gray to almost black, both with stripes or patches of black, brown, red, gray, or fawn. With age, brindle dogs tend to gray on the muzzle and eyebrows. Light, straw-blond fawn, with or without dark markings is now the rarest of the colors. A small white patch on the chest is allowed but no large areas of white.

History

The Berger Picard received his name from the Picardy region in northwestern France (*berger* means "shepherd"). Sheepdogs with the characteristic prick ears and long, hooked tails were recorded in artwork over several centuries. First seen at a dog show in 1863, the breed was grouped together with the shorter-haired Beaucerons and the longer-haired Briards. All three breeds are harsh-coated sheep- and cattle dogs found across the greater area in France and also in Europe. Primarily used with dairy and beef cattle, they also worked as drovers or tenders, protecting sheep flocks grazing in unfenced areas and keeping them out of cropland. The Berger Picard probably shares some ancestry with the neighboring Dutch and Belgian Shepherds,

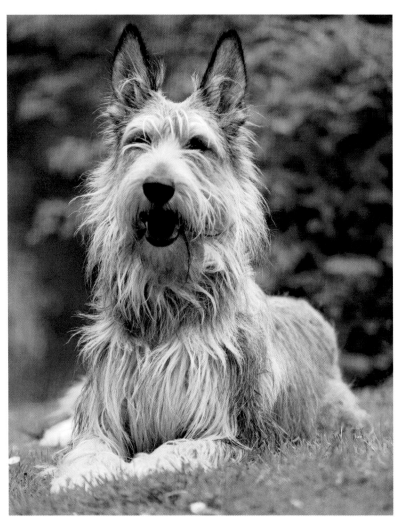

Though a bit whimsical and comical in appearance, the Berger Picard can be strong willed and is a good watchdog.

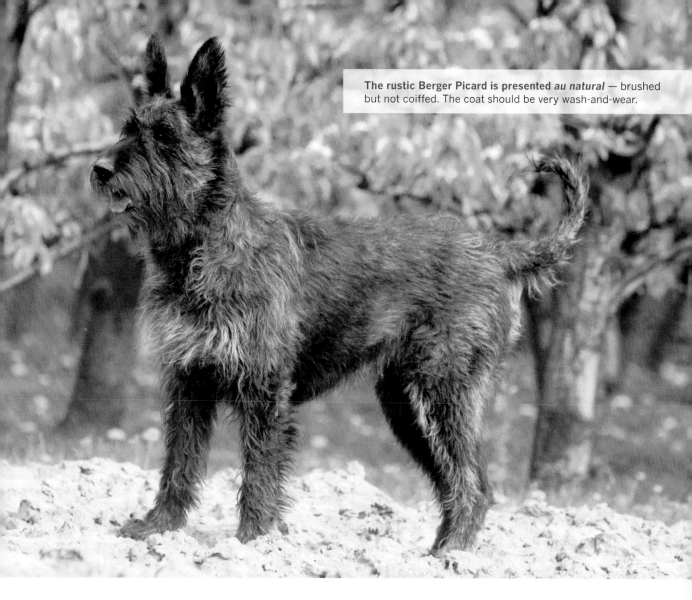

The rustic Berger Picard is presented *au natural* — brushed but not coiffed. The coat should be very wash-and-wear.

possessing a coat quite similar to the Belgian Laekenois.

By 1898, the Berger Picard was viewed as a separate breed, although a standard and official recognition by the French Shepherd Club would not come for 25 years. Tragically, his homeland was the site of great conflict in World War I, devastating to both people and animals. By the end of World War II, the breed was nearly extinct, surviving primarily as unregistered dogs on farms in rural areas. Efforts resumed to save the breed, with breeders searching out dogs of good type. The breed club, Les Amis du Berger Picard,

was founded in 1955. Today, there are about 3,500 Berger Picards in France, with another 500 dogs in Germany. They are also found in small numbers in other European and Scandinavian countries, primarily as a show or companion dog. Overall, the breed remains rare, a situation compounded by some fertility issues.

North America is home to about 400 Berger Picards. The 2005 film *Because of Winn-Dixie*, based on the award-winning children's book of the same name, featured a Berger Picard as an important character, and although many people thought the dog was

a mixed breed, it did increase the breed's visibility. The filmmakers actually had to import dogs from France to work on the production as there were no breeders in North America, despite earlier imports. Shortly thereafter the Berger Picard Club of America was organized to provide an educational and protective home for the breed. Two years later, the Berger Picard was placed in the AKC FSS and now is a member of the Herding group. Most Berger Picards in North America are companion or show dogs, although a few are used in herding activities.

Border Collie

Also known as Border, BC

Origin	Britain
Size	18 to 22 inches, 25 to 55 pounds
Coat	Smooth, medium, or rough outer hair with soft undercoat
Color	Black, black and tan, red, liver brown, yellow, blue merle, red merle — all usually with white markings; white with black, brown, or red spots; freckling common
Temperament	Independent, dominant, willing, high energy, high prey drive, strong eyed, intensity, gather, header, grip, silent

The intelligence, willingness, and athleticism that a Border Collie brings to every task translates well to performance events and dog sports, which can serve as a great replacement for the work this breed craves.

Border Collies, like high-powered sports cars, are not the right choice for everyone. Someone who wants a dog that is content with a romp in the yard, punctuated by a bit of herding once a week or so, will find other herding breeds better suited to a more casual working lifestyle.

Temperaments and personalities in working dogs range from reserved to bold, soft to hard, and calm to intense. Border Collies are bred to have a close working relationship with their owners. Neglect or harsh treatment, as well as owners' failures to lead, can result in serious problems. Generally strong willed, some dogs may challenge or confront their owners especially as they mature, while others are submissive. Children or other family members need to participate in basic obedience work with adult support. Highly intelligent, Border Collies are great observers of small motions and voice pitches, and can easily mislearn cues or behaviors. A high, quick voice speeds the dogs up, while a low, calm one slows them down. Often reserved with strangers, BCs need socialization to new experiences, people, and animals in order to build confidence.

A Border Collie is probably not a good choice for a home with small children, cats, or small pets. With his strong herding instincts, he may attempt to herd or control, sometimes by nipping ankles, or he may find ordinary commotion disturbing. Although the Border Collie is usually good with a second family dog, it is preferable to place him

with opposite sexes, and differing ages or personalities. He may learn to coexist with cats if taught not to chase or corner them. He cannot be allowed to roam free as he focuses on anything in motion and is likely to chase cars, bicyclists, stock, or other animals.

Border Collies have a high startle reflex, so some care needs to be taken when the dog is tightly focused on a moving object or handler. Touching the dog from behind can startle him and he may nip. Sudden loud noises can also disturb him and cause reactions from fleeing to frenzied barking to nipping. Some Border Collies develop serious fear reactions to certain noises. In the absence of mental challenges and physical activity, he may bark a great deal at visitors or disturbances; develop neurotic or destructive behaviors or obsessions; or become overly protective of food or objects.

Working traits. Border Collies are very focused dogs with fast reflexes, great balance, and stock savvy. Strong-eyed dogs, they remain in visual contact with stock, although some may be more medium eyed and others too *sticky*, meaning they become fixed at staring rather than moving sheep. Border Collies see stock on a broad scope from up to 300 to 400 yards away and are moderate to wide running to gather sheep. Most dogs work with an intense stare, head and forelegs lowered, hindquarters raised high, and tail held down with the bottom third upturned. Many dogs clap to the ground when stopped while others stand in a crouch. Handlers may prefer to keep dogs on their feet and ready to move.

Although Border Collies naturally gather, they can be taught to

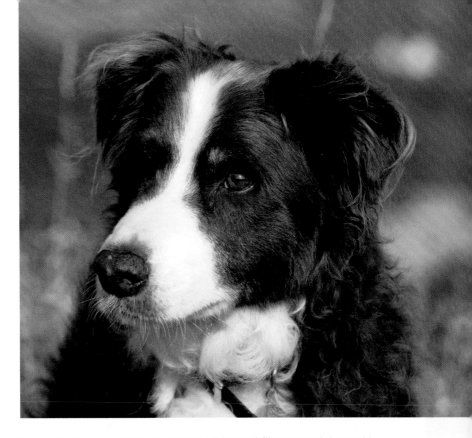

Border Collies are widely seen in television and films around the world, making them easily recognizable and popular, though they are not generally suitable as average family pets. Anyone considering a Border Collie as a companion rather than a working dog absolutely needs to determine if the daily activity and mental stimulation needs of this breed can be met. Far too many Border Collies are purchased as companions and then surrendered to rescue organizations or shelters.

drive stock away from the shepherd. Since trialing is about precisely controlling small numbers of sheep, Border Collies do well with flighty or light sheep. Some lines have been developed to handle tougher sheep and cattle with greater force. Border Collies are obsessive, dedicated workers, so heat exhaustion is always a threat in hot weather.

Prospective owners who need a Border Collie to work stock or compete at trial should purchase a pup from working parents. The breeder can also help select the right temperament or personality for the owner's needs and stock situations. Inexperienced handlers need professional training.

Appearance

There is no standard for a working Border Collie, other than the ability to herd in a certain manner. Height and weight are not specified. Border Collies may be lightly built or more heavily boned, and they should appear natural and unspoiled. Ears may be pricked, semi-erect, dropped, or any combination. Tails may be long or short and straight or curling at the tip. A dog's appearance is primarily considered irrelevant to working ability, although some owners have preferences.

Coat. Coats may be short, medium, or rough in length. The outer hair may be straight, wavy, or even curly. Most common is

a moderate double coat, with an undercoat that sheds heavily at times. As a working coat, it should be weather resistant, although longer coats may be silkier in texture.

Color. Border Collies are seen in black, black and tan, red, liver brown, yellow, blue merle, red merle — all usually with white markings. White with black, brown, or red spots also occurs, and freckling or ticking is common in white areas. Black and white dogs are most common and many sheepmen have a preference for dark-colored dogs, believing they have more influence over sheep or are more visible. Other unusual colors or patterns are seen occasionally. The eyes are amber to dark brown or blue, and dogs may have one of each.

The kennel clubs — AKC, UKC, KC, ANKC, NZKC, and FCI — do have Border Collie breed standards. Dogs bred for conformation shows, generally have medium to longer coats; long, slightly curved tails; erect or semi-erect ears; brown eyes except in merle colors; and perhaps gentler or more easygoing temperaments than working dogs.

History

One of the most important herding breeds, the Border Collie is found throughout the world. This a is a breed defined by its working style. Originally various types of sheepdogs were developed to meet the differing needs of shepherds and drovers. The rise of a specialized sheep economy in the more mountainous and highland areas of Britain demanded a particular kind of dog to work on hill conditions, gathering sheep to the shepherd. Several old breeds were eventually lost or absorbed into the new working sheepdog or collie.

The trademark strong eye and silent behaviors of the modern Border Collie were uncommon until the late nineteenth century. In the 1870s, the working dogs were rougher with stock and harder to control but were already displaying great concentration and focus that gave them power over sheep.

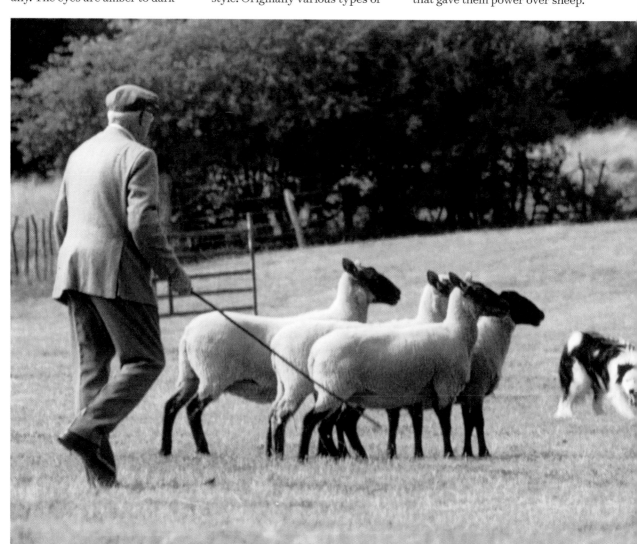

In 1893, when shepherds were attempting to combine the concentrated focus with a more controllable nature, Adam Telfer of England bred a special dog. Known as Old Hemp or Hemp 9, his strong-eyed, quiet, and powerful style became the model for all Border Collies.

Border Collies use a strong eye, or intense gaze, to control, hold, or move sheep quietly and calmly. Another part of that silent, predatory stalking behavior or prey drive is the characteristic low posture and movement of creep, crouch, and *clap* to the ground. The predatory chase became the gather displayed as the *outrun*, *lift*, and *fetch* in sheep trials.

Originally just called a working collie or sheepdog by the ISDS, the name Border Collie was first used in 1915, and was later added to pedigrees and records to distinguish the working dogs from the Rough or Smooth Collie. The name Border most likely refers to the Scottish-English borderlands, where the dogs were developed and worked. The ISDS remains the worldwide authority for the Border Collie and has thousands of members worldwide, with many affiliated registries and associated clubs. About 6,000 dogs are registered annually.

Across the Ocean

The specialized Border Collie was introduced to North America, Australia, and New Zealand beginning in the 1890s. Ranchers in many areas had different sheep-raising challenges — huge flocks, difficult climate or terrain, and the need for barkers, heelers, or long-distance drovers — but the Border Collie made great inroads for specific needs. Eventually some strains were also selected for working with cattle. The ISDS also sponsored exhibitions and demonstrations in North America. Farmers, ranchers, and sheepmen became breeders. By the 1920s and

Sheepdog Trials

Trials or competitions are part of dog life in many rural areas around the world. The first recorded British sheepdog trial was held in 1873 in Wales, but a Scotsman took first prize. By the turn of the century, sheepdog societies were forming in northwest England, Scotland, and Wales. In 1906, the International Sheep Dog Society (ISDS) was organized by group of Scottish and English sheepmen in order to form a registry and hold trials. The standard elements of those trials are still used today around the world and trialing itself has become a strong feature of Border Collie breeding.

'30s, sheepdog trials were held at agricultural and livestock fairs, spurring interest in forming sheep-dog organizations.

The American Border Collie Association (ABCA), an affiliate of ISDS, is the major register of dogs. The US Border Collie Handler's Association (USBCHA) sanctions sheep and cattle dog trials in North America. In Canada, the CBCA is also approved by ISDS and has a close working relationship with its American counterpart. Imports continue today, but some 14,000 dogs are born and registered by ABCA alone, in addition to a large number of unregistered dogs and crossbred working dogs.

The national club believes Border Collies should be bred only as a working dog, although they can be good companions for active people who pay attention to their dog. In Britain, the Border Collie was recognized by the Kennel Club in the 1970s, a move not welcomed by the ISDS. In Australia and New Zealand, as well as internationally through the FCI, the Border Collie is a recognized breed with a written standard.

In America, Border Collies were allowed to compete in AKC events as part of the Miscellaneous class for 40 years. In the early 1990s, a new club, the BCSA, advocated for full recognition that would allow for both conformation and event showing. All of the Border Collie organizations, state and national, were opposed to this change. However, in 1995, the AKC authorized a breed standard and gave full recognition to Border Collie. In response, none of the Border Collie

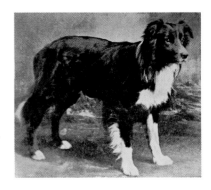

Born in 1893, Old Hemp is widely recognized as the father of the modern Border Collie.

registries granted access to their studbooks. Today the AKC registers about 2,000 Border Collies each year. Border Collies do not need a kennel club registration to compete in performance events or herding trials, other than those sponsored by a kennel club.

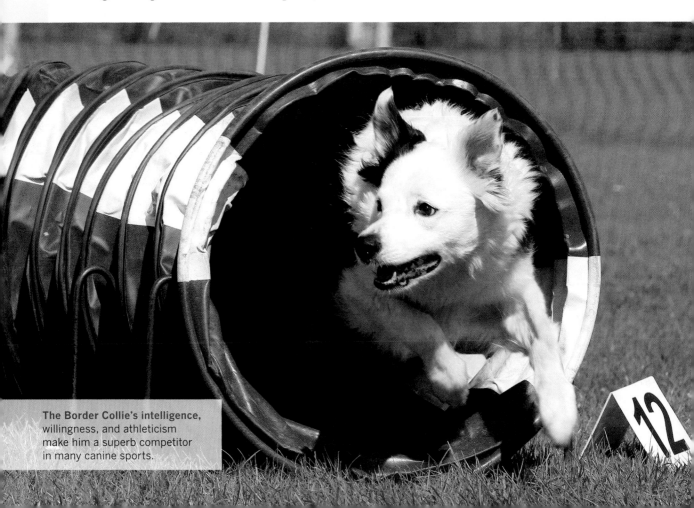

The Border Collie's intelligence, willingness, and athleticism make him a superb competitor in many canine sports.

Briard

bree-ARD Also known as Berger de Brie

Origin	France
Size	**Male** 23 to 27 inches, 65 to 100 pounds **Female** 22 to 25.5 inches, 50 to 75 pounds
Coat	Very long, harsh outer hair with fine undercoat
Color	Black, shades of gray, shades of tawny, shaded combinations of two colors allowed
Temperament	Dominant, independent, high energy, high prey drive, upright, loose eyed, tending, fetch, gather, head, close

The notably courageous, loyal, and spirited Briard is also gentle, lively, playful, and even a bit clownish with his family.

With strangers he projects an air of calm aloofness and dignified power, but he can be protective. Although he is intelligent, very willing, and quick to learn, his herding nature can also reveal some independence and stubbornness. Individual dogs can be dominant or pushy, while others are softer and lower in energy.

Everyone in the family should participate in training a Briard, so he comes to see them all as leaders. A Briard wants to be with his owner, following them from room to room. He should be fine with children but some care needs to be taken since this is a large, strong dog with high energy that may attempt to herd people.

Some dogs are same-sex aggressive, although the breed is generally fine with family dogs and pets if raised with them. He is likely to chase cats or other animals that flee. As a breed, the Briard does not tend to roam; however, all herding dogs need to be confined in a fence to prevent chasing. If he receives sufficient exercise, he is usually quiet and adaptable in the house. The Briard is well suited to various outdoor activities and dog sports.

Working traits. A Briard is a versatile herder who can be used in various situations. Working with his shepherd in his homeland, he moved stock out to graze during the day, tended them to keep them out of crops, returned them to their barns at night, and helped with general farm chores. He is suited to Continental or tending-style herding but can also fetch, circle, and drive. The Briard exhibits presence and power, and uses his size and strength, his head and body, to bump and shoulder stock. He heads stock but does not bark or bite.

Appearance

The Briard is an elegant dog with a striking appearance. His coat makes him appear even larger than he actually is. The body is slightly longer than tall. His head is very long and rectangular in shape, with a pronounced stop, a square muzzle, and a large nose. The high-set ears were traditionally cropped to stand erect, facing forward when alert, and completely covered by long hair. Uncropped, the natural drop ears are thick, about half the length of the head or less, and lift slightly. The eyes are large and open with very dark color. Like his cousin the Beauceron, he has double dewclaws on the rear legs. The tail is long, carried low, and ends in a J-shape or a crook. Raised when the dog is alert, it is never carried over the back.

Coat. The double coat has outer hair described as goatlike — coarse, dry, hard, and harsh to the touch — and it repels water and dirt. The slightly waving locks range from at least 6 inches long up to 12 inches with a fine undercoat.

The eyebrows arch up but don't completely cover the eyes. The head is well covered with long hair, parting in the center, falling over the ears, with a beard and mustache. The full beard soaks up and drips a lot of water after a drink and the coat attracts food particles and debris. Weekly grooming is required.

Color. Coat colors are black, shades of gray, or shades of tawny (fawn) color. Black can be a glossy blue-black, but this is less common. Some black dogs have a graying gene, becoming gray or silver over time. Gray-blue coats are seen more frequently, although pups may be born with a nose color that is too light instead of black. True gray coats are now rare.

Tawny may be a very light honey to a deep reddish tan, with deeper shades preferred. Tawny pups are born dark, gradually become lighter, and then darken again with age. The coat can be clear or have a black overlay, with or without a dark mask. Darker shading is found on the ears, muzzle, back, and tail.

Single white hairs may occur on the coat and a small white mark on the chest is permissible. Combinations of two permitted colors are also allowed, as long as the color is gently and gradually shaded, not appearing as bicolor.

History

The striking Briard is the probably the best known *chien de berger* (dog of the shepherd) in France. He is part of the large group of old French sheepdogs, found in differing sizes or coats, developed for work in different regions and methods of stock keeping. He is closely related to the shorthaired Beauceron, also found in the northern part of the country.

Through several centuries, written records and artwork often depict or describe similar dogs. Charlemagne is depicted in tapestries with large, shaggy dogs that look remarkably like Briards. Napoleon may have owned them and the *chien de bergers* that President Thomas Jefferson admired and imported may have been Briards as well, especially those obtained for him by the Marquis de Lafayette. As Jefferson reported, these sheepdogs were tall and quick to learn, used for gathering stock and poultry back to their shelters, and tending sheep to keep them out of the gardens.

Known at times as the French lowland sheepdog, he was truly an all-arounder — herder, drover, and protector that worked closely with his shepherd. At times they worked as cart dogs. In 1809, he was first named *chien de Brie*. Although he was named after the northern district of Brie, he was found in a larger area. There were at least two varieties of the long-haired Briard — wooly and goat haired. The wooly coat, due to its tendency to mat, was not favored and was already disappearing by the mid-twentieth century. The first standard was written in the late nineteenth century, with the first breed club established in 1909.

Recent History

During the First World War, the Briard was employed by the French army and earned an excellent reputation, both at home and abroad, as a messenger, sentry, and search-and-rescue dog. After the war, the breed club reorganized, but when the country was plunged into devastation again, many owners donated their dogs for use as sentries during the next world war. Postwar breeders again picked up the pieces and worked to restore the Briard, which is now found across Europe. Imported to Britain in 1960s, the British Briard Club was established within a few years. The Briard was introduced to Australia and New Zealand as well.

The Briard came to North America in the 1920s, quickly gaining a strong group of admirers who formed the Briard Club of America and achieved AKC recognition in 1928. Beginning in the 1970s, his popularity grew again, and though he remains relatively rare, he is also a familiar breed to the public through his frequent roles on television. Most dogs are companions, although many are involved in various dog sports and activities, including herding.

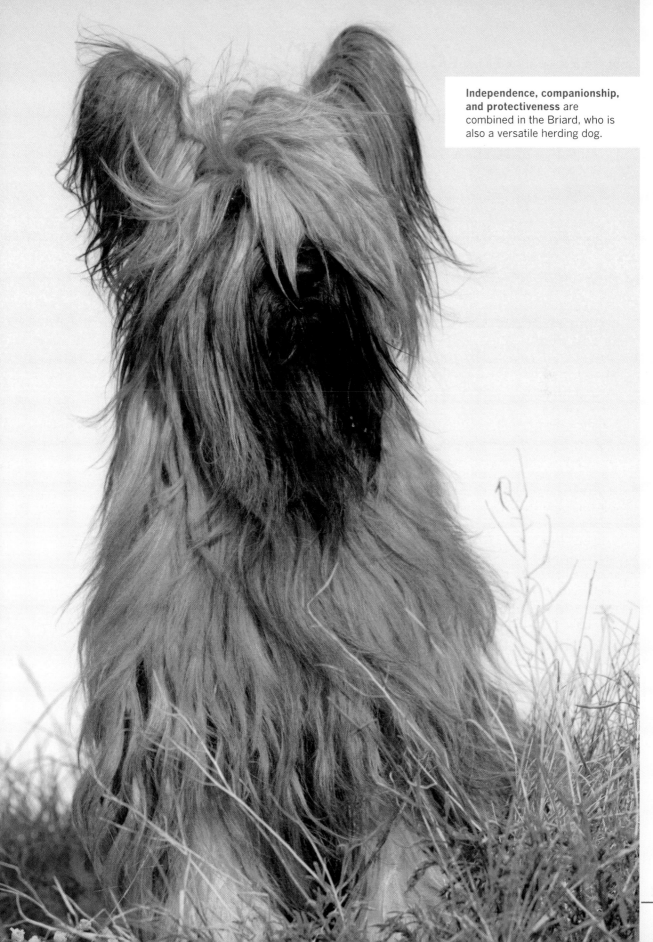

Independence, companionship, and protectiveness are combined in the Briard, who is also a versatile herding dog.

Cardigan Welsh Corgi

COR-ghee		Also known as Cardigan, Cardi

Origin	Wales
Size	10.5 to 12.5 inches **Male** 30 to 38 pounds; **Female** 25 to 34 pounds
Coat	Short to medium outer hair with dense undercoat
Color	Any shade of red, sable, brindle; black or blue merle, with or without tan or brindle points; white markings common
Temperament	Independent, moderate energy, willing, loose eyed, heeler

Cardigan Welsh Corgis (the Welsh plural is *corgwn*) are attentive, intelligent, willing, and quick learners, although their independence can make them a bit stubborn.

These friendly dogs will bark to let you know someone has arrived, but then welcome your guest inside. Although some owners believe they are slightly more aloof and serious than Pembrokes, they are nonetheless affectionate, even-tempered

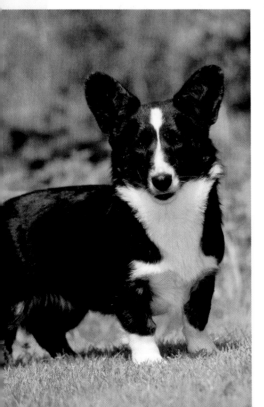

dogs that tend to follow their owners from room to room. With their need to supervise comings and goings in the house or outside, they can get underfoot. They are good family dogs that only rarely attach themselves to a single person. Cardis get along well with family pets, including dogs, and especially other corgis.

Like most herding breeds, Cardis are rule followers. Consistent and enforced expectations of good behavior allow owners to control the natural tendencies to herd or nip, as well as to bark when playing. Cardis do like children and can learn to behave around them. As with all herding dogs, be careful what you reward, because they quickly learn to repeat it. They are food- and reward-motivated learners. If given the opportunity, they overeat; they need to be kept lean to help avoid back and joint problems.

Working traits. The Cardi is a loose-eyed, driving dog who nips at the heels of cattle to move them out. Historically, he also drove strange cattle away, which is useful in moving stock away from gates or feeders. He can display authority in his work and is somewhat pushier than a Pembroke. Responsive to directions, both auditory and visual, he can learn to gather and drive sheep or poultry, although he is obviously not suited to fast or distance work. This can be an advantage for a new handler or someone keeping stock in small pastures.

Many Cardigans show an inclination to hunt rats and other small vermin in barns, making him a favorite of horse owners. Many farm owners find him a versatile, companionable helper, without the high intensity and energy of some other breeds.

Appearance

Though built low to the ground, the moderately heavy-boned Cardigan gives the strong impression of a medium-sized dog — larger, longer, and sturdier than the Pembroke. The chest is broad and deep with an appropriately sized head and muzzle. The erect ears are larger and rounder than its cousin and the head is not quite as foxy. The eyes

are dark except in blue merles when one or both may be blue. The "corgi with the tail" typically carries his brushy tail low and only slightly higher when alert or in movement.

The front legs bow somewhat around the chest and the front feet turn out somewhat but this should not be exaggerated. In general, the Cardigan has slightly longer legs than a Pembroke, but he is still a heavy-chested, long-backed dog, and care should be taken to prevent potential back injuries. Many breeders caution against allowing them to jump off high surfaces or travel down flights of stairs until they are grown.

Coat/color. A Cardigan's short to medium-length outer coat should feel harsh and weatherproof while his undercoat is dense and insulating. Low to the ground, the underparts get wet or muddy more easily than those of a taller dog. While the British have those of a simple guide to color — "any, with or without white markings" — the American standard is more specific. Dogs may be any shade of red, sable, and brindle, as well as a black or blue merle, with or without tan or brindle points. White markings are common in any color, including the feet and legs, the head, neck, chest, and underparts, as well as the tip of the tail.

History

It is believed that the Cardigan is an older corgi than his cousin the Pembroke. Over time, these small but tough Welsh corgis were known by several names. He was at first a *cur* with the old meaning of the word — a drover and watchdog on small farmsteads. *Gi*, or more properly *Ci*, is Welsh for dog and so *corgi* is often translated as

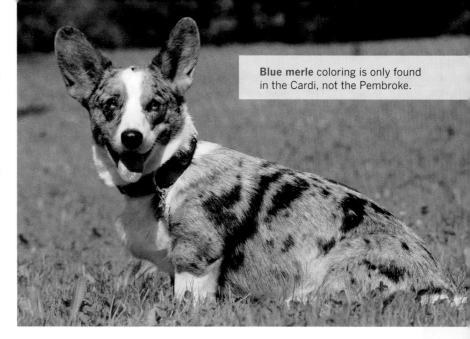

Blue merle coloring is only found in the Cardi, not the Pembroke.

"dwarf dog," but it may also mean "cur dog." In Wales, he has long been called *Ci Sodli* (heeler dog). In Cardiganshire, he was *Ci Llathaid* (yard-long dog). By any name, the original Cardiganshire *corgwn* were all low and long, weighing about the same as a modern-day corgi. Found in shades of gold, reddish-gold, or blue merle, some had rounded drooping ears.

The ancestors of the corgi may have come to Wales as part of the Celtic migration around 1200 BCE. The era of Viking raids and settlements began even earlier than the raid of 865 CE led by the son of the famous Ragnar Lodbrok, and they continued for another 300 years. The Vikings did bring their dogs to their settlements and there is a similarity between the Swedish Vallhund and the corgi. Genetic research may provide more insight into history and relationships between the breeds.

Wales was a Celtic nation until the English conquered it in 1282. *Ceredigion*, or Cardiganshire, was primarily home to fishermen, farmers, and town-based tradesmen who spoke Welsh. It was also home to the Cardiganshire corgi, a devoted

family and farm dog that was used primarily with cattle, but also made itself useful with the other stock and poultry in the farmyard. Until 1875, cattle were grazed on common Crown land, although families were quite possessive of the areas they preferred to use. Corgis were often used to drive away interloping cattle, just as they drove their own cattle and sheep up onto the hills for grazing during the summer days, in order to preserve the lowlands for winter use. They were also very useful drovers for short trips to town and around the cattle markets or yards, but were probably not used for true long-distance droving work. In addition, the corgi served as a watchdog and hunter of small barnyard vermin.

After the open lands were broken up and fenced into separate holdings, farmers on lowland grazing needed more of a fetching dog than the heeling corgi. The hill men kept to their traditional dog more strongly, although numbers began to dwindle. There was some introduction of other herding blood, including the Brindle Heeler and the collie. The resulting dog was still recognizably a corgi in size

and nature but became a bit more refined and a versatile herding dog whose ears now stood up. And it was on the Cardiganshire Hills, centered on the village of Bronant, that the foundation dogs for the contemporary breed were located. In the area, local people distinguished between the Pembroke and Cardigan types, with observable differences in size, color, and tail.

In the early 1900s, the Cardigan began to attract admirers in Wales and across the border into England as well. The hill farms were searched for the best specimens of the old Cardiganshire type. There was some variety in appearance and influence from outside herding and heeler dogs, but a serious effort was made to restore the authentic appearance and temperament of the original dog. In England, the first club was organized in 1926, with a standard adopted two years later.

Both the Pembroke and Cardiganshire corgis were recognized as two distinct breeds from the earliest days of showing, despite the few years the British Kennel Club combined them until they were properly separated again. The Cardi earned a devoted following as a fun-loving family companion but never achieved the popularity of the Pembroke, although this may have been fortunate, as he is today much like the dog found in the hills more than one hundred years ago. The British KC registers about 100 dogs each year.

Across the Ocean

Cardis made their way to the United States in 1931, with the Cardigan Welsh Corgi Club of America founded soon after. At first the AKC recognized the corgi breeds together but they were eventually separated. Early on some dogs found homes on family farms, where they clearly displayed their abilities. The breed was challenged in the 1960s when the eye condition progressive retinal atrophy (PRA) was discovered and dedicated breeders eliminated many dogs from their kennels to stamp out the disease. North American breeders have emphasized good temperament with the possible results that their dogs are somewhat friendlier and softer than those found elsewhere. By the 1990s, the AKC was registering more than 700 puppies a year.

Cardigans came to Canada before World War II, but were never as popular as their Pembroke cousins. The Canadian Corgi Club was recognized in 1981, when the breed was recognized by the CKC, but breeders were active in the American club much earlier. The Cardigan also became established in Australia and New Zealand in the 1950s and '60s, although fewer than 100 puppies are now registered yearly in Australia.

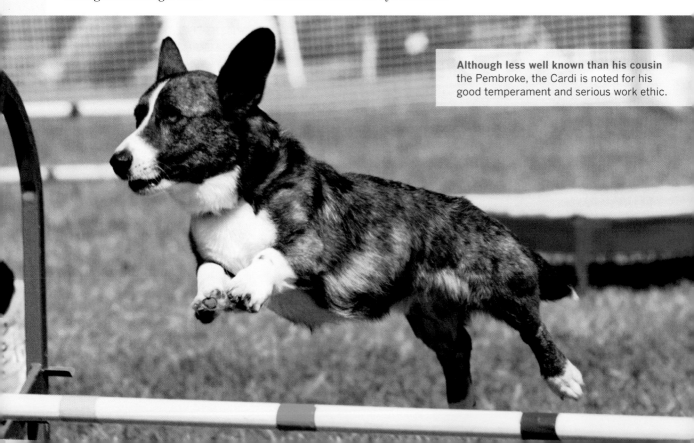

Although less well known than his cousin the Pembroke, the Cardi is noted for his good temperament and serious work ethic.

Rough and Smooth Collies

Also known as Scotch or Scottish Collie

Origin	Scotland, England, Wales, and Ireland
Size	**Male** 24 to 26 inches, 60 to 75 pounds **Female** 22 to 24 inches, 50 to 65 pounds
Coat Rough	Long, straight, harsh outer hair with soft, furry undercoat
Smooth	Short, hard, flat outer hair with soft, furry undercoat
Color	Sable and white, tricolor, blue merle, and white
Temperament	Dependent, moderate energy, low prey drive, willing, soft, upright, loose eyed, gather, close

The Rough Collie is one of the most recognizable and popular breeds in the world, but it shares many traits with its Smooth cousin.

These dogs form affectionate, intense bonds with their families and strongly want to be with their people; left alone too much, they may suffer separation anxiety. Owners report they can be quite sensitive to yelling and commotion. Despite their fondness for children, some dogs may attempt to herd or play too rambunctiously.

Although willing and highly reward motivated, Collies may shut down or become frightened by harsh methods. Although less energetic than other collie breeds, they love running and do need regular exercise. They do well in obedience, agility, and many other dog sports. A Collie can settle down in the house and relax, although lack of activity and attention can lead to destructive behavior or excessive barking.

Collies are often aloof with strangers, although some are very outgoing. The breed gets along well with other dogs and pets in the home and enjoys the company of another family dog. They are also known to be gentle with other animals if socialized to them. Alert and watchful of their home, Collies are not aggressive and tend to accept strange dogs. This is a very vocal breed.

Working traits. Although many Collies do not display strong herding abilities, most are willing to learn and follow direction and so can work capably. The Collie Club of America encourages owners to support herding activities and some dogs are used on small farms. The American Working Collie Association is dedicated to promoting and testing working ability. The upright, loose-eyed Collie is a sweet, gentle herding dog. He can work close using body or bark, but is not aggressive. His soft nature is well suited to work with ducks or lambs, but with sufficient drive and encouragement, he may be able to work with larger sheep or cattle.

Appearance

Under his coat, the Collie is a lean, medium-sized to large dog who should appear balanced and proportionate. British dogs are shorter and lighter in weight than American Collies. The head is very important; it should appear light, smooth, and clean, with a wedge-shape tapering from the ears to the nose with a slight stop. The muzzle is long and smooth but blunt. The almond-shaped eyes should be medium-sized and oblique. Eye color is dark except in blue merles who may have one or two blue eyes. The ears are small, narrow, and folded back although they lift and tip when alert. The tail is moderately long with a swirl at end. Carried low, the tail rises when the dog is alert but is not carried over the back.

Coat. In both Collie coats, the undercoat is soft, furry, and dense. The outer hair of the Smooth Collie is short, hard, and flat. On the Rough Collie, the outer hair is long, straight, and harsh. Ideally abundant, the coat should not be soft, curly, or "open," meaning lacking

163

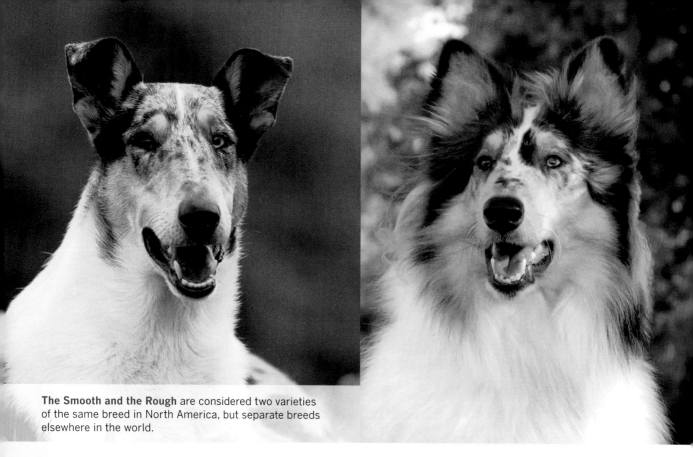

The Smooth and the Rough are considered two varieties of the same breed in North America, but separate breeds elsewhere in the world.

undercoat. The forelegs are well feathered and long and bushy on the hips. The mane and frill should be profusely haired, especially on males; the tail is also longhaired. Rough coats require about an hour of grooming per week.

Color. The AKC accepts four colors including sable and white, tricolor, blue merle, and white. Sable, merle, and white are also allowed by the CKC; the KC and FCI do not accept white. Sable or fawn is seen shades from light gold to dark mahogany with white markings on the chest, neck, legs, feet, and tip of the tail. A white blaze is also permissible on the face or skull. Tricolored dogs are black with white markings and rich tan shadings on head and legs. Blue merle is a silvery blue-gray, splashed or marbled with black, with white markings, with or without tan shadings. White is the least common in North America, where

the sable-and-white has long been the most popular.

While Collie breeders are sometimes criticized for their focus on appearance, this remains a beloved breed. Thanks to the testing efforts of the breed clubs, the Collie is also relatively healthy with a lifespan of 12 to 14 years or more.

History

In Ireland, Scotland, and Britain, different types of collies, including short- or longhaired and bearded dogs, were developed to suit the terrain and needs of the shepherds. Working sheepdogs were bred primarily for performance, not appearance.

Collies were closely associated with Queen Victoria, and while she certainly loved dogs, her collies were rustic or working types that were never shown. However, the Victorian Era saw the development

of dog shows and standardized breeds. The pastime of showing and the practice of improving and standardizing breeds led to breeding kennels owned by both the upper and middle classes. The rustic collie was first exhibited in 1860 as the Scotch Sheepdog, and it quickly came to the attention of the dog fanciers. The British Kennel Club was founded in 1873, and many of the founders were early collie breeders.

These breeders used dogs of Irish, Scottish, English, and Welsh origins. Victorian artists also romantically exaggerated the appearance of the collie, which may have created the ideal image for show breeders to breed toward. In 1885, Rough and the Smooth Collies were identified as separate varieties of the same breed, and both types became increasingly elegant and refined. Several Collie clubs were organized in Britain, a situation that still exists. The Rough Collie

Council was organized in 1966 to coordinate the various Collie clubs.

In the early years of the twentieth century, Victoria's daughter-in-law, Queen Alexandra, further popularized the Rough Collie. In 1908, there were 1,200 Rough and 170 Smooth Collies registered. The Royal Kennels crossed their Collies with another canine aristocrat, the Borzoi. The pups were often given away as gifts, but it is unknown if the Borzoi or any other breed, such as the Gordon Setter, was actually infused into the Collie breed in the early decades. In the years that followed the Collie found homes around the world, becoming a favorite family dog.

Across the Ocean

The first import of the modern Collie to the United States was in 1879, although the country was full of farm collies. The AKC was organized in 1885, and the Collie Club of America was formed by a group of wealthy breeders. J. P. Morgan, the wealthy financier, soon began to purchase Collies from Britain. He and other breeders would eventually pay up to $10,000 for a single dog. Imports would continue until the beginning of World War I, forming the foundation of the American-bred Collie. In 1914, the UKC recognized the breed as the Scotch Collie, a name that was not changed until recently. Most Collie breeders do not prefer either Scotch or Scottish Collie.

The Rough Collie quickly became one of the most popular breeds in North America. This was partially due to a series of books, films, and television programs. The sable and white Lassie was enormously popular and Collies were beloved as a family pet. White Rough Collies enjoyed a period

of attention as well, as the pets of presidents Coolidge and Johnson. Although registration numbers have fallen in the past two decades, the Collie still registers about 4,000 dogs annually.

In Britain, the Kennel Club was registering about 8,000 Rough Collies a year in the 1980s. Recently numbers have fallen quite precipitously, with some 1,000 Roughs and only 30 to 40 Smooth Collies. The Smooth Collie is now considered a vulnerable native

breed. In 1993, the KC made the decision to divide the two varieties into separate breeds, and this is how they are viewed worldwide except in the North America, where it is permissible to interbreed the two varieties. In North America, Smooth Collies have recently become more popular with agility enthusiasts. In Australia, ANKC registers about 375 Rough Collies and 50 Smooth each year.

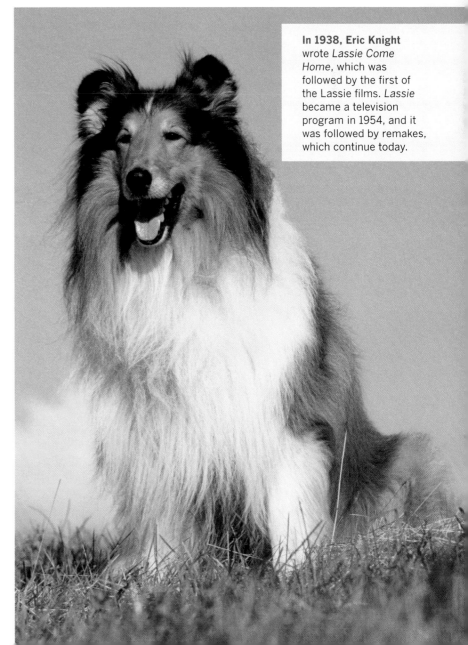

In 1938, Eric Knight wrote *Lassie Come Home*, which was followed by the first of the Lassie films. *Lassie* became a television program in 1954, and it was followed by remakes, which continue today.

Dutch Shepherd Dog

Also known as Hollandse Herder, Dutchie

Origin	The Netherlands
Size	21.5 to 24 inches, 50 to 70 pounds
Coat	Short, long, or wiry outer hair with wooly undercoat
Color	Shades of gold or silver with brindling
Temperament	Independent, high energy, high prey drive, hard, upright, loose eyed

Dutchies are intelligent, persistent, and loyal workers, but they are also independent thinkers.

These alert, active dogs need considerable physical and mental exercise as well as an experienced owner. They do very well in obedience, searching, tracking, and other dog sports. Socialized Dutch Shepherds should get along with other family pets, dogs, and farm stock. Some Dutchies can be territorial or have a tendency to form strong attachments with one person.

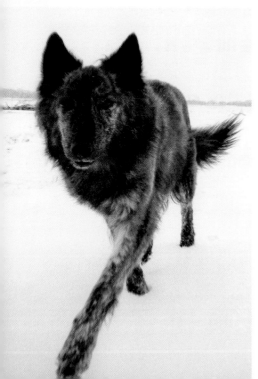

Be aware that Schutzhund or bite work breeders may cross-breed the Dutch Shepherd with the Belgian Malinois or other breeds. These dogs may have a certificate as a Hollandse Herder Cross (HHX). Many of dogs with HHX pedigrees are bred in North America for use as bite sport, Schutzhund, personal protection, police, or military dogs. These dogs are not desirable for a traditional working farm dog. Some observers believe the longhaired Dutchie, which is bred primarily as a companion, has a more reliably calm and mild temperament.

Dutch Shepherds are very useful farm watchdogs and guardians, droving style herders, and cart dogs. As herders, they tend to work close with an upright, loose-eyed style, but they also share a tending background of keeping stock out of crop fields.

Appearance

Dutch Shepherds are medium in size and bone, appearing rectangular. Weight is not specified but although muscled and fit, the Dutchie should never be a heavy dog. The Dutch Shepherd is generally smaller than both the Belgian and German Shepherds, although casual observers often mistake a Dutchie for one of these breeds. The wedge-shaped head is somewhat elongated, with a slight stop. Due to the coat, the head of a wire-coated dog may appear square or larger than it really is. The dark eyes are almond shaped and the medium-sized ears are carried high and erect when the dog is alert. At rest, the tail is carried down or slightly curved, rising upwards when moving.

Coat. There are three coat varieties, all double: short, long, and wire or rough. Shorthaired dogs have a good double coat that should be weather resistant. This type also has a ruff, along with some feathering on the hind legs and tail. Longhaired coats have straight hair, without any waves or curls. Rough or wirehaired dogs have a thick, harsh coat that appears tousled.

To promote conservation of the gene pool, regulated interbreeding between Dutch Shepherd coat types is permitted in the Netherlands from 2014 until 2034. This does result in some intermediate coat types that might not be correct for

the show ring, but perfectly suitable for a working or companion dog. In North America, the long- and wire-haired types are less common than the shorthaired.

Color. Dutch Shepherds are a brindle-colored breed. The base color may either be a shade of gold, from light fawn to dark red, or silvery white. A black mask is permissible. Brindling is sometimes hard to see in a rough- or wire-coated dog or in a dog whose stripes are so numerous as to appear nearly completely dark. Too much black color, as well as large white markings on the feet or chest, is not desirable.

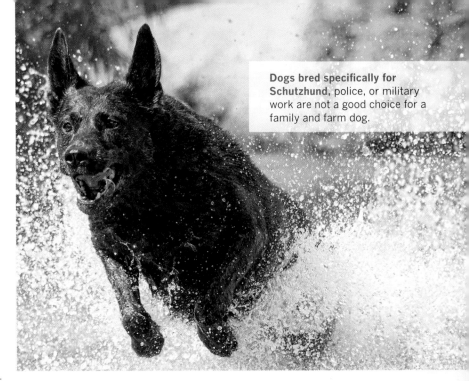

Dogs bred specifically for Schutzhund, police, or military work are not a good choice for a family and farm dog.

History

The roots of the Dutch Shepherd lie in the farming and sheep-raising countryside of the Netherlands. This dog was found on many farms performing several helpful jobs from watchdog and milk-cart duties to moving dairy cattle in the farm-yard, tending sheep, and droving animals to market. There was wide variety in coats, as still seen today, but also in color including yellow, shades of fawn, and white, in addition to brindle. Most likely these Dutch dogs, often called Hollanders, were related to their old Belgian and German herding cousins.

As sheepherding declined, the need for dogs declined and many of these intelligent, multipurpose landrace types were threatened with extinction. The Nederlandse Herdershonden Club was founded in 1898, created an early standard, and began to register shepherd dogs with a wide variety of coats and colors. Over a few years, different goals and purposes developed among the shepherd fanciers. The Royal Dutch Police Dog Association (KNPV) was founded in 1907, and is well known today as a premier organization that tests police dog candidates. The KNPV and other programs were organized to breed Dutch, Belgian, and German Shepherds for new work as police or military dogs, search-and-rescue dogs, and Seeing Eye dogs.

In an effort to distinguish the Dutch Shepherd from its Belgian and German neighbors, the color restriction of brindle-only was added to the standard in 1914. Unfortunately, this also limited the breeding population, as did the world wars. At various times, dogs with other coloring, including white, were allowed in the Dutch Shepherd registry, as well as some German Shepherds in the early twentieth century, and Belgian Malinois, Laekenois, and Tervuren after World War II. The German Shepherd introduction was not highly regarded in many ways and was eventually eliminated. The Tervuren and Laekenois influence is clearly recorded in the registry records, but the Malinois contribution has been greatly reduced or nearly eliminated today. Today the Dutch Shepherd, Belgian Shepherd, and German Shepherd are very clearly different breeds.

The breed club has very specific goals for the preservation of the Dutch Shepherd as a distinctly Dutch medium-sized, multipurpose breed. The breed remains rare but has achieved FCI recognition. Dutch Shepherds are also found in Scandinavia, France, Germany, and Switzerland.

In North America, Dutch Shepherds are recognized by the CKC and UKC and have been entered in the AKC FSS program. The American Dutch Shepherd Association is endorsed by the Dutch breed organization and remains committed to its standard. The Dutch Shepherd exists as a purebred dog in the Netherlands, but the larger Dutch Shepherd population bred by the KNPV and other police or sport breeders is typically a crossbred dog selected for that purpose.

English Shepherd

Also known as Sheppie, ES

Origins	United States
Size	18 to 23 inches, 35 to 65 pounds
Coat	Medium length, straight, wavy, or curly outer hair with soft, fine undercoat
Color	Black and tan; tricolor (black, tan, white); black and white; sable and white.
Temperament	Independent, moderate to high energy, high prey drive, upright, loose eyed, close, heeler, grip

The best home for an English Shepherd is with an active rural family where he has a job to do and can be in the company of his people.

The breed is a famously willing and hard worker that quickly learns farm and family routines. He forms close bonds with his owners, at times becoming a one-person dog. He is well suited to the role of chore companion and follows his owner from room to room, which is how he earned the nickname "the English Shadow." Usually very kind with children, he may attempt to herd them or chase cats, cars, and cyclists.

The moderately to highly energetic English Shepherd will be calm and relaxed in the house provided he receives enough exercise. Some dogs are fine with an hour or so of daily activity, while others need more exercise and purposeful work. Although most English Shepherds are family companions or working dogs, they do well in dog sports like obedience or agility and tracking or search and rescue. Owners caution that because of significant variation in the breed — physically, temperamentally, and in regard to working ability — some lines are more suited to specific tasks.

Working traits. An independent breed, English Shepherds are strong-willed self-thinkers and problem solvers who need socialization, confident handling, and consistent rules. While they aren't dominant, they do try to enforce the rules on people and family pets. They also maintain order around the farm, keeping stock in their proper locations. Owners report that English Shepherds are more trustworthy with stock on the farm than many other herding dogs, and can be taught not to harass or bother them when not working.

Usually reserved with strangers, the English Shepherd is a good watchdog, although some are more protective than others. They also tend to be territorial and less likely to roam or leave home. Often aggressive toward small predators around the farm, they are not large enough to deal with major predators. Some English Shepherds have a stronger hunting instinct than others, especially toward squirrels, rats, and mice. A strong prey drive can also lead to chasing or killing small domestic animals.

The English Shepherd is a versatile, multipurpose herding dog,

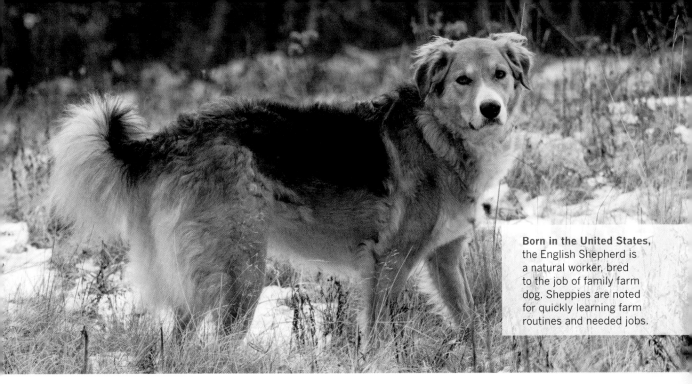

upright and loose eyed but showing stamina, grit, and power when dealing with difficult animals. Naturally a low heeler, he drives from the rear and has a moderate grip. He adjusts his approach when dealing with different kinds of stock, such as lambs or poultry. He gathers and drives, and can also head but is not especially vocal. The English Shepherd is especially helpful with chores around the barnyard, dairy cattle, and small flocks or herds.

Appearance

The English Shepherd is a medium-sized dog, slightly longer than tall. While dogs may vary between lithe or slightly stocky, they must be agile, strong, and fast. Larger dogs are not common and females are usually smaller than males. The head is broad and slightly rounded, with a moderate stop, and a moderately broad muzzle. While the head may be slightly wedge-shaped, it does not have the nearly straight profile found in a Rough Collie. The ears are placed widely apart, folding close to head when the dog is relaxed and usually rising slightly when he is alert. While they are often semi-pricked, ear set may vary a great deal and that is completely acceptable. The brown eyes are moderately round and set more on the front of the face than the side. Tail carriage and length also vary, but the tail is usually held low, rising higher with a slight curve when active. About 15 percent of dogs have naturally bobbed tails, but the tail is no longer docked.

Coat. The English Shepherd is double coated, with medium-length hair that may be straight, wavy, kinky, or curly. The undercoat is soft and fine. The texture is neither too soft nor harsh, but should be weatherproof and glossy. The hair is short and smooth on the face, the skull, and the front of legs. The coat has moderate feathering and breeches and the tail is plumed. An excessive mane, heavy frills, or long hair is not desirable. The coat should need only minimal grooming.

Color. Traditionally, English Shepherds are seen in four color combinations: black and tan, tricolor, black and white, and shades of sable and white. Sable dogs may have black-tipped hairs, a black saddle, or a mask. The UKC allows shades of fawn to red tan and white. White markings may be found on the face, neck, chest, lower legs, and the tip of the tail. White should not cover more than 30 percent of the body. A black mask is permissible on any color. Solid red or black dogs are uncommon and not preferable. Blue or red merle, white with spots, or all-white dogs are not found in the breed.

History

Despite his name, the English Shepherd is actually American born and bred. Colonists who came to the New World brought many types of dogs with them, including sheepdogs or collies, most often from England, Wales, Scotland, or Ireland. From this melting pot, dogs were further

selected for hunting and farm work in a new environment. Where the multipurpose, short-coated cur was best suited to the warm, humid temperatures of the South, longer-haired, double-coated farm collies could better tolerate the climate in the East and Midwest. Although bearded dogs were also present, the medium-haired collie or shepherd dog was often more favored. From the nineteenth century onward, many family photographs include a farm collie that looks much the same as the English Shepherd of today.

Essential to agrarian life, this multipurpose, humble farm dog was commonplace on small family farms and one of the most numerous dogs in America. Watchdog and family companion, he also controlled vermin around the barns and outbuildings. He handled various kinds of stock in the barnyard and nearby pastures, including dairy cattle, multipurpose cattle, goats, sheep, swine, and market flocks of ducks, geese, or turkeys. The farm collie was particularly good at learning routine tasks and being independently useful for bringing in dairy cows for milking or other daily chores. He was sometimes used for hunting, tracking, or treeing for squirrels, opossums, or raccoons and other small predators around the farm.

The farm collie went by a variety of names: English Shepherd, Scotch Collie, farm shepherd, old-fashioned collie, Victorian Collie, old-time farm shepherd, and others. Most likely the name English Shepherd was favored because the dogs looked and acted like the old rustic collies or shepherd dogs from Britain.

The English Shepherd is often confused with either a Border Collie or an Australian Shepherd, the other American-bred farm and ranch dogs. Inevitably there would have been some crossbreeding between farm collies, Australian Shepherds, and Border Collies, although there are distinct differences among them. The smaller Border Collie was developed for a strong eye, an intense stalk and crouch, and the ability to move stock in a silent, highly controlled manner.

Developed in the western states, the Australian Shepherd was used with large flocks or herds and to work in close, tight spaces with range cattle or sheep. Aussies are also closely associated with a distinctive blue or red merle color, which is not seen in the English Shepherd. The upright, loose-eyed English Shepherd was primarily found in the eastern half of the country as an all-purpose dog on small farms. And he is still well suited to this purpose today.

Not an AKC Breed

Practical and native working dogs, they did not attract the attention of the AKC show breeders in the United States despite their widespread popularity. Beginning in the 1950s, stockmen and farmers began registering their homebred English Shepherds in the Animal Research Foundation or the National Stock Dog Registry. As a working dog registry, the UKC had been registering farm collies as American Farm Shepherds since 1927.

The breed was officially renamed the English Shepherd in 2003 and included in conformation shows for the first time. There was much opposition to the idea of conformation showing among owners and breeders, who feared breeding for appearance over working ability. The English Shepherd Club maintains an independent public registry and a database that shares evaluations of the working characteristics, temperament, and structure of individual dogs. Some dogs are registered in more than one registry, often to facilitate entry in herding events.

The English Shepherd does not have the public recognition or popularity of the Australian Shepherd, but the majority of breeders prefer a natural working breed and have no wish to seek AKC recognition. A few English Shepherds have also made the trip back to England, where they remain rare.

Other Landrace Collies

For several years there was much interest in preserving the Old Time Farm Shepherd, Old Farm Collie, Farm Collie, or Scotch Collie as different landrace types. Several organizations were formed but it appears that many of these dogs are now registered as English Shepherds.

Old Time Scotch Collie Association — Landrace collies within a broad standard, focused on working ability and temperament. All colors and markings acceptable.

American Working Farmcollie Association — Primarily English Shepherds, but registers all collie breeds.

German Shepherd Dog

Also known as Deutsche Schäferhunde, Alsatian (Britain), GSD

Origins	Germany
Size	**Male** 24 to 26 inches, 66 to 88 pounds **Female** 22 to 24 inches, 48 to 70 pounds
Coat	Medium length or longhaired with soft undercoat
Color	Most colors allowed, except white
Temperament	high to moderate energy, high to moderate prey drive, high to moderate reactivity, hard to soft, willing, upright, loose eyed, tender

A German Shepherd Dog should be steady, courageous, watchful, and reliable. He should be aggressive only if provoked.

Intelligent and willing, he forms close, loyal, affectionate bonds with his owner. According to the standard, a GSD should be an all-around working, herding, and service dog who can be used for many different activities. He can be a fine choice for a rural or farm property. GSDs should accept other family dogs, although same-sex dogs can be problematic. With a strong prey drive and herding instincts, dogs may chase or kill small pets or animals. A well-bred GSD should behave appropriately with children.

Over many decades of popularity, the German Shepherd has been developed into two distinct styles: the traditional German type, with a stockier build and straight topline, and the more lightly built American type with greater angulation of the hindquarters. German- and American-style dogs differ in temperament as well as appearance. German-style dogs tend to be harder and more serious workers, with more desire to please, a stronger prey drive, and more reactive natures. These dogs have an extremely high energy level with a need for more exercise and mental activities. American-style dogs tend to be mellower, better sociable family companions, and less driven and reactive.

The reality is that both German- and American-style dogs are being bred in North America and in other countries. Unfortunately, there are also unscrupulous breeders who produce poorly bred dogs. With such a large population, GSDs have variable temperaments and personalities depending on a breeder's lines, selection choices, and purposes.

Prospective owners need to research the lines being used by breeders and ask where they place their dogs. Either style of GSD may suit a particular owner's purpose, but a family does not need a particularly dominant, assertive, high-drive, or aggressive dog, even if they want their dog to provide protection; GSDs are already naturally protective and territorial. Obedience training is both a must

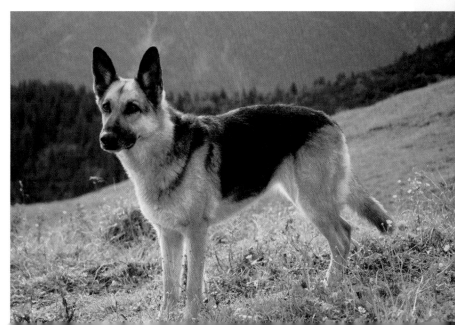

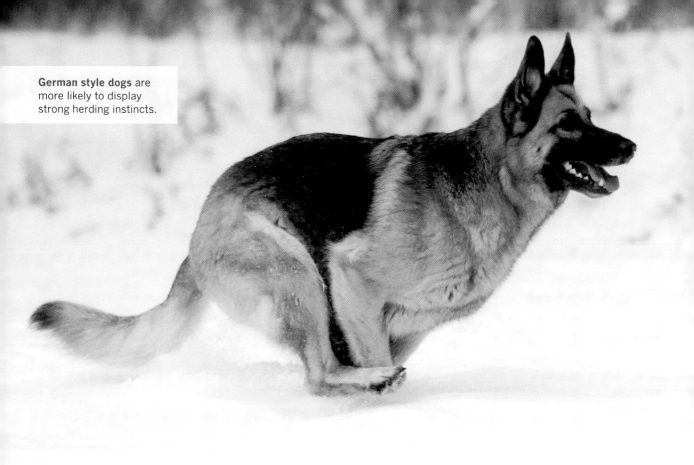

and a natural fit for a GSD. This breed needs a confident owner who provides positive training, because these dogs do not respond well to harsh methods. A dog trained for serious personal-protection work definitely requires a stable, sound temperament coupled with professional training.

Working traits. German Shepherd Dogs are not used very often for actual sheepherding in Germany, since other breeds tend to do that work. However, many GSDs are used in herding trials, such as the German HGH (Herding Utility Dog) tests. The GSD is a classical tender, creating a "living fence" between the sheep and cropland. A German Shepherd Dog moves back and forth, patrolling the boundary line, while keeping an eye on the sheep.

He is an upright, loose-eyed herder who can be taught to gather

or drive but should not display strong circling behavior. In testing situations, the GSD should not circle behind a moving flock, since he is required to change sides in front of the shepherd who is ultimately responsible for leading the flock. GSDs have a great urge to travel in a straight line, useful information when using these dogs in other activities. Traditionally, they do not bark when working with sheep but use a strong grip on the wooly areas. While German-style dogs are more likely to display strong herding instincts, all GSDs are willing, intelligent dogs who seek to please their owners.

Appearance

One of the most recognizable dog breeds, the German Shepherd Dog is medium sized and slightly longer than tall with a powerful,

athletic appearance. The head is an important feature: wedge-shaped, chiseled, and gradually sloping into the long, powerful muzzle. The dark eyes are medium sized and almond shaped and set slightly oblique. The erect, medium-sized ears should point forward.

The topline should run down a straight back to a slightly sloping croup to the base of the tail, which is carried down in a gentle curve. The tail may rise to level when the dog is moving. The German Shepherd's natural gait is a strong, extended trot. The German standard cautions that over angulation of the hindquarters reduces stability, stamina, and working ability.

German dogs are more variable in appearance since working ability is considered more important, while American breeders have focused more on appearance

and gait. Many observers note that German-style dogs tend to have larger heads, a shorter back, and less angulation than the more elegant American dogs. American lines tend to have more refined heads, more angulation in the hind legs, and a greater slope to the back line.

There is much criticism and controversy over this physical issue, in particular as typified by the exaggerated show stance or pose. Discussion over reversing this course of development is ongoing. American-style dogs tend to excel in the show ring, while German dogs are better suited to working as police or military dogs.

Coat. The GSD is doubled coated with harsh, straight outer hair that is short to medium length. Slightly wavy or wiry hair texture is permissible. The hair on the neck is longer and fuller, with fringes on the backs of the legs, and a full tail. This coat is referred to as a normal or "stock" coat.

German and FCI standards also include a second double-coated variety, called a "long stock coat." The hair is longer, fuller, and softer. It forms a mane on the neck, with tufts on ears, heavier fringes and trousers on the rear legs, and a bushy tail. Long silky coats and little to no undercoat are not acceptable. For 40 years, long coats were not allowed in the show ring or used for breeding, but this decision was reversed in 2010. The two coat varieties are not crossbred.

Color. German Shepherds may be variously colored with the strong, rich colors preferred. They are generally black with reddish-brown, brown, yellow to gold, or light gray markings. Dogs can also be single-colored, black or gray with darker shading, saddle, and mask. Underparts can be lighter in color and small white markings are acceptable. Pure white color is not allowed. Washed-out colors, blues, and liver colors are not desirable.

In North America, popularity also rebounded after World War I. Based on a program developed in Switzerland, a Seeing Eye Dog school was founded in New Jersey in 1929. The program gained national attention through the efforts of Morris Frank and his German Shepherd guide dog Buddy. Also important were the famous film dogs Rin Tin Tin and Strongheart. Rin Tin Tin himself was a survivor of the war, brought home by an American serviceman.

History

The heritage of the much beloved German Shepherd Dog is found in the traditional sheepherding breeds found throughout the countryside of Germany. While there was some transhumance in the Alps and shorter summer journeys of 20 miles or so, the *altdeutsche schäferhund,* or old sheepdogs of Germany, generally worked closely each day with a shepherd. Shepherd and sheepdog took sheep or cattle out to graze during the day, kept them in selected, unfenced areas away from cropland, and returned the stock to the farm in the evening. At times the sheepdogs were used as drovers; most often, however,

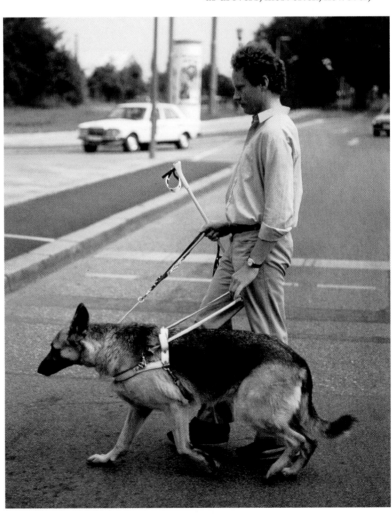

173

they worked as both drovers and general farm dogs and protectors.

These old German sheepdogs varied widely in appearance and went by a variety of local names, such as *Schafpudel*, *Kuhhund*, *Fuchs*, *Tiger*, *Schwarzer*, *Gelbbacke*, *Stroebel*, and *Alpenhütehunde*. Today, some of these surviving old types are being registered by the Altdeutscher Hütehunde, an association for old German shepherd dogs.

Captain Max von Stephanitz and others came to believe that many of the working sheepdogs in Germany were too small and lacked standardization. Beginning in 1889, Stephanitz led an effort devoted to the task of producing the perfect working German shepherd dog. The guiding principle was utility and intelligence over appearance or beauty; beauty would flow from excellent working ability. The official club, the Verein für Deutsche Schäferhunde (SV), was soon established along with a registry.

Horand von Grafrath, the first dog to be registered, was a Thuringian-type, wolf-gray, medium-sized dog, although his maternal grandfather was white. Stephanitz heavily inbred his early dogs to standardize and unify the bloodlines he was creating. He used his two primary founding male dogs on a wider pool of females, all primarily selected from the herding dogs of Thuringia and Wurttemberg. Physical traits such as larger size and bone, a swift trot, erect ears, and a wolflike appearance were highly favored. Two outside dogs and four wolf crosses were also supposedly entered into the studbooks, although genetic testing has revealed that wolf genes appear to be virtually nonexistent.

In 1899, the first German Shepherd specialty show awarded the titles of *Sieger* and *Siegerin* ("winner") to the best male and female, a tradition which continues today at the famous GSD Sieger shows. Within a decade, the popularity of the German Shepherd Dog grew rapidly, along with exports to other European countries. Concerned by the loss of agricultural work with the growing industrialization of Germany, Stephanitz created a series of tests that dogs had to pass before being allowed to breed. These tests led to the modern Schutzhund trials.

During the years of World War I, the German Shepherd Dog proved itself when it was used in large numbers by the German forces as a messenger, sentry, rescue, and guard dog. By 1925, the breed was clearly and recognizably a German Shepherd, although over the years the confirmation moved from a rectangular shape to a more sloped silhouette with greater hind end angulation.

Across the Ocean

The first registered GSD came to America in 1906, with the AKC recognizing the breed two years later. The German Shepherd Dog Club of America was founded in 1913. During the war years, anti-German sentiment in both Britain and the United States led to some interesting name changes. The AKC and the breed club temporarily dropped the word *German*, while the British Kennel Club registered the breed as the Alsatian Wolf Dog, a name that lingered until the 1970s. Nevertheless, the Alsatian became the most popular breed in Britain in the years following the war's end. By 1926, there were more than 8,000 Alsatians in the country.

By the mid-1920s, the annual registrations of German Shepherd Dogs surpassed 21,000 dogs a year in America and the breed had become one of the most well-known in the country. Unfortunately, to meet this demand for "German police dogs" too many puppies were bred indiscriminately and the breed's reputation suffered. In Germany, the SV had enacted strong breeding regulations and judging systems to ensure the breeding of quality dogs, but there was no such oversight in America.

As the breed's popularity grew worldwide, German Shepherd Dogs were imported to Australia in the 1920s. However, alarmed by the name Alsatian Wolf Dog and the belief that the dogs were bred from wolves, stockmen became concerned the dogs were dangerous and would interbreed with dingoes creating a larger, more powerful sheep predator.

Although these fears were all unfounded, the Australian government instituted severe restrictions including an eventual ban on the import of German Shepherd Dogs and prohibited breeding of the existing dogs in Western Australia and the Northern Territory. Breeders and their clubs struggled with limited bloodlines through the next several decades. The German Shepherd Dog Council lobbied successfully to have the ban lifted in 1974.

Post–World War II

World War II marked the beginnings of the perceived division in breed type between Germany and North America. American breeders had concentrated on certain lines, developing a dog with an extremely sloping back and sharply angled rear joints. This "American" show preference was also seen in British, Canadian,

Australian, New Zealand, and European show dog lines.

German breeders were faced with rebuilding their populations after the Second World War. Postwar years saw the development of even stronger working qualities shaped by the SV, with show dogs being required to complete a Schutzhund and endurance test. In Europe, breeding German Shepherds must earn Schutzhund, herding, or police dog certification. In Germany, hip x-rays are mandatory along with inspection of litters. The result is a darker, larger, high-quality working dog, with a strong, straight back. The German type GSD is sought around the world as a serious working dog. In 1974, the influential World Union of German Shepherd Dog Clubs was established to support the German standards of breeding and training.

Today the German Shepherd Dog is found worldwide, and the SV is the largest dog breed club in the world, with 100,000 members.

The GSD is the second most popular dog registered by the AKC, and breeders of both American and German style dogs are found in North America. Most German Shepherd Dogs are family companions and are also involved in many dog sports, as well as in therapy, guide, or service work. Working-style German Shepherds are heavily used in Schutzhund and other activities, as well as serving in protection, police, military, and other detection work.

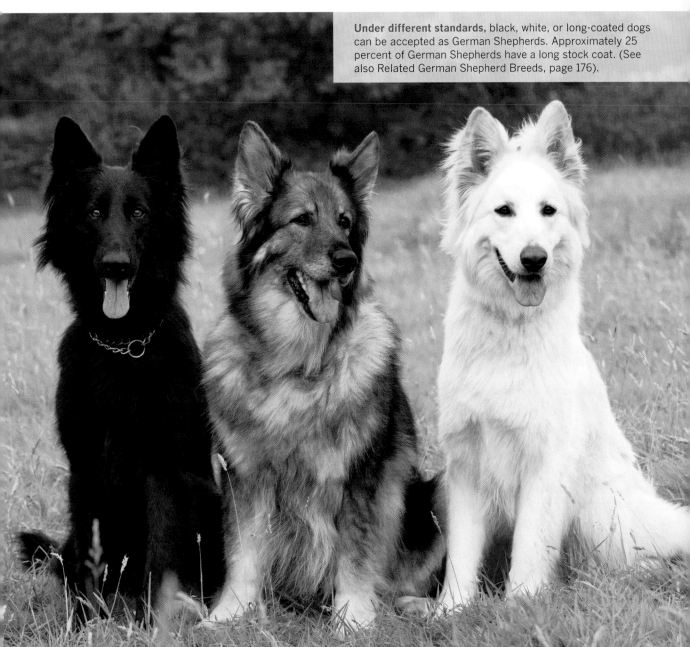

Under different standards, black, white, or long-coated dogs can be accepted as German Shepherds. Approximately 25 percent of German Shepherds have a long stock coat. (See also Related German Shepherd Breeds, page 176).

Related German Shepherd Breeds

These breeds and several others have been developed based on German Shepherds or are registered German Shepherds themselves. Prospective buyers need to do thorough research and meet the dogs to assess temperament. Not all of these dogs are being bred for true working abilities.

In particular, huge dogs can bring with them a host of bone and joint issues, so all dogs should come from stock that are carefully tested for hip and other issues. Giant size is also not generally conducive to serious working ability, as it impairs agility, speed, and endurance.

Old German Shepherd Herding Dogs

The umbrella group Altdeutscher Hütehunde promotes various unrecognized but landrace herding breeds in Germany. Some of these breeds are the heritage sources for modern breeds, such as the German and Belgian Shepherds, along with some others. The registry is not concerned with appearance but soundness and working ability. The organization also supports sheep-herding and shepherds.

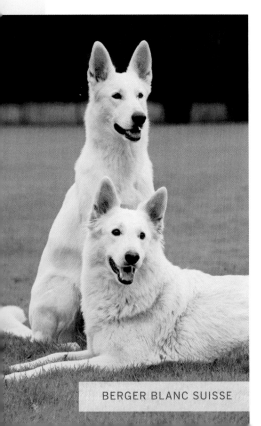

BERGER BLANC SUISSE

Berger Blanc Suisse/ White Swiss German Shepherd

The Berger Blanc Suisse is recognized by the FCI as a separate breed. After the German and FCI standards barred white dogs from the German Shepherd show ring, interest grew in preserving the white color in a breed descended from registered German Shepherd lines imported from North America to Europe. The Berger Blanc Suisse is a medium-sized breed, more upright in stance, and more relaxed in temperament than a German Shepherd. Berger Blanc dogs are not generally considered police or military dogs, but are working, show, and companion dogs. The registry is open to approved white German Shepherds as well. They are bred in Europe, North America, Australia, and New Zealand.

King Shepherd

The King Shepherd is a more recent creation in the United States, using American-bred German Shepherds, Shiloh Shepherds, and the longhaired variety of FCI German Shepherds. Outcrosses were also made to Malamutes, Great Pyrenees, and other breeds. King Shepherds are much larger than registered German Shepherds, have a straighter back, and are available in a coarse and a long coat, as well as a wide variety of colors. No major kennel club recognizes the breed, although there is an independent registry.

Old-Fashioned German Shepherd

There are many independent breeders of dogs variously described as larger, oversized, old-fashioned, old-style, old-world, or long-coated German Shepherds. Some of these dogs are registered German shepherds selected for specific traits or size, while others are not and may contain outcrossed breeds.

Shiloh Shepherd

The Shiloh Shepherd was originally the creation of a single breeder in the United States who wished to develop an old-fashioned German Shepherd–type dog. AKC-registered German Shepherds were the foundation dogs; however, they were selected for much greater size, a level back, two coat varieties (smooth and long or plush), a more relaxed temperament, and a wide variety of colors. Outcrossing to other breeds was also part of the breed development. No major kennel club recognizes the breed, although several clubs and registries have been organized. There are disagreements and differences of opinions between competing registries.

White Shepherd

White Shepherds in North America come from registered German Shepherd stock. Many of them are actually AKC-registered German Shepherds with white coloring that bars them from the show ring, although not AKC performance events. White coats, long present in the breed, were banned in the German standard. The AKC followed this precedent in 1959, followed by the CKC in 1998. Whites are considered highly undesirable in the British KC standard. In response, White Shepherd clubs were formed to promote and protect the dogs. The UKC German Shepherd standard recognizes both traditionally colored and white dogs.

The UKC also recognized White Shepherds as a separate breed for both show and performance events. Although White Shepherds are a direct descendent of German Shepherds, the UKC standard calls for less angulation, a flatter topline, and a squarer, more upright appearance. Both smooth and long double coats are permissible. Colors range from light cream to light biscuit with pure white being the ideal. White Shepherds are a working breed and they are moderately sized.

American Alsatian/Dire Wolf Project

In an effort to develop a larger German Shepherd–style dog but with several outcrosses to other breeds, this group has shifted its focus to its Dire Wolf Project. This is an attempt to create a dog who resembles the dire wolf, a member of the *Canidae* family that became extinct over ten thousand years ago. Dire wolves came to the attention of the public with the *Game of Thrones* books and television series, which actually used northern Inuit dogs and CGI to recreate the look of a fictional, gigantic wolf. This is *not* a working dog.

Icelandic Sheepdog

Also known as ISD, Icie

Origin	Iceland	
Size	20 to 35 pounds **Male** 18 inches; **Female** 16.5 inches	
Coat	Medium and longhaired varieties with soft undercoat	
Color	Tan in shades of cream to reddish brown, chocolate brown, gray, and black; black tricolor. All with white markings. Tan and gray may have black mask.	
Temperament	Dependent, moderate energy, willing, soft, loose eyed, fetching	

Icelandic Sheepdogs are noted for their alert, inquisitive, confident, and lively personalities.

This breed truly craves human interaction and attention, which it returns with loyalty and affection. While they are also enthusiastic learners and workers, they need a gentle hand in training to deal with their sweet or soft natures. Icies do not do well when left alone for long periods of time and can develop separation anxiety. They are also barkers, as they use their voice in their work of fetching and driving.

They often bark at birds, since chasing away birds of prey was a traditional responsibility as well. They also bark to announce visitors but are not naturally aggressive.

As herding dogs, their strong desire to chase objects means they absolutely need to be in safely fenced areas or on a leash. Although they have excellent endurance, Icies generally do not have high amounts of energy. Regular exercise and activity suit them, although some individual dogs have greater needs. They adapt well to life as a family companion. Icies are accepting of other family pets and dogs. Males tend to be more affectionate than females.

Working traits. The Icelandic Sheepdog is still used as a herding dog in his homeland and elsewhere. Upright, with a loose-eyed gathering style, he drives stock forward with barking, pushing, and even some gripping. He works in a horseshoe pattern, running back and forth to push stock into pens. Farmers were often on horseback during spring and fall movement of stock, so the Icie tends to work quite independently when needed. Due to his close

association and history, the Icie gets along particularly well with horses. He can work alone or in groups of two or three.

Appearance

Icelandic Sheepdogs are a small- to medium-sized spitz breed and rectangular in shape. Sizes vary somewhat, but females are definitely smaller and less stocky. The head is triangular, with some stop, medium-sized prick ears, and almond-shaped, dark-colored eyes. Double dewclaws are desirable on the rear. The curly tail is set high and touches the back.

Coat/color. The Icie has a very thick double coat, with coarse, waterproof outer hair. The coat comes in two varieties — short and long. Although called short, the coat is really of medium length. Both types of dogs have bushy tails.

Several colors are seen: a tan that ranges from cream to reddish brown, chocolate brown, gray, and black — all with white markings and often lighter shading on the underparts. Some darker-colored tan dogs have very little or no true white markings, only lighter tan. Black masks, hair tipping, and a few black hairs are often seen on tan and gray dogs. Black dogs are actually tricolored with tan markings over the eyes, on the cheeks, and on the legs. Tan dogs and black tri- colors are the most common. Wolf- gray has become rare.

History

Beginning in the late 800s, many Norse settlers made the 900-mile ocean journey to Iceland in large open Viking ships. They brought livestock, chickens, and dogs to their new home, which had no native animals other than insects, birds, the shy six- to eight-pound arctic fox, and an occasional visiting polar bear. The Viking settlers found a forested land with a challenging climate, active volcanoes, thin soil, and limited arable land. Fishing and farming were essential to survival. The farms were separated from each other, not clustered together as closely as in their homeland. Within a short time, all of the useable farmland was occupied and over time the island was overgrazed by sheep, as well as being greatly deforested and much eroded.

Each of the domesticated animals, all of Norse ancestry, eventually became a distinctive breed — Icelandic sheep, horses, cattle, goats, chickens, and the Icelandic Sheepdog — found only on their shared, isolated, island home. The herding and farm dogs were from the same stock as the Norwegian Buhund and Swedish Vallhund. Genetic research has shown a relationship between the Icelandic sheepdog of today and the black and white Karelian Bear Dog from Finland.

Remarkably, the Icelandic sheepdog became well known in Europe quite early. Described in 1492, the dogs are mentioned even earlier in the *Icelandic Sagas*, which relate stories of life in the tenth and eleventh centuries. Caius, in his famous study of British dogs in 1570, described the native Icelandic breed, as did the naturalists Buffon and Linnaeus. By most accounts, the Icelandic sheepdog looked foxlike, with prick ears and a long, thick coat. Royalty and wealthy people sometimes kept them as pets, but they were also sought after by working sheepmen in England.

What made a sheepdog from a small, sparsely populated island close to the Arctic Ocean so desirable? The lack of serious predators, or even a multipurpose use as a hunting dog, may have given the Icelandic sheepdog or *Íslandshunden* a particularly friendly nature, although he was also known for his intelligence, tenacity, and loyalty.

Sheepdogs were not highly trained for herding on Iceland, rather they relied on instinctual behaviors. The sheepdogs were highly skilled in retrieving the sheep from their summer of free roaming over the huge, open, and rugged landscape. The dogs were sent up into the hills to locate and drive the stock down into the valleys into sorting pens, where owners would divide them and drove them home. It was the dog's job to gather those who strayed from the group.

Closer to the homestead, the dogs were also used to keep the flocks contained in specific grazing areas and drive them away from hay fields, pastures, and gardens kept for winter use. At times, the dogs would be called upon to find sheep buried in snow. They were also used to herd the Icelandic horses, turned loose to graze, and accompanied packhorse trains, barking at the stragglers. Around the farm, the dogs warned off intruders, large birds of prey, or the arctic foxes that might venture too close to chickens or lambs. It was said that no Icelandic farm should be without one or more.

Throughout the centuries, periods of terrible weather, volcanic activity, crop failures, famine, disease, and epidemics severely affected the population of humans and animals on the island. Isolation

left the domestic animals without immunity against various diseases and infestations, which had devastating consequences after the first imports of European livestock and dogs in the nineteenth century. In response, the country enacted strict regulations over dogs and livestock, forbidding the import of many animals.

Due to the threat of disease and until quite recently, it was illegal to keep dogs in Reykjavík. When foreign dogs were first imported, Border Collies had also been crossed on the native sheepdogs, but without much favor since Icelandic farmers did not use their dogs in the same manner as British sheepmen. However, for all these reasons, the Icelandic Sheepdog population in Iceland had fallen drastically before the twentieth century.

Recent History

In the 1950s and '60s, various people began efforts to locate traditional Icelandic Sheepdogs, found in very remote areas. The Icelandic Kennel Club was established in 1969 along with a dedicated breed club 10 years later. As research determined the true genetic diversity in the breed, originally based on 36 unrelated dogs, the Icelandic Sheepdog International Cooperation was organized to treat the worldwide population as one group and to conserve the breed using common guidelines by all the member countries. Today the worldwide population is about 6,000 dogs, and the breed is recognized by the FCI.

Outside the country, Icelandic Sheepdogs were exhibited and recognized by kennel clubs in Denmark and Britain as early as 1897. Although Iceland Sheepdogs were brought to California in the 1930s, they did not flourish. Later imports saw the establishment of the Icelandic Sheepdog Association of America in 1997, followed by AKC and UKC recognition.

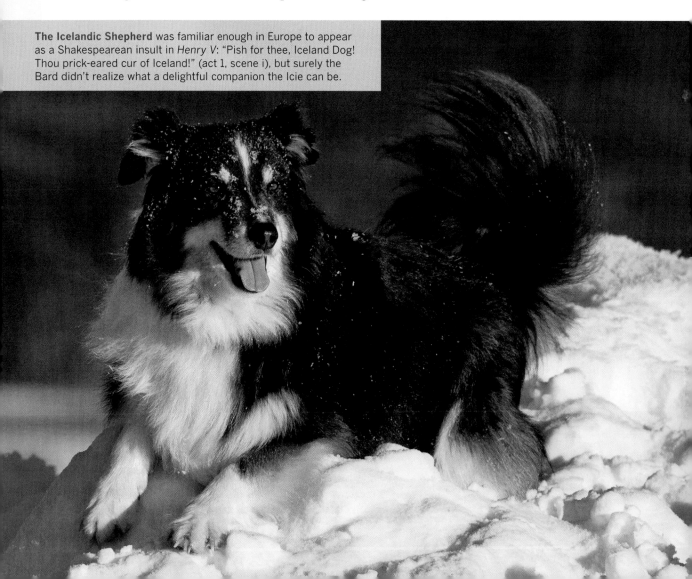

The Icelandic Shepherd was familiar enough in Europe to appear as a Shakespearean insult in *Henry V*: "Pish for thee, Iceland Dog! Thou prick-eared cur of Iceland!" (act 1, scene i), but surely the Bard didn't realize what a delightful companion the Icie can be.

Lancashire Heeler

Also known as Ormskirk Heeler

Origin	England	
Size	6–13 pounds **Male** 12 inches; **Female** 10 inches	
Coat	Short, hard, smooth outer hair with fine undercoat	
Color	Black or liver, both with tan markings	
Temperament	Independent, moderate energy, loose eyed, heeler	

A true multipurpose dog, the Lancashire Heeler combines heeling or herding ability with an inclination to hunt for rats or rabbits.

Although most of these dogs now live as companions, they can be useful dogs on a country home or farm, where a few are still used with cattle, in particular. They are also alert little watchdogs. The breed is best suited to living indoors but needs a good hour of daily exercise.

Lancashire Heelers can be quite terrier-like in personality, outlook, and determination. Bold and feisty, they require firm handling and training to prevent heeling or nipping and to encourage good behavior. They absolutely need socialization to dogs and children to prevent shyness or dog aggression. As family companions they should be friendly and affectionate. Because the population is so small, there is variability in type and temperament. It is recommended that you meet the parents and other Lancashire Heelers before choosing a puppy.

Appearance

The Lancashire Heeler is the smallest of the herding breeds, although some larger dogs are seen. The head is both foxy and terrier-like, with almond-shaped eyes and erect or tipped ears set well apart. Drop ears are not desirable. The body is sturdy and muscular with slightly turned out front legs. The tail is generally carried low at rest but rises when moving. There is a variation in tail carriage when the dog is alert, from upright to curved or even resting on the back to one side.

These double-coated dogs have short, hard outer hair with a fine undercoat. While the standard

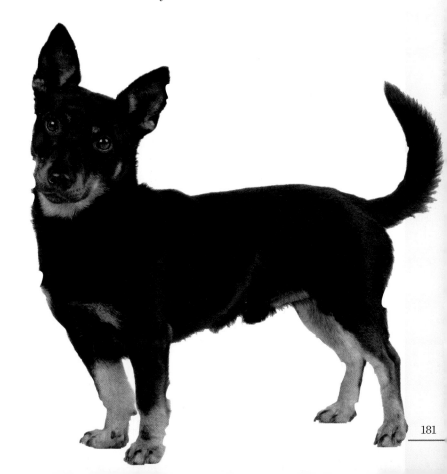

allows for some diversity in body type, in terms of color, breeders have focused on the pure black and tan, more recently adding the dark, rich liver-brown and tan. Tan can range from light to a richer mahogany. Tan color should appear on the muzzle, cheeks, and often as thumb marks above the eyes. The legs, inside the hind legs, and under the tail should also be tan.

A small "bow tie" of white is allowed on the chest. The breed standard faults the old white markings of the Ormskirk Heeler, and doesn't allow any other colors, although they do appear at times.

History

Coastal Lancashire lies in the northwest of England, near the northern Welsh border. As in many other areas across northern Europe, farmers used small dogs as all-purpose watchdogs, ratters, and heelers to move cattle or other animals. The native heeler dogs of Lancashire are no doubt related to these same dogs, including the corgis from across the border in Wales, the Viking spitz-type dogs, and other heeling or herding dogs.

Life changed drastically in Lancashire by the early nineteenth century, when it became an industrial center for cotton milling. These new urban areas of Liverpool and Manchester in Lancashire also became port cities. The meat markets imported tremendous numbers of sheep from Ireland, and heeler dogs were used to drive them through to the market and butcher yards. In smaller towns, cattle and sheep were also driven to market. By the mid-nineteenth century in more rural Ormskirk, heeler dogs were popular, displaying the typical colors and white markings of herding breeds. Meanwhile, in Manchester, the famous black and tan Manchester terrier was already a popular ratting dog.

A native type of heeler grew out of all these roots. Some were still at work on farms in the mid-twentieth century, with at least two types in existence: The Ormskirk heeler showed more herding-dog influence in color, dropped ears, and a long body, similar to some of the old-type corgis, although perhaps longer in the leg. There was also a Lancashire type that displayed the color of the Manchester terrier and possessed other terrier qualities, including the prick ears and short legs.

More Recently

Beginning in the 1960s, a group of English enthusiasts determined to bring attention to the native multipurpose heeler dog, who was near extinction. While some families may have been continuously raising the dogs for decades, in the early days of stabilizing the breed there was probably some use of corgi and Manchester terrier blood. The Lancashire Heeler Club was formed in 1978, with a breed standard and KC registration following soon after. In 2003, the KC labeled the native breed "endangered" due to its small gene pool and the resultant need to carefully monitor health issues. Breeders responded with a major pedigree and health initiative.

Lancashire Heelers have been exported in small numbers to Finland, Sweden, Norway, the Netherlands, and North America. The UKC and the AKC FSS registry recognize the breed. The United States Lancashire Heeler Club was organized in 2007.

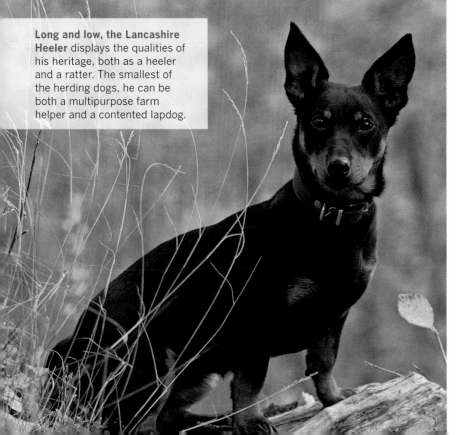

Long and low, the Lancashire Heeler displays the qualities of his heritage, both as a heeler and a ratter. The smallest of the herding dogs, he can be both a multipurpose farm helper and a contented lapdog.

Finnish Lapphund & Swedish Lapphund

Also known as Suomenlapinkoira, Lappie	Also known as Svensk Lapphund, Lappie

Origin	Finland
Size	**Male** 18 to 21 inches, 33 to 55 pounds; **Female** 16 to 19 inches, 28 to 48 pounds
Coat	Double coated, long, straight outer hair with dense, soft undercoat
Color	All colors
Temperament	High energy, willing, soft, loose eyed, bark

Origin	Sweden
Size	**Male** 18 to 20 inches; **Female** 16 to 18 inches
Coat	Long, straight outer hair with dense, soft undercoat
Color	Black, with small amount of white on chest, feet, and tail tip permissible
Temperament	High energy, willing, soft, loose eyed, bark

Although they can be independent and strong willed at times, Lapphunds are soft and submissive with their owners.

Lappies are quick, willing learners. They are vocal dogs that barked in their work as herders and now bark in play. Lapphunds have always been alert watchdogs but not guardians, as they are notably friendly to strangers. While not aggressive they may not get along with other adult dogs. A Lappie is also a good family dog and companion, not forming a strong attachment to just one person like many other spitz breeds. Owners report that they are excellent with children. Lively, active, and energetic, Lappies have great speed and endurance. They need exercise and enjoy vigorous walks, runs, and other outdoor activities even in winter.

Because Finnish Lapphunds (and Lapponian Herders) have a continued use with reindeer and on farms, their herding abilities are perhaps more pronounced than those of the Swedish Lapphund, who is primarily a companion dog today in Sweden and elsewhere. Lappies do well at herding instinct tests. They gather stock over distance, working them upright with a loose eye. They tend to work close and use their voice, just as they barked at the large reindeer herds to get them moving. They work well with sheep and cattle.

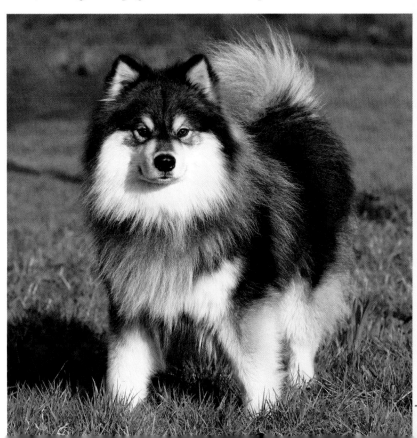

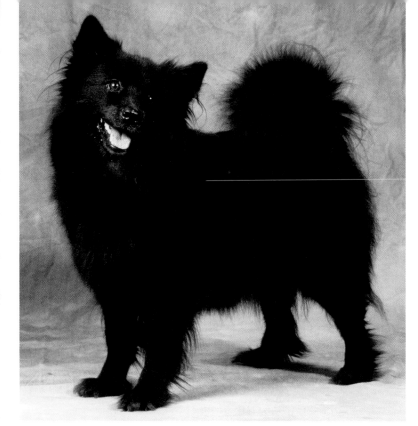

While the Swedish Lapphund is always colored black, the Finnish Lappie is found in a wide range of colors and patterns. Finnish Lappies are still used as reindeer herders, while their Swedish cousins are now found more often in homes as companions.

Appearance

Lapphunds are spitz dogs in appearance, with type being more important than size. Swedish Lapphunds are slightly smaller than Finnish ones. The head is broad with a clearly defined stop and slightly tapering muzzle. The ears are medium sized and carried erect or tipped. The eyes are oval shaped and dark. The tail is covered with thick, long hair and curves over the back, often ending in a small hook.

Coat. The coat is always profuse and forms a mane in males. The heavy coat can be an issue in very hot or humid climates; however, they are exceptionally well suited to winter weather and they still live outdoors in Scandinavia.

Color. The Finnish Lappie is a colorful breed, with only merle and silver missing from the palette. The standard says that the color should cover most of the body. Lighter shades or a secondary color can appear on the head, neck, chest, underparts, legs, and tail. Besides solid colors, dogs can be tan pointed, wolf-gray or -patterned, sable, brindle, or striped. Markings can include a mask, saddle, spectacles, and white or domino spots.

Swedish Lapphunds are always black, although bronzing on the fur is often seen. White on the chest, legs, and tail tip is permissible but should be very small.

History

The Sámi people (Sámit) have lived in the Arctic areas of Norway, Sweden, Finland, and the Kola Peninsula of Russia for thousands of years. Referred to as Lapps or Lapplanders in the past, the Sámit now consider this an unacceptable or even offensive name. Fishing and hunting have long been an essential aspect of their hunter-gatherer culture. Eventually many Sámi groups became more settled in fishing or farming communities, but a portion of the population continued to follow the wild reindeer migrations. By the 1500s, reindeer herds were kept in a semidomesticated state and former spitz-type hunting dogs had been selected for their herding abilities over large distances in a harsh, cold environment.

By the eighteenth century, the Lapphund (dog of the Lapps) was well known in Europe and described as a distinct breed. The modern world eventually interfered in the lives of the Sámit, who migrated over national borders and faced discrimination or other restrictions on their traditional way of life. Foreign breeds also introduced diseases, such as distemper, into their isolated dog populations. Early in the twentieth century, traditional dogs were threatened and soon snowmobiles and other technologies would change the Sámi methods of reindeer herding.

By the 1930s in both Finland and Sweden, concern grew over the potential disappearance of the traditional Sámi dogs, which were found in both long- and short-coated types. After World War II, breeders in both countries obtained traditional dogs and began selecting for both types. In Finland, they were raised together as one breed while Swedish breeders concentrated on longhaired, solid black dogs. Eventually the Swedish and Finnish dogs were recognized separately by the FCI. In 1966, the Finnish Kennel Club further

divided its Lapinkoira into a long-haired type, the Finnish Lapphund (Suomenlapinkoira), and a short-haired type, the Lapponian Herder (Lapinporokoira).

The Lapponian Herder is not a typical spitz dog. It is believed that Australian Kelpie-type dogs were used in its recovery and development. Some Lapponians have found their way to North America, but they are still very rare. Short- to medium-coated, Lapponian Herders are eager and energetic workers, who use their good trot to advantage in working long distances even today with the reindeer herds.

Finnish Lapphund

The Finnish Lapphund became a very popular dog in Finland and was exported elsewhere in Scandinavia and Europe. The breed came to the UK in 1989. Although individuals may have arrived earlier, the Finnish Lapphund was introduced to North America in 1987, where it found success as family companion and sport dog. The UKC and AKC recognize the breed. In 1995, the breed came to Canada and Australia; it is recognized by the CKC and ANKC. Lappies are generally family companions or active sport dogs but are equally suitable on a farm as a herding assistant.

Swedish Lapphund

The Swedish Lapphund was recognized by the Swedish Kennel Club as early as 1903. In the 1960s, preservation efforts were further supported by a grant from King Gustaf VI of Sweden. The southern areas of Sweden became the center of breeding efforts. Today there are about 1,200 Swedish Lapphunds worldwide. The majority live in Sweden, where fewer than 100 of them are registered each year. Small numbers of the breed are found elsewhere in Europe, England, the United States, and Australia. The UKC and the AKC FSS registry recognize the Swedish Lapphund. The Swedish Lapphund is rarer than the Finnish Lappie. Most Swedish Lappies are family companions, although some can still be found at work on farms as well.

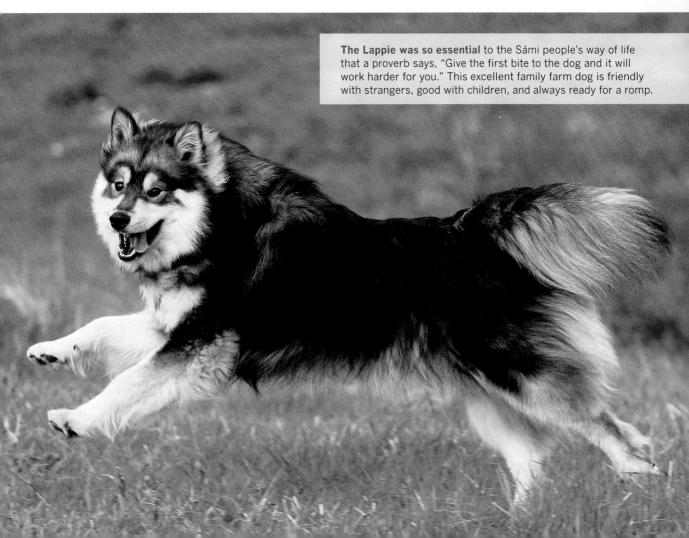

The Lappie was so essential to the Sámi people's way of life that a proverb says, "Give the first bite to the dog and it will work harder for you." This excellent family farm dog is friendly with strangers, good with children, and always ready for a romp.

Louisiana Catahoula Leopard Dog

cat-a-WHO-la | Also known as Catahoula, Catahoula Leopard, Catahoula Cur, Leopard Cur

Origin	Louisiana, USA
Size	**Male** average 24 inches, 65 to 75 pounds **Female** average 22 inches, 55 to 65 pounds
Coat	Short to medium hair
Color	All colors and patterns, with white not exceeding 70 percent
Temperament	Dominant, independent, high energy, high prey drive, upright, loose eyed, close, gather, header

The Catahoula is an intelligent, willing, and enthusiastic dog. He is also focused and assertive and works aggressively.

This is not a dog for an inexperienced or uncertain owner. He definitely needs a leader who will provide consistent and ongoing training. He tests his owners and will not tolerate abuse. Socialization to people, animals, places, and experiences is necessary to prevent shyness or fearful aggression.

A Catahoula has great endurance and high energy and is nearly tireless; he needs at least one hour of daily running exercise. He also needs work, obedience training, or other activities for his mental stimulation. A lack of exercise or work and ignoring or kenneling the dog without sufficient attention creates a very destructive dog.

Catahoulas raised with children should be fine with them, but may exhibit protective or herding behaviors. Traditionally worked in pairs or packs, most can live with other dogs, though they may fight for dominance. Catahoulas have a high prey drive and chase animals, including small dogs, cats, or anything else. They do not have a reliable recall when in pursuit of prey.

Working traits. Catahoulas are alert, naturally protective watchdogs that bark loudly, bluff, or display; some confront intruders. With combined hunting and herding instincts, they catch and bite. They are noted escape artists and must be securely fenced.

These dogs are upright, close, loose-eyed herders who work aggressively. They are strong header dogs who run ahead of stock and then bark, snap, and tease animals to lure them into following. As lead dogs, they are good at working with single animals or hogs. When they locate cattle or hogs they gather and circle to hold them. They track and bay or bark like hounds.

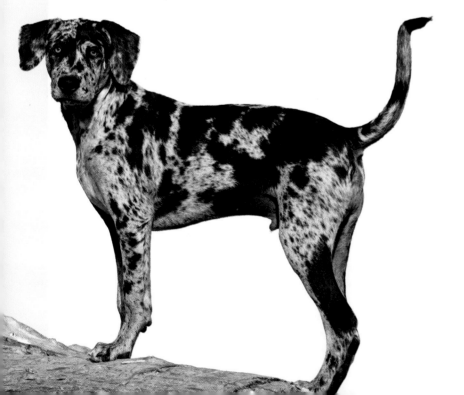

Catahoulas are used in hunting and tracking many types of game, including feral hogs.

Appearance

The Catahoula is a medium to medium-large dog, slightly longer than tall. Agility, power, and fit condition are more important than specific size in a Catahoula. There is tremendous variation in the breed and dogs can be considerably smaller or larger than average. The head should look powerful, but not exaggerated, with some more houndlike in appearance. The length of the skull and muzzle are about equal. The skull is broad and flat, with a well-defined stop, and a strong and deep muzzle tapering toward the nose. The lips are tight or only slightly pendulous.

Eyes may be any color, two different colors, or a combination of colors, including glass (light blue) and cracked or marbled (two different colors). No color is more valued than another. The ears drop, are short to medium in length, and triangular with slightly rounded tips. The tail is a natural extension of the topline, thicker at the base and tapering to the tip. Tails can be long or naturally bobbed, although docked tails are not generally acceptable in most registries. There is prominent webbing between the toes, which is useful in marshy areas or when swimming.

Coat. The Catahoula is single coated, with short or medium-length hair that lies flat and close. A wash-and-wear short coat, called slick, is often preferred. Hair can also be coarse with some feathering. Wooly, shaggy, or double-coated puppies occasionally appear, and although faulted in the standard, the coat

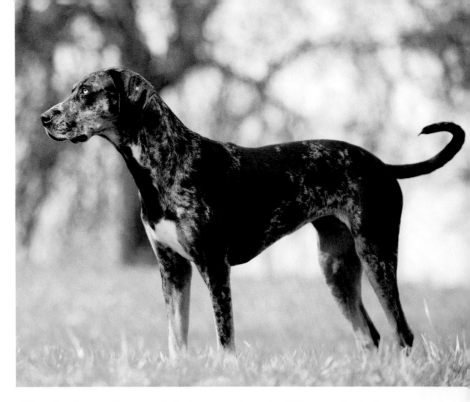

Although it is sometimes marketed as a rare breed, nothing could be further from the truth. For most of its history the Catahoula has flown under the radar, but it is widely believed to be the second most popular dog in the southern United States today, after pitbull/bulldog types (combining both registered and unregistered populations).

does not affect working ability. Single-coated dogs are not suitable for extremely cold climates or for living outside in winter.

Color. A true rainbow breed, the Catahoula shows tremendous variation in colors and patterns. Leopard-colored dogs are actually merles in black, blue, gray, liver, red, or patched. Dogs may also be brindled in a light or dark base color. Solid colors include black, brown, red, and yellow. Dogs can be bi-, tri-, and quadcolored. Patchworked, or patched, dogs may have a predominant color, often white, and splashes of any other color, colors, or merles or shades — with more than 70 percent white faulted due to concerns about deafness. Any color or pattern may be trimmed in black, buff, red, tan, or white. Blue merle or leopard colors are not more valuable or preferred.

History

Catahoula Parish lies in the northern half of the state and was settled by people from the southern states after the Louisiana Purchase in 1803. French settlers had moved into the southern part of state a century earlier. Two hundred years before that, Spanish explorers swept through the area. Each of these groups brought dogs with them, and they all played a role in the development of the landrace cur who would come to be known as the Louisiana Catahoula Leopard Dog.

The Native America dogs were generally prick-eared pariah dog types, found in shades of tan to red or black, with white markings, or bi- and tricolored. Spanish explorers in the area described them as wolflike, but smaller, and reported that they barked. Recent DNA

analysis has shown their ancestors came from Asia and were not interbred with the native red wolf.

The Spanish brought large mastiffs and cattle dogs, often single coated, that were used in Spain for catching and driving feral cattle or long-legged hogs, big-game hunting, guarding, baiting, or bull fighting, and as attack dogs in war. A particular favorite of the conquistadors was greyhounds crossed with mastiffs or other war dogs. Beginning with Columbus in 1493, the Spanish also brought cattle and pigs everywhere they went in the New World. French settlers also brought dogs with them.

Two breeds in particular are believed to have influenced the eventual development of southern cur dogs. The black and tan Beauceron, or Bas Rouge, was an old shorthaired shepherd and a general-purpose farm dog, protecting house, family, and stock. The French also brought another old hunting hound, the medium-large, mottled blue colored Grand Bleu de Gascogne.

And the American settlers who moved down into Louisiana also brought dogs with them. By the beginning of the nineteenth century, an amazing variety of dogs existed in the region. Across many of the southern states, cur dogs were widespread in use as general-purpose farm dogs as herders, hunting dogs, and watchdogs. Medium to medium-large in size, with drop ears, these dogs were athletic and highly energetic. Hounds, such as bloodhounds, coonhounds, foxhounds, and pinschers, were also part of this population of southern dogs.

Developing the Breed

Out of this true melting pot of dog types, abilities, coats, and colors emerged a recognizable local one. He was called variously Catahoula, Louisiana, or Leopard, and cur, dog, or hound. Leopard referred to the common merle color. By the 1850s, across the Gulf Coast region, the Catahoula cur was well known for catching cattle or hogs. Jim Bowie and Teddy Roosevelt both owned Catahoula curs.

Ideally suited to working in the swamps, hills, and brushy forests, the Catahoula often worked in packs. He was also used to hunt game from raccoon to bear, either trailing nose to the ground or with their heads held high, the dogs would gather up, circle, and bay until their owners arrived.

The Wright, McMillan, and Fairbank families bred at least three distinct lines. Differing in size and color, some are still maintained by breeders but most were eventually interbred a great deal. Beginning in 1950s, several Catahoula associations or registries were organized. Some were formed around a single line of dogs or the dogs found in a particular area. The official name changed from Catahoula Cur to Louisiana Catahoula Leopard Dog when the breed became the state dog of Louisiana. It wasn't until the 1990s that the breed came to greater national attention with recognition by the UKC and the AKC FSS.

Catahoulas may be registered with several different groups, which can be a bit bewildering to new owners. Most breeders of working dogs are not pursuing AKC FSS registration, preferring to remain with the UKC, NALC (where the majority of the dogs are registered), or other working registries.

With the recent wider attention, too many dogs are ending up in the hands of people unprepared to own an intense working dog, so these dogs are increasingly found in shelters or with rescue groups. Fortunately, most Catahoulas remain in working homes, where they are regarded as excellent stock dogs and used to help deal with the huge feral hog problem. Catahoulas are often crossed with other breeds, such as pit bulls and bulldogs, in an attempt to develop stronger catch dogs. Catahoulas are now bred in Canada, where they are also used for cattle and hunting. Recently they have been exported to Australia and New Zealand, where there is now a combined population of some 300 to 500 dogs.

Catahoula rescue folks advise these dogs must have obedience training, as well as one to two hours of daily hard running or play.

Cur Dogs

Cur dogs are uniquely American. In Fred Gibson's novel *Old Yeller*, set in Texas in the 1860s, the title character perfectly embodied the all-purpose dog who was the steadfast working companion of frontier farmers and ranchers. While "cur" meant a mongrel in the Old World, American curs were a group of specialized, multipurpose herding and hunting breeds, primarily found in the southern states. The cur was a mixture of hound, cattle or herding dog, and other canine immigrants of unknown background. In the deep southern states, the tough cur was indispensable for dealing with feral cattle or hogs. Eventually these fearless header dogs could also be found in the western cattle territories. Not only developed as specific breeds, curs were also bred in selected lines by families or in certain regions.

Still very popular in the south, curs are relatively unknown elsewhere in the country. Owners support various cur-dog registries and UKC working-dog events, but most owners are not interested in AKC or conformation events, believing their dogs are not suited to the show ring or to widespread popularity in nonworking homes.

Despite the variety of appearance and ability suited to specific needs and terrain, there is a common cur type. Curs are medium to medium-large in size, with drop ears, and smooth coats. They are athletic, enthusiastic, and highly energetic. Curs are smart, dominant, tough, aggressive workers. They work as catch dogs and as lead or upright, loose-eyed header dogs. Some are used more for game, hog hunting, or treeing rather than herding, scenting from the air or the ground. Curs were often worked in pairs or packs. Although devoted to their owners and alert watchdogs, curs have a high prey drive and chase small animals, which may include other family pets.

In addition to the Catahoula Leopard Dog, two other well-known cur breeds are the Black Mouth Cur and the Blue Lacey.

Black Mouth Cur (UKC)

Known by a variety of names, including Yellow Black Mouth Cur or Southern Black Mouth Cur, these dogs are variously attributed to Mississippi, Alabama, Florida, North Carolina, Tennessee, and Missouri, and they were developed into regional lines. The breed was eventually taken into Texas, where it saw widespread use.

Powerful, dominant, and independent dogs, Black Mouths still fulfill a need for a multipurpose hunter, herder, and homestead watchdog. They bond strongly to their owners and generally do well with children if socialized to them. Black Mouths are territorial and protective guards. They possess a high prey drive and easily chase and kill small animals. High energy and prone to wandering, Black Mouth Curs love to run.

Black Mouth Curs are medium to large in size, ranging from to 16 to 28 inches tall and weighing 40 to 95 pounds, with females slightly smaller. Dogs are either square in appearance or slightly longer than tall. The head is large with a broad, flat skull, drooping ears, a broad muzzle, close-fitting lips, and powerful jaws. Built substantially with a deep chest and muscular body, the tail is long and tapering, naturally bobbed, or docked. Shorthaired dogs are generally colored fawn or pale brown with a black muzzle and other small markings. Other dogs may be very dark, black, or brindle with or without a dark muzzle.

Blue Lacy

The Lacy family, who moved from Kentucky to Texas hill country in 1858, developed the Blue Lacy as an all-around ranch dog. Strongly pack oriented, the Lacy was the favorite dog of Texas cattlemen and hog hunters for more than 100 years. His widespread use declined during mid-twentieth century, but the Lacy remained popular in specific areas of the state.

Although still used as a stock dog, he has found more work as tracking, treeing, and hunting dog often used by professional trappers. Named the state dog of Texas, the breed has received considerable attention in recent years. While some Lacys are companion dogs, most are not well suited to a nonworking lifestyle due to their extremely high energy and drive. Blue Lacys remain rare outside of Texas.

Light and lean, Lacys are often smaller than many other curs. As a breed, they range from 18 to 23 inches tall and weigh 30 to 55 pounds. In addition to their characteristic slate-blue coat, Lacys are found in shades of light gray to black, cream to red, and tricolored, with a blue base color and red and white markings. The eyes are orange to yellow. The ears are 4 to 5 inches long. The straight tail may curl upwards. The coat is smooth, sleek, and short.

Mudi

MOO-dee

Origin	Hungary
Size	**Male** 16 to 18.5 inches, 24 to 29 pounds **Female** 15 to 17.5 inches, 18 to 24 pounds
Coat	Wavy or curly outer hair with soft undercoat
Color	Black, brown, shades of fawn, white, blue gray, and blue merle
Temperament	Moderate energy, willing, upright, loose eyed, strong drive, bite and grab

The Mudi is an intelligent, willing, and quick learner. He is calmer in the house than many herding breeds and more easygoing and playful, without the intense energy of the Pumi or Puli.

He forms close, affectionate bonds to his owner and does well with children and family pets, though he can be aggressive to strange dogs. He can be scrappy, tough, and a bit pushy, as well as independent and stubborn. His natural watchdog nature requires an owner who can provide positive training and socialization so that he becomes a good citizen. He is also very vocal, with a tendency to jump fences and dig. The Mudi can be a challenging dog, but his willingness to learn and please his owner often tempers these traits.

Working traits. The Mudi excels at dog sports and has been trained for search and rescue as well as nose work. He is not the tenacious ratter the Pumi is, but he lends a hand if there is vermin problem in the barn. As a herding dog, he is athletic and courageous. He is actually a harder driving dog than the Pumi. He bites and grabs, uses his voice determinedly, and has an aggressive chase. He needs to be trained to the different working styles of sheep and cattle.

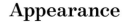

Appearance

The Mudi is a small to medium-sized dog. Size is more variable than the standard suggests, perhaps because he is essentially a working dog and larger size is more helpful in working some animals. He has a foxy and intelligent expression. The head is wedge shaped with erect triangular ears and oval eyes. The eyes are dark except with blue merle coats. Tail carriage is variable. Traditionally some dogs were docked, although the practice has fallen from favor in the breed. Some pups are born naturally bobtailed.

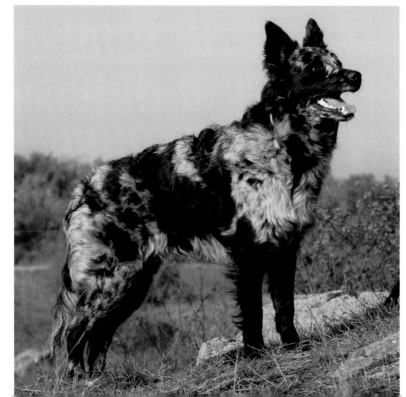

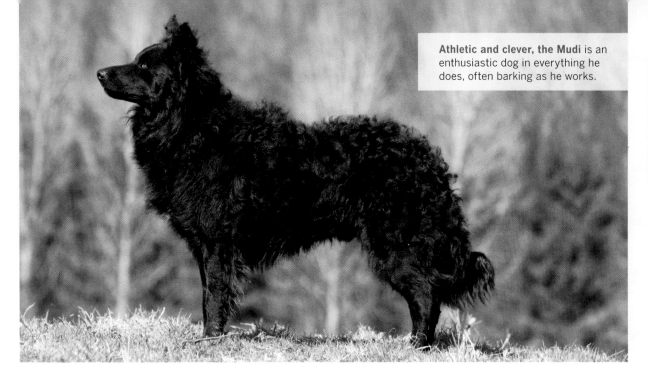

Athletic and clever, the Mudi is an enthusiastic dog in everything he does, often barking as he works.

Coat/color. The coat is rough in appearance with wavy, lightly curled outer hair and a soft undercoat. Medium in length with feathering on the tail and legs, it is low maintenance. Males have some ruff around their neck, and the ears are also well covered with hair. The FCI colors include black, brown, fawn (from pale yellow to red), white, blue gray, and blue merle. A small white patch on chest is permissible. In the United States, more colors are acceptable including gray brown, black merle, red merle, and brown merle.

History

The Mudi, it is often suggested, is a result of spitz crosses on the native dreadlocked Puli; however, the breed bears a remarkable resemblance to the neighboring Croatian Shepherd Dog, which was clearly described in 1374. It is quite likely the Mudi is part of a very old landrace type found throughout the area and a third native Hungarian breed to the Puli and Pumi. From the earliest records onward, this was a herding dog, although the Mudi also made itself useful on farms as a vermin hunter and watchdog. He was found throughout the country as a working dog and not as a dog of the city.

Dr. Denszö Fényesi, an early supporter of the native breed, was instrumental in the Mudi's recognition as a separate breed. The FCI standard was approved in 1936, but organized breeding was limited even in Hungary. Outside the country he was virtually unknown. World War II was hard on the breed, which didn't see much recovery until the 1960s. Based on a few specimens, the standard was redone to be more restrictive on size and permissible colors. This did not benefit the breed and as more working dogs were examined, the standard was revised in 2000 to restore most of the diversity of color and size.

The registry remained open to the examination and acceptance of working dogs without pedigrees. It was also inevitable that the Mudi, Puli, and Pumi would occasionally be interbred, and all the breeds occasionally see atypical pups born into litters. The process of standardization has taken some time, yet the remarkable diversity in the Mudi is also highly valued. At the beginning of twenty-first century, about 1,000 dogs were present in the country. Today the worldwide population is estimated at about 2,000.

The 1970s saw the first exports out of the country to Finland and Sweden, where the breed did well as a sports dog. Several decades later, the Mudi was brought to the North America. The American Mudi Association, affiliated with the Hungarian Kennel Club, was founded in 2003, followed closely by the Mudi Club of America. The UKC and AKC FSS both recognize the Mudi. Mudis or Mudik remain extremely rare in North America, where the clubs agree that the focus of the breed needs to remain on herding, dog sports, and active companionship rather than the show ring.

Norwegian Buhund

BOO-hoond | Also known as Norsk Buhund, Norwegian Sheepdog

Origin	Norway
Size	**Male** 17 to 18.5 inches, 31 to 40 pounds **Female** 16 to 17.5 inches, 26 to 35 pounds
Coat	Hard, medium outer hair with dense undercoat
Color	Light cream to yellowish red, with or without dark-tipped hair or facial mask; or black. White markings should be minimal in both colors.
Temperament	Independent, dominant, high energy, willing, loose eyed, fetch

The intelligent Buhund is a quick learner who is eager to please. Affectionate and loyal, these dogs bond closely to their owners, although they may be aloof with strangers.

Males tend to be somewhat less independent and more people oriented than females. With their high energy level, Buhunds must have a job or another fulfilling activity that involves regular vigorous exercise. Due to their intensity and independence, they need consistent training and socialization to be good workers or family members.

With an active, herding nature

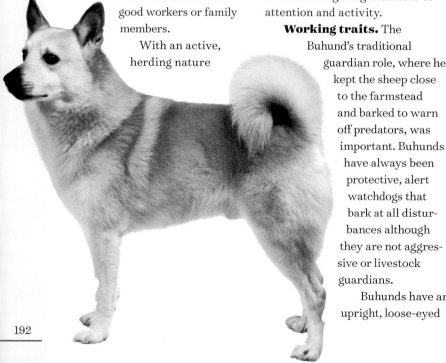

and love of chasing, Buhunds must be supervised and controlled around family members, other dogs, and farm animals. They are not suited to a life in which there is minimal contact with their owners and are much happier as a family farm dog or with owners dedicated to giving them lots of attention and activity.

Working traits. The Buhund's traditional guardian role, where he kept the sheep close to the farmstead and barked to warn off predators, was important. Buhunds have always been protective, alert watchdogs that bark at all disturbances although they are not aggressive or livestock guardians.

Buhunds have an upright, loose-eyed style of herding. They fetch, gather, drive, and sort. Traditionally, they were used to retrieve sheep from Norwegian mountain pastures at the end of summer, often out of sight of their shepherd, and were often sent out to fetch sheep hidden in the rough terrain, using their bark to flush out stock.

Appearance

The Buhund is a medium-sized dog with a solid and square appearance. The head is wedge shaped with erect, medium-sized ears. Dogs have dark, oval-shaped eyes. The high-set tail should curl tightly over the back. Buhunds are often born with double dewclaws on the rear feet; these are removed in some countries but not Norway.

Coat/color. The medium-length double coat is cold-weather hardy but not well suited for hard work in a hot or humid area. The undercoat is dense while the weatherproof outer coat is hard yet lies relatively flat. Long or wavy coats are faulted.

The Buhund standard allows for two colors: Wheaten is described as a light cream to yellowish red. The tips of the hairs may be dark

in color. The presence of a mask is also acceptable. Black dogs may be solid in color or with white markings, which should not be large. Supposedly the wheaten color was more visible in the western areas, which can be rainy or foggy, while the dark colors were easier to distinguish in the snowy interior mountains. Earlier, when there was more diversity in type, wolf-gray or wolf-sable coats were also seen. The British KC standard still allows for this color although other standards do not.

History

Spitz dogs are closely associated with the early farming and herding peoples in the Scandinavian area and evidence of their presence is found in many archeological sites. Dogs, believed to be the guardians of the underworld, were placed in graves with their owners to guide them on their journey in the afterlife. Dogs of various sizes and types are found, sometimes in the same grave, indicating that they served their masters in different ways. One such dog is much like the Norwegian Buhund in size. We also know that the Vikings took these dogs on their voyages of conquest and settlement, since they are found in graves in Greenland, Iceland, Ireland, the Isle of Man, Scotland, and the Shetland Islands.

In Norwegian, the word *buhund* refers to a dog "of the farm and the stock," or a herding and farm dog. These dogs worked with traditional livestock, such as sheep, goats, cattle, and pigs, as well as reindeer. They served as farm watchdogs, often living in the barns with the animals at night but, like all herding dogs, working closely with their owners when the flocks and herds

were moved to pasture during the day and up to high grazing in the summer. They were also used, much like their larger cousins the elkhounds, to hunt both large prey and predators. They were so ubiquitous that it was said "every farm has its buhund." Unfortunately, as foreign breeds were brought into the country in the early years of the twentieth century, they began to replace this well-known breed, for both work and show. There was a perception that these outside breeds had more status than a mere working dog.

Reviving the Breed

Although Buhund population began to fall precipitously, there was a quick response to the potential loss of a native breed. Owners were encouraged to show their Buhunds at local sheep and goat shows, especially in the sheep-raising areas of southwestern Norway, where there were still good numbers of dogs. Efforts to register and carefully plan the breeding of Buhunds also began. The Norwegian Buhund Club was founded in 1939. There is now organized support for all the native dog breeds by the Norwegian Kennel Club and through the national Norwegian Genetic Resource Centre for the sustainable use and conservation of genetic materials. Today about 150 Buhund puppies are registered each year in Norway.

Buhunds have also made their way to other Scandinavian countries, elsewhere in Europe, Britain, and North America. They were imported into Britain right after World War II. Imports continued and the Norwegian Buhund Club was founded in 1965. Buhunds came to America with a Norwegian woman who formed the Norwegian

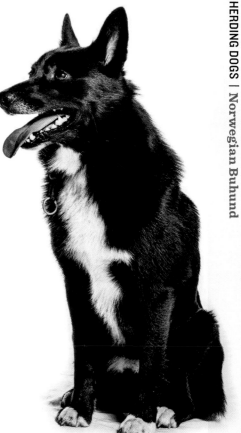

The traditional farm dog of Norway, the energetic Buhund is also an especially alert watchdog.

Buhund Club of America in 1983, before returning to her native country. The Club gained AKC FSS registration in 1996, with full recognition for the breed 13 years later.

The Buhund is also recognized by the UKC and the CKC in Canada. Buhunds are now found throughout North America, where they are well suited to country or farm life as well as various dog sports. His lively and animated presence has made him a favorite at dog shows as well.

The kennels clubs in Australia and New Zealand also recognizes Buhunds, but the breed is exceedingly rare in those countries.

Old English Sheepdog

Also known as Bobtail, OES

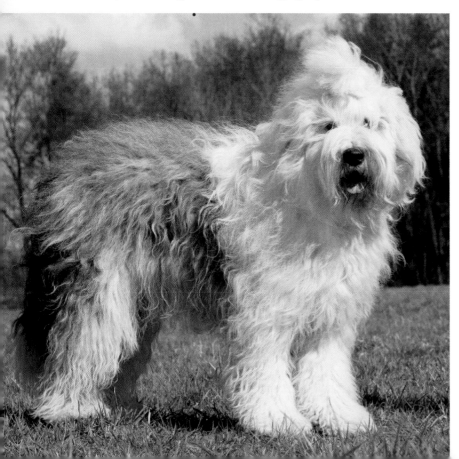

Origin	Britain	
Size	60 to 90 pounds; **Male** 22 inches and up; **Female** 21 inches and up	
Coat	Harsh, hard, rough, and long outer hair with extremely dense, waterproof undercoat	
Color	Any shade of gray, grizzle, or blue with or without white markings	
Temperament	Dependent, moderate energy, loose eyed, upright	

Instantly recognizable, the endearing and distinctive Old English Sheepdog is the quintessential shaggy dog.

Outgoing, active, and good natured, these dogs can become strong willed if their owners do not implement consistent rules for behavior. They need to respect their owners as leaders, and training should begin early. They are sensitive dogs, and harsh training is not productive. It can be difficult to maintain their interest in work or prevent creative play, which can be challenging in performance events.

While the OES is an independent-thinking breed, these are not aloof dogs. They have a strong need for human companionship and do not do well if left alone for long periods. They often follow their owners from room to room, trying to keep the family together. Their sweet nature makes them excellent therapy dogs. They also enjoy children and get along well with other family pets. Young dogs can be boisterous and may attempt to herd children by bumping them. Old English Sheepdogs do not mature until aged three, although some dogs remain rambunctious for a long time. They do well with three or four walks or play periods every day.

Working traits. Most OES will do well at a herding instinct test, but there has been little selection for working ability for quite some time. The breed club in America regrets this and wants to recover and reward this instinct. The OES is a softer herding dog who can be the right fit for a hobby farm, herding sheep, goats, ducks, or geese. An OES can also help with some carting work. He loves to be with his family and happily keeps them company during chores all day. Although

most OES bark at disturbances, they are not aggressive and do not make good guardians.

Appearance

The Old English Sheepdog is a square, compact, and sturdy dog. They are large dogs, but a full show coat lends the illusion of greater size. British dogs have a higher minimum height than American dogs. The back is short and pear shaped when viewed from above, narrower in the front, and broader in the rear with round muscular hindquarters. The loin is higher than the withers, a unique feature of the breed.

The head is square with a well-defined stop. The muzzle is also square. The head is covered in hair making it appear even larger. The medium-sized ears are carried flat. The eyes may be dark brown, blue, or one of each. The nose is always large and black. The distinctive neck is fairly long and arched.

The tail is either naturally bobbed or docked close to the body. If left undocked, the well-feathered tail is set low, hanging down unless the dog is alert when it rises but does not curl tightly over the back. The OES not only looks a bit like a bear, he also moves a little like one with his rolling amble or pace. He also has a ground-covering trot and gallop.

Coat. The OES has a profuse coat. The outer hair should be harsh, hard, and rough but not straight, curly, soft, or wooly. The head, ears, legs, and body are all well covered, with the hindquarters even more heavily coated. The undercoat is a very dense "pile," which should be weatherproof.

Color. The coat is colored any shade of gray, grizzle (bluish gray sprinkled or streaked with gray) or blue merle. White markings or splashes of white are typical. Young dogs frequently have light silvery coats than darken with age or very dark nearly black coats that turn lighter gray. Adult coats should not contain fawn or brown.

History

The breed was first seen in southwestern England, but little is known about its history. Genetic analysis has revealed that it shares some ancestry with the various old British sheepdog and collie types.

Caring for a Show Coat

The show coat is backcombed and kept very clean, neither of which are practical for a family dog who is active outside. Owners who wish to keep their dog in a full coat should expect to spend several hours a week de-matting and grooming, or be willing to schedule regular visits to a professional groomer. The beard sops up food particles and water, while the rest of the coat not only easily mats but also collects burrs, debris, fecal matter, and urine. Hair also needs to be trimmed on the feet, the rear parts, and wherever it is irritating the eyes. Some owners keep the hair above the eyes in a topknot. Dogs in a full coat can be more susceptible to heat.

There is concern among admirers that coats have become much too important to the detriment of the rest of the dog's conformation. Show coats can also discourage potential owners who think it would be a huge burden to maintain. Working owners know that long, soft coats are not practical or weatherproof. Today, many owners keep their dog trimmed in a puppy cut which is 1.5 to 2 inches long.

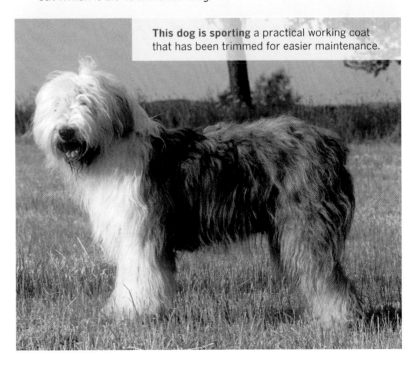

This dog is sporting a practical working coat that has been trimmed for easier maintenance.

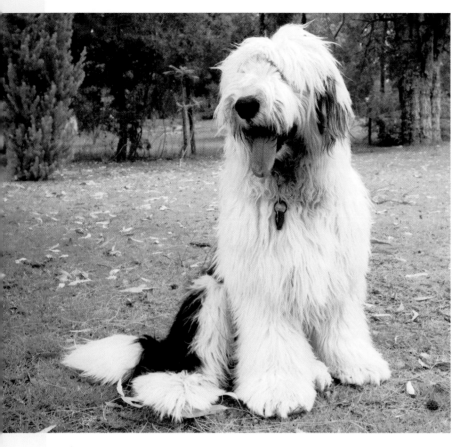

The Old English Sheepdog is a popular dog in many TV shows, films, and advertisements, especially in children's entertainment. This association with children has certainly contributed to the breed's popularity and the impression of these dogs as happy, clownish, and loveable.

The Bearded Collie may be a cousin. And it resembles the extinct old Smithfield drover, Sussex Bobtail, and Welsh Gray — all breeds from the western area of England. Large, shaggy drovers and sheepdogs were seen in Europe as well.

The early Old English Sheepdog was often called a bobtail shepherd or a butcher's dog. Developed as a larger droving dog for moving cattle and sheep on the road to the meat markets, the dog was naturally protective of the owner and his animals. He was also used to help move dairy cattle and sheep. He was generally used in smaller, fenced grazing land, or he helped with sorting and penning around the farmyard unlike the smaller,

faster sheepdogs that gathered the flocks.

The early Bobtail was not as profusely or softly coated as the modern show dogs. Instead he wore a more practical shorter, rough coat. He was often shorn yearly right along with the sheep. Some dogs were naturally bobtailed while others were traditionally docked, possibly to indicate working-dog status.

Bobtails were seen in mixed sheepdog groups at dog shows and at specialty drover's dog shows, where they attracted the attention of fanciers. Breeders began looking for good specimens among the local working dogs, just as the jobs for droving dogs were disappearing. By 1877, the Bobtail had become

the Old English Sheepdog, for reasons unknown, and the OES was soon after well known in England as a show dog. The Old English Sheepdog Club was organized in the 1880s and a standard was written.

Across the Ocean

The old Bobtail was seen in the North America as early as 1844, although it is likely the old shaggy, droving types may have made their way to the New World even earlier with colonists. However, in the 1880s, well-to-do American tourists, having seen this shaggy dog in Britain, began to import them. Old English Sheepdogs were bred as show dogs and kept in large kennels complete with staff to care for them. The Old English Sheepdog Club was organized, a standard was written, and the AKC recorded a litter in 1898.

At the Westminster Kennel Club Show of 1905, the tremendously wealthy Gould, Guggenheim, Harrison, Morgan, and Vanderbilt families exhibited Old English Sheepdogs. Their support attracted enormous attention to the breed. From that time, the OES was taken around the world, leaving his working roots behind him for life as a companion and show dog.

For all its public recognition, the OES breed is losing popularity. In the 1970s, the AKC registered 17,000 dogs yearly but this number has fallen to less than 1,000. In his homeland, where 5,000 dogs were registered yearly in the 1970s, fewer than 500 are now registered. In Australia, about 100 pups are registered yearly. Breeders and owners worry about his future, which is unfortunate because the OES is still a marvelous family dog who can be kept in a practical, short, working coat.

Pembroke Welsh Corgi

COR-ghee | Also known as Pem, Pemmie

Origin	Wales
Size	10 to 12 inches; **Male** 26 to 30 pounds; **Female** 24 to 28 pounds
Coat	Short to medium outer hair with dense undercoat
Color	Red, sable, or fawn with or without white markings. Also black- or red-headed tricolors.
Temperament	Independent, moderate energy, willing, loose eyed, heeler

The foxy face of the Pembroke Welsh Corgi is certainly much loved. Longtime favorites of Queen Elizabeth II and a frequent character in Tasha Tudor's charming stories and paintings, sturdy little corgis are the steeds of the fairy folk and the source of many adorable puppy pictures on the Internet.

One reason they are popular is that the Pembroke acts like a big dog who just happens to have short legs. Independent and strong willed, they are also very affectionate and willing learners. Owners often report that females are a little bossier than males, who tend to be more laid back. The Pemmie's reputation as a nippy dog is undeserved, as training results in a good companion to children or adults. Socialization to other animals, children, and adults is essential, as is basic obedience, including a *quiet* or *hush* command to stop barking. A Pem makes a good watchdog but also welcomes guests. All corgis, or *corgwn*, like routines and quickly learn what to expect at certain times.

The Pem can get underfoot, when people are coming or going in the house or yard. A Pem will happily follow his owner to oversee chores, but settles nicely in the house when work or activities are done. He often barks when playing and loves a high-speed romp, even by himself, which corgi lovers refer to as "frapping." Pembrokes are content with some active walking or playing each day.

They are also well suited to activities such as obedience and agility. Since Pems have slightly shorter legs than Cardigans, avoid overly short legs in a working or sport dog since the dog may be a little bit slower or less agile. Watch their weight and be cautious about their jumping high distances, which risks potential back injuries.

Working traits. Historically, corgis were more all-around farm dogs than some other herding breeds. While they would drive cattle to town or out to grazing, they also helped move cattle around the farmyard, gates, or feeders. They are definitely tough, barky, pushy, and nippy with cattle. They were also used to move geese and ducks. Pembrokes can learn to fetch sheep, but need to be trained to stay back in order to work sheep properly.

Whatever they are doing, these dogs are very responsive to their handlers. Pembrokes are closely associated with horse people; they make themselves useful in and around barns hunting for mice or rats, and are clever and quick enough to stay out of the way of horses.

Appearance

The Pembroke has a more refined and foxy head than his cousin, the Cardigan. Pems are also lighter and smaller, with a slightly shorter back and legs, but they still have moderately heavy bone. The dark eyes are oval and medium in size and the medium-sized ears are erect.

The Pembroke is a bobtailed breed. The early breeders observed that while many pups were born tailless or with a short stump, it was more usual to see partial and full-length tails. Since most Pembroke pups were docked shortly after birth, breeders saw no need to preserve the natural bobtail genetics. However, with the docking bans in various countries, breeders began again to select for a natural bobtail.

Coat/color. The double coat is medium in length, with coarse outer hair and a soft undercoat. While a moderate ruff and longer hair on legs and underparts is typical, overly long feathering on the ears and elsewhere is not. Dogs with these long, soft or silky coats are called "fluffies," and while they are fine pets, their coats are completely impractical in wet, rain, or snow.

While the traditional corgi usually appears in a handsome combination of red and white, a tricolored coat (black and tan with white markings) is also acceptable. While some colors or mismarks are serious show faults, they are unimportant in companion or working dogs. These include blue shading (called a bluie); white body color (a whitely); brindle; black with white but no tan; and areas of white on the back or sides.

History

Pembroke and Cardigan corgis were first called "cur," the useful drover and watchdog of the farmer. Corgi is often translated as "dwarf dog" since *gi*, or more properly *ci*, is Welsh for "dog" and *cor* is generally taken to mean "a small man"; however, it may also mean simply "cur dog." In Wales, these dogs have also been called Ci Sodli (heeler dog) and the Welsh Cur.

There are various suggestions of possible ancestors for the bobtailed, prick-eared Pembroke-type corgi. Deeply ancestral stock may have come to Wales with the Celtic tribes in 1200 BCE. Some believe the Cardigan was originally part of the Tekel or Dachshund group, while the Pembroke's roots might lie in the spitz group. There may have been additions of the Viking Vallhund and Lundehund dog stocks as well, brought to Wales in over three hundred years of raids and settlements beginning in 900 BCE. In southern Wales, Flemish weavers came to Pembrokeshire in 1107, bringing their Schipperke and Pomeranian dogs.

Vallhund and Schipperke dogs are certainly prick-eared, bobtail

With a sharp eye, believers can see the faint outline of a fairy saddle on a Pembroke's back.

breeds, and the Lundehund bears a striking similarity to the Pembroke, in both physical appearance and coloring. The black-and-tan Lancashire Heeler of England may also be related. Future genetic studies will likely tease out more relationships.

While larger, longer *corgwn* with tails were found in the lowland and hill farms of central and northern Cardiganshire, in the south a shorter, lighter corgi was more common. Many of these dogs were natural bobtails; others were docked. As heelers, they drove cattle and sheep but were also known as all-around helpers, used to drive geese and ducks, hunt rats, and serve as a family and farm watchdog.

In Wales, the Pembroke and the Cardigan were generally viewed as separate types at least by the end of the nineteenth century. In 1925,

a group of dog fanciers became interested in the old *corgwn* still found in and around the village of Llangeitho, in Cardiganshire. When they were able to locate the dogs, they formed the Welsh Corgi Club based in Pembrokeshire. After some discussion with Cardigan Corgi breeders, the decision was made to apply to the Kennel Club as separate breeds: the long-tailed Cardigan and the bobtailed Pembroke. For a few years, the Kennel Club lumped the two breeds together but they were again separated in 1934. The early Pembroke breeders were able to standardize the breed fairly rapidly.

A Royal Breed

In 1933, the future King George VI bought his daughters their first pet corgi. As corgi fanciers say, one corgi leads to another, and eventually the royal household had

a formal breeding program. The Pembroke became closely associated with the Queen Elizabeth II and achieved worldwide recognition especially in Commonwealth countries. A second Pembroke club, the Welsh Corgi League, was established in England in 1938. In many ways, the League serves as an international home of the breed.

Pems have continued to be associated with the Queen, but their popularity with the public has waned with the introduction of other small foreign breeds. In 2015, fewer than three hundred pups were registered with the KC, which listed the Pembroke as a vulnerable native breed.

The Pembroke corgi was brought to the North America in the early 1930s. For a time, the AKC also placed the two corgi breeds together. The little Pem rapidly garnered positive attention, though more as a delightful companion than a working dog. As interest in herding, agility, and other dog sports began to grow, breeders began to emphasize those qualities as well. For many years, the Pembroke has registered more than 5,000 pups annually.

In Australia, the Pembroke is both a family and farm dog. Unfortunately, Pem registrations have fallen from about 2,000 in the mid-1980s to only around 300. The Pem is also found in New Zealand, as well as many countries throughout Europe.

Polish Lowland Sheepdog

Also known as Polski Owczarek Nizinny, PON, Nizinny

Origin	Poland
Size	**Male** 18 to 20 inches, 40 to 50 pounds **Female** 17 to 19 inches, 30 to 40 pounds
Coat	Long dense outer hair with soft, dense undercoat
Color	All colors
Temperament	Independent, dominant, moderate energy, willing, upright, loose eyed, close, voice

The Polish Lowland Sheepdog is a boisterous, active, playful dog who needs exercise and a fenced yard to control his natural urge to chase cars, children, or animals.

A devoted dog who wants to be with his people and keep an eye on them, he can also be a bit reserved and serious as an adult. As a protective and territorial watchdog, he must be socialized with people and other dogs. The PON is a typically a socially dominant dog who needs a firm, positive owner who will train and handle him consistently. Due to his assertive personality, owners report that a PON will take over in the absence of a leader.

The PON is well suited to various dog sports. As a herding dog, he is confident and bold, working upright and loose-eyed. He also works close to stock using touch and voice.

Appearance

The Polish Lowland Sheepdog is a medium-sized, compact yet strong dog. Under all that hair, he is rectangular in shape. Weight is not specified in the standard. The head is in proportion to the body, although the abundant hair makes it look larger. Hair obscures the medium, oval-shaped eyes, which are brown with dark rims. The drop ears, described as heart shaped, are set moderately high and covered with long hair. PONs may have a natural bob or short tail or be docked, where allowed. Left undocked, tails can be of varying lengths but are always covered with long hair. Long tails should curve over the back when the dog is alert. Medium-length tails may be carried in different ways.

Coat/color. The long, thick coat of a Polish Lowland Sheepdog has coarse or crisp outer hair and a soft undercoat. The coat should be weather resistant and may be straight or slightly wavy. There is some difference in coat texture associated with color. The hair may be of any solid color or patches of color are allowed. The most common colors are white with black, gray, or sandy patches; gray with white patches; or chocolate.

Puppies typically appear darker than the eventual adult color, which tends to fade with age.

PONs look like shaggy, tousled farm dogs and they are often shown naturally. The coat picks up dirt and debris, and needs to be groomed regularly to prevent mats, skin issues, contamination, or odor. The beard soaks up a lot of water and food particles and needs frequent washing. Many owners choose to keep the dog in a shortened working clip, but never a shaved coat.

The PON coat may change color considerably through his lifetime, with some individuals cycling through dark- and light-shaded coats repeatedly.

History

Raising sheep, primarily for wool, was an important part of Polish agriculture for many centuries. Poland has many varieties of low-land and long-wool breeds, including the historic Polish Mountain Sheep. These coarsely wooled dairy sheep were moved to summer pastures high in the Carpathian Mountains, accompanied by both livestock guardian dogs and sheepdogs, and returned to lowland farms for the winter. Beginning in 1786, Merino sheep were imported to improve existing fine-wool breeds and create new ones. Bearded and longhaired sheepdogs, including bobtailed types were a common European type, and the medium-sized, shaggy sheepdogs that were essential to these efforts in Poland are found in records dating back to the 1500s.

Around the turn of the nine-teenth century, Polish sheepdogs found new homes on the estates and rural homes of fanciers who established breeding kennels. After World War I, national pride led to preservation efforts for Polish breeds of all kinds of animals. Unfortunately, as for many breeds, World War II had devastating effects on the sheepdogs. In 1948, Dr. Danuta Hryniewicz, a veteri-narian, became concerned that the sheepdogs that once populated the lowland countryside were rapidly disappearing. Searching farms over the next few years, she dis-covered eight good working dogs. A male named Smok typified the ideal sheepdog; he is found in the pedigrees of all modern-day Polish Lowland Sheepdogs.

More Recently

By the late 1950s, a standard had been accepted by the FCI, eventu-ally leading to international inter-est in the breed. Currently bred in a few European countries, they are often called the Nizinny from their official name Polski Owczarek Nizinny. This also led to the English nickname PON. Despite the small gene pool, the breed has remained remarkably healthy.

Although they are rare, they have attracted a devoted follow-ing. PONs were imported to North America beginning in 1979, with recognition from the CKC and AKC in 2001. Several clubs have orga-nized around the breed, promot-ing cooperation and good health, as well as providing support for owners who enjoy their dogs as companions or in dog sports. In 1985, the first PONs made their way to Britain and a breed club was organized. The Kennel Club recog-nized them as the Polish Lowland Sheepdog in the early 1990s and there are about 200 PONs in the country today. Approximately 100 PONs live in Australia.

Puli

POO-lee

Origin	Hungary
Size	23 to 30 pounds; **Male** 16 to 18 inches; **Female** 14 to 16 inches
Coat	Double coated: corded, long
Color	Black, rusty black, shade of gray, or white; also shades of fawn with or without a black mask
Temperament	Independent, dominant, high energy, highly reactive, willing, loose eyed, gather

Deeply loyal and protective, the Puli has great courage, determination, focus, and stamina.

Combined with his intelligence and ability to learn quickly, this makes for a hardworking herding dog, but he can also be a challenge for owners. A Puli (plural: Pulik) must have consistent training that starts early or there's a risk of him outwitting his owner. Socialization is very important, as he can be highly reactive to and suspicious of strange people. A Puli may be aggressive to other dogs and does best with opposite-sex family dogs. He may herd or harass cats or other family pets. An excellent jumper, he needs a well-fenced yard to prevent chasing behavior. These dogs require owners who enjoy their essential nature and high energy. This is also a very vocal breed.

Working traits. Although Pulik are mainly companion dogs, their herding abilities remain very strong. They form tight bonds with their handlers and are better suited to large flocks and widespread areas than to typical herding trials. In spite of being natural loose-eyed gatherers, they physically work close in to stock, using their voice and body to gather, lift, and drive animals. These dogs only rarely grip or bite, but use their speed and energetic, bouncy movements to great advantage. The Puli has a distinctively animated, light, quick movement, which he uses to advantage when herding. They are good assistants for a farm or ranch, working on both sheep and cattle.

Appearance

The Puli is a square, medium-sized dog whose shape is often disguised under its characteristic corded coat. The Puli is agile and athletic with moderate bone. The head, also covered in cords, is in proportion to the body with triangular drop ears; dark-colored, almond-shaped eyes; a somewhat short muzzle; and relatively large teeth. When alert, the moderately high-set tail is carried over the back curled, to the side, or straight. The tail may lower when the dog is relaxed.

Coat/color. The Puli is a double-coated breed whose coat forms cords. Although solid black dogs are most common, other acceptable Puli colors vary a bit by country. In North America, Puli colors include black, rusty black, any shade of gray, and white. Dogs may have a small white spot on the chest. Black or gray dogs may have a sprinkling of other colored hairs in black, gray, or white. The FCI and British Kennel Club standards also allow grayish black and shades of fawn, with or without a black mask.

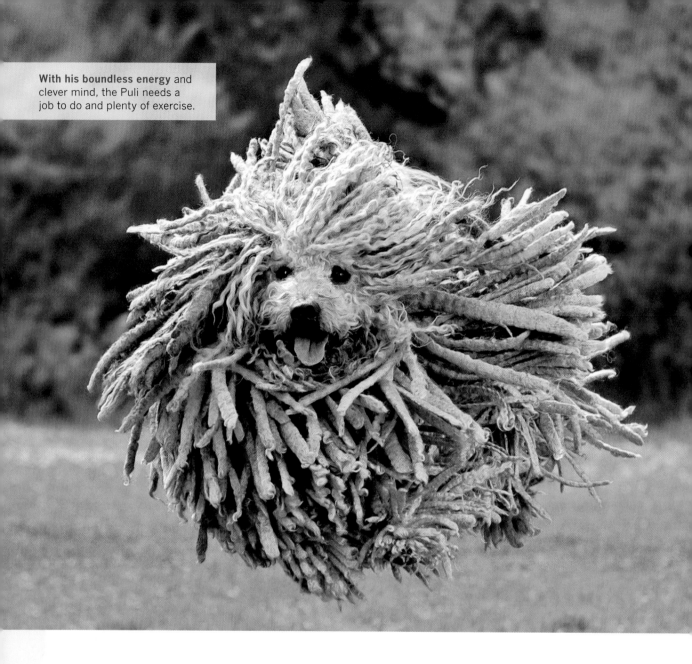

With his **boundless energy** and clever mind, the Puli needs a job to do and plenty of exercise.

Special Coat Care

The puppy coat begins to cord at about 8 to 10 months of age, when the softer undercoat becomes entwined with the coarser outer hair. Puppy owners can choose between growing a corded coat, a brushed coat, or a scissor-cut short coat from 1 to 3 inches long. To form the cords, the owner needs to frequently separate the coat into cords about 1-inch thick. Owners new to corded coats should seek advice as to the proper technique. The full coat takes four to five years to develop.

In adulthood, corded coats need regular attention to keep the cords separated and to remove debris. Unless the dog is being shown, owners tend to keep the coat 4 to 6 inches long. Owners generally trim the underparts and around the mouth. The ear canals and footpads also need attention.

Corded coats are easier to maintain in drier climates since wetness can encourage problems such as hot spots or mildew. White or gray cords are more likely to show stains or discoloration.

History

The grassland plain that covers much of Hungary is home to several native and distinctive breeds of livestock and dogs. The Magyar tribes from the steppes of Eurasia moved into the area with their stock and dogs, establishing their kingdom by 895 CE. Over time, the Mongols pushed another nomadic warrior people, the Cumans, into the area. The Cumans arrived with their animals, including their own livestock guardian and herding dogs. In the mid-thirteenth century, King Bela IV negotiated an agreement with the Cuman leader Koten Khan, which would allow the two peoples to share Hungary, yet live separately within their own villages and culture.

Genetic studies may someday reveal the actual ancestors of the Puli. Various theories suggest that he may be related to other similar herding dogs in Europe, that he is an old Magyar dog, or that he is related to similarly sized Tibetan dogs. However, it is undeniable that he resembles another famed Hungarian native, the Komondor, the livestock guardian dog of the Cumans. The Puli possesses the same corded coat and the serious nature of the Komondor.

The Puli moved sheep or cattle away from the villages out onto the plains for grazing, traditionally working closely with its shepherds, remaining at their side until directed away and then returning. Working long days, shepherds formed tight bonds with their dogs, carefully controlling their breeding and who was privileged to own one. Pulis, or Pulik, did not become city dogs or the dogs favored by the rich or nobility, but they were found across the countryside in large numbers. The actual name *Puli* was first seen in Hungarian literature in 1751, although the dogs were described a century earlier.

By the 1800s, western breeds were entering Hungary, including herding dogs, which were crossbred to the native types. With changes in agriculture, sheepherding also fell into decline. Accompanied by losses due to warfare, Puli numbers fell drastically, although some found homes as companions or police dogs.

Breed Recognition

Beginning in 1912, Dr. Emil Raitsits organized a Puli breeding program at the Budapest Zoo and a standard was accepted by the FCI. Pulik were separated into four sizes from a large police variety to medium, small and dwarf varieties — each promoted for different uses. There was also some standardization of colors as well as strong interest in very long coats. In 1959, as the breed began to recover, the Hungarian Puli Club decided to eliminate the large and dwarf varieties and combine the medium and small into one breed. This proved to be a positive decision, and the breed gained popularity both in Hungary and abroad.

In 1935, four Pulik were brought to Beltsville, Maryland, to participate in a USDA study on herding dogs. With the start of World War II, the Pulik were sold to interested breeders and accepted by the AKC. These four dogs formed the basis for the breed in North America, and were enriched by further imports. The Puli Club of America was founded in 1951, but it remains a rare breed here.

The Puli is now bred and shown throughout Europe. Puli numbers are small in Britain, where it is primarily a companion and show dog. Pulik are also rare in Australia and New Zealand.

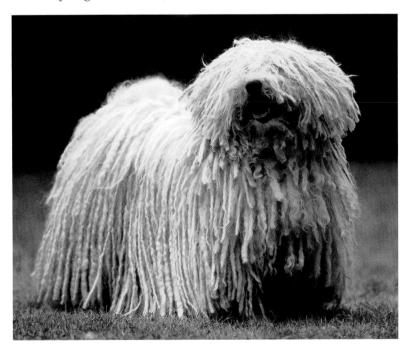

Deeply suspicious of strangers, Pulik are unusually protective and reactive for a herding breed. They must have consistent training and socialization.

Pyrenean Shepherd

PIR-ay-nee-an | Also known as Berger des Pyrénées, Petite Berger, Labrit, Pyr Shep

Origin	France
Size	15 to 30 pounds
Rough-faced	**Males** 15.5 to 18.5 inches; **Female** 15 to 18 inches
Smooth-faced	**Male** 15.5 to 21 inches; **Female** 15.5 to 20.5 inches
Coat Rough-faced	Medium-length harsh outer hair or longhaired wooly and corded with soft undercoat
Coat Smooth-faced	Medium-length harsh outer hair with soft undercoat
Color	Shades of fawn with or without black shading; shades of gray; merles; brindle; black; black with white markings
Temperament	dominant, high energy, soft, upright, loose eyed, close, bark, bite

A Pyr Shep is highly energetic dog who needs a job — herding, running with his owner, or participating in various dog sports.

Intelligent, intuitive, clever, and mischievous, he can also be stubborn. This is a dog that will take charge if boundaries and structure aren't imposed. Soft and sensitive, a Pyrenean Shepherd needs firm but positive and patient handling. He tends to mature slowly, becoming a calmer adult by about age three.

He is often a one-person dog, bonding devotedly to his owner and following him from room to room. He wants to be with his people all day and does not do well confined in a yard or kennel for long periods. He prefers being the only pet in the family, with a strong tendency to herd and boss other family pets.

Working traits. The Pyr Shep is a natural watchdog. He is suspicious of strangers and absolutely needs socialization with both adults and children. Owners note that he is a big barker, especially when working or playing. Left alone he can become an excessive barker.

The Pyrenean Shepherd is a versatile dog whose herding instincts remain strong. He is an enthusiastic, high-speed worker with excellent stamina. He works in an upright, loose-eyed style, close to his animals using his voice and bite. He excels at fetching and gathering stock and can cut and sort in a holding pen. He has some tending ability as well.

Medium-length coats (left) are low maintenance. Coats on all types typically don't require trimming, and dogs are shown naturally, appearing tousled and rough. Intermediate coat types also appear. The long coat (right) needs some extra attention to prevent matting and facilitate cording if it develops. Corded coats require specialized care and owners should seek advice and guidance from an experienced person.

Appearance

The Pyr Shep is a small dog who is built lean and light. There have long been two types: the *poil long*, a slightly bearded dog with long or medium-length hair, and *face rase*, with short hair on the face and a rough coat; they are designated rough-faced and smooth-faced by the registries. Rough-faced dogs tend to be more rectangular, while the smooth-faced dogs are generally larger and shorter backed. The head can appear somewhat small for the body; it has a distinctive triangular or wedge shape and the stop can be nearly nonexistent. The almond-shaped eyes are dark except in merle dogs. The ears were traditionally cropped straight across. Uncropped ears are short, either semi-prick or rose, and set high on the head.

Double dewclaws are often found on the rear feet. The tail was traditionally docked and natural bobtails can occur. Where the tail is undocked, it is set low and rises when the dog is alert, but doesn't fall over the back. It may have a crook at the end.

Coat/color. The Pyrenean Shepherd is double coated; the outer hair is harsh, coarse, and weather resistant, while the under-coat is soft. Either type or variety can occur in the same litter and they can be interbred but are shown separately. Some smooth-faced dogs do have slight bearding. The medium-length coat is sometimes referred to as "goat haired." The coat on longhaired dogs can be wooly on the back half of the body, often forming cords, or *cadenettes*. A mixed coat with some cording is perfectly acceptable. The eyes are not obstructed on either coat and dogs do not form full beards.

Pyrenean Shepherds are seen in several colors. Common colors include fawn, fawn with charcoal gray shading, brindle and gray with a black mask, solid black, and merle. Small white markings are acceptable in all colors. A dog's color may change somewhat as he grows older.

History

The native Pyrenean herding dog, *berger des Pyrénées,* has been recognized for hundreds of years. In the Pyrenees, shepherds used two

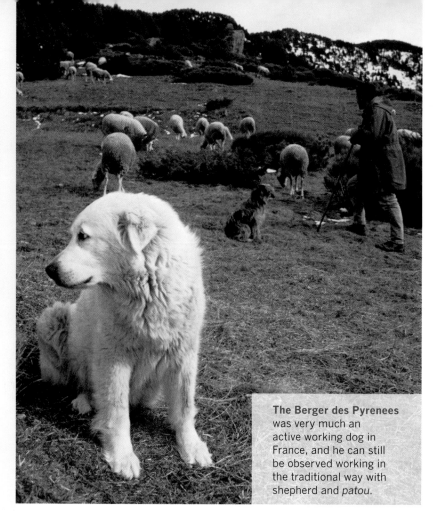

The Berger des Pyrenees was very much an active working dog in France, and he can still be observed working in the traditional way with shepherd and *patou*.

dog breeds working in partnership together — the *patou* (Great Pyrenees) and the *labrit* (Pyrenean Shepherd). The *labrit* (la-bree) was not expected to protect against the wolf, lynx, or bear, so he could be quite small. Large numbers of both breeds were found throughout the Pyrenees, along with their relatives found on the other side of the mountains — the Catalan Sheepdog and the Pyrenean Mastiff.

One *labrit* was considered sufficient for even large flocks, with perhaps two needed for flocks of a thousand. Sheep, shepherd, and the working partners traveled together up into mountain pastures for the summer, returning to the villages for winter. The *labrit* also worked at a distance from the shepherd, responding to his voice commands.

Although the *patou* was the protector, the *labrit* typically sounded the alarm at all disturbances.

While the *patou* remained with the sheep overnight, the shepherd and *labrit* returned to camp. In areas where the sheep were traditionally milked, the *labrit* was sent for the flocks twice a day. He held the sheep in pens waiting for their turn to be quickly milked. Afterwards, he gathered them together to return to graze. In the villages, he was also a popular companion and watchdog in the house as well as around the farmyard where he would help with cattle.

His service in World War I brought the breed great fame, as large numbers were used on the battlefields as couriers or messenger dogs. Others aided in search

and rescue work. After the war, shepherds continued breeding the dogs strictly for their herding ability, but breeders and preservationists worked toward a standard and recognition for the breed. The Reunion des Amateurs des Chienes Pyrénées was founded in 1923, in direct support for the two native working dogs of the Pyrenees. The French Kennel Club soon recognized the *labrit* as the Berger des Pyrenees but international interest would have to wait until much later.

Across the Ocean

Although Basque shepherds may have brought their *labrits* with them to United States in the nineteenth century, the Pyrenean Shepherd did not exist as a separate breed until new imports were made in the 1970s and '80s. Breeders of the Great Pyrenees, the *labrit's* working partner, were responsible for reintroducing the dog to the continent. The Pyrenean Shepherd Club of America was founded in 1987.

Although still a rare dog, North America is probably the strongest home for the breed outside of France. The UKC, CKC, and the AKC recognize him as the Pyrenean Shepherd. Called the Pyr Shep by his admirers, he has become wildly successful as an agility and sport dog.

Although the Berger des Pyrenees was occasionally imported to England, the Pyrenean Shepherd Club of Great Britain was not founded until 1992, and the breed is now on the way to full recognition by the Kennel Club. The breed remains rare and only the longhaired type tends to be found in the country.

Samoyed

SAM-a-yed		Also known as Bjelkier, Sami, Sammie

Origin	Russia	
Size	**Male** 21 to 23.5 inches, 45 to 60 pounds **Female** 19 to 21 inches, 37 to 55 pounds	
Coat	Long harsh outer hair with short, soft undercoat	
Color	Pure white, cream or biscuit, or white and biscuit	
Temperament	Independent, moderate energy, soft, upright, loose eyed, gatherer	

The Samoyed is an extremely friendly family dog, a cheerful companion, and a useful helper with herding tasks or chores on a small farm.

Although gentle and patient with children, Sammies do have a tendency to gather and direct their people. Since they traditionally worked in groups of dogs, they get along with other dogs and especially smaller dogs. Socialization with family pets and farm animals is needed, but the breed's hunting instinct is minimal.

Sammies are independent thinkers that depend on human interaction. More adaptable and trainable than most spitz breeds, they follow direction well, but do best with short, positive lessons, as they can be somewhat soft or sensitive. This is a vocal breed that makes a good watchdog, though they are not good protectors and barking can be an issue. Fencing is required as they are prone to chasing and roaming.

Working traits. Many Sammies do well at herding instinct tests, but some owners attribute this more to their strong working partnership with people than a powerful herding instinct. Natural gatherers, they circle to move stock, working in close, and may use voice

209

as well. Because they were used to move reindeer, not to shepherd them daily, they tend to prefer ranch or large flock courses to serious trialing.

Samoyed owners enjoy a variety of activities with their dogs including sledding, skijoring, packing, and hiking, as well as obedience and agility sports. Sammies would certainly enjoy some sledding work around a rural home. Due to the strong work ethic of the founding dogs, Samoyeds excel at weight-pull competitions in their size class. Sammies are an all-arounder sled dog — not the fastest or the heaviest — and tremendously well suited to the sport of skijoring. They do have a desire to pull, which can unfortunately make them difficult on a leash.

Appearance

The elegant Samoyed should look like its working spitz ancestors. With a deep chest, muscular body, and strong hindquarters, he has substance and endurance. The head is wedge shaped with a well-defined stop and medium-sized muzzle. The head can appear smaller than it is due to the profuse coat that frames it. The ears are medium in size, thick, erect, well covered with hair, and slightly rounded. The eyes are dark and almond shaped.

The breed's facial expression is important — the Sammie appears to be alert and smiling. The lips should be black in color while the nose and eye rims are preferably dark or black. The tail is profusely covered in hair and curled over the back when the dog is alert or moving.

Coat/color. The Samoyed coat is heavy, thick, and weather resistant. The outer hair should stand straight out, be free from curl, and form a ruff around the neck. The female's coat is usually softer and slightly shorter.

Sammies are pure white, solid cream, or biscuit, or white and biscuit with a silvery sheen. The coat requires regular care to prevent matting and deal with seasonal shedding, but the outer hair should shed dirt and debris. This breed absolutely loves cold weather and can be uncomfortable in hot, humid weather.

History

Sometimes confused with other northern spitz dogs, this popular breed has distinct roots of its own. *Samoyed* (or *Samoyede*, as it was spelled in the breed's early history), is actually a Russian word that was used to collectively describe a large group of indigenous people found in Siberia. These people lived over a large area in northern Eurasia and spoke related languages. The Samoyedic people are part of the greater Sámi culture found in the Arctic, hunters and fishermen who also followed migratory reindeer from the Arctic tundra in summer to forested land in winter. Eventually the Sámi learned to control and semidomesticate the herds.

The native spitz dogs worked as hunters and watchdogs, and also helped carry packs and pull sleds. Among the reindeer peoples, some of the traditional dogs also became herders, working in groups to move hundreds of animals. They also prevented reindeer from wandering into camp

The Sammie's alert and smiling expression reflects its friendly nature.

or away from the herd. With their owners, they drove off bear and predator attacks. Dog and man lived and worked closely together. Recent genetic and fossil evidence seems to indicate the ancient ancestry of the Samoyedic dogs.

In the western and southern areas of Siberia, Samoyedic dogs tended to be spotted, black, or brown *laika* types while in the eastern areas the preferred dogs were white, cream, or light tan. (*Laika*, meaning "barker," is the collective group of similar working and hunting dogs found throughout northern Russia.) The Samoyedic people developed especially close relationships with their white dogs, who were brought into shelters to sleep with the families. Samoyedic people often wore pelts and garments made of dog fur.

Beginning in the sixteenth century, Russian exploration and control of Siberia increased, and the native dogs, especially the white Samoyed, or Bjelkier dogs, came to the attention of Russian nobility. With their elegant and aristocratic appearance, they found their way into European royal homes, including in England where they are depicted in artwork with their owners as early as 1888. Early owners noted that the Samoyed dogs were more tractable and even-tempered than some of the other spitz dogs. Samoyeds eventually came to be found in many European countries, where they are still bred today, often under the name Bjelkier.

Samoyeds became valuable to explorers of the Polar Regions. Alexander Trontheim, a Russian, supplied hundreds of these dogs to the Europeans who were leading dog-sled expeditions. Trontheim tended to procure the white dogs from the eastern areas and supplied

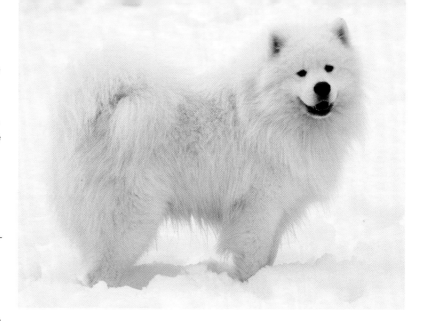

The Sammie is wildly enthusiastic about winter sports, from sledding to skijoring. The breed has retained its strong desire to pull.

dogs to many of the important explorers, such as Nansen, Amadeo, Jackson, Harmsworth, Amundsen, Scott, and Shackleton. Surviving dogs from some of these expeditions were among the founding dogs of the breed in England and elsewhere.

In the 1880s, zoologist Ernest Kilburn-Scott of the Royal Zoological Society and a member of an expedition to Archangel in Siberia returned with a Samoyed puppy and later acquired others. Kilburn-Scotts and other breeders continued to obtain dogs directly from Siberia, as well as surviving dogs from various polar expeditions. While some of the earliest dogs exhibited brown or black coloring, the fanciers focused on the white dogs, standardizing size as well. Most of the worldwide population is based on the dogs found in the important Samoyed kennels in England.

Across the Ocean

In 1904, the first Samoyeds arrived in the United States as a gift from the Grand Duke of Russia and were registered with the AKC two years later. However, the majority of the founding dogs in North America came from English kennels directly after World War I. The Samoyed Club of America was founded in 1923. One of the most important early breeders, Agnes Mason, was highly experienced and dedicated to dog sledding, and it is due to her influence that the breed retained much of its working heritage. Well established in North America, the Samoyed's popularity as a family companion continues to the present.

Samoyeds were also imported to Australia from England beginning in 1929, although others may have arrived as members of various polar expeditions. The Samoyed is numerous and popular in Australia and New Zealand, with several clubs organized around the breed. In North America, the Organization for the Working Samoyed promotes and supports the many activities that owners enjoy with their dogs, including herding, sledding, weight-pulling, and skijoring.

Schapendoes

SKA-pen-does

Also known as Dutch Sheepdog, Dutch Schapendoes, Dutch Sheep Poodle, Dutch Beardie

Origin	Netherlands
Size	26 to 55 pounds; **Male** 17 to 20 inches; **Female** 15.5 to 18.5 inches
Coat	Thick, long, wavy outer hair with short, soft undercoat
Color	All colors, including bicolor; blue-gray or black preferred
Temperament	Dependent, moderate energy, loose eyed, upright, drover

Schapendoes are watchful but not aggressive or protective; they happily welcome strangers.

Owners note that they are friendly, cheerful dogs. Affectionate toward their families, some Schapendoes can become clingy. Bred to be companions, they are good with other pets and children, although they may try to herd them.

The breed needs regular exercise and does well at many dog sports. They love to run and are excellent jumpers; they absolutely need good fencing. Schapendoezen (plural) are intelligent and attentive but sometimes can be stubborn. They are not driven or intense by nature, and are happy to be relaxed members of the family after work or exercise is done.

Health, appearance, and a companionable nature have been of primary importance to the breeders who have not focused strongly on herding qualities, although some Schapendoezen are again seen with flocks of sheep in the Dutch countryside. A courageous and agile dog that moves with a light and springy style, the Schapendoes traditionally works behind sheep and close, often nudging animals with its nose or shoulder. This breed also uses its voice to move sheep. Upright and loose eyed, it is more of a drover than a gatherer.

Appearance

The medium-sized Schapendoes is finely boned and lightly built under all its long hair. The head looks larger than it is due to the abundant topknot, beard, and moustache. The brown eyes are large and round. The ears are set fairly high on the head but drop freely. The long, feathered tail is carried down but raised and animated when the dog is alert or moving.

Coat/color. The Schapendoes double coat is meant to look rough, tufted, shaggy, and a bit unkempt. Weather-resistant outer hair is coupled with a short, soft undercoat. The hair is long and slightly wavy but not curly. Any color or color with white is acceptable, although blue-gray or black is preferred.

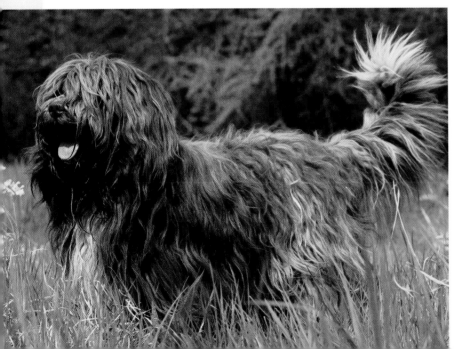

History

Though not well documented in art or literature, the Dutch Schapendoes was a common landrace breed, mainly centered in the northeastern province of Drenth, a sparsely settled agricultural area of fields, forest, and heath grazing that neighbored on Germany. It is likely related to the other bearded, longhaired European sheepdogs, such as the old German Schafpudel (sheep poodle), or even the English bearded collies found across the channel. This *schaper* (sheepherder) was always used primarily with sheep, helping move flocks to open areas near fields or roads for daily grazing. With no large predators to fear, the Schapendoes did not become a protective breed.

In the years leading up to World War II, the native breed was becoming less common as imported Border Collies entered the country, although the old dog was still favored by some sheepmen. When the breed was exhibited in the 1870s, fanciers never adopted it as a show dog.

Post–World War II

After World War II, the Schapendoes and other native breeds had become symbols for the Dutch Resistance and the Dutch kennel club promoted native breeds as a matter of national pride. A supportive club was organized and the Schapendoes was recognized as a breed in 1952, with a written standard two years later. The Schapendoes received FCI recognition in 1971.

The breed was restored based on a very small number of surviving dogs, and careful attention was paid to increase breed numbers in a

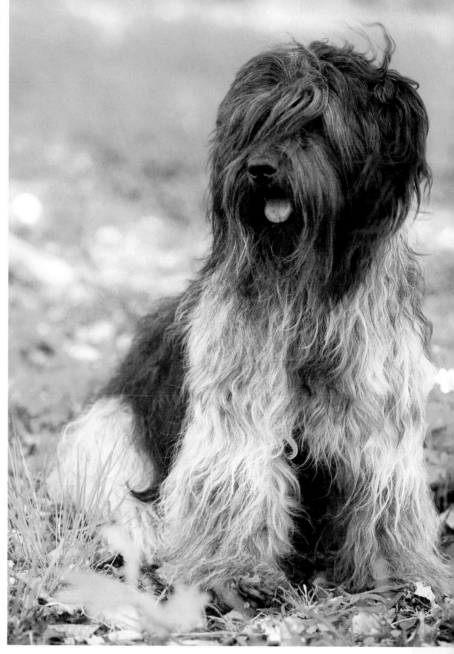

A more laid-back member of the herding group, the Schapendoes is a happy companion to a rural family and willing to lend a hand moving the sheep.

measured way. By 1981, there were only about 700 Schapendoezen. They arrived in France four years later and are now found in Belgium, France, Germany, Scandinavia, and a few other European countries. The population remains small worldwide, with about 250 puppies born each year. The International Schapendoes Federation is an alliance of several national clubs with the goal of facilitating cooperation and preserving health.

Schapendoezen were imported to North America in the late 1990s. Both the CKC and AKC FSS recognized the breed in 2005. They remain rare, although are perhaps more available in Canada due to connections with French breeders.

Shetland Sheepdog

Also known as Sheltie

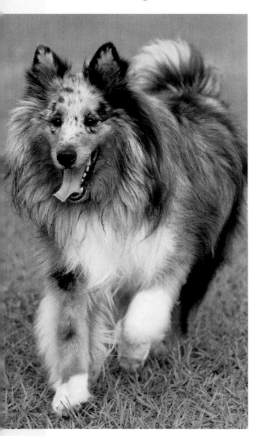

Origin	Shetland Islands, Scotland and England
Size	13 to 16 inches, 15 to 25 pounds
Coat	Long, harsh, straight outer hair with furry, dense undercoat
Color	Black, blue merle, or sable with or without white
Temperament	Dependent, moderate to high energy, willing, soft, upright, medium to loose eyed, gather, fetch, bark

The Sheltie's reputation as a good family dog comes from his affectionate, responsive, and loyal nature.

Although he can be reserved with strangers he is not aggressive. Most Shelties are sweet and good natured, although some individual dogs are nervous and sensitive to noise, stress, or commotion. If ignored or not actively engaged, he may develop annoying behaviors, such as excessive barking, nervous activities, or separation anxiety. This is an extremely vocal breed.

Shelties and children are a good match, although the dogs may attempt to herd children or people by getting underfoot or barking. Shelties are playful with other family dogs but may be reserved with strange dogs. They are also generally good with cats and family pets, but chasing behavior may need to be curbed.

The athletic Sheltie enjoys participating in activities with his owners; he is a rapid, willing learner. He needs plenty of attention and at least 30 to 60 minutes of daily exercise.

Working traits. A majority of Shelties still show strong herding instincts and are increasingly being used for trialing or work on farms. Potential herding dogs are best chosen from parents or lines successful at trial. Most Shelties are upright herders and only rarely crouch. They are medium to loose eyed, and most gather or fetch. Shelties tend to work close and use their voice. Highly intelligent and willing, Shelties are capable at most things they attempt, but their soft temperament requires positive reward-based training. Harsh or physical correction causes them to react fearfully. The breed is a top performer in many dog sports, such as obedience, agility, and rally.

Appearance

The graceful, elegant Sheltie is rectangular dog with a gentle, alert, intelligent expression. The refined head forms a long, blunt wedge, tapering from the ears to the nose, with a slight stop. The top of the skull is flat and the nose is black. The medium-sized, almond-shaped eyes are set obliquely. The small ears are set high and carried three-quarters erect with the tips breaking forward. When relaxed, they fold lengthwise into the neck frill. Shelties have an arched neck, a deep chest, and a level back with a slight arch at the loin and a gradually sloping croup. The tail is carried low and may lift when the

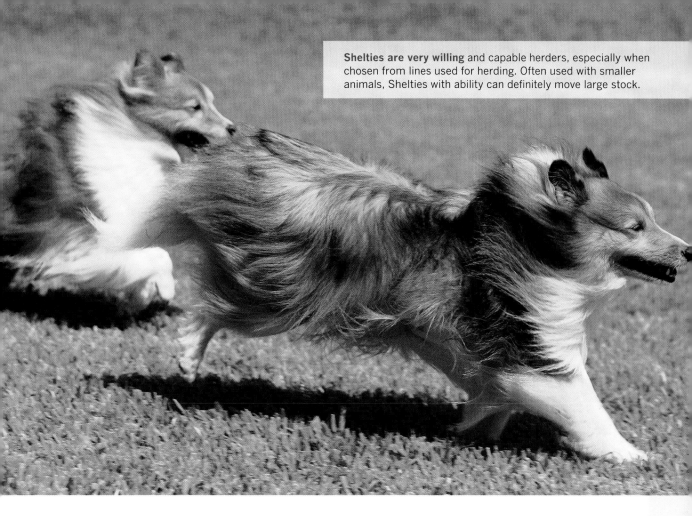

Shelties are very willing and capable herders, especially when chosen from lines used for herding. Often used with smaller animals, Shelties with ability can definitely move large stock.

dog is alert but is not curved over the back.

Coat/color. The Sheltie is double coated, with long, straight, harsh outer hair. The undercoat is short, furry, and very dense, which adds lift to the coat. The mane and frill are profuse, especially in males. The forelegs and upper hind legs are well feathered, and the tail is abundant. Weekly grooming is needed to avoid matting, but overbathing should be avoided, as it strips oils from the coat that is needed for weatherproofing. Shaving the coat is never recommended.

Shelties may be colored black; blue merle, splashed or marbled with black; and sable in shades of golden through mahogany. All colors may have white, tan, or white and tan. White should not exceed half of the body. The British and FCI standard also allows black and tan dogs.

History

In the nineteenth century, Shetland Islanders imported several sheep breeds in a desire to increase the size of the small, primitive, and fine-wool Shetland sheep that had existed unchanged on the islands for at least one thousand years. Until that time, the islanders had resisted any improved breeds from the mainland, keeping to their native breeds of ponies, cattle, pigs, poultry, and even dogs. Like their owners, the early dogs were Scandinavian in origin, similar to the small Icelandic and Norwegian sheepdogs.

Islanders relate that the old Shetland dogs were smaller than a Border Collie but not as small as a modern Sheltie. They were primarily black, although some had a bit of white or white and tan. The dogs served as watchdogs and companions, kept sheep from entering gardens or cropland, and possibly assisted with the twice-yearly sheep gathering.

When the imported sheep arrived, Scottish and English collies and sheepdogs came with them and were quickly crossbred with the native dogs, although some old-type dogs may have remained on isolated farms into the twentieth century. Farming families found that the crossbred dogs were excellent workers, inheriting strong herding traits as well as island hardiness and adaptability.

During the 1800s, Shetland ponies became well known — first as mine ponies in England, and then widely exported and bred elsewhere — and the image of diminutive animals became closely associated with the Shetland Islands. In the early years of the twentieth century, islanders began selling small dogs, which they called Shetland collies, to visiting tourists. In 1908, a group of breeders formed the Shetland Collie Club, followed soon after by the Shetland Collie Club of Scotland.

As the Shetland Collies made their way to show rings, some were mistakenly registered as Rough Collies, although they were criticized for their small size and appearance compared to a Rough Collie. When breeders applied for Kennel Club recognition, great disagreements arose over using the name "collie" and the suggestion that the dogs were miniature or toy collies. The Kennel Club eventually settled the issue by calling the breed the Shetland Sheepdog.

Despite the still common misconception, the Shetland Sheepdog is not a miniaturized version of a Rough Collie. The basic type arose from the original native dog, possibly with some infusion of Scottish or English sheepdogs or Border Collies due to crossbreeding on the islands in the nineteenth century. The suggestion of one or two outside dogs, such as a King Charles spaniel or Pomeranian, is not proven. In fact, the earliest Shetland Collies or Sheepdogs also resemble the Icelandic Sheepdog and Norwegian Buhund, modern breeds based on the old, small sheepdogs that also arose from isolated settlements.

In an effort to improve the Shetland Sheepdog, English breeders did cross smaller Rough Collies on Shetlands, giving them more a refined appearance, a more profuse coat, and more color. At first, English breeders set the height limit to 12 inches but this was eventually increased. Arguments continued between fanciers, both in Britain and eventually in North America, about size and preserving an older type versus an improved version. War years and economic hardships stifled the breed's expansion in Britain, while the breed began to flourish in North America.

Across the Ocean

The first Shelties arrived in the North America in 1908, and were soon recognized by the AKC. In the 1920s and '30s, more Shetlands arrived and the American Shetland Sheepdog Club was organized in 1929. World War II interrupted the import of more Shelties, and the two populations diverged from that point, remaining generally separate since that time. Bred to be a companion dog, the North American Sheltie is usually a larger dog, with a more classically refined Collie head and whiter color.

The Shetland Sheepdog rapidly became a favorite family dog in North America. By the 1970s, the Shelties had been one of the most popular breeds for 15 years. Although the breed's popularity has declined slightly, about 10,000 Shelties are still registered yearly. In Britain, the Kennel Club sees approximately 1,000 registrations each year; as well as about 700 dogs in Australia. The Shetland is also popular in Scandinavian countries and elsewhere in Europe.

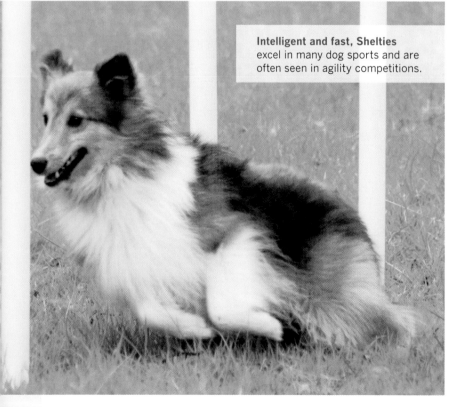

Intelligent and fast, Shelties excel in many dog sports and are often seen in agility competitions.

Additional Herding Breeds

Though not well known to the general public, these herding breeds are all recognized by the FCI.

Australian Kelpie/Working Kelpie

Kelpies were developed in Australia by sheepmen needing dogs suitable to the challenging climate and terrain and also capable of herding difficult Merino sheep over huge sheep stations. Beginning in the 1870s, a few breeders created lines of dogs based primarily on strong-eyed collie types from Britain or Scotland. Some believe that dogs were occasionally crossed with dingoes, though this is not documented. The breed was named for two of the founding dogs, who were named after the supernatural Celtic water horse.

Kelpies were bred to independently find and drive out the nearly free-ranging Merino sheep, as well as handling them in the close quarters of stockyards and loading pens. Working over huge areas for long hours, Kelpies needed to work quietly and lightly over the ground, with great endurance.

The first standard was created in 1904, becoming the foundation of the so-called show or bench Kelpie, recognized by the FCI and now primarily known as the Australian Kelpie. Working Kelpies are registered with the Working Kelpie Council, organized in 1965, to focus on ability over appearance. In Australia, up to 100,000 Kelpie and Kelpie crosses are believed to be working sheep and cattle. Working and show Kelpie lines have become quite separate over the past 100 years; to the point that some consider them to be different breeds.

Working Kelpies have also been widely exported around the world, coming to North America in the 1920s and '30s, where they were almost exclusively used and bred on working ranches. Numbering several thousand, they are not rare, but are not often seen in show or companion homes. The North American Australian Kelpie Registry was founded in 1991 to maintain pedigrees and records of the Working Kelpie. In North America, the CKC and UKC adopted the FCI standard for Australian Kelpies, although the population is low.

The Working Kelpie ranges from 12 to 23 inches tall, and weighs 26 to 45 pounds, with females smaller. Usually single coated with prick ears, Kelpies are fast, agile, medium-sized dogs. The slick coats are advantageous in the heat and prevent the accumulation of burrs or stickers in the coat or between the toes.

Working Kelpies are seen in various solid colors, including black, red, blue, fawn, and cream. Dogs can also be black and tan, red and tan, blue and tan, or fawn and tan. White markings are minimal. In North America, Working Kelpies with tan markings are more common. The various standards for the Australian Kelpie are more restrictive, allowing only black, black and tan, red, red and tan, fawn, chocolate, and smoke blue.

The best situation for this breed is a working home, as they possess very strong herding instincts and the urge to roam. Kelpies are intelligent and willing, as well as problem solvers and self-thinkers. This workaholic breed truly needs hours of exercise daily along with the mental stimulation of a job. They are very difficult to contain, being great climbers and escape artists.

Kelpies are famously known as one-person dogs and many handlers look for a dog that seems attracted to them. Kelpies are tolerant of children, but can be over-stimulated by the sound and commotion. Kelpies will attempt to herd anything, including cars, and can pose a danger to small animals or stock if not controlled. They are generally fine with other family or working dogs. Kelpies are alert watchdogs but not guard dogs.

Kelpies are medium- to strong-eyed dogs, showing great energy and focus. Although they employ a stealthy crouch or stalk, Kelpies do not clap or drop to the ground at the balance point. They cast or gather over both long and shorter distances. Owners appreciate their sense of appropriate distance when moving sheep, allowing them to walk over long distances. Kelpies will hold, back (jump on sheep; see page 118), bark, and bite at noses, not legs. Recently, many breeders have focused on breeding more forceful dogs for working cattle.

Australian Koolie

The Koolie has been an essential worker in various areas of Australia since the nineteenth century. While their actual ancestry is unknown, blue merle and smooth-coated sheepdogs from Britain appear to be the primary source of the breed. Although the dogs were sometimes called German Coolies, no actual evidence exists for any of the old German herding-dog types in their development. However, it is reasonable to assume that other herding dogs present in Australia, such as Kelpies, early British sheepdog types, or Border Collies, were bred with Koolies.

Koolies were bred to specific needs in various areas of the country, with observable differences between the strains. Aware that Koolie numbers have decreased and Koolies are increasingly being bred to other working dogs, the Australian Koolie Club seeks to be an important resource in connecting Koolie owners. The Koolie Club registers dogs but has no standard, holding that the breed can be variable as it is purposefully bred for working ability not appearance. Koolies are now being exported in small numbers to New Zealand, the United States, and Europe.

Koolies range from 17 to 22 inches tall and weigh from 28 to 48 pounds. They may be fine to heavy boned depending on locale and work. Dogs have diverse ear carriage and long tails. Coats run from short and smooth to medium and double coated. Koolies may be red or blue merle; solid red or black with or without white markings; and bi- or tricolored. They have varied eye colors, although blue eyes are common. Koolies are upright, loose- to medium-eyed dogs that work with all types of stock including dairy cattle, ewes with lambs, and feral cattle. Koolies head, heel, or drive, cast out (gather), block, and back (jump on) sheep.

New Zealand Huntaway

In addition to driving huge groups of sheep into paddocks or holding pens, the Huntaway was developed in New Zealand specifically to flush sheep out of hiding in hilly brush-covered land. Instead of working silently, the Huntaway uses its loud, deep bark to control the flock. Shorthaired coats were especially valuable in the brush, as was greater endurance and stamina to work all day on large farms.

Border Collies were likely crossed with a variety of breeds to result in this upright, loose-eyed dog who uses a great deal of voice and works in close. By the late nineteenth century, huntaway-type sheepdogs were in demand by sheepmen. The New Zealand Sheepdog Trial Association states the breed, recognized in 2013 by the NZKC as the first native breed, should never be shown or kept only as a pet. A few Huntaways have been exported to Australia and elsewhere, but the breed is not generally known outside of the country.

Huntaways are medium to large dogs, weighing 55 to 88 pounds and standing 22 to 26 inches tall. They are deep chested, sturdy, muscular dogs with long tails. Colors vary but most dogs are black and tan, often with white or brindle. Smooth coats are preferable but they can be medium-length rough or wiry. Ears are semi-erect when the dog is alert. Tails are long and may rise when active.

Cão da Serra de Aires

(Portuguese Sheepdog)

This is a single-coated, longhaired breed from the southern plains of Portugal, where it was primarily used to herd sheep, goats, or cattle and to serve as a protective farm watchdog. A fairly recent creation with no clear records to his exact makeup, the dog is believed to have been developed by Count de Castro Guimarães on his Monte da Serra de Aires farm in Alentejo, in south-central Portugal, sometime in the early twentieth century. The origin of the Cão da Serra de Aires' single coat, a truly uncommon feature, is unexplained, although there is a single-coated, longhaired herding breed found just to the south in neighboring Algarve — the Portuguese Water Dog.

Whatever his origins, a standard for the regional type was

NEW ZEALAND HUNTAWAY

accepted by the Portuguese kennel club in 1932, but after World War II the Cão da Serra de Aires became increasingly rare. In the 1970s, a small group of admirers worked to save the breed they affectionately called *cão macaca* (monkey dog), finding it a new purpose as a companion dog in suburban areas. A few of these dogs are still working, although breeders have been working toward enhancing his favorable traits and softening his harder herding temperament.

Popular in Portugal, they were practically unknown outside of the country until late 1990s, when the FCI granted recognition as a breed. Known as the Portuguese Sheepdog outside Portugal, these dogs have been exported to a few countries in Europe and are also recognized by UKC and CKC; however, there is no organized club to date. The AKC gave the breed FSS registry status in 2012, but it remains exceedingly rare in the United States.

The Portuguese Sheepdog is rectangular dog with a profuse coat, weighing 26 to 40 pounds and standing 16.5 to 21.5 inches tall (males are somewhat larger). Under all that hair, he is lean and athletic. The long, harsh coat is straight or slightly wavy; it forms a moustache, beard, and eyebrows but does not cover the eyes. The single coat is not well suited to very cold or harsh weather. The coat comes in yellow or tan, brown, gray, fawn, wolf-gray, or black; all with tan markings.

Like many herding dogs, he has a dominant temperament and is also intelligent and highly trainable, although he can be stubborn. He is a suspicious and alert watchdog who can become protective and territorial. This active, energetic breed does well at various dog sports and is devoted to and playful with his family. Herding instinct is still strong in some lines. He is an upright, loose-eyed dog who works in close to stock with agility and quickness. Traditionally, he was noted for his strong gathering abilities.

US BREEDS

Texas Heeler

The Texas Heeler is a crossbred dog using the Australian Cattle Dog with either the Australian Shepherd or Border Collie. They are hardworking, highly intelligent, high-energy dogs, generally bred to work cattle; they also excel in dog sports. Size ranges from 17 to 22 inches tall and 25 to 50 pounds. Texas Heelers are seen in many colors and coats, and are usually prick eared.

Hangin' Tree Cowdog

The Hangin' Tree Cowdog was developed in Oklahoma by Gary Ericsson, using Border Collies, Catahoulas, Kelpies, and Australian Shepherds. The result was a slick-haired, medium-sized, sturdy herding dog who both heads and heels cattle. Found in a variety of colors, Hangin' Tree dogs usually have short, easy-care coats, erect ears, and docked tails. This new breed has gained a considerable following and has established itself with a registry and breeders.

McNab Dog

Alexander McNab emigrated from Scotland to northern California in 1868. As he established his very large sheep ranch, McNab imported dogs to work his stock. Various histories describe these dogs as Scotch collies, fox collies, or Border Collies. They may or may not have been crossbred on local sheepdogs.

Whatever the original roots, the McNab dogs, also called McNab sheepdogs or sheepherds, became popular stock dogs throughout the central valley and coast of California, working both sheep and cattle on ranchland and in stockyards. Today, they are still found primarily in California, where they are also a hunting companion and a protective watchdog.

To enable them to cope with the hot climate and to shed burrs or stickers, McNab dogs were selected for short, tight coats. The upright, loose-eyed McNab dogs work both head and heel in a forceful, close manner using both bark and bite. They are primarily black with white markings, and the ears are usually pricked although some tip slightly. Tails are long or naturally bobbed. Weights vary between 40 and 70 pounds, with dogs standing 15 to 25 inches tall.

JACK RUSSELL TERRIER

⑥ Terriers and Earthdogs

A working terrier can be invaluable on a farm.

Rats and other vermin attract larger predators, which in turn threaten poultry and livestock. Some terriers also hunt small predators. Small hunting dogs, some long-bodied or short-legged, have existed since ancient times. Small dogs were also essential for killing vermin around houses, wharfs, and shops. By the fourteenth century in France, small scenthounds called *bassets* were common; they probably share deep roots with the Teckels, or Dachshunds.

The word terrier, from the Latin *terra* meaning "earth," was first used in sixteenth-century Britain. Terriers were used to hunt foxes, badgers, and otters in England, Wales, and Scotland. Foxhunters on foot worked with fell terriers or on horseback with hunt terriers. Hunt or fox terriers were housed in kennels and worked with packs of hounds or other terriers.

The golden age of mounted foxhunts, which began in the late eighteenth century, were linked to the enclosure movement that forced country people into the cities to provide for large-scale sheep raising. Land laws further restricted the common people from hunting, but gamekeepers used terriers to hunt predators that attacked game birds.

Farmers, especially in Ireland, also used larger multipurpose terriers as watchdogs and ratters. In North America, this working type was a common and beloved family companion. Feists and rat terriers helped their owners hunt rabbits, raccoons, squirrels, opossums, and woodchucks.

Some terriers were primarily stable dogs. Ratters were also invaluable in the city and country, working alone or in pairs. They became increasingly essential in crowded urban environments. In the nineteenth century, ratting became a popular sport, complete with rat pits, stands for spectators, and betting, leading to ratters that were bred as ferocious killing machines.

Physical Appearance

As a group, working terriers are physically more alike than different. Historically, although size varied by prey or quarry, a working terrier had to fit in the entrance to the burrow or den. This meant terriers had to be "spannable," meaning about 14 inches in circumference as measured by a man's hands wrapped around the chest behind the shoulders. While leg length varied their feet and paws were well suited for digging. Teeth and jaws were strong and powerful. A terrier's skin and coat needed to be protective underground and weather resistant. Bulging or prominent eyes and large ears were problematic, being prone to injury.

Working terriers are agile, fast, and athletic with quick reflexes. Conformation can be quite specific as to height, weight, leg length, chest size, and shoulder assembly. This structure is essential because it ensures that the dog is able to work on specific terrain and prey. Small size is usually preferable, though not too small to deal with an opponent.

Terriers can have smooth, silky, wavy, wiry, or mixed coats. Short, smooth coats are typically easy care, while other coats may demand specialized attention, such as clipping or stripping. Some terrier breeds are kept in natural coats. Other modern terrier breeds have been bred for coats that are impractical in the field, being too long or soft, or lacking weather resistance. Outdoors, they get wet or muddy and attract burrs or stickers.

A terrier must be *spannable*, as measured by a man's hands wrapped around the chest behind the shoulders, or about 14 to 15 inches in circumference.

Behavior and Temperament

The predatory sequence — search/stalk/chase/bite and hold/bite and kill/dissect/consume — that was present in the earliest dog ancestors is less altered in terriers than in most other breed groups. However, the instinct to dissect, consume, and guard prey was suppressed so that the dogs would kill multiple animals, such as rats. This very strong prey drive often overwhelms the normal pain response.

All terriers demonstrate the following characteristics and behaviors in various combinations and strengths.

Energy or drive. Lively, animated, active, and energetic, terriers typically require at least one or two hours of attention and exercise every day. They also need mental stimulation and physical challenges. Young terrier pups are often vigorous and boisterous in play. Most terriers have seemingly inexhaustible energy and they don't like to quit. Without sufficient activity, many dogs develop destructive or behavioral difficulties.

Intelligence. Terriers are clever and impulsive. They are also self-thinkers who often develop their own solutions to problems. Terriers are quick learners, capable of understanding many commands.

Independence. Terriers are independent and a bit stubborn. Some are also dominant and may assume leadership in a vacuum. Training a terrier can be demanding and challenging. Their intelligence, persistence, and curiosity must be engaged and channeled with positive reinforcement and

What's a Terrier?

Miniature Schnauzers and Dachshunds are often included with the terrier group due to their similar work; although they are not technically terriers, they share many behavioral traits. Some terrier experts firmly believe that only dogs that go to ground, including the Dachshund, should properly be called terriers. Ratters are often considered terriers, although some have never worked as earthdogs — small dogs that dig and enter quarry found in underground dens.

Some terriers, both medium and large, were actually bred and used as multipurpose farm dogs or game dogs. Some of the bully breeds that have "terrier" in their names, such as the Bull Terrier and Staffordshire Terrier, were essentially butcher's dogs, later used for bull baiting, dog fighting, protection, or hunting. The Tibetan Terrier and Black Russian Terrier are definitely not terriers — these are cases of mistaken identity. Some small or toy terriers were primarily companion dogs, although they may retain some terrier temperament.

rewards. Terriers that are hunting or chasing do not have a reliable recall and should never be off leash in situations where this could occur.

Strong prey drive. These breeds were bred to kill small animals, and their high prey drive may extend to cats, birds, or even small dogs or puppies. Many terriers are not safe unsupervised with small family pets; some may tolerate family cats, but not strange ones. The desire to chase is extremely dangerous when directed at vehicles. Training and socialization can help mitigate some prey drive, but owners should be alert to prevent problems.

Pluck and focus. Bold and courageous, terriers are easily aroused or stimulated. Most have a high pain tolerance and become extremely focused and tenacious once engaged. They can be persistent to the point of being annoying.

Low arousal threshold. Terriers possess quick fighting and chasing reflexes that are readily engaged by motion or touch. The need for terriers to be fiercer than their prey means they may snap or bite when aroused. Although puppies need to be raised with an understanding of acceptable behavior, some terriers can be difficult to manage with small children. Terriers don't respond well to harsh or physical punishment and may respond by snapping.

Barking and digging. All terriers bark, a trait referred to as "voice." Terriers use their voice to alert and sound alarms, and barking at prey is important for locating the dog when it is at work in a burrow or tunnel. Barking also harasses prey out of the burrow. Also, all terriers dig; this is how they pursue and unearth their prey.

Dog aggression. All terriers have some level of dog aggression. Terriers were often solitary workers, although breeds that historically worked in pairs or small packs may be more tolerant of other dogs. Some terriers can coexist with a different sex dog, a larger dog, or a dog whom they were raised with. Some terriers will tolerate a family dog but not a strange dog who challenges them. Some breeds tend to have less dog aggression, but most terriers are more likely to prefer human companionship over the company of another dog.

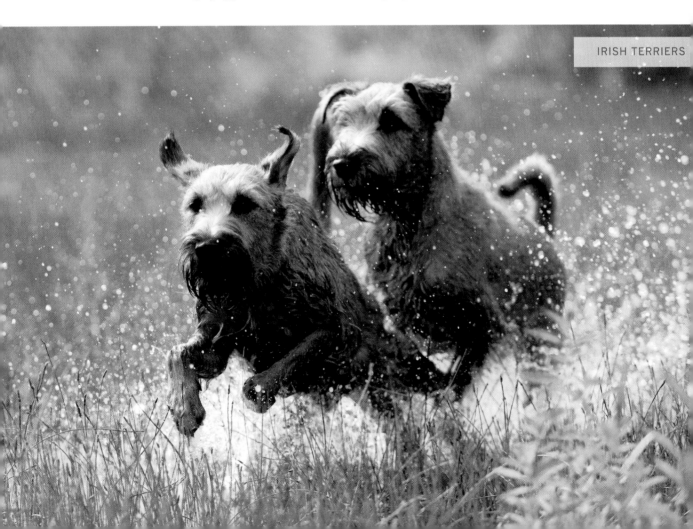

IRISH TERRIERS

Caring for a Wiry Terrier Coat

Hard, wiry coats were a protective feature for terriers working in dense undergrowth or underground in dens or burrows. The dead hair in a wiry terrier coat does not shed out completely on its own; it is traditionally tugged or plucked out. Terrier coats vary and some grooming techniques are more suitable for different breeds.

Stripping

Stripping is generally performed two or three times a year, with the dead outer hair pulled out by hand or with a stripping tool. Stripping should not be painful. Clippers are used on sensitive areas. Known as "taking the coat down," complete stripping leaves the dog in his undercoat until the new outer hair grows in over a period of 8 to 12 weeks. Properly timed, a stripped coat can be in perfect condition for a dog show. When hand stripped, the wiry outer hair often grows back with a wave, giving rise to the descriptor "broken coat." Not all groomers offer hand stripping and it is more expensive.

Rolling

With rolling, small amounts of dead hair — only enough to keep the new hair growing in while leaving the dog in a good coat — are stripped out twice a month or so. Some owners do this themselves. Groomers can also maintain a rolled coat with visits every 8 to 12 weeks.

Clipping

Clipping, which creates an attractive coat and can be easier or more convenient, doesn't remove the dead hair but only shortens it. The texture may become softer and coat color may lighten or dilute after clipping.

Natural coat

The coat is vigorously brushed weekly with a slicker brush to help remove the dead hair. The dog also rubs hair out while working. Baths may be needed more often. Natural-coated dogs look shaggy or tousled.

To maintain a good working coat, most terriers should be stripped by hand or with a special grooming tool.

Making the Right Choice

In addition to the variety of size, coat, activity levels, and prey drive in terriers and earthdogs, distinct differences exist in working traits among breeds. Breeds were developed for specific work or situations, which factors strongly in their essential natures. Some breeds are more relaxed in the home, while others are definitely dedicated and powerful workers. Differences exist in breeds with regard to living with other family pets and children in the home.

Roles for a Terrier

Terrier breeds were often developed for working in specific terrain, in a particular manner, and for certain prey. Knowing the history and purpose of a breed helps determine the best breed for a given purpose. While individual differences exist among dogs within a breed, each breed possesses distinctive combinations of instinctual behaviors and physical characteristics in addition to strengths and weaknesses.

Although terriers share common qualities such as higher energy and prey drive, some breeds are definitely more suited for a working life than the role of a family companion. A very strong drive may also be less desirable in a dog that is to be a part-time worker or general farm helper. However, if you are looking for a hardworking ratter, an independent, bold, and plucky dog will be tireless in pursuit of vermin around farm buildings and fields.

Breeds that tend to be more affectionate and less independent, or more likely to get along with other family pets or dogs, will be a better choice for a nonworking home or a less active family. Some dogs are very sensitive to touch, motion, noise, or commotion, making them less suitable for homes with younger children. If you are looking for a competition dog, you also need to consider size and eligibility.

Most important, truly assess the activity level and outlet for work that you are able to provide a terrier. Many terrier problems stem from lack of exercise and mental stimulation. Consider, also, whether you can handle a more dominant dog. Other factors include the amount or type of coat-care some breeds require and the availability of rarer breeds.

Common Health Concerns

In general, the smaller size of many dogs in this group reduces issues with hip or elbow dysplasia, although short-legged dogs can have other joint issues. Long-backed dogs are more prone to back injuries or disc problems. Owners can lessen potential problems by keeping their dogs fit and trim, and preventing excessive jumping from furniture and out of vehicles.

Wirehaired dogs can develop skin problems if the old, dead hair is not stripped out of the coat. Although many dogs are successfully maintained with clipped or natural coats, the hair follicles can develop acne. Growth of new hair can also be inhibited if the old hair is not removed.

"Nonworking" Terriers

Several terrier breeds with roots as earthdogs or ratters are not often seen at working trials or working homes. Some of these breeds have a long history of breeding for show or pet homes rather than for working instinct and conformation. Terrier temperament may have been purposefully softened. Some of these breeds are too large for earthwork, have impractical coats, or lack strong working instinct. In other cases, the population size is very low.

There are always exceptions and some individual dogs from these breeds have succeeded at instinct tests, barn hunts, or working trials. Choosing a dog from the low end of the breed standard for height, weight, and size of chest is important. A moderate length of back and good flexibility are also advisable. The dog needs to demonstrate a strong prey drive and other working terrier instincts. There is a growing interest among owners of some of these breeds to trial their dogs, often for the benefit of exercise and activity.

Bedlington Terrier	*Glen of Imaal Terrier*	*Sealyham Terrier*	*West Highland White Terrier*
Dandy Dinmont Terrier	*Scottish Terrier*	*Skye Terrier*	

What to Look for in a Terrier Pup

Unless you are experienced with terriers or are looking for a competitive or working dog, it is probably best to look for a pup who is moderate or soft in terms of temperament (see The Temperament of Working Dogs, page 24). Many breeders perform temperament tests, which can be very helpful for potential owners, as is asking the breeder for his observations about the litter. Meeting the parents is also important in assessing temperament.

In some breeds, temperament or conformation differences exist between dogs bred for show or companion homes, and working dogs. If you are looking for a serious working or performance dog, it is advisable to purchase one from working lines. Attending a trial or event is a good way to see the dogs in action and meet owners.

There can be differences between males and females. While both genders are good working dogs and family companions, people often have preferences. In some breeds, males may be more affectionate. In general, males are more outgoing or less sensitive, and females can be more quiet or composed. For a working terrier look for a pup who is:

- Self-confident, independent, and bold
- High in energy and prey drive
- Determined, persistent, and focused
- Curious
- Attracted to people, makes eye contact
- Easy to handle

- Healthy
- Structurally sound, balanced, coordinated, and well-angulated front and rear
 Avoid pups who are:
- Aggressive or dominant toward people or other dogs
- Shy, fearful, indifferent, or inattentive
- Sensitive to noise
- Uninterested in thrown objects or chasing
- Sensitive to a gentle pinch or pain
- Structurally flawed

Bringing Home a Terrier Pup

New puppies need a quiet place to sleep, hang out, and eat. Calmness is important in the first days. Introductions to children and family pets need to be done in small sessions and with supervision. It's important to set and maintain boundaries, expectations, and routines from the beginning. Both companion and working terriers need to be independent, confident workers. Socialization to people, experiences, and other animals is key. This doesn't mean just playing at a dog park, but lots of walks and exposure to many different locations and situations.

Terrier training needs to begin early and consistency is extremely important. Kindness and patience are vital, as are short, engaging, fast-paced, and varied lessons. Positive, reward-based learning works best, including food rewards or clicker training. Terriers love games and fun, and they may become bored in a large obedience class as they wait to take their turn or are asked to repeat things over and over. All members of the family should participate in training and handling. Include games and walks in your daily routine.

For the working terrier, it is important that he work with his owner rather than a dog trainer. Working together aids in forming a close relationship, as well as establishing the owner as a leader to follow and trust. Outdoor walks help him develop his vision and scenting abilities, as well as learn to navigate terrain. Scent games are an excellent tool to keep his sense sharpened. Squeaky and furry toys are a favorite and a good attention grabber.

Terrier pups need lots of exposure to people, places, other animals, dogs, and the outside world. Begin training early and remain consistent in your expectations.

Activities for Terriers

Terriers excel at the following activities, all of which have local and national organizations that are easily found online.

- Agility
- Barn hunt
- Disc sports
- Earthdog
- Flyball
- Natural hunting
- Nosework and tracking
- Obedience rally and freestyle
- Terrier and drag racing

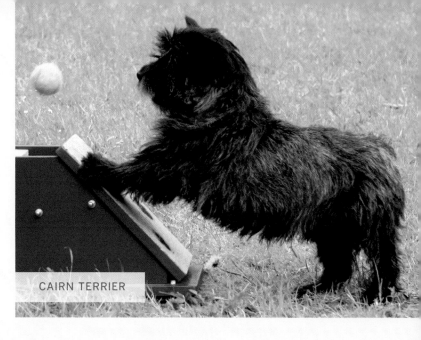

CAIRN TERRIER

Backyard Activities

Games are not only useful training tools for young terriers, they are great outlets for adult dogs as well.

- Fetch — Use tennis balls, discs, and other toys. Mix it up by throwing high and low.
- Find and Seek – While he observes, bury toys or small treats in a sandbox and let your dog dig them up.
- Nosework – Hide treats in the house or yard or create a scent trail for your dog to track.
- Tricks — Terriers are active learners. Clicker training is especially suited to building up complex routines.
- Backyard agility — Build a safe but flexible obstacle course that can be changed around or run in a different order. Terriers particularly enjoy smaller tunnels.
- Freestyle obedience — Exercise to music with your dog or combine commands in varying orders.

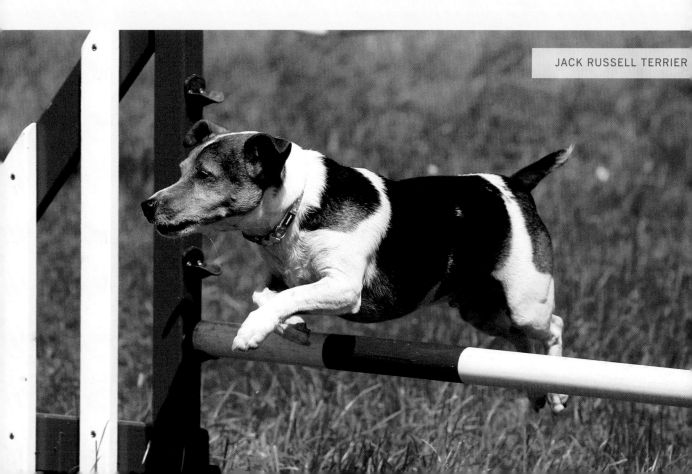

JACK RUSSELL TERRIER

Working Ability and Instinct Tests

Earthdog training events, fun meets, and instinct tests are an excellent way to learn and meet others. A working terrier should have a strong chase or prey drive as well as grip or bite for small furry objects. Test the pup for his willingness to chase a furry toy and hold on tight. Puppies can also be introduced to safely caged quarry, such as rats, but they often display short attention spans or less aggression than adults.

Do not force interactions but allow a pup to cautiously study the quarry. Enthusiasm and excitement can help encourage his interest, barking, and biting at the cage. Many puppies may not demonstrate strong hunting instincts, which often appear with age and maturity.

Trials and Tests

Instinct tests include the Introduction to Quarry or Rats tests offered by Earthdog, AKC, and Barn Hunt groups.

Earthdog den trials use man-made tunnels 30 to 35 feet long, where dogs must navigate in search of safely caged rat. Open to specific breeds, depending on organization.

Barn hunts, open to all breeds, use stacks of hay bales for dogs to hunt for hidden but safely caged rats.

Natural hunting or fieldwork demonstrates the dog's ability to enter natural dens and locate quarry.

Working Terrier Associations

Working terrier organizations often sponsor instinct tests, den trials, natural hunting, racing, go to ground activities, and rat hunting. Dogs can earn certificates of achievement and titles.

- American Working Terrier Association
- Barn Hunt Association
- Irish Working Terrier Federation
- National Working Terrier Federation (UK)

Kennel clubs, including the AKC, CKC, and UKC and breed clubs, such as the Jack Russell Club of America, also provide opportunities for classes, instinct tests, trials, and certificates or titles.

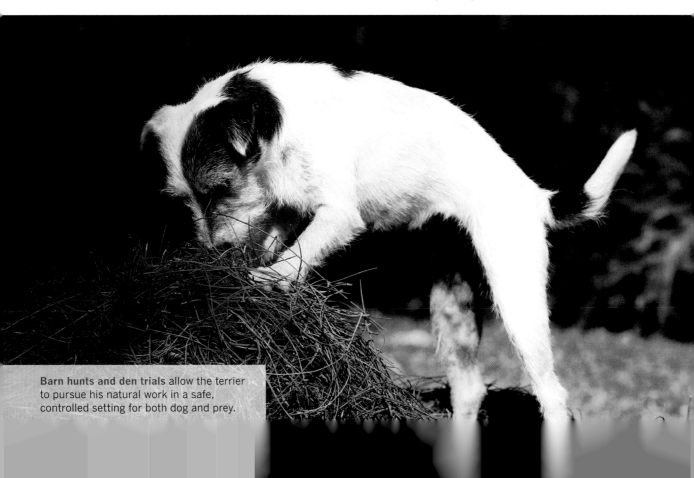

Barn hunts and den trials allow the terrier to pursue his natural work in a safe, controlled setting for both dog and prey.

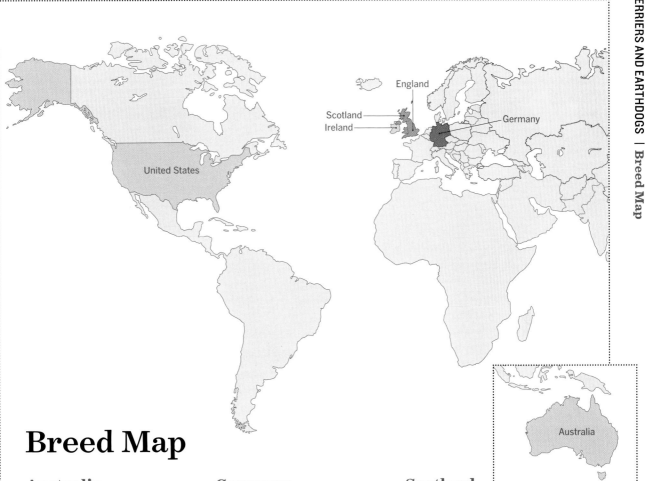

Breed Map

Australia

Australian Terrier
Russell Terrier
Tenterfield Terriers

England

Border Terrier
Smooth and Wire Fox Terrier
Jack Russell Terrier
Parson Russell Terrier
Lakeland Terrier
Norfolk Terrier
Norwich Terrier
Patterdale Terrier

Germany

Dachshund
Miniature Schnauzer
Jagdterrier

Ireland

Irish Terrier

Scotland

Cairn Terrier

United States

Rat Terrier
Treeing Feist

Australian Terrier

Also known as Aussie

Origin	Australia
Size	10 to 11 inches, 12 to 18 pounds
Coat	Harsh, dense outer hair with soft undercoat
Color	Blue with tan markings; solid sandy or red
Temperament	Independent, dominant, high energy, high prey drive

The Australian Terrier's original tough temperament has been softened a bit to adapt to his primary role today as a companion dog.

Although still a spirited, self-confident dog, he is amenable to living calmly and quietly with his people. The Australian Terrier is generally friendly and good natured and noted for his gentle playfulness with children. He definitely wants to be with his family and involved in whatever is going on.

This is an intelligent breed that learns quickly and is eager to please. Owners must establish leadership and begin early with consistent training and socialization to prevent bossiness or any aggressive behaviors.

Aussies tend to be territorial and will bark to sound an alert, although they are not nuisance barkers. They can be dog-aggressive, especially male dogs with other males. They can generally learn to live in a multidog household but may have issues with dominance or possessiveness. Due to their high prey drive, they chase cats, rabbits, squirrels, and other small animals. And they love to dig. Aussies need lots of daily exercise or play time; they are well suited to many dog sports.

Working traits. Although he often worked above ground rather than in tunnels, the Aussie remains an energetic hunter of rats and other vermin, especially where rats' nests are involved. The Aussie is a capable dog at both earthdog and barn-hunt trials. Experienced handlers have noted that some dogs show early aptitude for quarry, while in other individuals this instinct may be delayed until maturity.

Appearance

The Australian Terrier is a small, long dog with short legs and a natural, rough-and-ready appearance. The skull is long and flat, with a slight stop and a strong, powerful muzzle. The leather of the nose often extends up the muzzle to the bridge of the nose. The small wide-set ears stand erect and pointed. The eyes are small, oval, and dark in color.

The neck is strong and slightly arched, the topline is straight, and the chest is moderately deep and wide. The tail is set high and carried up, and traditionally docked to half-length, though it can be left natural.

Coat. The Australian Terrier is double coated. The outer hair is harsh, dense, and straight with a soft undercoat. The breed is maintained in a tidy but tousled rough coat with a maximum length of about 2.5 inches, including the large, dense ruff and apron, which originally served as protection from snakes. The distinctive, silky topknot is brushed forward and

encouraged to stand up without falling into the eyes.

The hair on the ears, the back of the neck and across the topline of the body, the lower legs, the feet, and the tail is kept shorter. The longer hair under the muzzle, in front of the eyes, and the underparts is neatened with scissors. The coat is easy to maintain with weekly brushing and infrequent baths. Twice a year the coat sheds heavily and needs either vigorous brushing or hand stripping.

Color. Aussies are seen in three basic colors — blue, sandy, or red. The blue may vary between silver-blue to darker, and a steel blue; it has rich tan markings on the face, ears, underparts, lower legs, and feet. The topknot is blue or silver, preferable in a lighter shade than the head color. The tan markings are not sandy or red, with richer colors desired. Dogs may also be a solid sandy or red, preferably without any darker markings or shading. The topknot should be silver or a lighter shade than the body.

History

Originally an immigrant, the Australian Terrier was remade by the needs of his adopted home. As British, Scottish, and Irish colonists began settling the continent in the late 1700s, they introduced rabbits and rats, followed by red foxes. As they moved across the region, they found themselves battling not only native poisonous snakes but growing numbers of rodents and other vermin. Terriers were certainly being bred in Australia by the 1820s, and by the time of the 1850s gold rush, terriers that hunted vermin and snakes had become invaluable. Homesteaders valued their multipurpose nature as a watchdog,

a hunter, and a companion for isolated families.

The earliest terriers imported from Britain were primarily old rough-coated types, including short-legged ones, from Great Britain. Sheep- and cattlemen from Scotland and the Border counties of England brought their dogs with them. Aussie admirers see strong influence from the old Scottish and Skye Terriers, along with coat color from the old Yorkshire Terrier and the topknot from the Dandie Dinmont Terrier.

In 1864, some three dozen native "Rough Coated Terriers" were exhibited at a dog show in Melbourne. At other times they were called the Broken-Coated or Blue and Tan Terrier. Twenty years later, a definite type had emerged, a standard was written, and the Australian Rough Coated Terrier Club, now called the Australian Terrier Club of Victoria, was organized.

At first the native terriers were regarded as mongrels and criticized for their hard-bitten appearance. They were certainly tough dogs to work and survive in such harsh conditions. There was even public objection to the name Australian, as though it would reflect badly on the country, but in reality the breed's hardiness symbolized the national character. In 1909, the Australian Kennel Club eventually acknowledged the Australian Terrier the first native breed to achieve that recognition. Today, the Aussie is primarily a suburban companion dog, with about 300 puppies recorded each year.

Across the Ocean

First imported back to England in 1896, the breed was not recognized by the KC until 1933. Although it

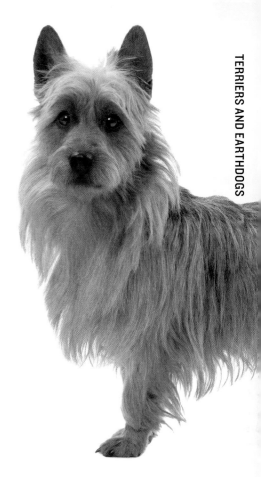

The Australian Terrier has found a home with people who participate in dog sports, in additional to life as a family companion.

has an active group of admirers, Aussies remain very rare there, with fewer than 30 registrations yearly. Following FCI recognition, the breed has also spread to other countries.

Although a few dogs may have arrived sooner, larger numbers of Australian Terriers made their way to North America in the years following World War II, many brought back by returning servicemen. The Australian Terrier Club was organized in 1958. Just two years later, 58 Aussies were exhibited at the Westminster Kennel Club show and the breed was recognized by the AKC. Still somewhat rare, there are about 300 registrations each year.

Border Terrier

Origin	England
Size	Typically 11 to 16 inches **Male** 13 to 15.5 pounds; **Female** 11.5 to 14 pounds
Coat	Wiry outer hair with dense, soft undercoat
Color	Red, wheaten, grizzle and tan, or blue and tan
Temperament	Independent, high energy, high prey drive, focus, pluck

Active and alert, Borders enjoy being with their owners as they go about their day but do not demand affection and attention.

They can also be good companions for older children. Basically good natured, Borders will bark to announce visitors but are not territorial or aggressive. As a result of their pack history, Borders are less dog-aggressive than many other terriers and should be able to live with other family dogs. As usual, opposite-sex dogs often get along best. Many Borders live with a family cat, especially if the cat was a member of the family first, but they are likely to chase unfamiliar cats. Due to their strong prey drive, Borders are not reliable with pet rabbits, rodents, or birds. They need to be on a leash or exercised in a fenced area.

Although Border Terriers are very intelligent, they can also be stubborn. Owners note that while basic obedience and manners training come rather easily, teaching more complex tasks needs some patience as the breed matures slowly. As self-thinkers, Borders can come up with creative solutions — owners need a sense of humor.

Harsh correction is not productive with a Border, who appears to be a hard dog but actually can be very sensitive and unforgiving; he may react to a physical correction by either shutting down or snapping. Borders are very responsive to tone of voice, either positively or negatively, as well as food rewards. They are vigorous chewers and need proper objects to demolish or they will use whatever is handy.

As high-energy dogs, Border Terriers need vigorous play or a long walk every day. Left alone they are likely to bark or dig. Many Borders are happily engaged in dog sports, such as agility, flyball, obedience, or rally, and earthdog or barn-hunt activities.

Working traits. Although most Borders are no longer worked in the traditional way, breeders encourage owners to try earthdog activities. The Border Terrier is one of the most accomplished competitive earthdog breeds. He retains good instincts and is persistent, game, and very focused on his quarry. He does mature late compared to some other earthdog breeds, so patience is advised; a young dog is often not ready to compete until age two. Borders also work well with another dog in a brace.

Appearance

The Border Terrier should be a working terrier above all. There is some concern that Borders are becoming too large. He must be spannable by both hands behind shoulders — about 15 inches in diameter. The body is deep, narrow, and fairly long. He should appear both muscular and racy, with small feet. The Border has a distinctive,

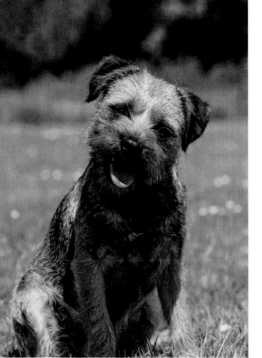

otterlike head, with a broad, flat skull; lack of definite stop; dark eyes; and a shortened, yet strong muzzle. Small V-shaped ears are set somewhat to the side of the head and drop close to cheek. The undocked tail is moderate in length, thick at the base and tapering, and not carried overly high. Borders have thick, flexible skin.

Coat. The double-coated Border has wiry, somewhat broken, outer hair that is dense but lies close without any curl or wave. Medium in length, the correct coat has a hard texture that sheds dirt or dried mud and burrs. With a dense undercoat, the Border is well suited for cold, but his coat may be too heavy for hard work in extremely hot weather. Along with weekly brushing and a little trimming of the head, neck, and feet, most Borders should have their coat stripped two or three times a year. Some owners choose to keep their Border in a rolling coat or a shaggy natural coat. Older dogs may be clipped for comfort.

Color. Border Terriers are seen in shades of red from rich and foxy to light or coppery; wheaten; grizzle and tan; or blue and tan. Grizzled hairs are tipped in dark color over a red or tan coat and may vary in amount. Blue and tan dogs have a black undercoat. Wheaten, a clear, light tan, is the most uncommon color. Most dogs also have dark muzzle and ears.

All Borders should have a ring of silvery, coarse hair one-third up the tail. A small amount of white on chest is allowed. Puppies are born dark and it may be difficult to determine their adult color for several weeks.

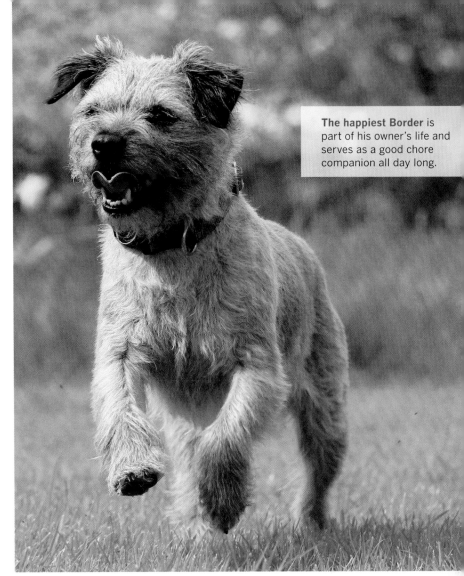

The happiest Border is part of his owner's life and serves as a good chore companion all day long.

History

The lovely Border counties lie on both sides of the boundary between Scotland and England. A land of mountains, lakes, moors, and hills, the area was home to farmers and shepherds, as well as foxes, badgers, and otters — all of which were hunted with hounds and terriers. Industrialization depended on coal mining, and the miners, factory workers, and tradesmen also used terriers as ratters.

On the rocky, upland grazing land known as the Fells, working terriers were often used in packs to hunt otter or fox. Fell terriers were generally silent workers with low-set ears, longer legs, and smaller feet for speed rather than broader feet for digging. Tenacious and scrappy, they were also small enough to fit in tight places. There was much crossing of various types, sizes, colors, and coats; as well as breeding for specific needs and preferences into types known by various names. Eventually these types were developed into breeds such as the Border, Lakeland, Patterdale, Dandie Dinmont, and Bedlington terriers.

For generations, the Robson family kept the Border Foxhound Pack for hunting on the moors of

Northumberland. The Robsons developed a specific type of rough-coated Fell terrier in the early nineteenth century. The terriers were used as support for the hounds and were sent to bolt the foxes from their rocky dens. It is from this geographical association that the breed earned the name Border Terrier.

The Border Terrier was shown at local agricultural shows in the 1870s but was not recognized by the Kennel Club until 1920, after an earlier rejection. Supporters also organized the Border Terrier Club. From the earliest days, breeders and owners sought to preserve the working traits of the breed without it becoming a flashy show dog. The standard was very short on points of appearance, other than those specific to its work. With his plain, no-nonsense character, the Border Terrier has become a very popular dog, though he is now found more often as a companion than a working dog. About 6,000 puppies are registered each year. In Britain there are seven regional breed clubs to mentor new owners.

Across the Ocean

The Border Terrier was recognized by the AKC in 1930, but it was not until the late 1970s that the breed began to increase in popularity. Today about nine hundred dogs are registered yearly. The UKC, which recognized the Border Terrier in 1948, also registers a large number of Borders. The Border Terrier is often owned by people who enjoy working with their dog in agility, flyball, earthdog, and other activities.

In the mid-1960s, a significant number of Border Terriers were imported from the UK to New Zealand to establish the Patterdale kennels, which focused on good temperaments as companion dogs. In the 1970s, Border Terriers from New Zealand were exported to Australia, where today about two hundred dogs are registered yearly.

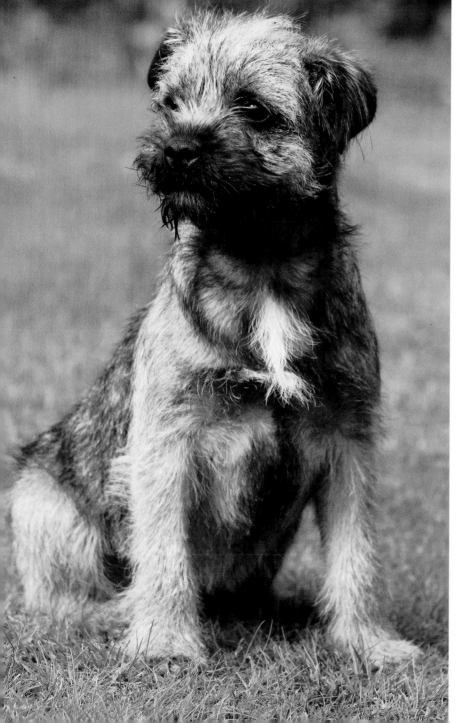

Without help, a Border's coat will not shed out completely. Twice yearly stripping or the regular use of a slicker brush will keep the natural coat in good condition.

Cairn Terrier

Origin	Scotland
Size	11 to 12 inches, 14 to 16 pounds
Coat	Hard, harsh outer hair with soft undercoat
Color	Any color except white
Temperament	Independent, dominant, moderate energy, high prey drive, pluck

The Cairn Terrier is fearless, cheerful, and assertive without being aggressive. Owners find the dogs to be playful, curious problem solvers who enjoy tasks or games.

Cairns don't like to be ignored and want to live with their families, participating in their activities. Most Cairns enjoy playing with children, although it is important to avoid teasing and to provide a private retreat, like a crate.

Cairns are alert watchdogs but friendly to introduced visitors. They need daily exercise and activities to prevent boredom, which can lead to nuisance digging or barking. They are intelligent and need firm handling and obedience training, as well as socialization. Although stubborn and independent, they can be sensitive to harsh treatment.

Breeders note males can be more affectionate than females. Owners also relate that individual differences are strong in the breed. They suggest meeting the parents of any potential puppy to assess temperament and personality.

Cairns are typically fine with other family dogs due to their history of working in packs, although there is potential bossiness or overprotectiveness of food or toys. Like many terriers, they can be aggressive with strange dogs, especially big ones. With their high prey drive, they need to be on a leash or securely fenced.

Working traits. The Cairn Terrier remains an efficient ratter around the farm. He retains much of his gameness, courage, and tenacity. He still functions well as a hunting or chasing terrier and is an enthusiastic participant in earthdog trials and barn hunts. He's noted for his good nose, cleverness underground, and appropriate size. He also does well in and around water.

Appearance

The Cairn's physique projects his active, hardy, working attitude. The head is small but shorter and wider than that of many other terriers. The skull is broad with a decided stop, a strong but not long muzzle, and large teeth. The medium-sized eyes are wide set and slightly recessed. The ears are small, pointed, and erect. Set wide on the sides of the head, they give the Cairn a foxy expression.

Rectangular, the breed has a level back that is not overly long. For its size, the Cairn is strong and muscled but not heavy. The short tail is set level on the back; it is thick at the base and carried up. The front feet turn out slightly, with large, strong feet and nails.

Coat. The correct water-resistant outer hair and warm undercoat are very important to the breed. The coat should be profuse, hard, and harsh. The hair is 2 to 3 inches long and a slight wave is acceptable. The head is well furnished, with shaggy eyebrows.

Although more stylish dogs are seen in the show ring, this is meant to be a wash-and-wear terrier. The

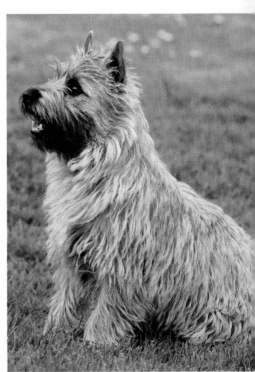

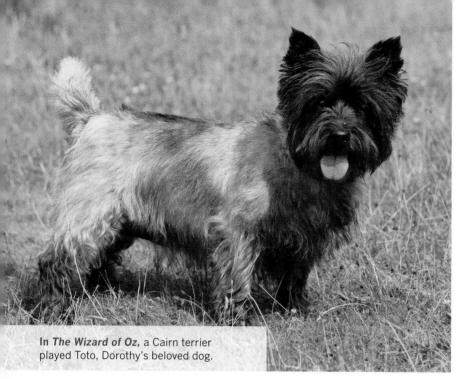

In *The Wizard of Oz*, a Cairn terrier played Toto, Dorothy's beloved dog.

coat is generally kept in a natural state with only a little tidying of ears, eyes, feet, and tail. Weekly grooming sessions keep the dog in good condition. During shedding seasons, the dead hair should be stripped or removed. Clipping damages the coat, as does overly frequent bathing. Dried dirt and mud should shed off a correct coat.

Color. The AKC standard accepts any color except white. The ears, muzzle, and tail tip are often darker. The KC details the colors as cream, wheaten, red, and shades of gray to nearly black. Brindling and dark points are acceptable. No solid black or white or black and tan are allowed, although white and black-and-tan puppies are still seen and, of course, make wonderful companion dogs. Many colors change with age, especially brindle, which can become very dark.

History

References to small, rough-coated Scottish or Highland terriers can be found as far back as the fifteenth century. More specifically, the ancestors of the Cairn lie in the group of Skye terriers, found on the northern Scottish Highlands and on the Isle of Skye in the Hebrides. The breed would eventually earn its name from its primary work, hunting on the rock piles or cairns of the highlands or coast rather than digging in soft earth. Small size and agility were key to fitting in the tight spaces, as was a weatherproof coat and sturdy, strong body. He needed to be tenacious and courageous to flush out badger, otter, or fox.

By the mid- to late nineteenth century, various types of Scottish terriers had arisen in addition to the Cairn. They were eventually developed as the Skye, the Scottish, the Dandie Dinmont, and the closely related West Highland White Terrier. Perhaps of all his relatives, the Cairn has most strongly retained his working nature. The oldest lines came from gamekeeper packs in Skye, maintained for decades for bolting badgers or otters from their dens.

The breed was first shown in Britain as the Shorthaired or Prick-eared Skye Terrier, but due to confusion with the longhaired Skye Terrier, the name was changed. In 1910, the name Cairn was adopted, the Cairn Terrier Club was organized, and the Kennel Club recognized the breed. West Highland Whites and Cairns were still interbred at the end of nineteenth century, but were separated in the studbook by 1908, and eventually white became an unacceptable color in the Cairn. Rather rapidly, the Cairn earned considerable popularity and exports soon followed.

Although the breed was more favored in the past, the KC still registers about 1,000 dogs each year. With a strong following in Scandinavia, the Cairn is found throughout Europe and and the rest of the world. By 1920, the modern Cairn Terrier was being bred in Australia. The breed's numbers began to increase after World War II, and today there are about 200 registrations each year.

Although rough-coated Scottish terrier types had no doubt arrived in North America sooner, the first imports of the recognized Cairn Terriers occurred in 1913. The Cairn Terrier Club was founded in 1917, followed by many more imports. From Canada, the offspring of an important English champion named Redletter McRuffie would help to establish the breed; his genes are present in the pedigrees of most Cairns in North America. The Cairn Terrier found many companion homes, but has also been widely adopted for agility, obedience, and terrier or earthdog events. The AKC registers more than 2,000 Cairns yearly.

Dachshund

DAHKS-huunt | Also known as Teckel, Dackel, Doxie, Dachsie

Origin	Germany
Size	(North America standard) **Standard** about 8 to 9 inches, approximately 16 to 32 pounds **Miniature** about 5 to 6 inches, 11 pounds and under
Temperament	Independent, moderate energy, high prey drive

LONGHAIRED DACHSHUND

Coat	Long, sleek, or slightly wavy outer hair with soft undercoat
Color	Solid red to cream; bicolored dogs include black, chocolate, wild boar or agouti, gray or blue, and fawn each with tan or cream markings; any color dapple or tiger (merle); brindle or striped; sable

SMOOTH DACHSHUND

Coat	Short, dense, shiny outer hair with soft undercoat
Color	Solid red to cream; two color dogs include black, chocolate, agouti, gray or blue, and fawn each with tan or cream markings; any color dapple or tiger (merle); brindle or striped; sable

WIREHAIRED DACHSHUND

Coat	Short, rough, wiry outer hair with soft undercoat; longer hair forms mustache and beard
Color	Any color or pattern, most common wild boar (agouti), black and tan, shades of red

Beloved family dogs for many generations, Doxies are often the trusted companion of children.

It is unfortunate that some Dachshunds have the reputation of being nippy or snappy, but this is generally due to overindulgence. Well-bred, well-trained, and socialized dogs should be good members of their families and nonaggressive to strange people or dogs. Owners relate some differences between the three different varieties, although individuals always vary. The Longhaired dogs are often quieter, calmer, and more docile. Smooth-coated dogs can be more loving, affectionate, and the most dependent on owners. Wirehaired dogs are usually the most energetic, courageous, and willful.

Dachshunds are tenacious and independent minded which means they can be a bit stubborn, willful, or mischievously clever. Doxies are also curious souls who need to check out everything. Puppies should begin training at a young age with any undesirable behavior not tolerated. Positive reinforcement is best and the breed is very food oriented. Doxies do not like harsh treatment and may react physically. Children, in particular, should be taught to behave appropriately with them.

Although lively, Dachshunds require only moderate exercise in order to be calm in the home. Miniatures are usually more active than Standards. Some care needs to be taken with a Doxie's back; young dogs should not jump down from high places or engage in intense

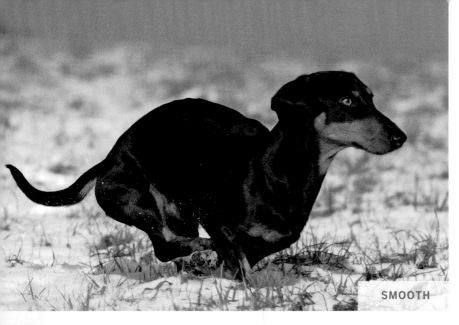

SMOOTH

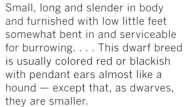

Small, long and slender in body and furnished with low little feet somewhat bent in and serviceable for burrowing. . . . This dwarf breed is usually colored red or blackish with pendant ears almost like a hound — except that, as dwarves, they are smaller.

—Johann Friedrich von Fleming, *The Complete German Hunter* (1719)

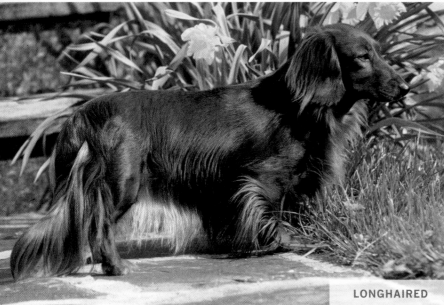

LONGHAIRED

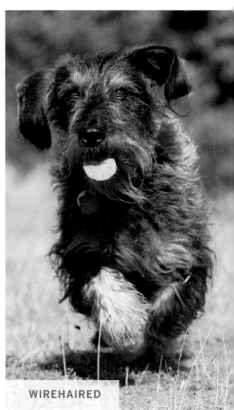

WIREHAIRED

exercise. Obesity, rough handling, or jumping can also strain the back.

A Doxie is an alert watchdog who will bark at disturbances. He is generally well behaved with strangers but devoted to his family. Some are more dependent and may develop separation anxiety if left alone. With a high prey drive, they may pose a threat to small family pets. Often kept in pairs or small packs, they get along with other family dogs and cats, though may be aggressive to strange dogs

if confronted. A Dachshund is a courageous dog who acts as if he were much larger than he is. And of course, he is a great little digger.

Working traits. Besides being great housedogs, Dachshunds are talented hunters with good instincts for both trailing and earthwork. When working, they are focused, enthusiastic, and consistent, with an excellent sense of smell; they earn many earthdog titles. Dachshunds are also used for hunting woodchucks, foxes,

and rabbits, as well as tracking wounded animals, such as deer. In some areas, Dachshunds are used to hunt prairie dogs.

Appearance

Standards vary between kennel clubs. If conformation showing is important, consult specific standards. Although they have long bodies, Dachshunds should be able to move freely and with speed. The long neck is slightly arched,

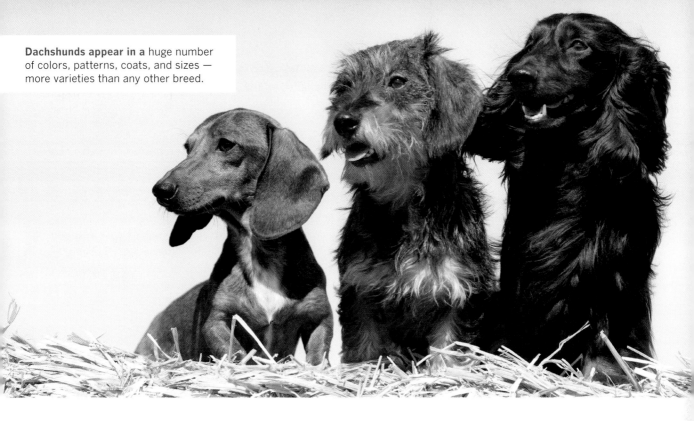

and the body is long and straight between the withers and the loin, with a rounded croup. The long tail is a smooth continuation of the spine and is carried upwards in a curve, to be more visible in tall grass. The forequarters are strong and deep. The shoulder blade, upper arms, and curved forearms wrap around the front. The skin is elastic but not wrinkled.

The expression is confident and bold. The head tapers from the skull to the tip of the nose. The skull is slightly arched, with very little stop and a slightly arched foreface. Although the nose is long and tapered, the powerful jaws open wide. The pendant ears protect the ear canal. The eyes are medium sized, almond shaped, and dark except when appropriate for coat color (e.g., merle dogs often have blue eyes).

The Dachshund has certainly diverged in type between its homeland, Britain, and North America. In North America, the dogs are divided into the two classes, Standard or Miniature, by the weight of the adult dog. Nonstandard "tweenie" dogs fall between the two ranges.

Weight ranges in the UK are 20 to 26 pounds for Standards and 10 to 11 pounds for Miniatures. Germany and other FCI countries divide the dogs by the circumference of chest measured at 15 months. The *Normalgrossteckel* is 35 cm (13.8 inches) with an upper weight limit of 9 kg (20 pounds). The *Zwergteckel* ranges from 30 to 35 cm (11.8–13.8 inches). The *Kaninchenteckel,* or Rabbit Dachshund, includes dogs up to 30 cm (12 inches). German and European Dachshunds are also longer in the leg than British or North American dogs.

Coat. The coat of Longhaired dogs should look sleek and elegant rather than profuse or heavy. The hair is soft, straight, or slightly wavy. Longer hair appears on the ears, neck, chest, underside, back of the legs, and tail, which all require regular grooming. Smooth Dachshunds have a short coat that is shiny, tight, and close to the body. Slightly longer hair is common on the underside of the body and tail.

Smooths are clean, easy-care dogs. Wirehaired dogs have a short, dense coat of harsh, rough, tight outer hair with a soft undercoat. Longer hair forms a mustache and beard. Wirehaired dogs require stripping two to three times yearly.

Color. In North America, despite some controversies, color is considered relatively unimportant in a Dachshund, although some colors and patterns are more common. As an example, piebald is nonstandard, although shown successfully. Great caution should be taken when purchasing a double dapple puppy (one from two dapple parents), since there is a greatly increased chance of blindness and deafness. German, FCI, and British standards do not allow double dapple or piebald dogs.

History

Is the Dachshund a hound? A terrier? A type of its own? All three points of view can be supported, but there is no doubt this is among the most recognizable breeds in the world. Short dogs bred for hunting badgers existed as early as the seventeenth century in Germany; called *dachskriecher* or *dachshunde*, they were similar to the French *basset* and looked much like the Dachshund of today

Besides badger hunting, Dachshunds were used to scent, chase, and dig out fox, weasel, and rabbit. In packs they trailed larger prey, such as deer and boar. Either straight- or crooked-legged, they also came in different sizes bred for specific purposes. The origins of the wire- and longhaired coats are up for debate. Perhaps bred from within the breed itself, it is also possible that there were crosses with the Affenpinscher, other wiry haired pinschers, or schnauzers, and the continental-spaniel types. Pinschers and schnauzers were all common ratting dogs in Germany.

Others wonder if British terriers were involved, but there is no proof of any very early British terrier imports to Germany. The three different Dachshund coats were recorded by the 1830s, along with the colors brindle, dapple, brown, fawn, and black. The dogs were also divided into different sizes based on the diameter of the hole they could enter.

Across the Ocean

Dachshunds first appeared in Britain in 1840, when several smooth-coated dogs were sent as a gift to royalty. These dogs were soon appearing in shows, where they were initially registered as German Badger Hounds, a mistranslation of *dachs* (badger) and *hund*, which actually means "dog." When the Dachshund Club was formed in 1881, smooth-coated dogs were still the only variety in the country, although the other varieties would eventually be included. The British interest in Dachshunds was always more as a companion than a hunting dog. The Germans were soon complaining that British dogs were longer, heavier, and shorter in the leg, with a larger forechest.

Dachshunds arrived in North America around 1870, coming with immigrants who often used them to hunt rabbits. Soon more dogs arrived from both Britain and Germany; the AKC registered the breed in 1885, and the Dachshund Club of America was founded 10 years later. By the beginning of World War I, the Dachshund was one of the top 10 breeds in the country. The war years were hard on the breed in both Britain and North America, where they were often vilified. Postwar, the breed's reputation and numbers were restored and the "wiener dog," "hot dog," or "sausage dog" again became a beloved family companion.

The Dachshund has been one of the most popular dogs in America for several decades, with more than 25,000 registrations annually. In Britain, the KC also registers more than 5,000 Dachshunds, with the Smooth Miniature by far the most popular variety. The Smooth Mini is also the most favored in Australia, with more than 1,200 registrations. The Smooth is the most popular in North America as well, with the Wirehaired the least common although it is the most popular in Germany.

What's a Teckel?

Although called the Dachshund elsewhere, in Germany the dogs are popularly called Dackels, and hunters have always called them Teckels and still do. Teckels are bred specifically for hunting and hunting performance events. The North American Teckel Club, focused on working Dachshunds, is a member of the German Teckel Club and the World Teckel Union.

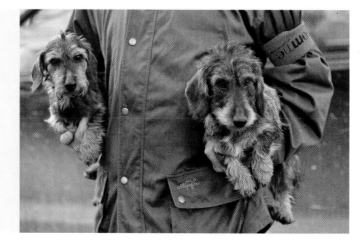

Fox Terrier

Origin	England
Size	Not to exceed 15.5 inches and 18 pounds
Temperament	Independent, dominant, high energy, high prey drive

SMOOTH FOX TERRIER

Coat	Smooth, flat, hard outer hair with soft, short undercoat
Color	White or white with tan, black, or black and tan markings; white should predominate

WIRE FOX TERRIER

Coat	Wiry, dense outer hair with short, soft undercoat
Color	White with black, tan, or black and tan markings; white should predominate

Strong-willed, tenacious, and stubborn, Fox Terriers are also curious, charming, and entertaining dogs who have long been known as affectionate and devoted companions.

Fox Terriers can be good companions for children, especially those old enough to play appropriately with the dog. Like all terriers they need to be raised with structure and expectations, firm and fair training, and thorough socialization to people, animals, dogs, and public places. Owners achieve better results if lessons are fun and positive, as harsh training is counterproductive. Any tendency toward snappiness needs to be curbed.

With socialization and training, they may get along with a family cat or dog, although there can be some dominance issues over food or toys. Due to their high prey drive, Fox Terriers are likely to chase cats, squirrels, rabbits, and small family pets, even toy-breed dogs. They also chase much larger animals or cars and must be fenced or leashed; they do not have a reliable recall when caught up in a hunt or chase. Fox

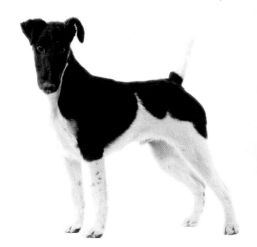

SMOOTH

Terriers are good watchdogs who may become protective if threatened. They are diggers and barkers; if left alone these traits can become troublesome.

Owners report some differences in temperament between the Smooth and the Wire. Smooths are often described as fun loving, charming, self-confident, and enthusiastic. They are capable of being relaxed at home and are happy to be with their family. Wires have the reputation of being scrappy, more dog-aggressive, and apt to answer challenges. They tend to be game, sporting terriers, always eager for activity, and with a greater need to be kept busy.

Working traits. Fox Terriers are active dogs that need both plenty of exercise and mental stimulation. Fortunately, they enjoy playing games with their people and participating in activities like

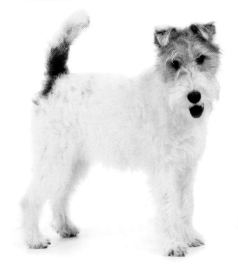

WIRE

241

Fox Terriers have long been seen in both coats, Smooth and Wire, and there are temperament and working differences between the two breeds as well.

flyball, agility, and obedience trials. Some Fox Terriers are no longer suitable as earthdogs, but smaller dogs with good instincts are still able to get in dens. Wires tend to be more aggressive and fast. Many Fox Terriers enjoy the work and do well at AKC and AWTC trials, barn hunts, and even natural hunting.

Appearance

The Fox Terrier standards are quite specific as to size, proportion, and gait. The head length should be 7 to 7.25 inches long, with a flat and narrow skull and a barely perceptible dip or stop. It should taper from the eye to the muzzle. The eyes are dark, deep set, and moderately small. The ears are small and V-shaped, folding over and lying close to the cheek. The back is short and level, and the tail is set on high and is carried up but not curled. If docked, the tail should remain at three-quarter length.

Coat. The Smooth Fox Terrier is noted for its easy care and clean double coat, which is flat, hard, and dense with a soft, short undercoat. The dog's underside must not be bare of hair. The Wire coat has wiry, very dense outer hair with a short, soft undercoat. Hair can be crinkly or slightly waved, but not curly. The furnishings on the face are crisp and long enough to bring the appearance of strength. The coat is generally hand stripped. Pet owners often choose to clip the coat for convenience, which changes the color and texture of the coat somewhat.

Color. Smooths are colored white or white with tan, black, or black and tan markings. White color should always predominate. Brindle, red, or liver color is undesirable. Wires are colored white with black, tan, or black and tan markings, with white color predominant. In both breeds, puppy markings often appear black but lighten over time.

History

In Scotland and the Border counties, fox hunts were traditionally conducted on foot, but in England, foxhunting became the pursuit of equestrians, who supported both hunt clubs and dedicated kennels. These kennels bred both foxhounds and fox terriers. The terriers usually did not run with the hounds but were carried in a bag or a basket by terriermen or hunt club staff, until they were sent out to bolt the fox from his den. In the early 1700s, these hunt terriers were shorter in the leg, chunkier, and broader in the skull than modern fox terriers.

Hunt kennels conducted organized breeding programs, seeking to improve and refine both working ability and appearance. The terriers were built on a foundation of the old Black and Tan terriers with introductions of the old English White and other terriers. They came in both smooth and rough coats and varied in size

from 10 to 15 inches. By the late 1700s, foxhounds and fox terriers were carrying more white color on their coats, possibly to help distinguish the dogs from the fox.

This new type of fox terrier was well known by the mid-1800s, before it began to be seen in show rings. Three dogs — Old Jock, Tartar, and Trap — are often regarded as the ancestors of the modern fox terrier. Trap was from a strain developed by the Reverend John Russell, an important breeder of fox terriers. Within 10 years, classes for fox terriers would be huge and the new breed would be one of the most popular terriers in England. The Fox Terrier Club was established in 1876.

As foxhunting became a sport of faster horses and foxhounds, many hunts stopped using fox terriers, but the founding dogs of the breed came from those hunt kennels. The old fox terriers, both smooth- and rough- or wire-coated, would eventually diverge into two types — the longer-legged Fox Terrier and the shorter-legged Jack Russell Terrier.

Smooth Fox Terriers were shown and recognized first, but recognition as separate breeds by the Kennel Club came relatively early. There has long been disagreement whether Smooth and Wire Fox Terriers are one breed with two varieties or two breeds created with different dog types in their heritage, such as Bull Terriers; Beagles; Welsh, Black and Tan, English White, or Manchester Terriers; and Whippets or Greyhounds. At times, Smooths and Wires were also interbred.

By the early twentieth century, the Fox Terrier was selectively being bred as a show dog. The head, neck, and legs had become longer, the face was straighter and narrower, the back was shorter, and the ears were set higher than the old fox terriers. The Smooth Fox Terrier was also the most popular dog in England, with the Wire Fox Terrier taking over that honor in the 1920s. King Edward VII owned a beloved Smooth named Caesar, and Fox Terriers were embraced as family companions throughout the country and far beyond. Unfortunately, their popularity has fallen drastically. The Wire registers just about 600 dogs annually, while the Smooth is considered a vulnerable native breed by the KC, with only about 120 puppies recorded yearly.

Across the Ocean

Smooth Fox Terriers were imported to North America in the late 1870s, with Wires following a few years later. The AKC recognized them as a single breed in 1885 and the American Fox Terrier Club was founded. Smooths and Wires would not be separated into two breeds with separate standards for another century. At times the two breeds were interbred. Fox Terriers became successful show dogs as well as attractive pets. In the 1920s, RCA featured a Smooth Fox Terrier named Nipper as its famous record player logo, and by the 1930s Fox Terriers were popular family companions. Today the AKC registers about 700 Wires and 400 Smooths each year.

Fox Terriers made their way to Australia in the 1860s, and increasingly large numbers of them were brought into the country from England. Fox Terriers became popular as show dogs and companions, although Smooths were always more favored. ANKC registers approximately 50 Wires and 270 Smooths each year.

A Fox Terrier is fearless and can play quite rough. His abundant energy and stamina need to be channeled into appropriate activities.

Irish Terrier

Also known as Irish Red Terrier

Origin	Ireland
Size	**Male** 18 to 19 inches, 27 pounds; **Female** 18 inches, 25 pounds
Coat	Harsh, wiry outer hair with fine, soft undercoat
Color	Bright red, golden red, red wheaten
Temperament	Independent, dominant, high energy, high prey drive, high reactivity, pluck, focus

The Irish Terrier's essential character, tough and intense, is present from his eyes to his stance.

This breed forms a close, affectionate bond with his people, and is courageous and protective of his territory. He is a serious watchdog and answers all disturbances with barking. Irish Terriers are famously game if challenged by another dog, especially same-sex dogs. With a high prey drive, he pursues rabbits, squirrels, and rodents; therefore, they may not coexist very well with cats. He is generally good with older children, especially if they have been taught how to respect and play with dogs.

Stubborn and self-assured, an Irish Terrier can be pushy or bossy. He needs firm, consistent training from an early age and socialization if he is to become a good citizen. However, like many terriers, he does not tolerate harsh treatment and may growl or snap if physically punished. Fiery, bold, and animated, the Irish Terrier epitomizes pluck. This also means he is very alert, sensitive to motion or touch, and has a high pain threshold when he is engaged.

Working traits. Due to his intensity, he completely commits to an action and pursues it without regard for his own welfare, which is how he earned the nickname "Daredevil." A high-energy dog, he loves to run, jump, and play, and is nearly inexhaustible. Without sufficient activity he may become destructive or invent his own entertainment. The Irish Terrier needs to be involved with very active owners or participate in obedience, agility, or another dog sport. He requires a tall fence to prevent climbing, chasing, and hunting behavior, or interactions with dogs that may challenge him. He also loves to dig, meaning the fence needs to be reinforced.

Still willing to lend a hand with ratting and small-pest eradication, the Irish Terrier remains a good hunter of small prey and a competitive tracker. Owners report that he is a good bird retriever as well.

Appearance

The Irish Terrier should look lithe and racy but also sturdy and strong. He is balanced, proportioned, and rectangular in shape with moderately long legs. The standard describes the ideal dog, but taller and heavier dogs are common. The head appears long, with a flat somewhat narrow skull, a barely visible stop, and a strong muscular jaw. The nose is large and black and the eyes are small and dark.

The ears are also small, V-shaped, and dropped forward close to the cheek. The top of the folded ear should lie above the level of the head. The neck is fairly long, the back is strong and straight with a slightly arched loin, and the chest is deep but not wide. The tail is set high and carried up but not over the back or curled. The tail was traditionally docked to two-thirds length, but may be left undocked.

Coat. The Irish Terrier has a double coat with dense, hard, wiry outer hair. The undercoat is fine, soft, and colored red. The hair on the face forms a short whiskery beard and eyebrows. The coat lies flat on the body, often with a slight frill of hair on the sides of the neck. Single coats or wavy coats are undesirable. Breeders recommend that the coat be hand stripped two or three times yearly, which may require professional grooming. Correct trimming leaves some furnishings on head and legs. A properly stripped coat is wash-and-wear and low shedding, and only needs regular brushing.

Color. Irish and FCI standards for preferred colors are red, red wheaten, and yellowish or golden red. The AKC standard also allows wheaten color. A small white patch on the chest is acceptable.

History

The Irish Terrier was a companion and working dog who watched over houses or farmyards, as well as a skilled ratter and hunter of small game. He could also lend some help in handling or moving cattle. Possibly descended from the old Black and Tan, he is probably related to the Wheaten and perhaps the Kerry Blue.

The Irish Terrier was first shown in the 1870s by dedicated supporters in both Belfast and Dublin who sought to distinguish and promote their favorite terrier apart from the other native terriers. The Irish Terrier Club was soon organized in both Ireland and England. There was still much variability in colors — red, black and tan, light brown to gray, brindle, and wheaten — but an orangey red was already favored. Type and size were also diverse. One bright red female named Poppy passed along her distinctive, attractive color to her offspring and by the end of nineteenth century, the breed's color was defined as red in shades of wheaten to brick red and its size was settled.

In 1888, the members of the Irish Terrier Club were the first breed group to decide that ear cropping, a common practice in dog fighting, should be banned. They eventually won Kennel Club endorsement of the idea, which became popular in other terriers and breeds as well. By this time, the Irish Terrier was one of the most popular breeds in Ireland and Britain. When Irish terriers served as messenger dogs in World War I, their reputation as a faithful and dedicated dog was enhanced.

The Irish Terrier was exported to North America in the late 1800s, where they were warmly welcomed and soon recognized by the AKC and CKC. By the end of World War I, the Irish Terrier was a popular family dog. After World War II, the breed began to lose popularity and today the AKC only registers about 180 dogs each year. Although he is found in various countries around the world, he is now considered a vulnerable breed in Britain as well.

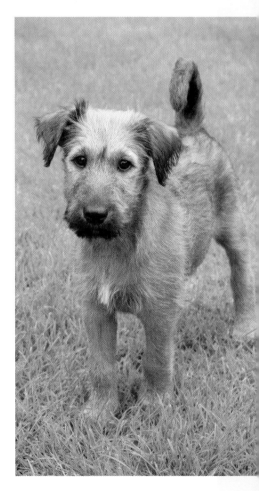

Even as a puppy, the Irish Terrier approaches life with seriousness and intensity.

Jack Russell, Parson Russell, and Russell Terriers

JACK RUSSELL TERRIER ALSO KNOWN AS JACK

Origin	England
Size	10 to 15 inches, weight proportional
Coat	Smooth, rough, or broken
Color	White with tan, black, or brown markings
Temperament	Independent, dominant, high energy, high prey drive, focus, pluck, voice

PARSON RUSSELL TERRIER

Origin	England
Size	12 to 15 inches, 13 to 17 pounds
Coat	Smooth or broken with undercoat
Color	White, white with tan or black markings, or tricolor
Temperament	Independent, dominant, high energy, high prey drive, focus, pluck, voice

RUSSELL TERRIER

Origin	England, developed in Australia
Size	9 to 10 inches ideal; weight proportional
Coat	Double coated: smooth, broken, or rough outer hair with undercoat
Color	White with black and/or tan markings
Temperament	Independent, dominant, high energy, very high prey drive, focus, pluck, voice

Fun-loving Jacks are devoted to their family, yet always ready for action and adventure.

These curious, intelligent dogs are also very independent-minded characters. With their extremely high energy levels, they need lots of exercise and mental engagement. Boredom and lack of exercise can lead to destructive, aggressive, or vocal behaviors.

Although smart and clever, a Jack Russell can be challenging to train. Owners need to begin firm, consistent yet positive training early and be prepared to deal with the breed's assertiveness. Jacks must be socialized to people and other dogs to prevent aggression or shyness. Owners should not allow play biting in puppies. The breed does not tolerate harsh treatment by adults or children, therefore many breeders do not recommend this breed for families with children under the age of six years old.

Jack Russells tend to be dog-aggressive. Although socialization may increase the tolerance of an existing family dog or cat, family pets should always be

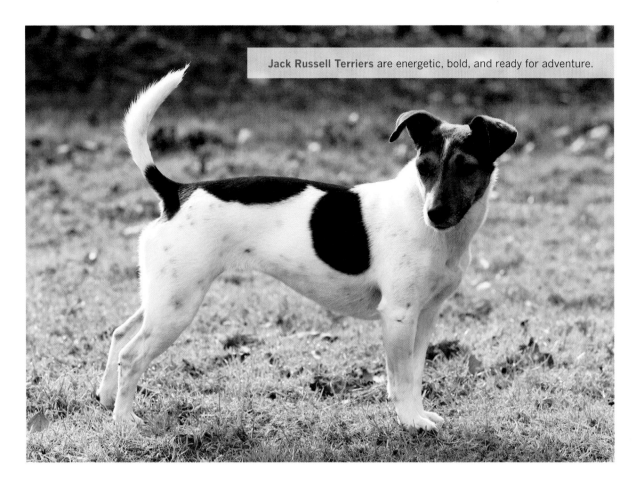

Jack Russell Terriers are energetic, bold, and ready for adventure.

supervised, because Jacks may forcibly assert their dominance or possession of objects. Opposite-sex dogs may live together better or a Jack may live more peacefully with a larger dog, although he does not back down from it. A Jack's high prey drive is likely to be directed toward puppies, cats, or other family pets; he is more likely to behave soundly around larger animals, such as horses, than poultry or small animals.

As working earthdogs, Jack Russells are bold and fearless, and compete successfully at both natural hunting and artificial trials. They work on a variety of different quarry including woodchucks, badgers, foxes, or rats. Expressing their instincts at a young age and maturing into enthusiastic competitors,

they are highly focused and gamy, and use their voice.

Appearance

Jack Russell terriers have many physical characteristics in common, though coat type and color vary among the breeds. The skull is flat and moderately broad, with a defined stop and a strong, rectangular muzzle that is slightly shorter than the back skull. The small V-shaped ears drop forward and are held close to the head. The dark eyes are medium sized and almond shaped and do not protrude. The forelegs are strong and straight and the topline is level. The chest must be spannable by a man's hands. The tail, which is set high and carried with a slight arch over

the loin, was traditionally docked at about 4 inches in length or level with the top of the skull.

Jack Russell Terrier

The British and American Jack Russell Terrier clubs and their affiliates seek to preserve the working type or strain known as the Jack Russell Terrier, a fox terrier developed for bolting foxes and hunting other quarry. Established in 1976, the Jack Russell Terrier Club of America is an independent and open registry whose members are opposed to kennel club recognition. The club is the largest registry of Jack Russell Terriers worldwide. Working certificates and sizes are recorded in pedigrees to assist owners in choosing a working dog of a certain size.

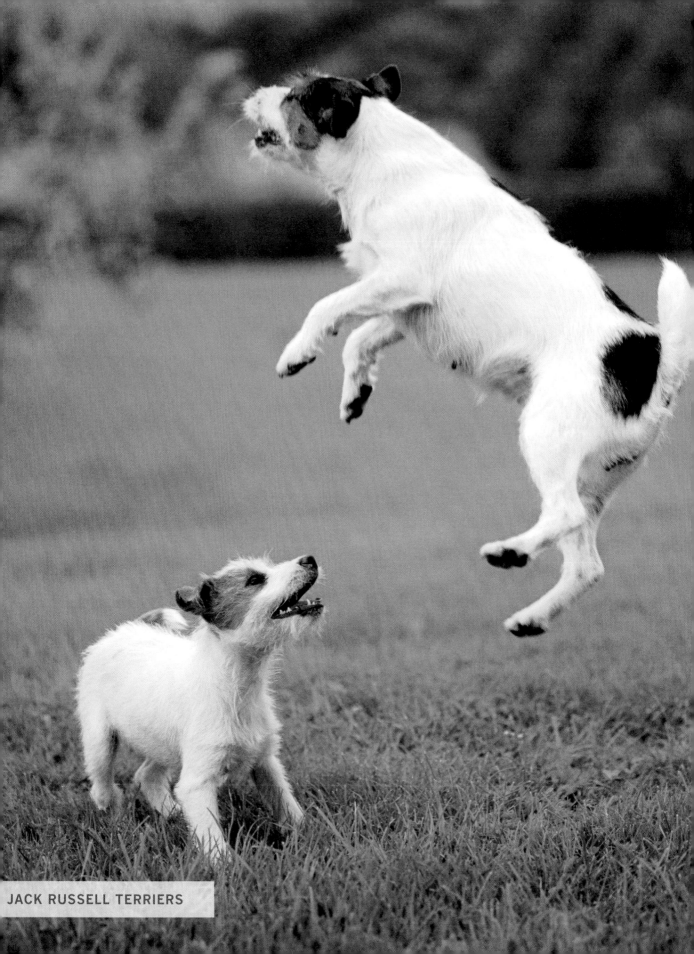

JACK RUSSELL TERRIERS

The standard is broad and purposefully allows for diversity. Dogs are registered as adults on their own merit, not as puppies. The JRTCA conducts both hunting and conformation trials. Conformation entries must earn at least one hunting certificate.

Neither too large nor too small, the sturdy Jack Russell Terrier must have a compact chest, straight legs, sloping shoulders, a flexible back, and conformation that allows him to work as an earthdog. Size varies between 10 and 15 inches, grouped into 10 to 12.5 inches and 12.5 to 15 inches. Smooth, rough, or broken coats are permitted. Dogs are white with tan, black, or brown markings. White should predominate and brindle is unacceptable.

Parson Russell Terrier

Jack Russell terriers were recognized by the British Kennel Club in 1990 as the Parson Jack Russell Terrier and at first considered a variety of the Fox Terrier. In 1999, the breed was officially recognized as the Parson Russell Terrier by the KC, followed by the AKC, CKC, ANKC, NZKC, and UKC, although the UKC uses a different broader standard that includes smaller dogs. The Parson Russell population is considerably smaller than the Jack Russell population, and most of the dogs are either show or companion dogs.

Parson Russell Terriers are square, long legged, and spannable. Heights range from 12 to 15 inches, with weights from 13 to 17 pounds. The ideal male stands 14 inches with females 1 inch shorter. Dogs are double coated, with a smooth or broken coat. The outer hair is harsh, close, dense, and straight. Furnishings provide only a slight hint of eyebrows and beard.

Colors include white, white with black or tan markings, or tricolor. White should be predominant. Grizzle is acceptable but not brindle. The KC standard differs slightly and allows rough coats and lemon color markings.

Russell Terrier

In 1964, some Australian equestrians returned home with three small Jack Russell terriers after encountering them at British stables. These smaller terriers had originally been selected for carrying in terrier bags and working in smaller dens in more rugged areas. Within a few years, the Jack Russell Club of Australia was organized to record pedigrees and promote the dogs. The Jack Russell as it was developed in Australia is shorter in the leg with heights of 10 to 12 inches and longer in the body than either the Parson Russell or the working Jack Russell.

ANKC recognized the Jack Russell as breed in 1991, leading to worldwide FCI recognition. In North America, the "Australian or FCI type" has recently been recognized by the AKC as the Russell Terrier to avoid confusion with the larger population of working Jack Russell Terriers.

Rectangular in shape, ideal dogs stand 9 to 10 inches tall, although they can be as tall as 13 inches. Weight should be in proportion: approximately 1 pound to 1 inch. Although short, the Russell Terrier gives an appearance of sturdiness. Double coated, the hair may be smooth, broken, or rough with an undercoat. Dogs are white with black and/or tan markings. Tan may be shaded from very light to richly dark. Ticking is acceptable.

History

Although divided into at least three different breeds, and at times called by similar names in various countries, the Jack Russell Terrier is quite recognizable. All variations within the breed type have the same roots in the fox terriers bred by the Reverend or Parson Jack Russell, born in 1795 in

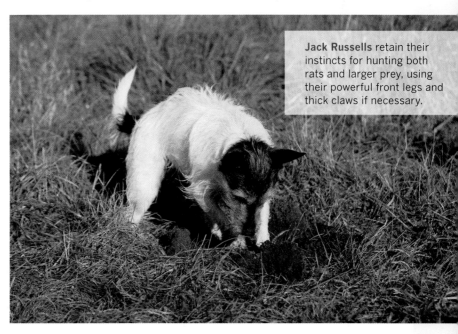

Jack Russells retain their instincts for hunting both rats and larger prey, using their powerful front legs and thick claws if necessary.

Devonshire, England. A founding member of the Fox Terrier Club and the British Kennel Club, he was a leading breeder of fox terriers who developed the strain that would come to bear his name. Russell's fox terriers were long legged, narrow in the chest, wiry-coated, and courageous enough to drive a fox out of the burrow but not so driven as to kill it. As fox terrier breeding turned toward the modern show type near the end of the nineteenth century, Russell-type fox terriers would diverge over the coming years into shorter-legged and longer-legged types.

Despite the lack of formal recognition, Jack Russell–type terriers continued to work as farm dogs, stable ratters, hunting dogs, and family companions in Britain, Ireland, Australia, and elsewhere. At some point they also made their way to North America, where they were fairly well established by the 1970s. The breed found itself in the limelight in the 1990s through high profile roles in the television series *Fraiser* and *Wishbone*. Far too many people wanted a cute Jack Russell puppy, and the population exploded in North America.

Many of these homes were unprepared for owning or raising a working terrier, and a large numbers of dogs ended up in rescue and shelter situations. The breed's reputation suffered greatly. Meanwhile, Jack Russell terriers remain excellent barn and farmyard ratters, exceptional earthdogs, and good companions in the right home. Jack Russells are good competitors in a several dog sports, including agility and flyball. Most dogs possess strong terrier instincts and enjoy participating in earthdog, barn-hunt, and natural hunting trials.

The Reverend John Russell is credited with developing the original line of terriers that has been further divided into three types, who all share the abundance of energy and drive that make them outstanding farm dogs.

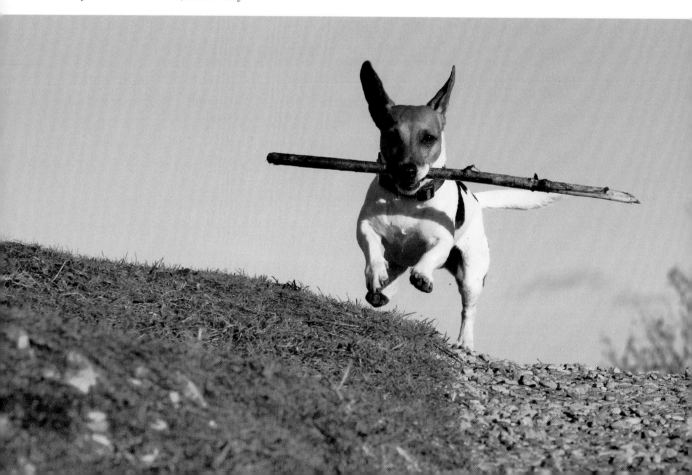

Lakeland Terrier

Also known as Lakie

Origin	England	
Size	14 to 15 inches, 17 pounds	
Coat	Hard, wiry outer hair with soft undercoat	
Color	Black, blue, liver, red, and wheaten; many dogs have saddle markings in blue, black, liver, or grizzle on a wheaten or golden tan coat	
Temperament	Independent, dominant, high energy, high prey drive, focus, pluck	

Independent thinkers and problem solvers, Lakeland Terriers can be manipulative, strong willed, and dominant.

With training, socialization, and a positive upbringing, Lakies can become sociable, affectionate, and playful family members. They should be supervised with young children, since they can be sensitive to touching or roughhousing, and protective of food or toys.

Lakie puppies are extremely exuberant and highly energetic, but they settle down with age, although lack of exercise or boredom can cause destructiveness. Training should start early. Consistency, patience, and firmness are important, while harsh treatment or overindulgence can cause issues. Lakelands are not food oriented and are easily bored, so lessons need to be creative and brief.

Lakelands can be dog-aggressive and do not back down from a challenge. They are most happy as an only dog in the family, but should there be a second dog, an opposite sex one is the best choice. Lakies can be fine with an established family cat but not other cats or small animals, which they will chase and possibly kill. The

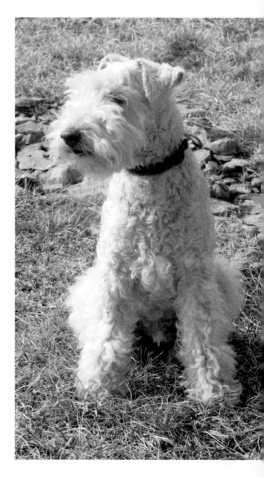

breed needs a fenced yard to prevent hunting, chasing, or exploring. They are good jumpers and diggers and should be leashed away from home, since like most terriers they are apt to ignore a recall when focused.

Working traits. Lakies are good watchdogs, alert and naturally territorial, but they need some training to become discerning about disturbances. They may bluff a potential threat or intruder, but are rarely aggressive with people. Lakeland Terriers take their work seriously, and do well with activities, such as earthdog, nose work and tracking, and agility. At AKC and AWTA events they are courageous, tough, tenacious, and very focused on prey. Owners have observed they can get bored with artificial tests and often prefer natural hunting. On the farm, they are fearless ratters.

Appearance

The Lakeland Terrier is a small, square, sturdy dog. The head is rectangular in profile, with a flat skull and a foreface that appears straight, partially due to grooming. Small V-shaped ears fold over just above topline of the skull with the inner edge held close to the head. The moderately small eyes are set

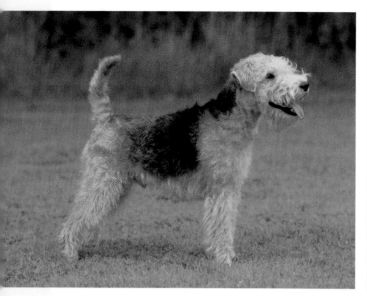
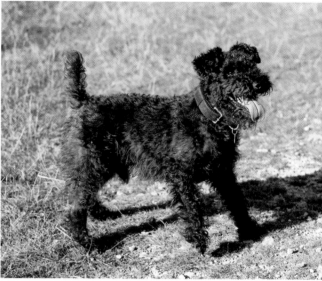

Small and sturdy, Lakelands can be maintained in their traditional coat (left) or a more rustic and tousled natural look (right).

fairly wide. The jaws are powerful. The body is deep and narrow, with a long neck and a short topline. The high-set tail is carried up and traditionally docked to a length level with the top of head.

Coat. Lakies are double coated, with hard, wiry outer hair and a soft, close undercoat. The furnishings on the foreface and legs are more plentiful. The beard and eyebrows contribute to the rectangular appearance of the head. The coat is hand stripped short, measuring 0.5 to 1 inch in length on the body. The hair on the front legs is shaped to look straight and on the rear legs to enhance angulation. The hair on the skull, ears, forechest, shoulders, and behind the tail is trimmed short and smooth. Some owners choose to clip rather than hand strip or to leave the dog in a natural long and curly coat.

Color. Lakies are seen in solid black, blue, liver, red, and wheaten. Many dogs have saddle markings in blue, black, liver, or grizzle on a wheaten or golden tan coat. Grizzle is red or wheaten hair mixed with black, blue, or liver.

History

Lakeland Terriers are a type of Fell terrier used to bolt foxes from their rocky dens in the Lakes District. Fell terriers were long legged but narrow enough in the chest to work their way into a tunnel or burrow. There was much crossbreeding of different Fell types as well as outcrossing to other breeds, since the breeder's primary concern was working ability. The modern Lakeland Terrier is closely related to the Fell and Patterdale Terriers, as well as to the unregistered working Lakelands that are often called Borderlakelands or Fells Patterdales.

The Lakeland Terrier was first exhibited at local agricultural shows in 1912, where it attracted supporters. There was disagreement over pursuing Kennel Club recognition, but a majority of early club members agreed to seek breed status, which occurred in 1928. Lakelands excelled as show dogs and became attractive family dogs, being smaller than similar breeds like the Welsh Terrier or Airedale. Working terriermen tended to use the unrecognized Fell, Patterdale, and working Lakeland terriers. Today's Lakeland Terriers remain primarily show and companion dogs, with a vulnerable population that sees about 175 registrations yearly.

Lakeland Terriers were imported to North America in the 1930s, when a founding member of the breed club immigrated to the United States. The AKC soon recognized the breed and the US Lakeland Terrier Club was established in 1954. Although the breed has its admirers, it remains relatively rare in North America, with about the same annual registrations as in the UK. Lakelands were imported into Australia, beginning in the 1940s, but the breed remains very rare with only 50 puppies recorded each year by ANKC.

Miniature Schnauzer

SHNOU-zer

Origin	Germany	
Size	12 to 14 inches, 11 to 20 pounds	
Coat	Harsh, wiry outer hair with soft undercoat	
Color	Pepper and salt, black and silver, pure black (AKC), plus white (KC, FCI)	
Temperament	Independent, willing, moderate energy, high prey drive	

Character and temperament are important in the Miniature Schnauzer, who is primarily a family companion. He is an independent dog but not dominant or aggressive.

He wants to be with his special person or his family and demands to be included in all activities. Owners describe him as spirited, spunky, and playful. A socialized and trained Miniature Schnauzer is reliably gentle with children and well behaved with introduced strangers and dogs. He generally lives well with other family dogs and cats, especially if raised with them, but may not be reliable with smaller pets, such as rodents.

The Miniature Schnauzer is less aggressive and easier to train than most ratting terriers, although he can be stubborn or fearless at times. He is an alert watchdog who barks at disturbances but is not known as a problem barker. He is an intelligent, quick learner who responds to positive training. Some Miniatures are soft, making harsh methods counterproductive. His exercise needs are moderate and can be met with walking, jogging, or other activities. The Miniature Schnauzer excels in agility, obedience, and other dog sports.

He is still a good little hunter of rats and vermin in the barn and farmyard. Though not a traditional earthdog, he has solid prey drive and does well in earthdog trials. Miniature Schnauzers are also enthusiastic participants in barn-hunt activities.

Appearance

Miniature Schnauzers are sturdy, muscular dogs with a square appearance. Dogs smaller than the standard are not more valuable and are not a recognized "toy" or "micro-mini" breed.

The head has a strong, rectangular profile, narrowing slightly from the ears to the nose. The skull is flat and long, with a slight stop and a strong, blunt muzzle. The whiskers and beard

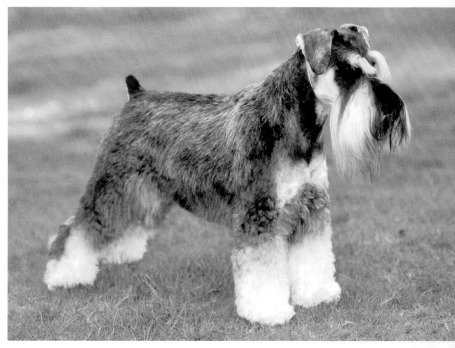

contribute to the rectangular appearance of the head.

The ears are set high and are cropped erect or left natural. Uncropped ears are small, V-shaped, and dropped with the inner edges lying close to the head. The oval eyes are smaller and dark. The eyebrows should not impede vision. The tail is set high and is docked short. If left natural, a sickle or sabre carriage is desirable.

Coat. The Miniature Schnauzer has a double coat with harsh, wiry outer hair and a soft undercoat. The coat is maintained by stripping or clipping short the head, neck, chest, body, and tail. Longer furnishings are kept on the underparts, legs, beard, and eyebrows.

Color. The AKC and CKC in North America recognize only three colors: pepper and salt; black and silver; and solid, pure black. Pepper and salt coats are composed of pure white, pure black, and black-and-white banded hairs in shades from very light to dark. Black and silver dogs are striking with a pure black body and silvery-white legs, beard, and points. In Germany and elsewhere, white is also an acceptable color. Nonstandard colors, including particolor or bicolor, are available from some breeders but they are not more valuable than the traditional colors.

History

The Miniature Schnauzer is not technically a terrier, despite that classification in North America. Like his close relatives, the Standard and Giant Schnauzers, he is classified as a working or utility dog worldwide. Dating back to the Middle Ages, all of the Schnauzer breeds belong to the old group known as "pinschers". The pinschers were general farm workers, watchdogs, herders, and vermin hunters. They were seen in a range of sizes, colors, and coats.

First called Wirehaired Pinschers, both smooth and wirehaired puppies were often found in the same litter through the mid-nineteenth century. Among the most common dogs in Germany, the native breed was standardized in 1880. The name Schnauzer is believed to refer to the distinctive

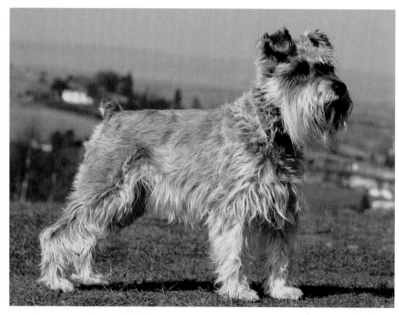

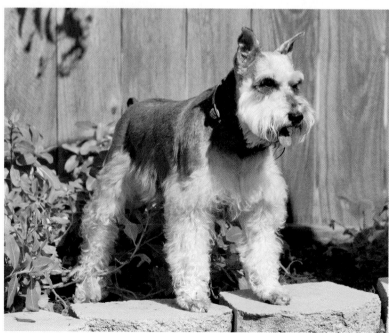

Many Miniature Schnauzers wear a more practical working coat (above) if not being groomed for showing (below).

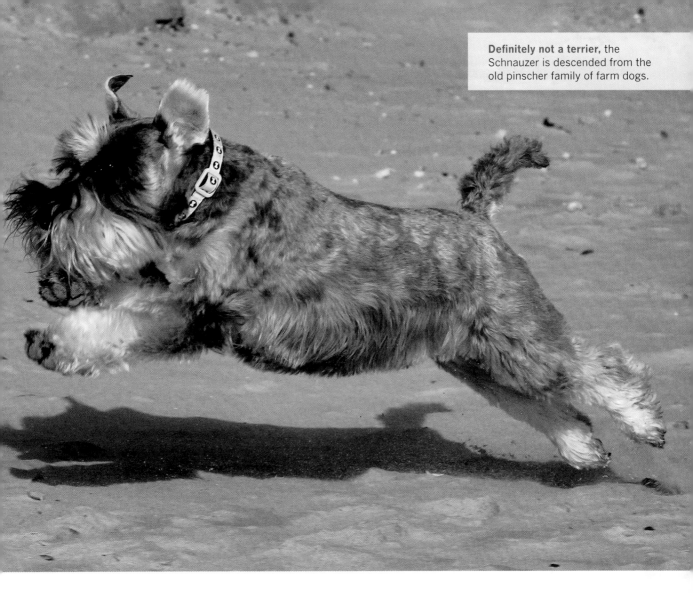

beard — *schnauze* meaning "muzzle" or "snout." In developing the *Zwerg*, or dwarf-sized, Miniature Schnauzer, early breeders may have crossed smaller Schnauzers with other small pinschers and the very old Affenpinscher, or selectively bred only smaller Schnauzer dogs. The breed was first exhibited in 1899 and its popularity spread rapidly throughout Europe.

Out of the Country

In North America, the first imports of the Miniature Schnauzer occurred in 1923. An immediate hit as family and city dogs, more imports quickly followed. The Standard Schnauzer had arrived earlier in the United States, and was recognized by the AKC as the Wirehaired Pinscher. At first grouped with the Standard, the name of both the breed and the club was soon changed to Schnauzer. The Schnauzer Club served both breeds until it was resolved to split them into two separate breeds. When the Standard Schnauzer was moved to the Working Group, the Miniature remained in the Terrier group. The Miniature Schnauzer rapidly became the most beloved of all the Schnauzers, with more than 10,000 puppies registered yearly.

Although the Miniature Schnauzer arrived in Britain in 1928, the breed took longer to establish itself. In the UK, dogs with cropped ears could not be shown and at that time all the American and German dogs had their ears cropped as puppies. Despite the slow start, by the 1960s and '70s, Miniature Schnauzers had become very popular, and today the KC registers more than 5,500 dogs yearly. Miniature Schnauzers were imported to Australia in 1962, where they also became well established, registering about 1,200 puppies each year.

Norfolk and Norwich Terriers

NORFOLK TERRIER

Origins	England	
Size	9 to 10 inches, 11 to 12 pounds	
Coat	Harsh, straight outer hair with soft undercoat	
Color	Shades of red, wheaten, black and tan, grizzle	
Temperament	Independent, moderate energy, high prey drive, focus	

NORWICH TERRIER

Origins	England	
Size	10 inches ideal, approximately 12 pounds	
Coat	Hard, straight outer hair with soft undercoat	
Color	Shades of red, wheaten, black and tan, grizzle	
Temperament	Independent, moderate energy, high prey drive	

Both the Norwich and the Norfolk are affectionate, even-tempered dogs that are often called the softest of the terriers.

Since they were bred to work cooperatively in packs, they are less dog-aggressive than most other terriers and can usually be kept together with other dogs in a family. They are typically fine with a family cat as well, although they are not trustworthy with other small pets, such as rodents. They do get along well with children, although young children should always be supervised.

Both the Norfolk and Norwich will bark to alert, but are friendly with welcomed visitors. Socialization is needed to prevent shyness or any sort of aggressiveness. Reward-based training works well in addition to short positive sessions. Both breeds can be assertive and stubborn but sensitive to corrections. These dogs want to be part of an active family's lifestyle and need 30 minutes or more of good exercise and activity daily. They need a fenced yard, as they chase rabbits and squirrels. If they are bored, digging and barking can become a problem.

Working traits. The Norfolk and Norwich are still great barn dogs and ratters who know how to behave around horses. They also perform well at agility, obedience, scent work, and earthdog or barn-hunt activities. They work very well together in braces. Although in the past they were used on fox or badger, they are mainly ratters and enjoy it. When working, both breeds are persistent, moderately paced, and harder to recall than some other earthdogs. Enthusiastic barkers, they need to learn *quiet* and *leave it* commands.

Experienced owners relate that there are observable working differences between the breeds, although individuals certainly vary. In general, Norfolks are more focused and intense ratters, more independent, and faster to train for earthdog activities. The Norfolk only needs light encouragement. The Norwich tends to be more attached to his owner, more submissive and dependent, and needs more positive encouragement.

Appearance

These two breeds are among the smallest of the terriers. They are compact and stocky, with a short back and legs, but good substance and bone. The Norfolk is slightly longer, with more angulation, while the Norwich slightly heavier for his size. In both breeds, the skull is broad, slightly rounded, and wide between the ears. There is a well-defined stop and the muzzle is strong and wedge shaped. The eyes are small, dark, and oval.

The Norwich has a foxy expression with medium-sized, erect ears with pointed tips. The Norfolk has

a softer expression, with small, V-shaped, drop ears that break at the skull line and are carried close to the cheek. The tail is set on high and carried erect. Where docked, it is medium in length; undocked the tail tapers toward the tip and is as straight as possible.

Coat. The double coat has harsh, wiry, straight outer hair with a soft undercoat. The outer hair forms a mane on the neck and shoulders, and is slightly longer on the legs, eyebrows, and whiskers or mustache. Both breeds are shown in a natural coat only slightly tidied up. The coat needs weekly combing and should be stripped twice a year. Some owners choose to leave their dog in natural coat, with a scruffy, tousled appearance. Norwich coats tend to be harder or coarser, growing more away from body rather than close.

Color. Both breeds are seen in shades of red, wheaten, black and tan, or grizzle (red and black hair mixed together).

History

Both the Norwich and Norfolk Terriers were developed in the areas around Cambridge and Norwich, a city in the county of Norfolk. Their roots lie in a range of small terrier types. Some were farm dogs, occasionally used to hunt rabbits in the hedgerows. Others were employed as ratters or fox bolters, carried in saddlebags or arms until they were needed to harass the fox from his den. Many of the earliest breeders and owners were horsemen, and their terriers also kept mice and rats controlled in barns and stables.

Beginning in the 1870s, little red or black-and-tan terriers were popular ratters around Cambridge University. One of the primarily sources for these terriers was a livery stable on Trumpington Street, leading to the name Trumpington Terriers. In 1900, a Trumpington Terrier named Rags came to live at the Norwich Staghounds stable. Rags is widely viewed as the founding father of the Norwich breed, as he was in

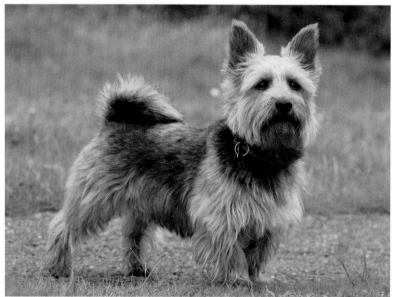

Although there are differences between the closely related breeds, both terriers are very family-friendly dogs and good ratters. To instantly tell them apart, remember that the NorWICH's ears are shaped like a witch's hat!

Many of the early breeders were horse people, either involved with fox hunting or racing stables. Among the earliest breeders was horseman Frank Jones. As early as 1914, several North American horse buyers brought home Jones Terriers, as they would be called for a long time even after AKC recognition. The early Norwich Terriers were mainly located in Pennsylvania and Virginia, and the breed is still most common in the eastern United States.

Differentiating the Breeds

In Britain in 1932, the Kennel Club registered both the prick- and drop-eared types together as the Norwich Terrier. Within a short time, the AKC and CKC also recognized the breed. Breeders often had preferences between the drop or prick ears and tended to focus on one or the other. Nearly all disliked the ears that resulted from breeding drop and prick dogs together, so the types were generally kept separate. In 1957, British club breeders decided to treat the two types as two separate breeds. After the separation, the name Norfolk was the popular choice and a new breed club was formed. The CKC and AKC agreed to separate the breeds in the late '70s.

As time has passed, the two breeds have begun to diverge even more, although both remain uncommon. The KC registers only 160 or so Norwich Terriers yearly, with the AKC registering more at 600 to 800. Popularity is somewhat reversed for the Norfolk, with only about 300 dogs registered yearly with the AKC, but some 550 with the KC. Both breeds are very rare in Australia.

high demand by different breeders who used him on various other types and breeds of terriers, but also bred back to Rag's line and other Trumpington Terriers.

This group of breeders established a strain of small, sturdy, harsh-coated Norwich Terriers.

The dogs were generally red, but also brindle or grizzle. Ear carriage wasn't foremost in the minds of most early breeders and the dogs sported prick, drop, or even cropped ears. They were usually shown in their natural coats.

Patterdale Terrier

Also known as Black Fell Terrier, Smooth Fell Terrier, Fell Terrier

Origin	England
Size	10 to 15 inches, weight proportional
Coat	Smooth, broken, or rough hair with soft undercoat
Color	Black, chocolate, red, or black and tan
Temperament	Independent, high energy, high prey drive, focus, pluck

Although Patterdales are more laid-back in nature than many other terriers, this is a working breed that is not well suited to life as a companion dog or for homes with small children.

These dogs need lots of exercise and play. Puppies, in particular, can be terrifically bold and highly energetic. They can live with other dogs in the home but are not as tolerant with strange dogs and are not recommended for homes with cats or other small pets. With their high prey drive, they must have a fenced yard.

Willing to please, Patterdales respond best to positive training rather than harsh treatment. They are usually not dominant with their owners, but some Patterdales can be pushy. Obedience training and socialization are necessary. Given the breed's healthy streak of independence and stubbornness, owners need to be patient and have a sense of humor when asking a Patterdale to perform.

Working traits. As working dogs, Patterdales are courageous, persistent, and hard driving. They focus earlier on prey than many other terriers. If a Patterdale has been used for natural hunting, he may find artificial earthdog trials boring or stilted. Younger dogs do take to trialing enthusiastically. Patterdales can compete at AWTA and UKC events, but they are not approved for AKC activities. Some owners participate in agility events and Patterdales perform in the highest levels of competitive flyball in the UK, Europe, and North America.

Appearance

There is no specific height or weight standard for the Patterdale Terrier, although they generally weigh about a pound per inch. Size is crucial for a working terrier and Patterdales must be spannable. The head is strong and wedge shaped or trapezoidal when viewed from front. The muzzle is equal in length to the skull or slighter shorter. The eyes are set far apart and are never protruding. The ears are small to moderate in size, triangular in shape, and should fold tight

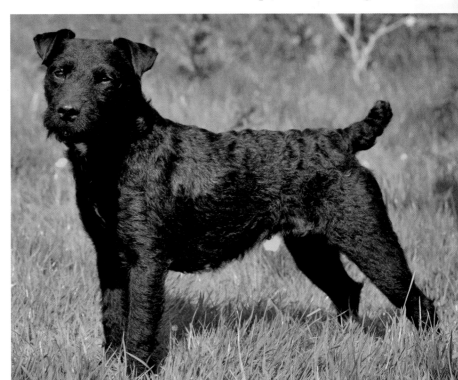

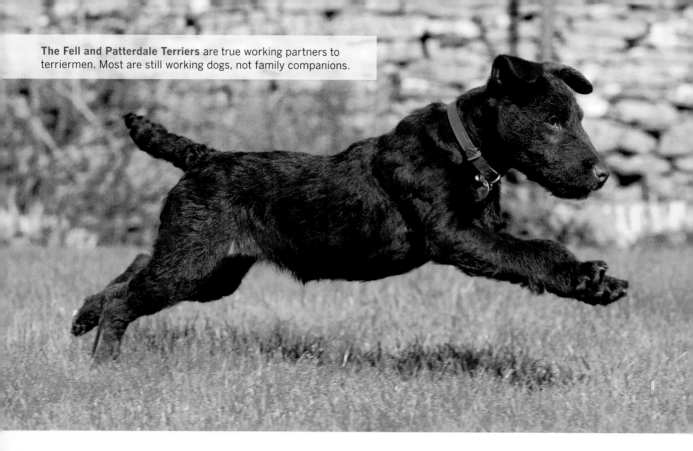

to protect the ear canal. Working Patterdales need a strong neck and powerful jaws and teeth. Square or slightly longer than tall, the back needs to be long enough to be flexible. The tail is set high and must be strong. It is left natural or docked long enough to grasp.

Coat. The Patterdale is double coated with a short dense undercoat. The UKC standard allows for smooth or broken coats. The smooth coat is short and glossy with stiff, coarse hair that is dense and flat with no long guard hairs. The broken coat has some longer, coarse, wiry guard hairs. The face may have some furnishings.

The PTCA recognizes three coats — smooth, broken, and rough. The broken coat has smooth hair on the head and ears, with longer, coarse hair elsewhere. The coat should be flat, hard, and dense. Dogs may have slight whiskers on the muzzle and chin. The rough

coat has coarse, harsh longer hair with more furnishings. All coats only need minimal grooming.

Color. Although Patterdale Terriers are most often black, the UKC also allows bronze, black and tan, grizzle, liver or chocolate, and red. Dogs may have white markings on the chest and feet. The PTCA recognizes black, red, chocolate, or black and tan — all with some variation in shading or color and with or without white markings on the chest and feet.

History

The rocky hills or fells of the Lake District provided grazing for sheep, which in turn provided targets for foxes. The fox was hunted by packs of hounds and foxhunters, often on foot, accompanied by native fell terriers. Farmers or terriermen would also go out hunting with a fell terrier or two. This old fell terrier is

the source of several breeds, including the Patterdale, Lakeland, and Border Terriers.

Fell terriers were small dogs usually standing less than 15 inches tall and weighing less than 15 pounds. Their heads were somewhat long with strong muzzles and small drop ears that lie close to the head. The fell terrier was also narrow chested and spannable, with long legs, and tails docked long enough to serve as a handle when hauling a dog from a hole.

There was much overlap between the founding members of the fell terrier breeds. Various terriermen bred many different strains of these dogs; some are still in existence today. By the 1950s, Lake District terriermen had developed a specific type of black fell terrier and the name Patterdale became associated with this type.

In the UK, working fell-type terriers are still in abundance

and used as ratters, rabbit hunters, and earthdogs. The wiry or broken-coated black dogs are usually called Fell Terriers. Some have recently been imported into North America for use as working dogs. Also a fell terrier, the Patterdale is usually a black, smooth-coated dog in Britain. He also remains a working terrier and is never shown.

Patterdales were imported as working terriers to North America in the late 1970s. The Patterdale Terrier Club of America was formed in 1993, and serves as a registry and pedigree service for the breed. The PTCA accepts smooth-, broken-, and rough-coated dogs in four colors. The Patterdale was also recognized by the UKC in 1995. Their standard allows smooth and broken coats in several colors. Although Patterdale Terriers can be shown in conformation classes, most are working dogs used for hunting groundhogs, raccoons, and other vermin. Some breeders now dual-register their dogs with PTCA and UKC.

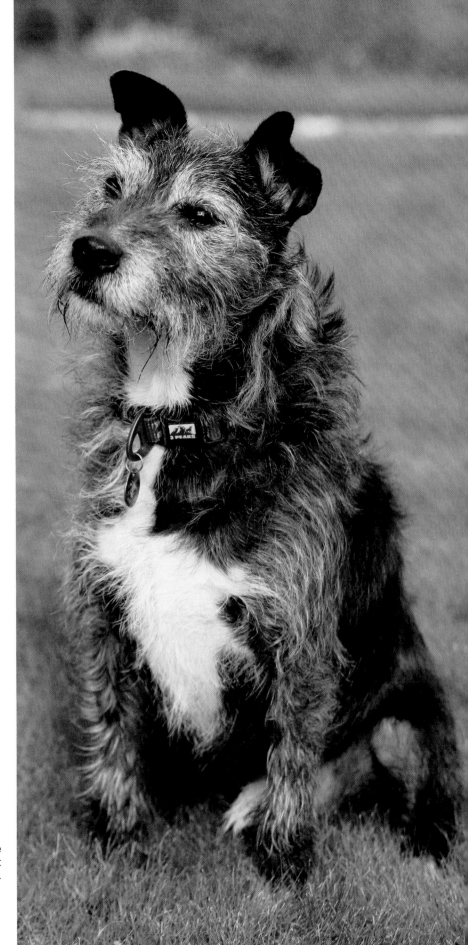

Working ability and appropriate size are the most important characteristics of the Patterdale.

Rat Terrier

Also known as Rat

	Origin	United States
	Size	Miniature up to 13 inches; standard 13 to 18 inches
	Coat	Single coated: short, dense, smooth hair
	Color	Solid white, bicolor, or tricolor
	Temperament	Dependent, moderate energy, moderate to high prey drive

Although sometimes confused with other terrier breeds, the Rat Terrier has a distinctly different temperament than many other terriers.

Rats tend to be calm dogs that relax in the house. They are more sensitive to their owners, and make loving and affectionate companions. Rats are very vocal and talkative, though they are not problem barkers. Breeder lines or strains differ, so it is best to meet the parents to assess whether a pup is likely to have a more easygoing nature or a stronger working or independent nature.

Rat Terriers are very trainable, although some dogs can be more independent minded or stubborn. They are intense, persistent, and curious dogs who love to play and be mentally challenged. They want to please and enjoy being involved with their owner's daily activities. They can be motivated with positive reinforcement and treats. Rats can suffer separation anxiety if left alone for long periods, with boredom sometimes leading to destructive activities.

Rat Terriers are generally good with children they are raised with. They are vigilant and alert watchdogs who tend to welcome introduced visitors, although some dogs can be protective of their homes. Rat Terriers were often worked in small packs and are more tolerant of other dogs in the family than many other terriers. Rats are usually accepting of family cats and other pets, although some care should be taken with small furry animals or strange cats. They must be securely fenced to prevent hunting or chasing.

Working traits. Rat Terriers are very agile, good jumpers, and fast. They are successful participants in agility, flyball, and obedience activities. Rat Terriers hunt by sight or scent, enjoy digging, and go to ground. They are good hunters of rats or mice, squirrels, rabbits, moles, and larger animals, such as raccoons or opossums. Individual Rat Terriers are eligible for AWTA den trials and can participate in barn-hunt activities or AKC earthdog events.

Appearance

The Rat Terrier is a small to medium-sized dog, slightly longer than tall, with a refined appearance. He is more finely boned and elegant than other working terriers yet well muscled and athletic. Weight is not specified, although Miniatures usually range between

10 and 18 pounds, with Standards between 12 and 35 pounds. The skull is broad and slightly domed, with a moderate stop. The head has a blunt wedge-shaped appearance and tapers slightly toward the muzzle.

The UKC standard calls for round, small, and somewhat prominent eyes, although the AKC describes them as oblique and oval. The ears are V-shaped and may be erect, tipped, or button in carriage. The forelegs are straight, the back strong and level, with a slightly sloping croup. Although a natural bob or docked tail is preferred, the tail may be any natural length and is carried upward when the dog is

alert. The bobtail gene is common in the breed.

Coat/color. Rat Terriers have a single coat that is short, dense, smooth, and shiny. The coat is easy care and clean. There is no undercoat for protection against very wet or cold weather. Rats come in a wide variety of colors including solid white. Most are bicolor or tricolor, with white predominant. Colors include black, shades of tan including reds, chocolate, blue, blue fawn, apricot, and lemon. Ticking and sable overlay is permitted, but not brindle, merle, or solid colors other than white. The AKC standard differs somewhat and allows fawn as a color.

History

The Rat Terrier is an American original, but his roots lie in an older type of dog known as the "feist." Dating back to colonial days, American feists were small, above-ground hunting dogs of squirrel, rabbit, opossum, raccoon, or rodents. They tended to work silently unless their prey was treed, when they would bark loudly. The British feist, also a small hunter of vermin, had become a more established type by the 1820s. The British feist was believed to be a cross between the smooth fox terrier and the ratting Manchester terrier. This feist gained popularity

not only as a hunting terrier but also in the rat pits where dogs competed to kill the largest number of rats in a specific period of time.

British ratting feists began to appear in America in the mid-nineteenth century but their numbers increased in the 1890s. Crossed with the American hunting feist, these dogs were found throughout the southern states as hunters and farmyard ratters. The feist tended to be a black-and-tan dog with folded or button ears, and weighing about 18 pounds, much like Teddy Roosevelt's beloved Skip.

Over time, in different areas of the country and for varying purposes, people crossbred feists with established breeds such as the Smooth Fox Terriers, Beagles, Miniature Pinschers, Whippets or Italian Greyhounds, and perhaps others. Commonly called Rat Terriers, the dogs displayed a wide range of colors, a leaner body, and a more refined appearance. Smaller sizes or shorter-legged types also emerged, perhaps developed from crosses with Toy Fox Terriers, Toy Manchester Terriers, and Chihuahuas.

By the 1920s and '30s, the Rat Terrier had become one of the most popular family dogs in the country, especially on farms where they maintained their working ability. Around the 1950s, as the humble Rat Terrier began to lose ground against both new and recognized breeds, efforts were undertaken to preserve this native type. The National Rat Terrier Association was organized as an independent registry for Rat Terriers in various sizes and body types. UKC recognition was achieved in the 1990s, with the American Rat Terrier Association serving as the parent club.

Rat Terriers still exhibit a great diversity of colors and other characteristics, as well as two size varieties — Miniature and Standard. Both the AKC and CKC have recently recognized Rat Terriers. And Rat Terriers are now occasionally seen outside North America. Rat Terriers with shorter legs are recognized by the UKC as the Ted Roosevelt Terrier. Decker Hunting Terriers are a larger strain of hunting Rat Terriers.

The White House staff appreciated the way the President's "rat terriers" dispatched vermin.

Additional Terrier Breeds

Jagdterrier (Yahkt terrier)

Jagdterriers were developed in Germany to create an all-purpose hunting terrier that would also go to ground; breeders used Fox Terriers and black-and-tan Patterdale Terriers. In Germany, they are used on traditional terrier game like badger and fox, but also with larger game like wild boar. Jagdterriers stand 13 to 16 inches tall and weigh 17 to 22 pounds. They are typically colored black and rusty tan. Most kennel clubs recognize the Jagdterrier.

In North America, the Jagdterrier is often used as a multipurpose hunting or treeing dog and for barn-hunt events. The smaller Jagdterrier may be suitable for earthdog work. Very much a working breed, the Jagdterrier is a high energy, high prey drive, fearless, dominant dog who can be very protective. He requires an experienced owner.

Tenterfield Terrier

Tenterfield Terriers are descended from a variety of smooth-coated ratting terriers brought to Australia by British immigrants. Found throughout the countryside on farms, the dogs also became family companions. Though often called Mini Foxies, they are not miniature versions of Fox Terriers. In the 1980s, interest grew to preserve the native breed, but it wasn't granted recognition as a native breed by ANKC until 2002.

Tenterfield Terriers have a square appearance, pricked or semi-erect ears, and a docked, bob, or natural tail of various lengths. The dogs stand 10 to 12 inches tall and weigh about 10 pounds. Bi- or tricolored white with black, tan, or liver markings, Tenterfields are friendly, active dogs.

Treeing Feist

Often called Squirrel Dogs, the group of small treeing feists is diverse in appearance, as they are primarily selected for working ability. Treeing feists stand 10 to 18 inches tall and weigh 12 to 30 pounds. Feists are shorthaired and seen in any color or pattern. They are eligible for ATWA den trials, UKC Drag Races, and barn hunts.

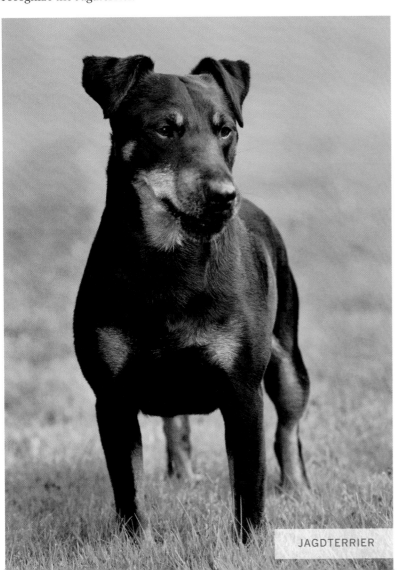

JAGDTERRIER

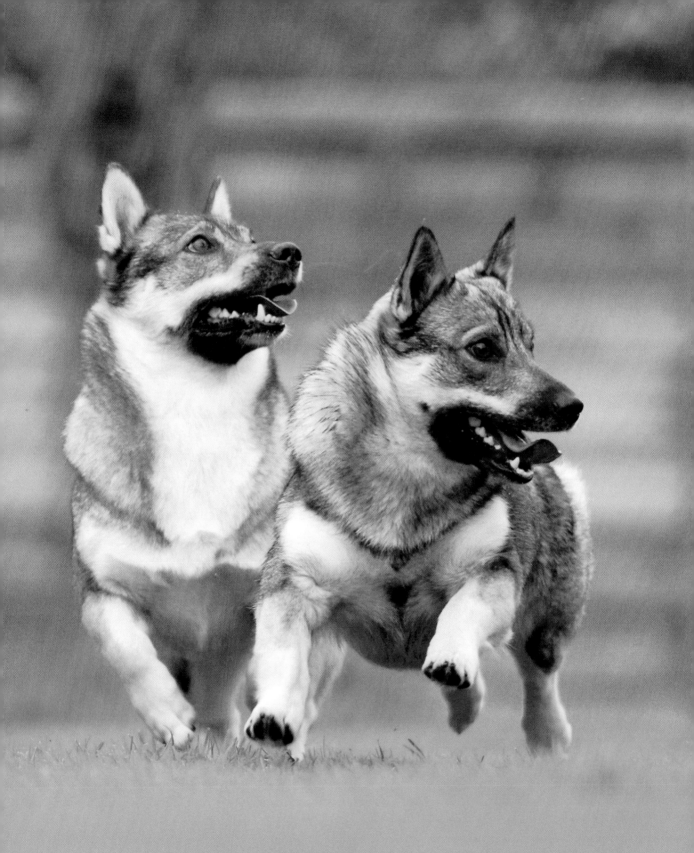

SWEDISH VALHUND

Traditional and Multipurpose Farm Dogs

The multipurpose or general farm dog has been an essential worker and partner on small family farms throughout the centuries. He was not a specialist at gathering or moving large flocks of sheep or a full-time livestock guardian or an earthdog. As a jack-of-all-trades, he was an extra farmhand and a companion on chores all day.

He helped shepherd the sheep or goats to pasture or drove them to market. He worked with stock in the barnyard, keeping sheep or cattle off a feed bunker or from escaping through a gate, and brought the dairy cows in for milking. He was a watchdog or a guardian that protected the farm and family. He helped to control rats or other vermin, and might accompany his owner while hunting. He pulled a cart to market and his owner counted on him to protect it. Most of all, he was a reliable and devoted companion for children and families who often lived alone out in the country.

Today, many farm dog breeds are primarily family companions that live indoors but participate in outdoor activities, enjoy plenty of space for exercise, and keep a watchful eye on everything. Many of these dogs, however, traditionally slept outside in a doghouse or barn, patrolling around poultry pens, small animal enclosures, and outbuildings at night, and some are still content to live outside part- or full-time. Many of the livestock guardian, herding, terrier, and earthdog breeds can also fulfill the role of general farm dog, but the breeds discussed here were often developed exactly for this job.

Roles for a Multipurpose Dog

The breeds in this group show tremendous diversity in temperament, behaviors, working abilities, and size. Some breeds possess high energy, high prey drive, or high reactivity to threats. Other breeds are more laid-back and amenable to providing comfortable companionship. Some breeds are aloof, independent workers while others are primarily companions and housedogs. Each breed combines these traits differently.

Carefully consider the abilities you are looking for in a multipurpose dog. Do you need a protective guardian or an alert watchdog? Do you desire a family companion, a serious farm worker, or something in between — a dog that will keep you company as you go about your chores? Will your dog help out with herding or be expected to hunt vermin around your farm? Will your dog share an active lifestyle with you or participate in specific dog sports? Do you want a dog that will pull a cart?

Physical Appearance

Traditional farm dogs range in size from medium to extra large and come in a tremendous variety of body shapes and coat types. What they have in common is their working ability on the farm. Historically, specific work needs varied in different areas, and all of these breeds provided more than one service; some were truly all-arounders who fulfilled numerous roles. Some of these breeds had stronger herding or terrier backgrounds, others provided important draft labor, and some were serious protectors.

Carting and Drafting

Carting or dry-land mushing is traditional work for many breeds. Most breeds medium-sized and larger can pull an appropriately sized cart. Dogs often enjoy the exercise and interaction, and they can provide useful work around the farm hauling garden or yard waste, bedding, feed, or firewood.

Dogs can pull two, three, or four-wheeled carts. Owners can walk alongside or ride, often in lightweight two-wheel sulkies. Carts have either two shafts or a dorsal hitch that attaches to the top of the dog's harness. Harnesses vary depending on the style of the cart, but in all situations there should be no weight on the dog's back. The dog responds to voice commands, although owners can also control the dog via a leash while walking. Most dogs can easily pull twice their weight, although some carting breeds can pull three or four times their weight. Dogs can work singly or in teams. Conditioning and training is very important.

There are fun events for novice carting dogs and owners as well as more challenging tests and competitions. Rules and regulations about equipment vary. Events include weight tests, carting or drafting exercises, obedience, maneuvering, and freight hauling. The Bernese Mountain Dog Club of America, for example, allows all AKC and mixed breeds to enter events. Other breed clubs with carting events include the American Working Collie Association, Bouvier, Entlebucher, Great Pyrenees, Greater Swiss Mountain Dog, Leonberger, Newfoundland, and Rottweiler.

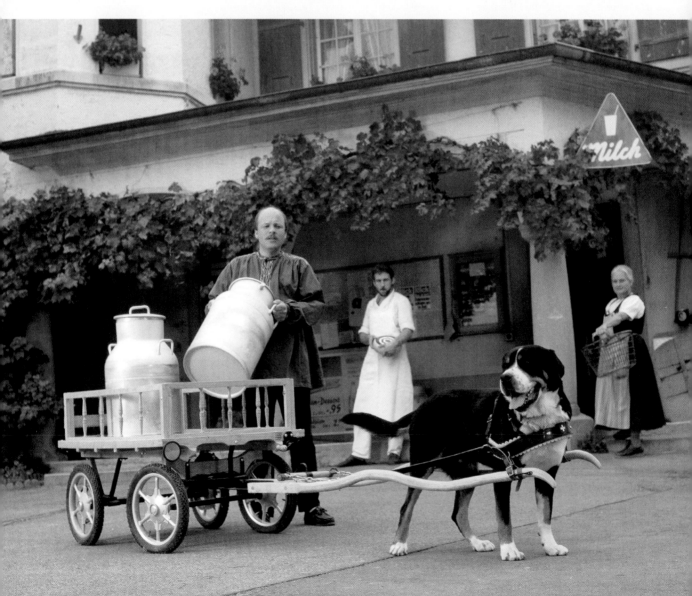

Behavior and Temperament

As with all groups of breeds, there are significant differences in temperament, behaviors, and energy levels among these breeds, but as working dogs they tend to be independent self-thinkers, dominant in nature, and naturally protective. Many require an experienced or confident owner dedicated to training and socialization. When the breed has a herding or terrier background, consult those chapters for more specific information about expected behaviors. None of the breeds in this chapter are suitable as full-time livestock guardians.

Making the Right Choice

When choosing a breed, seriously consider the jobs you expect a dog to perform or the activities he will be involved in. Is a high-energy, high-drive breed the best choice for your situation or would a more laid-back dog make a better family companion and working partner? It bears repeating that some of these breeds are very protective or dominant dogs that require an experienced and dedicated handler. Finally, in this group of breeds there are major differences in size and coat to be considered.

Common Health Concerns

Many of the traditional farm breeds are very large dogs, making them susceptible to various bone and joint issues, including hip and elbow dysplasia. Bloat and overheating are also issues for giant breeds. Some of the Swiss mountain breeds (*Sennenhunde*) do not do well in hot or humid climates at all. And sadly, some giant breeds have a life span of only seven to eight years.

Always research the specific health concerns of any breed that interests you. Good breeders test for these health conditions and provide guarantees.

What to Look for in a Puppy

If you are looking for a general farm and family companion, basic puppy temperament testing is very helpful. Breeder observations are valuable and can help match your specific needs to appropriate temperament and behaviors. If you are interested in specific abilities in herding or ratting and earthdog work, read those chapters for specialized suggestions.

Crossbred Dogs as Farm Dogs

Crossbred or mixed-breed dogs are certainly valued and beloved members of farm families. There are a few important points to consider, however, before adopting a mixed-breed dog for life on a ranch or farm. The most important factor is to determine the likely behaviors and instincts that a particular dog might have inherited. A terrier or herding dog, with its very high prey drive, crossed with a livestock guardian breed could turn out to be a large dog who is dangerous with stock. A pup from parents with very different coats can inherit a difficult coat to groom or one that is not weatherproof. A pup from parents of similar breeds and types is far more likely to have a balanced and predictable set of behaviors.

Crossbreeding does not ensure that the pups receive only the best traits from each parent. It also doesn't even out strong traits across an entire litter. Pups can look like one parent and act like the other. The unpredictability of crossbreeding is especially problematic in working dogs, which inherit so many specific instinctual behaviors, as well as strengths and weaknesses. Certain inherited traits from two different breeds may conflict with each other. If you are looking for a working dog with a specific ability or set of behaviors, a crossbred dog is not the way to go.

Crossbred dogs aren't necessarily healthier, either. If one or both parents have serious inheritable health or temperamental issues, chances are the offspring will have them also. Only health testing can reveal certain medical issues. Only knowledge about the parents can help predict temperament and inherited working behaviors.

Finally, keep in mind that the offspring of two different breeds is not itself a new or rare breed.

Bringing Home a Multipurpose Pup

It's essential to determine at the outset what role your dog will play on your farm and with your family. If your new pup will be living in your home, he can be raised as any other housedog. His training and socialization should be supplemented by supervised chores around the barn and with the stock. While basic puppy classes are excellent, more dominant breeds will definitely need additional obedience training.

If he is to live and work outside, he needs to be in a safe and sheltered outdoor area from the very beginning. It can be cruel to raise a pup in the house and then move it outdoors; the confused dog will continually attempt to return to the house or other area where he feels secure. Snug doghouses or warm spots in a barn or outbuilding are excellent and traditional homes for a working farm dog. Start him there and give him lots of attention in that place. Also give him plenty of positive experiences in the car and away from home.

While none of these breeds are suitable as full-time livestock guardians, they can work well as general farm and family guardians. In addition to basic training and socialization as a family companion, a farm dog needs some socialization to your stock in controlled situations. Take your pup with you as you do chores, leashed if necessary. Some folks attach the leash to their belt to allow for hands-free work. Do not trust a dog to behave appropriately around other animals until maturity around two years of age. Some breeds are never reliable with small animals, stock, or poultry and must always be supervised.

Many owners assume that a farm dog will learn its boundaries and just naturally stay home without fencing. This is usually not true and presents safety issues to your dog or stock as well as liabilities for damage to your neighbor's animals. Unless you live in a truly remote area, the days of freely roaming neighborhood dogs are over.

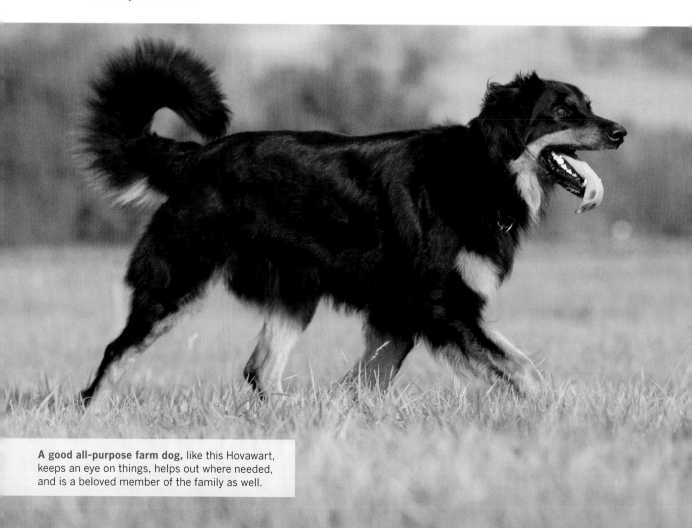

A good all-purpose farm dog, like this Hovawart, keeps an eye on things, helps out where needed, and is a beloved member of the family as well.

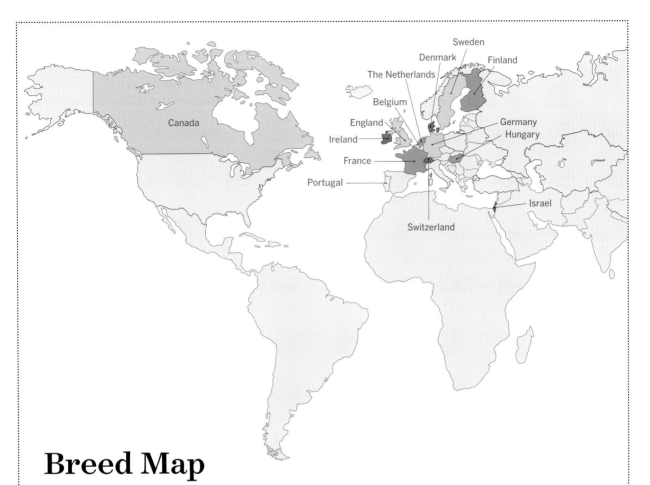

Breed Map

Belgium

Belgium Shepherd Dogs:
 Groenendael, Laekenois,
 Malinois, Tervuren
Schipperke

Canada

Newfoundland

Denmark and Sweden

Danish Swedish Farmdog

England

Airedale Terrier

Finland

Karelian Bear Dog

France

Bouvier des Flandres

Germany

Standard Schnauzer
Giant Schnauzer
Hovawart
Leonberger
Rottweiler

Hungary

Pumi

Ireland

Kerry Blue Terrier
Soft Coated Wheaten Terrier

Israel

Canaan Dog

The Netherlands

Keeshond

Portugal

Portuguese Water Dog

Switzerland

Swiss Mountain Dogs:
 Appenzeller Sennenhund,
 Bernese Mountain Dog,
 Entlebucher Mountain Dog,
 Greater Swiss Mountain Dog
Saint Bernard

Airedale Terrier

Origin	England
Size	Males about 23 inches, with females slightly smaller, 40 to 65 pounds
Coat	Medium-length, hard, wiry outer hair with soft undercoat
Color	Black and tan; black may be grizzled with white or gray hairs
Temperament	Independent, dominant, high energy, high prey drive, pluck, focus

Airedales have many terrier traits — they are intelligent, independent, and clever. Affectionate with their family, they are often serious and aloof with others.

Natural problem solvers and self-thinkers, Airedales are also energetic and require about an hour of exercise daily. Even with sufficient activity, they are likely to dig and bark.

Airedales are strong willed and assertive, and they can be stubborn. They need early and continued training and have a reputation for wanting to work with you, not for you. They don't respond well to harsh methods, are easily bored, and dislike repetition. Airedales certainly show the traditional terrier pluck. They are courageous, with a high prey drive and a high pain tolerance.

They are large dogs who play boisterously, making them better suited to homes without small children. They also chase small animals, including cats or other small pets. Airedales are likely to be aggressive with strange dogs, and may have issues with other family dogs especially if the same sex or if they are challenged.

Working traits. Airedale owners often participate in obedience, agility, scent work or tracking, and water sports. Breed enthusiasts promote the Airedale's houndlike hunting abilities on land and water, with an extensive program of events and trials. Some Airedales are still used to assist with moving livestock on the farm, although they chase them without training and supervision. Airedales are alert, responsive dogs, making them good watchdogs, and they can be protective guardians, but they need to be well socialized to prevent aggression.

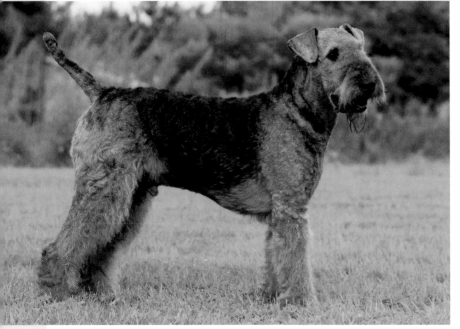

Appearance

The Airedale is the largest of the AKC terrier group. Square in shape, he should be cobby or stocky rather than leggy. A specific weight is not specified. The head is long with a flat skull, little or no stop, and a strong and deep foreface. The ears are small, folded, and V-shaped, carried to the side of the head with the top of the fold not above the skull. The eyes are dark

and small. The chest is deep but not broad and the back is short and level. The tail is set up on the back, carried high, and traditionally docked long where permitted.

Coat. Airedales have a rough, medium-length double coat. The outer hair is wiry, hard, stiff, and dense with a short, soft undercoat. The outer hair may be slightly waved or crinkly. Airedale coats are traditionally kept short and neat by hand stripping. Left natural, the coat grows thick and wooly. The coat needs weekly grooming to prevent mats, with regular clipping or professional grooming three to four times a year. Hair is traditionally trimmed on the front legs to emphasize their straightness. The beard sops up water when the dog drinks. Occasionally "sheepcoats," or soft coats, appear in litters.

Color. Airedales are colored black and tan. The black area may be grizzled with white or gray hair. Some red may appear in black areas. A small white blaze on the chest is acceptable.

History

The Airedale Terrier's size and appearance make him instantly recognizable. The breed was developed in the Aire River Valley of Yorkshire in the mid-nineteenth century. It is often suggested that the Airedale was developed through crosses of the Otterhound, the old Black and Tan Terrier, and other hounds and terriers. In reality, the Otterhound was still being developed in the area as well, with the use of wirehaired French Griffons to develop a stronger land-and-water scenthound. At the time, Black and Tan Terriers were common throughout northern England and Wales, and would later be bred

Many Airedale owners swear these dogs have a sense of humor.

into the Welsh, Fell, Lakeland, and Patterdale terriers.

Out of this mix of dogs, local owners sought to combine terrier traits with the scenting and water ability of the Otterhound or Griffon. As the Airedale emerged, it was variously called the Waterside, Bingley, Warfedale, or other names. He was too large to go to ground like a working terrier, but worked alongside Otterhounds to hunt

water rats and otters on the riverbanks or in the water, as well as foxes, badgers, and weasels on land. Nicknamed "the King of Terriers," he is large enough and has the right temperament to serve as a capable watchdog and guardian for families.

The Airedale was shown as early as 1864. Fifteen years later the name Airedale was chosen for the breed, which soon earned

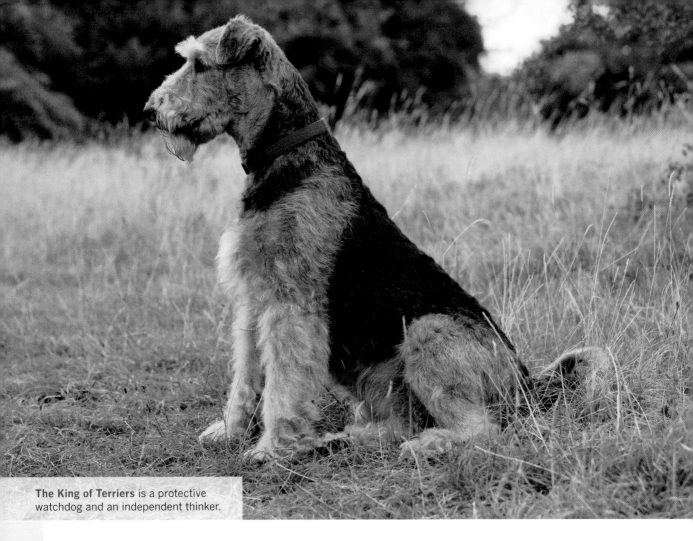

The King of Terriers is a protective watchdog and an independent thinker.

Kennel Club recognition. The Airedale's larger size also made him an appropriate breed for other uses. In World War I, Airedales were used as messengers and Red Cross ambulance dogs and to search for wounded soldiers. The British Army and police forces also used Airedales before the widespread adoption of other breeds. The National Airedale Terrier Association acts as a home club for the breed today and sees about 600 registrations each year.

Across the Ocean

Airedales were imported to North America in the 1880s, where they were soon exhibited at dog shows and recognized by the AKC. The Airedale Terrier Club was founded in 1900. In the early years, there was some debate about removing the word "terrier" from the name. In both Canada and the United States, the Airedale became an all-around farm dog and family companion. Although the breed was not used with stock in England, North American owners found Airedales to be tough dogs helpful in driving cattle and other stock on a farm. They also earned their keep as a ratter or varmint killer, watchdog, and protector.

Hunters of wild boar, bear, or mountain lion also utilized Airedales — President Teddy Roosevelt took them on his hunting trips. They were the favored pet of other presidents, including Harding, Coolidge, and Wilson. This public visibility contributed to the breed's substantial popularity, which peaked in 1949. During the 1920s and '30s, a strain known as the Oorang was bred for much larger size. Some very large Airedales are still bred today, although the breed club does not sanction them. Today the AKC registers about 1,700 Airedale Terriers yearly.

Airedale Terriers were also imported to Australia in the late nineteenth century, generally following the same rise of popularity as the breed did in North America. Primarily a companion or show dog, more than 200 dogs are registered each year.

Belgian Shepherd Dogs

Also known as Chien de Berger Belge, Belgian Sheepdog

Origin	Belgium
Size	**Male** 24 to 26 inches, 55 to 66 pounds **Female** 22 to 24 inches, 44 to 55 pounds
Coat	See individual breeds
Temperament	High energy, high prey drive, high reactivity, willing, upright, loose to medium eyed, tender

Belgian Shepherds are intelligent, willing, enthusiastic, and high-energy dogs. Always alert, they are aware of everything going on around them.

These dogs need lots of purposeful activity, challenges, and attention; often too much to make typical companion dogs. Owners suggest that Belgian Shepherds need about two hours of exercise and training each day. They become bored easily and need experienced, confident owners who enjoy working with their dog in this type of relationship.

Obedience training is a must; it should be positive and reward based, with professional training recommended for high-drive or more aggressive dogs. Belgian Shepherds are quick learners and highly perceptive and often outsmart their owners. They are also fast and have rapid reflexes and great endurance.

Belgian Shepherds form strong, affectionate bonds with their owners and can tend to be one-person dogs. They are often sensitive dogs that need socialization and confidence building to become good citizens. If ignored or left alone for long periods of time, they may develop separation anxiety or destructive behaviors. Some Belgian Shepherds can be

One Breed or Four?

The naming scheme and standards for the Belgian Shepherd or Belgian Sheepdog can be confusing. In his homeland, the Belgian Shepherd is considered a single breed divided into four varieties based on appearance. Britain, Australia, Canada, the UKC in America, and the FCI-affiliated countries around the world follow this opinion.

The AKC and the New Zealand Kennel Club recognize four completely separate breeds: Belgian Sheepdog (Groenendael), Laekenois, Malinois, and Tervuren. The varieties or breeds all share a common history; however, due to breeder choices there are now some differences beyond appearance.

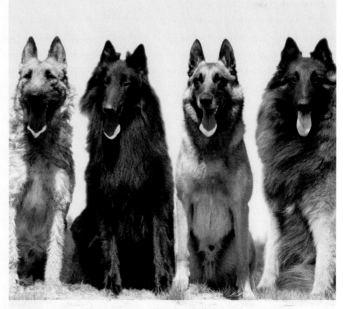

LAKENOIS, GROENEDAEL, MALINOIS, TERVUREN

more hard than soft in temperament. Potential owners should meet the parents of any pups they are interested in to assess basic temperament.

This protective breed is acutely aware of all situations and naturally distrustful of strangers. Dogs may misinterpret the actions of children or other animals. Although they are usually good with children and other family pets if raised with them, individual dogs may have issues, such as jealousy or being overly possessive or having protective reactions. Most do well living with another family dog, although some are same-sex aggressive. Like all herding breeds, the Belgian Shepherd may attempt to keep people or animals together, including children. They are very likely to chase animals, joggers, or bicyclists. Good fencing is a requirement.

Working traits. Besides excelling at protection activities and sports, Belgian Shepherds shine in obedience, agility, and other dog activities. As herding has become less important to the breed, not all varieties or dogs show strong instincts. Owners who seek a dog for herding activities should look toward breeders selecting and using dogs in this manner. Noticeable differences exist between the varieties or breeds, with some dogs extremely aggressive in their herding style.

Traditionally, Belgian Shepherds were tenders, and they have a strong urge to keep their stock together. They are upright, typically loose-eyed workers who also circle and bunch stock naturally. In fact, owners observe that the breed has a real tendency to move in a circle rather than in a straight line. Some handlers have noticed stronger-eyed behaviors in Belgian Shepherds. Highly trainable and fearless, Belgian Shepherds also compete in fetching or driving and can work cattle.

Appearance

Regardless of breed or variety, Belgian Shepherds are physically much the same. They are square, medium-sized to large dogs — powerful and strong but without heaviness. Belgian Shepherds project both elegance and confidence. The long and chiseled head has a muzzle equal to or slightly longer than half of the head length, with a moderate or mild stop.

The brown eyes are medium sized, slightly almond shaped, and oblique. The small, sharply triangular ears are set high and carried erect. The medium-length tail is strong at the base, raised when the dog is alert but not carried high. The tip curls slightly but is not hooked. See individual profiles on pages 278 to 281 for more detail.

History

The Belgian Shepherd's roots are found in the old continental sheepdogs, including the Dutch, German, and French shepherds, as well as the early Flemish Bouvier cattle dogs and the Briard and Beauceron. Dutch and Belgian shepherds actually share some common founder dogs, although they are two different breeds today. In the eighteenth and nineteenth centuries, the *chien de berger Belge*, seen in a great diversity of coats and colors, was working as a sheepherding and general farm dog.

Flocks of small to larger numbers of up to two hundred sheep were penned at night, driven out during the day on roadways, tended by dog and shepherd on grazing areas, and returned by evening. At times, the dogs were also used to manage small herds of cattle or dairy sheep or as draft animals. From the beginning, providing protection to the farm and the animals was an important part of their job.

The Club du Chien de Berger Belge was organized in 1891 for the defined purpose of surveying and examining the national sheepdogs as to type, coat, and color. Club members identified dogs and created a standard for one Belgian breed with three varieties, later expanded to four. Some interbreeding and common ancestors were involved in the development of the separate varieties, which were eventually named for the kennels or areas where they were principally bred.

Interbreeding is no longer allowed, but occasionally puppies born into one variety exhibit the appearance of another variety — they are excluded from conformation showing by the AKC but not elsewhere. In spite of early disagreements over coats, colors, and varieties, supporters of the breed agreed on the overall structure, temperament, and working qualities of the Belgian Shepherd. The standard describes a shepherd dog who also guards property.

Breeders continued to work toward standardization in the years leading up to World War I, and Belgian Shepherds began to be seen in the show ring. Belgian Shepherds were an early choice for police work in Belgium, and their use quickly spread to Paris and New York City. During the war, they were employed by the military as messengers, drafters, and ambulance dogs, which further enhanced

their reputation as an outstanding working dog.

Recent History

In the early years of the twentieth century, some Belgian Shepherd breeders reasoned that with so few sheep being herded anymore, trials should be expanded to include other tests of abilities, such as dressage or ring work, obedience, and swimming. In both France and Belgium, these ring tests became important in determining which dogs should be bred. Today, Belgian ring sport competitions consist of obedience, jumping, and bite work. As a breed, the Belgian Shepherd was focused on police, military, and ring sport. His athleticism, strength, and intelligence have made him popular in many countries throughout the world.

The first Belgian Shepherd, a Groenendael, arrived in the United States in 1907. The Malinois soon followed. Four years later the AKC recognized the breed as the Belgian Sheepdog instead of the Belgian Shepherd. By the end of the 1920s, the Belgian Sheepdog was among the five most popular AKC breeds. The AKC divided the breed into two varieties: Groendael for all dogs with long coats and Malinois for short coats. Through the years of the Great Depression and World

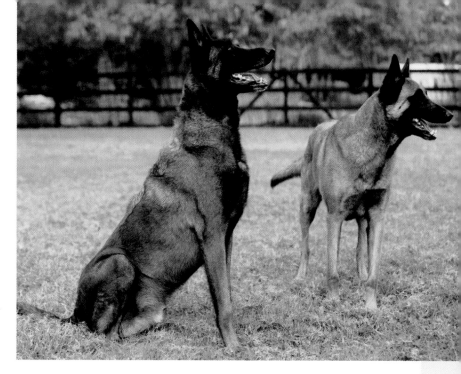

A nonworking home cannot provide the required activity and training for a Malinois, who is used almost exclusively for military, police, or competitive sport work.

War II, registrations plummeted. The Groenendael recovered first and the Malinois was reinvigorated by new imports. The first Tervuren was also imported and the Belgian Sheepdog Club of America (BSCA) was reestablished after languishing for many years.

As a result of efforts by some breeders and a desire to prevent inter-variety breeding, the AKC made a somewhat controversial decision to divide the Belgian Sheepdog into three separate

breeds in 1959. The Groenendael became the Belgian Sheepdog and two new breeds were created — the Belgian Malinois and the Belgian Tervuren. In 2010, the Laekenois was recognized as a fourth separate breed, entered into the Foundation Stock Service (FSS), and assigned to the Herding Group. The Malinois now has the highest number of registrations due to its great popularity as a police, military, search-and-rescue, bomb-detection, and sport dog.

What Is Schutzhund?

Schutzhund means "protection dog" in German; it is one of several protection training and sport programs that test both the handler and the dog. Royal Dutch Police Dog Sport (KNPV) and Schutzhund began in the early 1900s. Originally Schutzhund was a test of the breeding suitability of German Shepherd Dogs, including obedience, tracking, and protection work. Other tests or trials, such as the KNPV, are based on the requirements of police work and provide certifications for police dog service work.

Competitive ring sports — including Belgian Ring, French Ring, and Mondio or "World" Ring — test obedience, agility or jumping, and protection. Several national and international organizations govern each of these sports.

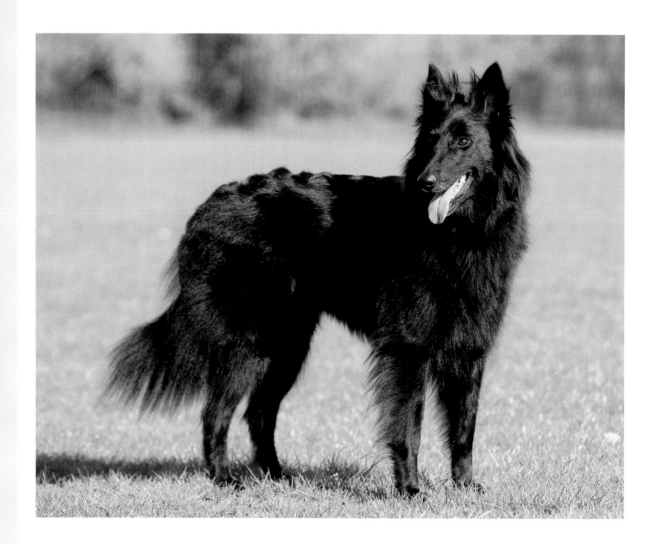

Groenendael

The elegant Groenendael (GROAN-en-dahl) received its name from Château de Groenendael, the home of a dedicated early breeder. The breed quickly gained popularity based on its appearance and versatility. Widely exported as both working and show dogs, they came to typify the entire breed by the early 1900s. Groenendaels are still serious working dogs. In North America, the variety is bred for show, work, obedience, or other dog sports, and as companions.

Coat/color. Often called the "beautiful" Belgian Shepherd, the Groenendael has profuse long hair that feels smooth and hard, never silky, wooly, or wiry. The hair is straight with a dense undercoat. There is an abundant mane or ruff on the neck and an apron, or jabot, on the chest. Tufts of hair protect the ear opening and upright hair frames the head. Hair is also longer on the back of the thighs, forming culottes, or breeches, and the Groenendael has a plumed tail. The double coat needs weekly grooming.

The Groenendael is always pure black in color. White is limited to a small patch on the chest, a tiny area on the toes, and frosting on the muzzle.

Laekenois

The Laekenois (LAK-in-wah) is often viewed as the rough and tumble dog in this breed. Although perhaps the oldest of the varieties, he is the least common worldwide and has been slower to gain official acceptance. He is still not fully recognized by the AKC. Widely used as a herding dog in the Belgian countryside, his name comes from an area outside of Brussels where shepherd dogs of various coats and colors herded sheep on the grounds of Laeken Castle.

The Laekenois suffered from color controversies and never achieved the popularity of the other varieties, and its numbers were further reduced after both world wars. Like the other Belgian Shepherds, the Laekenois' protection instinct is strong, although due to his low numbers the variety is not often seen in serious protection training.

Coat/color. The Laekenois' rough double coat is harsh, wiry, and dry but weather resistant. He has a tousled appearance, never silky, curly, or wavy. Furnishings on the muzzle and above the eyes do not obstruct sight. Hair length is about 2 to 2.5 inches. The coat grows very slowly and should not be shaved or clipped. Some breeders recommend regular plucking or stripping during shedding season, but others believe regular brushing is sufficient.

Originally, this variety was described as dark ash gray in color, eliminating fawn dogs from the breeding pool. Early supporters objected and defended the traditional fawn color. The AKC breed standard now accepts all shades of red to fawn to grayish shades with traces of black overlay primarily found on muzzle and tail. Other standards may accept only fawn.

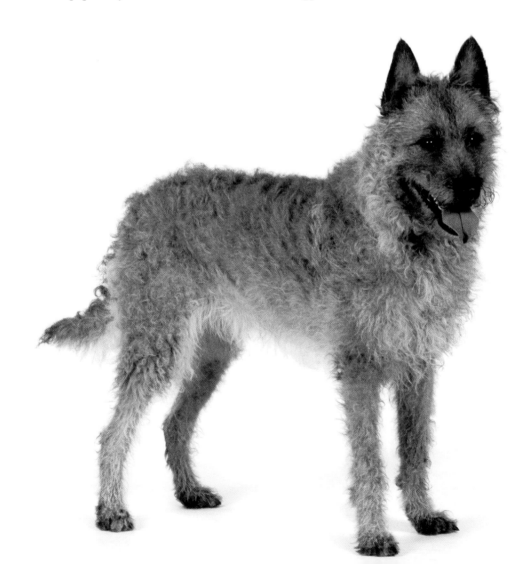

Malinois

The Malinois (MAL-in-wah) projects a very athletic and bold appearance. These dogs are bred to work an eight-hour day, with a high energy level that is especially evident in puppies but can last up to five years of age. They also have high prey and bite drives. This is a serious working animal with high demands for activity and training. Most individuals can be described as possessing a strong desire to please their owner or handler. Temperaments can vary, so a good breeder should match the dog to the owner's needs.

Today the Malinois is bred almost exclusively for personal protection, detection, search and rescue, police or military use, and sport work, such as Belgian Ring, French Ring, mondioring, and Schutzhund. Many experts regard the Malinois as the near ideal breed for ring sports, but not a breed for a nonworking home.

The preferred choice of many national military and police forces, the Malinois is also used for cross-breeding with other protection breeds to create specialized lines for the military or other working needs, which are often referred to as Belgian Malinois. The Royal Dutch Police Dog Association (KNPV), the premier organization that tests police dog candidates, also breeds Malinois crosses as police or military dogs, search-and-rescue dogs, and seeing-eye dogs. Crossbred Malinois dogs, known as Mechelse Herders in Dutch, are registered with the initials xM.H.

Coat/color. Although the coat is uniformly smooth and short, it is hard and weather-resistant with a dense undercoat. The hair does form a fuller neck collar and the back of the thighs and tail are fringed. The only color is a rich fawn to reddish mahogany, with black overlay on the tips of hairs. The ears and mask are black, as is the tip of the tail. The mask includes the ears, eyelids, and top and bottom lips. A small white patch on the chest and the tips of the toes is permissible. Gray and with a black overlay is permissible in some standards. Color often darkens with age. Breeders emphasize that color is not as important as physical structure and solid temperament.

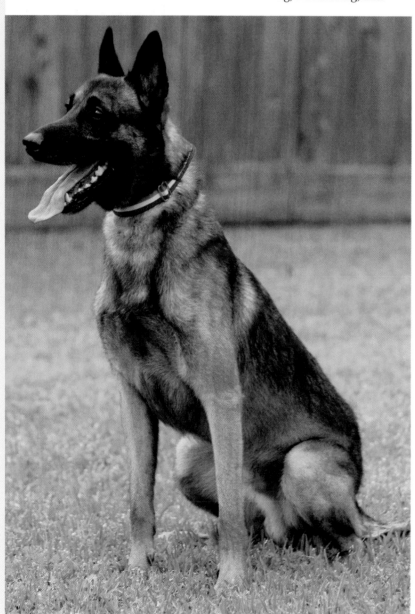

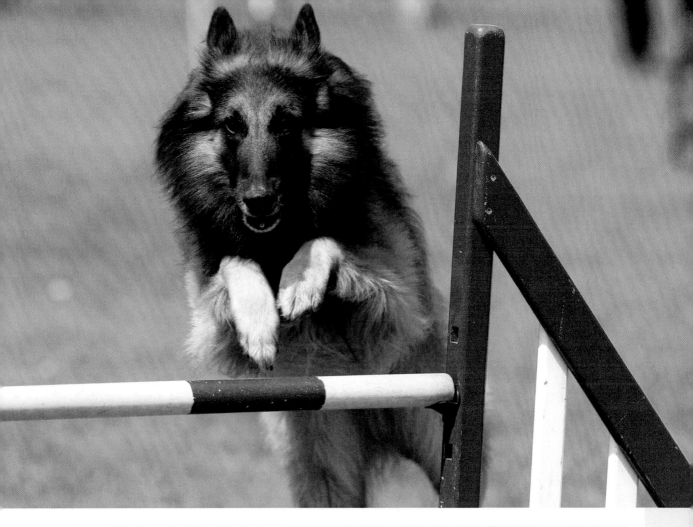

Tervuren

Although black was the preferred color for the longhaired Belgian Shepherds, other early breeders promoted the fawn or gray dogs. One of the earliest breeders was from the town of Tervuren (tur-VYUR-uhn), which gave the variety its name. Lacking the popularity of the Groenendael, Tervurens were scarce after both world wars in Europe. Interbreeding was allowed with the Groenendael and Malinois. Arriving later in North America, it was recognized as a separate breed by the AKC. Although rare, the Tervuren is now well established as a working dog or pursuing a variety of activities including showing, and obedience or dog sports and living as companion dogs.

Coat/color. The Tervuren is a striking dog, with the coat of the Groenendael and the color of the Malinois. He has long, abundant hair that is smooth, but never silky or wiry. The hair is straight with a dense undercoat. The hair forms a ruff or mane on his neck and an apron, or jabot, on the chest. Tufts of hair protect the ear opening and upright hair frames the head. The hair on the back of the thighs creates culottes, or breeches, with a plumed tail. The double coat needs weekly grooming and only minimal trimming.

The Tervuren is seen in shades of pale yellowish fawn to reddish mahogany or gray with varying amounts of black overlay on the tips of the hair. He has a black mask and black on the tip of the tail. The underparts are lighter in color. A small white patch on chest and tips of toes is permissible, as well as frosting on muzzle. The mask must include the ears, eyelids, and top and bottom lips. Fawn is preferred in the AKC standard with gray a fault.

Bouvier des Flandres

BOO-vee-ay day FLAWN-druh | Also known as Bouvier, Bouv

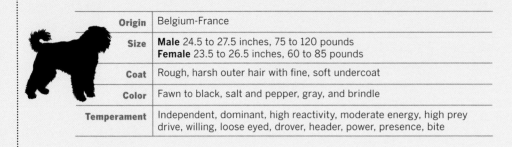

Origin	Belgium-France
Size	**Male** 24.5 to 27.5 inches, 75 to 120 pounds **Female** 23.5 to 26.5 inches, 60 to 85 pounds
Coat	Rough, harsh outer hair with fine, soft undercoat
Color	Fawn to black, salt and pepper, gray, and brindle
Temperament	Independent, dominant, high reactivity, moderate energy, high prey drive, willing, loose eyed, drover, header, power, presence, bite

Bouvier des Flandres breeders are the first to say this is a breed for experienced owners of strong-willed, socially dominant dogs.

Positive training by the owner is best, along with establishing rules and expectations for behavior. If a Bouvier assumes leadership of the family, he may become aggressive towardw humans. A Bouvier is suspicious, protective, and fearless. With cause, he may employ defensive aggression, although with a lower reactivity than some other protection breeds. He tends to begin with physical intimidation, but will use his body or bite. He does not need protection training to be a family and home protector. Socialization is required to raise a Bouvier to be a good citizen.

Although he can appear aloof at times, the Bouvier is very devoted, forming close bonds with his family and wanting to be with them at all times. Generally good with children when raised with them, he may protect his children from unknown playmates and may become agitated by screaming or running. He can suffer from separation anxiety if left alone too long. With moderate energy for a herding breed, he can relax in the house given sufficient exercise and a job to do.

Like many breeds with a high prey drive, he may herd or nip. He must be safely fenced, even in the country, as he chases pets, other animals or stock, bicyclists, or cars. Bouviers are dog-aggressive, especially same-sex dominant, and may not be good with existing family dogs or small pets.

Working traits. The Bouvier is essentially a cattle dog, a header and drover, with power and presence. He tends to work quietly,

but uses bite and his body to move stock. Owners looking for a working cattle dog should seek out a breeder selecting for herding ability as the breed's original herding instinct has been further modified in some lines to chase and capture.

Appearance

The rough-coated Bouvier des Flandres can present an intimidating presence. He is a powerful, strong-boned dog — compact and short-coupled, with a square appearance. His impressive head looks even more massive due to the heavy beard, mustache, and upstanding eyebrows. The head has a slight stop, a broad muzzle, and dark oval eyes.

Covered in short hair, the ears are set high and traditionally cropped in a triangle. Uncropped ears are held flat against the cheek with only a slight lift. The tail is set high and customarily docked. Some dogs are born with short tails and natural tails are also allowed.

Coat/color. The double coat appears tousled, but not curly or wooly. Water resistant and rugged, the harsh outer hair grows continuously, but it is generally trimmed to about 2.5 inches. The coat can mat easily and needs weekly grooming, plus trimming every two to three months. The heavy beard and moustache soak up water and collect debris.

Bouviers are found in shades of fawn to black, salt and pepper, gray, and brindle. The most common colors are gray, brindle, or black overlay. A small white spot on the chest is allowed.

History

The historic region of Flandre, or Flanders, was home to several important and wealthy trading cities. Today the region is located primarily in Belgium, with smaller portions in France and the Netherlands. On this flat and fertile agricultural land, Flemish cattle dogs were essential workers on farms, not only driving cattle to market but also protecting the farm, pulling carts, and even providing the labor on treadmills used to churn butter or grind grain. At times, they were also used to herd sheep or drive game.

In the 1890s, a distinctive, bearded droving dog was first documented in Flanders, variously called *vuilibaard* (dirty beard) or *koehund* (cow dog) in Dutch, and *bouvier* (cow herder) or *toucheur de boeufs* (drover) in French. His ancestry is unclear, although various breeds have been suggested including the old *barbet* (sheep poodle), as well as the schnauzers, pinschers, Belgian or Dutch shepherds, Beaucerons, Briards, and others. It has also been suggested that the Ter Duinen Monastery, an important early breeder of the Bouvier des Flandres, crossed deerhounds from Britain with local cattle dogs.

Various standardization efforts stalled when World War I swept through Europe, particularly focused on the Bouvier's homeland. The breed was noted for its courageous service during the war, gaining an international reputation as a messenger dog, ambulance cart dog and drafter, mine detector, guard dog, and attack dog. With the combination of postwar destruction, economic upheaval, and the increasing use of trucks to transport cattle, the breed was in dire straits until the French and Belgian breed clubs began to work together to unify their separate standards.

Across the Ocean

As the breed's popularity increased abroad and a second war loomed, breeders deliberately sent some dogs to safety in the United States, where the AKC already recognized the breed. The Bouvier was again called to service in the Second World War. Afterwards, recovery was slow as breed numbers were reduced to a few hundred or fewer. Again, joint efforts by the Belgians and French secured FCI recognition.

By this time, America had become central to Bouvier breeding, ultimately sending dogs to European breeders to aid in its restoration. Another boost to public awareness of the breed was Lucky, the Bouvier owned by President Ronald Reagan. The Bouvier remains an established breed in both the United States and Canada, where it is found primarily as a companion and show dog, but also used in dog sports and tracking.

Postwar, the Bouvier has developed greater popularity especially in the Netherlands. In Europe, the breed is also a working dog used in protection sports, search and rescue, and police and military functions. Since the end of World War II in Europe, the Bouvier has been bred primarily for this work and not as a general farm or herding dog.

Canaan Dog

Also known as Kelev K'naani

Origin	Israel
Size	19 to 24 inches, 40 to 55 pounds
Coat	Short to medium, harsh, straight outer hair with dense undercoat
Color	Sand to red-brown, white, black, or spotted, all with or without black mask and white markings; AKC standard more restrictive
Temperament	Independent, dominant, moderate to high energy, high reactivity, high prey drive, soft, loose eyed, gather

Given their primary duty as a watchdog, Canaan Dogs are highly territorial, very alert, and suspicious of strangers or anything unfamiliar.

They are keenly aware of their surroundings and highly reactive to stimuli. They respond vocally to all disturbances in the vicinity and bark continuously, looking for their owner's response. Although they may bite if the threat continues, they are not acceptable attack dogs, personal protection dogs, or livestock guardian dogs. Mature dogs become more territorial, sometimes including the places they regularly visit besides their home. Canaans can be dog-aggressive, especially with males of the same sex or strange dogs, which is understandable — as free-living dogs they protected their territory against wolves, jackals, and hyenas.

A good home for a Canaan is with people who desire a natural dog and are willing to accept the more primitive traits. Although some dogs have a high energy level, daily walking, playing, or running will allow them to be settled in the house. A fenced yard is necessary, and many owners note they are clever escapees who love to chase and dig and often ignore a recall.

Canaan Dogs are intelligent and can learn quickly, but they can also be willful and become bored with repetition. Typically soft dogs, they shut down if corrected harshly. Owners need to determine what motivates their dog and be careful of unintended learning. Canaans can also be distracted by what is going on around them or a perceived threat. They need to know their place in the pack, or they may become dominant or repeatedly challenge their owners. Without extensive socialization dogs may react aggressively or fearfully. Owners need to remember that the flight option is a survival trait.

As independent self-thinkers, Canaans are not overly dependent

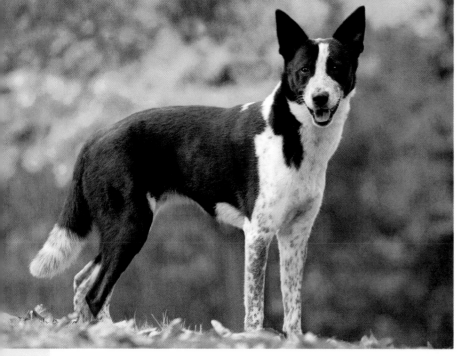

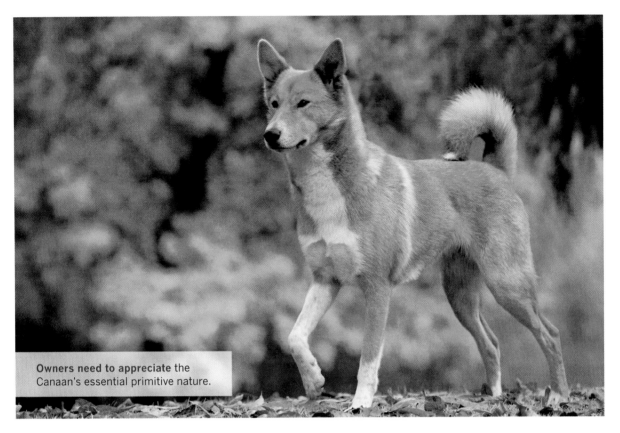

Owners need to appreciate the Canaan's essential primitive nature.

on human companionship, but they can form strong, loyal bonds with their owners. They are generally good with children, as long as the children are respectful. Many Canaans have a high prey drive and will chase, kill, and eat small animals. As free-living dogs, they attack domestic animals, including sheep, goat, calves, piglets, or large birds.

Working traits. About half of Canaan dogs exhibit a herding instinct. As herding dogs, they are intelligent, quick learners but also easily bored and distractible. They often make their own choices about what needs to be done. They are close, loose-eyed workers with a natural drive. They gather and naturally tend or keep animals in a location. They can manage groups of two hundred to three hundred animals. Canaan Dogs are better

suited to working with their owners than performing in a trial.

Appearance

Canaan Dogs are medium sized and should resemble the feral or primitive type. Some breeders note that dogs from Israel, especially the *miyun* dogs (see page 286), tend to be heavier in build and coats than dogs in North America, but this is regarded as a valuable genetic introduction. Canaan Dogs have a blunt, wedge-shaped head with low-set ears that are erect, short, and broad. The head has a slightly defined stop and a sturdy muzzle. The dark brown eyes are almond shaped and slightly slanted. The thick, brushy tail tapers to a tip. The dogs are agile and graceful, with a light, energetic, quick trot.

Coat/color. The double coat has harsh, dense, and flat outer hair, which is short to medium in length. Some ruff is seen in males. Overly long or single flat coats are not desirable. The undercoat is close and dense, providing insulation against both heat and cold. Canaans are noted as clean dogs and the coat is generally easy to maintain.

The Israeli standard describes acceptable colors as sand to red-brown, white, black, or spotted with large or small spots. Black and white, black and white with ticking, red and white, and cream and white are also seen. On all colors, dogs may or may not have a black mask or white markings. The traditional desert colors — sand, gold, red, and cream — are most common. The more restrictive AKC standard forbids white dogs.

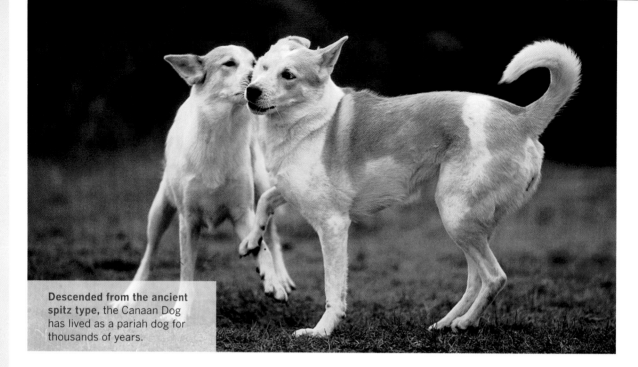

Descended from the ancient spitz type, the Canaan Dog has lived as a pariah dog for thousands of years.

History

Primitive pariah, or free-living, dogs are still found in modern Israel and the surrounding areas. The Bedouins have long used pariah dogs as camp and flock watchdogs. Traditionally, male dogs are taken from the wild and tethered until mature or bonded to the territory. These dogs are not truly tamed, and many remain unapproachable. In Bedouin villages, both genders are kept in a more domesticated state and handled by owners. The secluded, religious communities of the Druze, located in the north of the country, also use pariah dogs.

The Canaan Dog itself is the product of an organized breeding program that began in the 1930s, based on free-living dogs found with the Druze and Bedouin. The majority of dogs were found in the arid and rocky Negev desert, and the breed was named for the ancient land of Canaan. The goal of the project was to preserve the natural traits and ability to survive in the climate and geography of the area. Free-living dogs continued to be brought into the breeding program, run by Dr. Rudolphina Menzel, with the initial goal of providing sentry dogs for remote Jewish settlements. The project eventually supplied more than 4,000 dogs to the Israeli army, where they were used as sentries, messengers and Red Cross, tracking, and mine-detector dogs. Some puppies were also placed as companions or home guardians.

The Israeli Kennel Club formally recognized the Canaan Dog as a breed in 1953, followed by FCI acceptance. The Canaan is classified as a primitive breed with an open registry, meaning it is possible to introduce free-living or unregistered, landrace dogs into the gene pool, strengthening diversity and health.

This is done through specific selection criteria called *miyun*. Individual dogs must come from a remote location where there is little likelihood of intermingling with outside breeds. The parents are examined if available. The dog itself is examined when it is at least nine months old. Finally, the dog is bred to a registered dog, and the puppies are also examined after nine months of age.

The Canaan Dog is now the official national dog of Israel, where the army still uses them extensively for guard and patrol work. Many Canaans serve as home watchdogs and companions, as well.

Out of the Country

In 1965, four carefully selected dogs were sent to the United States to establish another breeding population and to expand the breed's visibility. The Canaan Club of America was organized and responsible for recordkeeping until the breed earned UKC, CKC, and AKC acceptance. One of the largest populations of Canaan Dogs outside of Israel is in North America, with small numbers found in continental Europe and Britain. Fewer than 100 puppies are born each year, and the breed remains extremely rare. The worldwide population of domestic Canaan Dogs is estimated at about 1,500.

Danish Swedish Farmdog

Also known as Dansk-Svensk Gaardhund, DSF

Origin	Denmark and Sweden
Size	15 to 25 pounds; **Male** 13 to 15 inches; **Female** 12 to 15 inches
Coat	Short and smooth
Color	White with patches of shades of fawn, tan, brown, black; with or without tan markings and flecking
Temperament	Moderate to high energy, high prey drive, willing

The Danish Swedish Farmdog is an excellent multipurpose family and farm dog who happily accompanies his owner on chores all day long.

Owners report that they are slow to leave their exuberant puppyhood behind, which can lead to a long period of stubborn mischief and trouble. Consistent, positive training is important, as is keeping them busy and exercised. Alert and active, they are less independent and calmer than terriers, and with their gentle, affectionate natures, they make good companions in the home and playmates with children.

Vocal watchdogs, they alert their people to disturbances and visitors but are not aggressive toward people or other dogs. With their strong urge to chase, they need to be kept in a fenced area or on leash. They may or may not tolerate noncanine family pets.

Working traits. Most Danish Swedish Farmdogs today are family companions, but they do need a dedicated owner who engages them in activities or dog sports that fulfill their ratting background, such as barn-hunt, earthdog, or nose work. With their high energy, speed, agility, and quickness, they do well in vigorous sports, such as flyball, agility, and even lure coursing. The DSF is a good, self-directed mouser and ratter in and around farm buildings and sheds. With his plucky courage, he can also help move cows between fields and milking barns. Many Farmdogs do well when asked to perform on herding instinct tests and have also been used with sheep.

Appearance

The Danish Swedish Farmdog is a compact dog with a head that can appear somewhat small in proportion with his overall size. The standard does not describe a specific weight, and smaller or larger dogs are also seen. The medium-sized ears may be button or rose. The DSF is naturally bobtailed, with varying lengths occurring; longer tails are carried straight with a slight curve. The tails are still docked in countries where this is allowable, although many owners with DSFs involved in dog sports have chosen to keep long tails.

Coat/color. The Farmdog is a single-coated breed, with short hair that is harsh in texture but smooth against the body. Dogs lack insulation against cold or extreme weather. White predominates, with patches in shades of fawn, tan, brown, or black. Coats may also have tan markings or flecking.

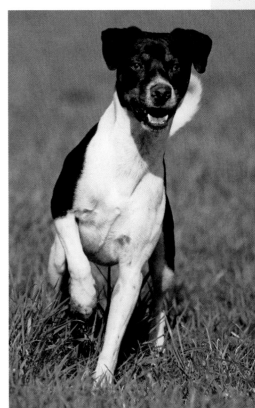

287

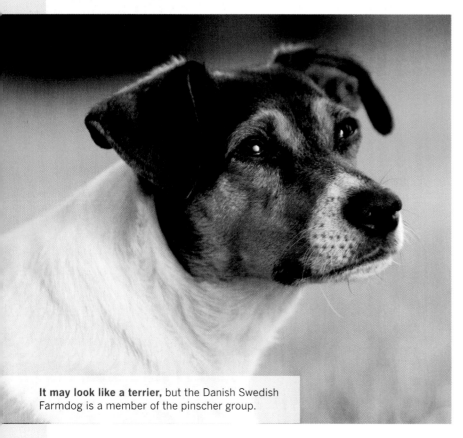

It may look like a terrier, but the Danish Swedish Farmdog is a member of the pinscher group.

History

This small multipurpose farm dog and ratter represents a type of dog that was popular for many centuries with farmers across Europe and Britain. Although it has been suggested that the Danish Swedish Farmdog is a cross between the British fox terrier type and European pinscher, there is no definite proof. Today, the breed is not considered an actual terrier, but a working farm dog with some terrier roots.

From the time of the Vikings until the eighteenth century, the homeland of the Danish Swedish Farmdog spanned the north of Denmark, the historic southwestern province of Skane in Sweden, and Schleswig-Holstein, the northernmost area of present-day Germany. Today these areas belong to separate nations, but this old native breed was found across this greater area on the small homesteads of northern farmers. He served as a farmyard and house watchdog, hunted rats, and assisted when dairy cattle were moved from barns to fields.

From the early years of the twentieth century through World War II, Queen Alexandrine, wife of King Christian of Denmark, owned several of these farm dogs as family pets while others were kept in the horse stables. Other farm dogs were well-known performers in the Danish circus at about the same time.

Restoring Popularity

From 1978 to 1982, the popular Danish television series *Matador* (which depicted life in a fictional town from the late 1930s to the mid-1940s), featured a beloved farm dog as the companion of one of the regular characters. In many ways, this particular little dog sparked public attention and efforts to recognize and save the traditional breed, which seemed to be disappearing from the countryside. Not yet a recognized breed, these dogs went by various names: Danish Pinscher, Danish Terrier, Ratdog, Smooth Haired Terrier, and the Skansk Terrier. Adding to the confusion, some publications called it the Danish Chicken Dog.

Although some efforts were made in the 1960s, it wasn't until 1985 that the Danish Kennel Club pursued a census of the little farm dogs. After inspections, they approved 130 dogs. After their Swedish counterparts undertook the same mission, the groups decided to work together to conserve the breed. Given a new, inclusive name, Dansk-Svensk Gaardhund, the breed was recognized by both clubs in 1987. The FCI placed the breed in the pinscher group in 2008.

Several hundred Danish Swedish Farmdogs are registered yearly and unregistered dogs can still be found across the area. Today most DSF are happy family companions rather than working dogs.

Although a recent arrival in North America, the DSF is already participating in many dog sports. The Danish/Swedish Farmdog Club of America was founded in 2006, and secured UKC recognition. A second club, Danish-Swedish Farmdogs USA, pursued AKC FSS recognition, which was received in 2011. Although rapidly growing in popularity, the breed is still relatively rare in both Canada and the United States.

Giant Schnauzer

SHNOU-zer

Origin	Germany	
Size	**Male** 25.5 to 27.5 inches, 60 to 85 pounds **Female** 23.5 to 25.5 inches, 55 to 75 pounds	
Coat	Hard, wiry outer hair with soft undercoat	
Color	Shades of pepper and salt or solid black	
Temperament	Independent, dominant, high energy, high prey drive, hard, upright, loose to moderate eye, bark, power	

The Giant Schnauzer is not just a larger version of the Standard Schnauzer. This is a more dominant and harder dog who requires an experienced and confident owner, or he will assume control.

European lines, in particular, have been bred for police and guard-dog work. Obedience training and socialization need to begin when the dog is still a puppy.

Giant Schnauzers have naturally strong protective and territorial instincts, making them excellent and loyal watchdogs or guard dogs, without the need for guard-dog training unless the owner chooses to pursue Schutzhund work. The Giant Schnauzer needs a minimum of an hour a day of hard work, as well as mental challenges. Without a job and activity, he can become quite destructive.

Even with socialization, they are reserved with introduced strangers. Giants are also prone to dog aggression and will attempt to dominate other family dogs. Breeders do not recommend them for homes with small children or existing pets. Giants are best suited to be an only dog with a dedicated owner who enjoys training and working with a challenging dog. They require excellent fencing.

The versatile and intelligent Giant excels at obedience, Schutzhund, agility, carting, search and rescue, and other activities. He also remains a talented cattle dog, who works upright and close with a moderate to loose eye, bark and physical power to move stock.

Appearance

The Giant Schnauzer is a robust, powerful, and imposing dog. The body is square in outline. The head is strong and rectangular, narrowing slightly from the ears to the nose. The skull is broad and flat, with a slight stop, and a strong muzzle.

The high-set ears are traditionally cropped erect. Uncropped button ears soften the expression. The medium-sized eyes are oval and brown. The back is straight, and the tail is set moderately high. When docked, the length should be between 1.5 and 3 inches. A natural tail is carried slightly above the topline.

Coat/color. The Giant Schnauzer has a double coat, with hard, wiry, and very dense outer hair. Longer on the head, the coarse hair forms eyebrows and a beard. The coat is typically stripped for showing but may be kept trimmed or clipped in a companion dog. In North America, a softer, more profuse show coat

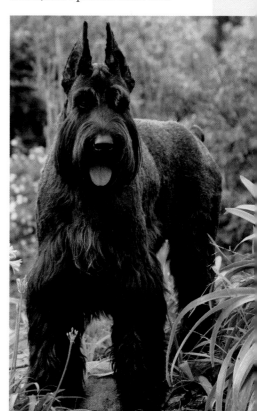

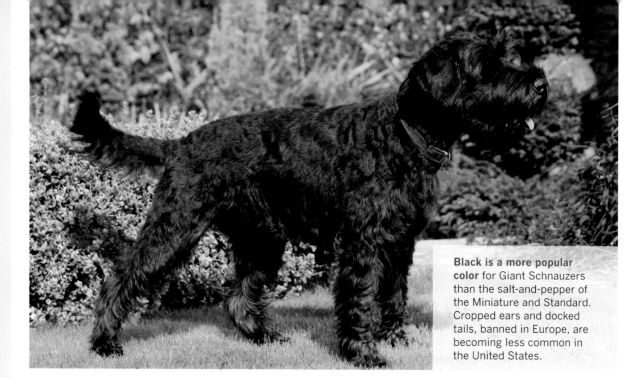

Black is a more popular color for Giant Schnauzers than the salt-and-pepper of the Miniature and Standard. Cropped ears and docked tails, banned in Europe, are becoming less common in the United States.

is accepted, with a range of coats available between the correct hard coat and the soft show coat.

In North America, the Giant is most often seen in black rather than pepper and salt, which is popular in the Standard and Miniature Schnauzers. Some breeders produce silver or tan colors, which are not acceptable for showing and not more valuable.

History

The Schnauzers are members of the pinscher family, which dates back to the Middle Ages in Germany. Pinschers were general farm and cattle dogs, as well as ratters and guardians of the farm and merchant's wagons. The Giant Schnauzer may also be related to the old German herding and droving breeds called the *Altdeutsche Schäferhunden*, which included wirehaired types.

In the southern city-states of Bavaria and Württemberg, cattle dealers and farmers bred a large, powerful droving dog, similar in size and temperament

to the nearby Swiss cattle drovers. Known as the Munich Schnauzer, Bear Schnauzer, or Russian Bear Schnauzer, this shaggy-haired droving breed eventually lost its job as the railroads began to transport cattle, which happened sooner in Germany than mountainous Switzerland. The Bear Schnauzer continued his role as a guard dog in the cities, often working at stockyards, factories, and even breweries. In the late nineteenth century, the decision was made to stress this aspect of the breed, renamed the Giant, or Riesenschnauzer.

The Giant Schnauzer was put to work as a police and military dog, where it excelled in both world wars. In Europe, the Riesenschnauzer is bred today as a working breed like the German Shepherd and Doberman Pinscher, and must be tested in Schutzhund trials to qualify for conformation titles. In North America, a Working Riesenschnauzer Federation has been established for owners interested in training and testing their Giant Schnauzers.

Across the Ocean

The first imports of the Giant Schnauzer to North America occurred in the 1920s, with AKC recognition following; however, the breed remained rare until a dedicated breed club was established in 1962. The breed's numbers grew through the 1970s and '80s, peaking at about 1,000 registrations per year. Since then the Giant Schnauzer has lost ground to other recently imported large or giant breeds and now fewer than 100 dogs are registered yearly. The Giant Schnauzer Club has revised its AKC standard to be in accord with the German guidelines, although some differences remain between American and European dogs. American and Canadian breeders are now stressing the serious working abilities of the Giant.

Since its arrival in Great Britain in the 1960s, the Giant Schnauzer has established a following there. The population is fairly stable at around 300 registrations yearly. Giants are rare in Australia with only 30 or so registrations each year.

Hovawart

HO-va-wart	Also known as Hovie

Origin	Germany
Size	**Male** 25 to 28 inches, 66 to 88 pounds **Female** 23 to 26 inches, 55 to 77 pounds
Coat	Long, straight or slightly wavy hair with thin undercoat
Color	Black, blond, black with gold markings
Temperament	Independent, dominant, moderate energy, variable prey drive

Most Hovawarts are dominant, independent dogs that are protective, alert, and suspicious of strangers.

Warmly affectionate with family, they are generally aloof with outsiders. Some dogs are sweet and soft, though many are stronger working types. Hovawarts bond to their family like a pack, but often choose a special person. Hovies are usually tolerant or even playful with children if socialized to them.

Given an hour of exercise, a Hovie can relax in the house. He wants to be with his owner but can tolerate time alone and even live outdoors if he receives substantial attention and interaction. These dogs definitely need to be kept in a fenced yard due to their protective nature, but they aren't inclined to wander.

Male Hovawarts tend to be more assertive, especially if intact, and may have aggression issues with other dogs, including family dogs. They are generally good with other family pets, including cats if raised with them, but may chase strange animals. Prey drive varies within the breed.

Working traits. This energetic dog needs human interaction and has too much prey drive to make a reliable working livestock guardian. However, he is very well suited to the role of a watchdog on a small farm. Hovawarts are natural, territorial guardians who need no training to do their job. They are usually discerning about threats, behaving defensively rather than reacting aggressively. Heavy socialization, structure, and basic obedience training will prevent overly aggressive guarding. Their independent, willful, assertive nature makes the breed harder to train and motivate, but they are also sensitive, intelligent dogs that shut down with harsh measures. Experienced owners warn that Hovies test their owners from time to time and in the absence of jobs to do, they invent their own.

291

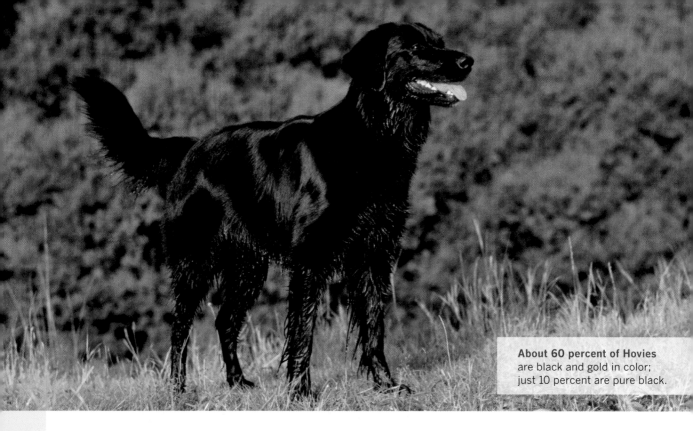

About **60 percent** of Hovies are black and gold in color; just 10 percent are pure black.

Hovies are excellent walking or jogging companions and enjoy other active dog sports. They are particularly good at scent work or tracking, and search-and-rescue training. Breeders seek to maintain this breed as a versatile working dog but also a devoted companion and watchdog. Herding instinct has not been a focus of the breeding effort.

Appearance

The Hovawart is a medium to large dog that is slightly longer than tall. He has a moderately broad head and stop, with a strong muzzle that may taper slightly. The ears are triangular and set medium to high, which gives the skull a broader appearance. They hang loosely down but may be raised slightly forward when the dog is alert. The dark eyes are oval.

The dog has a strong level topline, and the bushy tail hangs low at repose but may rise over the back when the dog is alert. Some dogs are leggier and narrow, but overall the Hovawart should appear substantial, hardy, and muscular.

Coat/color. The Hovawart is often described as naturally beautiful. He has a double coat that should be weatherproof. The undercoat is sparse or thin, which reduces matting and coat care. The outer hair is long, straight or slightly wavy, dense, and close.

Hovawarts are seen in three separate color variations and all three can appear in the same litter. At times unrecognized "wild colors" appear, the result of the various breeds used in reconstruction. Black should be pure and shiny, with no red or rusty shading. Blond, a medium shade of gold, is shiny and shaded lighter on the underparts.

Black-and-gold dogs are mostly shiny black, with no red or rust shading. They have distinct, golden eyebrows and markings on the cheeks and muzzle that may extend down the throat, as well as shading on the legs, chest, and belly up to under the tail. A few white areas on the chest, toes, and tail tip are allowed in all colors.

History

The Hovawart may look a bit like a Golden Retriever, but at heart he is very much a guardian of home and family. His name comes from the German *hof* (yard or farm) and *wart* (watcher). Mentioned as early as the thirteenth century, the Hovawart appears in records and artwork throughout the Middle Ages in Germany. At times he worked as an estate guardian, much like the Hungarian Kuvasz, and was also used to trail and pursue thieves.

Beginning in 1915, zoologist Kurt F. König and a few other breeders in Germany and Austria began to search for dogs that resembled the old descriptions of the Hovawart. They located dogs in various areas including the Black

Forest in the southwest part of the country, nearby Odenwald, and the Harz mountains in the north. Using these dogs and introducing some outside blood, they began to reconstruct the old landrace breed.

Originally there were four centers of Hovawart breeding, each of which utilized different percentages of outside blood, which included old-type German Shepherd Dogs, Newfoundland, and Kuvasz. There were also small additions from Leonberger, Bernese Mountain Dogs, and a single North African Sloughi female (a sighthound). Although the first Hovawart litter was entered in the German Breeding Registry in 1922, breed reconstruction was an ongoing effort for another decade.

The original Hovawart may have been more of a traditional livestock guardian or mountain breed similar to the Kuvasz. Although some LGD blood was included in these breeding efforts, the contemporary breed is not an LGD. The Hovawart was selected to be a protective watchdog and versatile companion, much like the German Shepherd Dog.

By 1937, the Hovawart breed had reestablished itself and was earning attention. With a diminished population surviving after World War II, the Hovawart club re-formed, and by the mid-1960s the breed had earned full German and international recognition. Now a popular dog in his homeland, where it is recognized as a native breed, he is seen again in the countryside, guarding the yards of houses and small farms. In Germany, there are strict regulations regarding breeding dogs with hip dysplasia, which has kept incidence low in the breed. This is also a goal of the International Hovawart Federation.

Hovawart popularity spread first to neighboring European countries then further east in Europe. First imported in to the UK in 1980, a club was soon organized. Although growth has been slow, today the population is around 300 dogs and has earned KC recognition. Hovawarts have made their way to North America as well and clubs have formed around the breed. The Hovawart was placed in the AKC FSS in 2010 and has been assigned to the Working Group. The breed is also recognized by the UKC. In Canada, the CKC granted the breed full recognition in 2005.

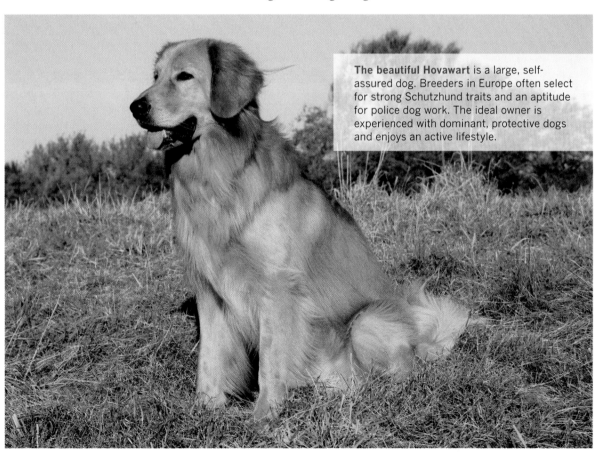

The beautiful Hovawart is a large, self-assured dog. Breeders in Europe often select for strong Schutzhund traits and an aptitude for police dog work. The ideal owner is experienced with dominant, protective dogs and enjoys an active lifestyle.

Karelian Bear Dog

kuh-REE-lee-uhn	Also known as KBD, Carelian Bear Dog (CBD), Karelian Bearhound

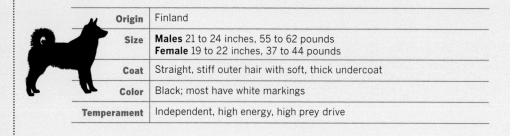

Origin	Finland
Size	**Males** 21 to 24 inches, 55 to 62 pounds **Female** 19 to 22 inches, 37 to 44 pounds
Coat	Straight, stiff outer hair with soft, thick undercoat
Color	Black; most have white markings
Temperament	Independent, high energy, high prey drive

The Karelian Bear Dog is absolutely not a traditional farm breed or a livestock guardian breed.

A hunting breed, it is included here strictly for its significant value in deterring grizzly bears and other large predators, such as pumas. These predators can pose a serious threat to farmers, ranchers, and others, especially in the western portions of the United States and Canada. The use of Karelian Bear Dogs is a nonlethal approach that is proving valuable in these situations.

Trained Karelian Bear Dogs and handlers are used in some US and Canadian national parks and in several western states or provinces. Since 1990, Wind River Bear Institute has trained Karelians for bear-management specialists, trained volunteers, and people in bear country. There are three essential and specialized roles for KBDs: bear conflict dogs for management specialists, rangers, or wardens; bear protection dogs for biologists, ranchers, or outfitters; and companion dogs for hikers and others.

KBDs are used to push or shepherd bears out of human conflict areas both urban and recreational. They also locate bear dens in winter to prevent interactions from construction crews or for biological studies. Biologists use their assistance for tracking and locating bears or pumas in monitoring efforts. Authorities use them for capture efforts of problem animals and nonlethal deterrence efforts or adverse conditioning.

Working traits. Socialization to people is very important for Karelians. They definitely require an owner with experience and confidence in handling dogs of this type. For working dogs, puppy aptitude testing and advanced training is essential. Owners who work their dogs report that the dogs are not content with just a couple of long walks each week. This breed needs a job and can be destructive when bored or frustrated. There are volunteer opportunities in some areas for owners to use their trained dogs in organized efforts for predator control.

KBDs bond closely to their owners yet can be quite independent in decision-making. They have a high prey drive and strong desire to chase. Owners report that they easily jump 6-foot fences in order to hunt. Females reportedly have a higher prey drive and are more independent. Karelians are territorial and protective. When working they are courageous, intense, and focused. Karelians are often dog-aggressive but should not be aggressive to people. They are generally not well suited as pets, especially in urban environments.

If you are looking for a Karelian Bear Dog in North America, check for a United Kennel Club, Canadian Kennel Club, AKC, Finnish Kennel Club, or FCI registration — other dogs are being misrepresented as KBDs. Sound temperament is essential in a powerful working breed. Avoid crossbred dogs for this specialized work.

Appearance

The Karelian Bear Dog is medium sized with a strong, robust appearance. He is not a heavy dog, but built for endurance and running. The broad skull has very little stop and tapers slightly to the nose. The erect ears are medium-sized and thickly furred. The eyes are small, slightly oval, and brown. The high-set tail generally curves over and touches the back, although a natural bobtail occurs and is acceptable.

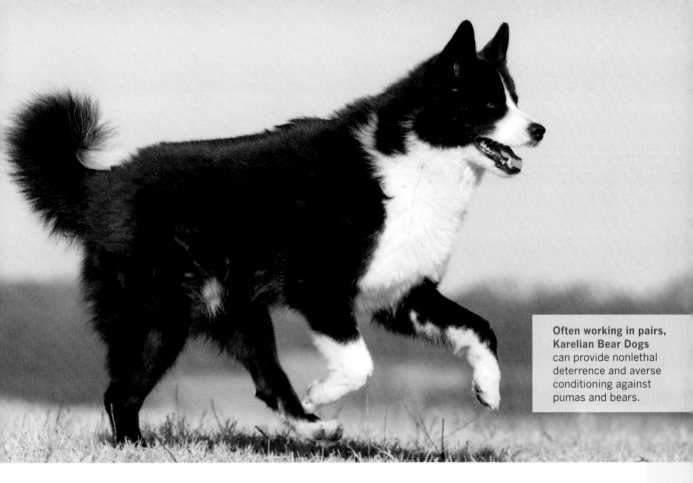

Often working in pairs, Karelian Bear Dogs can provide nonlethal deterrence and averse conditioning against pumas and bears.

Coat/color. The Karelian Bear Dog is double coated, short to medium in length. While the undercoat is dense and soft, the outer hair is harsh and straight. The hair is longer on the ruff, back, and upper thighs. The Karelian is primarily black, although there may some brown shading to the hair. Most dogs have white markings on the head, neck, chest, and underparts.

History

Karelian Bear Dogs are part of a large, aboriginal group of spitz-type dogs used as watchdogs and for hunting in a huge area from Scandinavia into Siberia, dating back to the Neolithic era. Related to the elkhounds and laikas, this group includes the largest northern dogs, which were used to hunt large game, such as elk, moose, bear, other large predators, and smaller

game. Hunters use these dogs for searching or tracking and holding the game at bay. Traditionally, dogs were used in pairs that worked closely with their owners.

As foreign breeds made their way into Scandinavia, interbreeding threatened this landrace breed. In 1936, following the establishment of the Finnish Kennel Club, efforts were undertaken to conserve the breed named the Karjalankarhukoira, or Karelian Bear Dog. Progress continued through the war years as the standard was adopted. Registrations began after the war as breeders also searched for surviving Karelian Bear Dogs.

Although faced with much destruction during World War II, some dogs made it safely into western Finland when Russia gained control over much of the Finnish province of Karelia. Forty-three

of those dogs were identified and used in successfully restoring the breed. Today 800 to 900 dogs are registered yearly in Finland, where the breed is celebrated and popular. Karelian Bear Dogs were recognized by the FCI in 1946, and are now bred elsewhere in Europe and in North America.

In North America, interest in the breed for bear-control efforts began in the 1980s. The Canadian Kennel Club recognized the KBD in 1980, and more imports followed in the 1990s. In 1996, the UKC recognized the breed and the nonprofit Wind River Bear Institute, founded by biologist Carrie Hunt, began using Karelian Bear Dogs for both black and grizzly bear conservation and nonlethal control efforts. In 2005, the AKC granted the Karelian FSS status.

Keeshond

KAYZ-hawnd		Also known as Dutch Barge Dog, Wolfspitz

Origin	The Netherlands
Size	35 to 45 pounds; **Male** 17 to 19 inches; **Female** 16 to 18 inches
Coat	Long, straight outer hair with short, dense undercoat
Color	Shades of gray with black-tipped hair, dark ears, muzzle, and areas of shading; spectacles around eyes
Temperament	Dependent, moderate energy, soft

The Keeshond is a very alert watchdog, but not aggressive to strangers or other dogs.

While long bred to sound watchful alarms, Keeshonden also lived in close quarters with their owners as companion dogs. Keeshonden tend to lack hunting instinct, which also makes them a good choice for a family companion and watchdog on a farm, since they are not inclined to chase or hunt small animals.

Despite their warm coats, Keeshonden (plural) are not suited to life as outside dogs, since they strongly want to be part of their family's day and activities. The breed has a tendency to become clingy or suffer separation anxiety. Keeshond puppies need socialization to new and different situations in order to prevent shyness or fearfulness. Keeshonden are smart, quick learners who need calm, gentle, positive training. Noted as good companions and playmates for children, they also get along well with other family pets, including the smallest.

Appearance

The foxy Keeshond is a sturdy, square dog with a distinctive physical appearance, air of intelligence, and alertness of expression. Weight and size are not as important as type. From above, the head is wedge shaped. His erect ears are small and triangular, and set high on the head. The dark brown eyes are almond shaped. The Keeshond is a short-coupled dog with a specific gait — a straight, brisk trot that double-tracks on parallel lines with very little reach. Fanciers believe this gait may have been practical on a moving barge or boat.

Coat/color. Another important feature is his standoff, profuse coat, which forms a lionlike ruff, especially in the male. The hind parts thickly furred, with a high-set heavily plumed tail tightly curled over the back. This heavy coat is not good for hot or humid climates.

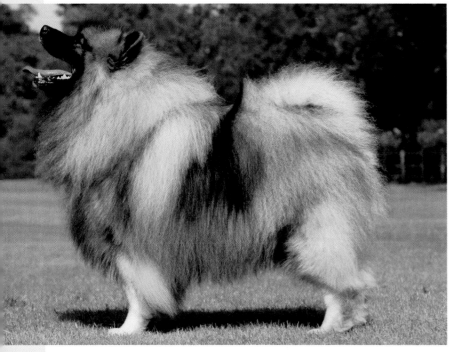

Keeshonden have very specific coloration in shades of light to dark gray, black, and cream. The hair on the body is tipped in black, which forms areas of dark shading. The undercoat is always pale, as are the underparts.

The breed has an expressive feature in its spectacle markings, in which color forms light areas around eyes, circled in dark, with a pencil line from outer edge of eye to lower ear. A light gray shoulder line is also present, along with a black tip on the tail. Keeshonden darken in color over time.

History

The legendary founding of Amsterdam by two foundered sailing men and their dog has long been depicted on the great seal of the city. In deference to this legend, it became an important symbol of good luck to keep a dog aboard ships, smaller boats, and barges. The barge dog now known as the Keeshond is a descendent of the ancient spitz group and especially the German spitz family of closely related breeds.

These Dutch dogs also performed the task of watchdog on docks where barges or boats were docked. This long association gave rise to the nickname "barge dog," but he was also a landbased alarm system for storekeepers and others who needed their livelihood protected.

In 1781, the barge dog became the official symbol of the rebel group known as the Patriots, who sought to restore the Dutch republic as well as gain greater individual freedoms and rights. The Patriots were in conflict with the supporters of the House of Orange, whose symbol was the pug, the little dog of royalty. One of the important leaders of the rebel political movement was Cornelius "Kees" de Gijselaar. His followers, the Kezens, choose the little working *Kees hond* as their symbol. The Keeshond was depicted on the pins they wore to show their support for the Patriots.

This Keeshond looked a bit different from today, since he sported a fashionable haircut much like a poodle. Throughout eighteenth-century Europe, many dogs sported these popular clips. After the rebellion was suppressed in the 1780s, many Keeshonden disappeared as their owners feared connection to the failed effort.

By now, however, the Dutch dog was widely known throughout Europe. Away from the cities, farmers, villagers, and barge owners kept their dogs, as well as their own breeding records, and the breed survived well into the twentieth century. He went by various names at times — Keeshond, Dutch Barge Dog, Fox Dog, and, in Germany, Wolfspitz. Centuries of barge travel on the Rhine into Germany gave the dogs a close relationship with their German cousins. A club for German spitz, founded 1899, included the gray and black Wolfspitz known as the Keeshond in Holland.

More Recently

Barge dogs made their way to Britain by late nineteenth century. In 1925, a club was formed and the breed was recognized separately from its German cousins. Following World War I, efforts at organized breeding began in the Netherlands, with the Dutch Keeshond Club formed in 1924. The breed also arrived in the United States in the 1920s. In light of the recent war with Germany, the AKC preferred the name Keeshond to the German

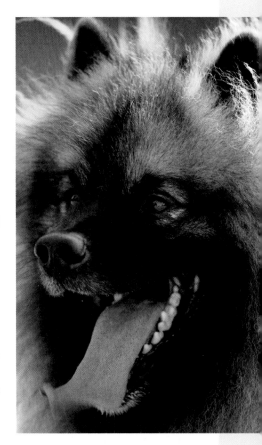

The spectacled Keeshond is a good watchdog who also makes a reliable, affectionate family companion.

Wolfspitz. After the Second World War, Keeshonden were imported to Australia and New Zealand.

Internationally, the FCI includes the Keeshond (Wolfspitz) and Pomeranian (Toy Spitz) as varieties within the large German spitz group, which also includes the Giant, Medium, and Miniature Spitz. The Keeshond is a separate breed in the UK, Canada, US, Australia, and New Zealand. In the Netherlands, the Keeshond has regained his close connection to his homeland and is recognized as a national symbol. Today, around the world, the Keeshond is primarily a family companion although his roots as farm watchdog are not far behind him.

Kerry Blue Terrier

Also known as Irish Blue Terrier, Kerry

Origin	Ireland	
Size	18 to 19.5 inches, 33 to 40 pounds, females slightly smaller	
Coat	Soft and wavy single coat	
Color	Blue in shades of light blue gray to deep slate; black points permissible	
Temperament	Independent, dominant, moderate energy, high prey drive, pluck, upright, loose eyed, bite	

Affectionate and playful, the Kerry Blue is a good watchdog who is suspicious of strangers, territorial, and protective of home and family.

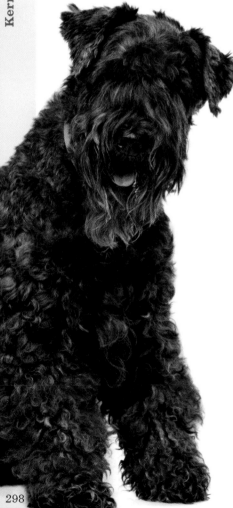

Kerries can be good playmates for older children, as they are fun loving, enjoy games, and have a mischievous sense of humor. Although Kerries have more of an outgoing, people-oriented nature than many other terrier breeds, they still need extensive socialization to people, places, and animals to prevent aggression later in life.

Being a terrier, the Kerry is not generally good with other dogs, especially strange dogs or dogs of the same sex. He does not do well in multidog households and should be carefully supervised around cats or other small animals. He traditionally chased rabbits and remains helpful around the barnyard as a ratter.

Working traits. Kerries are intelligent, quick learners, and problem solvers; but they can also be dominant and headstrong. Early training is necessary, coupled with positive and consistent leadership. Harsh treatment is counterproductive. Easily bored, they do best with short lessons.

A Kerry strongly wants to be with his owners and supervise what is going on. He wants a job to do and performs well in agility, obedience, and other dog sports. He requires moderate exercise but needs attention and mental stimulation or he may invent destructive pastimes.

The Kerry was a general herding dog in Ireland, where he was originally used with Kerry cattle, sheep, or hogs. He is an upright, loose-eyed worker who bites heels and noses.

Appearance

Although its strikingly beautiful color is unusual, the medium-sized Kerry Blue definitely looks like a terrier — upstanding, sturdy, and muscular, with moderately long legs. The head is long but not exaggerated, with a flat skull, very slight stop, and strong jaws, and the dark eyes are small. Also small, the V-shaped ears are carried forward close to cheeks with the top of the fold held slightly above the line of the skull. The neck is moderately long, the back is short and straight, and the chest is deep and broad. The tail is set on high and carried erect. Tails are docked long except where prohibited.

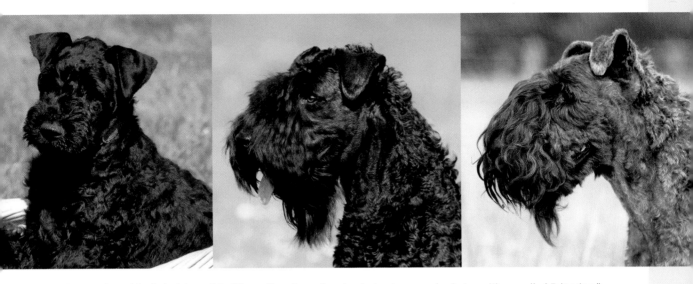

Puppies are born black, but from 6 to 18 months of age they begin to change color in transitions called "clearing," eventually resulting in their adult coat color. During this time, the coat may be marked with shades of brown and mixtures of darker blue color, with small white markings possible.

Coat/color. Mostly a non-shedding breed, Kerries have a single coat of soft, dense, and wavy hair, which is usually left longer on the legs and beard. The soft coat attracts debris and needs to be brushed daily to prevent matting. The beard does soak up water and collect food particles. Owners scissor the hair for showing, although many pet owners use clippers to keep the coat uniformly trimmed. Kerries are gray in shades of light blue-gray to deep bluish-slate, with black points permissible.

History

Practical, all-purpose dogs of Irish farmers and workingmen, large terriers came in many colors, often in the same litter. Over time and with the early attention of show breeders, they were shaped into distinct breeds in different areas. The Irish Blue or Kerry Terrier was found primarily in the mountainous areas of County Kerry. A family companion and watchdog, he often helped move cattle. Used for hunting water rats, otters, or small game, and for

retrieving birds, he was a ratter but not an earthdog in size or coat.

The Kerry Blue is single- and soft-coated like his cousin the Wheaten, but he also resembles another cousin, the harsh-coated Irish Terrier. He may also have single-coated poodle or water dog relatives or perhaps the Bedlington Terrier was involved. By the late 1800s, descriptions of a dog called the Harlequin Terrier — bluish slate, often with darker patches and tan markings — seem much like the color transition stages of a young Kerry Blue Terrier.

Whatever his ancestry, he was first shown as the Irish Blue Terrier in Ireland in 1916. Shown in untrimmed, rough coats, the dogs ranged in height from 16 to 20 inches tall. The breed became a well-known symbol of nationalism in Ireland because Michael Collins, the revolutionary leader, was a breeder and exhibitor of Irish Blues. Shortly after Collins was killed in 1922, the Irish Kennel Club was organized, partially as a symbol of defiance against the English Kennel Club. The Irish

Blue was the first breed registered and at the first dog show, held on St. Patrick's Day, 257 Irish Blue Terriers were shown in their rough coats. Those years were also the peak of the breed's popularity.

In England, the Kennel Club chose to recognize the breed in 1922 as the Kerry Blue Terrier, where he was shown trimmed up and eventually standardized in size, type, and refinement. Irish or Kerry Blue Terriers also arrived in the United States and were recognized by the AKC in 1924. There were more imports from both Ireland and England during the next two decades and the breeders eventually united in one club.

Although the breed never enjoyed tremendous popularity, Kerries are bred in several European countries as well as Australia. The primary breeders remain in Ireland, England, the United States, and Canada. The Kerry remains rare, but breeders continue to produce quality dogs who are well suited to family and country life.

Leonberger

LEE-ahn-ber-ger | Also known as Leo

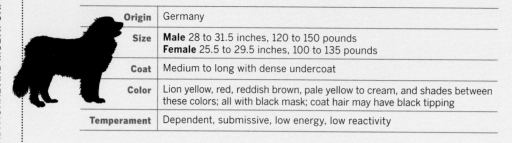

Origin	Germany
Size	**Male** 28 to 31.5 inches, 120 to 150 pounds **Female** 25.5 to 29.5 inches, 100 to 135 pounds
Coat	Medium to long with dense undercoat
Color	Lion yellow, red, reddish brown, pale yellow to cream, and shades between these colors; all with black mask; coat hair may have black tipping
Temperament	Dependent, submissive, low energy, low reactivity

A Leo is above all else a family dog. Bred to be a good companion, he is not happy being kenneled away from his family and their activities.

The breed is notably undisturbed by noise and has a calm, steady temperament. Although self-assured, Leonbergers are submissive rather than dominant dogs. Typically, they are friendly to children although their giant size and playful, rowdy puppyhood can be problematic. Males can be a bit more headstrong.

Leos have earned the nickname "Lean-on-berger" because they lean on or jump up in greeting if not trained. Everyone in the family should participate in handling the dog. While not an aggressive breed, this is a strong and powerful dog with a deep bark and protective presence. They are generally reliable with visitors and friendly toward family pets, including dogs, although there can be some same-sex aggression.

Working traits. The breed is well suited to country life and can contribute some work as a drafter as well. Leos do not need a large amount of exercise but are more athletic than many other giant breeds and they love water.

Swimming and water work, hiking, drafting or carting, weight pulling, nose work, search and rescue are all enjoyable activities for them. As a giant breed, Leos tend to have a median lifespan of seven to eight years.

Appearance

Leonbergers have an imposing, dramatic presence, accompanied by a friendly and soft expression. True gentle giants, males are quite a bit larger and significantly more powerful than females. The breed is moderately rectangular, with medium to heavy bone, but not overly bulky. The head is deeper than broad with muzzle and skull balanced in length, a moderate stop, and a slight Roman nose. There should no facial wrinkles and the lips should be tight.

The medium-sized eyes are oval to almond in shape. The medium-sized, pendant ears are set high and held close to the head, moving slightly forward when the dog is alert. Although the chest is broad and deep, there is no dewlap. A level topline merges into a tail that hangs straight and low but rises to a slight and level curve when active.

Coat/color. Leos have a plush, double coat with a dense undercoat that insulates against cold and heat. The long, outer hair is moderately soft to coarse, and straight or with a slight wave. Males have a lion-like mane on the neck and chest. Both sexes have feathering on the legs and breeches on the thighs, as well as slightly feathered ears. The tail is also well furnished. Impressive and elegant in the show ring, Leonbergers can often acquire a messy, muddy coat in day-to-day life and are heavy shedders. Although not droolers, they are slobbery drinkers.

Leonberger colors include lion yellow, pale yellow to cream, golden to red, reddish brown, and all shades in between. All colors have the breed's signature black mask, and individual hairs may be tipped in black as well. A small white patch on the chest or toes is permissible.

History

The Leonberger is a majestic giant who is true to his main function as a good family dog, although his origins are unclear. Part of the story lies in the Victorian Age, when large, impressive dogs were greatly in demand. An animal breeder and marketing genius named Heinrich Essig, born in the early years of the nineteenth century in Leonberg, Germany, was a major breeder for several decades, often gifting nobility and celebrities with his Leonberger dogs as a public relations ploy. The dogs found their way to Britain, the United States, and many other places around the world.

Other local breeders began to produce these magnificent dogs, sometimes promoting them with different names and selling them for high prices. Serious fanciers complained that the Leonberger was simply a mixture of dogs. Essig kept no records and neither did his niece and nephew, who also ran the kennel; he eventually said that he used Newfoundlands, Pyrenean Mountain Dogs, and Saint Bernards. Today it is believed dogs such as Alpine mastiff and mountain-dog types were also involved.

After Essig's death, various clubs of Leonberger owners and breeders were organized, a standard was written, and the breed was recognized by the FCI in 1895. The early Leonberger dogs came in white and other colors according to the contemporary pictures; however, in the years before World War I, the tawny, black-masked type became more standard.

The Leonberger's main function is to be a good family dog. With his extra-large size, he is well suited to country life.

Recent History

The years after the war mark the actual beginning of the modern Leonberger breed. Faced with the loss of most of the dogs through the war years, two dedicated breeders located a handful of breeding quality Leonbergers, some with partial pedigrees and some without. Recordkeeping started from scratch and breeding continued through the Second World War, although not without difficulties.

A single club emerged as the leadership for the breed and the original standard was revised. Breed numbers and popularity grew again beyond Germany, Austria, Czechoslovakia, France, and the Netherlands — the traditional areas of strength — and Leonbergers are now found around the world. The International Leonberger Union was formed in 1975 by 17 member countries.

Although Leonbergers had been imported to Britain in the past, the first serious imports began in the 1970s. In 1986, the breed club was established and gained KC recognition two years later. Today there are about 2,000 Leonbergers in the UK. Australia and New Zealand are also home to several breeding kennels.

In North America, a pair of Leonbergers produced two litters of puppies in the 1920s, but they disappeared. In the 1970s, several people imported Leonbergers and established kennels, a national club, and an independent registry. For 20 years, before entering the AKC FSS, the American club followed the strict German regulations for breeding, which mandate a three-generation pedigree free of hip dysplasia. The Leonberger received full AKC recognition in 2010.

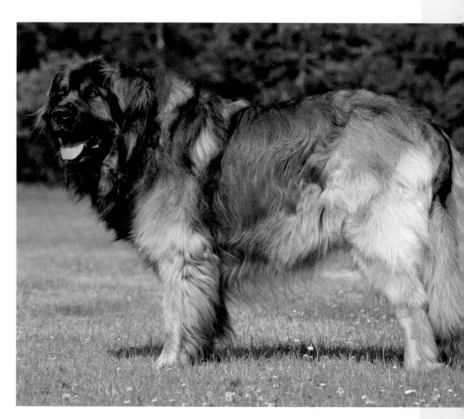

Newfoundland

Also known as Newfie, Newf

Origin	Canada
Size	**Male** average height 28 inches, 130 to 150 pounds **Female** average height 26 inches, 100 to 120 pounds
Coat	Long, straight, or slightly wavy outer hair with soft, dense undercoat
Color	AKC: black, brown, gray, and Landseer (white and black); CKC: black or Landseer; KC and FCI: black, brown, Landseer
Temperament	Dependent, low energy, soft

A sweet temperament is "the most important single characteristic of the breed," according to the breed standard.

A lovely and gracious companion, the Newfie is affectionate with the whole family and may suffer from separation anxiety if left alone too long. He is excellent with children and family pets. Some care may need to be taken with a rambunctious young dog or one that seems unaware of his massive size.

Newfies should learn manners while they are still young, since they grow up to be very strong. Like all draft breeds, they have a tendency to pull when leashed. Training should be firm, but patient and kind. Many Newfies are headstrong at times but most are food motivated. They also need socialization to prevent any potential nervousness or fear. There can be dominance issues with same-sex dogs, and this can be a problem if the other dog is much smaller in size.

Working traits. Despite his large size and loud, deep bark, the Newfoundland is more of a protective guardian to people and property than an alert watchdog. Generally unaggressive, the Newfie is fairly discerning about the intent of strangers. He is not an acceptable full-time livestock guardian, due to his soft, dependent, and nonreactive nature, but this beloved breed is well suited to life in the country.

Newfies are powerful, athletic swimmers who love to play in water. Their rescue and retrieving instinct may cause them to rescue people who don't need it, and owners warn that it can be necessary to keep a keen watch near swimmers and water. Many owners participate in water-rescue trials and other water activities. Newfies also enjoy scenting or nose work. Although they can have a lumbering gait, Newfies are strong cart dogs and can lend assistance around the yard and farm.

Appearance

This is a giant breed — heavy boned, deep bodied, and slightly longer than tall. The Newfie's expression is soft, gentle, and kindly but dignified. His head is massive with a broad skull,

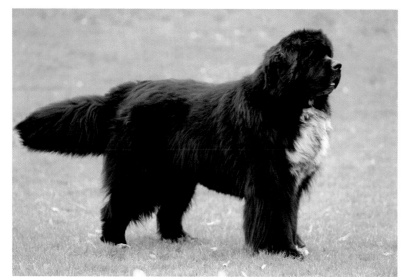

well-developed brow, moderate stop, and a broad and deep muzzle. The forehead and face should be free of wrinkles. The Newfie is a notorious drooler and slobberer. His dark brown eyes are small, deeply set, and spaced wide apart.

The small, triangular ears with rounded tips are set level or slightly below and lie close to the head. The Newfie has the strong neck and shoulders of a drafter, with a full and deep chest, and a broad and level back. The tail is broad at the base and strong; at repose, it hangs straight or with a slight curve at end. There should be noticeable webbing between the toes.

Coat. Newfoundland Dogs have a thick, heavy double coat. The long, coarse hair can be straight or slightly wavy. It is also shiny, oily, and highly water resistant. The legs are well feathered and the tail is covered with long hair. The soft, dense undercoat insulates the dog from cold air and water. This thick coat must be regularly groomed to prevent mats — it can be difficult to work through the mass of hair. Newfies are heavy shedders and the oily coat can stain. Bathing should be kept to a minimum. These dogs definitely need a cool retreat in hot weather.

Color. There are differences in permissible colors for the Newfoundland Dog breed. The Canadian standard only allows black, with white markings on the chest, toes, and tip of tail permissible; and Landseer, which is white with black markings. The AKC standard is broader, allowing solid black, brown, or gray, which may have white markings on the chin, chest, toes, and tip of tail; and Landseer. In the Landseer dog, the head is usually black or predominantly so, with a black saddle and rump. Finally, the FCI and British standard allows black, brown, and Landseer (black and white).

History

In the eleventh century, Leif Eriksson's explorations led him to the large island of Newfoundland off the coast of Canada and settlement followed. As usual, Viking dogs accompanied the settlers, although evidence cannot prove that these dogs survived to become a deep ancestor of the Newfoundland dog. The next three hundred years saw large numbers of migratory fishermen from Portugal, Spain, France, and Britain visiting the Great Banks of Newfoundland. During these years, the native Beothuk people also inhabited the island, although a British survey in 1768 recorded the absence of any indigenous dogs.

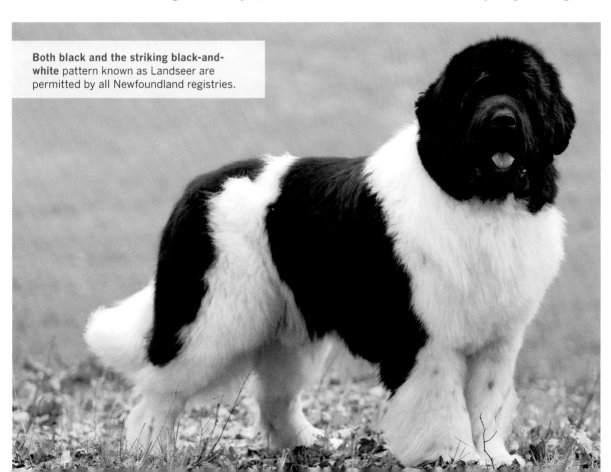

Both black and the striking black-and-white pattern known as Landseer are permitted by all Newfoundland registries.

Beginning in 1610, English, Irish, and Scottish settlers immigrated to Newfoundland, followed later by French colonists. All of these people brought their animals, including, possibly, the old *barbet* and *pudel*, which were waterfowl retrievers, and the Portuguese or Spanish Water Dogs that performed exactly the same work for Iberian fishermen that the Newfoundland Dog eventually would. Settlers likely owned all-purpose farm dogs, hunting hounds, and mastiff-type dogs.

Out of this mix, distinctive working dogs emerged. By the end of the eighteenth century, visitors described two historic types of native Newfoundland dogs. One type, called the Greater Newfoundland, or Great St. John's Dog, was a heavier, long-coated dog who hauled in fishing nets, carried lines to or from boats, rescued items or people that had fallen overboard, and pulled carts or sledges filled with cod or firewood. By the early nineteenth century, it was estimated that some 2,000 dogs were at work pulling delivery and milk carts in the city of St. John's alone. Dogs lived ashore and aboard boats.

These large dogs were seen not just in the traditional black, but also other colors, including bicolored white and black, which was popular and more numerous at the time. A slightly smaller dog with a flatter coat also worked among the fishermen and performed as a waterfowl retriever. This type, often called the Lesser Newfoundland or St. John's dog, was the ancestor of the Labrador Retriever.

Unfortunately, free-roaming dogs were also responsible for harassing and menacing sheep, as the growing population of sheep-owning farmers and traditional fishermen clashed over control of the island. In 1780, a law was enacted that limited the ownership of dogs to one per household. The effect of this law was the drastic reduction of dogs and the future development of the Newfoundland Dog as a breed in England, where the dogs became extremely popular.

In Europe

As a native breed, the Newfoundland Dog was nearly extinct on the island by the beginning of the twentieth century. Harold Macpherson, businessman and politician from St. John's, eventually restored the breed in Newfoundland, when he established the Westerland Kennels. Eventually exported around the world, his dogs would eventually contribute heavily to the foundation lines of the breed in North America.

The giant Newfoundland Dog was taken back to Europe in very large numbers, where he was adopted throughout Britain, and on the continent. Newfoundland Dogs worked on the waterfront and found homes among royal and ordinary families alike. During the 1800s, it was required that two Newfoundland Dogs work at every lifesaving station on the English coast. English breeders further developed the Newfoundland, most likely introducing mastiff or other large-estate dog breeds that increased size and created a heavier head and muzzle.

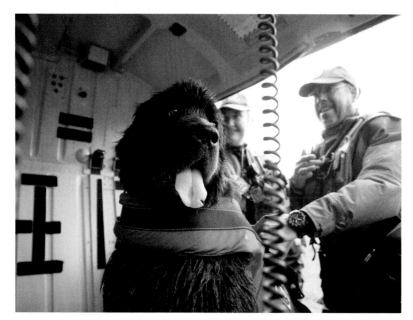

The Newfoundland Dog is truly an old and historic breed, well rooted in the New World. There are hundreds of documented human rescues by heroic Newfoundland Dogs in North America, Europe, and Australia. The breed is still used by various water-rescue organizations and volunteers around the world.

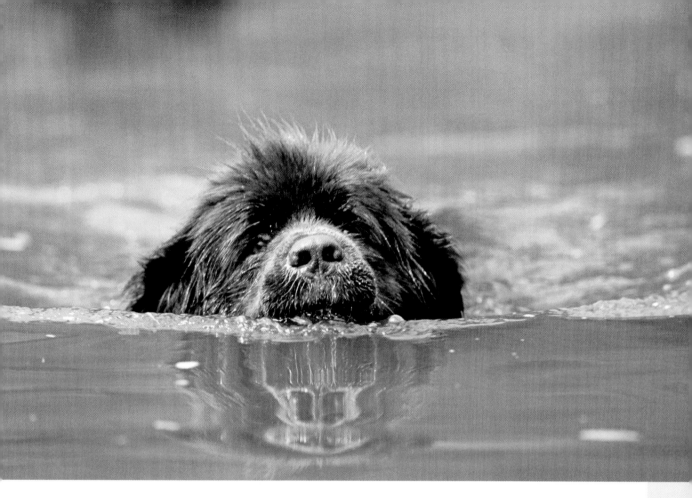

Many breeding kennels were established and the breed flourished. The first Newfoundland Dogs were exhibited at a show in England in 1860. The English breed standard would eventually come to influence other standards worldwide. Newfoundland Dogs were also used in the development of several other European breeds and the restoration of the St. Bernard.

By the mid-nineteenth century, the gentle giant was the subject of much artwork and literature, including the famous paintings of Sir Edwin Landseer, which often depicted brave, lifesaving Newfoundland Dogs. This link was so established in the mind of the public, that Landseer became the official name for the black-and-white Newfoundland Dogs.

Although by the late nineteenth century, the black Newfie had become far more popular. During and after both world wars, food rationing drastically reduced the numbers of giant breeds in Britain. This was followed by a very slow recovery. Today about 1,000 pups are registered yearly.

Across the Ocean

Newfoundland Dogs were both taken down into the United States from Canada, and imported from Europe, where they were used not only as water-rescue dogs but, more often, as family companions and show dogs. During the nineteenth century, the Newfoundland was widely believed to be a near perfect family dog and was found in the homes across the country. The AKC recognized the breed in 1886, with the first Newfoundland Dog club established in 1914. The Newfie remains a popular family dog with about 3,000 dogs registered yearly.

The first Newfoundland Dog arrived in Australia in 1788, on a convict transport ship from England, but more Newfies did not make their way down under until 1864. Bred in small numbers, registrations stopped after World War I. New dogs were finally imported in the 1960s. Since then, numbers have grown slowly, and the breed remains relatively rare. There are a few breeders in New Zealand as well.

Portuguese Water Dog

Also known as Cão de Água, PWD, Portie

Origin	Portugal
Size	**Male** 20 to 23 inches, 42 to 60 pounds **Female** 17 to 21 inches, 35 to 50 pounds
Coat	Tightly curled or long, wavy hair
Color	Shaded black or brown, or solid white; in dark coats, white is permissible in specific areas
Temperament	Independent, dominant, moderate to high energy, willing, upright, loose eyed

Bred exclusively as a working animal until the 1930s, the PWD remains spirited, energetic, courageous, and hardworking.

He has long been regarded as a self-willed dog with a strong disposition who respects his owner and forms deep attachments. Although tending to form a tight bond with a single person, he is also able to extend his loyalty and affection to his "crew mates" in a wider family situation. The Portie thrives on attention and needs people to the point that he can develop separation anxiety if left alone for long periods. The breed is good with children and family pets, although younger dogs may play somewhat rough.

The original standard described the tough Cão de Água as a "brawler by nature" but this is no longer true. Breeder focus has been toward improving its companion-dog traits and lessening some of the harder nature. While alert, protective, and cautiously suspicious, these dogs are not aggressive and make poor guard dogs. Although it can be sensitive to harsh treatment, the PWD is still a dominant breed that requires positive training and guidance in appropriate behavior. It is also a vocal breed that when left alone may become a problem barker.

Working traits. The PWD adores retrieving and water work. Water trials in Portugal are more demanding than in North America. Working in the ocean with waves and rougher surf, PWDs demonstrate their capability in rescuing and towing one or more adults to shore. The retriever instincts do lead to mouthiness, especially in puppies.

Although the breed is not a recognized herding dog, its close cousin, the Spanish Water Dog, remains an excellent herder and his ancestry does lie in herding stock. The tougher instincts are somewhat diminished as breeders aim to soften the temperament, although they are still found in some dogs. Porties may lack the ability to work with cattle, and individual dogs may lack a natural interest in stock. Where the breed is used successfully, it is primarily as a loose-eyed, upright worker on sheep or ducks. The PWD is willing, and attentive and has a desire to please his

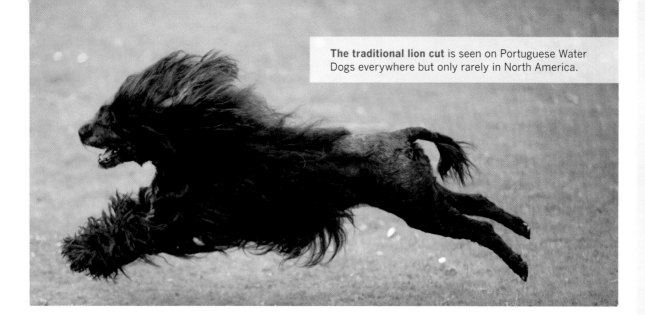

The **traditional lion cut** is seen on Portuguese Water Dogs everywhere but only rarely in North America.

owner. He can make a good dog for someone who needs a helpful, obedient dog to assist with herding.

Appearance

With his profuse coat, the Portuguese Water Dog can appear larger and thicker than he is. Slightly longer than he is tall, the PWD is almost square in outline. He is a medium-sized dog with strong bone and a rugged appearance. The breed has become somewhat taller in recent years due to better nutrition and health care. Breeders do not want the breed to become overly large for function but regard balance as more important than absolute size requirements.

The head is large for the breed's size, with a broad skull. The eyes are medium-sized, a bit oblique, and preferably dark. The ears, heart shaped and thin, are set well above the line of the eyes; they lie flat against the head and should not drop below the jaw line. The long tail is an essential feature of the breed. The base is thick but tapering, shaped like a scimitar, and used when the dog is swimming. When the dog is alert the tail rises into a ring held above the back.

Coat. The PWD has a single coat without a mane, ruff, or any undercoat. The coat has long been seen in two varieties — wavy or curly. In the curly coat, the shorter hair falls in dense, compact, cylindrical curls all over the body, including the top of the head. The hair on the ears may appear wavy. In the wavy coat, the longer, straighter hair displays a greater sheen or luster, falls more gently in waves, and is woolier in texture. The hair on the head is more upright.

In Portugal and everywhere except North America, the only acceptable trim for the coat is the traditional lion cut, which appears different on the two varieties of hair coat. In the United States and Canada, a more natural retriever clip, with the hair trimmed to about 1 inch in length all over the body, is also permissible and is often the choice of owners for practicality. The coat must be brushed thoroughly to prevent mats. In both clips, the hair on the tip of the tail is left in a long plume. The PWD's coat is not suitable for living outdoors in a cold climate.

Color. The PWD color palette includes black or brown in various shades with or without white on the muzzle, topknot, neck, chest, belly, tip of tail, and lower legs. White dogs are found although actual white is rare and the majority of white dogs are actually cream or pale yellow with a black nose, mouth, and eyelids. Historically, the breed was primarily black although brown was present. In North America, black or black-and-white dogs are the most common.

History

Portugal, Spain, France, Germany, and nearby European areas were the historic home of the old medium-sized *barbet* and *pudel* dogs — longhaired dogs with curly, wooly, or corded coats. Originally herding dogs, some offshoots were used as waterfowl retrievers. There are genetic links between the Portuguese Water Dog and his cousins the Spanish Water Dog, the French Barbet, the Irish Water Spaniel, and the Poodle. The earliest record, dating to 1297, describes the rescue of a fisherman by a dog with "a coat of rough, black hair, cut to the first rib and with a tuft on the tip of his tail." This account is remarkably close to the description

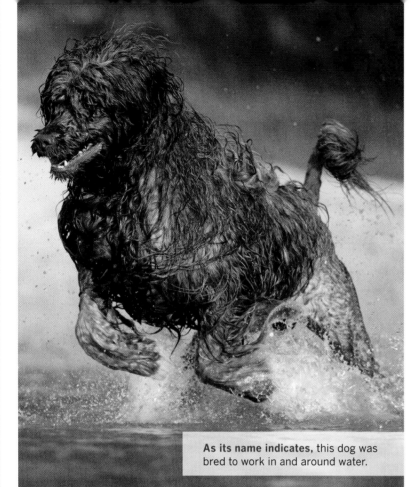

As its name indicates, this dog was bred to work in and around water.

Outside of Portugal

It was fortunate that the Portuguese Water Dog or PWD, as he is known outside of his homeland, had been exported to several new homes in Scandinavia, Germany, and the United States. Founded in 1972, the Portuguese Water Dog Club of America breeders began with a small population of dogs that grew steadily. By 1982, they numbered over 500, and dogs were being exported back to Portugal, contributing valuable lost genetics to the original population. Forty years later, there are almost 16,000 PWDs in the United States, and the breed is flourishing in its homeland as well.

PWDs are now found in Finland, Germany, Norway, Sweden, Australia, and elsewhere in Europe, although in smaller numbers. The Portuguese Water Dog Club of Great Britain was founded in 1989, gaining KC recognition. Four years later, a breed club was organized in Canada and the breed was recognized by the CKC. The First International Congress of the PWD was held in 2013, a positive sign of the cooperation and communication breed fanciers have for the health and welfare of their dogs.

Public visibility for the breed was certainly aided by two well-known PWD owners, Senator Ted Kennedy and President Barack Obama, who received his first PWD dog as gift from Senator Kennedy. The White House dogs have become ambassadors for the breed in the United States. Popularity is a mixed blessing for any dog breed; however, the breed clubs are credited with stressing the true working nature of the breed, awareness of the breed's narrow gene pool, and proactive health testing of breeding dogs.

of the modern breed, which still wears the "lion cut" of past days, a symbol of power and might.

Living aboard fishing boats, his traditional work included jumping into the water to retrieve fallen equipment or tackle and nets that had come loose. At times, he helped to herd fish into nets or swam between boats carrying messages or towropes. As the early account described, he also helped save fisherman who had fallen overboard or from capsized boats. When the boats were docked, he served as the watchdog guarding the boat and equipment from thieves.

The *cão de água* (water dog) was seen as an invaluable partner, with his strong swimming and retrieving abilities. The native breed was long seen in two different types of coats, one longhaired and wavy coated, and the other more tightly curly coated.

By the mid-twentieth century, as a result of changes in fishing, the breed was primarily found in Algarve, which may be its birthplace. Motivated by concern over the falling population, Vasco Bensuade, the owner of successful shipping interests, secured dogs from Algarve in the 1930s. Brought to Lisbon for a breeding kennel, Benuade's favorite stud dog, Leao, figures in half the pedigrees of all modern PWDs. Other breeders joined in this effort and the Portuguese Kennel Club was an early supporter, as part of its active dedication to preserving native breeds. The first standard for the Cão de Água was written in 1938; however, by the 1970s the breed was still in dire straits.

Pumi

Origin	Hungary
Size	**Male** 16 to 18.5 inches, 22 to 33 pounds **Female** 15 to 17.5 inches, 17.5 to 28.5 pounds
Coat	Curly, wavy outer hair with soft undercoat
Color	Black, white, shades of gray, shades of fawn with or without black or gray shading
Temperament	Independent, dominant, highly reactive, high energy, willing, tenacious, loose eyed, driving, bite, grip

The Pumi is a demanding breed, combining the traits of herding, terrier, and protective dogs.

They need active owners who can meet the breed's restlessness and highly energetic nature. Most owners are involved in dog sports or other work with their dogs.

Pumik (plural) are loyal dogs who want to be with their families but are naturally aloof with strangers. They are generally fine with children, although they may attempt to herd them. Like their Puli cousins, Pumik are excellent watchdogs, naturally suspicious of strangers, protective, territorial, very vocal, and potentially reactive. They need firm, consistent training or they may tend to challenge their owner. They also need socialization to people and animals. They may be dog-aggressive with strange dogs and do better with opposite-sex family dogs. Being good ratters, they are not always reliable with small family pets or farm animals. They are motivated to both chase and kill.

Working traits. These dogs are very intelligent quick learners who are highly motivated to work hard. In all activities, they prefer working with their owner. Without lots of exercise and mental stimulation, this breed is prone to anxiety, barking, destructiveness, and aggression. In the right home, however, the bold, tenacious Pumi can be good multipurpose farm dog as a ratter, watchdog, and herder.

Pumik do well at herding instinct tests. Their herding style includes the use of their voice, with high drive, energy, and toughness. Less a natural gatherer, they excel at driving and holding, moving sheep with bounding leaps and charges. They strongly bite and grab. In Hungary they were used primarily with sheep and to lesser extent with cattle, and pigs.

Description

The Pumi is a square, small to medium-sized dog of moderate proportions. He projects a whimsical, clownlike expression. The muzzle or foreface is longer and narrower than that of a Puli, often with a small beard or mustache. Important to his appearance are his V-shaped, medium-sized ears, set high on his head. Erect and tipped, they are covered with long hair that grows out upwards. The eyes are oval and dark. The well-feathered tail must be of medium length, held high and arched over back when the dog is alert. The tail is not docked

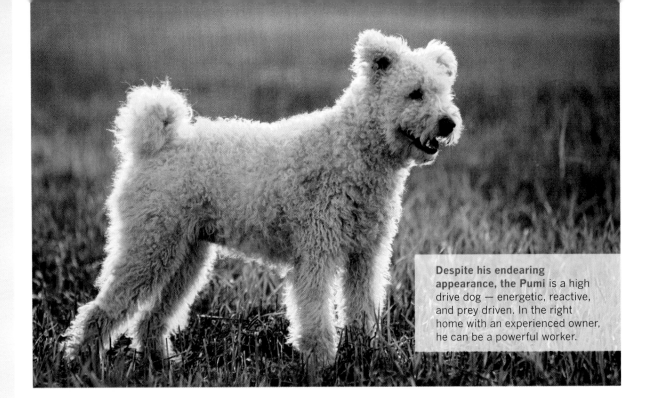

Despite his endearing appearance, the Pumi is a high drive dog — energetic, reactive, and prey driven. In the right home with an experienced owner, he can be a powerful worker.

although some puppies are born tail-less or bobtailed.

Coat/color. The double coat is curly and wavy, and 1 to 3 inches in length. The undercoat is soft and the outer hair is harsh. The coat should appear shaggy, not corded or smooth, although it can form corkscrew curls. It should not be trimmed other than on the face or legs. The recognized Pumi colors include: solid black; shades of gray; shades of fawn with or without black or gray shading or a mask; and white. A small white spot on chest is allowable as well as a sprinkling of other colored hairs in the coat. Gray dogs are born dark and lighten with age.

History

The Pumi's cousin, the dreadlocked Puli, is an old native Hungarian breed that was found throughout the country as the primary sheep-herding dog. As western European breeds began arriving in Hungary in the seventeenth century, they were crossbred with the native dogs. These European breeds came from Germany or from France and Spain, imported with Merino sheep. Several types or breeds, such as terrier, schnauzer, or spitz may have been involved. The result was a feisty, multipurpose farm dog capable of ridding the barns of rats and other vermin, herding the farm stock, and performing watchdog duties.

By the early 1800s, the word *pumi* was being used to describe sheepherding dogs, especially this little herding dog with a terrier-like head. The origin of the name is unknown. The little Pumi was often shown as a variety of the better-known Puli, just like the closely related Mudi. In 1915, Dr. Emil Raitsis, who was deeply involved in preserving native Hungarian breeds, described the Pumi as a "sheepdog terrier" and by 1927, the three breeds Puli, Pumi, and Mudi had been separated in the Hungarian registry.

Since the dogs had been so closely linked and even interbred, two completely different standards for the Puli and Pumi did not exist until 1960, with recognition by the FCI coming six years later. Over this time, the Pumi appearance and nature became more distinct from the Puli. The registry also remained open to working dogs without pedigrees.

Lacking the dramatic appearance of his cousin the Puli, the breed remained virtually unknown outside of Hungary until the 1970s when a few were exported to Finland. They quickly achieved success as agility and sport dogs, spreading to Sweden, Germany, the Netherlands, Italy, and finally to the United States in the 1990s. The Pumi soon received UKC recognition, and the Hungarian Pumi Club of America was founded in 2005. The AKC recently accepted the breed as well. Pumik are still rare in North America, but they have found homes as show, companion, and sports dogs. They are also well suited to the role they originally performed, as a general-purpose farm dog.

Rottweiler

RAHT-wy-lur or *ROTE-vile-er*	**Also known as Rottie**

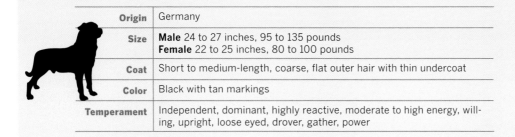

Origin	Germany
Size	**Male** 24 to 27 inches, 95 to 135 pounds **Female** 22 to 25 inches, 80 to 100 pounds
Coat	Short to medium-length, coarse, flat outer hair with thin undercoat
Color	Black with tan markings
Temperament	Independent, dominant, highly reactive, moderate to high energy, willing, upright, loose eyed, drover, gather, power

A well-bred, well-trained Rottweiler should be calm, confident, courageous, and steady.

Although dominant, this is very intelligent and highly trainable breed with a strong work ethic. Rottweilers are also independent, fearless, and highly territorial. They must be securely fenced, with experienced owners recommending a 6-foot fence as ideal. Consistent obedience training is required from an early age. A Rottie is a very strong, protective dog and must be under your control.

A Rottie needs up to one hour of vigorous exercise daily. Given sufficient exercise and mental stimulation, a Rottie should be quiet and well behaved in the house. He becomes very attached to his owner and does not do well confined and away from people. Neglect, mishandling, or abuse can lead to an overly aggressive dog.

Rottweilers are generally fine with existing family dogs if raised with them; however, they may have dominance issues as they become older and may not accept new dogs. Both sexes can be dog-aggressive, which neutering can lessen. Rotties may get along with other family animals, such as cats, but high prey drive is an issue in some dogs. Rotties should be supervised with children, as they may misinterpret play and running behavior.

Working traits. Besides dog sports, Rotties are well suited to carting, weight pulling, nose work, tracking, and many other activities. As herding dogs, their purpose was to drive cattle to market, handle cattle for butchers, and guard the stock and owner against theft. They are upright, loose-eyed dogs who gather and drive. They are forceful and aggressive with stock if needed. Although a Rottie may be a good companion on a farm, he is not a livestock guardian dog and is not suited by temperament or coat to live outside with stock.

Rottweilers are naturally protective and aggression should never be encouraged. Choosing to pursue additional protection training is a serious responsibility and requires expert instruction. Because the breed is so popular, choosing a breeder is very important. There are large numbers of poorly bred dogs with widely varying temperaments and great unpredictability. Clearly communicate your goals for a potential puppy, meet the parents, and avoid fearful, shy, or aggressive pups.

Description

The Rottweiler is a medium-large dog with a robust, powerful appearance. Males are more massive with heavier bone. The FCI standard for ideal size is located in the middle of the weight range at about 110 pounds, although dogs are sometimes bred larger and heavier. The head is broad between the ears, with a well-defined stop, and strong, broad jaws. The medium-sized ears are pendant and triangular. They are set high and hang forward with the inner edge held flat against the head. When the dog is alert, the ears, always uncropped, raise to level with the skull, broadening the appearance of the head.

The dark brown eyes are medium sized, and almond shaped and set moderately deep. The tail hangs naturally and rises to level when the dog is alert. Although the tail was traditionally docked very short, the German standard now describes a natural tail and docking is banned. The natural tail is becoming more common in North America, although the AKC still requires a short dock.

Coat/color. The Rottweiler is double-coated, with generally shorter hair, although the standard describes a dog with a medium-length coat. The outer hair is coarse, straight, and flat. The undercoat is primarily present on the neck and thighs and may be very thin or nonexistent elsewhere. Like his cousins the Sennenhunde, a Rottweiler can handle cool temperatures better than he can handle hot; although without a dense insulating undercoat he does not do well living outside in either very hot or cold climates.

A Rottweiler is always black with rich tan or rust to mahogany markings. The markings are found on the cheeks, muzzle, throat, chest, and legs and over both eyes and under the base of the tail. Different colors or coats are not more valuable for their "rareness" despite deceptive marketing.

History

In 73 CE, the Romans founded the settlement that would become the city of Rottweil, located today in southwestern Germany, near the border of Switzerland. The Roman army traveled its supply routes with cattle, as well as its droving, guard, and war dogs. After Roman rule and Frankish control, Rottweil became a self-ruling city and an important trade center. From the fifteenth century to early nineteenth century, Rottweil was a member of the Swiss Confederacy.

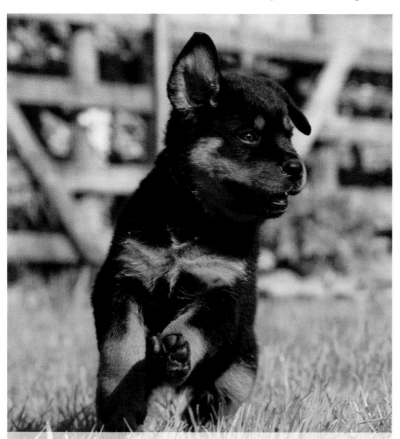

Very careful selection of a pup is essential due to the immense popularity of the breed. Meet the parents to assess temperament or behavior issues. Be honest with your breeder about your ability, experience, and plan to handle a highly dominant and reactive breed.

Although the Confederacy had political power, its essential mission was to manage trade interests and the trade routes through the Alps.

The Rottweiler *Metzgerhund* (butcher's dog) is clearly related to the old Swiss tricolored Sennenhund. Although these dogs are known primarily for their role as cattle dogs, they also lived on farms guarding the property, stock, or humans, and pulling carts for farmers or tradesmen. The use of these dogs for draft work was widespread across Western Europe. In the Rottweil area, there was much variation in size, conformation, coats, and color, as might be expected in a place of active trade and commerce. In addition to the familiar black-and-tan dog, dogs were seen in brown, slate gray, wolf-gray, red, and shades of tan, with black masks or red markings.

Efforts to separate out the various types and organize breeding did not begin until late in the nineteenth century, just as many of these dogs were disappearing. The railroads came sooner to Germany than Switzerland, ending most transport of cattle on roadways and the use of dogs for draft work. By the 1880s, very few traditional Rottweiler dogs were to be found. However, there was also widespread European interest in developing new roles for the larger dog breeds for police and military work. In Germany, Belgium, and the Netherlands, the focus of specific breeds moved toward this purpose.

Various Rottweiler clubs were organized beginning in 1914, all seeking to develop and standardize the native type. They eventually came together to form the Allgemeiner Deutscher Rottweiler Klub in 1921, which remains the controlling authority for the Rottweiler breed and the worldwide standard. Rottweiler breeding in Germany and affiliated countries is strictly regulated with evaluation of breeding suitability, endurance testing, and obedience trials Rottweilers compete in Schutzhund trials with tests of tracking, obedience, and protection work.

In Germany today, Rottweilers are used by the police, military, and customs agencies. They are also used for rescue work. The original drover, herding, and property guardian has been primarily bred as a serious working dog and versatile companion for the past century.

More Recently

Exports to various countries began slowly in the 1930s but gained momentum by the 1970s. In Britain, Kennel Club recognition of the Rottweiler came in 1965. By the late '80s, the breed numbers had grown to more than 10,000 registrations annually, although the breed has seen a reduction since that time. The Rottweiler was introduced into Australia in 1962, with the same rapid growth in popularity seen elsewhere. In the '80s, more than 5,000 Rottweilers were being registered yearly, although this number has dropped considerably to fewer than 2,000.

The American Rottweiler Club was established in 1973. By the mid-1990s the Rottweiler was the second most popular breed in the AKC. At one time, registrations were as high as 70,000 dogs per year or more. By 2014, numbers had fallen to about 13,000 dogs. In addition to the official breed club, other German-affiliated Rottweiler clubs have been organized in North America, centered on German breeding requirements and Schutzhund or IPO working trials.

This explosion in the worldwide Rottweiler population was ultimately fraught with problems: far too many badly bred dogs; poorly prepared or inappropriate owners; and mishandled dogs all leading to temperament or behavior issues and some overly aggressive or poorly controlled animals. The Rottweiler breed developed a tremendous public relations problem, which has led to legal issues for the breed and negative perceptions from the public. The Rottweiler breed associations are now focused on educational efforts and the promotion of well-bred dogs.

A Rottweiler requires responsibility. This is not a dog for inexperienced owners who can't commit to continual training and socialization and who aren't willing to find an outlet for its intelligence and energy.

Schipperke

SKIP-er-key **or** *SKEEP-er-ker* | Also known as Schip, Skip

Origin	Belgium
Size	9 to 15 pounds average, 6.5 to 20 pounds permissible **Male** 11 to 13 inches; **Female** 10 to 12 inches
Coat	Medium-length, straight, thick outer hair with short undercoat
Color	Black (Belgium, USA, and Canada); other whole colors permissible (UK, ANKC, NZKC)
Temperament	Independent, dominant, high energy, high prey drive, willing, reactive, focus

Noted for his curious and energetic nature, the Schip is a busybody who wants to inspect everything his owners do all day long.

He is nearly tireless and highly tenacious when it comes to accomplishing something; this essential quality of the breed explains the nicknames "little black devil" and "little black fox." Schips can be excellent companions for active people — they are loyal, affectionate, and good with the children.

Schipperkes have always been noted for their strong watchdog nature. They are alert to disturbances, dedicated to patrolling their house or yard and barking sharply at anyone who approaches. They may snap at a person who they see as threatening something they are guarding. Schips believe they are actually much larger dogs and can be quite fearless.

They are smart, confident, and strong willed; they need socialization and training starting in puppyhood in order to become good family members. Without sufficient mental and physical activity, boredom may lead them to destructiveness.

Working traits. The Schipperke is a good ratter and hunter of small vermin. He makes himself quite useful in barns and is a favorite in horse stables. His high prey drive can make his behavior around small animals or pets questionable. Schips can live with other family cats or dogs, although they do best with opposite-sex dogs. They must be kept on leash or in a well-fenced yard, as they love to chase. Schips participate in all sorts of dog sports, and some dogs still display their herding instincts.

Appearance

Though small in stature and finely boned, the Schipperke is a solidly built, square dog. This is not a dwarf breed, and leg size should be in proportion to the body. The wedge-shaped head has a relatively short muzzle and small, erect, pointed ears. Traditionally, the tail was docked very short and formed an important portion of the breed's silhouette. In places where docking is illegal or breeders choose not to dock, puppies are sometimes born naturally bobtailed. Others have a stumpy, low-set saber, or high-set and curled tail.

Coat/color. The medium-length coat pattern is also distinctive and important in this breed. The longer hair forms a wide ruff, a long mane or cape, and culottes on the thighs. Elsewhere the hair lies close to the body, with short hair on the head, ears, front legs, and rear pasterns.

In Belgium, the standard specifies only solidly black dogs, which is the dominant color. The undercoat may be a dark gray but should not been seen through the outer hair. The FCI, AKC, and CKC standards agree with this color requirement while the British, Australian, and New Zealand standards allow for other solid colors.

Cream, fawn, gold, and chocolate brown are the most common nonblack colors, with apricot, blue, grey, and others very rare. Some breeders in North America have organized an alternative club to encourage the presence of other colors and undocked tails in the breed. Colored Schips are permitted in AKC competitions and all UKC events.

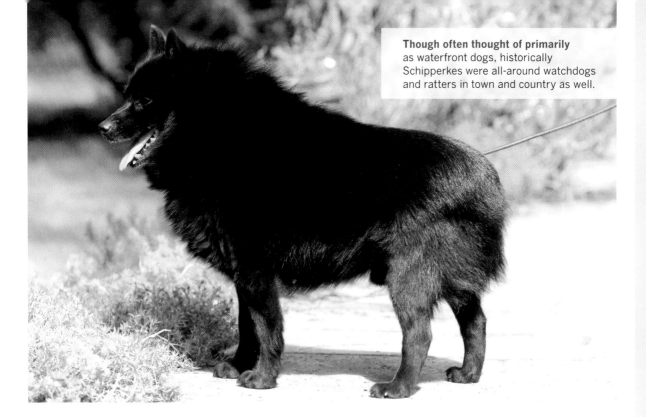

History

By the seventeenth century, this little dog was hard at work in the northern or Flemish areas of Belgium, as a watchdog and ratter on farms, in homes, and the shops or workrooms of guildsmen and artisans. In Brussels, owners outfitted their little companions with finely decorated brass collars and held competitions to show them off. One such event in the Grand Palace may have been the very first dog show.

This small helpful dog was sometimes called Spits or Spitzke (*ke* means small) and he did resemble other small spitz-type dogs found throughout Europe. In the same area, there was also a medium-sized, prick-eared, black Flemish *schaper* (shepherd) called the Leauvenaar. Schipperke may mean "small shepherd" and the Schip does have herding ability. In Flemish, *schipp* also means "boat" which led to the conclusion that Shipperke meant "little boat man."

Some Schipperkes did live aboard boats or barges, like the Dutch Keeshond, but most did not.

The Schipperke Club was founded in 1888 to protect the native breed, with a standard soon recorded with the Belgian Kennel Club. There was some difference in types among Antwerp, Brussels, and Louvain, but the decision was made almost immediately to focus on the distinctive coat of the robust little black dog with the bobbed or docked tail often found in Antwerp. Queen Marie-Henriette had adopted a Schipperke a few years earlier, extending the breed's admirers from the working and middle class to the upper classes.

The Schipperke quickly found homes in several other countries. Large numbers of exports combined with the losses sustained from two world wars reduced the population in his homeland, but today the Schipperke has regained its status as a national breed.

Across the Ocean

English tourists returned home with dogs called Schips or Skips, and organized the Schipperke Club of Great Britain in 1890. The foxy Schipperke became quite popular. Colors other than black were acceptable, with cream and gold also seen frequently. The breed spread to other commonwealth countries and elsewhere in Europe.

The first Schipperkes came to the United States in 1889 and they were entered in the AKC stud book soon after. In the 1920s, additional significant imports occurred and disagreement arose between kennels that followed the Belgian standard for color and coat and supporters of the English approach to accepting colors other than black. Two separate clubs existed for some time but the Belgian approach prevailed and the Schipperke Club of America was founded in 1929. Today about 600 dogs are registered annually.

Sennenhunde — The Swiss Mountain Dog Breeds

Appenzeller Sennenhund	Bernese Mountain Dog
Entlebucher Mountain Dog	Greater Swiss Mountain Dog

The tricolored mountain or cattle dogs of the Swiss Alps are collectively known as *Sennenhunde* or dogs of the Senn, the Alpine herdsmen.

They are typically tricolored dogs with shiny black as the primary color or mantle across the back; symmetrically edged by reddish yellow to rusty brown points; and white markings on the face, chest, feet, and tip of the tail. The two yellow to rust-colored spots over the eyes are called "four-eye spots," and they complement the "kiss marks" on the cheeks.

Sennenhunde were used in the Alps at least since the late Middle Ages, when cattle raising increased with the timbering of high forest land. They are related to the large European droving dogs such as the Rottweiler, as well as the shepherding and spitz dogs of central Europe. Further back, their origins may lay in the ancient Roman mastiff and drover dogs.

Although Sennenhunde are known primarily for their role as cattle dogs, they also lived on farms guarding the property, stock, or humans and pulling carts for farmers and tradesmen. Farming and dairying were traditional occupations in the Alps, where cows were moved to higher pasture and cheese making continued all summer. The smaller dogs were the agile herders, while the larger dogs were often found down in the valleys, protecting the farm, and hauling milk. Others were employed as butcher's dogs or for driving stock to market. The use of these dogs for draft work was widespread across mountainous Switzerland, where they served as the primary beast of burden.

The Sennenhunde began to disappear in the late nineteenth century, as the importance of traditional agriculture waned and transportation was modernized. At this time, the dogs were not recognized as separate breeds and existed in many different types, varying from valley to valley. Foreign breeds were increasingly brought into the country, often crossing on the native landrace breeds.

Efforts to separate out the various types did not begin until early in the twentieth century. Much of this effort was led by Albert Heim, a noted geologist in the Alps, who became a passionate supporter of the native Sennenhunde and promoted their recognition as separate breeds.

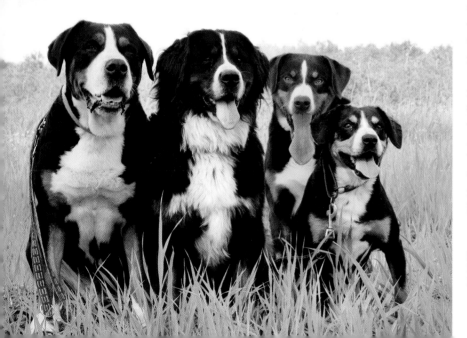

From the left: Greater Swiss, Bernese, Appenzeller, and Entlebucher

Appenzeller Sennenhund

APP-en-zel-er SEN-nen-hundt

Also known as Appenzeller Mountain Dog, Appensell Cattle Dog, Blass (blaze)

Origin	Switzerland
Size	55 to 70 pounds; **Male** 19 to 24 inches; **Female** 18 to 20 inches
Coat	Short, smooth outer hair with thick undercoat
Color	Tricolor black or Havana brown, with red-brown, and white markings
Temperament	Dependent, high energy, willing, drover, heeler, bite, bark

This family-oriented breed is an excellent farm or family guardian and a good herding dog who deserves greater popularity.

The Appenzeller is generally a good-natured dog with high energy and spirits. He bonds closely with his family; sometimes more closely with one person. He is affectionate and seeks attention, which may overwhelm small children. Friendly and outgoing as a pup, he often turns steady and quiet as an adult. He is an intelligent dog who responds well to training. At times his confident and self-assured nature can test his owner, but he respects leadership.

If ignored, treated harshly, or not socialized, he may become shy or aggressive. Obedience training is a must as he matures into a strong dog, one who enjoys jumping up to greet family members. All members of the family should participate in his training. He also needs socialization to farm stock and other family animals, although he may have issues with other family dogs or small pets.

Working traits. The Appenzeller is a good watchdog, naturally territorial and protective of home and farm. He barks at disturbances and is more suspicious of strangers than his cousins the Bernese or Great Swiss mountain dogs. He is comfortable living outside, which is how he was traditionally kept on farms, but he can live as a companion dog in homes with lots of space. He prefers to be watchful of his domain, although he deeply enjoys family attention and work. He needs to keep busy and is well suited for carting and weight pulling.

Despite occasional references to the Appenzeller as a livestock or flock guardian, the Swiss standard describes a cattle dog and watchful guard dog. In the mountains or on the road, he worked with his owner to protect stock from thieves. Still widely used with cattle in his homeland, he is a bold, high-energy cattle herder who uses his bark and bite at heels or nostrils to move cattle. Aggressive and tenacious, he is a good judge of stock movements. Tough, hardy, and with great endurance, he is a natural drover, and can tend a grazing herd of 40 to 50, or move larger groups on the road.

Appearance

Although similar to the other *sennenhunde*, the Appenzeller is distinctly different in some ways. Medium-sized to large and more square than rectangular, the Appenzeller has strong bone and a compact, muscular body. The head is more refined — wedge-shaped, with a slight stop and a moderate muzzle with a strong jaw.

The brown eyes are small, almond shaped, and slightly oblique. The small to medium-sized ears are broad and triangular with rounded tips. Set high, the ears hang flat and close to the cheeks, but they raise and turn forward when the dog is alert. The tail is set high and curls tightly over the back when moving, which is unique among the Swiss mountain dog breeds.

Coat/color. The Appenzeller has an easy-care short coat that is smooth, glossy, and close with a thick undercoat. The hair is straight, although slightly wavy hair on the withers and back is tolerated. He is tricolored black or Havana brown with symmetrical red-brown and white markings. The red-brown markings are located as spots over the eyes, cheeks, and

chest, and on the legs. A white blaze flows down the face reaching partially or totally around the muzzle, from the chin down the throat to the chest, with white on all four feet and the tip of tail.

History

The Appenzeller Sennehund is from the regions of Appenzell and Toggenburg in the eastern part of Switzerland. In the mid-nineteenth century, the breed was clearly described as a "short-haired, medium size, multicolor cattle dog of a quite even Spitz type . . . used partly to guard the homestead, partly to herd cattle." (*Animal Life in the Alps*, 1853) Appenzeller dogs were used by cattle dealers as a drover and by the *Senn*, or dairymen, who took their herds to graze in high summer pastures. The dogs served as herders and watchdogs of both the cattle and the huts. They also worked as butcher's dogs, as drafters, and watchdogs for the farm. At times they herded sheep and goats.

As the numbers declined, the earliest supporter of the breed was Max Siber, the head forester, who organized a government-funded breeding effort in 1895 to conserve the breed. Approximately 30 excellent dogs were located by searching the cattle markets and local farms. This effort had the active support of the local farmers, who remain the primary owners and breeders of these dogs today.

With support from Albert Heim, the Appenzeller Sennehund Club was formed in 1906. A stud book was organized and an official standard published in 1914. Although the other three Swiss mountain dog breeds have gained more popularity outside of the

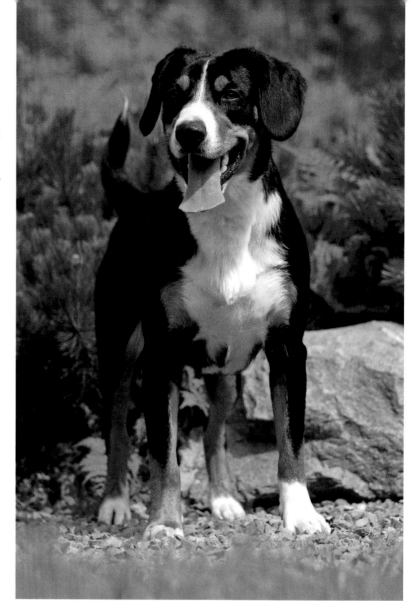

country, the Appenzeller is found throughout Switzerland as a companion, show dog, and working dog. He is also used in search and rescue, avalanche work, and tracking.

More Recently

The Appenzeller is still carefully bred primarily on farms and has retained strong working instincts. Before dogs can be bred, they must not only meet the standard, but also pass temperament testing and strict regulations for hip dysplasia. The breed is now found in small numbers in Austria, Germany,

France, Belgium, Netherlands, Denmark, and North America. Worldwide demand for the breed exceeds supply and Swiss breeders remain concerned that too many excellent dogs are being exported out of the country.

American and Canadian owners organized the Appenzeller Mountain Dog Club of America to serve as a registry for the newly imported dogs. The breed received UKC recognition in 1993 and was entered into the AKC FSS five years later. The breed remains very rare in North America.

Bernese Mountain Dog

Also known as Berner Sennenhund, Berner, BMD

Origin	Switzerland
Size	**Male** 25 to 27.5 inches, 80 to 120 pounds **Female** 23 to 26 inches, 70 to 100 pounds
Coat	Medium to longhaired, slightly wavy or straight outer hair
Color	Tricolor black with rich rust and white markings
Temperament	Dependent, low energy, willing, soft, drover

A Berner should be both confident and gentle; good temperament has long been a priority in this breed.

The Berner is loyal and devoted, forming close bonds with an entire family. He may develop separation anxiety if left alone for long periods. He is an intelligent dog who wants to please his owners. He enjoys mental stimulation and learning new things, and does quite well in obedience activities. Temperamentally, he can be a sensitive or soft dog, so all training should be positive and encouraging.

The Bernese Mountain Dog is an alert watchdog who sounds a loud bark but is not aggressive. Socialized dogs are polite with visitors, while unsocialized dogs are more likely to be shy or nervous. The Berner is typically excellent with children — gentle, affectionate, and tolerant — but can be too boisterous or mouthy when young. He is usually fine with other dogs, even small ones, and farm animals.

A Berner is slow to mature with some growth issues and an unfortunately short lifespan of just seven to eight years. Due to numerous potential health issues, it is extremely important that potential puppy buyers look for conscientious breeders who utilize health screenings.

Working traits. The Berner's energy level is low for a herding or working breed, and a minimum of 30 minutes or more walking or playing is sufficient for most dogs. Berners enjoy walking, hiking, carting, and weight pulling. The breed has a very low herding instinct, best described as gentle or mild but willing. As a family companion, the Berner is well suited to country life. He is good company during the day and can lend his support to moving small groups of stock to pasture.

Appearance

The lovely Berner is a large and strong dog but not stocky or massive. He has a gentle and kind expression. The skull is broad and flat, with a well-defined stop and a strong, straight muzzle. The dark brown eyes are slightly oval. The medium-sized ears are triangular and slightly rounded. Set high, the ears hang flat and close, although

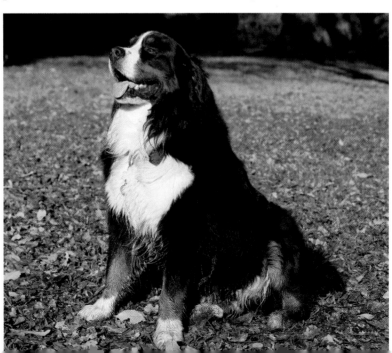

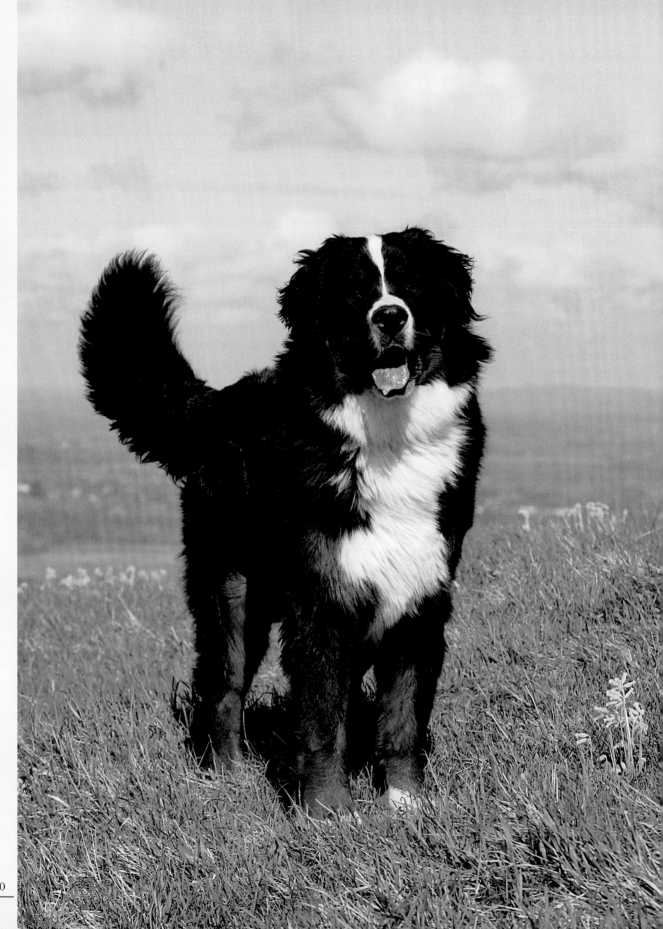

when the dog is alert they rise at the base and are brought forward.

The Berner is a dry-mouthed breed with only slight flews. It has a level back and a deep chest. The tail is bushy, long, thick, and tapering. When the dog is relaxed the tail hangs down and is carried level or slightly above when moving.

Coat/color. The Bernese is double coated with medium to long hair. The outer hair is thick, shiny, and straight or slightly wavy. His coat makes him appear larger and heavier than he is. Thorough grooming is required weekly as the Berner is a heavy shedder. The Bernese coat is not suitable for living outdoors since he does not do well in hot or humid weather, like the other Swiss Sennenhunde.

The classical tricolor coat is jet black, with rich tan markings above the eyes, on the cheeks, on each side of the chest, and all four legs. A white blaze runs down the foreface to the nose and includes a muzzle band. White color on the throat and chest usually forms an inverted cross. White is also found on the feet and the tip of the tail. While symmetry is desired, variations in markings are common.

History

Bernese Mountain Dogs were general-purpose farm dogs who acted as cattle herders, draft dogs, companions, and watchdogs. In the area around the city of Bern, the dogs that did this work were often referred to as *Küherhunde* (cow dogs). They assisted with moving small groups of cattle to farm pastures, but were not used as long distance cattle drovers or to take herds up into the mountain pastures. They were also used to deliver milk and cheese from the farms or tradesmen's goods to houses in the city.

The early Bern Sennenhunde were seen in various coats and colors — including red, yellow, or black; red and white; or red and yellow — but it is the classic black-mantled tricolor that was so distinctive, as well as his longhaired coat. At times the local farmer's dogs were called *Gelbbäckler* (yellow cheeks) and *Vieräuger* (four eyes).

All of the Sennenhunde began to disappear in the mid- to late nineteenth century with the adoption of truck and rail transport in mountainous Switzerland, one of the last European homes of traditional dogcarts. Beginning in 1892, Franz Schertenleib started searching for the old Bern farm dogs and found his first good specimen in the village of Dürrbäch. These striking dogs attracted the interest of other supporters, who also began to locate dogs and exhibit them in local dog shows. This native type was originally called the *Dürrbächler*.

Albert Hein, the Sennenhund expert, examined the dogs and encouraged the owners in their pursuits. The breed was ultimately renamed the Berner Sennenhund, to better represent the wider origin of the breed and the relationship to the other Swiss Sennenhunde. The following decades saw slow but continuous growth. After World War II, when there was some concern about the closed studbook, a single outside breeding to a Newfoundland Dog occurred and was later judged a successful outcross.

Growing Popularity

The popularity of the beautiful Berner spread throughout Switzerland and into Germany. Although the Greater Swiss Mountain Dog was initially more numerous, the Berner was the first Swiss mountain dog breed to gain a strong following outside of the country. The Berner arrived in Britain before World War II but did not establish a lasting foothold until the 1970s, when a breed club was established. In both New Zealand and Australia, Berner imports in the 1970s developed into a flourishing population as both show and companions.

The Berner was first imported to America in 1926. Ten years later, the AKC recognized the Berner Sennenhund as the Bernese Mountain Dog. In the 1960s and '70s the population began to grow steadily and the Bernese Mountain Dog Club of America was organized. In the space of 15 to 20 years, the breed began to register more than 3,000 dogs annually — a massive explosion of popularity in a brief time considering the size of the breed. This story was paralleled in Canada.

Extremely rapid growth in popularity always leads a spike in dogs being turned over to rescue. Many of the new owners were unprepared for the realities of owning a big, hairy dog. Great demand also leads to the production of lesser quality dogs by unscrupulous breeders and the resultant increase in medical issues. Berner life expectancy has gone down as the number of serious health issues has grown. Both the national breed clubs have risen to the challenges of this growth. Supportive of owners and prospective buyers, the clubs focus on education, rescue, and health research.

Entlebucher Mountain Dog

EHNT-lay-boo-kher | Also known as Entlebucher Sennenhund, Entlebuch Cattle Dog, Entles

Origin	Switzerland
Size	Weight proportional to height **Male** 17 to 21 inches; **Female** 16 to 20 inches
Coat	Short, hard, close outer hair with short dense undercoat
Color	Tricolor black with fawn to mahogany and white markings
Temperament	Independent, dominant, moderate to high energy, drover, heeler, bark, grip

Intelligent and willing, Entlebuchers are athletic, agile dogs who love to run or play. With moderate to high energy, they need a solid hour or more of exercise daily.

They make good jogging or biking companions and are well suited to active families. The breed is lively and high-spirited with its owners. Because they are very strong for their size and inclined to chase or nip, their play activity with children should be supervised.

Entlebuchers can also be dominant and pushy or a bit willful. They need obedience training but can be hard to motivate. Positive methods are best since the breed ignores harsh reprimands. As a herding breed, they bond with their owners and want to be with them at most times. They prefer to live inside and can develop separation anxiety if left alone for long periods. They are loyal and excellent companions on daily chores around the farm.

The breed can be protective and territorial, but with socialization and training most dogs are not aggressive, although they can remain aloof with strangers. They need fencing or they may chase cars, people, and other animals. Entlebuchers enjoy the company of another family dog, but not strange ones, and are usually good with other family pets.

Working traits. Entlebuchers are physical, bold, and assertive herders who nip, grip, bark, and push cattle. They are drovers and heelers with good endurance. They can also be used on hogs, sheep, and goats but may need to learn to be less aggressive with small stock. Owners report that they can also work as tenders, keeping stock in a prescribed grazing area.

Appearance

Though medium-sized, Entlebuchers are compact and muscled, making them very strong. Rectangular and with substantial bone, they project a friendly appearance. Dogs that are too small or too large are not well suited to herding purposes. The head is wedge shaped, with a broad skull and a very minimal stop. The muzzle should be strong, fairly long, and not pointed. The brown eyes are slightly small and almond shaped. The ears are triangular, rounded at the tips, and pendant. Set high on the head, they rise slightly and turn forward when the dog is alert. The tail may be long, bobtailed, or docked where permissible. It may be raised level but should not curl over the back.

Coat/color. The Entlebucher is a clean dog with a close, easy-care double coat. The outer hair should be hard, harsh, and shiny with a short, dense undercoat. Wavy or soft coats are seen but not preferable. Despite the short coat, this mountain breed is adapted to cold climates and is not suitable for hot, humid climates; it is very susceptible to heat stroke.

The coat is always tricolor, with black as the primary color. The tan markings may be shaded from fawn to mahogany and are located in specific areas: above the eyes; on the cheeks, muzzle, throat, and sides of chest; under the tail; and on all four legs. White markings are found as a small blaze that runs down top of head to nose partially or completely covering the muzzle; from the chin down the chest; and on all four feet and the tip of tail. An inverted white cross on the chest is desirable, as are symmetrical markings. Although traditional coloring is important, working ability and soundness should predominate.

History

The docked or bobtailed Entlebucher is the smallest of the Swiss mountain breeds, used primarily as a cattle dog around Lucerne, located in the Entlebuch Valley in the center of Switzerland. Until 1913, Entlebucher dogs were often lumped together with the larger and similar Appenzeller Sennenhund, but when Albert Heim and other judges saw four bobtailed Entlebucher dogs together at a show, they were convinced that this was a separate breed.

No dedicated breed club was established until 1926. Since that time and with FCI recognition, the breed's numbers have grown slowly but steadily, recently finding new homes outside of Switzerland and Germany. In their homeland, Entlebuchers are primarily companion dogs. They are now found in several European countries and North America, although they remain rare.

In the late 1980s, Andrew Luescher, a Swiss veterinarian, immigrated to Canada and began to import Entlebucher dogs. The CKC granted the breed recognition in 1989, followed by the UKC. The breed has found loyal fans throughout North America, based on its companion and working qualities. The National Entlebucher Mountain Dog Association now serves as the AKC parent club, where the breed is entered in the Herding Group. Most dogs are companions or show dogs, with very few working on farms.

Entlebuchers were not introduced to Britain until the early 2000s, but a club exists and members are working toward KC recognition. There are about 50 registered dogs in the UK.

Greater Swiss Mountain Dog

Also known as Great Swiss Mountain Dog, Grosser Schwiezer Sennenhund, Swissy

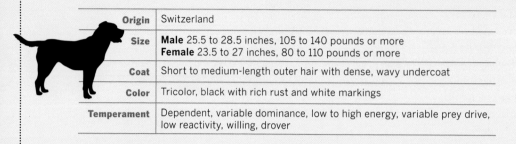

Origin	Switzerland
Size	**Male** 25.5 to 28.5 inches, 105 to 140 pounds or more **Female** 23.5 to 27 inches, 80 to 110 pounds or more
Coat	Short to medium-length outer hair with dense, wavy undercoat
Color	Tricolor, black with rich rust and white markings
Temperament	Dependent, variable dominance, low to high energy, variable prey drive, low reactivity, willing, drover

The giant Swissy is so attractive that many people assume he is a placid companion instead of the working dog he truly is.

His traditional work as a drafter, guardian, and droving dog can make for variable and competing instinctual traits. These traits can be expressed differently in individual dogs, so prospective owners should be prepared for a range of temperaments that could include the calm, steady drafter, the higher energy and prey drive herder, and/or the protective guardian.

A Swissy is usually quite trainable and willing, although the herding side of his nature can make him a bit pushy or dominant at times. It is vital that he learn how to walk on a leash. His eager desire to pull needs to be under control early because he grows up to be very strong. A Swissy also needs a leader or he becomes the leader, and he needs to respect and obey all the members of the family. Although large and strong, most Swissies attempt to be gentle and tolerant of children; young dogs, however, are boisterous until about three years old. The Swissy desires the close relationship and attention of his family and does not do well when

ignored or kenneled. Some dogs can suffer from separation anxiety with destructive results.

Swissies with stronger herding instincts also tend to have higher prey drive and less tolerance of other animals. This can lead to herding or chasing family pets, small animals, or children. Some Swissies have difficulties with same-sex dogs, although most tolerate another canine family member. He should be confined in a fenced yard when outdoors.

Working traits. Draft dogs are expected to be patient, steady, and nonaggressive. They should be socialized to accept introduced visitors, to behave well away from home, and to be tolerant of dogs and other animals. Swissies are still serious watchdogs; they are territorial, alert to disturbances, and loud barkers. If confronted by a real threat, they don't back down. They attempt to bluff, though they are not truly aggressive guardians. Swissies should be discerning in their reactions and have low reactivity.

Carting comes naturally to this breed and many Swissies enjoy the work. However, too much exercise at a young age can be damaging to the joints of a giant breed. Bloat is a real threat to this breed. Average lifespan is 8 to 10 years.

Herding instinct is extremely variable in the Greater Swiss, from a stronger cattle dog instinct to the gentle Bernese attitude. Dogs who have stronger herding traits also have high prey drive. Basically a drover, Swissies tend to work mildly with reluctance to bite or grip.

Appearance

A Swissy should look powerful and sturdy and be well muscled with heavy bone. Despite his size, he should be capable of work and agility. He should not be overly large or exaggerated in head or body.

The Greater Swiss has a gentle expression. The skull is flat and broad, with a slight stop and a large, blunt muzzle. The head is stronger in males. The brown eyes are medium sized and almond shaped. The medium-sized ears are triangular and gently rounded. They

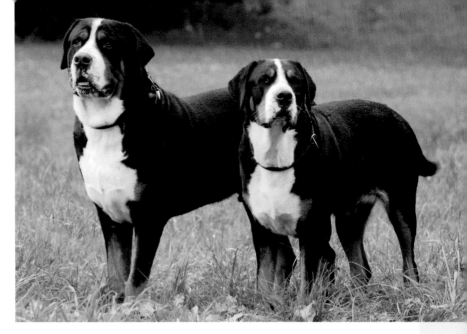

are set high on the head and held close unless the dog is alert. The Swissy should be dry mouthed with only slight flews. The tail is thick and tapers slightly; it is carried down, unless the dog is alert or in movement when it curves slightly upward but does not curl over back.

Coat/color. The Swissy topcoat is dense and short to medium measuring up to 2 inches in length. The short undercoat is thick and curly or wavy. The coat is definitely wash-and-wear, very weather resistant, and insulating, although these dogs are heavy shedders.

Greater Swiss are tricolored black with reddish-brown and white markings. The rich red markings are found over the eyes, on the cheeks, the undersides of the ears, both sides of the chest, all four legs, and underneath the tail.

The white blaze on the face can be of varying size and length. The blaze can meet with white patches or a white collar on the neck. White also runs from the throat to the chest, on all four feet, and the tip of the tail. Symmetry in markings is desired but less important than working type and ability.

History

Swiss *Sennenhunde* of this type were believed to be the most commonly used dogs in the mountain areas, even into the mid-nineteenth century. Draft dogs were in widespread use in Switzerland, as the essential and indispensable beast of burden in the mountainous countryside. Large draft dogs, hitched singly or in pairs, drew milk, cheese, market products, peddler wares, or other loads. These large dogs, known as *Metzgerhunde* (butcher's dogs), were also used by cattle dealers to guard and move cattle, and they served as a farmer's multipurpose dog.

Unfortunately, the *Metzgerhunde* were on the road to disappearance with the loss of their primary job as a drafter. In 1908, Franz Schertenleib brought two of these shorter-coated dogs to a show of longhaired Berner or Bernese Mountain Dogs. One of these dogs, Bello, was of great quality and beautifully marked. Albert Heim, the famed Sennenhund expert, saw the possibility of selecting this admirable type out of the greater variety of what he described as old-type butcher's dogs. Heim also named the breed the Grosser Schweizer Sennehund. Grosse means "great" in the sense that this is the largest of the Swiss Sennenhunde. "Great" or sometimes "Big" is used in Europe, but "Greater" is used in North America.

The Greater Swiss was soon recognized as a separate breed with the standard patterned on Bello. More dogs were found in the valleys around Bern and were entered into the registry without pedigrees until 1936. Through this time, breeders sought to develop consistent tricolor and coat quality while preserving a robust dog.

Developing the Breed

Breed numbers grew slowly. After it was used as a military drafter in World War II by the Swiss forces, the population was estimated at 350 to 400 dogs. While earlier crossbreeding with the Bernese Mountain Dog was inevitable as the breeds are closely related, it was done purposefully in the 1950s. The results were not viewed positively and that influence is now gone from the breed. With FCI recognition, the breed expanded beyond its traditional areas.

Greater Swiss Mountain Dogs arrived in the United States in 1968, and their population grew steadily. There has been an upsurge in interest since AKC recognition in 1995, with about 700 annual registrations. The breed is also recognized by the UKC and, more recently, by the CKC in 2006. Swissies made their way to Britain, where a club has been organized and the breed is on the road to full recognition by the KC, though numbers are still very low. The largest population of Swissies is now found in the United States, followed by Germany, Switzerland, and several other European countries.

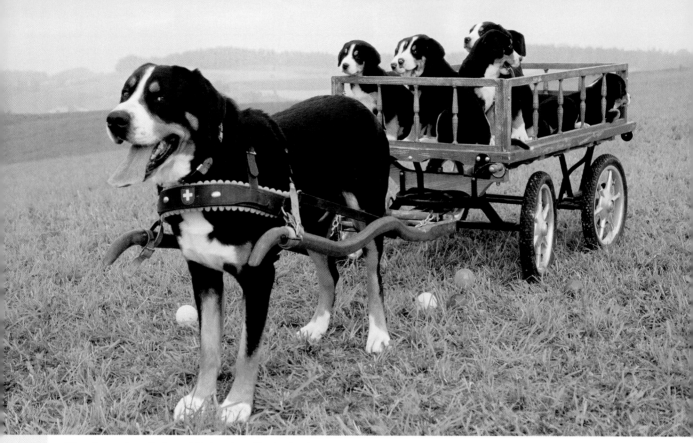

The strong, heavily boned Swissy is well suited to its traditional draft work, though few are required to make deliveries from dairies and bakeries these days.

The Saint Bernard

The Saint Bernard's roots certainly lie in the common heritage of the Swiss Sennenhunde, found throughout the mountains and valleys of the Alps. The Monastery at the Saint Bernard pass used the local dogs as watchdogs. By the early eighteenth century, the Hospice Dogs assisted the monks in providing aid to distressed travelers. As the dogs gained fame, they were exported and crossbred to a variety of breeds, such as the English Mastiff, Newfoundlands, and Leonbergers. As a result, very tall, massive, long-haired dogs became the norm in many places.

The breed gained its name in 1880, as it became established in many countries with different standards. Efforts to restore a more moderate type have been successful in some places, although the passion for very large Saints still exists.

The modern Saint Bernard is strikingly different from the original dogs. Saints are truly giants, with males standing 28 to 30 inches tall and weighing 140 to 180 pounds; females are some-what smaller. Even more massive Saints also exist. Both short- and longhaired varieties have a very dense undercoat seen in white and red or brindle. The strongly developed flews result in drooling. Size and health issues have left the breed with a lifespan of 8 to 10 years.

For nearly two hundred years, these dogs have been bred primarily as beloved companions and are not a true working breed. Saints should be affectionate, gentle dogs that bark at strangers but are nonaggressive. More moderately sized dogs with good physical conditioning can be active members of their families. They are not suited to living outdoors or working as farm or livestock guardians. Care needs to be taken to prevent overheating.

Soft Coated Wheaten Terrier

Also known as Irish Wheaten Terrier, Wheaten

Origin	Ireland
Size	**Male** 18 to 19 inches, 35 to 40 pounds **Female** 17 to 18 inches, 30 to 35 pounds
Coat	Soft and silky in wavy or loose curls
Color	Shades of light to golden reddish wheaten
Temperament	Variable independence, variable dominance, moderate to high energy, moderate to high prey drive, upright, loose eyed

There is a variety and range in temperament among Wheaten terriers. Some dogs are definitely less scrappy and aggressive, while others have more terrier-like attributes of gameness and pluck.

They also have varying levels of energy. Wheatens may become dominant, willful, or stubborn if not trained with consistent, gentle, yet firm leadership from puppyhood. All terriers were bred to be independent, intelligent workers, so it can be a challenge to channel their interest, although some owners find success in obedience or agility pursuits.

Wheatens tend to be more people oriented than some other terrier breeds but they still need good socialization to people and animals. Rather than demonstrating that typical terrier independence, some Wheatens may develop separation anxiety or destructive behaviors if left alone or underexercised. Affectionate and playful with family, Wheatens bark at strangers but are not generally aggressive. Raised and socialized with children, Wheatens tend to be friendly or playful, although like most boisterous breeds, they may not be a

good match for homes with very young children. Some Wheatens, however, positively adore children.

If raised and socialized with cats and other dogs, Wheatens may interact more peacefully than many other terriers, although they can show possessiveness of food or toys. Terriers are typically dog-aggressive, especially with same-sex dogs, so care should be taken with strange dogs.

Working traits. Wheatens naturally have a strong prey drive as well as the urge to chase small animals, cats, bicycles, or cars; therefore, they need a fenced yard. They remain dedicated hunters of mice, rats, rabbits, or squirrels and may not be safe with small family pets.

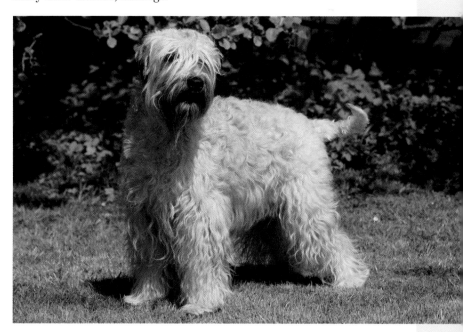

Wheaten owners in the United States are petitioning the AKC to accept the breed for herding tests, and the breed already successfully participates in AHBA and other club trials. Wheatens were traditionally used with cattle but are now working with sheep at trials. The Wheaten is an upright, loose-eyed herding dog who exhibits versatility and a gentle manner with animals.

Description

The Wheaten Terrier is a medium-sized and compact dog, tending toward a square outline. He should have a moderately long head, a flat skull, a defined stop, and a strong jaw and muzzle. The brown eyes are medium sized. Small to medium-sized ears are carried forward and should fold level with the skull. The neck is moderately long, the back strong and level, with the tail set and carried high, but not curled over the back. The tail is traditionally docked long but a natural tail is now permissible except with the AKC.

Coat. The single-coated Soft Coated Wheaten has abundant, long hair everywhere on the body, growing up to 5 inches if untrimmed. The hair should be soft and silky, falling in wavy to loose curls. It is generally trimmed shorter on the body and very short on the tail. There is profuse feathering on the legs and a long fall of hair over the eyes and under the jaw. Hair may be trimmed but is never plucked. Companion dog owners may choose to keep their dog in a more relaxed all-over puppy clip or a terrier trim.

Either way, the mainly nonshedding coat needs regular trimming and grooming to prevent mats. The facial hair is prone to becoming soaked with water and soiled with food. The soft coat attracts debris or dirt and needs regular bathing.

Color. The coat color is light wheaten to golden red wheaten, but neither red nor white. Occasionally, white, red, or black guard hairs may be found in the coat. The ears and muzzle may also show darker shading. Puppy coats, which may be darker or lighter at birth, change texture and color over a period of two to three years as the adult coat develops.

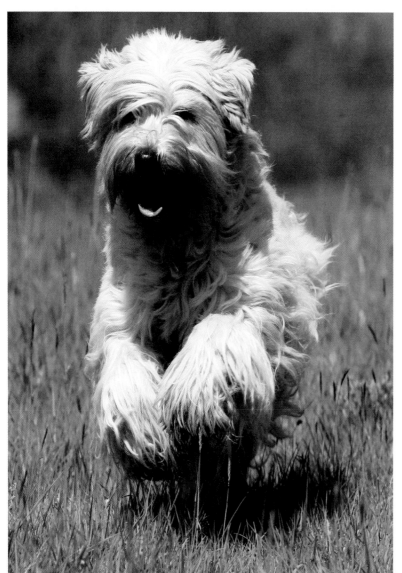

History

Gold- or wheaten-colored terriers, depicted in artwork and recorded in literature, have existed in Ireland for a considerable time, but only recently have they entered the show and companion world outside of Ireland. Their ancestors worked as all-purpose farm dogs, family companions, and watchdogs. They helped move cattle, killed mice and rats, and hunted vermin and small game. They remained a practical, utilitarian dog longer than some other terrier breeds, not attracting the interest of breeders until the 1930s, when they were possibly in danger of disappearing.

Supporters first suggested the name Irish Wheaten Terrier, but eventually agreed to avoid confusion with Irish Terriers with

a slight name change. The Irish Kennel Club recognized the breed in 1937. There was some controversy about overscissoring the natural coat of this tousled, open-coated terrier, leading to the decision that the breed would be shown only lightly trimmed. The Wheaten took his place as one of the national breeds of Ireland, where he remains well supported today.

The first exports were made to England during the early years of World War II, but the breed did not gain much attention until a breed club formed in 1955. Exports from Ireland increased in the 1950s and '60s, and soon after the breed achieved full recognition with the Kennel Club. With recognition of the Irish standard by the FCI, exports also began to the Netherlands and other European and Commonwealth countries. Numbers remain somewhat low but are growing, with about 400 Wheatens registered yearly with the KC and 90 with ANKC, in Australia.

Post–World War II

The postwar years saw the first documented imports of Wheatens to the United States, but the breed did not begin to flourish there until the mid-1950s. The breed club was organized in 1962 and about 10 years later achieved AKC and then UKC recognition. The Wheaten also became established in Canada at this time. The breed has steadily gained in popularity as a family dog, with some 2,000 dogs registered by the AKC annually.

Irish breeders contend there has been a divergence of temperament, type, and coat from the original breed's, primarily in North America, but also in England. Britain, Australia, and New

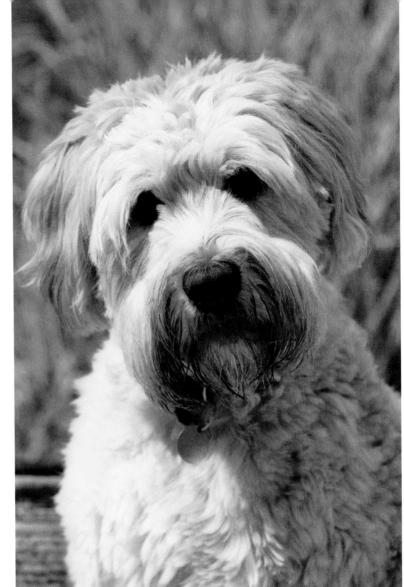

In Ireland, larger terriers traditionally worked as a multipurpose farm dogs — ratters, herders, watchdogs, and family companions. The roots of the Wheaten are firmly in this heritage.

Zealand follow the KC standard, while the United States and Canada have separate standards of their own. There has been some effort in North America to breed for a less game or aggressive terrier temperament, in order to develop a family companion dog.

In North America, Wheatens are also presented in the show ring with more groomed or sculpted coats. Some English and North American breeders have

now begun to breed for the original softer and silky Irish coats, believing that the American-style coats have become too heavy, too soft or cottony, and too high-maintenance for nonshowing owners to groom. Overtrimming has been strongly resisted in Ireland, where dogs are shown in tidy and terrier fashion but with a more natural, tousled appearance.

Standard Schnauzer

SHNOU-zer

Origin	Germany	
Size	**Male** 19 to 20 inches, 40 to 45 pounds **Female** 17 to 19 inches, 35 to 40 pounds	
Coat	Hard, wiry outer hair with soft undercoat	
Color	Shades of pepper and salt or solid black	
Temperament	Independent, dominant, moderate energy, high prey drive, hard, upright, loose to moderate eye	

The Standard Schnauzer has long been a family companion and protector who is loving and loyal to his people.

Owners report he forms close relationships with his family's children, although he may choose to protect them from other children. The Standard Schnauzer is a dog for an experienced owner who is capable of dealing with a dominant, independent, and strong-willed dog. It is important to establish leadership or the dog tends to take charge.

Consistent, fair, and firm training and socialization should begin early to ensure a well-behaved family member and canine citizen. Many Schnauzers have hard temperaments as well.

Standard Schnauzers are naturally protective, territorial, and suspicious of strangers. Owners caution the dogs are able to scale 6-foot fences. They are dog-aggressive regardless of sex, and are best suited to the role of only dog in the household. They may accept other family dogs but seek to establish dominance. They often do well with family cats but are not trustworthy with other small pets, such as rodents.

Working traits. Schnauzers are intelligent problem solvers who need their activities to be purposeful and stimulating. The breed is well suited to agility, obedience, and other dog sports. Schnauzers are eligible for herding tests and events due to their history of working with cattle. They work upright and close with a moderate to loose eye and bark to move stock. They also remain excellent ratters and hunters of small prey.

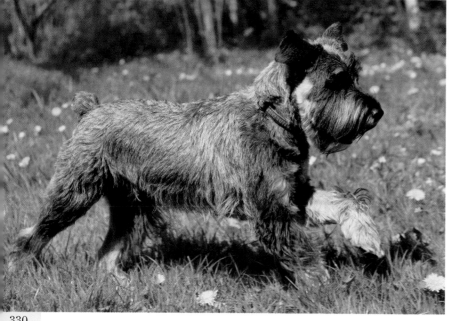

Description

A Standard Schnauzer should look sturdy and robust, with a square profile. His weight should be proportionate to his height. The head is strong and rectangular, with a flat skull, a slight stop, and a blunt, wedge-shaped muzzle. The whiskers on the muzzle

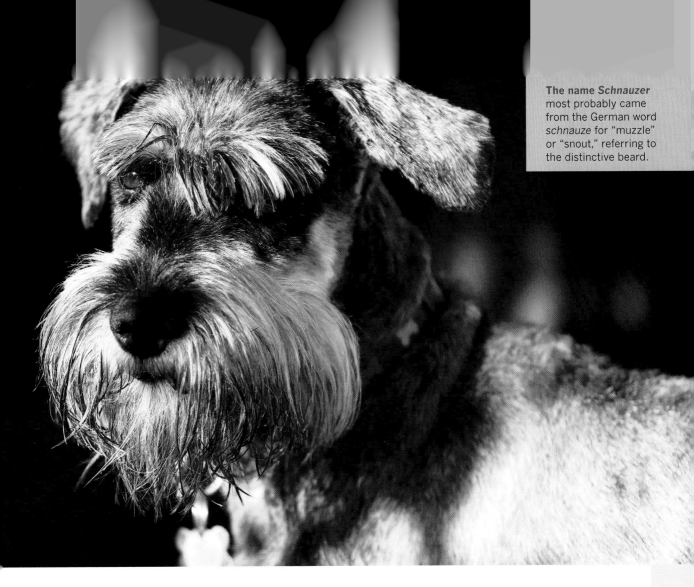

The name *Schnauzer* most probably came from the German word *schnauze* for "muzzle" or "snout," referring to the distinctive beard.

are trimmed to accentuate the rectangular head. The eyes are medium sized, oval, and brown. The brushy eyebrows should not impair the vision.

The V-shaped ears are set high. If not cropped, the ears are medium-sized and break at the skull level and are carried forward. Although some show breeders still crop ears to stand upright it is becoming more common to see the natural ear, especially in companion dogs. The topline has a slight slope downwards from the withers to the faintly curved croup. The tail is set moderately high and carried erect. If docked, length should be 1 to 2 inches.

Coat/color. The Schnauzer is double coated with harsh, dense, tight hair and a soft undercoat. Dogs are shown with longer furnishings on the legs and a beard and eyebrows on face. The rest of the coat is closely trimmed or stripped. If not stripped, the coat is trimmed more frequently. Frequent grooming is needed to keep furnishings clean and unmatted.

Standard Schnauzers are seen in shades of pepper and salt from dark to light gray, which is a mixture of white and black hairs or black-banded white hairs. Although very uncommon in North America, dogs may also be solid black with a black undercoat.

History

In existence in Germany since the Middle Ages, the schnauzers are not terriers but part of an old group of working dogs known as *pinschers*. They were employed as general farm helpers to protect house and yard, kill rats, and assist with moving cows on the farm or cattle to market. Often kept in stables, schnauzers were comfortable with horses. Farmers, merchants, and tradesmen used the schnauzer to protect their property at home and on the road. The dogs were also seen in a wide range of sizes. In more recent times, they were used for police and military work.

The Schnauzer was first called the Wirehaired Pinscher, and both smooth- and wire-haired puppies could still be born in the same litter through the mid-nineteenth century. At that time, they were among the most common dogs in Germany, a status that continues today.

As the Germans became interested in dog shows, the native breed was soon recognized, with the first standard adopted in 1880. The breed became popular in Europe very rapidly. During this time the breed was also divided into three sizes — the Miniature, the Standard, and the Giant.

The Wirehaired Pinscher, or Schnauzer, and the equally old Affenpinscher were the first pinscher dogs imported into Britain and North America. In Britain, the Kennel Club placed the dogs in the Utility Group, recognizing that they were not a British terrier breed.

In North America, they were placed in the Terrier Group, an error that was not rectified until 1945. The national breed club represented both the Miniature and Standard Schnauzer until 1933. After the two breeds were separated, the Miniature would go on to become a very popular breed. While the Standard has always had a devoted following, the breed registers only about 500 puppies annually.

Not a terrier, Schnauzers are members of the pinscher family of multipurpose farm dogs. With their energy and intelligence, they enjoy many activities.

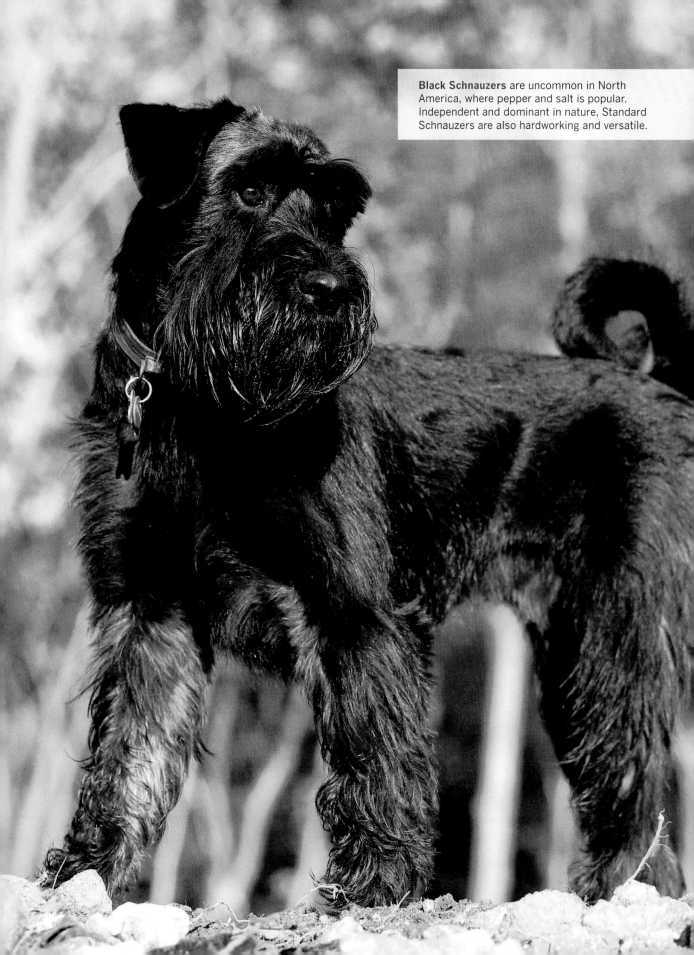

Black Schnauzers are uncommon in North America, where pepper and salt is popular. Independent and dominant in nature, Standard Schnauzers are also hardworking and versatile.

Acknowledgments

To my editor, Deb Burns, for her continued ideas, encouragement, and support.

So many friends and folks in the dog community have been incredibly generous with their time, knowledge, experience, thoughts, and friendship. The following friends will find many ideas and concepts here that they developed: Anna Abney, Tracy Bassett, Cindy Coombs, Orysia Dawydiak, Peggy Duezabou, Cedric Giraud, Mary Hughes, Sue Kocher, Louise Liebenberg, Margaret Mellor, Robyn Poyner, LaRae Pranter, Kathryn Ray, Sheila Reed, Deborah Reid, Tamara Rhoades, Stuart Dudley Richens, Ania Rynarzewska, Judy Simmons, Kim Snyder, Philip Sponenberg DVM, Heidi Stucki DVM, Cat Urbigit, Elizabeth Walters, Theresa Marie Keeney Wegner, and Cindy L. Wilber.

Thanks also for gracious assistance from Ilker Unlu, Janet Crock, Cindy Kolb, Frauzon Zekria, Sarah Bell, Jacqueline Chambers Zakharia, Cindy Kolb, Brendi Lelli, Tam Mrose, Pedro Mauricio, Lois Jordan, and Deborah Green.

Resources

Kennel Clubs and Associations

American Kennel Club (AKC)
akc.org

American Rare Breed Association (ARBA)
arba.org

Australian National Kennel Council (ANKC)
ankc.org.au

Canadian Kennel Club (CKC)
ckc.ca

Fédération Cynologique Internationale (FCI)
fci.be
Not a registry but the international association of kennel clubs and member countries.

Irish Kennel Club (IKC)
ikc.ie

The Kennel Club (KC)
thekennelclub.org.uk

New Zealand Kennel Club (NZKC)
nzkc.org.nz

United Kennel Club (UKC)
ukcdogs.com

Working Dog Associations

Herding

American Herding Breed Association (AHBA)
ahba-herding.org

American Tending Breeds Association (ATBA)
atba-herding.org

Australian Sheep Dog Workers' Association
asdwa.org.au

Australian Shepherd Club of America (ASCA)
asca.org

Canadian Border Collie Association
canadianbordercollies.org

International Sheepdog Society
isds.org.uk

Jack Russell Terrier Club of America (JRTCA)
therealjackrussell.com

New Zealand Sheep Dog Trial Association
sheepdogtrials.co.nz

United States Border Collie Handlers' Association (USBCHA)
usbcha.com

Verein für Deutsche-Schäferhunde (SV)
schaeferhunde.de

Working Terriers

American Working Terrier Association
awta.org

Barn Hunt Association
barnhunt.com

Irish Working Terrier Federation
iwtf.ie

National Working Terrier Federation (UK)
terrierwork.com

Dog Training and Behaviorists

American Veterinary Society of Animal Behavior (AVSVB)
avsabonline.org

Association of Professional Dog Trainers (APDT)
apdt.com

Canadian Association of Professional Pet Dog Trainers (CAPPDT)
cappdt.ca

Certified Applied Animal Behaviorists (CAAB)
Animal Behavior Society
*animalbehaviorsociety.org
/web/applied-behavior-caab
-directory.php*

International Association of Animal Behavior Consultants (IAABC)
iaabc.org

International Association of Canine Professionals (IAPC)
canineprofessionals.com

National Association of Dog Obedience Instructors (NADOI)
nadoi.org

Websites

American Border Collie Network
abcollie.com

The American Herding Breed Association
ahba-herding.org

American Kennel Club
akc.org

American Working Terrier Association
awta.org

Australian National Kennel Council
ankc.org.au

The Border Collie Museum
bordercolliemuseum.org

Canada's Guide to Dogs
canadasguidetodogs.com

Canadian Kennel Club
ckc.ca

Dogapedia
dogapedia.com

DogChannel.com
dogchannel.com

EasyPetMD
easypetmd.com

Fédération Cynologique Internationale
fci.be

Herding on the Web
herdingontheweb.com

Irish Kennel Club
ikc.ie

JaneDogs
janedogs.com

The Kennel Club
thekennelclub.org.uk

Leerburg
leerburg.com

Livestock Guardian Dogs
lgd.org

New Zealand Kennel Club
nzkc.org.nz

Old-Time Farm Shepherd
oldtimefarmshepherd.org

Sheepdogging for Newbies
littlehats.net

Working Aussie Source
Stockdog Library Page
workingaussiesource.com

Terrierman.com
terrierman.com
Website of Patrick Burns

United Kennel Club
ukcdogs.com

The Whole Dog Journal
whole-dog-journal.com

The Working Sheepdog Website
workingsheepdog.co.uk

Bibliography

American Kennel Club. *The New Complete Dog Book: Official Breed Standards and All-New Profiles for 200 Breeds*, 21st ed. i5 Publishing, 2015.

American Kennel Club. *Meet the Breeds: Dog Breeds A to Z*, 4th ed. i5 Publishing, 2013.

Antoniak-Mitchell, Dawn. *Terrier-centric Dog Training*. Dogwise Publishing, 2013.

Beauchamp, Richard G. *Anatolian Shepherd Dog*. Kennel Club Books, 2003.

———. *Welsh Corgis: Pembroke and Cardigan*, 2nd ed. Barron's, 2009.

Beregi, Oscar, and Leslie Benis. *Komondors*. TFH Publications, 1993.

Bradshaw, John. *Dog Sense: How the New Science of Dog Behavior Can Make You a Better Friend to Your Pet*. Basic Books, 2011.

Budiansky, Stephen. *The Covenant of the Wild: Why Animals Chose Domestication*. William Morrow, 1992.

———. *The Truth About Dogs: An Inquiry into the Ancestry, Social Conventions, Mental Habits, and Moral Fiber of* Canis familiaris. Viking, 2000.

Burns, Patrick. *American Working Terrier*. Printed by author, 2005.

Burton, E. Hywel. *Pembroke Welsh Corgi: A Comprehensive Guide to Owning and Caring for Your Dog*. Kennel Club Books, 2000.

Buzády, Tibor. *Dogs of Hungary*. Nora-Fonda-Herp Publishers, 2004.

Clutton-Brock, Juliet. *A National History of Domesticated Mammals*, 2nd ed. Cambridge University Press, 1999.

Coppinger, Raymond and Lorna. *Dogs: A Startling New Understanding of Canine Origin, Behavior & Evolution*. Scribner, 2001.

Coren, Stanley. *The Pawprints of History: Dogs and the Course of Human Events*. Free Press, 2002.

Cummins, Bryan. *Terriers of Scotland and Ireland*. Doral Publishing, 2003.

Cummins, Bryan, and Patricia Lore. *Pyrenean Partners: Herding and Guarding Dogs in the French Pyrenees*. Detselig Enterprises, 2006.

Cunliffe, Juliette. *The Complete Encyclopedia of Dog Breeds*. Parragon, 1999.

Dawydiak, Orysia, and David Sims. *Livestock Protection Dogs: Selection, Care and Training,* 2nd ed. Alpine Blue Ribbon Books, 2004.

De Vito, Dominique, with Heather Russell-Revesz and Stephanie Fornino. *World Atlas of Dog Breeds,* 6th ed. TFH Publications, 2009.

Derr, Mark. *Dog's Best Friend*, 2nd ed. University of Chicago Press, 2004.

———. *A Dog's History of America: How Our Best Friend Explored, Conquered, and Settled a Continent*. North Point Press, 2004.

———. *How the Dog Became the Dog: From Wolves to Our Best Friends*. Overlook Duckworth, 2011.

Derry, Margaret E. *Bred for Perfection: Shorthorn Cattle, Collies, and Arabian Horses Since 1880*. John Hopkins University Press, 2003

Dohner, Janet Vorwald. *The Encyclopedia of Historic and Endangered Livestock and Poultry Breeds*. Yale University Press, 2001.

———. *Livestock Guardians: Using Dogs, Donkeys, and Llamas to Protect Your Herd*. Storey Publishing, 2007.

Ewing, Susan M. *The Pembroke Welsh Corgi: Family Friend and Farmhand*. Howell Book House, 2000.

Frier-Murza, Jo Ann. *Earthdog Ins & Outs,* 2nd ed. VGF Publications, 2010.

Hall, Sian. *Dogs of Africa*. Alpine Blue Ribbon Books, 2003.

Hancock, David. *Dogs of the Shepherds: A Review of Pastoral Breeds*. Crowood Press, 2014.

————. *Sporting Terriers: Their Form, Their Function and Their Future*. Crowood Press, 2011.

Hartnagle-Taylor, Jeanne Joy. *Herding Dogs of the World*. Rope the Moon Publishing, 2014.

Hartnagle-Taylor, Jeanne Joy, and Ty Taylor. *Stockdog Savvy*. Alpine Publications, 2010.

Hobgood-Ostler, Laura. *A Dog's History of the World: Canines and the Domestication of Humans*. Baylor University Press, 2014.

Holland, Vergil S. *Herding Dogs: Progressive Training*. Howell Book House, 1994.

Howard, A. J. "Origins of the Australian Cattle Dog." 2009. Available online at: http://home.exetel.com.au/itsozi/images/ACD%20Condensed%20Web.pdf

Hounsell, Steve. *The Hungarian Kuvasz*. Kuvasz Club of Canada, 2013. Available online at www.kuvaszclubofcanada.org/ebook/intro.htm

Hubbard, Clifford L. B. *Working Dogs of the World*. Sidgwick and Jackson, 1947.

Kohlberg, Nancy, and Philip Kopper, eds. *Shetland Breeds; Ancient, Endangered, & Adaptable*. Posterity Press, 2003.

Kuvasz Club of America. "Kuvasz History." http://kuvaszclubofamerica.org/kuvasz/hist.

Levy, Joy C. *Komondor*. Kennel Club Books, 2007.

London, Karen B. and Patricia B. McConnell. *Feeling Outnumbered? How to Manage and Enjoy Your Multi-dog Household,* 2nd ed. McConnell Publishing, 2008.

Matheson, Darley. *Terriers of the British Isles*. Vintage Dog Books, 2005.

McCaig, Donald. *The Dog Wars: How the Border Collie Battled the American Kennel Club*. Outrun Press, 2007.

McConnell, Patricia B. *How to Be the Leader of the Pack . . . and Have Your Dog Love You for It!*, 3rd edition. McConnell Publishing, 2007.

Mehus-Roe, Kristin, ed. *The Original Dog Bible*, 2nd edition. BowTie Press, 2009.

Messerschmidt, Don. *Big Dogs of Tibet and the Himalayas*. Orchid Press, 2010.

Miklósi, Ádám. *Dog Behaviour, Evolution, and Cognition*, 2nd edition. Oxford University Press, 2015.

Milleville, Lynette Rau. *Hear My Voice: An Old World Approach to Herding*. Rowe Publishing, 2015.

Morris, Desmond. *Dogs: The Ultimate Dictionary of Over 1,000 Dog Breeds*. Trafalgar Square Publishing, 2001.

Moustaki, Nikki. *Kuvasz*. Kennel Club Books, 2007.

Oliff, Douglas, ed. *The Ultimate Book of Mastiff Breeds*. Ringpress Books, 1999.

Renna, Christine Hartnagle. *Herding Dogs: Selecting and Training the Working Farm Dog*. Kennel Club Books, 2009.

Riddle, Maxwell. *Dogs through History*. Denlinger's Publishers, 1987.

Serpell, James, ed. *The Domestic Dog: Its Evolution, Behaviour and Interactions with People*. Cambridge University Press, 1995.

Schwartz, Marion. *A History of Dogs in the Early Americas*. Yale University Press, 1997.

Tahtakiliç, Lesley and Margaret Mellor. *The Kangal Dog of Turkey*. Towcester, 2009.

Thurston, Mary Elizabeth. *The Lost History of the Canine Race: Our 15,000-Year Love Affair with Dogs*. Andrews and McNeel, 1996.

Trut, Lyudmila N. "Early Canid Domestication: The Farm-Fox Experiment." *American Scientist* 87, no. 2 (March–April 1999): 160–169.

Urbigkit, Cat. *Shepherds of Coyote Rocks: Public Lands, Private Herds and the Natural World*. Countryman Press, 2012.

Waldbaum, Laura. *Carting with Your Dog: Positive Draft Training for Fun and Competition*. Dogwise Publishing, 2011.

Wendt, Lloyd M. *Dogs: A Historical Journey*. Howell, 1996.

Credits

Index

Page numbers in *italic* indicate photos.

Boost Your Barnyard Knowledge

with More Books from Storey

by Paula Simmons & Carol Ekarius

Shepherds around the world look to this trusted volume for information on breed selection, lambing, feeding, housing, pasture maintenance, and disease prevention and treatment. Visit storey.com to learn about the other books in our best-selling Storey's Guide to Raising series.

by Carol Ekarius

Learn about 163 common and heritage North American breeds with this browsable guide. From the common Guernsey cow to the near-extinct Guinea hog, each profile includes a brief history and details the breed's unique qualities and quirks.

by Judith Dutson

Colorful photos and detailed profiles bring to life the 96 horse breeds that call North America home. This comprehensive volume includes ponies, donkeys, and mules, offering insight into the purpose for which each was bred and where it is now found.

Also by Janet Vorwald Dohner

Dogs, donkeys, and llamas can be the perfect solution to protecting your livestock from predators. This definitive resource offers comprehensive breed descriptions as well as tips on training, guardian-livestock bonding, and thorough problem-solving advice.

Join the conversation. Share your experience with this book, learn more about Storey Publishing's authors, and read original essays and book excerpts at storey.com. Look for our books wherever quality books are sold or call 800-441-5700.